Although Mrs Delany is best remembered for her captivating
paper collages of flowers, her artistic flourishing came late in life. This nuanced,
deeply researched biography pulls back the lens to explore Delany's art in the
broader context of her family life, her relationships with royalty,
and her endeavor to live as an independent woman.

Clarissa Campbell Orr, an authority on the eighteenth-century court, charts
Mary Delany's development from a young woman at the heart of elite circles to
beloved godmother and celebrated collagist. Orr traces the varied connections
Mrs Delany fostered throughout her life and which influenced her intellectual and
artistic development: she was friends with prominent figures such as Methodist
leader John Wesley, composer G.F. Handel, the writer Jonathan Swift, and England's
leading patron of science, Margaret Bentinck, Duchess of Portland.

Mrs Delany reveals its subject to be far more than a widow befriended by
George III and Queen Charlotte; it restores this ground-breaking artist to her proper
place in the aristocratic society of her era.

MRS DELANY

Mrs Delany
A LIFE

CLARISSA CAMPBELL ORR

YALE UNIVERSITY PRESS
NEW HAVEN AND LONDON

Published with assistance from the Annie Burr Lewis Fund.

The publisher is grateful to those who have given permission to reproduce works illustrated in this book. Any omissions are inadvertent and will be corrected in future editions if notification is given to the publisher in writing.

For information about this and other Yale University Press publications, please contact:
U.S. Office: sales.press@yale.edu yalebooks.com
Europe Office: sales@yaleup.co.uk yalebooks.co.uk

Set in Van Dijck MT by IDSUK (DataConnection) Ltd
Printed in Great Britain by Gomer Press Ltd, Llandysul, Ceredigion, Wales

Library of Congress Control Number: 2019941046

ISBN 978-0-300-16113-7

A catalogue record for this book is available from the British Library.

10 9 8 7 6 5 4 3 2 1

Contents

CONTENTS

Illustrations

12. Mary Pendarves by C.F. Zincke, *c.* 1740.

13. John Carteret, 2nd Earl Granville by the studio of William Hoare, *c.* 1750–2. © National Portrait Gallery, London.

14. Edward Young, 1770s. © National Portrait Gallery, London.

15. Bulstrode, *c.* 1781 by Samuel Hieronymous Grimm. British Library, London, UK / © British Library Board. All Rights Reserved / Bridgeman Images.

16. A marble bust of Patrick Delany by John van Nost the Younger. Reproduced by kind permission from the Board of Trinity College Dublin, The University of Dublin.

17. *A view of the Bridge and Grotto at Calwich* by Mary Delany, 1756. National Gallery of Ireland, Dublin.

18. Bishop Robert Clayton with his wife Katherine by James Latham. National Gallery of Ireland, Dublin.

19. A photograph of Wellesbourne Hall. Leamington Courier Collection held at Warwickshire County Record Office, PH(N) 600/522/2.

20. *A view of Hollymount in the road to Down Patrick* by Mary Delany. National Gallery of Ireland, Dublin.

21. *Delville fireside 27 February 1750/51* by Mary Delany. The Lilly Library, Indiana University, Bloomington, Indiana.

22. *A view of part of Ye little grove of evergreens at Delville wth. ye Country beyond it & Bay of Dublin* by Mary Delany, 1744. National Gallery of Ireland, Dublin.

23. *The Indian Seat at Wroxton* by Mary Delany. National Gallery of Ireland, Dublin.

24. A photograph of the Bath House at Wellesbourne Hall, exterior. Jill Tate.

25. A photograph of the Bath House at Wellesbourne Hall, interior. Jill Tate.

PLATES BETWEEN PAGES 238–239

26. Scarlet Geranium and Lobelia Cardinalis by Mary Delany, formerly in an album (Vol. V, 29), 1773. British Museum, Department of Prints and Drawings (1897,0505.529). ©The Trustees of the British Museum. All rights reserved.

27. *Mr Richardson ... reading to his Friends ...* by Susanna Highmore. Reproduced by kind permission of the Syndics of Cambridge University Library.

28. Jean-Jacques Rousseau with 'The Tomb of Jean Jaque Rousseau' by James Caldwall, published by Robert John Thornton, after Allan Ramsay, 1801. National Portrait Gallery, London.

ILLUSTRATIONS

29. David Garrick and his wife by his Temple to Shakespeare, Hampton, by Johan Joseph Zoffany RA, *c.* 1762. Yale Center for British Art, Paul Mellon Collection.

30. Sir Brooke Boothby by Joseph Wright, 1781. © Tate, London 2014

31. Richard Hurd, Bishop of Worcester, by Thomas Gainsborough. Royal Collection Trust / © Her Majesty Queen Elizabeth II 2019.

32. George III, Queen Charlotte and their six eldest children by Johan Joseph Zoffany, 1770. Royal Collection Trust / © Her Majesty Queen Elizabeth II 2019.

33. William Mason by William Doughty, after Sir Joshua Reynolds mezzotint, published 25 November 1779. © National Portrait Gallery, London.

34. Queen Charlotte, consort of George III, needlework pocketbook, 1781. Royal Collection Trust / © Her Majesty Queen Elizabeth II 2019.

35. BELUM.T771, The Delany Quilt, Mary Delany. © National Museums NI Collection Ulster Museum.

36. BELUM.T771, The Delany Quilt, Mary Delany. © National Museums NI Collection Ulster Museum.

37. BELUM.T771, The Delany Quilt, Mary Delany. © National Museums NI Collection Ulster Museum.

38. Leonorus Tataricus (Didynamia Gymnospermia) by Mary Delany, from an album (Vol. VI, 9), 1777. British Museum, Department of Prints and Drawings (1897,0505.509). © The Trustees of the British Museum. All rights reserved.

39. Delphinium Consolida (Polyandria Trigynia) by Mary Delany, from an album (Vol. III, 70); Common Larkspur, 1776. British Museum, Department of Prints and Drawings (1897,0505.271). © The Trustees of the British Museum. All rights reserved.

40. Carduus Eriophorus by Mary Delany, formerly in an album (Vol. II, 62); Cotton-headed Thistle, 1781. British Museum, Department of Prints and Drawings (1897,0505.163). © The Trustees of the British Museum. All rights reserved.

41. Spirae by Mary Delany, formerly in an album (Vol. IX, 34); a red meadow-sweet, 1778. British Museum, Department of Prints and Drawings (1897,0505.835). © The Trustees of the British Museum. All rights reserved.

42. Ononis Fruticosa by Mary Delany, from an album (Vol. VII, 17); Rest Harrow, 1778. British Museum, Department of Prints and Drawings (1897,0505.617). © The Trustees of the British Museum. All rights reserved.

43. Lobelia Cardinalis by Mary Delany, from an album (Vol. VI, 29); Scarlet Cardinal Flower, 1780. British Museum, Department of Prints and Drawings

ix

(1897,0505.529). © The Trustees of the British Museum. All rights reserved.

44. Gentiana Centaurium (Syngensia Poly. Frust.) or Lesser Centary by Mary Delany, from an album (Vol. IV, 57), 1774. British Museum, Department of Prints and Drawings (1897,0505.358). © The Trustees of the British Museum. All rights reserved.

45. Geranium Sanguineum by Mary Delany, from an album (Vol. IV, 58); Bloody Cranesbill. British Museum, Department of Prints and Drawings (1897,0505.359). © The Trustees of the British Museum. All rights reserved.

46. Passiflora Quadrangularis (Gynandria Pentandria) by Mary Delany, formerly in an album (Vol. VII, 56); Granadillos (Water Lemon), 1778. British Museum, Department of Prints and Drawings (1897,0505.656). © The Trustees of the British Museum. All rights reserved.

47. Phytolacca Icosandria by Mary Delany, formerly in an album (Vol. VII, 75); American Nightshade, 1778. British Museum, Department of Prints and Drawings (1897,0505.676). © The Trustees of the British Museum. All rights reserved.

48. Volkameria Lanceolata, Solandri (Syngenesia Polygamia) by Mary Delany, formerly in an album (Vol. IX, 99), from a drawing by Lady Anne Monson, 1780. British Museum, Department of Prints and Drawings (1897,0505.898). © The Trustees of the British Museum. All rights reserved.

49. Passiflora Laurifolia (Gynandria Pentandria) by Mary Delany, formerly in an album (Vol. VII, 54); Bay Leaved, 1777. British Museum, Department of Prints and Drawings (1897,0505.654). © The Trustees of the British Museum. All rights reserved.

50. Dianthus Superbus by Mary Delany, formerly in an album (Vol. III, 73); Feather'd Pink, 1774. British Museum, Department of Prints and Drawings (1897,0505.274). © The Trustees of the British Museum. All rights reserved.

51. Magnolia Grandiflora (Polyandria Polygynia) by Mary Delany, formerly in an album (Vol. VI, 57); the Grand Magnolia, 1776. British Museum, Department of Prints and Drawings (1897,0505.557). © The Trustees of the British Museum. All rights reserved.

52. Sarah Trimmer by Henry Howard, exhibited 1798. © National Portrait Gallery, London.

53. Leonard Smelt by Joshua Reynolds, 1755. Witt Library, Courtauld Institute of Art.

Acknowledgements

Throughout my academic career at the various incarnations of Anglia Ruskin University, I wrote numerous essays, articles, and entries to reference works, and edited, and was included in, several collections; but until Mrs Delany re-entered my life in the late summer of 2009, I had never written a monograph or contemplated a biography, in spite of quite a lot of my essays being built around a single figure. It seems appropriate now to acknowledge a few of the people whose example and advice led me to this exception that proves the rule, as well as mentioning gratefully the help and collegiality which have brought this project to fulfilment.

The first person I should mention is a teacher whose name I no longer remember, and who was not an historian or writer of any kind. For sixth form I attended King's High School for Girls in Warwick – yes, the female counterpart to the school attended by Mrs Delany's three nephews. It was re-founded in 1879 to add to the number of grammar-type schools for girls who wanted the same – or nearly the same – grounding in mathematics, classics and the sciences as their brothers had been receiving since AD 914. On Friday afternoons we were allowed to choose between art, music, sport and needlework; I chose the latter. We were not required to sew the same garment but whatever we had chosen, we had to make it to the highest standards of our teacher, who gave us plenty of expert tips. I was soon making a matching coat and dress for a family wedding; I can still recall the particular shade of blue I chose. But I took a short cut with the lining causing the top and bottom colour of the seams' lining thread, which would be completely invisible when the garment was finished, to have a white

as well as a blue thread. I had to undo this and start again with the correct colour on both pieces of material.

Well. This *was* a counsel of perfection! It made me realise that I might like the creative part best – choosing pattern and cloth, cutting out and fitting – but that you always need a third set of skills, the finishing off, and this is where I was inclined to tail off with a slapdash, 'won't this do?', attitude. But a benchmark had now been irreversibly set and, as skills are transferable, every piece of subsequent writing has made me switch gear into perfectionist mode and follow the guidance on referencing and bibliography required by different publishers. In the case of Yale I have been incredibly fortunate in a talented team. First came Marika Lysandrou, who kept a steady hand on the tiller throughout and quickly enlisted a typesetter when Microsoft upgraded and closed access to earlier versions. She also inaugurated the initial round of slimming my manuscript, and expertly advised on improving the Introduction. Rachael Lonsdale was an eagle-eyed and very patient editor, and Sophie Richardson not only sorted out systematic referencing but miraculously managed to shave off six words here and twenty words there to reach an appropriate word length when I could no longer see for looking. Finally, Matt James assisted with obtaining illustrations and permission to reproduce them.

Sparing the reader the full story of my intellectual formation at King's High School, I will mention only that the sixth form culture encouraged wide reading and engagement with current affairs, just as Mme LePrince de Beaumont did for her pupils, as the reader will find out. One thing we debated vigorously was C.P. Snow's essay on the two cultures, which made me recognise and regret how divided A-Levels were between the humanities and the sciences at that time. I was studying English, History and Latin at A-Level. But the literature curriculum was never restricted to a few set texts – we didn't even read them until the second year – so we all knew that Romanticism included a large number of writers, for instance Mary Shelley as well as her husband. (These days it's the reverse: most students know a lot about Gothic literature and Frankenstein, but are barely aware of Percy Bysshe either as a poet or a literary critic.) Much later, my Anglia Ruskin colleague Professor Nora Crook roped me into helping edit Mary Shelley's essays on French literature, leading me to delve into the era of Louis XIV and letter-writers such as Mme de Sévigné, and many other writers of the seventeenth century that Mary Delany knew and loved.

ACKNOWLEDGEMENTS

At King's High there was a cultural rebellion brewing against Oxford, which our headmistress had attended, and the Leavisite diet of Cambridge English – i.e. literature and its cultural and historical background. I abandoned the goal of Law and reading for the Bar. Part I English proved something of a disappointment but I knew that a Part II option existed in History and Philosophy of Science, which proved a tremendous gateway to the more rounded kind of cultural history I had been seeking. Eventually, I had the enormous privilege of studying for a year with Professor R.A. Leigh, the editor of Jean-Jacques Rousseau's correspondence, and one of the greatest European scholars of his time. Who knew that his magnum opus would help me understand the attractions of Rousseau to Mrs Delany's brother so many years later, and show me that a decent immersion in a collected correspondence would include not only letters to and from the main subject but also between third parties *about* the main subject. At this point I barely knew what I was doing – essentially a History of Science project – so it was very daunting when Professor Leigh commented that if I admired Voltaire so much, why didn't I emulate his wit? Imagine! I was only about twenty-four at the time! However, here was a second example of extremely high standards, this time of scholarship rather than needlework. And it turned out that Professor Leigh was a great cat-lover, so that made him seem less daunting. I hope that some Attic salt does get sprinkled through the pages these days too.

Later academic debts are owed to Roy Porter, who made me write on Swiss Romanticism; Jane Rendall for her mentoring on women's history; Mary Abbott for introducing me to family history; Frances Harris and Elaine Chalus for illuminating conversations; Amy Meyers and Amanda Vickery for roping me into an exhibition, then inviting me to be a Senior Research Fellow, at Yale Center for British Art; Jonny Yarker at Lowell Libson & Jonny Yarker Ltd, for helping me understand the eighteenth-century art world as well as the contemporary one.

On a more personal note, there are many friends I need to thank not just for being friends, in many cases for a lifetime, but for their practical help and wisdom. Chronologically, the first was probably Helen Sykes, whom I have known since we were both recent graduates needing to find our footing in the world of work. She established herself in East Sheen and has been a long-time hostess when I visited my many friends in south-west London over the years. It dawned on me eventually that however hard I tried I would never feel fully at home in Cambridge, despite the many advantages there were for my professional role, such as a first-

class research library for which I had borrowing rights a mere ten-minute cycle from my home, and a ten-minute walk to work. This was simply a geographical issue – I never felt at home under East Anglian skies. Eventually I recognised this was incurable and one New Year, we discussed the fact I should do some research about selling up in Cambridge and relocating to the Thames Valley. Within a year this came about and there I was, warmly welcomed into her vibrant extended household and neighbourhood. This included the gentlemanly Obi and the hyper energetic rescue-cat Pixie, who was expected to grow up lean and lithe but somehow turned out a little fuller of figure.

Helen swung into action as hostess and provider of invaluable contacts. First of all this meant that a terrific team of Polish craftsmen, headed by the inimitable Adam Jackowski, immediately started work and within a week I had a functioning library and a study. Grown women paled at the scale of unpacking that remained, as the house was much like a Rubik's cube: one could seem to sort things out in one area without much appearance of anything being assimilated. But it was a start, and eventually there was a net reduction of bag and baggage, and the rediscovery of my jewellery in the last box to be tackled. My house is en-route to the seventeenth century Ham House and the family that runs the ferry across the river still speak of Mrs Delany's cousins, the earls of Dysart, attempting to oust them in the 1880s as though it all happened very recently and not about 140 years ago. It is not improbable to think that Mary walked very near my home as she certainly knew the wife of one of her Dysart cousins and the 3rd Earl and Countess of Bute, who resided in the street parallel to mine. I am grateful for many warm welcomes in the neighbourhood, including from the Parry Wingfields, busy trustees of Turner's House, and the Reverend Jeff Hopkin Williams of St Mary's parish church.

Also deeply rooted among my acquaintances is the Hayward family, Charles, Julie and their sons Guy and Hugh, who after briefly living in Cambridge moved to Bath. I couldn't number my visits there in total, but they have often been combined with working visits when I was using the Lansdowne Archives at Bowood House near Calne, and later on the Newport Public Library where the manuscript versions of Mrs Delany's letters and autobiography are stored. I could not have asked for more congenial company to look at the manuscript originals and, as I am a non-driver, Julie kindly drove me to several Delany-related locales.

I am grateful to the vice-chancellor of St Mary's University, Twickenham, for accepting me as Senior Visiting Fellow, and to Professor Glenn Richardson

for facilitating this. It was invaluable to have all of Horace Walpole's correspondence available through open access and to have up-to-date IT for processing electronic proofs. Dr Emma Jay was the first to read the complete version of *Mrs Delany*, an heroic task given its original length.

As always, libraries and rare book collections have been indispensable adjuncts to all stages of research. I must thank the staff at Cambridge University Library, the Huntington Library (Brenda in particular) and British Library Prints and Manuscripts, especially Kim Sloan for a happy, sunny summer looking at the original paper-cuts pictures.

Granville Family Tree

SIR BEVILL GRANVILLE
d. 1643 for Charles I
at Battle of Lansdown

HON. BERNARD GRANVILLE

HON. BEVILL GRANVILLE

JOHN 1ST EARL OF BATH

GEORGE GRANVILLE cr LORD LANSDOWNE
=1713
MARY VILLIERS, widow of
THOMAS THYNNE, 1ST VICOUNT WEYMOUTH
owner of Longleat

SIR BEVILL GRANVILLE

BERNARD = **MARY WESTCOMBE**

ANNE *Maid of Honour to Queen Mary* = **SIR JOHN STANLEY**

ELIZABETH *Maid of Honour to Queen Mary* d. unmarried

GRACE, later
COUNTESS GRANVILLE and
VISCOUNTESS CARTERET
=
GEORGE CARTERET

BERNARD squire of Calwich, Staffs

BEVILL

MARY = (1) **ALEXANDER PENDARVES** = (2) **PATRICK DELANY DD**

ANNE = **DEWS** squire of Wellesbourne

JOHN CARTERET 2ND EARL GRANVILLE AND **2ND EARL OF BATH** STATESMAN
= (2)
HON. SOPHIA FERMOR
= (1)
FRANCES WORSLEY

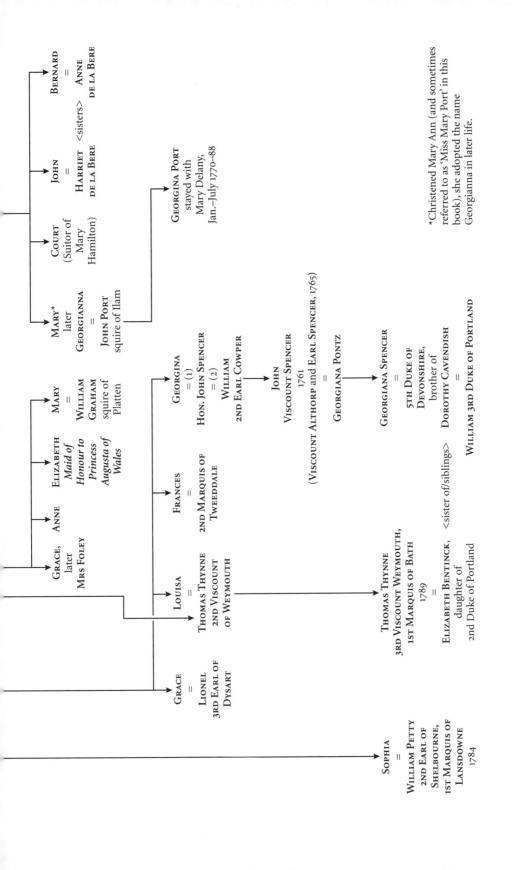

BERNARD
=
ANNE
DE LA BERE

JOHN
=
HARRIET <sisters>
DE LA BERE

COURT
(Suitor of
Mary
Hamilton)

MARY*
later
GEORGIANNA
=
JOHN PORT
squire of Ilam

GEORGINA PORT
stayed with
Mary Delany,
Jan.–July 1770–88

GRACE,
later
MRS FOLEY

ANNE

ELIZABETH
Maid of
Honour to
Princess
Augusta of
Wales

MARY
=
WILLIAM
GRAHAM
squire of Platten

GEORGINA
= (1)
HON. JOHN SPENCER
= (2)
WILLIAM
2ND EARL COWPER

JOHN
VISCOUNT SPENCER
1761
(VISCOUNT ALTHORP and EARL SPENCER, 1765)
=
GEORGIANA PONTZ

FRANCES
=
2ND MARQUIS OF
TWEEDDALE

LOUISA
=
THOMAS THYNNE
2ND VISCOUNT
OF WEYMOUTH

GRACE
=
LIONEL
3RD EARL
OF DYSART

THOMAS THYNNE
3RD VISCOUNT WEYMOUTH,
1ST MARQUIS OF BATH
1789
=
ELIZABETH BENTINCK,
daughter of
2nd Duke of Portland

GEORGIANA SPENCER
=
5TH DUKE OF
DEVONSHIRE,
brother of

<sister of/siblings>
DOROTHY CAVENDISH
=
WILLIAM 3RD DUKE OF PORTLAND

SOPHIA
=
WILLIAM PETTY
2ND EARL OF
SHELBOURNE,
1ST MARQUIS OF
LANSDOWNE
1784

*Christened Mary Ann (and sometimes
referred to as 'Miss Mary Port' in this
book), she adopted the name
Georgianna in later life.

Introduction

\mathcal{A} grey-haired woman, shrouded in black, Mary Granville Delany sits for her portrait. Superficially she seems isolated, impoverished and resigned to her fate as long-grieving widow. John Opie's 1782 painting of Mary as an elderly woman would memorialise her in history, but shows Mary in only one light, and, as such, misrepresents her.

Opie was not alone in perceiving Mary to be a poor, friendless widow. Her friend, Lady Louisa Stuart, when recollecting who had benefited from George III, drily observed:

> We are told that the king heard by chance of an old gentlewoman of the name of Delany in distress and made some provision for her . . . All in *charity* you would think – the old *gentlewoman* who bye-the-bye was née Granville and the last of that noble family had been familiarly known to the K and Q for several years, and peculiarly the object of their respect and affection.[1]

Mary was far from the charitable case she was made out to be by her later contemporaries – an image that has held fast in public perception. She was, in fact, a vibrant, multi-talented and well-connected woman throughout her long life. She was not solitary: she was constantly at the heart of family life and something of a matriarch with four nieces and nephews, several great-nieces and nephews and two godchildren who had children of their own. Mary took her role as godmother seriously, and among her own kin ensured the Granville name was preserved. Most importantly, in her later years, between

1

1772 and 1782, the time of Opie's portrait, Mary Delany invented an extraordinary new kind of flower portraiture by using collaged paper cut-outs on a black ground. This new art form in turn gave her great esteem in her circle of intimates, who also admired her skill as a letter-writer.

Mary Delany's collages are the achievement for which she is best known today, a result of Ruth Hayden's 1992 charming biography, still the best short introduction to her, and the 2009 Yale Center for British Art exhibition. But despite her success, Mary did not regard the collages as true art, and was always of a mind that friends like the connoisseur and scientific patron Margaret Cavendish-Bentinck, 2nd Duchess of Portland, or her sister Anne, were much more knowledgeable than she was about plants. Arguably, Mary even preferred collecting fossils and shells to making what became known as the *Flora Delanica*, twenty of which were given to the queen. Far from being the central achievement of Mary's existence, her paper cut-outs were a by-product of her life as an amateur artist working in oils, pencil and crayons, and as a talented decorative artist who enriched her homes and those of her friends.

As a young woman, Mary Delany defied expectation. She first became a widow at the young age of 24, and, instead of quickly remarrying as would have been the norm in Georgian society, soon adapted to single life and relished her independence. In about 1742 Mary's Anglo-Irish friend Anne Donnellan wrote a pen-portrait of Mary as a 'Contented Aspasia'. The term was derived from a legendary classical figure, the companion of the Greek statesman Pericles, but in the eighteenth century was used to denote a cultured, wise woman with great conversational gifts, and with no overtones of a sexual nature. But Mary's contentment was hard won, and seemed especially unlikely after her uncle, Lord George Lansdowne, had mismanaged her original marriage settlement.

As a happy single woman, Mary may not have had to earn her living in the modern sense, but she hated being idle and was extremely self-disciplined with her time. She was a keen observer of fashion and designed many of the dresses she wore at court. She was also as keenly observant of manners and morals as she was of landscapes pictures and gardens. She was a stickler for propriety but did not believe that being a good Christian meant leading an ascetic life. Being profoundly devout did not mean being dull. Mary was well-read and interested

in the status and education of women, the nature of marriage and even whether women ought to marry at all. The term 'feminist' had yet to be invented, but there were already conversations between moralists, opinion formers and theologians about how to regulate sexual behaviour and what made a happy marriage. These were directed more to women than to men, but questions about both sexes were in the air, and Mary never stopped pondering them and observing how variously women experienced wedlock. And so a portrait of Mary's life, and the circles in which she moved, sheds much light on the wider issues and debates of the day.

The first part of this biography will explore how Mary's talents developed and how her familial and personal resources, spiritual, intellectual and cultural, enabled her to become a pattern gentlewoman in a libertine age, an era that could be brutally exploitative of young women, many of whom were more vulnerable than Mary. She never found herself in financial straits (even so her relatives tried to obtain a courtier role for her, with a salary and a pension); indeed she was more worried about how to find formal positions and thus financial security for two of her Granville cousins. As to marriage, Mary had more than eight proposals during the course of her lifetime, and most of them were from entirely suitable and sometimes well-off suitors. But she turned them all down, sometimes to the annoyance of men who thought they knew what she wanted better than she did herself, and often to the frustration of her family.

The question then arises, if she was so happy to stay unmarried, what was it about Patrick Delany, an Anglo-Irish clergyman and noted public intellectual in Dublin, that in 1743 he persuaded her to change her mind? The second part of the book explores how Mary became an Anglo-Irish wife, how her new husband put his egalitarian principles into practice, how their marriage turned out, what their households in Dublin and County Down were like and how much her nieces, nephews and godchildren meant to her, as well as friends of long standing who recurred during her long life.

The third and final part of this book looks at how Mary became a matriarch, and how she ensured that the Granville name would be perpetuated. She was pleased to be an artist praised by Horace Walpole for inventing her new form of art. Not everyone in her extensive network of relatives and connections will be

discussed – if they were, this book would be too heavy to pick up – but I hope something of an intricate web of kin and friendship can be glimpsed, as well as the many-faceted character of her simultaneous interests, as we follow her dance through the music of time.

In 1861–2 Mary's great-great-niece Lady Llanover introduced her to the mid-Victorian reading public by publishing two substantial volumes of letters from the family's collection. This is a great resource, which will be drawn on throughout the book. Although the oeuvre has been endlessly cherry-picked for quotes on Georgian social and cultural life (frequently cited out of context by subsequent historians), it nonetheless sheds light on the wide number of figures Mary was related to and met, including the young John Wesley; the flamboyant Georgiana, 5th Duchess of Devonshire; and composers, writers and philosophers such as G.F. Handel, Jonathan Swift, Jean-Jacques Rousseau and Charles Burney together with his daughter Frances. The Llanover volumes present a rich selective picture, as so many intimate letters were destroyed because of conventions of decorum, and still others because they revealed too much of a patron–client society constantly engaged in string pulling. The biographer becomes constantly aware of these gaps, but nonetheless hopes her readers will enjoy this exercise in making Mary's wider context, and particularly her musings on marriage and family life, more evident.

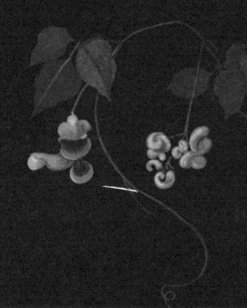

Part I

The Early Years

Miss Mary Granville

One morning in mid-November 1715 15-year-old Mary Granville was asleep with her 9-year-old sister Anne – they were sharing a bed, a very usual custom for the time – when her parents' house in Poland Street, London, was disturbed. Her first thought was that she was being woken up early to continue her sittings for a portrait commissioned by her father, but instead there were two armed soldiers in the room. 'I shrieked with terror, and started up in my bed. "Come, Misses," cried one of the men, "make haste and get up for you are going to Lord Townshend's"' – the new Whig Secretary of State, one of two responsible for security and foreign affairs. Mary recalls that as she cried out, the soldiers tried to calm her, and the maid was allowed in to help the sisters dress.

The sisters found that at least twenty soldiers had entered the house, and their mother was equally shocked and hysterical. Mary recalled that her father, Colonel Bernard Granville, tried to soothe the whole family. He knew that his imminent abrupt departure to the country, which had clearly been leaked to the authorities, was chiefly to economise.

At this juncture, Mary's aunt, Lady Anne Stanley, arrived, and insisted on being let in. A former Maid of Honour to Queen Mary II, co-monarch (1688–94) with her husband William (1688–1702), Lady Anne was now housekeeper, that is, manager, of Somerset House, the palace given to royal consorts – an honorary not a menial position. Her intercession was effective, and within a short time the girls and their parents were travelling along terrible muddy winter roads to the depths of the Gloucestershire countryside – a journey that took five days. Their glory days in the metropolis were over.

How had it come about that Mary's father was suddenly leaving London with his family in an apparently suspicious manner? His great-uncle, John, 1st Earl of Bath, had succeeded in getting ever closer to the centre of British politics and the royal court, and now a spate of deaths and childless marriages was bringing Mary's branch of the family close to inheriting his title. What had gone wrong? Answering these questions entails following of the intertwined fortunes of the Granvilles and the royal Stuart dynasty in the first fifteen years of Mary's life, and the reckless misjudgement of her uncle Lord George Lansdowne, which was at the root of the problem.

A WILTSHIRE CHILDHOOD

Mary's parents had been married since 1690 the year when King William's victory at the Battle of the Boyne in Ireland had secured the Protestant succession and prevented a French-supported invasion by the deposed James II from establishing any 'Jacobite' claims there. It would have seemed a propitious moment for a serving officer, albeit the youngest son of a younger son, to marry and become a 'spare' Granville, and to strengthen the family succession, from descendants of the 1st earl's brother. None of Bernard's brothers was married yet, and his eldest cousin John was childless. Bernard's bride was Mary Westcombe, daughter of the former consul in Cadiz, Martin Westcombe, who had been knighted for his services and had an estate in Gloucestershire. It is impossible to know whether this was a love-match or a partnership of strategic calculation or something in between, as almost no papers have survived. Young Mary's memory of the contrasting responses of her parents to the dramatic departure from London in 1715 is virtually the only description of the chemistry between the two: he affable and calming, she more highly strung – not a bad balance.

The silences about Mary Westcombe are, however, deliberate, since the marriage concealed a secret that remained hidden until research by Dr Francesca Suzanne Wilde in the papers of Mary's descendants. The fact is that it was Mary Westcombe's second marriage – and her first one had been very irregular, and not really a marriage at all: she had been a mistress of Ireland's only duke, the princely seigneur James Butler, 2nd Duke of Ormonde, who was also Bernard's former commanding officer.[1] All that can be gleaned from the surviving papers is that having wooed her as though he was single, some kind of financial settlement was made to Mary Westcombe, and

that this was deemed to be a dowry and/or a pension for Bernard's military services, to be paid from the Ormonde estates. Marriage of a regular sort was unavailable, as the duke was already married legally.[2] But it would be consistent with the code of honour of a man like Ormonde to treat his mistress as the gentlewoman that she was. Clearly Westcombe did not repudiate his daughter for her 'lapse' from strict virtue. When she and Bernard Granville married, her father allowed them to live in his house in London's Holles Street.[3] It must be underlined how fortunate Mary Westcombe had been to have had a surviving father who seems to have protected her interests, and to have found an affable spouse from a good family after her amorous interlude with a grand seigneur. Such was seldom the case for women, even gentlewomen, in her situation.

In 1700 when Mary, the third child of Col. Bernard and Mary, was born on 14 May, her parents were living in a small estate in a village in Wiltshire, two counties further east than the Granville family base, Stow, on the border of Devon and Cornwall, which had been lavishly rebuilt after the Restoration by the 1st Earl of Bath. East Coulston was about 25 miles south-east of Bath, which was already visited for its reinvigorating waters. Coulston was a tiny village of sixty-two adults in 1676.[4] Why her father had chosen to acquire or rent a small estate there is unknown. But one good reason was that it was only a few days journey from London, yet it was less expensive, and may only have been a summer residence when Parliament was in recess, before important families returned to the capital when parliamentary and legal life revived in November. Another reason for choosing Coulston was that it was the home of one branch of a large Cornish family, the Godolphins, with whom the Granvilles were well acquainted, through their overlapping networks at court and in the army, and this would prove congenial company for Mary's mother whenever her husband was absent.

The Granvilles and the Godolphins were both Norman French in origin, reaching Cornwall soon after the 1066 conquest. The latter's wealth derived from tin mines more than farming and their family seat was near Helston in the far south-west of Cornwall. If the Granvilles were known proverbially for their loyalty to the crown, the Godolphins were famous for their wit – a term used at that time to denote quick, adroit intelligence, not just a capacity to amuse. By 1700, an Elizabeth Godolphin and her husband and cousin Charles had inherited the Manor House in Coulston. They were childless but had adopted a great-niece of Charles's, whom they brought up as their own daughter. This was

not uncommon in the eighteenth century and would have been an early example to young Mary of how important a great-aunt could be. With further inherited wealth the Godolphin couple each founded a school; Elizabeth's was for the daughters of poor gentry, and still flourishes today as a private school for girls emphasising high academic standards and leadership qualities.

Charles Godolphin's brother was Sidney Godolphin, created 1st Earl of Godolphin in 1706, and one of the greatest statesmen of the era following the Glorious Revolution of 1689, described as 'Glorious' as it was relatively peaceful. James II had been ousted in favour of his daughter Mary and her cousin and husband William III. When out of office Godolphin mixed increasingly with the future Queen Anne, and her favourites, Sarah and John Churchill; once Queen Anne came to the throne, and with a strong recommendation from the Churchills, she made Sidney Godolphin Lord High Treasurer. A second key political figure after Godolphin was Robert Harley, who had all the vices and virtues of a deal-maker trying to hold contrasting strong personalities together in the cause of stability. In due course Harley's granddaughter, Margaret, would become the 2nd Duchess of Portland and Mary's great friend. The third in the 'Triumvirate' was John Churchill, soldier, diplomat and future duke.[5]

For Mary's parents it was exceptionally useful to know the kin of such a powerful statesman as Godolphin, who was also a man of great integrity, Anglican piety and devotion to the public administration. Although he was familiar with the libertine court of Charles II and not immune from its gambling mania, Godolphin found that his wife, the devout Margaret Blagge, had helped him keep his religious faith steady. Margaret had had a close platonic friendship with the horticulturalist and civil servant John Evelyn, and there was a member of the Evelyn family living in Coulston as well, to add to the small circle of the genteel.[6] In financial terms Mary's parents were not all that wealthy, but in social terms they belonged to a thick web of family connections formed from Cornish relatives, together with political and military associates. They would provide Mary not only with valuable 'social capital' in the form of useful connections at the top of British society, but also some genuine, lifelong friends.

WAR AND PATERNAL ABSENCE

Within eighteen months of Mary's Wiltshire birth, a series of deaths in her own family and those of the royal families in Britain, Spain and Germany quite liter-

ally changed her life and that of the nation. The deaths meant on the one hand that Mary's branch of the Granvilles came ever closer to inheriting the earldom of Bath; but, equally, as army officers, they were in danger of losing their lives in defending British claims to the throne. For the British, the first significant death was that of William, Duke of Gloucester, Princess Anne's longest surviving child, who died in 1700, aged 11, following his birthday party. Louis XIV now withdrew his prior recognition that William III was 'in fact' (de facto) the king on the British throne, by recognising as a superior claim that of James II's son, James Stuart, as the true heir by right (de jure). 'Jacobites' like Denis Granville, great-uncle of Colonel Granville and a high-ranking churchman, accepted this, and when James II died in 1701 Denis considered the rightful king to be James III, crowned or not, and in spite of his being a Catholic. He and some Anglicans believed they could not repudiate their allegiance to James II and his offspring while they were alive. But most English folk wanted to keep the throne Protestant and accepted Parliament's nomination of Sophia, Dowager Electress of Hanover, a direct descendant of James I, and *her* heirs as the rightful Protestant rulers, who would take over after Princess Anne succeeded her brother-in-law William on the English throne in 1702.

On the wider European stage, conflict was looming between the French dynasty, the Bourbons, still under the leadership of Louis XIV, in alliance with the Spanish Habsburgs, led by Carlos II in Spain, and their opponents in the Austrian Habsburg monarchy, led by Leopold I. Based in Vienna, the latter included a variety of inherited lands, such as the kingdoms of Hungary and Bohemia. Intermarriage between the two Habsburg branches had made Carlos infertile, crippled and an imbecile – but he had nonetheless been king for thirty-five years. As his death finally seemed imminent, various attempts to partition the vast and varied Spanish inheritance (which included land in the Americas as well as the Philippines) or to find a neutral candidate had failed, and when he actually died in 1700 Carlos opted to leave all the hereditary lands to either the French Bourbon candidate, Philippe, Louis XIV's younger grandson, or Leopold's younger son, Karl. For the English, this meant their chief political and colonial rivals, the Bourbon dynasty, would be ruling two powerful adjacent kingdoms. War with the Bourbons became almost inevitable, and the last years of William III's reign were spent constructing a military alliance between Britain, the Austrians and a number of German princes, including the Hanoverians, to challenge the Bourbons on behalf of Karl. As

John Granville said in Parliament in 1701 after the young Duke of Gloucester had died, the nation should rally 'for the safety of England, the Protestant religion and the peace of Europe'. In the new year he drew up an address pledging support against the claims of the 'pretended Prince of Wales' – that is the Jacobite 'James III' – and to reduce 'the exorbitant power of France'.[7]

The war that ensued, the War of Spanish Succession (1702–13), would establish Britain as one of the great powers of Europe. From having had few continental involvements, the country would begin to achieve an astonishing range of victories. Successful generals and admirals would attain peerages and wealth, so the war gave new opportunities, as well as risks. But equally significant for Mary's life, this war was the context in which her other uncle, the poet and playwright George, Lord Lansdowne, would move into a successful political career, serving eventually as Secretary at War – the minister responsible for the administrative support of the English military and naval forces – and get his own English peerage title at long last.

As with the European monarchs, the older generation of Granvilles was leaving the scene: in 1701, Mary's grandparents died, then her great-uncle John, the Earl of Bath since 1660 when the monarchy had been restored after the civil wars and the republican interlude of 1649–60. Great-uncle John and his cousin, General Monck, had been central to this Restoration and both had been elevated to the peerage.[8] As 1st Earl of Bath, John Granville successfully began reconstructing the Granvilles' wealth and standing. But the 2nd Earl of Bath, Charles, died two weeks after his father. With cousins John, Bevill and George all unmarried, Mary's father Bernard, and her eldest brother, also Bernard, moved closer to inheriting a peerage.

By the time Mary was 3 her father and uncle were once more on active military service. Bevill had gained the favour of William III during the Flanders campaigns, in the build-up to the war with Spain, and the king made him Governor of Barbados in the West Indies. The appointment was confirmed by Queen Anne, and in 1703 he set sail, taking his brother Bernard with him. Their tour of duty lasted until 1706, but sadly Bevill died on the voyage home, aged only 41. With Mary's father and other uncle on active duty as soldiers, George would be the acting head of the family. He now repositioned himself to enter political life, and also pursued his literary career as a poet and playwright. Mary would be as proud to be the niece of a writer who was considered to have inherited the mantle of the Poet Laureate, John Dryden, just as much as she was proud to

be the daughter and niece of brave soldiers. George had exquisite French manners, literary sensitivities and dreamy allegiances to a tiny handful of beloved, idealised mistresses. His literary talents were a political asset, as public issues could take cultural form, in various media – literature, plays, opera, even garden design.[9]

UNDER THE SIGN OF MINERVA: THE APPRENTICESHIP OF A MAID OF HONOUR

For Mary, her mother and her siblings, it must have been an intense relief to have Bernard home, unscathed. But it may also have been a challenge to assimilate him into the dynamics of their household. Mary was now 6, so those first formative years in any child's life had been spent without a consistent paternal presence. Paternal authority might well have been invoked in disciplining her, along the lines of 'your father will not like that kind of behaviour when he comes home', but exhortations to please an absent father, who may have seemed a very hazy figure in her life, may not have been all that effective. In her autobiographical fragment she recalled that her Aunt Anne found her impetuous as a teenager:

> Her penetration made her betimes observe an impetuosity in my temper, which made her judge it necessary to moderate it by mortifying my spirit, lest it should grow too lively and unruly for my reason. I own I often found it rebellious, and could ill bear the frequent checks I met with, which I too easily interpreted into indignities, and have not been able wholly to reconcile to any other character from that day to this; nevertheless, the train of mortifications that I have met with since, convince me it was happy for me to have been early inured to disappointments and vexations.[10]

Mary also recalled, though, how much she loved her father and wanted to please him: 'I loved him excessively, and admired everything he said and did.' He disapproved of young women who were too extrovert and immodest: 'He loved gentleness and reserve in women.'[11]

She would please both parents by being prepared for a court career. Monarchs had a formal household, or court. A Maid of Honour could expect to have her dowry paid for by her employer and being at court would give her and her family a wider 'pool' of potential husbands. The Lord Chamberlain's department had a

whole range of subordinate departments, and Sir John Granville became Groom of the Stole. He therefore managed the most immediate attendants on the king, his Gentlemen and Grooms of the Bedchamber. The greatest advantage of these groups was their constant access to the monarch. Sir John was pivotal to anyone seeking to get his relatives or protégés some kind of advantage: a military or naval commission, advancement in the Church, royal enthusiasm for a composer, artist or scientist, or some kind of administrative post in the range of boards, commissions or committees that managed public business.[12] He duly used his position to secure more for his family. His brother Bernard became one of the Grooms of the Bedchamber, and he managed to wed Anne Morley, an heiress from Yorkshire, for the court was a good marriage market for people from all over the country. She was an earl's granddaughter, and brought five healthy children into the family: three sons, George, Bevill and Bernard, Mary's father, and two daughters, Mary and Anne.[13]

The libertinism of Charles II's court was widely recognised and also deplored. After William and Mary had become co-monarchs in 1688, the king encouraged his wife to become a figurehead for the moral purification of court culture. He discouraged her from attending the public theatres, with their sleazy atmosphere. She also associated herself with the Societies for the Reformation of Manners, which were encouraged by the Church of England as a means of practising charitable works and checking vices such as promiscuity and gambling. Their activities included the founding of schools for poor Anglicans, boys and girls alike, and the dissemination of Bibles.[14]

The queen's immediate entourage, which included Anne, later Lady Stanley, as a Maid of Honour, also set a moral tone. According to one clerical panegyrist, when the queen and her Maids sat together embroidering, someone read devotional works out loud to inspire them in their charitable activities.[15] Aunt Anne's most prized possession from her stint at court was a seal made of amethyst set in gold, with the figure of Minerva wearing a helmet carved into it, the crown and the initial M in one corner, and an inscribed motto.[16] Minerva was the Roman version of Athena, the Greek goddess of wisdom, who in legend sprang full-formed from the head of Jove. She was associated with poetry, with female learning and cultivated self-improvement, as well as with the ability of women to govern well (Plate 3). For Anne Granville this gift must have signified the approval by a queen for women who were intellectually and religiously serious, who wanted to lead honourable lives, and bring up their families likewise.

DON'T BE A TULIP: ANGLICAN FEMINISM AND THE GRANVILLE FAMILY

Queen Mary and then Queen Anne were used both as a figurehead and desired patron by English women, and some men, who advocated better education for women. The first priority was to teach young Mary French, the language of courtly life and polite society, rather than attempt to imbue her with the kind of classical learning admired in the first half of the seventeenth century. She was therefore sent, aged 6, to a school run by a Huguenot refugee, Mlle Puelle. The latter was part of the diaspora of French Protestants (Huguenots) who had taken refuge in England when Louis XIV revoked their rights of religious toleration in 1685. She taught a select group of twenty young girls, daughters of peers and also of 'new money'. One school friend was the Scottish Lady Jane Douglas, who admired young Mary's already budding dexterity in cutting out paper shapes of flowers and birds, and to prevent their being crumpled in her pocket would pin them to her dress.[17] Social boundaries were becoming fluid: another pupil was Miss Dye Bertie, who was illegitimate, but nevertheless 'after leaving school, was the *pink of fashion* in the beau monde, and married a nobleman'.[18]

As court life revived, the theatre was re-established, and all kinds of discussion between men took place in clubs, coffee houses and the Royal Society. There was consequently an increasing need for aristocratic and gentlewomen to have enough of an education to be able to take part with their families in the broader cultural conversation. New magazines such as *The Tatler* and *The Spectator* included short essays on literary criticism, and popularisations of recent scientific and philosophical achievements, aimed at women, and men who had not had a university education. Mary's education reflects new arguments about the role and potential of women, expressed in the sprightly essay by Judith Drake entitled *An Essay in Defence of the Female Sex*, published in 1696, and dedicated to Princess Anne, then heiress presumptive to the throne. Drake encouraged them to converse with wit and verve in English and French, and to keep up with modern authors, and argued they could keep abreast of new writers by attending the theatre. She thought girls and boys should share the same education until they were about 6 or 7, and asserted that women who went visiting with their mothers and therefore had the advantage of *hearing* good conversation, also had more time to enrich their vocabulary by reading novels, romances, plays and poems, whereas boys were already being drilled in their Latin and Greek.[19]

Another advocate of women's education was Mary Astell. Her perspective derived from an austere self-disciplined High Anglicanism. This strand of 'womanist' argument was also likely to have influenced Mary's family educators, both in her early years in London and when the family was forced into their rustic exile. Both Drake and Astell could be described as Tories, but Astell's loyalty to the Stuarts veered off into Jacobitism: she was a close friend of Bishop Atterbury of Rochester, who by 1722 was plotting along with George Lansdowne to replace George II with James 'III'.

Astell belonged to the wing of the Church of England that led the way in reforming 'manners' and founding schools after the Glorious Revolution of 1688. Drake and Astell differed very substantially on their beliefs about how humankind acquired knowledge, and the implications this had for female capacity. Whereas Drake had embraced John Locke's theory that knowledge was derived initially from sensory experience, upon which reasoning capacities should be exercised to organise this data into coherent patterns, Astell was an adherent of the French philosopher Descartes' belief in the rational capacity of the unsexed human mind to reason clearly from first principles. Her *Serious Proposal to the Ladies*, whose first part appeared in 1694, was a bracing call to women of quality to value their intellectual abilities. She advocated the formation of a college for women, who would thereby have the opportunity to spend some of their later adolescent years prior to marriage in a secluded, sisterly environment, unharassed by marriage suitors.[20]

Astell was earnest and high-minded, but managed to convey her elevated moral message to her own sex in an attractively pithy style. Near the start of her essay, she challenged her reader: 'How can you be content to be in the World Like Tulips in a Garden, to make a fine show and be good for nothing; have all your Glories set in the Grave, or perhaps much sooner?' But even a childless, unmarried lady could regard the whole world as her family; 'her opportunities of doing good are not lessen'd but increas'd by her being unconfin'd'. Astell recognised that a bad marriage could in fact be a kind of prison. In these circumstances, the only solution was for a Christian woman to see in this arduous experience a spiritual discipline preparing her for her future life beyond the grave. Sometimes obscured by Astell's religious fervour and philosophical polemic, her fundamental urge is to get women to value themselves, and thus be valued by others.[21]

Great-uncle Denis had several relatives and friends who were devoted High Tory Anglicans, who supported the moral and spiritual re-education Mary

Astell advocated. One of them was his nephew through marriage, the land-owner, cleric and polymath, Sir George Wheler. The French Bishop Fenelon's *Traité de l'éducation des filles* (1687) was another book advocating women's education. When translated into English by George Hickes, a cleric and Anglo-Saxon scholar, he also recommended Astell's *Serious Proposal to the Ladies* in his notes. Ironically he dedicated the translation to Anne, Duchess of Ormonde – the rival, legal wife to Mary's mother when she was associating with the duke.

CHELSEA AND WHITEHALL

After Mary had spent two years with Mlle Puelle, her parents moved from Poland Street to the village of Chelsea, where the fresher air was considered more beneficial to her mother's health. Chelsea was still a separate village on the Thames, upriver from the city of Westminster, with many trees and houses with large gardens. There were market gardens whose produce supplied the capital, and the Chelsea Physic Garden, founded in 1673 by the Society of Apothecaries to teach apprentices about medicinal plants. It soon became a centre for cultivating specimen plants from all over the world. Plant specialists and seedsmen were also attracted to the area. The flowers Mary cut out for her school friends might have been based on those she saw growing in various locales in the neighbourhood. The most prominent building was the Chelsea Hospital, founded in 1682 by Charles II for 'the succour and relief of veterans broken by age or war'. Mary Astell ran a charity school in rooms in the hospital so it is very possible that she met Colonel and Mrs Granville in person. This was the point at which Mary, now 8, stopped living consistently with her parents and stayed in the West End with her Uncle and Aunt Stanley. As respite from the smells and dirt of London they cherished their country villa, Northend, in rural Fulham, a short distance away from Chelsea. The Stanleys spent the summers there and visited at weekends during the year, so Mary was not completely cut off from her parents and young sister. Her aunt now supervised her education, supplemented by specialist masters.

What did Mary learn? Music was considered more important for her to learn than drawing or painting. Courtiers needed to know how to dance, which in turn instilled elegant posture and movement in boys as much as girls. Music pervaded court life: at chapel worship, as military fanfares for ceremonial entrances and exits or parades, as background or 'chamber music' in the evenings or while dining, and through opera and plays. Her oldest brother Bernard

had an extremely good ear, and she might have started learning keyboard music very young when he was also being instructed. A lady with a fine voice might perform in private to entertain her family and friends, though she would lose caste if she sang in public, or for money. Nevertheless there was no stigma attached to an amateur performing privately to a professional standard.

In 1710, Mary met the composer G.F. Handel, who was making his first exploratory visit to London after his patron, the Elector of Hanover, future King George I of Great Britain, had made him his Kapellmeister in Hanover. He was introduced to her uncle, Sir John Stanley, by the musical impresario Heidegger. Mary already had a little spinet, 'on which that great musician performed wonders'. As soon as he left Mary sat down and tried to recreate what she had heard. When her uncle teased her whether she would ever play as well as Mr Handel she replied, 'If I did not think I should I would burn my instrument!' It was a telling indication of Mary's intensity of spirit.[22]

Mary's first visual training probably came through needlework rather than painting or drawing. As the future manager of a household she was expected to know many household skills in order to instil good standards in her servants, and supervise them correctly. Mary would have started by being shown the basic stitches for plain sewing, used for undergarments and household linen, before being taught more specialist stitches and embroidery in silk or wool. The close decorative stitching necessary to produce the right effects would have encouraged attention to exact colour matching and pattern: an excellent training for the eye, even if such practical applied work was not valued as 'fine art'. Ladies were also traditionally associated with supervising the dairy, making preserves and concocting remedies to assist in the health of anyone in the household.

Religion would have permeated her schooling, as well as being a matter of specific instruction. Many a young girl wove in her Scripture with her needlework lessons when embroidering a sampler, which demonstrated her mastery of various stitches and usually included a religious text as part of the design. A lady would also be expected to have a good 'hand', that is to say, to be able to write consistently and attractively. Some families were less bothered if girls had weak grammar and spelling but this was not the case with Mary's family, and she would later insist on her niece attaining high standards. Reading out loud, important as evening entertainment, often entailed listening to a book, poem or play being so read, and as Judith Drake would have recommended, Mary must eventually have been reading modern authors, some of them her Uncle George's friends.

THE GRANVILLE SUCCESSION QUESTION:
ENTER THE MATRIARCH

The Granvilles had almost as many problems ensuring their own succession as did many of the ruling families of Europe in the first decade of the eighteenth century. When Queen Anne's ministry was remodelled in 1710, with Harley at its head, George Lansdowne finally gained an important political job as Minister of War. His family influence in Cornwall at the election that year had been particularly important, and he personally had been able to unseat Hugh Boscawen, nephew of Sidney Godolphin, as MP for the county, as well as to secure the election of Mary's father Bernard as MP for Fowey, an important Cornish borough. He also obtained the governorship of Hull for his brother. Their patron Harley was raised to the peerage as Earl of Oxford, and George had hopes he too would get a title. In May 1711 the young Earl of Bath had died. After so much promise, the 1st Earl of Bath's attempts to create a glorious chapter in the history of the Granville family through his direct descendants seemed to be faltering.

However, to George Granville this was an opportunity to press his own claims and he petitioned Queen Anne to revive 'the honours of my family in myself'.[23] He was not yet successful. What he did do, though, in preparation to receive a title, was to marry. This increased his wealth, as his wife was the widowed Lady Mary Thynne, who had an exceptionally large jointure of £12,000 p.a. She also had good court connections as she was a member of the Villiers family. She was young enough to create a second family for George, and they had four daughters. Mary would remain friendly with all her Carteret cousins, especially Georgina. The following year George finally attained a title when Queen Anne created twelve peers to ensure sufficient government influence in the House of Lords to pass the peace preliminaries at the end of the Spanish War. Referring back to his great-grandfather's gallantry in the Civil War, George chose the title of Baron Lansdowne, the hill near Bath where the latter had been killed defending the troops he was bringing from Cornwall to Charles I in Oxford. George made sure his brother Bernard and his heirs were mentioned in the patent.[24]

But he had reckoned without the drive and Granville loyalty of the female side of the family. The 1st Earl of Bath's only surviving daughter, Grace, thought the earldom should descend in the female line, which was not unprecedented. New marital allegiances did not preclude daughters from claiming succession rights in their birth families where there was no male heir, and

19

Grace claimed a share in the estates for herself, and the heirs of her sisters Jane and Catherine. Grace was married into the Carteret family, another Anglo-Norman family; their power-base was in the Channel Islands, which they had defended for centuries against invasion. From 1711 to 1715 Grace, already a widow, pursued her claims and was awarded a share of the Granville lands, together with the title of Countess Granville in her own right. Such litigation was not a modern pursuit of equal legal rights for women: nevertheless, it shows how women in elite families were constantly alert to the 'family business' of getting and maintaining status, when the opportunity arose. To the family she was 'the Dragon', and her son John was an influential statesman in the reigns of both George I and George II.[25]

Mary Granville also became very friendly with some of her Leveson-Gower cousins, which linked her through marriage to the royal family. Jane Leveson-Gower's daughter, another Jane, married her first cousin, Henry Hyde, 2nd Earl of Rochester, and *his* cousins were none other than the Stuart princesses Mary and Anne. But of all the Hyde family, the cousin and playmate of Mary's to whom she was closest was Catherine (Kitty) Hyde, Jane and Henry Hyde's daughter. Mary Granville and Kitty remained in touch for many years in court circles. The other playmate Mary remembered was a relative of her uncle Sir John Stanley, Judith Tichborne. The diffident Judith remained her friend and her marriage into the Churchill network was later regarded as a useful connection for Mary's family.[26] For girls as much as for boys, those with whom you were schooled with could be as important and useful as what you learnt.

EXPULSION FROM EDEN

The Granville hopes to get Mary placed at court were dashed when Queen Anne died in 1714. George Elector of Hanover now came to Britain with his entourage. His son and heir, George, Prince of Wales and his wife Caroline of Ansbach, accompanied the king with three children, leaving the oldest, Frederick, in Hanover, to represent the Electoral family. The fact that George I was divorced meant there would be no queen's household requiring Maids of Honour, and the only opportunities that would occur would be in the Princess of Wales's household, which was much smaller than a consort's. But aside from a shortage of female opportunities, Mary was now handicapped by her family's Tory affiliations. The king felt that Queen Anne's Tory ministers had betrayed the

alliances with German princes like himself by initiating peace moves in 1711, and he preferred to appoint Whigs to his ministry and household. George Lord Lansdowne lost his job as Treasurer of the royal household in October, and Mary's father was dismissed from his military position as Governor of Hull. Coupled with the arrears on the payment of her mother's dowry, the family's financial position was disadvantageous. Their two sons were not at home: Bernard was 'at the academy' – that is, a military academy – and Bevill was still at Westminster school, popular with families who wanted their sons to have a role in politics. Mary was now mainly domiciled with her parents. Then in 1715 the exiled James Stuart's supporters staged a rising in his favour. George Granville's known Jacobite leanings made him a figure of suspicion and he was arrested. So it was that Mary experienced the family drama of near arrest on suspicion of treason themselves, and the family hurried to remote Gloucestershire. Instead of being in the charmed circle of court life, with Lord George regarded as the premier poet of a new peaceful era under Queen Anne, his misjudged sympathy for the Pretender's claims had blighted the lives of his brother Bernard and his children, and young Mary's career as a courtier had apparently finished before it really started.[27]

Cornish Bride

FIRST VISIT TO LONGLEAT HOUSE

*T*wo years after Mary's family had been obliged to move to the Gloucestershire countryside, her uncle Lord George Lansdowne made a decisive intervention in their life. Now a free man, he invited her to his home at Longleat House in Wiltshire, about 20 miles away.[1] The estate was not that far from the Lansdowne site where the cavalier Sir Bevill had died fighting for Charles I. In the late seventeenth to early eighteenth centuries it was recovering after political upheaval and war. Two features of the estate would be especially influential to Mary – its gardens and its libraries. When Mary was an infant, its owner, Thomas Thynne, MP and diplomat, created 1st Viscount Weymouth (1640–1714) commissioned a truly magnificent garden in the formal French style, using 70 acres to the east of the house. His granddaughter, Frances Thynne, later Lady Hertford, whom Mary knew, followed her father and grandfather's example of being a literary patron.

MARY GRANVILLE'S LITERARY EDUCATION

After the quiet two years at Buckland, this Longleat visit was both a social initiation to sophisticated society, and also a kind of informal further education for young Mary Granville. Lord Lansdowne was too recently implicated in Jacobite plotting for him to be inclined to attend the royal court yet, or be welcome there, so neither he nor his wife could reintegrate Mary back into the

metropolitan world she had been forced to leave so abruptly. But the range of guests, the conversation and the entertainment at Longleat would nonetheless prepare her for when this might happen. However, after Mary's father had accompanied his daughter to her uncle, the latter took him on one side and explained he was reducing his brother's allowance, as he should have lower expenditure in the countryside. Downcast at this, Col. Granville could not help confiding this new trouble to his daughter. The episode is ambiguous: was Lord Lansdowne preparing to make Mary more open to an arranged marriage if she was aware of her parents' straitened means? Was her father speaking spontaneously or deliberately to help her see how important it might be to follow up the opportunities the Longleat visit might bring? Yet there is no clear evidence that her father was aware of Lansdowne's ultimate plans. For some time after her father had left, Mary wished she had returned with him, 'that I might by my duty and tender affection show him that I preferred his house and company to all the flattering views that were laid out before me; but it was his pleasure I should stay'.[2] His reasons must have included the fact that with less income he would have less ability to introduce her at court with the help of Lady Stanley: Longleat might substitute for London husband-finding.

The one positive result was that Mary's uncle became her literary mentor. There was regular shared reading out loud, which would have included reading of plays: Shakespeare, Dryden, the French masters of tragedy such as Racine, and Lansdowne's own, including *Heroick Love* (1697), based on a brief incident in book one of Homer's *Iliad* (as translated by Dryden). True to the spirit of Judith Drake, there was now an increasing number of modern translations of the classics. One important new translation was put together by the poet and critic Samuel Garth and dedicated in 1717 to Caroline Princess of Wales, praising her dignity and forbearance during the political estrangement of the heir and his wife from King George I between 1717 and 1720. Garth had commissioned some of the best writers of the day to translate the Latin poet Ovid's *Metamorphoses*. The translators included Lansdowne's hero, Dryden, the essayist Joseph Addison and the satirist and wit, John Gay. Each of the fifteen sections of the book was dedicated to an elite woman, including the Princess of Wales's daughter, Anne, princess royal, and the countesses of Hertford and Burlington, both Ladies of the Bedchamber to Princess Caroline. Such women were clearly among the target audience for the book. Perhaps this recent deluxe publication had followed Lansdowne down to Longleat.

Other books shared by her uncle could have been more of the heroic French romances that had been so popular at the court of Louis XIV, written by women like Mlle de Scudéry and Mme de Lafayette, Italian stories from the Renaissance by Boccaccio or romance epic poems by Ariosto. In a more modern vein there were the new literary magazines, *The Tatler* and *The Spectator*. Lansdowne's friend Jonathan Swift had been a leading light in the former magazine, while the latter, edited by Joseph Addison and Richard Steele, was more strongly associated with the Whigs. The aim of this magazine was to 'bring Philosophy out of closets, to dwell in Clubs and Assemblies, at Tea-Tables and in coffee-Houses'.[3] In other words, it aimed to reach women and non-university educated men, in addition to gentlemen with the expected classical education, and give them an *entrée* to the current cultural conversation.

The magazines were part diversion, part conduct book, for a newly mobile society. More specifically sermonising were the actual conduct books, such as the one edited by Sir Richard Steele in 1712, *The Ladies Library*. Though appearing under his name or as simply 'By a Lady', it was actually compiled by a young clergyman Mary would soon know and admire, the theologian and philosopher George Berkeley. Notwithstanding its title, the three volumes it comprised were written for men as much as women, with exhortations to both sexes to live in a spiritually responsible and godly way – advising, for instance, how they used their time or their wealth. Its advice to women dealt with the different stages of their lives, as daughters, wives and widows. Berkeley strongly advised young women whose destiny was marriage to think of themselves as having legal agency; after all, they would resume legal independent identity as widows. This legal personality would therefore be much more powerful than before marriage, when daughters were normally under a father's supervision. Thus Berkeley's advice discourages women from ignorance of financial matters:

> T'is very necessary that women of Quality, and of Estates, should know exactly what those Estates are, what part in Land, what in Houses, what in Money, where and in whose Hands: They should be as well acquainted with the Rentals of their Lands, the Draughts of them, the Situation, Leases and condition of their Houses, as their Husbands; what debts they owe, as well as what are owing to them. By this they regulate their domestic and other Expenses, provided for the future Settlement of their Children, and answer the Ends of Marriage, to be Helper to their Husbands in the Discharge of Paternal Duties.[4]

This legal knowledge, as well as good taste in books, is in Berkeley's view much more important than ability in household management or domestic medical remedies, which he takes for granted they will also possess. We cannot know if Mary Granville was given *The Ladies Library* to read, but it is not unlikely, and the example of Lady Anne Stanley, clearly an able partner in her marriage to a courtier and landowner, exemplifies the type of woman who is both respectful of her husband's position while being an effective manager if he were absent. Most gentry marriages were, arguably, based on this model.[5]

The literary world of Lord Lansdowne was mainly a male one. The women who wrote for the commercial press were not considered ladies, however successful they were. But exceptions included a relative by marriage of Mary Granville: this was Lady Mary Wortley Montagu (1689–1762), who was the most prominent female literary figure at this time. One of her sisters, Evelyn, was married to Mary Granville's cousin John Leveson-Gower, 1st Baron Gower, while the other, Frances, was the second wife of the Jacobite conspirator, John Erskine, 6th Earl of Mar. So Lady Mary, like Mary Granville, knew what it was like to belong to a family divided by recent political events. As a woman of quality, Lady Mary had no financial need to write, but she did have a strong vocation to do so. Many of her poems and letters circulated in manuscript, not print, but nevertheless some must later have been known to Mary Granville once she became friends with Henrietta, Lady Harley, an exact contemporary of Lady Mary. The two had grown up near each other in Nottinghamshire, and as young women they had anxiously written to each other and their circle of friends about whether their arranged marriages would lead to Paradise or Purgatory.

Lady Mary was what was known as a female wit: a woman renowned for being able to hold her own in conversation with some of the cleverest literary men in the country. Lord Lansdowne's protégé Alexander Pope wrote idealising love poems to and about her when she was in the Ottoman Empire, accompanying her husband on a diplomatic mission (1716–18). However, Lady Mary was an uncomfortable paradox, to herself and others. Such women might not only scare the gentlemen, they could also discomfort their less well-read and less morally serious female contemporaries. When it was increasingly evident that Lord Lansdowne was enjoying the interest his niece was taking in their literary conversations, it certainly displeased his wife and his unmarried sister Elizabeth who lived with them. Mary Granville quickly perceived this:

My two aunts soon grew jealous of the great favour shown me by my uncle, and would never suffer me to spend an hour with him alone, which mortified me extremely; for though I did not pretend to much penetration or any judgement, I soon found their conversation much less instructive, as well as less entertaining than his. I had been brought up to love reading; they never read at all, or if they did, idle books that I was not allowed to read. . . . Alcander [Lord Lansdowne] delighted in asking me read to him, which I did every day, till the ladies grew angry at my being so much with my uncle.[6]

Nevertheless perhaps it was during this winter that Mary began to have tentative aspirations to being considered a wit herself: a literary-minded woman, a good letter-writer, a fluent conversationalist. It would have been an ambition to cherish much more keenly than any facility with her needle or scissors, let alone her paintbrush. Her aspirations to a literary life might also have originated in the long winter evenings at Buckland as the family read aloud with only the Rev. Tooker for company, or in conversations with her friend Sarah Chapone: she would later tell John Wesley that as a girl she had once sworn she would only marry a wit.[7] But although Mary's immediate family was bookish, her uncle's discussions with her must have given her a much deeper and wider engagement with the life of letters. In her autobiography she characterised Lansdowne as having 'learning and wit . . . with the greatest politeness and good humour imaginable'.[8] Perhaps this was her beau ideal – but it set the bar high. However, her hopes would come to some level of fruition from an unexpected direction when she met Patrick Delany and his circle on her first visit to Ireland in 1731. The literary life she shared with Patrick would be integral to their later marriage. But first her life was painfully moulded to quite another pattern, consistent with her upbringing and family ties.

ENTER 'GROMIO'

Mary was young enough, spirited enough – and attractive enough – to be able to tease and laugh, as well as converse soberly with her uncle. Also of the party that winter was her aunt's younger brother, the Hon. Henry Villiers, who had a scornful turn of humour.[9] He and Mary soon had someone to amuse them. One stormy winter evening a visitor was announced while the household was at dinner: her uncle immediately welcomed him delightedly to the table.

I expected to have seen somebody with the appearance of a gentleman, when the poor, old, dripping almost drowned Gromio was brought into the room, like Hob out of the well, his wig, his coat, his dirty boots, his large unwieldy person, and his crimson countenance were all subjects of great mirth and observation to me. I diverted myself at his expense several days, and was well assisted by [Henry Villiers].[10]

This was the first impression she had of Alexander Pendarves, a wealthy 57-year-old Cornish landowner, who was to become her first husband. *Hob in the Well* was a comic-pastoral farce written in the 1720s, featuring a young country bumpkin.[11] Arriving like this on horseback in bad weather, Pendarves might have seemed like a visitant from a different world. In fact he was more sophisticated than he seemed, and he was very much from Mary Granville's world. He was from an old Cornish landowning family intermarried with those considered the best families in the county, including the Granvilles, and he was also a close political ally of Lansdowne. The Pendarves came from the Helston area and had tin-bearing lands; they had been settled at a Cornish village, Pendarves, since the Elizabethan age, when Mary's ancestor Sir Richard Granville was already a dashing buccaneer. They had political influence and financial clout, managed their estates well and, in addition to being an MP for various Cornish constituencies – Helston, Saltash, Launceston – in 1714 Alexander had been appointed Surveyor of Crown Lands by George I. He was a childless widower, his first wife, Lady Dorothy Bourke, having been a wealthy Irish heiress, and daughter of the 8th Earl of Clanricarde.

Pendarves' own estate was at Roscrow, above Falmouth Bay, more than half-way to the south-east tip of Cornwall. Pendarves' mother, Bridget Carew, was a sister of Sir John Carew, 2nd Baronet, who like the Granvilles were a prominent family with marriage ties to the Prideaux family. Alexander's brother John was a wealthy clergyman whose daughter Mary was set to inherit her father's and her uncle's money. This Cornish Mary had married into another of the old Cornish families, the Bassets, and their son, John, later married a Prideaux lady. But here was Alexander Pendarves' grievance: Mary and John Basset were stalling at allowing their son and heir to incorporate the Pendarves name as a condition of his inheritance. Including the name would be a recognition and perpetuation of Alexander's branch of the Pendarves family and his wish was not at all unusual (and eventually they agreed on this). But when

Alexander arrived at Longleat he was, he declared, en route to London to sell his estates, to forestall the inheritance going to his recalcitrant niece altogether.

Again, it is not altogether clear that the Longleat stop-over was as spontaneous as it seemed, though given the customs of hospitality of the time it would not have been unusual. Lansdowne's Jacobite initiative had damaged Pendarves: he too had been arrested for suspected conspiracy in 1715 and there had been some sequestration of his estates. Mary's uncle therefore felt some obligation to help his political crony. There were two ways he could do it: he could dangle his pretty young niece before Pendarves, who as a second wife might give him the heir he lacked and frustrate the Bassets altogether, and he could also point out that Mary had a very useful connection, who could help restore Pendarves' estates. This was because her old school friend, Judith Tichbourne, had just married as his third wife Charles Spencer, 3rd Earl of Sunderland. He was the most important statesman in the land, combining the roles of First Lord of the Treasury and Lord President of the Council: effectively, though neither the concept nor the term yet existed, Sunderland was prime minister.[12] Any parliamentary bill he chose to support would receive little opposition. At one stroke Lansdowne could help his friend and provide for his niece.

Even if Lord Lansdowne had not completely thought out this plan before Pendarves arrived, it must have soon occurred to him when he saw that Pendarves was very taken with his vivacious young niece. For her the farce of his arrival soon turned into something much darker. 'Gromio' was supposed to stay for a brief respite on the way to London . . . but he stayed . . . and he stayed . . . and he stayed. Inexperienced though she was it was soon quite clear he was lingering because of her: 'I (to my great sorrow) was after some time convinced I was the cause of this delay: . . . and I could easily perceive I was the only person in the family that did not approve of it.'[13] She was emotionally isolated: her father gone, her aunts hostile, her uncle busy manoeuvring. The more charming Pendarves tried to be, the more she squirmed literally and metaphorically away from him. His bulk, his gout, his sullen temper were all distinctly off-putting, and she reacted by being sure to dress unattractively and never be in a room alone with him in case he proposed. Her aunts told her she was being 'childish, ignorant and silly and that if I did not know what was for my own interest, my friends [that is, her family] must judge for me'.[14] Recollecting the two months of suspense and cringing, as she wrote all this down Mary began to shake with nerves, and was unable to continue her section about this episode.

Resuming the story, Mary revealed how, after they were married, Pendarves told her how much he had hesitated to make his proposal, and how much her deliberately displayed hostility had nearly broken his nerve. Equally intolerable to him was the amusing banter between her and Henry Villiers: to an older man aware that he might be humiliated by a young girl, it was pure torment. In the end, Pendarves appealed to Lansdowne to do the main work for him. One evening all the guests and family seemed of one accord to go into the music room, leaving Mary alone with her uncle. She tried to follow but her uncle requested she stay back as his gout impeded him.

> My spirits foreboded what he was about to say and when he bid me shut the
> door, I turned as pale as death; he took me by the hand, and after a very
> pathetic [that is, affecting] speech of his love and care for me, and of my
> father's unhappy circumstances, my own want of fortune, and the little
> prospect I had of being happy if I disobliged those friends that were serving
> of me, he told me of Gromio's great passion for me, and his offer of settling
> his whole estate upon me; he then, with great art and eloquence, told me all
> his good qualities and vast merit, and how despicable I should be if I did
> refuse because he was not young and handsome.

Finally, after the velvet glove came the mailed fist: her normally so polite and urbane uncle finished with the threat that if she were still harbouring romantic inclinations towards her first Gloucestershire admirer, Robert Twyford, whom she had actually put right out of her mind, he would ensure Robert would be dragged through the horse-pond if he ever came near Longleat.[15]

This bluster made her realise how futile it was to try to argue with her uncle: the threat to Twyford was surely hypothetical, but the manner in which Lansdowne made it forced her to realise how determined he was that she should obey him. Perhaps the intensity of his insistence was to arm himself against any counter-persuasions from Mary; he must have realised he was being cruel, and felt guilty. She said she would do what he asked and that she was aware of his concern for her, but begged to be allowed the privacy of her room. When she reached it, she wept for two hours, but that was all the respite she had for this brusque determination of her future. Any hopes or dreams she might have had of finding a soulmate of whom her family might approve, a wit who would take her penniless as she was, were abruptly curtailed. Nor was she left alone to weep the night away: a succession of

servants made it clear she had to join the family at supper. She went down, holding onto a single shred of hope that someone in the household might sympathise with her, or that she could even persuade Pendarves not to force the issue. But, as she put it, 'no-one considered the sentiments of my heart'. They could only discuss the financial and social advantages opening before her.[16]

Effectively, the bargain Mary was being given was this: she was a penniless daughter of a younger son, overshadowed by political disgrace, with no money for his daughter to make her debut. This marriage would make her comfortably off, relieve financial pressure on her family and give her a fortune once she was widowed. Like her great-aunt Lady Joanna Thornhill (Plate 2), also forced into an early marriage to a wealthy man, she could then become a philanthropist and patron, or divert herself in other ways of her choosing.

Meanwhile she would have the status of a wife in a circle of Cornish peers and gentry, and a footing in London polite society whenever her husband needed to be at Westminster. The social freedoms accorded married women and their female friends would enable her to enjoy London's amenities when her husband did not require her company. Nor she was a passive beneficiary in the bargain: her own Granville kin would confer social capital on the Pendarves family. Her aunt and uncle Sir John and Lady Stanley were in good standing with the royal court, as were her Carteret cousins, which might help rehabilitate her husband provided he stayed aloof from Jacobite scheming. This he was likely to do while negotiating for the restitution of his estates. And here, above all, she was absolutely pivotal in her own right, insofar as she was an old school friend of Lady Sunderland, third wife of the prime minister. His second wife had been a daughter of John and Sarah Churchill. Mary was in her own way a route to the Whigs, the current party of power – and fashion.

This did not make the terms of the bargain any less intolerable. She was being forced to marry someone she thought was completely incompatible, but the combination of her uncle's pressure and her sense of obligation towards her family made it impossible for her to refuse. She had not really been in the metropolitan social world, which might have given her more room to agree to a managed choice, and now the door was firmly shut. And the most repellent prospect of all was that of obligatory intimacy with this elderly man, who was physically disgusting to her, but who was besotted with her. He was hopeful he could leave his money to his own heir, and not his niece and her son, if he could only father a boy by his new bride.

In her own words, this was like the sacrifice of Iphigenia in Euripides' Greek tragedy, in which King Agamemnon sacrifices his daughter in order for the winds to change so that his ships can sail to the Trojan wars. Mary knew her classics well: Iphigenia *willingly* permits her father's plans, just as she bowed to her uncle's demands. But in the play, a deer is substituted at the last moment and Iphigenia lives. But for Mary there was no last-minute substitution: as she was led to the altar in the Longleat chapel, 'I wished from my soul I had been led, as Iphigenia was, to be sacrificed. I was sacrificed. I lost, not life indeed, but I lost all that makes life desirable – joy and peace of mind . . .'[17]

Yet, insofar as she had agreed to the bargain as an act of unselfishness towards her parents, she had not been an entirely passive victim: she had been able to choose the moral high ground, albeit in a much attenuated and excruciatingly difficult way. She knew that they would have supported her in a refusal, but that this might have rebounded on them all; she was able to console herself that she had prevented further troubles. To the modern mind, she had internalised too strongly a desire to please her affable father, clear proof of female abjection: but we must remember that she did not see it like this. Rather, '[my] considerations gave me courage, and kept up my resolution'.[18] She felt that she was, just a little bit, in control. Her *feelings* had been ignored, but she could still clothe her enforced choice with moral *reason*.

Lord Lansdowne had evidently not made Mary's parents privy to his plans, but as soon as he had exacted her consent he sent a messenger to Buckland summoning them to Longleat, giving them the impression that Mary was entirely pleased with the arrangement. She realised she would now have to act consistently with her decision. 'I had now nothing to do but to submit to my unhappy fortune, and to endeavour to reconcile myself to it.'[19]

I think we must presume that one way she coped was to consider this as a trial sent by divine providence: that it was a spiritual challenge as well as an emotional one. How she must have wished that Mary Astell's college for women was a reality, and that she might have had a few more years secluded from pressures to marry, sharing congenial female company, practising her music, doing some quiet charitable work . . . But if this was not God's will, she must have told herself it was a means of developing patience and grace, and of doing good to others. If her reward was not on earth, it would be manifest in the hereafter. Struggling against these good resolutions were her natural feelings of despair at her 'imprisonment'. Pendarves now had the right to court her – to compliment her,

enjoy her company alone, make himself personally agreeable with some restrained amorous gestures such as kissing her hand or her forehead and fondling her a little – but he 'saw too well my insurmountable dislike'.[20] Her uncle showered money and clothes on her and the wedding in Longleat chapel on 17 February 1718 was full of pomp. 'Never was woe drest out in gayer colours', she recalled.[21]

Everyone around her saw how pensive and forlorn she was, but all, her parents included, chose to interpret this as her apprehension over leaving familiar scenes as well as her family to go into an unknown part of the world. Her little sister was a consolation to her because of her utter ignorance of what this marriage entailed: we can imagine Anne as entranced with the generous trousseau her aunt and uncle now authorised for her sister, and excited at the mere thought of Mary being a bride and chatelaine of an estate. It is a testament to Mary's generosity of heart that, recalling these events twenty years later, she emphasises what threads and scraps of silver lining she was able to find at the time. She explained Mr Pendarves 'showed me all the respect and tenderness he was capable of' and she reciprocated as pleasantly as she was able. This probably alludes to his consummation of the marriage – doubtless an excruciating experience – and not just to his general behaviour.[22]

FROM LONGLEAT TO ROSCROW

Mary and her husband stayed on at Longleat, she painfully adjusting to the status of bride, which in social etiquette gave her first place at table. Then it was time to leave for the distant 'country' of Cornwall. Her parents and sister left for Buckland, but she was to have the consolation of her elder brother, Bunny (Bernard), to accompany them and stay for a time. It was not unusual for a bride to have some family or friend to keep her company in the early days of marriage, but more usually a sister would be chosen. However, Bunny was available, as he was trying to sort out his financial status as a half-pay officer,[23] and as well as adding to the social life indoors, he could ride out with his sister for exercise when Pendarves' gout kept him confined.

The journey to distant Roscrow took two weeks. It was a fortified castle rather than a country home, hidden behind high walls and entered through an old-fashioned gatehouse. It looked like a prison, and moreover a near derelict one that had not been inhabited for thirty years. The hall was dark, the windows high and the parlour leading off it had rotten floorboards and a collapsed

ceiling. Her tense, overwrought nerves gave way completely and she burst into tears of shock and dismay.

Mary soon made the effort to dry her tears, and to busy herself. Her husband, disturbed by her violent sobbing, immediately agreed she could refurbish some of the castle. For someone of her artistic talent it must have been a pleasure to think out these improvements: 'the liberty of fitting it up conveniently to my own fancy . . . helped amuse me greatly'. As the castle was altered and considerably reduced in the nineteenth century it is impossible to know exactly what changes were made. Visiting in 1861 Lady Llanover explored the remaining bedrooms, one of which had a little closet leading off it, with a good view. She supposed this must have been Mary's, which she could use as a dressing room and also a room where she could read, sew and create her paper-cut pictures.[24] As the lady of the house, Mary had her sphere of activity and authority that must have helped her regain some kind of self-possession. The routines of each day must have given some consoling shape to life in Roscrow, no doubt beginning and probably ending with prayers.

As with the abrupt transition to Gloucestershire from London, Mary was able after a while to take pleasure in the landscape. As the days grew longer she and her brother made a joint effort to make the most of nearby sights, so unfamiliar to them both, and she regretted that their rides were often curtailed by her sense of obligation to 'hasten home many a fine evening that I had rather have spent anywhere than in the castle of Averno' as a courtesy to gout-ridden Alexander.[25] Mary had used the term 'Averno' or hell to describe her first impressions of the gloomy castle; Lake Averno near Naples was believed by the Romans to be the gateway to the Underworld. But looking towards the sea was a glimpse of paradise; to 'every eye which beheld it at a distance the whole appeared a garden, and in great bloom at its proper season. Indeed nothing could be more delightful or beautiful in the months of May and June: the whole terminated in an unlimited view of the sea.' Also cheering was the constant harbour activity.

Mary's marriage to a Cornish landowner and MP who had been in prison for his Jacobite sympathies inevitably classified her as a political wife – and one who was assumed to be in opposition to the Hanoverians. This did not mean she had to do any active political work – simply by being Mrs Pendarves it was assumed she was incorporated into her husband's politics. Mary's uncle wrote to her soon after her arrival in Cornwall: 'I have been informed that 'tis a mark of *disaffection to the Government* to lead you from the church to your coach, and that

an unfortunate neighbour has lately been in trouble upon that account.'[26] Politics was so much a part of 'family business' that social gestures and friendship patterns could easily be interpreted as signs of political allegiance. An MP's wife might support her husband in many ways – one of them being through her role as hostess and social networker, cementing political bonds in the social sphere.

This was Mary's first visit to the Granville county of origin so she was not personally familiar with the thicket of families that constituted her ties by blood and marriage, as well as being elements of her uncle's political connection: Bassets, Carews, Prideaux, Godolphins. It was not only her marriage that made her feel imprisoned: here was this confining, clannish web as well, which now crowded in on her. Almost everyone she met was not really a complete stranger and could talk to her about her own family background: she must have felt suffocated by kinship, while knowing all the while how important it was to stay poised, choose her words carefully, remember who everyone was and how they were related and avoid tactless sociability with her husband's political rivals. All this would make her a credit to her husband. She was very successful at this: Lansdowne wrote to her five months later of his satisfaction in the good reports he had heard of her.[27]

The first month of her marriage was spent at Roscrow, receiving wedding congratulations from such local visitors and connections; then Pendarves decided it was time to introduce his wife to the recalcitrant Basset niece and nephew. To be paraded as a wife who might help him supplant their inheritance if she had a child was bound to be uncomfortable on all sides: but Mary was not averse to leaving the gloomy Roscrow, and the ongoing refurbishment. The Basset house was more cheerful than Roscrow and Mary soon found herself laughing for the first time since her arrival in Cornwall at her suave host's dinner-table jokes. Simultaneously her husband grew more taciturn and gloomy. He would spend more time in his room 'and when I was alone with him, he would sigh and groan as if his heart would break'. Eventually Mary asked him what was wrong: he had always been kind and civil to her, even if he had not won her heart. 'At last the mighty distress broke out in these words: "Oh! Aspasia, take care of Bassanio; he is a cunning treacherous man, and has been the ruin of one woman already, who was wife to his bosom friend," and then he burst into tears.'[28]

Mary was speechless at how unmanned her husband had become by his jealousy. She protested, 'I am miserable, indeed, if you can be jealous of this ugly man', and soon she was in tears herself. Pendarves immediately assured her he

did not blame her and that she had not been inviting unwanted attentions – it was simply that he could not bear to see how charming she seemed to Basset/Bassanio. Mary begged that they should return as soon as possible to Roscrow, but her husband insisted they stayed for the agreed time, as proof that he had complete trust in her behaviour. But of course the pleasures of the visit had now altogether vanished for Mary. Their host devised interesting things to do: looking for shells on the seaside – which induced in Mary a lifetime fascination for them; going fishing; visiting the Gull Rocks, which had unusual stalactite formations. But she was on tenterhooks in case his attentions discomforted her husband, and did not go on any excursions that Pendarves could not manage. No-one can fault Mary for failure to respect her husband's dignity; she was far from the teasing young ingénue who had giggled when 'Gromio' had first been welcomed to Longleat. Now she made it clear to Basset that his sly comments, designed to make her husband look foolish when he was out of the room, were entirely unwelcome. She had never imagined it could be a relief to return to Roscrow, but it was.[29]

Once more 'all the neighbourhood came and paid their compliments, and the house was continually full of company'. It was uphill work trying to win over the Pendarves relatives, 'but my youth and the application I had to oblige them gained their favour, and I had the satisfaction of being well treated by them all'.[30] However, this kind of neighbourhood hospitality continued to be a moral minefield. Mary was constantly on the alert against unwelcome male 'gallantry': verbal or actual sexual harassment was pretty well endemic in early eighteenth-century society, including 'polite company'. Mary though was absolutely determined to uphold her husband's dignity, especially in front of others. 'I would rather have had a lion walk into the house, than anyone whose person and address could alarm Gromio.' She had taken on the mantle of stern young matron.[31]

On Mary's second wedding anniversary, in February 1720, Lord Lansdowne wrote to her: 'I cannot forebear congratulating with my dear niece in memory of this day, which I hope and make no question, will prove in every circumstance a happy one to you.' Was 'every circumstance' a hint about childbearing? 'As a proof it is an auspicious one', her uncle continued, 'Mr. Pendarves's Bill was read the second time, and committed this morning in the House of Lords . . .'[32] Her reward for being a useful conduit to power in getting Pendarves' lands restored was supposed to be the creation of an additional marriage settlement

to her first, which would confer these estates on her once she was widowed. Unfortunately, Lansdowne neglected completing this legal work. He was now in London, re-establishing his standing there.

Pendarves was in London for his second wedding anniversary, but Mary was not alone at Roscrow. Brother Bernard had had to rejoin his regiment but his parents and sister Anne went to Cornwall to keep Mary company. This was a long visit, until November, and for Mary a kind of family idyll: 'O happy year! That made me some amends for what I had suffered.' Her father was made much of by all the Granville friends and connections; Mary discovered her 12-year-old sister was 'very conversable and entertaining'; and even her depressed mother recovered her spirits and made every effort to help entertain the Pendarves' connections. Her husband wrote by every post, but having decided to stay in London, he soon required Mary to come and join him. The respite from married life was over. In her head she knew her husband was kind, but she could not overcome her instinctive antipathy. The family party returned to Buckland, but after a further month, Mary could no longer avoid London, and her father accompanied her there.

Pendarves had been in London first to oversee his legal restitution, and the following year, 1721, he was re-elected to Parliament, this time for Launceston, Cornwall's chief town, close to the Devon border, and a Cavalier town in the Civil War. Lord Lansdowne had previously been one of its two MPs, and Pendarves was now taking over from his relative Sir William. Mary was unaware of all the details of her husband's life, but she certainly knew that after being sober for the beginning of their marriage, Pendarves was drinking heavily and spending much time with his cronies. After a flow of affluence, too, money was tighter, and it is possible Pendarves had lost funds to the insatiable maw of the South Sea Bubble. 'This', recalled Mary, 'was the *last misfortune* I could have expected; I thought myself at least secure of an easy fortune.'[33]

Now Pendarves was only at home when hobbled by gout. Mary then spent hours at a time reading to him while shivering with cold as he could not tolerate a fire. There is no mention of what she read; but her husband had taken an Oxford degree, and was probably interested in modern history, as well as news-papers and pamphlets, or might have liked revisiting classical translations. Otherwise he frequently did not come home until six or seven in the morning, thoroughly inebriated. There were even hints that he was maintaining a second, illicit ménage.[34]

The pair were installed in the lodgings her husband had taken in a now unfashionable part of town, near Covent Garden, but the new fashionable areas were pushing further west. She resumed her domestic supervision of the household, which probably included some unfamiliar servants hired in London. By 1721 one of them included her black servant, John, who was baptised in 1721 at Buckland. We know nothing else about this individual. It is very likely that he was a boy of about 10 who acted as a page-boy for her, sending messages and doing errands and accompanying her on visits: in effect, a fashionable accessory; or he might have been a man old enough and/or tall enough to be a handsome footman for when she was driven by coach. Technically, such servants were slaves until, in 1772, Lord Mansfield, the Lord Chief Justice, who was by then a friend of Mary, ruled that no-one resident in Britain could be considered a slave, whatever their origin. Meanwhile, in effect John was a tied servant; in ensuring he was baptised Mary Pendarves would have considered he was also a free soul and that the best thing she could possibly give him was this sacred initiation into the Christian community.[35]

Also in the household was an unhappy, discontented older sister of Pendarves, who had married a Scottish fortune hunter. Alexander had not allowed him to get much of his sister's money and he had soon deserted her. Mary had begged Pendarves that when in London this sister-in-law would not be living with them, and he had agreed; but this was now disregarded. Mary reasoned that if she insisted on the promise being kept, it might seem she had something to hide: but 'as I feared no spy, I would not put it into the power of her malice to say that I did'. She acquiesced, so everything she said or did was under the surveillance of this sister-in-law, and attentive servants.[36]

These constraints did not prevent some enjoyable times. When her father accompanied her to London they of course made contact with his married sister, Lady Anne Stanley, who with her husband Sir John still divided her time between her duties at Somerset House and their villa in Fulham. An early letter to sister Anne back in Gloucester speaks of spending all day with the Stanleys, and also of going to some of Handel's new operas. He had returned to London in 1720 and created an opera company called the Royal Academy of Music. This was not a teaching institution in the modern sense but a commercial company.

Mary's friend Judith, Lady Sunderland, whose husband was a close political ally of Carteret, was among the ladies in court circles who were prepared to follow the example of Caroline, Princess of Wales, and adopt the practice of

inoculation. This had been introduced to England by Lady Mary Wortley
Montagu, who had observed its use in the Ottoman Empire. The process
involved introducing infected matter by incision, in the hope that a mild case
of smallpox would produce immunity. It was often successful – three of the
royal children survived perfectly – but it was still controversial, and sadly
Judith's daughter died.[37] Judith was a widow by 1721, and Mary could soon
report to her family on her fresh suitors. Mary's friendship with Lady Sunderland,
and her own cousinhood with Lord Carteret were both exceedingly important
since they prevented the automatic assumption that she was tainted by her
uncle's and her husband's Jacobitism. Mary socialised and attended court
instead with Lady Carteret and her daughters, who were all fine musicians, and
included her in opera visits.[38]

Mary was also much in the circle of the cultured Lord and Lady Harley, the
future 2nd Earl and Countess of Oxford. Their son and daughter-in-law lived
the normal life of a fashionable young couple, living partly in London and
partly at their country estate of Wimpole, near Cambridge. The future 2nd
Earl kept entirely out of politics, and concentrated on his calling as bibliophile
and connoisseur. His wife's huge fortune enabled him to indulge these tastes:
she had inherited both from her mother, Margaret Cavendish (1694–1755),
heiress to Henry Cavendish, 2nd Duke of Newcastle, and her father, John
Holles, for whom the title Duke of Newcastle was recreated. Mary's friendship
with the Harleys was one of the most important in her life. Music was one
area in common: Mary was continuing with her spinet lessons, and was always
glad when the Harleys could lend her their opera box when they were not in
town.[39] Her friendship with them would extend to their daughter, Margaret,
2nd Duchess of Portland, who was only a child of 7 when Mary described a
delightful musical river party with Lady Henrietta, on 14 July 1722:

> We went into the barge at five in the afternoon, and landed at Whitehall
> Stairs. We rowed up the river as far as Richmond, and were entertained all
> the time with very good musick in another barge. . . . While we lay before
> Richmond, we eat [sic] some cold meat, and fruit, and there was some variety
> of wines . . .[40]

Given the constant tightrope she was walking, it is small wonder that Mary
admired the French novels of the seventeenth century. They depicted a world

she could recognise in her own milieu, one full of surveillance: men and women scrutinised one another in order to unravel the true motives and feelings disguised beneath the stylised, polite behaviour. Spontaneity and sincerity were impossible – and not considered desirable. The most famous of these novels was Mme de Lafayette's *Princesse de Clèves* (1678), which reflects the court world of Louis XIV, but applied to features of the London world too, and she described a challenging incident in terms of this novel. One of her admirers was much trickier to handle than the gallants in the Stanleys' circle. This was the Hanoverian minister in London, Friedrich Ernest von Fabrice, whose role was to be the link between the king and the Regency government in Hanover, which managed political business for George I in his capacity as Elector. Although the same person was both the King of Britain and Elector of Hanover, the governments of each of his domains were meant to be kept entirely separate: so von Fabrice was in a position of trust and importance. When a showdown came, Mary Pendarves was discerning enough to use this to her advantage. Von Fabrice met and danced with her at a ball given by the Danish ambassador. Mary incorrectly assumed that as he was not a young fop, he would not try any amorous advances, but she was wrong. He arranged a musical evening for her and some of her friends, at which he stared fixedly at her many times. Any enjoyment of the music was completely impossible. When she put on her cloaked hood to leave, he managed to slip a love letter into the hood, on the pretence it had dropped out of it. 'I threw it into the fire with the utmost indignation!' she later remembered. She was soon able to escape to the country on a visit to her parents.[41]

This annual summer visit to Gloucestershire proved to be a very sad one. Her father had been in declining health – hence the visits to Bath for the curative waters. That autumn he had some kind of attack – perhaps a heart attack – so Mary stayed on to be a comfort and help to her mother and sister. After three months he died in December 1723, and was buried in a stone box tomb in the west end of the graveyard of Buckland parish church. One consolation, though, grew from the last weeks over the sick-bed: a much deeper friendship developed with her sister, now 15. She:

> was now grown a very reasonable and entertaining companion, though very young: she had a lively genius, improved beyond her years, loved reading, and had an excellent memory. I was surprised at her understanding, having

never before attended to her but as to a child, and the goodness of her heart, and the delicacy of her sentiments delighted me still more. From that time I had a perfect confidence in her, told her some of my distresses, and found great consolation and relief to my mind by this opening of my heart, and from her great tenderness and friendship to me.[42]

Anne, left mostly in the company of her mother and families like the Chapones, had had few opportunities to mix with girls of her own age; books and the conversation of her parents, and especially her mother, must have created this ability to empathise. Bereft of their kind and cheerful father, the sisters came to rely on each other, though the main burden of keeping up their mother's spirits would clearly fall on Anne. Mother and daughter instantly moved to Gloucester: Mrs Granville could no longer endure the melancholy and now the memories she associated with Buckland. There was also the pull of her unacknowledged daughter by the Duke of Ormonde, now married to a wealthy lawyer, John Viney.

When Mary returned to London, Alexander Pendarves realised how much she was grieving, and was sympathetic – but that was no deep consolation to Mary. To cheer her, in the summer Pendarves suggested a short, private visit to Windsor, and they rented a house near the Great Park of the castle. The king was in residence there, but as Pendarves had still not had himself and his wife presented at court, he wanted their sojourn to be very low-key. So, to avoid meeting any of the court entourage, Mary walked in the park early in the morning, accompanied by her maid and footman.

However, one of the residents at Windsor was a friend of Mary's, Petronella Melusina von der Schulenburg, Countess of Walsingham, called Stella in the autobiography. She was the daughter of the divorced king by his unofficial second wife, the Duchess of Kendal. She and Mary were both very fond of music and had attended many musical parties together. Mary felt obliged to agree to the request of the clockmaker Pinchbeck to recommend his inventive musical timepieces to such a well-connected court lady. This was to lead to a dramatic incident, just like an episode from *The Princesse de Clèves*. Mary was invited to drink tea with her, but to her dismay found that von Fabrice was present. This was natural enough, given their Hanoverian connection, and that Stella knew nothing of his amorous intentions, but Mary still tried to signal 'by my cool behaviour, that my thoughts of him were still the same, and that I had a thorough contempt for him'.[43]

Stella wanted to be friendly to Mary, and suggested she might want to walk in the private Little Park, normally kept locked, which Mary had seen from the window of the house she and her husband were renting. Germanico, alias von Fabrice, must have taken note of the arrangements and bribed the servant: 'I walked up and down towards the castle, expecting to see "Stella" in Q[ueen] E[Elizabeth's] Walk: when, to my equal surprise, I saw only Germanico!' The gate to this part of the park was now locked, so a quick escape was impossible.

> I soon apprehended this was a plot of the audacious wretch's contrivance, and a thousand fears crowded into my mind: however, I thought it best to walk towards him with some confidence, though I trembled so much I could hardly keep my feet. He came up to me and threw himself upon his knees, holding my petticoat, and begged I would forgive the stratagem he had made use of, for an opportunity of declaring how miserable he was on her account.

Mary was angry and flustered, and at first could not think how to discourage him effectively. Eventually she had the wit to say she would get Stella to help her complain to the king himself, and that if she did not help, '*I had friends*' – she probably meant her cousin, Lord Carteret, or his formidable mother – 'that would not bear to have me insulted and persecuted in such a manner; and that if he did not instantly go and acquaint Stella of my being there, I would go up to the windows of the apartment where I knew the king sat after dinner, and should not scruple making my complaint of him out loud.'[44] This was the best threat she could have made, terrifying von Fabrice with the thought of losing his footing with the king. 'He was alarmed at finding me so resolute (for he expected a dove instead of a tiger), and he asked my pardon.'

MARRIED LIFE: THE LAST CHAPTER

Mary Pendarves' letters to her sister indicate that in 1724 she was socialising close to court circles and with Whig supporters, even if her husband was slow to demonstrate his loyalties by presenting her at court. As he was laid up with gout for a lot of this year, she stayed at Fulham with the Stanleys. She visited Lady Carteret while she was preparing to go to court on the occasion of the king's birthday on 29 May. This was a big moment in the social calendar, and it was customary for court insiders to wear new clothes. Lady Carteret wore

'pale straw lutestring . . . flowered with silver' with a head-dress made of Brussels lace. Her friend Judith, Dowager Lady Sunderland, was wearing 'the finest pale blue and pink, very richly flowered in a running pattern of silver frosted and tissue with a little white', and had borrowed some jewels from Henrietta Harley, now Lady Oxford. This borrowing of finery among friends was not unusual and must have been a source of fun among them.

In December Judith Lady Sunderland married Sir Robert Sutton, a diplomat who had recently served in Paris. Mary enthused about the new home they were living in: it was in George Street, near Hanover Square, in the fashionable new West End of town, and 'furnished with a mighty good taste . . . with pictures, glasses [mirrors], tapestry and damask, all superfine of their kind'.[45] Lady Lansdowne, her uncle's wife, had been in England since the previous summer, paving the way for her husband's reconciliation with the king. The Pretender's advisers were at odds with one another and full of mutual suspicion. By the autumn of 1724 Lord Lansdowne had finally concluded that his attempts to reconcile the different Jacobite factions had only made 'James III' indifferent to his own loyalty, and that it was pointless to stay on. In order to undermine Jacobites in England George I always made it as easy as possible for men like Lord Lansdowne to be reconciled to the Hanoverians. For Mary, her aunt's return was a real headache, as it again confronted her with steering clear of the libertines while trying not to offend her family. One day she said forthrightly to her aunt that she deprecated her libertine friends. She was never forgiven. To make matters worse, Lady Lansdowne tried to manoeuvre the French-born Earl of Clare [Clario] into her niece's path, and he confessed to being ardently in love with her. After this Mary avoided Lady Lansdowne's house, remaining much in the company of her sick husband, whose ordeals with gout were intensifying.[46]

Ignorant of Lady Lansdowne's intrigues against Mary, after two months Pendarves reminded his wife that stopping her visits might upset her uncle. Reluctantly Mary made to George Street and, finding her aunt alone, complained of Clario's stratagem in delivering a love-note to her. Her 'prudery' was laughingly shrugged off, but nevertheless when Lord Clare came in Mary found herself locked in the salon with him. More people eventually arrived, singing lewd French songs and playing cards. When one of the guests invited the others to reassemble at her house, Mary declared, ' "I was engaged for as many days as she could name;" glad of the opportunity of showing my detestation of so

dangerous a society.'[47] Fortunately Lord Clare returned to France soon after this uncomfortable incident.

On 7 March 1724 Mary was having a quiet day visiting her friend Judith, named Placidia in the autobiography, while her husband was out with 'his *usual set*'. But she felt surprisingly ill at ease. She had had bad dreams the night before and all day long had a sense of foreboding. Instead of staying for supper as agreed, she called for a sedan chair and went home. 'Gromio had got home just before me. He said many kind things to me on my having made him "a good wife, and *wished he might live to reward me*". I never knew him say so much on that subject.'[48] He wanted to sign his will, but Mary, anxious he should rest, urged him to wait until the next day. She slept fitfully, aware of her husband's laboured breathing, and finally had three hours of sleep. When she awoke, he was black in the face and dead beside her. Mary was a widow.

CHAPTER THREE

❦

The New Widow and the
American Prince

FINDING HER FEET

*A*fter waking to this grim picture, Mary had immediately run out of her room screaming in a state of utter shock. Several doctors concluded that Alexander had probably died a couple of hours before. A servant sent for a neighbour and close friend, Catherine Dashwood. Aunt Stanley insisted on her coming to stay with her, to which Mary agreed, despite friendly offers from her other aunt, Lady Lansdowne: even in the middle of this ghastly death, Mary could think clearly enough to avoid staying with someone of such equivocal reputation. 'I knew the wisdom and goodness of Sebastian and Valeria [Sir John and Lady Anne Stanley] would be the surest refuge I could fly to at a time when I might be exposed to the insinuating temptations and malicious arts of the world. I was now to enter it again, on a new footing.'[1]

It took some time, but gradually the terror of the death and the tensions of the marriage faded away, and 'finding myself free from many vexations, soon brought me to a state of tranquillity I had not known for many years'. It was almost as if, after the marriage forced upon her, she could now have a fresh start. The first anxiety was financial: but even though her fortune 'was mediocre, it was at my own command'.[2] Her £100 per annum was enough for her to rent, and eventually to buy, her own house, and still have enough income to remain a part of polite society. She would have had more disposable income, too, if she had not tried to assist her scapegrace younger brother Bevill. Her relatives did try to find extra income for her from obtaining a place at court,

but to her mind this would have been useful rather than necessary. Financial independence was now hers, and although deferring to her family's opinion was still to be important, she could no longer be pressured into anything on the grounds of financial desperation.

A WIDOW UNDER PRESSURE

All the same, Mary had very little time to reflect on her marriage and the traumatic way it had ended before being urged to remarry by her family. They dragged her one way, while her heart took her in a different direction. It was very common in the circles in which she moved for widows or widowers to marry a second or third time. Their reasons ranged all along the spectrum from normal human desire for love and companionship, to being penniless, to wanting better status, more money and more influential connections. A man might always be allowed to fulfil his sexual needs by keeping a mistress or taking his chances with commercialised sex, but although in a permissive moral environment this did not damage his reputation, it could risk his health. Women were more circumscribed given the double standard, but it was commonly assumed that a widow, now sexually initiated, would want to join in the sexual merry-go-round. Of course, without legal vows any such affair would be a problem were she to fall pregnant.

In July 1714 Lady Mary Wortley Montagu had contributed – anonymously – a lively essay to Addison and Steele's *Spectator*, responding to the description in a previous issue of a club of nine merry widows whose love lives illustrated a number of possible scenarios.[3] The essay, which was in the form of a 'letter to the editor', shows the extent to which the common currency of much correspondence and social conversation was a constant depiction of character and retailing of anecdote. The line between creating imaginary lives in essays and novels, and letter-writing that reported on real people, was very thin. Whole pages of letters between Mary, her sister, and her friends and relatives, consist of information about marriages, remarriages, elopements, births and deaths, and details of wills and marriage settlements, with some extending to a quick character sketch. Part of the enduring attraction of Mary's correspondence is the way it includes so many brief depictions of an individual life – we remain fascinated by how variously the facts of birth, marriage and death, money and status, manifest themselves within an endlessly permutating kaleidoscope.

Unlike Lady Montagu's merry widows, Mrs Pendarves did not want to trifle with men, nor have her strict principles compromised. But even the suitably high-minded suitors who began to approach her automatically assumed a woman, especially a not-too-rich woman, would be eager to remarry. A widow would still need to consider her family and defer to its head, and family lawyers would be vigilant to prevent her widow's inheritance from benefiting either new step-children, or her own offspring by the new husband. A widow could also find that her original marriage settlement contained financial penalties, such as loss or diminution of her dowry, if she did remarry, though this did not apply to Mary.

Her own financial position took a while to clarify. Mary's marriage with Mr Pendarves had been represented as an advantageous opportunity. The family zeal now to find her another husband was partly fuelled by a certain amount of guilt that her own wishes had been so little regarded, and that although her marriage had been brief, it had not secured her the anticipated windfall. Lord Lansdowne wrote to her from France that he did not recollect the details of her marriage settlement but thought her father had had a copy and that it could be found among his papers. His daughter Grace had reported to him that Pendarves had died and that Mary was now 'a handsome widow'; he added, 'I hope you will find yourself [to be] a rich one.'[4] But Lord Lansdowne had been remiss in failing to follow through with a second settlement after Pendarves had retrieved his sequestered estates. At this early stage of widowhood Mary professed herself to be uninterested in the financial details and ready to wait for the lawyers to battle it out with her niece by marriage, Mrs Basset, who remained the main heiress of the late Alexander Pendarves.[5]

The first person to recommend a speedy marriage was, surprisingly, her Aunt Stanley, her consoler and succour. It seems insensitive of Lady Stanley to have overlooked how much time her niece might have needed to recuperate. The candidate was her nephew Henry Monck, son of Sir John Stanley's eldest sister, and also a descendant of Sir Bevill Granville's sister Grace. To Mary, Henry Monck must have seemed a little like the third husband of the *Spectator* widow: 'a lively and good-humoured young man very well in his person and manner' but he possessed only 'a moderate understanding, was uncultivated, trifling, without knowledge of the world'. She did not want to upset either her kind uncle or her aunt, but firmly declared she had no inclination to marry anyone.[6]

There was, however, a much stronger reason for Aunt Stanley to press her jejune young nephew's claims: she feared Mary would fall for Lord Baltimore, a

friend of 'Gromio' whom Mary had met through his sister. Up to that point he had always treated her 'respectfully'.[7] He had not called on her until six months after Mary's widowhood: but he then stayed two hours. Alarm bells started ringing in Aunt Stanley's ears. She immediately summoned Mary to tell her of Henry Monck's wish to pay court to her, how suitable it would be to unite the two families and how well Sir John would endow her and his nephew. By presenting a superficially attractive alternative, she hoped she could head off Lord Baltimore.

Next day, brother Bernard was deployed to help persuade Mary of Henry Monck's suitability. Happily for Mary, he only briefly mentioned the marriage offer and understood her objections. Mary made no secret to her aunt of the tenor of her conversations with Lord Baltimore: her increasing partiality for him strengthened her resolution to withstand pressure to favour young cousin Monck. Lord Baltimore seemed attentive and 'respectful' – that is, likely to offer marriage after a courtship with no sexual overtures.[8] But she did begin to refer to him in her letters to her sister, Anne, as 'The Basilisk' – the legendary venomous serpent with extraordinary powers of hypnotising his prey by a single glance. She knew she was dangerously fascinated by him, and tried to resist his charm.[9]

IN THE PROVINCES: GLOUCESTER AND RURAL RETREATS

In 1723 Mary's sister and their newly widowed mother had moved from the Buckland estate to the cathedral city of Gloucester (Plate 7). Mrs Granville and Anne first lived in apartments in the cathedral deanery, then moved to an old tall house in Eastgate, a street forming part of the crossroads of two major thoroughfares at the town centre. From there, the post to London took only three to four days, and it was easy to find carriers to exchange goods with London, including lampreys, a type of eel found in the River Severn, considered a delicacy. Anne had a closet up in the attic, for her books and letter-writing, probably a better place for catching morning and in the summer evening light than any parlour lower down. There was also an enclosed garden for Anne to plant seeds and develop species given by her sister's friends, such as Lady Sunderland and the Duchess of Portland, or sent down from London nurseries.

Much of their lives revolved around the cathedral services and charitable activities, which meant more to them than any political or commercial bustle.[10]

47

Music too was part of the scene, as the Three Choirs festival had already begun its rotation between Gloucester, Worcester and Hereford. One of the early musical benefactors of the festival was Mrs Catherina Bovey, an heiress of Anglo-Dutch extraction and a widow since the age of 22, who combined philanthropy with a taste for fashionable dress – showing that the good need not be the dowdy. She also figured anonymously in *The Spectator* as a beautiful, confident yet unattainable widow – another kind of example for Mary Pendarves. Richard Steele dedicated the second volume of *The Ladies Library* to her.

The Viney family lived in a splendid house recently built on the College Green outside the cathedral, where there was a sixteenth-century grammar school, as well as houses belonging to cathedral clerics. John Viney senior had been a lawyer who undertook work for the cathedral dean, and his son John, Mrs Granville's son-in-law, followed in his footsteps. In 1731 an advertisement appeared in the *Gloucestershire Mercury* about their runaway black servant; people of colour, undoubtedly shipped into Bristol from the West Indies, were now being employed in domestic service by the upper middling sort. Considering that her husband and brother-in-law had been based in Barbados, and that her daughter had a black servant ten years earlier (see Chapter 2), it is possible Mrs Granville also had a black servant or servants at this time.

In the spring and summer, the Granvilles took a respite from the crowded busy city, the cacophony of the markets and the smells of urban living, by renting a small cottage at Cranham, near Painswick, giving more opportunities to Anne's green fingers and botanical knowledge. When Mary came to stay it was also an opportunity for her to renew her friendship with Sarah Kirkham. In 1725 Sarah stayed close to home by marrying a local clergyman and school-teacher, John Chapone, vicar of Childswyckham, another small village on the Gloucestershire/Worcestershire border. Together they ran a small school in addition to his clerical duties. Sarah probably had had a long understanding with John Chapone that they would marry, but she did not lack other suitors or fond admirers.

The most significant of these was the young cleric and Fellow of Lincoln College, Oxford, John Wesley, soon to be the originator of the 'Methodist' movement within the Anglican Church, who first visited the Kirkham family in 1725, about eight months before Sarah's wedding on 28 December. Wesley's diary suggests he was immediately taken with the vivacious Sarah, but despondent that she was spoken for. However, Sarah managed to convert this attrac-

tion into a platonic and sentimental friendship, which (mostly) prevented her husband becoming jealous, and that suited Wesley's reticent nature.

For the next ten years Wesley kept in touch with this interlocking series of families, including staying at Stanton with the Chapones, and at Gloucester with Mrs Granville. These friends offered Wesley the pleasures of cultivated conversation, country walks and sports, music, singing and dancing, among company a little higher up the social ladder than his own family. Such conversation, especially with women, was held to be a refining influence and it must have given Wesley a little extra social polish.[11] The seventeenth-century French chivalric romances of Mlle de Scudéry, author of *Clélia*, provided a template for the analysis of refined feelings and different kinds of love. Sarah Chapone explained to Wesley how their respectful friendship could harmonise with her happy marriage:

> I would certainly tell you if my husband should ever resent our freedom, which I am satisfied he never will . . . the esteem as it is grounded on reason and virtue and entirely agreeable to us both, no circumstance of life will ever make me alter.[12]

For Sarah, being able to retain such close friendships after marriage was part of a woman's civil freedom that marriage did not curtail.

It was probably Mary Pendarves, the keenest of the group on French literature, who initiated the friendship circle's adoption of pastoral, neo-classical nicknames, borrowed from French romance or Italian opera; Wesley was Cyrus, his brother Charles, Araspes, Mary was Aspasia, and her sister Anne, Selima. Sarah Chapone was sometimes Sappho, the legendary Greek poetess and learned woman; sometimes Deborah, the biblical female judge and Israelite leader.[13] Such names were useful both in skating over the real if subtle differences in social rank and connection between them all, and creating an enchanted imaginary world of high-minded friendship. They also helped differentiate this world of passionless but intense friendship from the ordinary rituals of courtship.[14] Wesley made a second visit in the Christmas vacation from Oxford. The book of the season was Swift's recently published *Gulliver's Travels*, and they all enjoyed its being read out loud and wept at the sentimental parts.[15]

On Sundays Wesley was often guest preacher at Stanton and Buckland. Religious discussion was intrinsic to these visits, as well as natural philosophy.

The ways in which the natural worlds could be understood as both the work of God and the object of systematic scientific study must have been a frequent theme, since the friends talked of whether animals had reason, of comets and astronomy and why medical doctors tended to atheism – a question raised by Sarah herself.[16] But none of this highly wrought sentimental discussion dented Mary's determination to stay single.

MRS PENDARVES AND THE NEW COURT

Pending settlement of her widow's jointure from the Basset family, the Carterets also had in mind that Mary should be on the look-out for a salaried place at court. This would be prestigious, in line with family expectation, and helpful financially. As a widow, Mary was suitable as a Woman of the Bedchamber, and her young sister Anne could now be considered as a Maid of Honour, with Mary and others pulling the strings on her behalf. With the accession of George II and Caroline as king and queen in June 1727, there might be new possibilities when their households were formed. Under the auspices of the Carterets, and also Sir John and Lady Stanley, Mary's attendance at court became assiduous.

Court levées were usually held at the Palace of St James's but, under the first two Georges, the royal residence of Kensington Palace became an additional and more exclusive social venue. As well as the regular court levées, held by a monarch for men only, a king with a living queen consort held drawing rooms on Sundays where men and women were both present. Court dress was required for both: for men and women alike this meant the best silk clothes they could obtain. George II's reign gives the impression of a decline in the court, partly because he was a widower after 1737, but he still held drawing rooms with the assistance variously of his daughter, Princess Amelia, his daughter-in-law, Princess Augusta of Wales, or even his mistress, the German-born Sophie von Wallmoden, who was given the English title of Countess of Yarmouth. After giving birth a queen would also have her own regal version of a 'lying-in', when women would visit the mother and newborn to drink caudle (a special sweet-tasting wine). There were also set-piece occasions with particularly lavish decorations and entertainments, such as the birthday of the king or queen, when new clothes were customarily worn: a royal wedding; anniversaries of the monarch's accession; or other dates in the political calendar, such as the Restoration of the monarchy in 1660 or of the Glorious Revolution of 1688.

George II succeeded to the throne in 1727 when his father died on one of his regular visits to the Hanoverian summer palace at Herrenhausen. There was now an opportunity for a splendid coronation to help further establish the Hanoverian dynasty in the public mind after its early success in preventing a Jacobite restoration. Mary and the Carterets were swept up into several of the ceremonial occasions, and as Anne had gone back to Gloucester after her usual late spring visit to London, Mary made sure to make her letters as vivid and informative as possible. This means that her description of the coronation and mayor's feast in 1727 is one of the best descriptions of these occasions, and has been much quoted.

'No words can describe the magnificence my eyes beheld,' she said to her sister. The coronation procession started from and returned to Westminster Hall, where Mary was situated. She did not consider the queen was sufficiently finely dressed, despite her petticoat having £24,000 worth of jewels stitched to it! But Mary conceded that she carried herself very well. The young princesses Anne, Amelia and Caroline (aged 16, 14 and 12 respectively) held the tip of their mother's train, dressed in silver gowns with their own long trains, and wearing, reflecting their royal status, purple ermine mantles, with diadems on their heads. The lords' dress was harder to carry off, but Mary thought those with good deportment, such as Lord Sunderland and the Duke of Richmond, looked the best.

The next day Mary was again part of Lady Carteret's circle, to attend the Lord Mayor's Feast in the City of London. The City of London, then and now, was governed by its own corporation, and it made and still makes its own welcome to the sovereign after a coronation or special event. The streets were so crowded with carriages that it took Mary's party more than an hour to get down the Strand from Somerset House towards Temple Bar, the boundary of the city's Square Mile of territory. Everyone had to get out at Cheapside and walk to the Guildhall (the mayor's official headquarters). They were shown into the room where the lady mayoress was, with the wives of the aldermen, who seated them at her table, in deference to Lord Carteret's standing as the king's personal representative in Ireland. Meanwhile the mayor was processing through the city and greeted the king on his arrival. George II was in purple velvet and his coach and horses were also dressed largely in purple: these horses were all a beautiful cream, with manes and tails plaited with purple ribbon. Unlike the restrained and plain-living George I, George II and Queen Caroline were determined to restore more

ceremonial glamour to the public face of monarchy. Altogether Mary had enjoyed being a part of these events: 'it was not disagreeable to be taken notice of by one's acquaintance when they appeared to so much advantage . . .'[17]

During the first five years of the new reign, Mary followed the peripatetic calendar of those 'in society'. In November she was usually in London, first staying with the Stanleys at Somerset House and then renting her own house. By April or May she tried to have Anne come to visit her in London before they both went back to Gloucester, and sometimes her mother came to London too and visited the Isaacson cousins at Brickhill, Bedfordshire, en route.[18] Mary was back in London by late autumn. Here the main 'business' of networking for a position at court, and later helping to prepare Anne for a similar future, recommenced. Attending concerts, plays, balls and operas were the chief public pleasures. Her family took up much of her horizon, especially young Bevill, and Lady Stanley, increasingly an invalid; but the Carterets and other relatives were also demanding.

Steering her way through the ebb and flow of fashionable pleasures and social life made her increasingly reflective about what really mattered in human relationships. More and more she considered that real friendship was what counted, and that the moral centre of her life was only to be found with the kind of sisterly friendship she enjoyed with Anne and a few other chosen ones – many with Irish connections. Mary quoted to her sister a well-known phrase from the Restoration wit Lord Rochester's 'A Letter from Artemesia in the country', saying that she was 'That cordial drop heaven in our cup has thrown'.[19] Mary thought and commented ceaselessly about the marriages she saw around her – and underlying this was the perplexing attraction to Lord Baltimore, 'the Basilisk'. Were she to make a marriage of her own inclination, who would be a worthy mate? Might it be him? But did he really love her and was he a reliable character?

'PEN-PEN'

In the twenty-first century Mrs Delany has come into her own as the creator of the paper collages, her sensitive flower portraits. But, given the influence of her uncle George, Lord Lansdowne, and his encouragement of her literary education, she was likely better known in her circle for writing letters and occasional verse – and perhaps some high-minded fables or poems. Her nickname of 'Pen', sometimes 'Pen-Pen', appearing in letters to her sister and close friends surely

alludes to more than a play upon her married name. However, the whole idea of women writing for a field beyond their immediate circle was still intensely problematic. Outspoken prominence even in leisured circles of the cognoscenti made a woman too exceptional, while writing openly for the literary market meant she was trading on her talent, which no *lady* wanted to be seen to do.

If Mary was writing any poetry herself at this time it would most likely have been either devotional poetry that she kept to herself, or occasional verse in lighter vein shared within the circle of family and close friends, prompted by a birthday, social occasion or current amusement. She would have classified this kind of writing as mere rhyming or versification, not real poetry. It is at this period that Mary specifically praises Anne Finch, Countess of Winchilsea, who had been part of the Longleat circle before Mary's uncle George settled there. Mary wrote to her sister, alluding to a Dr Grenville, probably a cleric, who was based in Gloucester and marrying someone known to herself and Anne:

> I am afraid the Dr. will think I set up for a poet, and that is a character I detest, unless I was able to maintain it as well as my Lady Winchilsea. Nothing is as impertinent as dabblers, despised by men of sense . . .[20]

It is not hard to see why the young Mary Granville would have liked Anne Finch's poems. They used modern colloquial diction very attractively, and Mary emulated this in the little snatches of verse contained in her letters to her sister. Many of Finch's poems were witty; some were devotional; they celebrated a theme dear to Mary Pendarves' heart – friendship; and they included translations from Italian and French authors. Like her contemporary Mary Astell, Finch also satirised the frivolity of fashionable ladies. Her best-known poem was an 'Ode to the Spleen' – the eighteenth-century term for the recurrent depression that plagued her, and must have been intensified by her awareness as a woman that her inclination to write was considered so wrong. In it she recalled her resistance to two models of femininity, either that of the empty-headed woman trifler, or the over-domestic *femme managère*. Addressing the spleen, she laments:

> O'er me alas! Thou dost too much prevail;
> I feel thy force, while I against thee rail;
>
> . . .

Through thy black Jaundice I all objects see,
As Dark, and Terrible as Thee,
My lines decry'd, and My employment thought,
An useless Folly, or presumptious Fault.

Feminine pursuits – 'in fading Silks compose/Faintly th'inimtable Rose/ Fill up an ill-drawn *Bird*, or paint on Glass' – provide Anne Finch with no solace.[21]

Here Mary might have felt less affinity with her favourite poet, as she could always busy herself with some decorative or artistic project. On one occasion she signed a letter 'Penelope Darves', which may suggest her identification with the Greek heroine Penelope in Homer's epic *Iliad*.[22] In the poem, Penelope, wife of King Odysseus, who took ten years to journey home after fighting in the Trojan wars, put off her suitors by telling them she would listen to their suit once her needlework was complete. To gain time she unravelled what she had done during the day. Similarly Mary could always find something else to do rather than pay attention to unwanted admirers.

If Mary had read Anne Finch's poems at their first appearance, Finch's admiration for common flowers not normally praised in eighteenth-century poetry, such as poppies and cornflowers, might have helped her 'see' such everyday blooms with a fresh eye once she was marooned in the countryside. She certainly reproduced them later in her embroidery designs. If she had known of Finch's justification for being a female poet (confided to an unpublished manuscript volume) she would have agreed with its biblical basis: Finch evoked Old Testament biblical women, such as those who rejoiced when Noah's Ark floated safely to rest.[23] Mary was always acutely aware of the highest exemplars of any art that interested her. She consistently rated her own talents as inferior: she had the instincts of a perfectionist.

Even if most women of rank shied away from publishing or publicising their own creative work, preferring to circulate anything ambitious in manuscript,[24] in a broader sense more of them were becoming women of letters through being literary patrons. The literary apprenticeship Mary was experiencing at this time included acquaintance with several women who showed what a woman could achieve. One was the young heiress Frances Thynne (first cousin of Lady Frances Carteret), who became a friend of Mary's. As Countess of Hertford she would become an influential patron to the pious writer Elizabeth Singer Rowe, and later the leading poet James Thomson, who wrote the poem 'Rule,

Britannia!', as well as the pastoral epic *The Seasons*. Mary's modest means limited her scope for patronage, but she was rich in connections, and in a few years' time was able to use these to help secure support for a neglected female scholar.

BROTHER BEVILL'S LITERARY AMBITIONS

Meanwhile, her youngest brother, Bevill, also had literary inclinations, and took some time to find his métier; Mary recalled in her memoir that she 'suffered infinite vexation on his account for many years', during which she helped him financially. Bevill had attended Westminster school with brother Bernard, and at some point, probably in 1711, was tutored in the classics by Edward Young, an aspirant poet who was moving in the orbit of Lord Lansdowne, to whom he dedicated his first poem, a celebration of the peace of 1713 with the Treaty of Utrecht.

In her autobiographical letters, the story of her relationship with Lord Baltimore dominates the narrative. Before leaving for Fulham one summer day in 1726, he pressed her to join a water-party on the River Thames. He assured her that his sister Jane would be included – this meant she would be effectively chaperoned – and implied it was all arranged mainly to please her. As he had not declared whether he was formally courting her or not, Mary thought it prudent to refuse. To seem, or to be thought to be accepting, special treatment from an eligible single man, would signal to any fashionable observer that she was either mistress to the Basilisk or about to be his betrothed. But she had now begun to classify him as a 'flutterer' – someone who blows hot and cold.[25]

Lord Baltimore dismissed the boats and went off to play 'real' or indoor tennis, a game much like modern squash. He was struck very hard on the forehead and had to be carried off, unconscious and bleeding, to his sister's house. A letter from Jane brought Mary back to town from Fulham. Lord Baltimore begged to see her, but the implied intimacy of visiting a man on his sick-bed was again too imprudent for the correct Mrs Pendarves. 'I could not bring myself to do it, as he had never *positively* made any declaration that could warrant my granting him such an indulgence . . .'[26]

Mary herself began to feel the stress of these encounters and pleas and stayed safely away in Fulham. She did, however, send from time to time to enquire after his progress, and Jane told Mary that he was so encouraged by this it was almost as if he wanted to recover for Mary's sake. When he had gone to

the country to complete his convalescence, he himself wrote 'that his recovery was more owing [to her concern] than to the skill of his physicians'.[27] Mary did not reply to these letters – again, this was prudential behaviour: to accept letters would imply a kind of intimacy. Towards the end of that summer of 1726, she spent some time at the fashionable spa of Tunbridge Wells with her uncle and aunt. Next time he called on her he still looked ill and drawn. He told her he was planning to spend three months on a little cruise to Italy. With some hesitation he begged her a favour: could he have a miniature of her to take with him? Again this would imply some kind of undefined but clandestine intimacy, and again she refused. They parted company, each cross and disappointed with the other.[28]

LOBBYING AT COURT

Mary's concerns for her Aunt and Uncle Stanley ran parallel to these literary and fraternal preoccupations, together with the underlying issue of Lord Baltimore. Mary was ill with a cold over the New Year of 1727–8, and when she sent her greetings to Anne was beginning to feel restless at her confinement to the Stanley circle as she convalesced. Lady Anne's companion, Mme Tellier, had also been ill, and Sir John Stanley was also sickening. 'I who am no friend to idleness am obliged to saunter away a good deal of time', Mary complained to Anne. Jane Hyde, Lord Baltimore's sister, was coping that winter with her youngest son having a fever, and a daughter, to whom Mary was godmother, so ill that her life was despaired of.[29]

Mary's serious reading at this time was one of the most important philosophical works of the immensely influential Roman lawyer and moralist, Cicero, *On Moral Ends*. In the spirit of Judith Drake, she was tackling the classics in translation – here it was probably an edition published in 1702. The book is a weighty discussion and by no means light reading. Essentially it shows how much she was thinking about the different kinds of love. Friendship differed from passion as it had a basis in shared interests and values. It also differed from the shallow, instrumental acquaintanceship that was often the currency of the social networking needed to secure patronage. Meanwhile, down in the country Anne was busy reading John Gay's *Fables*.

The talk of the town that winter of 1728 was the mock-heroic *The Beggar's Opera*, with libretto by Gay, which took the capital by storm. It was a satire

implying that leading politicians of the day such as Robert Walpole were no better than the criminals and thief-takers (that is, the public informants on criminals, who colluded with them), and who were ostensibly the characters in the play. Musically, it was also a send-up of Italian opera, and its songs were easily tuneful, based on popular melodies. They continued to be sung throughout the century, entering the national memory. Mary was soon singing them herself, and promised to send the sheet music to Anne so that she could encourage an amateur performance in Gloucester, but she worried, as many did, that its success would make Italian opera financially non-viable. After attending a rehearsal of Handel's *Tolomeo* that spring, she lamented 'the taste of the town is so depraved, that nothing will be approved of but the burlesque'.[30]

The letters refer to many acquaintances whom Anne had met in London or who were visiting from Gloucestershire. Among these are the first mentions of their 'friends from Ireland', the Perceval family. They were an Anglo-Irish family, originally from the west country of England, who had acquired extensive lands in Ireland since the early seventeenth century. John Perceval (1683–1748) became an English MP at the start of George II's reign, sitting for the eastern port of Harwich, Essex; his wife, Catherine Parker, whom he had chosen carefully and to whom he was devoted, came from the neighbouring county of Suffolk. One of his closest friends was the philosopher and churchman George Berkeley, author of *The Ladies Library*. Berkeley dedicated the first volume of his key work, *A Treatise concerning the Principles of Human Knowledge* (1710), to his friend, and Perceval in turn became a keen supporter of Berkeley's project to evangelise the native North Americans from a college based in Bermuda.[31] This was not a success but by 1731 both men were becoming interested in a new scheme organised by the career soldier and MP for Hazelmere (1696–1785) James Oglethorpe. The latter was energised by the travails of poor English debtors, and set himself the goal of founding a new colony in North America to aid them. Perceval and Oglethorpe initiated legislation in the English House of Commons, which culminated in the founding of Georgia in 1733. Their other philanthropic schemes included helping Thomas Coram start the famous Foundling Hospital in London.[32] Mary Pendarves would have known all about these projects, but her closest friend in this circle was Anne Donnellan, niece of John Perceval. His brother Philip sat in the Irish House of Commons, and had married an Irish widow, Martha Donnellan, whose first husband had been a prominent member of the Irish legal establishment; Martha's other daughter,

Katherine, was the wife of an Irish-born clergyman, Robert Clayton, who was soon to obtain an Irish bishopric. Anne Donnellan and her sister Katherine Clayton would figure significantly in Mary's future life.

One bit of marriage news that winter concerned the stipulations in the will of Thomas Tufton, Lord Thanet, a peer based in Kent. His daughter, Lady Bell Tufton, was to inherit £2,000 a year but only on condition that she did *not* marry her preferred suitor Lord Nassau Paulett, whose estate yielded an income that Lord Tufton deemed inadequate for Lady Bell. Mary declared, 'I have no notion of love and a knapsack, but I cannot think riches the only thing that ought to be considered in matrimony: however, this will prove Lord Nassau's love, if he does not persist in his addresses to her now.'[33] This is not a defence of marrying for love per se, but for love united with a prudent eye to a sufficient income.

On the other hand, Lord Baltimore's sister, her friend Jane Hyde, was a warning example of the cares marriage could bring. One day in March Mary had walked in the park with a Miss Thornhill and intended to go to court that evening. But once home she found a letter from Jane, begging her to come and dine and then accompany her to a concert. 'I thought it barbarous to disappoint one who has so few pleasures in this life. Matrimony! I marry! Yes, there's a blessed scene before my eyes of the comforts of that state. – A sick husband, squalling brats, a cross mother-in-law, and a thousand unavoidable impertinences: no, no, sister mine, it must be a "Basilisk" indeed . . .' But soon Mary was longing for her summer respite from London society, returning to Gloucester to her mother and sister, where she stayed from June to November.[34]

When she returned to London, she was again in the Carteret orbit and encouraged to make herself visible at court. The family evidently thought that as Queen Caroline needed to confirm the make-up of her household as queen consort not Princess of Wales, there might be some scope for a new appointment. They were thinking in terms of the role of Woman of the Bedchamber, which gave an income of £300 p.a. together with a dress allowance. Unlike the higher standing of a Lady of the Bedchamber, it did not require the post-holder to be the daughter of an earl; being a great-niece would suffice. But sometimes all this putting herself about to attract notice seemed a dispiriting process, especially compared with the recent cosy family time in Gloucester. When her little cat (white with black spots, brought to Somerset House from Northend) was absent one November evening she was disproportionately upset:

Last night I returned from Court, cold and weary, with the expectation of finding a letter at home to recompense me for the toils I had endured; but, alas! I was sorely deceived, for I only found a room full of smoke, the wind and rain beating against my windows my pussey [sic] lost (as I thought) but she was found. Well into my bed I tumbled about half an hour after one . . .[35]

On another evening the court was so thinly attended she thought there were about twenty people all told – but these included Lord Baltimore, whose wit was a bright spark for a dull evening. On this occasion the king asked her why she had not been to Bath, presumably thinking as it was in the Gloucester orbit, it would have been a sociable interlude in her quiet summer. Mary reported this to Anne, showing that the king obviously knew who she was and where she came from – a plus for a place-seeker.[36]

It soon looked as if all this networking might bear fruit. In December 1728 the 20-year-old Frederick, Prince of Wales left Hanover and came to live in England, which meant she had even more reason to continue the court routines, urged on by the Carterets. Their assumption was that Frederick would soon be married and his wife would need her own household.[37] Mary was soon favour-ably impressed with the prince: 'What can be happier in appearance than that young man is at present? But he will pay dear enough for it when the weight of the nation lies upon his shoulders.'[38] However, as yet there was no talk about his marriage, and by February 1729 she had decided to take no more steps towards obtaining a future position or promise of one. There were also practical concerns; it was not clear that anyone attending on a Princess of Wales, once she materialised, would have the same salary and perks.

As winter changed to the spring of 1729, she spent a lot of time with her ailing aunt, though she managed to attend enough operas to give Anne a rundown on the new singers Handel had brought back from Italy; the new stars included the castrato Antonio Bernacchi and Anna Maria Strada, who was to help Handel create some of his finest soprano roles. Anne had recently had either chickenpox or smallpox, as Mary sent her a recipe for 'rotten apple water' to help restore her complexion. And Mary was encountering Lord Baltimore, first at a concert, then when he called at the Stanleys in Somerset House, his manner unchanged.[39]

Mary attended the court that celebrated the queen's birthday with Lady Carteret and two of her daughters. Mary had helped design the former's

dress – for which she was fulsomely complimented by the queen herself. Might this have been a promising hint that the queen would have liked in her entourage a woman with such flair? 'Like a jay in borrowed feathers', Mary was also wearing jewels lent by Lady Sunderland.[40] It was a very crowded evening in cramped St James's, which made it hard for the small family parties to keep together. One person the Carteret group spotted was 'Ha Ha', dressed in azure blue. Ha Ha was the nickname for Henry Hervey, one of the many younger siblings of Lord John Hervey, Vice-Chamberlain to and confidant of the queen. Henry, who was another Westminster school contemporary of Bernard Granville's, was now a junior army officer, and was currently rather smitten with Anne Granville. But he had extravagant tastes, and as he adroitly married an heiress, Catherine Aston, the following year, he was clearly prudent enough to prevent this inclination from going too far. Mary's account of this whole evening is a wonderful evocation of how little private exchanges could be had while people talked ten to a dozen around them and queued to pay their addresses to the royal couple. Everyone was constantly aware of how everyone else was succeeding at getting their few moments of conversation with the royal host and hostess.

Mary was soon parted by the throng from the Carterets, and could not even see them past the people who were dancing. Lord Baltimore came to her rescue and found her a seat that happened to be opposite his aunt Lady Betty Lee. Mary urged him to pay his respects but he declared he disliked her 'ugly' looks, yet he declared in his usual half-teasing, half-ardent way that he wished Mary was as ugly as her, and then he would be a happy man. This gives a flavour of his courtship – though adroitly done, the implication was that it was Mary's fault he found her so enticingly attractive.[41]

On her next visit to court a few days later, Mary felt she was making more headway with the king, who had a longer conversation with her. Although she had decided not to press her claims for a position with the queen, or with Frederick's putative circle, too far, the Carterets still clearly had this in mind as financially beneficial. Mrs Basset's lawyer had recently discussed things with her: the Bassets wanted to buy her out of her widow's jointure, which was paid from the Pendarves estate income, and endow her with an annuity of some kind, and of acceptable value, from different moneys at their disposal. She did not feel under pressure to agree, and was content to take advice from her uncle Stanley, 'but if they offer very largely I shall be tempted'.[42]

It is evident that different generations of the Carterets were now recommending different strategies about securing a place for her in the queen's household. The Carterets were probably underestimating the queen's desire to keep her team of Maids, Ladies and Women largely unchanged from when she was Princess of Wales.[43] Furthermore, one of the Bedchamber women who was carried through was Bridget Carteret, a niece by marriage of Countess Granville's, the mother of Lord Carteret. Mary told Anne: 'I am mighty easy in the matter; but my cousins, who are mighty fond of me, insist upon my going another way to work; they say that if it was only named to the King and Queen Caroline I should be accepted.'

GOODBYE TO THE BASILISK

Lady Stanley was as ill that spring as the previous one, but on the Carteret side of the family cheerful scenes beckoned. Lord and Lady Carteret were marrying off their eldest daughter Grace, aged 16, and had allowed her choice in the matter while ensuring she was being introduced to suitable young men. Grace was being courted by a wealthy young Scottish peer, Lionel Tollemache, 4th Earl of Dysart, whose properties included the glamorous Thameside courtier house, Ham House, built in 1610. At the Restoration of the monarchy in 1660 its chatelaine and heiress, Elizabeth Tollemache, 2nd Countess of Dysart in her own right, had married one of Charles II's closest political allies, John Maitland, 1st Duke of Lauderdale, and together they had lavishly decorated and furnished the house. Even more than the Granvilles, the Lauderdale couple had been at the centre of the Restoration court. Now a new chapter beckoned: one task for the young couple seventy years after its Restoration glamour was to repair and restore the neglected mansion.[44]

Mary reported to her mother and sister that Grace 'looks neither grave nor merry though she has no reason to be displeased . . . She has a better chance of being happy, than most young ladies in her situation, because her mother and father . . . would not force her inclinations', and Lionel had assured Grace that he wouldn't press her either if she was not in favour of the match. The tone of Mary's comment suggests her successful detachment from any such inclination herself: 'But there's the difficulty: *moneyed men* are most of them covetous, disagreeable wretches; *fine men* with titles and estates are *coxcombs*: those of *real merit are seldom to be found . . .*'[45]

In September, the queen sent word she wanted to be at Somerset House and for Lady Stanley to welcome her in her capacity as housekeeper, but the latter was now too frail to do this, and Sir John deputised. One reason why Mary turned to art this year, doing portraits in pencil in the spring, and then followed Lady Carteret in the autumn with the new craze for japanning, was surely that she spent much of her time attendant on her ailing aunt and uncle. She was undeniably interested in artistic pursuits, but they were also a means of preventing the idleness she deplored while she was unavoidably staying at home so much of the time. Absorbing herself in learning new artistic techniques must have also helped distract her from the worries of close attendance on an invalid.

The 'japan' ware consisted of painting paper boards with a black or red background and then adding oriental decorative motifs to imitate Japanese lacquer work; these imitations were often made into little boxes for trinkets or makeup. Their visual impact stored itself away in her memory and would bear fruit much later with the black background of her paper collages.[46] Anne was less impressed with real japan ware; Mary describes seeing some genuine japanned work of the kind Anne 'much despised'. The sisters were still doing paper cut-work, and Mary advised Anne on her progress in that field.

Mary was soon astonished to hear news about that other 'fantastic thing', Lord Baltimore, in a series of reports that sound more and more like the plot twists in an Italian opera. First in November she heard from his sister, Jane Hyde, that he had fallen ill in Italy and was not expected to recover.[47] Mary's only recorded comment to Anne about this was that she was sorry for her friend Jane's sake, as he had been a good brother to her. When she encountered Jane's mother-in-law, the latter was more doleful: either he had drowned en route, or if not would certainly be too weak to survive the journey. This was all confirmed the next day when she was at the opera – which she was immediately unable to enjoy, although, bringing reason to the fore, she thought this might be because it was not one of Handel's better efforts.[48] Then, attending a court drawing room a fortnight later with the Donellan sisters, while they were waiting in an anteroom for the crowds to thin a little, whom did she see but the American Prince in person?[49] In her later autobiographical account, she recalled being so astonished she half believed it was a ghost she was seeing, but quickly recovering her self-possession, she teased him that he had put it about he was dead in order to discover how many of his friends would be sorry.[50]

The letter she sent the following day to Anne puts it a little differently. She could not prevent his sitting beside her and asking after her friends and family. To her anodyne comment that 'Mrs Hyde and his family had been under great apprehension and concern' he replied pointedly 'he wished he knew if I *had once thought of him or was sorry* when I heard he was cast away?' This was a leading question and not a very gentlemanly one since it was patently an attempt to elicit from her a declaration of her feelings. So Mary gave an adroit and rather an impersonal reply: why should he suppose 'I had so much ill-nature as not to be sorry for so unfortunate an accident to an acquaintance?' This irritated him immeasurably – 'common compassion' was not at all what he wanted: he desired intense feeling. When they saw each other next, at the opera after Christmas, he escorted her to her sedan chair and again blamed her for his unhappiness, and his flight from London. She answered 'it was so large a charge' she 'would be sorry to have it laid to my account'.[51]

His next visit was to her at Lady Stanley's, when he seemed more self-possessed. But he was still in a mood to criticise. One senses here the echoes of much rehearsed differences of outlook that had been canvassed on previous occasions: 'He sat down and immediately asked me "if I did not think they were miserable people that were strangers to love; but, added he, you are so great a philosopher that I dread your answer".' Lord Baltimore evidently knew that Mary was inclined to serious reading. 'As for philosophy, I did not pretend to it', Mary replied, 'but I endeavoured to make my life easy by living according to reason, and that my opinion of love was that it either made people very miserable or very happy.' Lord Baltimore rejoined that it made him very miserable – to which Mary answered in her turn, 'That, I suppose . . . proceeds from yourself: perhaps you place it on a wrong foundation.' Quite flummoxed by this robust reply, which implied he trusted too much to feeling and too little to self-control, and did not believe that anyone had the power to react in a measured way to what happened to them, he changed the conversation and soon left. Mary was equally affected but hid it, and subsequently found she did not encounter him socially at court or at the opera for a while.[52]

The emphasis she placed on reason was not just about self-control, though. In her letters to Anne she had been trying to articulate a modus vivendi that stressed the essential subjectivity of experience – rather like Hamlet's 'there is nothing either good nor bad, but thinking makes it so' – combined with a trust in Providence that all was for the best. The implication is that everyone needs

to find some inner equilibrium, thereby becoming less dependent on either people or circumstances. The tenor of this mirrors what she had been reading in Cicero's essay *On Moral Ends*. The denouement of this unsatisfactory relationship, a courtship with no clear end in view, was drawing near. The New Year of 1730 saw Mary much in attendance on Lady Stanley at Somerset House, although by now Mary had her own house in Pall Mall, as well as trying to help young Bevill find his feet. The recent death of Mrs Tellier, Lady Stanley's companion, had been a hard blow, further weakening her health, but one evening in early February she urged her niece to go out to the opera, thinking that she was spending too much time nursing her. Lord Baltimore immediately spotted her and lost no time in coming to sit behind her. He declared that he had been in love with her for the previous five years, but insisted that her ability to hold him at a distance had awed him into keeping silent. Astonished at this direct candour Mary could only urge him to desist in order for her to listen to the opera, but she agreed he could visit the following morning.

When he came conversation was a little formal, touching on the society news of the day. 'Some marriage was named, and we both observed how little probability of happiness there was in many fashionable matches where interest and not inclination was consulted.' Now the Basilisk came to the point: he would never marry unless 'he was well assured of the affection of the person he married'. 'Can you have a stronger proof', Mary replied, '(if the person is at her own disposal) than her consenting to marry him?' 'He replied that was not sufficient. I said that he was *unreasonable*, upon which he started up and said, "I find, madam, this is a point in which we shall never agree." ' Mary's refusal implicitly to 'give proof' by becoming his mistress put all discussion at an end. 'He looked piqued and angry, made a low bow and went away immediately, and left me in such confusion that I could hardly recollect what had passed, nor can I to this hour – but from that time till he was married we never met.'[53]

CHAPTER FOUR

⟨✦⟩

Irish Idyll

CONVALESCENCE

*B*etween 1731 and 1733 Mary was in Ireland. It was to prove both life enhancing and life changing. At first, prior to her journey, the emotional impact of these final encounters with the Basilisk, combined with the fatigue of nursing her aunt, took its toll on Mary's own health. She 'fell ill of a fever' and 'as it fell on my spirits I was for some days in a great deal of danger'.[1] Anne came all the way from Gloucester to look after Mary, staying for about a month. Lord Baltimore had clearly decided to abort all his feeling for her, as he never sent to enquire after her health, even though he would have known from his sister that she had been unwell. But by the time Anne returned to Gloucester Mary had recovered sufficiently to be able to write as light-heartedly as Lady Mary Wortley Montagu might have done about some of the men in her circle who were taken for her admirers:

> There's first Dom Diego, solemn and stately, and if you will take his own
> word, well read in all the arts and sciences . . . The next is a deserter; he can
> be of no use, he was a pretty plaything enough, could sing and dance, but
> . . . he has listed under another banner.[2]

Behind this sprightly, sophisticated, social persona, though, she was still struggling with her feelings of outrage, attraction, rejection, and determination to maintain her apparent poise. Struggling too with grief, since it was clear to all

who loved Lady Stanley that her decline was irreversible. Her death on 1 March 'was a most sensible [that is, deeply felt] affliction to me. I lost a wise, tender, and faithful friend.' She tried to console Uncle John, too, but when they both went to Northend the place was so full of painful memories that this made things worse, not better.[3]

Mary's inclination was to withdraw from the social round, but propriety dictated the need to be visible in the usual haunts of polite society, or gossip might have linked her absence to romantic disappointment or pique over Lord Baltimore. So initially she made the effort to mix. But she also found a solution to cheer herself up that would plausibly move her from the Basilisk's orbit. She suggested to Anne Donnellan that they rent a property in fashionable Richmond, 10 miles further upriver from Westminster on the Thames. Anne was convalescing after a bad cold and saddened as her sister Mrs Clayton and her husband, nominated as Bishop of Killalla in Ireland, had already set out for Dublin. The prospect of fresh air, new scenes and each other's company suited both the young women.

In her memoir Mary remembered this as a brief unclouded interlude where they could follow a relaxed daily schedule at no-one's beck and call. She told sister Anne, 'Never did people live with more tranquillity: we enjoy everything in perfection without hurry or trouble . . . Sometimes we walk out without design of going to any particular place, and never fail of discovering some new agreeable prospect.'[4] Among the gardens they visited by design were those at Bushy Park, which they reached by water. It is possible, too, that the ladies went to Ham House, to visit the new Lady Dysart.[5] So content were they with this brief visit that Mary was delighted at the prospect suggested by her friend that she come with her to Ireland when she went to visit her sister. She thrilled at the opportunity – '*the real reason of my going was entirely locked within my own heart*'.[6] Meanwhile it was a beautiful spring and there was always the Fulham retreat to enjoy: in May she told her sister 'the birds, the breezes, and all things conspire to make this place the seat of pleasure and delight, but wanting you I can't enjoy them in perfection . . .'[7]

Lord Baltimore had wasted little time after his abrupt termination of his passion for Mary in wooing a rich bride, choosing a banker's daughter, Mary Janssen.[8] The marriage took place on 20 July 1730. Meanwhile, 'Poor Betty Lee [Baltimore's aunt] is much to be pitied, for she is left with three children to maintain and not a farthing to support her.'[9] Within only four months she had

chosen to marry the poet Edward Young, now established prosperously in Hatfield. She was happy to be dependent on a good, kind man, and if the marriage began with rational calculation, it developed into a very affectionate partnership. From Mary's point of view, the constant postponement of the Irish trip was unhelpful, yet the conventions of the time dictated that she had to consult the then head of the family, now her brother Bernard, who was 'point blank'[10] against her going. Mary had to tread water for what turned out to be another year.

THE ANGLO-SAXON SCHOLAR

One way to occupy herself was to turn again to literature, and broaden her horizons and those of her sister. Additional fluency in reading and writing French, and acquaintanceship with modern literature in English and French, were among the cultural accomplishments that would qualify Anne as suitable for a court post.

Mary also made her successful first effort to be an active literary patron, not just a subscriber to a publication. In its way, it was a feminist project, a means of helping a contemporary 'woman worthy'. Sally Chapone had brought to her attention the sad lot of a very learned female scholar, Elizabeth Elstob, who had fallen on hard times. Elstob and her clerical brother, William, born in 1683 and 1674 respectively, had belonged to the circle of antiquarians in the early part of the century attached to the Oxford scholar and High Anglican, George Hickes. Later, when Elizabeth kept house for her brother in Oxford, she shared his scholarly endeavours and mixed with his friends, in this way becoming a kind of unofficial member of the university.[11] In the preface to her 1709 translation of *An Anglo-Saxon Homily on the Birth of St Gregory* – St Gregory being the saint who converted the English to Christianity – she argued that Englishwomen, if denied the classics, could now regain the archaic version of their mother tongue. In the spirit of Judith Drake, they could leave classics to their brothers, and concentrate on English and its own ancient roots. She drily remarked that people never mind women spending time away from household management in polite socialising, but only objected if they developed their intellectual capacities.[12]

Elizabeth's mentor George Hickes was a consistent Jacobite, but when she published her *Rudiments of Grammar for the Anglo-Saxon Tongue* in 1715 she

dedicated it to Caroline Princess of Wales, in this way adroitly signalling that she fully accepted the transfer of the crown to the Hanoverians. She pointed out that Caroline's children would inherit the Saxon line and that the Saxon tongue unites the German *and* the English. When William Elstob died the year her book came out, Elizabeth, now in her early thirties and well regarded for her exceptional achievements, was left utterly without resources and was effectively destitute. She seems to have resided in Chelsea for a time, perhaps to be near Mary Astell. Eventually in 1718 she was obliged to leave London, abandoning her books and manuscripts, which must have felt like a form of self-immolation. By 1728 she was living in Evesham, Gloucestershire, under an assumed name, teaching basic literacy in a little school for modest wage-earners; her new identity was almost certainly assumed to prevent creditors tracking her down. Sarah Chapone had learnt of her true identity, though, and told Mary about it.

To help relieve her destitution, Sally composed a letter in 1730 to Queen Caroline, hoping she would reward Elstob with a pension, and Mary drew on her court contacts to get the letter to the queen. The conduit was Sir Stephen Poyntz, a diplomat, and at that time Governor of the Household of William Duke of Cumberland, younger brother of Prince Frederick. The queen and the duke were both reported to be so touched that Elstob was immediately awarded a gift of £100. Stephen Poyntz was also questioned closely by the duke about the Rev. Chapone's school, and declared he would send Chapone a 'scholar that may make his fortune' – that is to say an aristocratic pupil whom he would tutor and who would in turn help his clerical advancement.[13] Soon Mary could depart to Ireland feeling she had done something eminently worthwhile as a woman of letters with a regard for the achievements of her own sex.

A PRIEST, A PROPOSAL AND A PAINTER

Inexorably Mary was turning towards Ireland; her cousin Maria had recently married William Graham, squire of Platten, and there were the prior links from Uncle Stanley and his Monck relatives, the Carteret Vice-Royalty, and the nexus of Donnellans, Ushers, Percevals and Wellesleys, all leading her there. She ran around town when she could spare the time, acquiring additions to her wardrobe: a blue satin dress sprigged with white, and a very pretty pink damask informal gown.[14] In quiet moments at home she was hurrying to finish a set of chair covers for her mother for the new house.[15]

Just before she finally left for Ireland, she received a proposal from a recently widowed English baronet, Sir John Brownlow, who in 1718 had received an Irish title, 1st Viscount Tyrconnel, although his lands were mainly in Lincolnshire. He was an independently minded Whig MP and also profoundly anti-Jacobite; this was probably why the Dowager Lady Carteret favoured his suit, and criticised Mary when she unhesitatingly rejected 'so vast a fortune, a title, and a good-natured man'. But as she and others considered him 'silly', Mary had no hesitation in turning him down.[16] Happily for her, brother Bunny supported her refusal, so, as she wrote to Anne, 'Hang my Lord Tyrconnel, I don't relent or repent one bit.'[17]

When Mary recounted this episode to Anne, she offered it as proof that she would not marry 'money without worth'. She did indicate, though, worth without sufficient money was equally undesirable. It seems that one of 'Ha Ha's' friends, a Mr Yate, nicknamed 'Puzzle' by Anne and Mary, had taken a great liking to her, but she discouraged him: 'I am glad his fortune is so good, 'tis a very handsome maintenance for a single man. I think he has a great deal of merit . . . had I any inclination to marry and a fortune double what I have, I would prefer him to anyone I know.'[18] She had offered him her friendship instead, but 'Puzzle' was in no mood to settle just for that.

Almost the last decision Mary made before she set out for Ireland was about whom to commission to paint a portrait miniature of her old school friend Lady Sunderland. Many people in her circle chose the Dresden-born enamellist Christian Friedrich Zincke (c. 1684–1767). He virtually cornered the market in enamel miniatures: the king and queen, Lord Harley, and the Prince and Princess of Wales were all his patrons, and he had painted the 2nd Lord Harley, his wife and his daughter, Margaret, more than once.[19]

But now Mary had met an emerging British talent, who was painting the Wellesley family as well as Anne Donnellan, and his skill in rendering a likeness had determined her to choose him instead. 'I think he takes a much greater likeness, and that is what I shall value my friend's picture for, more than for the excellence of the painting.' In addition, William Hogarth, for it was he, had said he would give her some instructions to improve her own efforts, 'some rules of his own that he says will improve me more in a day than a year's learning in the common way'.[20] Mary was going to Ireland with a newly stimulated eye, and fresh confidence in her attractions to the opposite sex, even if she felt so many of them were dull or vain. It was a propitious moment in her development, and it changed her life.

DUBLIN

Dublin was Great Britain's second city after London. Ostensibly it was the capital of a separate kingdom, united with the English crown. In reality Ireland was politically and economically subordinated to Britain. Its Parliament could not introduce legislation without prior approval by the English Privy Council, and its manufactures and trade were regulated to prevent undue competition with England, Wales and Scotland. The Lord Lieutenant (sometimes referred to as the Viceroy) represented the monarch and held court at Dublin Castle. As approximately 67 per cent of the population was Catholic, and had resisted the supplanting of James II, Dublin also had the largest garrison in Europe. Catholic landownership was virtually impossible unless the head of the family converted to the Church of Ireland (the Irish version of the Anglican Church in England). There was no Catholic institutional structure, so for church rituals Catholic peasants had to make do with makeshift arrangements conducted by itinerant 'hedge' priests. Meanwhile in the northern counties, not yet separated from the rest of Ireland, a better educated Presbyterian Protestant minority resented paying tithes and financed their own voluntary churches, as they did in England.

Most of the old Gaelic princely and noble families had either exiled themselves or had converted to Protestantism during seventeenth-century rebellions and upheavals. Next to them in antiquity of line and as part of the ruling elite were families such as the Fitzgeralds (earls of Kildare, then dukes of Leinster) and the Fitzmaurices (earls of Kerry), who could trace their Irish roots back to the Norman Conquest and subsequent interventions. Mary would have readily understood their ancestral mindset as it paralleled the way that old Cornish families such as hers looked back to kinship with or advancement by William the Conqueror. Many gentry families had deep-rooted ancestry from the Middle Ages or the Tudor Age. Still others had benefited when land had been confiscated from the disloyal throughout the seventeenth century, a process that had quickened since 1688. Cumulatively, this meant that the Church of Ireland had a key role to play in encouraging Loyalism. During any Interregnum the premier archbishop, that of Armagh, acted as Regent until the new king was proclaimed. Many of the bishops lived in a princely style and maintained a Dublin town house as well as a diocesan palace. As Lords Spiritual they sat in the Irish House of Lords and were as much a part of the political structure as were the secular peers.

After the Glorious Revolution, Dublin was developed rapidly as a capital city with an architectural and cultural infrastructure to support its political, judicial and military role. New Royal Barracks were erected in 1701; the castle, seat of the Lord Lieutenancy, was renovated between 1710 and 1717; and the new library of the university (known as Trinity College) was begun in 1712. Two years before Mary's visit, a purpose-built building, the first of its kind, was started for the two chambers of the Irish Parliament. Politically subordinated to Westminster it might have been, but it had the most modern and elegant buildings of any representative assembly in Europe. The clerical Protestant Ascendancy were likewise building handsome palazzi and terraced town houses in locations such as St Stephens' Square, where both the Percevals and Bishop Clayton had houses. In fact the latter's, where Mary and Anne Donnellan were staying, was the largest non-detached town house in Dublin. In 1731 the Society of Arts was founded to improve technology, manufacturing and the decorative arts, and to bring them up to standards elsewhere in Europe.[21] One result of this was that town and country houses, and even parish churches, acquired at this time the most beautiful rococo plaster decorations, mostly accomplished by Italian-born *stuccadori*, which many would argue are still unsurpassed.[22]

FIRST IMPRESSIONS

Mary wrote to her sister as soon as she could, detailing the warm welcome Bishop Clayton and his wife had given to the travellers and the splendour in which they lived. Their house was pronounced '*magnifique*, and they have a heart answerable to their fortune'. On the first day only close relations came, including Don's (that is, Anne Donnellan) aunt, Mrs Usher, a visit repaid the following day. One of the first new people Mary met, who was also staying at the Claytons' house, was Dorothy Forth, the shyest of a trio of sisters, daughters of a local Dublin squire. She was, Mary noticed, capable of making very witty comments in an entirely unaffected way; she would become a lifelong friend. The first Sunday began with attending church and the same evening it was more or less open house 'for Mrs Clayton is extremely liked, and visited by everybody'. Her host and hostess kept a generous table, with six courses of food at dinner and supper. The house had a large entrance hall, well staffed with footmen.[23] Mrs Clayton soon decided she would have a weekly reception on

Wednesday evenings, and Mary was to preside over the card table for the game known as Commerce.

Meanwhile, a sequence of public sociability began. The group attended court at Dublin castle, where the 2nd Duke and Duchess of Dorset, who had succeeded Lord and Lady Carteret as the vice-regal couple, were holding a drawing room in the morning, and another in the evening. On 30 October, a month ahead, there would be a ball to celebrate the king's birthday, in parallel with London.[24] Another public, social event was a troop review in Phoenix Park, north of the Liffey river. Altogether four regiments paraded in front of the Duke of Dorset and his duchess, 'in great state, and all the beau monde of Dublin'.[25] It was noticeable that Mrs Clayton's carriage was the second grandest after the duke and duchess, and Mary considered this no mean feat, given how well the Dubliners knew about dressing and projecting a good image. She also considered Phoenix Park to be larger and more handsome than Hyde Park or St James's. By now Mary was also familiar with the outdoor amenity on her Dublin doorstep, St Stephen's Green. It was larger than most London town squares, with at that time a broad gravel path parallel with a grass one, shaded by trees. Every morning Mary and Don walked around it three times for exercise.

Three weeks later, Mary, Don and Mrs Clayton took an opportunity to watch the Irish House of Commons at work, by going to hear a disputed election discussed. As at Westminster, ladies could observe proceedings and they particularly went along if family interests were involved. The day proved to be a long one, starting at 11 a.m., and when the session was adjourned at 4 p.m. the official known as Black Rod took them to his rooms where there was a warm fire, hot tea and meat sandwiches. Back they went at 5 p.m. to listen to proceedings for another three hours until the indefatigable Mary realised everyone else was tired. As she continued to see the Percevals, she realised that young John was completely absorbed in his parliamentary life, which is why Anne back home in Gloucester heard nothing from him: 'he is so far from remembering those that are absent, that he *hardly sees* those that he is every day with'. Had Anne perhaps entertained some hope that, having met him on her visits to London, he might have become a suitor?[26]

Much of the London social round was replicated in Ireland, along with concerts, plays, ridottos, and private dinners and assemblies. But Mary noticed one real difference – a greater heartiness and spontaneity, which also reminded her of the Cornish folk. She realised that back in London she was wont to hold

back her own natural warmth, and that this might be mistaken caution on her part. During her marriage, especially the second half of it in London, she had always been aware of what spying servants might report to her husband, and after she was widowed, she had been careful not to be drawn into wrong company by Lady Lansdowne, or into emotional indiscretion by her attraction to Lord Baltimore. She had been afraid of appearing too outgoing. Now, in a fresh but not strange milieu, she was able to relax. 'Our spirits ought to have their full career when our inclinations are innocent', she concluded, 'and should not be checked but where they would exceed the bounds of prudence.'[27]

'AMONG THE WITS'

In parallel with this socialising, Mary told her sister in early October: 'I am just begun an acquaintance *among the wits* – Mrs Grierson, Mrs Sycon, and Mrs Pilkington; the latter is a bosom friend of Dean Swift's, and I hope among them I shall be able to pick up some entertainment for you.' As the friend of the two Donnellan sisters, whose kin had a firm footing in the Church and the Law, Mary had already entered Irish society at a very prestigious level. But she had her own head of steam propelling her there too, other than her Carteret, Stanley and Monck kin, and the new marital tie of the Graham marriage: she was the niece of Alexander Pope's patron, Lord Lansdowne, and Pope was a close friend of Ireland's greatest patriot and author at that time, Dean Jonathan Swift. The prospect of her mixing in literary circles may well have been the one that elated both sisters the most, since they were still exchanging verses for their album.[28]

It was an open secret that Swift was the author of the satirical *Drapier's Letters* (1724), a protest in the persona of a textile merchant against the economic dominance of England over Ireland. In Swift's *Gulliver's Travels* (1726) the country of Laputa, which was full of enterprising inventors, was described as hovering over another island, an image usually taken as a metaphor for this Anglo-Irish control. Lord Carteret's stint as Lord Lieutenant had begun in 1724 when the uproar over awarding a recoinage contract to an English contractor, John Wood – which had provoked the 'Drapier' to protest – was at its height; part of the resentment was that Wood had attained his contract through the influence of the king's mistress. Carteret had proved adroit at cooling the temperature, aided by his wife, and both had been eager patrons of the literary, dramatic and musical life of Dublin.

Mary's visit coincided with the moment when Trinity College Dublin, Ireland's university, open only to communicants in the Church of Ireland, was a centre of progressive thinking. Some of this centred on improving the economic prospects of the country and the care of the poor. The building boom of the early 1730s was part of a wider economic resurgence, assisted by Irish parliamentary subsidies and bounties to improve the infrastructure and stimulate trade, the crafts associated with this building boom, and other manufacturing – particularly textiles.[29] Women could be a part of this economic patriotism by purchasing dress and furnishings made in Ireland. The year Mary arrived in Dublin saw the foundation of the Royal Dublin Society, modelled on the Royal Society in London. It was a catalyst for schemes for improvement.[30] Plans to build up the linen industry, for instance, were often linked to training and employing the rural poor, since unlike in England there was no parish-based safety net of the Poor Law to provide minimal help. Patrick Delany was one of the Royal Dublin Society's founding members, and the Rev. Samuel Madden, whom the Granvilles already knew, was a prime mover.[31]

In speaking of wits, though, it is noticeable that Mary immediately instances three literary *women*, not the male thinkers like Patrick Delany among Swift's inner circle who were also forwarding the Dublin Society's endeavours. Swift was generally considered to be an encourager of female intellect. He never married, but enjoyed female company – though not as a libertine. In the recent assessment of the scholar Margaret Anne Doody, Swift could not bear the prospect of routine coupledom, nor was he wealthy enough to make a 'good' marriage in worldly terms. But he had two rich and complex friendships, as intense as love affairs, and as devoted as marriages, first with Esther Johnson, known as 'Stella', and second with Hester Vanhomrigh, known as Vanessa. Both relationships are in the end uncategorisable, though friendship may be the best label to give them; Doody considers that the companionship with Stella was never consummated, though that with Vanessa may well have been. In any case both had been ended by death before Mary Pendarves entered Swift's circle.[32] Swift was eccentric, could be very irascible, and was apt to manipulate people; but as a writer he displayed less misogyny in his satires than did either Pope or Young. Moreover, Swift liked and admired Mary's favourite poet, Anne Finch, Lady Winchilsea.

The only woman Mary met on this visit, though, was the newest member of the literary coterie, Laetitia Pilkington and her husband, Matthew, both of whom Patrick Delany had introduced to Dean Swift. The diminutive couple

became regular visitors to him, as he rather enjoyed patronising clever but not too famous younger litterateurs. He could tease and torment them and get them to run literary errands, and in return they were witty and mettlesome enough to return some sprightly repartee. In 1729, Matthew, who was a clergyman, had had a volume of his poems published in Ireland that had attracted attention and the financial reward of £50 from Lord Carteret. He had married Laetitia Van Lewin, daughter of Dublin's leading male obstetrician – who was a contemporary of Patrick Delany's at Trinity College.

NEWS FROM HOME: MARRIAGES AND FINANCIAL SCANDALS

Mary kept in touch with family and friends back home as best she could, but the social pressures of constantly being a guest often limited her private time.[33] One marriage in the offing was that of Thomas Thynne, 2nd Viscount Weymouth, the step-son of Lord Lansdowne. The young viscount was very spoilt and self-willed, but Mary, who after all had known him since he was a child, believed he was essentially good-natured and susceptible to advice from people he loved, such as herself. What was needed was for him was to be attached to the right person. Mary decided the ideal wife would be the second of Lord Carteret's daughters, Louisa, who was sweet, pretty and yielding enough to cope with a headstrong young husband while being attractive and vivacious enough to win his attention. Moreover:

> Her fortune was small, but she had been bred up in magnificence, and knew how to spend a large one gracefully and manage it prudently: his fortune was very large, but his good-nature and want of resolution turned his natural generosity into profuseness.[34]

This is the recipe for marital harmony that many gentry and peerage families hoped to follow: of course there had to be a parity of wealth, or at least a complementarity of attitude about how it should be managed if one marriage partner had more than another: but there had to be an affectionate compatibility of disposition as well.

The Carterets were as positive as Mary about this marital prospect, so as there were no barriers on her side of the family, Mary took pains to drop lots of

hints to Thomas about Louisa's suitability. At one point he reacted to all this nudging by exclaiming that if he was to marry at all he would as soon choose Mary, but she managed to deflect his attention and show it was Louisa she had in mind for him. Grudgingly he admitted he liked her best of the Carteret sisters, but wouldn't commit himself until he had made a visit to France.[35]

During Mary's Irish stay, the scandals associated with the Charitable Corporation in London became a very hot topic. Widows like Mary Pendarves had control of their own money and naturally did not want to be defrauded of it. As an investment vehicle it had attracted a lot of female investors. In the view of Lord Perceval, the furore over this fraud was an important catalyst for female investors to pay attention to Parliament. Moreover, the Charitable Corporation's problems implicated in serious fraud Sir Robert Sutton, husband of her friend Judith, Lady Sunderland, as he was on the management committee of the company. Judith had recently moved into a splendidly furnished new house, but Mary was not a bit envious: 'Ah, my dear sister, what enjoyment has my Lady Sun: had of her of her new house? . . . the continual irritation of mind she has been under on Sir R's account, has been purchasing her magnificence at a dear rate.'[36]

Mary liked being in Ireland, but she also alluded to examples of libertine masculinity that she deplored. The next monthly letter following her discussion Judith Sutton's misfortune contains a vehement outburst about the double standard of sexual morality. Either Anne or another friend had suggested that Mary was on a crusade to rid society of 'odious men', as if Mary were a contestant in some kind of chivalric epic. In reply, Mary said:

> Would it were so, that I went ravaging and slaying all odious men, and that would go near to clear the world of that sort of animal; you never had a good opinion of them, and everyday my dislike strengthens; some few I will except, but *very few*, they have so despicable an opinion of women, and treat them by their words and actions so ungenerously and inhumanly . . . The minutest indiscretion in a woman (though occasioned by themselves), never fails of being enlarged into a notorious crime; but men are to sin on without limitation or blame; a hard case!

In default of appealing or suitable suitors Anne had advised her sister to value her new female friends.[37] Mary assured her that none could ever replace her, and that although she considered 'Philomel', Anne Donnellan, was pre-eminent while they

were in Ireland, 'I can protest to you my love to you has not diminished, but rather increased since my intimacy with her.' Her hostess, Mrs Clayton, she valued as Donnellan's sister. Otherwise she liked two of the new circle particularly well. The first was Laetitia Bushe (*c*. 1705–57). After the recent death of her father, a high-ranking official from a modest gentry background, Laetitia had virtually no family relatives, other than a brother who lived far away in County Cork. But following the resolution of a property lawsuit she had enough rental income, approximately £100 per annum, to be able to live independently – and in Ireland this £100 would stretch much further than Mary's similar sum would do in London.[38] This alone must have interested Mary: here was a woman who might never be married and who seemed unconcerned about it, even though she lacked the extensive web of kin that framed Mary's life. Miss Bushe did not own or rent a house of her own but spent most of her time staying with friends in Dublin, who gave her an *entrée* into the small overlapping circles at the top ranks of the Protestant Ascendancy. Aged about 25 when Mary first met her, she had just lost some of her looks to a bout of smallpox, but fortunately this had not damaged her eyesight. For what Mary valued most in this Laetitia was her artistic skill, which was an inspiration to her. Clearly Mary considered her talent for portraiture and landscape far superior to her own, and she treasured the sketches Laetitia always included in her letters to her, describing the places and people she had been visiting. Laetitia also painted some oil and watercolour scenes for her.[39]

The other friend was the youngest of the three Forth sisters, Dorothy. Mary recognised she was not as intellectual as her sisters, but she was good-humoured, socially adept, vivacious – and also an extremely good painter. Ireland was giving Mary examples of women who were as talented with the paintbrush as with the pen. Dorothy would soon marry the well-born cleric Francis Hamilton, son of the 6th Earl of Abercorn, whose mother Mary also admired: 'I esteem Mrs. Hamilton as a woman of excellent sense and conduct, and I would (were I under her circumstances of life) place her as my pattern; she is easy, unaffected, has read a good deal, and her memory serves her very well on all occasions.'[40]

FÊTES CHAMPÊTRES

As winter gradually faded in Dublin, Mary had to consider her plans, which were dependent on the movements of the Percevals, so she was delightedly able to double the length of her stay. This almost certainly required her brother

Bernard's approval as well, and may be why she took pains to write him a good description of a high point of the Irish Court Calendar, the drawing room held for the queen's birthday on 1 March. Similar to that held in October for the king, it had a customary addition in the supper room of a holly-tree illuminated with a hundred expensive wax tapers, with servants nearby behind a buffet dining table, to help serve manifold plates of meat, fruits and sweetmeats.

> When the doors were first opened, the hurly-burly is not to be described; squalling, shrieking, all sorts of noises: some ladies lost their lappets [head-dresses], others were trod upon. I and my company were more discreet than to go with the torrent; we staid till people had stayed their curiosity and hunger, and then took a quiet view of the *famous tree*, which occasioned more rout than it was worth.[41]

Mary and Don were able to make visits and enjoy the rest of the Dublin season before the town emptied out in June. The most enjoyable social occasions were visits to various members of the Clayton and Wellesley circle. One was to the latter's home before he had come into his fortune, a small house in the Butlerstown district, now lived in by his relative Kit Usher and his mousy but obliging wife. A toothsome collation was laid on, including pigeon pie, cockles, Dutch beef and 'the finest syllabub that ever was tasted'.[42] On the way back the party stopped at the Wellesleys' Dublin house, and with Mary seated at the harpsichord, joined by Wellesley on his violin, they held an impromptu dance. The party only ended at half-past one in the morning.

On 27 May 1732 the Claytons, Mary, Don, her brother Nehemiah, her cousin William Usher, and Mr Lloyd set out on their travels. Miss Kelly and Miss Bushe came with them as far as the first halt to rest the horses, and then parted with much sentimental regret. Their sequence of country visits until Christmas must have seemed at times like pastoral perfection, thanks to the generosity and flair of their various hosts. The first stop was the Wellesley home at Dangan, County Meath.[43] This was a new, Italianate two-storey house built near the ruins of the ancient keep of Dangan castle. Wellesley was busy planting trees and creating canals in the vast gardens, which included a 26-acre lake on which several ships could be sailed: this was the latest vogue for gentlemen with enough land to create or remodel lakes. Mary scribbled a quick letter to her sister, exclaiming 'we live magnificently, and at the same time without cere-

mony'. The next stop was Killala, way over to the west in County Mayo, over-looking the Atlantic. The church had good views of the ocean beyond it. Here was Bishop Clayton's cathedral, which to Mary's surprise was really no bigger than a parish church: it had been constructed only the previous century from ruins of the earlier one. But the diocese dated from the fifth century, the era of St Patrick, and there were legends of the numerous baptisms he had performed there in the first era of Celtic Christianity. The setting reminded Mary of rugged Cornwall. The sparsely populated wild landscape was ripe to be clothed with the fanciful imagination of the group, who were busy reading a romance by Madame de La Fayette, *Zaïde* (1669–71), set in Spain about fifty years after the Moorish conquest. The group read it aloud to one another in the mornings in the original French, then spent the afternoons, now lengthening towards the summer, constructing a grotto using local shells. This was living the sophisti-cated pastoral dream indeed, and they gave one another classical names to keep up the illusion: Mary was nominated as Madam Venus; Mrs Clayton, the bish-op's wife, was Juno; Phil (Anne Donnellan) acquired the extra soubriquet of Minerva; the three Forth sisters were transformed into the Three Graces; the clergyman Mr Lloyd became Hermes, the winged Messenger of the Gods; while another cleric, a Mr Crofton, was the Genius or guiding spirit of the grotto.[44] The group went on various jaunts but the most lively outing of all was a visit to the local fair at Killala to celebrate Mrs Clayton's birthday. She rode in her carriage with six Flanders mares, very much the local Grande Dame, to what was a very local event, with improvised horse-races along the beach, when all the riders went bareback without 'saddle, whip or spur'. The afternoon was a bit more decorous, with the Bishop's party 'in great state, all attired in our best apparel' sitting on chairs outside, and the locals dancing to the Irish pipes.[45]

PATRICK'S FIRST MARRIAGE

But frolicking visits did not occupy all their attention. As befitted a clerical house party, their serious evening reading included the latest books by Bishop Berkeley and Patrick Delany. The former had written an accessible work to refute recent free-thinkers such as Anthony Collins, the 3rd Earl of Shaftesbury, and Bernard Mandeville – all in their different ways open critics of Trinitarian Christianity and advocates of the idea that human reason was a substitute, not a supplement to, divine revelation. Berkeley's *Alciphron* took the

form of dialogues comprehensible to the intelligent female reader. According to Anne Donnellan's mother, in February of that year, 1732, the book 'was the discourse of the Court, and . . . the Queen publicly commended it at her drawing room'.[46]

Patrick Delany's book was a biblical commentary, *Revelation Examined with Candour*. His Introduction and Preface, the former addressed to the king, both show that like Berkeley he too considered that a dangerous element of licentiousness was now pervasive in society. Delany was concerned not just with free behaviour (code for sexual promiscuity) but the undermining of religious values and beliefs. He argued that what was needed was thorough scholarship and deep thinking; only superficial intellectualism would conclude that true piety was at odds with reason.

That August, Patrick and the widowed Mrs Tennison had married in London and were staying with Don's mother in Little Chelsea. It is hard to know what Mary made of this: he was already betrothed when they first met, so she could have entertained no idea they could ever have been anything than friends. In her autobiography, she wrote of the 'excellence of his heart, his humanity, benevolence charity and generosity, his tenderness, affection and friendly zeal', which 'gave me a higher opinion of him than of any other man I had ever conversed with, and made me take every opportunity of conversing and corresponding with one from whom I expected so much improvement'.[47] This was all very high-minded praise, but was it the case that this warm-hearted and decent man was marrying partly with his wife's wealth in view?

In fact the marriage settlement made at the time of the wedding suggests a genuine affection between the two. Mrs Tennison had indeed inherited money from her father, but her first husband died greatly indebted in 1722. Much of her time in the intervening decade before her remarriage had involved remortgaging property to pay these debts, protect the money from her father she had brought into the marriage, and provide for her two daughters. Unusually, she and Patrick made a private agreement that Patrick would not benefit from his wife's financial position; she was to be able to dispose of any of her fortune, although she would keep him informed of what she was doing, and he would only benefit from what remained of it if he outlived her. Moreover, the surviving daughter would only inherit her share of her father's money if she married. As a widow, then, Mrs Tennison embodies the business capacity recommended by Bishop Berkeley in *The Ladies Library* as needed for all women

of financial standing. As the younger of the couple she was likely to outlive her second husband, so Patrick was not really marrying for money, but for love.

The private agreement between herself and Patrick was drawn up by a former pupil of his from Trinity College, who had not yet completed his training; the single copy was wrapped in a blue wrapper tied with black ribbon, and kept by the new Mrs Delany among her own papers. They had both endorsed it on the outside, saying it was to be read by no-one else. Thus, on the verge of marriage each had their money kept separately, and were confident in each other. It was not legally enforceable, and exemplifies the capacity for disinterested friendship Mary had quickly discerned in Patrick's attitude to women. And of course it was the direct opposite of the Basilisk's mercenary attitude.[48]

After the rustic summer pleasures, Mrs Delany's party returned to Dublin briefly to regroup. Visits of various kinds then continued. At Lismullen, 5 miles from the county town of Navan, and home of the ancient Dillon family, was a ruined abbey that attracted Mary's attention as she was always intrigued by traces of antiquity: 'a vast building enclosed with large trees, great subterraneous buildings, with arches of cut stone, which make no other appearance above the earth than as little cells, rather than continued passages to any place: they are very low . . .'[49]

By the end of August Mary was back in Killala, where a similar party to the previous visit stayed until the middle of September. There were more 'pick nicks' and rural horse-races. When Mary described all this to Anne she also included a letter from Don describing a proposal of marriage Mary had recently received, which she had first found presumptuous before laughing it off as ridiculous. The unlucky suitor was a cleric in Bishop Clayton's entourage named Robert Faussett, Precentor to the Diocese of Killala. Respectable though he was, Reverend Faussett was clearly thought to be reaching well above himself in aspiring to the hand of a woman who was second cousin to a one-time viceroy.[50] The last important visit that autumn was to Kit Donnellan's parish at Nenagh, county town of Tipperary. Kit too was bent on 'improvements' to his grounds and farm, which Mary considered a worthy goal:

> For next to being with the friends one loves best, I have no notion of a higher happiness, in respect to one's fortune, than that of *planting* and improving a country, I prefer it to *all other expenses*.[51]

HOMEWARD BOUND

The newly married Dean Delany had resumed his Thursday evening 'salon', so Don and Mary also resumed being part of the 'witty club'. Mary mentions absolutely nothing about the new bride, and it is possible she was resident always at Delville, given she had a daughter to look after. But somewhere along the line she did meet the new Mrs Delany, since, after her death, when Patrick was free to court Mary, he mentions that his late wife had considered her 'the person in the world that friend most esteemed and honoured'. The guests whom Mary does enumerate at these soirées were Miss Kelly, the Earl of Orrery, Swift, Kit Donnellan, and Patrick's friend, Dr Helsham, 'a very ingenious entertaining man'. Mary increasingly found that Swift was very partial to Miss Kelly, so she was losing her role as the dean's favourite: 'Miss Kelly's beauty and good humour have gained an entire conquest of him, and I come in only a *little by the by*', and that Miss Kelly was engrossing all Don's attention as well.[52] It is clear she was rather miffed about this displacement, although this did not stop her subscribing to a forthcoming collected edition of his works, nor interrupt the cordiality between all three women.

In any case Mary had realised that the main role of the circle was to listen to Swift hold forth: 'Swift is a very odd companion (if that expression is not too familiar for such an extraordinary genius): he talks a great deal and does not require many answers; he has infinite spirits, and says abundance of good things in his common way of discourse.'[53] Miss Kelly fell ill at about this time and the circle were very solicitous towards her; Mary observed that while Dean Swift visited her sick-bed, Delany 'will make a more desirable friend, for he has all the qualities requisite for friendship: zeal, tenderness, and application'. His gentle consistency shone out in contrast to Swift's dominating and sometimes enigmatic, compulsive playfulness. She added to Anne of Delany, 'I know you would like him, for he is worthy.' The seeds of a solid attachment were being sown.[54]

She and Don continued to attend his Thursday evenings when they could. Alongside the literary soirées there was a busy mix of plays, dinners and assemblies, with a fortnight spent at Dangan with the Wellesleys in early April.[55] This time their host had given everyone a walking stick labelled with a classical deity: Wellesley was Paris, Kit Usher was Vulcan, Kit Donnellan was Neptune and Nehemiah Donnellan, Mars: thus they could imagine themselves as walking in Parnassus, grove of the gods and muses.[56] Before she finally set off home Mary

had the good news that her step-cousin, Thomas Thynne, was engaged to Louisa Carteret, as she had hoped, but to her disquiet the news was contradicted by Thomas's own mother. Subsequently, when Mary reached England she learnt that Thomas was indeed very much the man about town. In the country he was spending much time on sport, and the estate was not well-managed.[57]

Hearing of all this 'I was much grieved about it', Mary wrote in her autobiography, 'believing if continued he would be ruined in every way.' Mary must have been thinking not only of money being frittered away but also of her cousin's health being undermined by too much alcohol, or by contracting sexual diseases, both of which might prove fatal.

> He was very glad to see me, obliging as usual, and pressed me extremely to make him a visit in the country, I told him I should be very ready to do it, when he had company there which it was fit for me to keep . . . He looked confused, and asked me what I meant? Upon which I told him what I had heard, and freely blamed his conduct; and told him he could not be a happy man, nor make a figure suitable to his birth and fortune, till he married somebody equal to him in rank and condition. A few days after he came to see me again, and said, '*I can tell you a piece of news that will surprise you; Louisa is absolutely engaged – her father told me so this morning.*'[58]

Thomas was actually playing a little trick on his serious-minded cousin Mary. When she reacted with surprise, having recently seen Lady Lansdowne, who would surely have been told of this by her husband, he laughed and said it was perfectly true Louisa was engaged – to him! On 3 July 1733 the marriage was solemnised, and Thomas led his bride up the steps to Longleat while a band played. Mary's constant efforts to keep in touch with her family while she was in Ireland had been rewarded.

CHAPTER FIVE

Woman of Fashion

'DEAN SWIFT'S MRS. PENDARVES'

*T*he widowed Mrs Pendarves must have felt newly energised and confident after her first Irish visit. She had put further social and emotional distance between herself and the 'American Prince'. She had proved herself to be an attractive member of several overlapping social sets in Ireland, which included families such as the Percevals, who were sophisticated and cultured, yet also devout. Following in the wake of her cousin Lord Carteret, whose tenure of the Lord Lieutenancy had been so successful, she had met the cream of Irish intellectual life, and mixed with the literary wits. In all these circles she had found it easier to relax and shine than when she was in London, where life was so much more frenetic and competitive.

On her immediate arrival back in England she had no qualms about intimating to her friends and family that she could now be accounted a guest and correspondent of Jonathan Swift. For this was an important social and cultural achievement, although it was not a formal position like those open to men. They could now join a range of clubs and societies, such as the Society of Dilettanti, founded in 1732, which was open to young gentlemen who had been to Italy on their Grand Tour. Ostensibly the club's purpose was to perpetuate the study of antiquity once they had come home, but as Horace Walpole famously observed, 'The nominal qualification is having been in Italy, and the real one being drunk.'[1] There was no equivalent society for women who had been to Dublin and mixed in its literary high society, but in the small world of eighteenth-century court and aristocratic

84

circles, those who knew Mary Pendarves and her family and friends would absorb the knowledge that she had been welcomed as a woman worthy of Dean Swift's attention. She would become 'Dean Swift's Mrs. Pendarves'.

In her first letter to Swift on her return, dated 29 May 1733, Mary explained with disarming candour how their friendship had changed the way that other people would now see and value her:

> I did not forget to brag of your favours to me: if you intended I should keep them secret, I have spoiled all, for I have not an acquaintance of any worth that I have not told how happy I have been in your company. Everybody loves to be envied, and this is the only way I have of raising people's envy; I hope sir, you will forgive me, and let me know if I have *behaved myself right*.[2]

The letter shows how well Mary had mastered the tone of ironic banter that prevailed in their Dublin soirées, whereby Swift acted as a kind of master of ceremonies, and the ladies had to project themselves as receptive to his correction for their use of language and demeanour.

Swift's reply has not survived, but it evidently included comment on some carelessness in Mary's letter, as she now spiritedly declared in return:

> I will write henceforward to you as carelessly as I can; and if it is not legible thank yourself. I do not wonder at the envy of the ladies, when you are pleased to speak of me with some regard: I give them leave to exercise their malice on an occasion that does me so much honour. I protest I am not afraid of you and would appear quite natural to you in hopes of your rewarding my openness and sincerity, by correcting what you disapprove of . . .

The letter evidently had described Mary as a sorceress – perhaps one like Alcina in Handel's opera of the same name – for she declared:

> I wish you could make your words good, and that I *was* a '*sorceress*': I should then set all my charms to work to bring you to England and should expect a general thanksgiving for employing my spells to so good a purpose.

In late October Mary was able to write to Swift about her visit to Lord Bathurst. Bathurst, like Lansdowne, was a Tory with distinct Jacobite sympathies, but

once the Tories lost office under the Hanoverians, planting his woods was a safer occupation than dabbling in plots.[3] He created a new landscape with Pope's advice for his park at Oakley Wood, on the edge of Cirencester, about 20 miles from the Granvilles at Gloucester. In an estate that was already well wooded, he planted acres of trees with avenues cutting through them and groves nestled within them, together with garden buildings acting as eye-catchers. Mary expressed her admiration for the 5-mile-long grand avenue with its 5,000 trees. She told Swift about the improvements since he had last stayed there in an old farmhouse in the grounds, using Milton's words to describe how this was now rebuilt as a crenelated folly, 'a venerable castle, and has been taken by an antiquarian for one of King Arthur's, "with thicket overgrown, grotesque and wild"'. But she was dissatisfied with her attempt to sketch it on paper for Bathurst instead of picturing it in words. She also described to Bathurst Swift's garden in Dublin, and Dean Delany's creation at Delville, adding 'the cold weather, I suppose, has gathered together Dr. Delany's set: the next time you meet, may I beg the favour to make my compliments acceptable? I recollect no entertainment with so much pleasure, as what I received from that company; it has made me lament the many hours I have lost in insignificant conversation.'[4]

WEDDINGS OF COUSINS AND PROPOSALS TO THE WIDOWED MRS PENDARVES

The New Year of 1734 was spent at Longleat with Mary's Carteret cousin Louisa, now Countess of Weymouth. The mutual devotion of the host and hostess was palpable; marriage had had the desired settling effect on the viscount. On returning to London for the season in February, Mary soon recognised the extent to which two more of Louisa's sisters were moving in the highest circles: 'Our cousins are now growing the most considerable people in the kingdom . . . Well, dear sister, we are certainly the poorest of our family, but yet I would not change with any one of them *every* circumstance of my life; what say you?'[5] The cousinly grandeur was the result of their generous dowries and high-ranking husbands. Wealth, though, was not everything. Grace Tollemache, Lady Dysart, the eldest, and her husband Lionel, were finding that restoring the fabric of their home was easier than continuing the family line; five infants had already died.[6] However, Lady Grace was expecting another child the summer Mary returned to England, and mercifully for the parents this third son, Lionel, survived and thrived.

If anything Georgina Carteret married into even greater wealth and afflu-ence the following spring. Her groom was the Hon. John Spencer, brother of Charles Spencer, 2nd Duke of Marlborough. Being the granddaughter of the formidable dowager Grace Carteret, 1st Countess Granville, Georgina had been fortunately prepared to have as a mother-in-law the even more formidable dowager Sarah, 1st Duchess of Marlborough, who controlled the marriages of her children and grandchildren through the power of her purse as well as the strength of her character. She gave the groom £5,000 per annum, his brother conveyed country estates to him in Bedfordshire and Northamptonshire – including Althorp House – as well as Sunderland House in London, while Georgina herself brought a fortune of £30,000 to the marriage. The actual wedding was mainly a family affair of about two dozen people at newly built St George's, Hanover Square, but the clothes and jewels were lavish. Mary described the dresses to her sister. The bride wore 'white satin embroidered with silver, very fine lace' and jewels lent by her new grandmother-in-law. The finery would be worn again a few weeks later when George II's eldest daughter, Anne, princess royal, was to marry William, Prince of Orange. For this occasion, Mary had found some inexpensive brocaded lutestring, with 'great ramping flowers in shades of purples, reds and greens' on a white ground, to be accesso-rised with purple and gold ribbon and a black hood: 'it looks better than it describes and will make a show'. Mary was hoping that this court news would entice her shy sister into the prospect of being a Maid of Honour, either to Princess Anne, or Princess Amelia, who was then rumoured to be marrying William, Prince of Hesse-Cassel. To bring such an appointment about, Mary was lobbying Lord Carteret's former ward, Frances Lady Hertford, now Lady of the Bedchamber to Queen Caroline.

Mary did not go to the royal wedding of Princess Anne but she did hear all about it and went to the royal drawing room held the day after, wearing her new dress. The royal bride's marital choices were very limited, since, as the daughter of a king, most German princes were not considered grand enough. The idea of her marrying her Hohenzollern cousin, Frederick, the future King of Prussia, had been the pet project of his mother and grandfather, but George II had cancelled this plan to show his own independence from George I. Although this royal Frederick's interest in women was distinctly limited, the cousins would have had musical passion in common, and would later correspond on musical matters.[7]

Instead Anne's chosen groom was William of Orange – but a William who lacked the charisma or political *nous* of his ancestor William III, alongside whom Mary's father and uncles had fought. From a side-branch of the Orange dynasty, this William was the hereditary ruler of only one of the seven Dutch provinces and the elected ruler of only two others. Moreover, he had a spinal curvature, which complicated his health. But Anne did not want to stay at home playing second fiddle to her brother Frederick, Prince of Wales, and professed herself very content with her future husband – and in fact it proved a happy union.[8]

Mary described to her sister the glittering attendees in the drawing room. The groom's gold coat embroidered with silver was handsome but not showy, while the king's gold fabric was more resplendent and the Garter Star shone out.[9] Her description of the Maids of Honour – who would have included Lady Sunderland's daughter from her second marriage, Isabella Sutton – must have been of especial interest to her sister. Indeed Mary accompanied the doubtless proud and grand Dowager Duchess Sarah to the drawing room, the party choosing to go early at 1 p.m. and avoid later crowded jostling. Even so it was slow progress to reach the queen, but Mary was rewarded with her dress being praised. They were through by 5 p.m., and then in the evening went to the ball, where Lord Baltimore, whose first encounter with Mary this was since her return to London, helped them find more breathing space by letting them up in to a new gallery built for the occasion to link the drawing room and the Chapel Royal. Receiving these descriptions down in Gloucester Anne shared them with about a dozen friends, knowing that by word of mouth the information would soon spread all around town, to add to the newspaper accounts of the wedding itself. She was fed up with some of their Gloucester circle that made her look forward to April when she and her mother would go to the little villa they rented a few miles out at Cranham.[10] To cheer her up and implicitly support her sister's decision to avoid all place-seeking at court, in her reply Mary retailed the list of Princess Anne's household appointments with accompanying comments on how unprepossessing or dreary they were: 'Miss Herbert, *commonly called pretty*, that *might* have been married and *would not*; Miss Howe . . . a black frightful witch . . . Her ladies, Lady Southwell . . . as disagreeable and affected as ever you saw any creature . . . indeed my dear, without any compliment, *you would have been the flower of the flock* had you made one among them.'[11]

In late March Mary was still busy with arranging the details of her widow's jointure from the Bassets, who were driving a hard bargain, and Uncle John

Stanley helped prevent her being short-changed. In the end, weary of discussion, she settled for less than she might have claimed. It would amount to £100 a year, which she would need to manage carefully, together with receiving a one-off fee for altering her legal security on the income, plus her legal costs. But 'it is well to get rid of trouble', and she would be 'rich' after a fashion.[12] The key point remained: 'As to my fortune, it was very mediocre, but it was *at my own command*.'[13] She could spend what she had without any further consultation with the trustees who normally controlled a wife's endowment.

None of these weddings made Mary any less reluctant to remarry herself, especially now she had established her own financial footing. But she could not avoid attracting serious proposals. In early April she wrote in detail to Anne about her most recent one. She recalled to Anne how she had described how, on returning from Ireland the previous summer, she had felt pestered after church services by a Mr Prideaux, to whom she had been very discouraging. This was Edmund Prideaux, a Cornish landowner whose family were intermarried with the Granvilles. Now, to Mary's annoyance, he was renewing his suit, with the assistance of a mutual acquaintance, Mrs Harris, who had invited her to have tea one evening.

On arrival, Mary found Prideaux already there. Somewhat dismayed, she listened to his conversation – probably more a monologue – about himself, his house, his library, his pictures, his music . . . She recognised that his father was a noted churchman, Humphrey Prideaux, who had been Dean of Norwich: she was acquainted with some of his books, and the library that her suitor described was of his father's making. These were all topics calculated to appeal to Mary, if she had found him prepossessing in the first place. But she did not, and tried to put him out of her mind when she got home. However, the next day she had a visit from their hostess, who had agreed to prepare the way for his proposal. All was laid out: he was a widower with five children, but none of the four sons was at home, and the fifth child was a 9-year-old daughter. He had £5,000 a year and could settle £20,000 on her, and Mrs Harris claimed he was of good character. Mary must have felt cornered, but eagerly seized on the five children as a reason to refuse. 'To tell you the truth', she told Anne, 'matrimony is *so little* my disposition, that I was glad to lay hold of a reasonable excuse for not accepting the proposal, and I was *as glad* to find he had *five children* as some people would have been at hearing he had *five thousand a year*!'[14]

Mary was worried her mother might judge this refusal rash, and she had not yet dared tell Uncle John Stanley about it: but she had Bunny's support. It is

clear that the idea of marriage itself was off-putting, let alone step-mother-hood. The settlement from the Bassets, which bypassed financial need for remarriage, had come in the nick of time. Yet, had her experience of Alexander Pendarves' ill-health, drink-problem and clumsy embraces not risen to the surface – as they must have done – she and Edmund did indeed have shared interests as well as the Cornish connection. Since inheriting Prideaux Place in 1728, Edmund had been restoring it in keeping with its Tudor origins, and developing the grounds. He was a good architectural draughtsman and his taste had been honed not only by his father's antiquarian interests but also by knowledge of the building or rebuilding of country houses in Norfolk. On the face of it Mary must have seemed a very suitable candidate as a second wife.

At least when Mary rejected another proposal in the summer, also from a Cornish relative, she gained the approval of Countess Granville. Her suitor this time was Countess Granville's maternal cousin Sir Richard Edgecumbe, MP for various Cornish constituencies during his political career. He was the chief government 'manager' of the Cornish parliamentary seats and succeeded in keeping them more on the king's side than on Prince Frederick's. Such a marriage would have made Mary very much a political wife, and eventually a peeress when Edgecumbe was made a baron in 1742. He probably considered that, with her previous experience of being married to a Cornish MP, she would have been an asset to the necessary socialising his role entailed. Lady Granville's reaction was: 'I can't bear the thought of you being hurried into Cornwall to be a mother-in-law [that is, step-mother] *without a good-settlement*'; evidently Mary's suitor had assumed she would be ready to remarry at the drop of a hat.[15] Mary's refusal to be won over at least looked financially prudent, though that was surely only a useful pretext for her real desire to stay single.[16]

METROPOLITAN LIFE

Mary was still enjoying the company of her London friends, including the Carteret ladies and the Perceval circle. In the absence of a spouse, an advantage of brother Bernard's spending his spring military leave in London was that he could be her co-host. One evening, as well as Bunny, the guests included Don; Mr and Mrs Perceval; the former's niece, Lady Catherine Hamner, and her husband Thomas; Uncle John Stanley; and her Lower Brook Street neighbour – the composer Handel, who brought along the singer Anna Maria Strada, a

high soprano known for her wide vocal range. She created many parts for the composer, and had not left his company when in the previous year many others migrated to the Opera of the Nobility. That spring she sang the love interest, Elmira, in a revival of his *Sosarme* (1732). The connoisseur and aesthetician Lord Shaftesbury, knowing his friend Handel would be there, begged Mr Perceval to bring him along as well. Mary told Anne:

> Mr Handel was in the best humour in the world, and played lessons and accompanied Strada and all the ladies that sung from seven of the clock till eleven. I gave them tea and coffee, and about half an hour after nine had a salver brought in of chocolate, mulled wine and biscuits. Everybody was easy and seemed pleased, Bunny staid [sic] with me after the company was gone, eat a cold chick with me, and we chatted till one o' the clock.[17]

Mary could feel crowded out with company and never minded time without visitors. (Of course she was never entirely alone, since she had at least three resident servants.) She enjoyed the plays and concerts, balls and suppers, and kept track of the latest fashions, or gossip about the marriages and elopements; but her letters to Anne also show her intellectual and moral seriousness. They are about the books she admired and recommended to her sister, encouraging her to keep up her French by reading a novel rather than one of the elaborate seventeenth-century prose romances.[18] She pictured Anne at local dances and soirées, knew she would fit in just as gracefully in London life, yet could see that she sometimes preferred talking to a thoughtful yeoman farmer about his crops. But Mary appreciated metropolitan polish and could spot a provincial in a trice. One of her visitors from Gloucester was the young Rev. Thomas Seward, a friend of Sarah Chapone's; much later his clever daughter, the better-known poet Anna, attracted the attention of Mary's eldest nephew, Court Dewes. Mary thought Seward a little donnish and affected: but it will 'probably wear off with seeing more of the world and of good company'.[19]

One day in May she had some time to take stock:

> I am full disposed to fill this sheet, every inch of it; I will not so much as leave a margin, for I have not had this many a day the comfort of talking with you without interruption. It is now just eight of the clock; I have drank my two dishes of tea, and *my charge* [Anne Donnellan] is gone to Islington

wells, my man to market, my maids at breakfast: and nothing moves about me but my two cats and a little hopping canary bird, that hangs up in my dressing-room [i.e. its cage hung there], where I hope to indulge an hour in thinking of my best of sisters.

This time Mary pondered about the advantages of travelling, and whether one should ever settle abroad. It shows that she still felt a little restless after the two-year sojourn in Ireland. Anne had evidently maintained that people should stay in the country they were born, as the Anglican prayer-book enjoined; Mary rejoined that there were few scriptural precedents for this, and that the decision should be directed by reason. She reassured her that she was not thinking of leaving England, but admitted that her visit to Ireland had shown her how much she enjoyed travelling, and she wished she had more money at her disposal to do this. The possibility that the Percevals might go permanently back to Ireland was a distressing thought. But the real riches were in her friendship with Anne, which unlike material wealth would outlast death, for they would still find each other in the hereafter.[20]

Mary was really thinking about the pull Ireland and its inhabitants still had on her. A few weeks later she was relieved to tell Anne that the Percevals would visit Ireland but not settle there, and take Don with her, too, to see if it might benefit her health. Then her deeper inclinations burst out: 'I assure you I wish *you and* I could be conveniently transported there for one year, no place could suit your taste so well; the good-humour and conversableness of the people would please you extremely.'[21] Meanwhile, to help fill the gap she felt in her heart for her Irish self and friends, there was one thing she *could* do: train the visual capacity stimulated by seeing Irish scenes.

EDUCATING EYE AND HAND

The visit to new places in Ireland had sharpened Mary's eye for landscape, prompted her to compare and contrast it with Cornwall or Gloucestershire and to make the best visual record she could of the fresh scenes, composed to include the congenial friends who had shared her pleasures. Her return to the metropolis coincided with a new surge of artists and their patrons aimed at advancing British-born talent. A host of middlemen seized the opportunity to cater to these trends, by taking commissions, importing and copying Old Masters,

making engravings, selling high-quality prints, giving lessons and providing artists' materials. These included prepared canvases, and the colours that were so messy and difficult for amateurs to grind themselves.[22]

Britain still lacked official art institutions such as a royal academy, showing how much the country lagged behind the Continent, where such institutions set artistic standards, provided exhibition space and helped train artists. But Londoners enjoyed all kinds of informal sociability and every enthusiasm could be catered to. Men gathered in coffee houses to talk about art and network over commissions, and clubs proliferated, such as the Society of Dilettanti. Women could not participate directly in these forms of sociability, but on the other hand, the fact that in Britain's thriving urban economy art was becoming another 'product' to be bought and sold meant that if they had some purchasing power women were not entirely excluded either. If they came from families where women were increasingly expected to have some cultural polish, fathers, uncles, siblings and husbands could all encourage female talents.

Although this artistic participation depended upon a woman's means and opportunities, it was not simply a question of being able to pay a drawing master such as Arthur Pond, George Vertue, the several members of the Lens family, or Louis and Joseph Goupy, an uncle and nephew. The precondition for learning to draw and paint was knowing what to look at and what to value. The eye had to be educated as well as the hand. To develop a good 'eye', to know what was considered excellent and tasteful, became the hallmark of a gentleman. Some of this discussion of aesthetic principles filtered into the periodical magazines such as *The Guardian* and *The Spectator*, to be read by women and less well-educated men. Having good taste made women more eligible as wives of the kind of gentlemen who wanted to rebuild or commission a family seat or create a land-scape garden. If it was the wife's dowry that was financing this outlay, as in the case of Lady Dorothy Boyle, married to one of the great connoisseurs and patrons of the age, Richard Boyle, 3rd Earl of Burlington, it could make it an even more enjoyable joint project if she acquired artistic intelligence and skill herself.[23] At the very top of society Queen Caroline was setting an example to well-connected ladies of the possibilities of female patronage, by re-displaying the royal collection of pictures and sculpture, commissioning Charles Bridgman to re-design the gardens at Kensington and Richmond, and William Kent, the Burlingtons' main protégé, to design her a library at St James's. Lady Dorothy was one of Queen Caroline's Ladies of the Bedchamber and entertained her

royal mistress at the exquisite villa and park at Chiswick that Kent created for the couple. The queen competed intensely with her son Frederick, Prince of Wales in her various enthusiasms, and after her death in 1737 it was Frederick and his wife Augusta who would continue to inspire the admiration and the emulation of Mary Pendarves and her friend the Duchess of Portland.

Mary thus became one of a generation of cultivated women who developed their artistic potential because of her own connections to several families whose knowledge and enthusiasm was an education in itself. Landscape gardening was already part of her visual repertoire, thanks to her uncle and his friends such as Pope and Lord Bathurst, together with her Irish contacts, such as the Wellesleys. To train her eye for pictures and engravings, she had the inestimable advantage of her friendship with Edward Harley, 2nd Earl of Oxford, and his wife, the parents of the future Duchess of Portland. Although the duchess was to become one of her closest friends, Mary was nearer in age to her parents, born respectively in 1689 and 1694, and she was used to socialising with them after she was first widowed. Lord Oxford was not only a great bibliophile and patron of literature, he was the foremost collector of his time, extravagantly purchasing Old Masters and commissioning engravings with the help of George Vertue, as well as acquiring coins, medals, antiquities and objects of curiosity. His wife Henrietta Cavendish Harley was artistically knowledgeable, too, and very conscious that the family fortunes passed three times in the female line in the course of three generations. When she was widowed a decade later she arranged family portraits at their country seat, Welbeck, to indicate this lineage, and some of the Duchess of Portland's enormous wealth came directly from her mother.[24]

In London in 1736 Mary mentions to her sister that Lord Oxford was showing her 'drawings from antiquities and reliques of Rome' and his collections of the seventeenth-century Bohemian topographical artist, Wenceslaus Hollar, who had worked in England.[25] When her visits to Bulstrode, the Portlands' country seat, coincided with Lord and Lady Oxford, she would draw in the mornings and discuss pictures and look at engravings with Lord Oxford in the evenings.[26] Inspired probably by similar Irish sites, she was especially interested in topographical prints and trying to draw ruins, and told Anne she found landscapes the easiest thing to do. When Anne Granville was included in visits to Bulstrode, she also drew, and the duchess encouraged her, saying she was as good as Lady Andover, who came from an entire family, the Finches, noted for its artistic talent.[27]

If it was her uncle's literary friends who had educated her eye for landscape, and the Harleys who helped her connoisseurship, it was a Carteret relative who actually encouraged her to take lessons in drawing after she had 'resumed her pencil' in June 1734. Grace, Lady Dysart, caught her cousin up in the fashion for drawing with pastel crayons. This was sparked by the enthusiasm for Venetian art, which, significantly for lady amateurs, included the work of the pastellist Rosalba Carrera (1675–1759). Carrera rose from painting miniatures for the lids of snuff boxes to being an academician in France and Rome, much in demand for portraits by royalty and nobility across Europe. Mary reported to Anne, 'Lady Dysart goes on extremely well with her drawing; she has got to crayons, and I design to fall into that way . . . I aim at everything.'[28] She decided to get Arthur Pond, one of the main artists, teachers and dealers in 1730s London, and a great promoter of Rosalba Carrera's work, to teach her as well as Lady Dysart, but realised that she needed to improve her drawing before attempting to add colour. However, among the pictures in her family's possession at her death, Lady Llanover included a copy by Mary Delany of Rosalba Carrera's evocation of Summer as a smiling young woman, so Mary's confidence in using pastels must have increased.[29] Pond taught, portrayed and supplied many people in Mary's circle, and that of Prince Frederick, including her cousin Anthony Westcomb, the Duchess of Portland and the Percevals.[30] In June 1737 the Duchess of Portland was at Pond's shop and saw his picture of Lady Dysart, which she thought needed no further alteration.[31]

The lessons taken from art masters by women like Mary Granville, Lady Dysart or Lady Andover would all have concentrated on showing them how to copy Old Masters, either from prints or originals. All artists, male or female, professional or amateur, learnt by copying; it showed that you knew what was esteemed to be excellent of its kind and therefore were willing to learn the techniques involved in creating it. The cult of the individualistic genius developing his or her unique self-expression did not emerge until after Mary's death. We know that to help her understand the Old Masters Mary purchased books of engravings from Arthur Pond.[32] Later in Ireland she was using a large folio collection of prints of pictures owned by the French connoisseur Crozat, one of the best collections of coloured prints available.

She took lessons from a variety of teachers, not only Pond but also Louis Goupy, who taught the Countess of Burlington and her daughters. When he died in 1748 she remembered him as 'so modest, quiet, civil, honest and an

incomparable master!'[33] The copies she made were for two purposes: first to decorate the homes of her family – her mother, her uncle, her brother – or her own; and, second, to commemorate these relatives by her portraits of them and their forebears. Already during her first Irish visit she had felt frustrated by the inadequacies of her effort to paint her mother – another incentive to get better instruction once back in London.[34] After several years of her lessons she must have felt she had improved enough to give her Uncle John Stanley a large-scale Madonna (we do not know the original she based this on) and an Apollo.[35] These might have been in oil, crayon or gouache.[36]

Painting, then, was part and parcel of a range of decorative endeavours linked on the one hand to fine art for its own sake, and on the other to furnishing her home and those of her relatives. In 1734, when she took up crayons, she also told Anne, 'I have got a new madness, I am running wild after shells' – as she had done in Ireland. Shells had a devotional as well as a decorative purpose: 'The beauties of shells are as infinite as of flowers, and to consider how they are inhabited enlarges a field of wonder that lead one insensibly to the great Director and Author of these wonders.'[37] She used them to decorate frames and make vases for her own home, and to make a grotto at Northend for her uncle. In the summer of 1736 she eschewed making visits to the country and instead, when he was taking the waters at Tunbridge, she worked on this project, while also practising her painting and her music. Anne described her sister's house as a 'cabinet of curiosities' and wonderful paintings.[38] Her flair for décor was doubtless related to her newly cultivated eye for landscape and painting, but we must not discount the example of her mother, who is described as settling her Gloucester house with inherent style, or the opportunity to help Bunny decorate his new town and country houses.

What marks out Mary at this point then is not necessarily her skill, or even her potential, but her dedicated attitude. Just as she had reacted to hearing Handel as a schoolgirl by vowing she would aim to emulate him, so she now decided to be as intensely engaged with the visual arts. This accorded too with her religious outlook – her natural intensity was reinforced by the biblical precept, 'whatsoever you do, do it with all your might'. One day at Northend she told her friend Kitty Collingwood she worked at the grotto from six in the morning to two in the afternoon.[39] She was not deterred either that other women in her circle, like her cousin Lady Dysart, had a lot more money to spend, since she was happy to create decorative effects inexpensively with her shell-work,

which at first glance looked similar to those achieved by the expensive *stuccadori*. But if the spirit was willing, and the flair readily available, the flesh was sometimes weak. Although she complains about this so seldom that previous biographers have failed to make much of it, Mary had recurrent problems with her eyes being inflamed or weak.[40] The attraction of using crayons was that 'it tries my eyes less than [needle]work, and entertains me better'.[41]

One solution to the risk of eye strain was to engage with her other muse, that of music. And here too there was family encouragement. Like his sister Bernard was as musical as he was artistic, and he urged her to practise her harpsichord and take further lessons. Finally, in November 1736, he pinned her down by paying the first fee for a course of lessons from Joseph Kelway, organist at St Martin-in-the-Fields, and buying her Handel's *Book of Lessons*.[42] Handel admired Kelway's playing so much that he would go and listen to him play the organ, and Kelway was equally skilled on the harpsichord. (A future bond for Mary with Queen Charlotte was that thirty years later the queen also became his pupil.) Mary persisted with both music and painting, and during one of Anne Granville's London visits had no time to see her on Thursday mornings as they were allotted first to Goupy, then to Kelway. Her sister Anne told their mother that Mary's drawing had improved well through this dedication, though the winds had recently made one eye very watery, so 'music *must satisfy* her *now* for not being able to use her pencil'.[43] And Anne worried that spending time on her scales was at the expense of her sister's taking exercise. Whatever Mary undertook to do, she liked to do it as thoroughly as possible – but at the same not to make too much of what she was able to achieve.

PATRICK DELANY AND SALLY'S CHRISTIAN FEMINISM

Mary told sister Anne in January 1733 that Sarah was 'in raptures with Dr. Delany's book on Revelation'. The book was *Revelation Examined with Candour* and the reason for the raptures was that the dean's biblical commentary gave Sarah a new theological platform for the sexual equality that she had always believed in.[44] After several drafts,[45] Sarah's literary project finally appeared in public as *The Hardships of the English Laws for Wives*; additionally, some excerpts were included in the very widely read *Gentleman's Magazine*. The pamphlet was among the earliest to discuss the legal disadvantages of married women under English common law, which it will be remembered decreed that all property brought to

a marriage belonged to a single legal personality, the husband, unless protected under the court of equity – a separate legal regime regulating the creation of trusts that could hold property on behalf of wives, and pay out income from them. As we have seen, Mary and her sister might have read Dr Berkeley's *Ladies Library* when young, which encouraged gentlewomen to think of themselves as legal agents after their marriages, so that they could help manage the family property. But Sarah was also seeking a way for women to believe they had a civil identity even *during* their marriages, and that their deference to their husbands need not mean an entire subjugation.

It is difficult to say what prompted Sarah to write this pamphlet. She was probably used to listening to legal discussion in her home circles: Wesley, for example, records discussing law and juries with her father, back in the early days of her marriage.[46] Clerics often played a part in the lowest levels of justice when Justices of the Peace (JPs) considered referring cases to the higher courts, and could act as character references for first offenders or to appeal more lenient sentencing.[47] It is tempting to wonder if financial problems in her own marriage might have prompted her to take note of some legal cases in the papers, especially as the Chapone household finances were never very stable. She said to her protégé Elizabeth Elstob in 1735, 'a pretty large family and a precarious fortune leaves me little room for generosity, except to that of the heart'.[48] Might whatever dowry she had brought to the marriage been swallowed up in problems with landlords or their school?

In her pamphlet, though, Chapone emphasised that it was her intellectual sympathy and not her personal biography that made her want to highlight the difficulties married women faced. She counted herself lucky that unlike most wives, her husband 'let her be a some body [sic]', and in her pamphlet articulated what marriage could and should be, clearly implying that this is the kind of marriage she enjoyed. She was fiercely loyal to her quieter, supportive husband, defending him stoutly in 1735, to the newly installed Bishop of Gloucester, Martin Benson, from accusations of impropriety.[49] Reading between the lines, it seems apparent that Sarah had negotiated her marriage on her own terms, but that she was also a devoted wife and mother. In fact Mary found her rather tiresomely domestic a few years later, complaining that she found 'fireside epistles' about 'Jacky and Sally, Harry and Kitty' a disappointing kind of letter to receive. Perhaps she thought the sparky combative Sarah had become too bound up in maternal sentiment?[50]

Patrick Delany's theological framework is essential for understanding the way that Chapone's feminism is worked into the discussion in her pamphlet. Moreover, since the pamphlet was first published in Dublin, it is possible that Sarah had written to him about his biblical commentary, and that he had helped her secure its publication there. She considered that the undermining of Christian belief by Deism was ultimately making women more vulnerable to the legal restrictions integral to English marriage. One task therefore was to show that Christianity was really true: this is where Bishop Berkeley's defence of it came in. The second stage was to reiterate that Christianity, put into practice, could temper the legal authority allowed to men in marriage and turn the institution into a form of friendship. This was not in itself a new idea, as preachers such as Jeremy Taylor in the Restoration era had used this kind of language to articulate a concept of companionate marriage. These ideas are also integral to sermons published later by Delany himself, and dedicated to Princess Augusta of Wales. But Sarah wanted to draw the conclusions more fully as to how this might help the legal and financial consequences of marriage law being detrimental to women.

When looking ahead to marriage it is important – she was thinking of Mary Astell's ideas here – that a girl thinks carefully before she agrees to such a significant change in her life. A voluntary decision means that marriage is not in itself a type of slavery but, Chapone explains, often women chose it rather than being 'solitary, unfriended and ridiculed' for being single.[51] Such a woman looks for a good financial settlement and neglects 'to attain a fund of reason, learning and knowledge sufficient to furnish entertainment for her whole life'. A wife will accept that the fallen condition of mankind means she should defer to her husband's direction: this discipline, regularly practised, helps a woman master her passions (presumably her own untamed independence is meant here) and therefore she begins to cancel her burden of original sin. Consequently, in a good marriage, women retain their civil existence, including their right as widows to be guardians to their children, which at that time was not fully acknowledged. She protests also at the sexual double standard: a man is granted the power to 'own his wife's person', that is, his conjugal rights, and can sue her lover for 'criminal conversation' and claim damages. But wives do not have the complementary right to sue a woman who has seduced her husband.[52]

Delany prefaced his biblical commentary on the book of Genesis by deploring the spread of 'Epicureanism', and superficial religious knowledge, which has

inclined people to atheism. In his view, a more probing analysis of the Bible shows that it is only after the fall of man that women are subjugated; before that, nature was in a state of perfection and the sexes were equal, and there was not 'the least hint of subjection or dependency'. Moreover, God intended men to benefit from female company: a view that accorded with the new emphasis on how women's conversation helped to ennoble and socialise men.[53] This theology therefore underpins Chapone's consolatory conviction that if women begin to work off the curse of subjection by accepting a degree of deference in their marriages, they proportionately recover their prelapsarian equality, here in present-day life and not delayed to the hereafter. With these vivid sentiments in print in 1735, it is surely no coincidence that Anne Donnellan told Jonathan Swift that same year: 'I am a great asserter of [women's] rights and privileges.'[54]

THE SIBLINGS IN LONDON

In 1734, remarriage was still unimaginable for Mary. She was happily establishing her own base as a fashionable yet devout widow, with a house sufficiently large to accommodate visits from her sister, and joint entertainment with her brother and their common acquaintance. Bernard was now in the metropolis more often, as in 1735 he had come into his share of the Granville inheritance from his Stanley uncle and his aunt, who died within a few weeks of each other. The same year the widowed and mad 2nd Duchess of Albemarle also died, so the Granvilles pursued their claims on the Monck money she had inherited from her husband, Charles, 2nd Duke of Albemarle, cousin to the Granvilles' father.[55] The legal tussles over the Albemarle estate caused some friction with the imperious Countess Granville, who thought that Bernard would have done better to consult her son, the statesman Lord Carteret, rather than his 'attorney' (in modern British usage, solicitors, who ranked as the lowest type of lawyer).

Bernard now abandoned his desultory peace-time army career and embarked on the customary routine of the leisured *bon ton*: visits to London in the New Year and autumn, and summer in the country, interspersed as he got older with visits to spas for health reasons, often around November. In March 1735 he bought a small townhouse in Hyde Park Street, near Mary in Upper Brook Street. Mary and Anne came up to London, having spent the winter in Gloucester nursing their mother back to health. Anne had also been poorly, so they

also planned to consult better doctors. Bernard engaged as his housekeeper an old Granville servant, Susan Badge, who wrote enthusiastically to Mrs Granville senior that her son now had an 'enchanted palace', where she was 'delighted with the prittiness [sic] of the place and the great convenceis [sic] in so small a compass, and the goodness of the master of it'.[56] He also began to look for a country estate and in April returned to Gloucester where he was considering purchasing a property in the village of Dowdeswell, 12 miles away. Like his Uncle John Stanley in Fulham, nicknamed the 'knight', 'the squire' would have his own rural 'Paradise' too. Mary continued to visit the 'knight's' green retreat regularly from the hectic West End, and sent greetings to the 'squire' from Sweep, the latest kitten in residence there.[57]

Anne's future also had a brighter aspect with her brother's accession to affluence, since he now provided her with a personal allowance and promised her a dowry were she to find a husband – hence her new family nickname of 'Prospects'. Anne Donnellan wrote to Jonathan Swift with the details of Bernard's handling of the matter: 'Mr Granville is become possessor of eight hundred pounds a year, and twenty thousand pounds in money . . . [he] is . . . a very kind brother, and has it now in his power to provide for their sister Miss Granville.'[58]

Musical life must have been an especially pleasurable part of their London visit that spring. Handel was still calling in to play extracts from any music he was composing; soon after Anne's arrival he played the harpsichord for them for three hours – a private musical feast. When the opera season resumed, Mary, Anne and Anne Donnellan all went one morning to his house to hear Handel play extracts from his latest composition, *Alcina*, in advance of its première. Like its heroine Alcina, Mary thought Handel was making magic; 'I could not help thinking him a necromancer in the midst of his own enchantments.'[59]

To Swift, Mary wrote of the opera 'wars' that raged that winter and spring, between the rival opera companies. 'Our operas have given much cause of dissension; men and women have been deeply engaged; and no debate in the House of Commons has been urged with more warmth: the dispute of the merits of the composers and singers is carried to so great a height, that it is much feared, by all true lovers of music, that opera will be quite overturned. I own I think we make a very silly figure about it.' Tellingly, she could not help enquiring after Dean Delany. He had given up his Dublin house, which meant he no longer hosted his weekly soirées, but stayed at Delville all week – with, of course, the new Mrs Delany. 'I am sorry the sociable Thursdays, that used to

bring together so many agreeable friends at Dr Delany's are broke up . . .'[60]

Letters to Swift show that Anne Granville's health continued to be of concern. Mary accompanied her to Bath when winter set in during November and then they returned together to London in the new year of 1736. Now that Anne's 'prospects' were better, another reason to socialise in both places was to become more visible to acceptable suitors. Bath was a great centre for match-making for young and old, with its numerous card-parties and assemblies. And during this second extended London visit, Anne was presented at court, the most important way of demonstrating her *entrée* into society, likely under the aegis of a grand relative such as Lady Carteret.

The powerful Carterets must also have been the ones to spearhead a new attempt to find Anne Granville a place at court, in the household of the king's daughter Princess Amelia, who was three years younger than Anne. They were presumably aiming at a place as a Maid of Honour. However, Anne declined this and, according to Mary, writing after her sister's return to Bath and then to Herefordshire to visit the Foley family, this was a topic of some discussion in court circles 'so whilst you think yourself in such a retired corner of the world, you are the subject of a Princess's thoughts!' But why did Anne refuse this offer? Part of the answer is that she had a great sense of obligation to her ageing mother, and, recognising this, Mary had not tried to 'make interest for her' when Princess Anne married in 1734, and new households for the remaining royal sisters, Caroline and Amelia, were being formed.[61] Anne Granville had also a decided preference for the occupations of country life. She told her friend Kitty Collingwood, 'all country pleasures give me so much pleasure that I pity all my friends who do not taste them or have opportunities to learn', occupations such as looking after her poultry and seeking out wild flowers.[62] But as well as being more a country than a town mouse, she may have rightly considered that she and Princess Amelia were not likely to suit each other, given that Amelia was an avid follower of politics and an energetic huntswoman. Mary had already considered back in 1734 that if Anne had wanted to try her luck with a position, Princess Caroline, who was bookish, devout and quite the invalid, would have been a better choice.[63]

However, before she left London in 1736, Anne had one more chance to be on the fringe of the glamorous side of court life, when Frederick, Prince of Wales married Augusta of Saxe-Gotha. Her home duchy was small but wealthy, with a strong theatrical and musical life. This wedding was a new dynastic link for the

Hanoverians, and Frederick's marriage meant the king and queen would now give him a proper financial allowance, settling previous friction between him and his parents since he had come to England from Hanover. Even if neither sister had been able to attend the wedding on 27 April they would have heard all about it from friends such as Lady Colladon or her daughter Mrs Charles Montagu, whose husband was auditor to Prince Frederick.

Mary described the day Anne returned to Gloucester as a 'melancholy Monday'. Deciding it would be too affecting to say a final goodbye, she lay in bed when she heard Anne get up early to slip away. Later she had to put on a cheerful face and a court dress to attend a drawing room held jointly by the Prince of Wales and his bride. First Mary looked fondly at a dried flower arrangement Anne had made her: 'I kissed the little nosegay made up of rosebuds, daisies, seringos [sic] and heartsease – the lovely emblems of your friendship, which blooms and blesses me every year.' Then:

> I curled, powdered and dressed, and went to Mrs Montague at one; from thence to Court, where we were touz'd and hunched bout to make room for citizens in their fur gowns, who came to make their compliments to the royal pair. They received them under their royal canopy. With great difficulty we made our curtsey to the Princess of Wales . . . it was more crowded than the day we went to be presented. From the Prince's court we went to the Queen's; we made our reverence, but retired without any particular honours. Hot and dispirited we were . . .[64]

THE DUCHESS OF PORTLAND AND HER EARLY CIRCLE

When Anne was staying with Mary in London they both mixed with the young Duchess of Portland, who followed the fashionable calendar and resided in Spring Gardens, Whitehall, when she and her new husband needed to be in London. The Countess of Oxford and Lady Mary Wortley Montagu had known each other since they were 15, and were neighbours in Cavendish Square. Mary Pendarves was half a generation younger than the duchess's parents, Lord and Lady Oxford, and thus half a generation older than their daughter. There was the same half-generation gap between Lord and Lady Oxford's London neighbours, Lady Mary Wortley Montagu and *her* husband, Edward Montagu MP, and

their daughter, yet another Mary, who after her marriage in 1735 became the 3rd Countess of Bute. She was to become a close friend of our Mary after the death of Dr Delany, and forty-five years later supplied her with many specimens for the *Flora Delanica*. The roots of this friendship were planted back when the future countess lived next door to the Montagu family in the elegant town houses of Cavendish Square, which had just been built as an investment by the Harley family. These heiresses, Margaret Harley and Mary Montagu, were also the same age as Mary Pendarves' young sister Anne, so it is natural that Mary Pendarves had friends in both age groups.

Mary Montagu's mother kept her in London for all of the following summer of 1735 to prevent her from mixing with a rackety set of young people in Richmond who were enjoying a lot of parties and private theatricals. The husband her parents initially had had in mind for Mary Wortley Montagu was Lord Egmont's son and heir John Perceval, by no means a young rake and by now well known to Mrs Pendarves. Mary Montagu was allowed to refuse him, although he had persisted in his courtship for eighteen months.[65] John Stuart, 3rd Earl of Bute, a poor but well-connected Scottish peer, whose Campbell uncles were leading political figures associated with Sir Robert Walpole, also presented himself, first of all with her parents' (or at any rate her mother's) approval. They soon changed their minds, but young Mary had taken a liking to him – ironically, they both had a taste for amateur theatricals – and they became star-crossed lovers, waiting on her parents' willingness to make a settlement for them. As this was not forthcoming, the pair married without it, though with both her parents accepting the choice and attending the wedding.

Another confidante of the young Duchess of Portland and the Granville sisters was Kitty Collingwood, whose father was a distant cousin of the Duke of Portland, and had been executed for his part in the rising of 1715.[66] Mary and Anne first met Kitty in the duchess's milieu in 1735. The widowed Mrs Collingwood now lived in London and was presumably glad to draw on her links to the Portlands, which safely established her as loyal to the Hanoverians. Soon the duchess and her friends were concerned at reports that Catholic Colly was going to become a nun, and they all urged her against this; instead she married the Catholic widower Sir Robert Throckmorton, with estates in Buckinghamshire and Warwickshire.[67] This new set of connections would soon play an important role in Anne's finding a suitable husband.

In effect, on marriage the duchess established her own little court, to

keep her company when her husband was off hunting or attending to estate management, and to keep her calm during her pregnancies. Anne Dewes refers to the duchess as 'our lovely Queen' when explaining to Mary she is behind in her letters.[68] In this spirit the friends assisted her in London where she had her formal 'lying-in', the occasion when a woman received company in her bedroom soon after giving birth. Mrs Pendarves' first visit to Bulstrode to see Margaret in her married state was in October 1736. She wrote to Kitty:

> We made use of the fine weather, and walked all over the park and gardens; they are very fine, and so is the house, though we live as magnificently as the Prince of Wales, I am as easy as if I was at home, which is charming and very uncommon . . . We have variety of amusements, as reading, working [needlework] and drawing, in a morning; in the afternoon, the scene changes, there are billiards, looking over prints, coffee, tea. Cribbage, and by way of interlude pretty Lady Betty, comes upon the stage, and I can play at bo-peep as if I had a nursery of my own. She is the best humoured little dear that I ever met with.[69]

It was literally true that the silverware and porcelain in use was like the Prince of Wales's milieu, since the duke and duchess acquired silver tableware from the same silversmith, George Wickes, who supplied Prince Frederick. Only the year before Mary's stay they had bought silver-gilt tea caddies and a sugar box in the newly fashionable Chinoiserie style. Entertainment could be very lavish: in August 1736, young Lady Betty's first birthday was celebrated with a gathering of 600 people in the Bulstrode garden and 'an illumination and fireworks, rockets, dumps, line rockets, fireball, fire wheel, and mine – they were all charming . . .'[70] It was enlightened of the duke and duchess to be so exuberant over their first-born given she was not the all-important male heir: some families would have toned down any birthday celebrations.

The duchess was demanding in a light-hearted, charming kind of way. On a New Year's visit in December 1738, Mrs Pendarves observed to her sister, 'It's not to be told how many pretty engaging ways our dear friend has to gain the love and admiration of those she honours with her friendship, and this you well know.' Mary found her time for letter-writing was curtailed because she was using the mornings to copy drawings of Stonehenge lent her by Lord Oxford, in pursuit of her landscape studies. Letter-writing had to be done in the evening,

but it was hard to extract herself:

> Well, I must drink coffee at five, and play with the little jewels – it is the
> ceremony of the house: then says the Duchess, 'Don't go, Penny, till I have
> net one row in my cherry net', which proves a hundred meshes. . . . Then
> comes Lady Elizabeth, Lady Harriott, and the noble Marquis [the son and
> heir, known as the Marquis of Titchfield]: after half an hour's jumping, they
> are dismissed, and we soberly say, 'Now we will write our letters'. In comes
> the Duke, '*the tea stays for the ladies*': well, we must go, for there's no living at
> Bulstrode without four meals a day . . . eight of the clock strikes; then we
> start up, run away, and here I am, brimful of a thousand things to say to you,
> but have no time to write them, and that you know is a sad case.[71]

The duchess was not a natural letter-writer, unlike Mrs Pendarves.

A GOVERNESS FOR THE DUCHESS

One project Mary and Anne, together with Sarah Chapone, shared at this time
was to give further help to Elizabeth Elstob. When they first obtained the
pension from Queen Caroline, Sally had also mentioned Elizabeth's presence in
Evesham to an amateur antiquarian, George Ballard, who lived nearby in
Chipping Campden and was trying to learn Anglo-Saxon. (His mother was a
hard-working midwife who had attended Sarah in childbirth.) George Ballard
was actually a trained tailor, and his sister, another Elizabeth, was also a mid-
wife, but both spent most of their time – rather unusually, given their lower to
middling rank – as amateur antiquarians and coin collectors. George was also
interested in the tradition of learned and pious women; Elizabeth Elstob
confided her story to him, but as promised he never revealed it.

Ballard's connections to a fresh generation of like-minded antiquarians and
Oxford scholars who had begun to take him up meant that Elizabeth Elstob
was gradually drawn out of her obscurity. The gift from the queen had relieved
her immediate situation, but in 1737, when Queen Caroline died any further
royal generosity died with her. Now she was in her mid-fifties, Elizabeth's school
was deemed by Sarah and the Granvilles to be too draining of her energy and
unworthy of her talents, so they thought she might become headmistress to a
more upmarket charity school, run by the philanthropist Lady Betty Hastings.

Then Mary approached the Duchess of Portland and together they came up with the idea that Elstob should become governess to her children.

The duchess would probably have known that her father's librarian, Humphrey Wanley, had catalogued Saxon manuscripts transcribed by the Elstob siblings in their heyday, so she might have felt that there was a logic – and perhaps an imperative – that she should help his impoverished protégée. Despite this, Lord Oxford was concerned that although the proposed governess could read and translate French, she did not speak it – and learning to speak it was essential for eighteenth-century children of such high rank. The duchess proved ready to assert her independence of judgement.[72] The decision was taken that Elstob would join the duchess's household in 1739, but that her salary would be backdated to Christmas 1738. She was finally settled with the Portlands in November. She held Mary in high regard for all the help she had provided, and told George Ballard on arrival at her post, 'Mrs Pendarves is every way accomplish'd by Nature and Genius, and may justly be esteem'd an Honour and ornament to her Sex.' Meanwhile, George Ballard took up an earlier project of Elizabeth's, that of writing a series of essays on learned women who were also pious and respected. These included Mary's favourite poet, Lady Anne Finch. The anthology was to demonstrate that well-educated women eschewed egotism and maintained their religious decorum.[73]

Contented Aspasia

FEMALE 'PATRIOTS'

Between 1739 and 1741 Mary made visits not only to Bulstrode but also to her mother and sister in Gloucester, and to Bernard's newly purchased estate, Calwich Abbey, on the border of Derbyshire and Staffordshire. It is not known why he abandoned his search in Gloucestershire and chose the Peak District. There were obvious reasons for Mary's visits – her mother was often unwell, and she and Bernard shared decorative enthusiasms. But there was an additional reason for her to be out of London, especially during the parliamentary and court season. In 1737 the endemic conflict between the ruling king and his grown heir, the Prince of Wales, which characterised the reigns of George I, II and III, had broken out into the open, and the king made it known that anyone attending the prince's entertainments would be unwelcome at his court. Absence from the metropolis altogether was one way to avoid a public demonstration of where you stood. Although Mary was not particularly ambitious for a place at court – the push for this usually came from the Carterets – she probably felt the easiest way to avoid causing offence was to keep out of the way. However, Lord Carteret was able to keep on good terms equally with the king and the Prince of Wales, so this provided some useful 'cover' for Mary's varied social contacts.

In March 1739 Mary was among several ladies of quality attached to Prince Frederick's circle who went to the House of Commons to listen to debates on a negotiated agreement with Spain, known as the Convention of Prado, which attempted to prevent outright conflict. This was not only nationally significant;

their own menfolk might lose or gain political prominence depending on the success of the diplomacy, or be directly involved together with sons and brothers in wars as naval or military officers. The Granvilles might have felt especially interested in anything to do with Spain given that their mother had largely been brought up in Cadiz. Mary went twice to Parliament, with her brother's knowledge and implicit approval.

She told her sister, 'Like a most notable patriot, I have given up all private advantages for the good of my country.' Her first visit was to the gallery overlooking the House of Lords on 3 March, her companions being her distant cousin the Duchess of Queensberry and the viscountess Wallingford, a mutual friend of the Duchess of Portland and herself. On the Thursday Mary went again, with Lady Westmoreland, Kitty Queensberry and Mrs Fortescue, a friend from her Irish visit. There were sixteen ladies in all, including Viscountess Cobham, the Patriot leader's wife, who was a Lady of the Bedchamber to Princess Augusta, and Lady Selina Hastings.[1] This time they had much more trouble gaining places. All ladies were being barred from entering the gallery and they were also being crushed in the pressure from MPs who wanted to listen to the Lords' debating. Mary's group 'bore the buffets of a stinking crowd from half an hour after ten till five in the afternoon, without moving an inch from our places, only seesawing about as the motion of the multitude forced us'.

Hungry and exhausted, 'our committee resolved to adjourn to the coffeehouse of the Court of Requests, where debates began, how were we to proceed?' They decided to appeal to Black Rod, the parliamentary official who regulated protocol between the House of Commons and the House of Lords, who decreed that ' "whilst one lady remained in the passage to the gallery, the door should not be opened for the members of the House of Commons;" so we generously gave them the liberty of taking their places'. Once the door was opened, though, the entire crowd rushed in, sweeping up the ladies with them. 'Some of them had the gallantry to *give us their places*, and with violent squeezing, and such a resolution as hardly was ever met with, we wriggled into our seats. I think that was the first time I wished to be a man – though nothing less than a peer.'[2] Those opposing were in the minority but included the Earl of Chesterfield, who, Mary thought, 'spoke exquisitely well, – with *good sense, wit and infinite spirit*'; it was worth all the labours of that day to hear him, and 'Everything after him was dull and heavy.' The government ministers spoke in flowery language but Mary thought their real arguments would be '*in their pockets*', that is in the pensions

and advancements they could distribute to boost support for the government. Theirs was a Pyrrhic victory, she thought, despite a majority of twenty-one.

Summarising this to Anne, she wrote: 'Am I not a furious politician? But enough of these affairs, those of friendship suit my nature better, where the struggles that arise are from very different principles than what animate courtiers and politicians . . .'[3] These women were not proto-feminists agitating on behalf of political participation for *all* women. Eighteenth-century politics was family business, and ladies of quality naturally expected to know about the political concerns of the men in their families. The only kind of political activity Mary could concern herself with was this quintessentially aristocratic type, managed by the relatively small number of peerage families in the Lords and their connections in the Commons, alongside the county gentry, and the merchants and worthies of cathedral and market towns. Mary knew about this family-managed political business from her relatives and from her own brief period as wife of an MP, but was evidently relieved it was, for her, largely a spectator sport. The key phrase in this account to her sister therefore was, 'I think that was the first time I wished to be a man – *though nothing less than a peer*' (italics added).

In between these two visits to Parliament Mary had had an urgent note from her cousin Grace Granville down at Longleat, saying that Grace's half-brother Thomas, Viscount Weymouth, was about to remarry. His marriage to Louisa Carteret, Lord Carteret's daughter and Grace's cousin, had given him a brief interlude of stability and happiness, but after only four years, in 1736 she had died of puerperal fever soon after giving birth to her third son, Henry. She was only 22. Mary comforted herself with the thought that Louisa was now 'in more glory, and eternal happiness', but the christening of little Henry was unbearably poignant. Now Grace and her two younger sisters were dependent on the generosity of their half-brother, and a new marriage settlement might be very detrimental to their prospects. Their half-brother was deeply in debt so his income already had enough demands upon it. Either the married or the single state made women vulnerable – the first because of the dangers of childbirth, the second from the likelihood of poverty. Not only was Louisa dead, so was the vivacious Mary Graham, Grace Granville's next sister, who had entertained Mary in Ireland, but had died in 1735, after only five years of marriage. And in August the Duchess of Portland's life was positively despaired of after the birth of her third daughter, Margaret. Almost miraculously, though, the duchess pulled through, and by 22 August was declared to be out of danger. One reason

an attractive single woman like Mary Pendarves might refuse marriage was, quite simply, that if it led to pregnancy – one of the reasons for wedlock in the first place – it might kill her.

ANNE GRANVILLE FINDS A HUSBAND

Pen's philosophic and contented singleness made her apprehensive when those close to her married. But she was realistic enough to know that for a woman of genteel rank, wedlock was the best option financially, providing that a man with sufficiently sound character could be found, and that no wedding took place until legal settlements were complete, so as to protect whatever money a bride brought to the marriage, and provide for her widowhood. Early in 1740 she was occupied with the prospect of the advantageous match of her cousin Grace Granville.[4] Grace chose extremely well for herself, for her husband was Thomas Foley, whose family had made an early industrial fortune in iron smelting.[5] The wedding took place in London during the social season, when balls and entertainments resumed after the New Year. The first big event was a ball held by the Prince and Princess of Wales on 21 January at Norfolk House, which the royal couple was renting. Mary attended with her friend 'Dash' and her Carteret cousin Lady Dysart, and the next day treated Anne to a thorough description of clothes and jewels: Princess Augusta of Wales wore 'white satin the petticoat, the robings, and facings covered with a rich gold net, and upon that flowers in their natural colours embroidered, her head crowned with jewels; and her behaviour, (as it always is), affable and obliging to everybody'. The finest gown, she thought, was worn by the Duchess of Bedford, and included a green petticoat embroidered with 'festoons of shells, coral, corn, cornflowers, and sea-weeds', with the flowers and coral in colour and rest in gold or silver.[6] Mary could not resist a teasing comment on Lord Baltimore's wife: she looked 'like a frightened owl, her locks strutted out and most furiously greased, or rather gummed and powdered'; the sight of her former suitor in a married state no longer perturbed her. Mary Granville was 'told by critics in the art of dress that she was well dressed'.[7]

Within a few weeks Mary could report to her sister that the Foley wedding preparations were far advanced. 'Yesterday *the lover* dined here, and went through the Travels of Hercules before he could come to his Omphale, for he was obliged to pay away above £20,000 in the morning, and was in every corner

of the town; but he came to us at four: I don't know which looked most modest of the two, and both behaved very properly.' With the financial settlements approved, he could be free to pledge himself to his intended openly: 'After dinner and coffee we left them alone, and he made a declaration of his passion, and said everything that was proper: Miss Grace is perfectly well pleased with his behaviour.'[8] There was a little whirl of visits between the Foleys and Granvilles, who took it in turn to have everyone dine, with the wedding taking place at noon on 29 March at the Audley Street chapel. This was all very satisfactory, but left the problem of the bride's unmarried sisters Elizabeth and Anne unresolved. Elizabeth Robinson, a member of the duchess's set and two years from marrying into the extensive Montagu family and becoming the famous Bluestocking heiress, commented: 'Lord Weymouth supports them, but how long he will be willing to do that no-one knows, he is extremely good natured but his companions do them no good offices.'[9]

Meanwhile, Anne Granville had quietly been making her own plans to marry, and had not confided in Mary, presumably because she knew her sister might be discouraging, especially as she was not likely to think anyone good enough for her dearest sister. Perhaps, too, as a younger sister who had always deferred to and depended on her sister's counsel, she now wanted to make this adult decision more independently. Nor was the man in view a tremendous 'catch' for a Granville, as far as rank was concerned. However, Anne was keener to evaluate his qualities of temper and character than to quibble over 'pedigree'. She was now 32, and although she had been enjoying her visits to London, Staffordshire, Gloucestershire and Bulstrode, must have yearned for something a little more settled than this agreeable round, and probably wanted children of her own.

Her introduction to her husband, John Dewes, grew out of the circle of sociability around her old friend Kitty Collingwood (now Throckmorton). Sir Roger was an enlightened spouse who was quite happy, Kitty explained to Anne after the latter's wedding, for her to continue the female friendships she had enjoyed while single – 'You see I write in the old free style, depending on your *not* shewing my letters to your husband, as I *never* show yours to mine.' Back in the autumn of 1739 Anne and her brother Bernard had stayed in Bath at the same time as the Throckmortons, making use of the medicinal waters as well as enjoying the social life. Once back home in Gloucester, Anne wrote to Kitty pretending she was enquiring on behalf of a friend, about the gentleman and lawyer, John Dewes:

My friend thinks a *chez nous* with a man of sense and worth is preferable to
the unsettled life she now leads, and being continually divided in her heart
what friend to remain with; for while she is with one the other wants her, and
makes a perpetual uneasiness in her mind . . .'[10]

Anne thought the Throckmortons might know more about him because of their
Warwickshire connections; her alleged friend, she explained to Kitty 'has no
notion of happiness in a married life, but what must proceed from *an equality of
sentiments* and *mutual good opinion*; therefore she would be glad to know if Mr D —
has agreeable conversation, generous principles, and is not a lawyer in his
manners'.[11] Anne's recipe for happiness envisions a companionate marriage based
on shared interests with someone who, though a provincial solicitor, would be
enough of a gentleman to be socially compatible.

Whoever had suggested that John Dewes look in Anne Granville's direction —
might it have been her brother Bernard? — had been discerning.[12] They were intro-
duced in person in early March, and quickly decided they were suited to each other.
All the remaining evidences about John Dewes suggest the kind of affable, digni-
fied, decent eighteenth-century squire depicted in a Jane Austen novel: a cross
between Mr Knightley, his younger brother, and Mr Weston in *Emma*. The Dewes
family were not as grand as the Granvilles but they could claim noble ancestry in
their original home in the Low Countries, which placed them well in that subtle
gradation from non-titled gentry to titled nobility that characterised eighteenth-
century England; ancestors included the famous antiquary Sir Simonds d'Ewes
(1602–50). A substantial number of the manuscripts he had assembled during his
research were bought by the Duchess of Portland's father, the 2nd Lord Oxford; it
is likely that Bernard Granville knew this, and approved of John's wider family
being connected to such a cultured scholar.[13] John Dewes' branch acquired landed
estates at Maplebury in south-west Warwickshire. He was earning his living as a
solicitor, but had the prospect of inheriting these estates from his consumptive
bachelor brother, Court. Thus John's current position as a second son belied his
future standing among the important Warwickshire gentry, and he had the
demeanour of a gentleman of private means, which mattered so much to Anne.

As Anne had suspected, Mary's reaction to the decision was initially rather
cool; but the sisters' brother Bernard was in favour, which is what counted. He
contributed the dowry and paid for his sister's trousseau out of his own sub-
stantial income. Once the money matters were finalised, Mary wrote to Anne

that she and Bernard would meet John in person in London where his legal work was bringing him, and the sisters could then concentrate on wedding clothes and the venue.[14]

Behind this measured response was worry about whether Anne would become the victim of a bad husband. Her friends at Bulstrode knew that although by August 'Pen' had met John Dewes and had begun to appreciate all his good nature, she could not yet be convinced all would be well. As Elizabeth Robinson (then only 22, and single) sententiously explained to Anne Donnellan:

> Our friend Penny is under great anxiety for the change her sister is going to make I do not wonder at her fears, I believe both experience and observation have taught her the state she is going into is in the general less happy than that she has left, however Pip has a good prospect for they say the gentleman has good sense good nature & great sobriety, these are very good things . . .[15]

Mary and Anne spent the three months of the engagement largely in London, preparing and purchasing the trousseau.

In May, Mary had an account of a much grander wedding, that of George II's daughter Princess Mary, who, instead of Princess Amelia, mooted bride only a few years before, married Prince Frederick, the heir to the German principality of Hesse-Cassel. Now, neither Mary nor Anne Granville were of a mind to seek court advancement. Meanwhile, Anne and John's wedding grew nearer, with both, according to Elizabeth Robinson, suffering headaches in unison as it approached.[16] It was solemnised in Gloucester cathedral by Bishop Martin Benson on 23 August 1740. No personal accounts survive but brother Bernard must have given away the bride and friends in the Gloucestershire circle doubt-less attended. Gentry weddings at this date were seldom large occasions. The next day Grace Foley wrote warmly from Herefordshire:

> I most heartily wish you every blessing which can be possibly possest [sic] in this world. The character I hear of Mr. Dewes gives me the greater satisfac-tion imaginable, for with such a partner your friends, I thank God, have no doubt to make of your happiness, which will be, I hope, of long continuance.

And the other Granville cousins, Anne and Elizabeth, seconded the best wishes, the former writing 'though I have not the pleasure of knowing Mr. Dewes, I am

sure he knows how to distinguish sense, virtue, religion and merit, by his choice of you'.[17]

The problems of the two maiden cousins were still much on Mary Pendarves' mind when she wrote to her sister, shortly before setting off to visit Grace at Stoke: 'I have had an account from Mr Harbin [chaplain to Lord Weymouth] that my Lord Weymouth is settling his affairs, but designs to allow his sisters only £200 a year for the entire maintenance of both, and that to depend on his will [i.e., it would not be in the form of a settled annuity]: what a prospect is this for them after the expectations he has given them!' Mary wrote to Lord Weymouth, his new brother-in-law, and the chaplain, to press their claims, while the Duchess of Portland was likewise lobbying for them through their mother's family.[18]

Meanwhile, the newly wed Dewes settled at their small house, Bradley, near Droitwich, 'our cot between two aged oaks', as she described it to Kitty Throckmorton. 'I can't help thinking that there is for the generality more happiness in a middling class than in a great fortune, and it is very proper for me to be of that opinion now, as Mr Dewes's fortune is moderate, but his qualities are extremely good which are to be preferred to riches . . .'[19] 'Cot' it may have been, but it had room enough for sister Mary, who soon came to stay fresh from her visit to the Foleys in Herefordshire. Bernard put in an appearance en route home to Staffordshire, and Sarah Chapone came from Cheltenham. Soon Anne was expecting a baby, but pending its arrival, she and John Dewes doted on their dogs, including Ponto, a present from Grace: 'Bradley is a much *happier castle* than *Stoke* to Ponto, and he finds himself now a king when behold a little while ago he was looked on as just a dog.'[20]

When Mary arrived at Bulstrode, the duchess's two eldest children, Elizabeth and William, wrote little letters to 'Pip', who had sent them notes. Five-year-old Elizabeth said, 'Dear Pip, I love you with all my heart . . . I learn very well the Common Prayer-book and Bible, and have almost got by heart the Turtle and Sparrow' – quite a feat as it was a poem by Matthew Prior of about 450 lines – while 2-year-old William, who must have dictated his note to someone, was more focused on his luxurious toy transport: 'I have got a gold coach-and-six papa gave me, and the horses are two dragons [dragoons], two sober-sides, and two snips; but you are too big to ride in my coach . . .'[21] Happily for Mary after all her concern, by the end of this year of weddings she was able to confirm to Kitty Throckmorton that '*I hope I may venture to say* I do think my sister happily settled.'[22]

FRIENDSHIP AND RIVALRY AT BULSTRODE

Taking stock of her life as she reached her fortieth birthday, Mary Delany was probably ready to count her blessings. She had her own home and enough income to support a life of gentility; she had her sister and brother Bernard, and until 1744 and 1747 respectively, her uncle, Sir John Stanley and her mother; she had her friends such as Anne Donnellan and Margaret Duchess of Portland, together with their overlapping circles, as well as a wide network of kin; and she had plenty to occupy herself given her artistic, musical, literary and philanthropic interests. Above all she was blessed with good health and, unlike Anne Donnellan, had no cause to search fruitlessly at spas to cure her ills or recover her spirits. If she was unwell, she seldom complained in her letters, only mentioned troubles when they were over, and did her best to conceal them from her sister or mother lest they should worry.

This determination to dwell on the brighter side of life must have made her a refreshing companion. Her sister – admittedly, a biased observer – wrote when she was setting off on a trip to Sir John at Northend, 'you carry delight with you, and then fancy you find it there . . . you were certainly born to cheer as well as charm all your friends'.[23] Mary still showed no inclination to remarry, and it was generally known in the Bulstrode circle that she was a critic of marriage, and that she dealt briskly with suitors. 'Pen' was that relatively rare woman in the mid-eighteenth century, a woman who was positively content to remain single, having done her duty by a difficult first husband.

It was widely recognised among the family and guests that Mary was an especially talented woman, given her visual and literary gifts. She was compared to the goddess of the arts, Pallas Athene, that is, Minerva, and also to the ancient Greek lady Aspasia – in eighteenth-century terms 'Aspasia' represented a cultivated woman who could hold her own in conversation with intellectual men. In the spring of 1740, while Mary was in London during her sister's engagement, she and the duchess sat for portrait miniatures of themselves commissioned from the German artist Christian Friedrich Zincke, widely regarded as the best miniaturist of his day (Plate 12). These were made for the duchess into an oval gold and enamel box, whose lid and base were both hinged to reveal a total of four portraits, celebrating her closest female friends at that time. The additional two pictures were of Elizabeth Robinson and Mary, Lady Andover. The duchess was pictured as the goddess Flora, and Elizabeth

wore Tudor costume, possibly signifying Henry VIII's wife Anne Boleyn. Given that Anne was executed for alleged adultery the choice may seem odd: however, Anne was widely credited with being an early supporter of Protestantism, and was the mother of Queen Elizabeth, who was so widely admired in the Bulstrode circle.

The duchess's choice of these three friends should not, though, lead us to assume that they all got on equally well with one another. Mary was a lifelong friend of the duchess and of Lady Andover, the latter becoming an even closer confidante again, indeed almost a sister figure, after Anne Dewes died. Lady Andover had a country house near Bernard Granville's Calwich estate, and her own brother, Heneage Finch, 2nd Earl of Aylesford, had an estate at Packington in Warwickshire, not so far from the Dewes, locations that facilitated meetings and the exchange of news. The friendship with Elizabeth Robinson (later Montagu) was a little different. Mary Pendarves was originally a friend of the duchess's parents, and was fifteen years older than Margaret, and eighteen years older than Elizabeth. Mary and Elizabeth were never really very intimate: Mrs Pendarves was not only much better connected and, as a widow, in a completely different stage of life; she was also more talented, especially musically and artistically.[24]

Elizabeth Robinson's friendship with the Duchess of Portland is hard to fathom unless we realise it began very early in the lives of each woman, since she was by no means as accomplished or as well connected as the duchess or some of the Bulstrode circle. Her father, Sir Matthew Robinson, was from the Yorkshire baronetage, but their peerage connections were not as pronounced as either Mary's or Margaret's. The family was not without court connections either, but again this was not on a par with the range of influence represented by the Carterets. Elizabeth's uncle, Sir Septimus Robinson, became governor to two of Princess Augusta's sons, the dukes of Gloucester and Cumberland, between 1751 and 1756.[25] Septimus' elder brother, Sir Richard, went into the Church and in 1765 became Archbishop of Armagh, and thus Primate in Ireland. Elizabeth and her sister Sarah were also friendly with a Miss Grinfield, a dresser to the princesses Caroline and Amelia, and Maid of Honour to Augusta. Despite these links, probably Elizabeth's greatest frustration in her teens was that her father did so little to parlay his family connections and interests into a wider sphere of action, either in politics or metropolitan cultural activity. He was known among connoisseurs as a gifted amateur artist, but when Elizabeth was growing up he only went to London irregularly to mix with his arty and intellectual friends,

rather than renting a house annually for the season. He preferred to base himself at the Kent estates his wife's dowry had brought him, and to make his children contribute to his need for intellectual stimulus by encouraging them to have high-spirited conversations around the family dinner table. Elizabeth pined for a greater social circle than that to be found at home, or at the dances and election balls held by their immediate neighbours in the Canterbury milieu. Sometimes her father would not even go to these local social events, such as the races, so Elizabeth was driven back on her own resources, like her correspondence with the young duchess.[26] When this ripened into visits, she saw an opening to a wider world, and seized it eagerly.

The future Elizabeth Montagu could be an entertaining conversationalist, but she did not bring too much else to the table when invited to Bulstrode. She took little interest in natural history, was not musical and disliked playing cards intensely. Given the absorption in art there, she soon regretted she had paid so little attention to her father's artistic instruction: she told the duchess she had disliked drawing old men's heads so much when her father gave her drawing lessons that she gave up.[27] But she made the most of one advantage: in 1738 her brother Matthew, who was in the Merchant Navy, was sailing to Bengal, and she got him to promise to bring back some interesting shells for the decorative craze. When his ship was caught in flood tides with many casualties she gave scant mention to the extensive loss of life, or her brother's survival, assuring the duchess he would be able to bring back prettier shells when he got to China.[28]

It is clear from Elizabeth's letters to her own sister, Sarah, that she was both overawed by Mary Pendarves' poise and rather envious of her decorative flair, as well as her facility with pen, pencil and scissors.[29] Moreover, Elizabeth was often in poor health and, unlike Mary, rather liked to make much of her aches and pains. As well as these gaps in experience and attitudes, Mary for her part wanted to keep detached from the ambitious young Elizabeth, who was so obviously keen to ingratiate herself in the exalted Bulstrode circles. Nonetheless Mary was kind to her, accompanying her to the cold baths that Elizabeth was taking for therapeutic purposes in Marylebone, still a village near London.[30]

Perceiving they were likely to get on, Mary introduced Elizabeth to her great friend Anne Donnellan. And get on they did, sharing many confidences about their illnesses and the cures they followed, as well as news of their mutual friends. Elizabeth fully acknowledged 'Don's' outstanding singing: as she wrote

to the duchess, 'What she says gives pleasure, what she sings delight.'[31] Sarah was to meet the duchess and Mrs Pendarves when they were all in London that winter. 'Don' and Elizabeth's correspondence weathered the cooling between Elizabeth and the Duchess of Portland, which set in about 1747, as well as Mrs Pendarves' marriage to Dean Delany and her move to Ireland, which meant she saw much less of the increasingly grand young Miss Robinson, who became Mrs Edward Montagu in 1742. And indeed the grander the now wealthy and well-connected Elizabeth became, with increased powers of patronage and the means to give stylish entertainments, the more Mary Pendarves began to find her pretentiousness irksome.

If she had known of the competitiveness the young Elizabeth felt towards her in the summer of 1740, she might have cooled towards her sooner. At that time the ladies were making embroidered aprons, which were for show not use – a kind of Arcadian shepherdess look. The ladies were currently reading Sir Philip Sidney's Elizabethan prose romance *The Arcadia*, an idealised version of pastoral life with intersecting stories illustrating the romantic and political vicissitudes of elite, court life. Elizabeth told her sister once Mary left that she had abandoned the story, as she didn't really like it; but she affected to be pleased when Mary returned to Bulstrode and reading resumed in the autumn.[32] Mary's apron was probably the one that has survived among her descendants and may not have been directly embroidered by her; rather, she contrived the design and a skilled professional embroideress carried it out. These aprons were wide, since they were worn with the extremely wide 'mantua' dresses of the period, which rested on cane panniers, and had a silk underskirt or petticoat or an apron filling in between the two sides of the mantua at the front. They were made of silk embroidery, sometimes formed by raised stitching, on a heavier silk grosgrain base. The flowers in Mary's apron included carnations, roses, anemones and pinks, together with auriculas, cornflowers, orange blossom and lilies of the valley.

At some point during the summer Mary must also have been preparing a design for a petticoat to be worn beneath a court dress for the following winter season, as implied when Elizabeth wrote to her sister to enlist their father's help in providing good, similar flower patterns. At first she got nowhere: 'I am very sorry my Pappa won't send me any flowers for they are prettier than those of Mrs Pendarves' gown which is *not inimitable*.'[33] Mrs Pendarves obligingly had said she would provide her with the apron pattern, but, by the end of July, Elizabeth

was impatient: 'I have not got the pattern of the apron yet from Mrs Pendarves, she is busy about her sister's wedding but pray save the flowers and get Mr Hately [?] to paint on Anemones, for I shall want one much.' This was Edward Haytley, who specialised in flower pictures but was just beginning to paint portraits and landscapes. He was known to the Robinson's Kent neighbours, the Brockmans, whom he painted in their landscape garden, and may have painted the only portrait of Sarah Robinson.[34]

After the Dewes wedding, Mary found time to send Elizabeth her apron pattern, which intensified the latter's desire to go one better and gratify the duchess at the same time. Elizabeth wrote to sister Sarah that their father had made some good flower designs, and:

> Mrs Pendarves has sent me a pretty pattern Enough in black &white only outlines, it consists of Auriculas, Anenomes, a poppy Roses & buds Orange flowers & lilies of the Vally, to help me in shading she lent me the prints of the flowers which my Pappa had said would be admirable directions if they were coloured but I have only in black and white, now what I should be infinitely obliged to my father and you for would be to get me a pattern done by Mr Hately of Auriculars in abundance Convolvulus (that is the blue flower in the print in the facing) the lilies you mention, poppies, & tulips (of which I have painted ones very fine) . . . the Dutchess has a great mind for an Apron & as I am obliged to work very often I had much rather be imploy'd for her than anyone . . . The Dutchess will have me work upon a black ground . . .[35]

It is unknown whether Mr Robinson had advised on the embroidery for the dress Mary was designing for wear in the winter season of 1741. It is generally agreed that the surviving panels of flower embroidery on a black ground, one in mint condition, belonged to this dress, and that it would have formed a front petticoat, with a mantua worn above it in lighter shades. In flickering candlelight the lustrous silk flowers would have stood out from their dark background: they included pink auriculas with yellow centres; white roses streaked with pink, and pink carnations with white; lilies of the valley, and a thistle. Mary felt though that the best designed gown had been achieved by Kitty Queensberry. This consisted of a white satin base, with embroidered brown 'hills' along the bottom border, out of which 'grew' green wild grass and tree

stumps, up which 'climbed' various flowers including ivy, honeysuckle, convolvulus and nasturtiums. The effect must have been to anyone keen on reading pastoral romances as though a shimmering nymph was walking through a meadow. Mary was taken aback at the success of this naturalistic design and wished she had thought of it 'for it is infinitely handsomer than mine'.[36]

There was, however, another form of art where Elizabeth was prepared to concede – or at least to appear to concede – that Mary was far more accomplished at than she was – this being the decorative shell-work she put together, which created similar effects to expensive Italian stucco work. Pending the arrival of shells via Matthew Robinson, Elizabeth's father admired a pair of shell-work vases for a mantelpiece, which he had seen in Mary's London house. Elizabeth told the duchess, 'I propose to go this week down to the seaside to gather shells for your Grace. My Pappa has a mind I should make a couple of Vases like those he saw at Mrs. Pendarves . . .'[37]

As well as reading the Elizabethans, the Bulstrode set kept up with the latest books. In 1740 the printer Samuel Richardson published his novel *Pamela: or, Virtue Rewarded*. He had already written a letter-writing manual and now he used this epistolary format to tell the Cinderella story of a country maid taken into the gentry home of a widow, who lived there with her libertine son, the squire Mr B. His mother had recognised an innate gentility in her maid and had educated her; Mr B's eye fell on her with seductive intent. Many young girls in real life were seduced by the higher-ranking men in the households where they toiled, but Pamela held out against the squire, and, eventually, and most unusually, became his wife. The novel was read up and down the land in all levels of literate society, including the Bulstrode ladies. The ladies also discussed the letters of the French *salonière* Mme de Sevigné, who had known the court of Louis XIV.[38]

Mary was embarking on the philosopher Francis Bacon's book *Novum Organum* (1620).[39] She acknowledged it was occasionally dry, but liked getting her mind around it. Francis Bacon was a much revered English cultural figure in the eighteenth century, for his critique of medieval scholastic philosophy, and advocacy of empirical scientific method rather than pedantic theory; he had also recommended that the state should sponsor scientific academies, botanic gardens, libraries and so forth, to advance research through collaboration. He argued that the investigation of the natural world was in harmony with religious knowledge, since the book of God's word – the scriptures – was

explicated by the book of God's works – the observational collation of data that revealed the wonder, intricacy and interconnectedness of the world God had created. This parallelism was attractive to the spiritually attuned Mary Delany.

RE-ENTER EDWARD YOUNG

Lord Bacon's views on religion's link to natural philosophy – the term given to scientific enquiry – would also have been endorsed by a new literary figure who began to visit Bulstrode. This was Edward Young, now settled as vicar at Welwyn in Hertfordshire, where he not only served the parish's spiritual needs but encouraged the town's development into a spa and resort. The duchess had encouraged him to visit Bulstrode, and one of her projects was to approach the statesman Henry Pelham-Holles, 1st Duke of Newcastle, to whom she was related, in order to ensure Young received clerical preferment.[40] Young was regarded at Bulstrode as supportive of women; Miss Robinson commented 'tho' he has satirised the worst of our sex he honours the best of them extreamly [sic] & seems delighted with those who act & think reasonably . . .'[41]

Edward Young may also have talked with the Duke of Portland about his philanthropic projects, since the duke was a founding governor of the new London charity, the Foundling Hospital. This took in abandoned children, or children brought by parents whose poverty prevented them from looking after them. The charity raised money from the great and good partly through cultural attractions: Hogarth and his fellow artists, including Gainsborough and Haytley, decorated the chief rooms, which thus acted as a gallery for new English art, while Mrs Pendarves' friend Handel later conducted an annual performance by the children's choir and guest soloists, of his oratorio Messiah. When Elizabeth Robinson alludes to Mrs Pendarves 'doing good in the world' she may have been referring to her as one of the hospital's lady visitors, since many in the court circles she belonged to were early subscribers.[42]

Early in 1741, Edward Young made an attempt to woo Mary Pendarves, with strong encouragement from the duchess. She may have considered that as Anne Dewes' marriage had turned out so well, her sister might now entertain a more positive view of wedlock. Young was a widower, and indeed since 1736 had been grappling with multiple bereavements, when one after another his step-daughter, his wife and then his son-in-law (husband of his step-daughter),

had all died. In the incurable insomniac nights that ensued ever after, he began to write one of the most famous poems of the century, *The Complaint: or, Night-Thoughts on Life, Death, & Immortality*, and in a few years his fame would spread throughout Britain, America and Europe.[43] Ostensibly perhaps the intellectually minded and deeply devout Mary looked a suitable choice to cheer a clerical, literary widower. But the duchess entirely misread her friend's independence of spirit, and the utter inappropriateness of backing this specific suit, since the poet's first wife was Lady Elizabeth Lee, aunt of Mary's suitor Lord Baltimore. Mary would scarcely have wanted to wake up every day next to a man whose first wife was aunt to 'The Basilisk'.

Edward Young's desire to remarry soon after being widowed was not unusual for the time. At the very least, he needed someone to manage his household and help him bring up his 9-year-old son by Elizabeth, named Frederick (after his godfather, the Prince of Wales). This could have been done by a housekeeper – and indeed it eventually was – but plainly Young had liked being married and wanted to repeat the formula. Before the autumn house party at Bulstrode had dissolved at Christmas 1740 he had joined in the general household teasing of Mary's dislike of spiders, making learned comparisons with Pallas Athena, who had turned her rival weaver, Arachne, into a spider. While it is often effective to make the woman you desire laugh, choosing the subject of her pet aversion is probably not the most promising start.[44]

His letters to the duchess after Mary had been very discouraging in January 1741 suggest how much his idea of marriage was at variance with Mary's hard-won self-reliance. He was baffled by both women, and complained to the duchess,

> I thought 'ere long I shd have known her very well; But I know her no more than I know your Grace; And you, Madam, of all Female Riddles are ye most exquisite, & impenetrable: Why was this Favour so often promised.

He did not elaborate specifically on what Mary had said when he called, but to please the duchess made a revealing botanical comparison:

> What so fragrant as ye Woodbine? Wt so Luxuriant and Fruitfull as ye Vine? How they ravish our Senses? . . . Such, Madam is your Sex: But then, as You are made Exquisite like these, so, like These, in Compassion to poor mankind, you are made Feeble too: You were *Both* designd to give a tender Twine around

somethg Stronger than yrselves: The Vine & Woodbine, were not designd for
Celebacy, but to mingle their branches wth ye rough oak, or Elm: Obliging, &
Obligd; receiving succour while they confer ye most Ornament, & Delight.[45]

Edward's problem was that unlike Elizabeth Lee, Mary was not the clingy
type, nor did she have any inclination to entwine herself with his masculine
vigour.

The duchess encouraged him to persist, but Mary remained immune to his
charms, such as they were, and he had to concede defeat. Nonetheless they
remained friends, later corresponding on Richardson's publications – Young
became one of the authors he published – and she also admired the *Night
Thoughts*, expressing surprise that Sarah Chapone took the opposite view.[46]

CONTENTED ASPASIA

Edward Young may have been typical of his sex in the 1740s in finding Mary's
contented singlehood hard to understand, but to her friends who were also
genteel singlewomen, Mary was an inspiration, as Anne Donnellan's pen-portrait
of her written for the Bulstrode circle in 1742 attests. To 'Don', Mary was an
Aspasia, and a much more robust and poised personality than she was. First she
commented on how attractive Mary still was in her early forties; it was no
surprise that 'her situation (as a widow) must have given hopes to all'. Yet there
was also an inherent reticence: Mary was no flirt. She had negotiated the amoral
currents around her – 'Don' hints at the bad example of Lady Lansdowne – by
being confident of her own principles, which deterred others from making
untoward advances. Instead she combined a 'general benevolence' with 'her
tenderness to every particular friend'. She found this generosity of spirit by
subtracting it from 'self-love, that principle which fills the heart of others'. Her
charming manners were diffused to all. 'Don' considered that Mary was able to
make room for so much unselfish giving because she wasted so little time on the
arts of dress. This suggests that although she must have much enjoyed planning
her wardrobe, once she had designed a dress and commissioned its being made
up she did not think too much more about it. Finally, and congruent with this,
Don noticed how she hated to be idle. She took an insouciant air towards all her
accomplishments and was always ready to explain how she had invented some
new handiwork. 'Her house is a little abstract of all sorts of ingenuity, and like

her heart is always open to the virtuous, to the ingenious, or to the distressed.'[47] Mrs Pendarves disliked anyone fussing over her, or being over-praised: once she had got one thing out of the way, she would readily turn to the next.

In April 1741 Mary escaped from the dust, noise and hurry of her move to a new house in Clarges Street, to the 'sweet air, tranquillity, and leisure' of Northend to stay with her uncle. One of her frequent visitors there was a recent bride, Mary Osborne, 4th Duchess of Leeds, who was also a connection from her Wiltshire childhood, her grandfather being Sidney, 1st Earl of Godolphin, while the groom was a first cousin of the Duchess of Portland. Mary hoped the two duchesses would prove role models: 'if the Duchesses of Portland and Leeds with the charms of youth and every other attraction *cannot* bring *virtue into fashion* I am afraid we must not expect to see her tread the stage in our days'.

In the middle of all the packing up she had also been sending parcels of fabric for baby caps to her sister, and assumed Anne would be obtaining or making the traditional white calico quilted cot blanket for her baby, due in July. She was going to have the baby at their mother's house in Gloucester, where Mary would join them, and the two sisters would then go back to Bradley together with the 'bantling'.[48] It was born in July after a difficult labour. As the son and heir, he was christened Court after his paternal uncle. Anne took a while to recover and was still reported weak in early September when her cousin Grace wrote to congratulate her; but the Dewes and Granvilles must have been happy simply that this time both mother and son had survived, and that if Anne was still weak, she had not succumbed as so many young mothers did to post-partum fever. Among the autumn visitors to Bradley to see the baby was Sarah Sandford, now the experienced mother of four children, Jacky, Sally, Harry and Kitty, and intensely absorbed in motherhood and domesticity. Anne and Mary were both godmothers to young Sarah, often called Sally, who stayed behind at Bradley when her mother left. Knowing how outspoken Sarah Chapone could be, Mary expressed to Anne the hope that Sarah's daughter would not grow up to be an opinionated young woman. 'Conceit or opinionativeness becomes no sex or age', she wrote, but the worst of all was a conceited girl.[49]

If the Duchess of Portland had tried her best to marry off her friend, the New Year of 1742 brought initiatives from the formidable Countess Granville, mother of Lord Carteret, to organise the lives of her Granville connections, including the still unprovided for cousins, Anne and Elizabeth, and John Dewes. In March Dewes was hurrying up to town, partly to see a good dentist but

also because Lady Granville had been dropping hints that she might be able to obtain a legal position for him as one of the commissioners of the bankruptcy courts. John Dewes' letter to his wife about this, one of the few between them surviving, shows the easy rapport and mutual understanding between them:

> My dear Love, I had your kind letter of the 5th instant, and am glad to hear you have so well recovered your journey, and hope you are quite well again. . . . I am very glad the little boy is so stout, and is such a comfort to you, but hope he has lost his cough . . . Mrs Pendarves said I should go see the Countess again before I went out of town, and I seemed not inclined for it, upon which she took me up *pretty short*, as you know she is sometimes inclined to do; so then I *drew back a little*, for one you know must give way, and I think I have learnt to do that pretty readily, though it seemed a little awkward at first; so the argument dropped, but I believe I shall practise in this particular something of what I have *learnt from you*, that is, to say little, and then do what I think best. I am, with the truest sincerity and affection, Most heartily and entirely yours, J. D.[50]

That spring Anne Dewes paid a visit to Bulstrode and then joined her husband in London, after which he returned to Bradley and she and her mother went to join Mary at Bernard's estate in Calwich, Staffordshire. In June a rumour had reached the Foleys in Herefordshire that Mary had got married, the groom supposedly being the effete retired politician and diplomat, Sir Thomas Hanmer, an important associate of the duchess's grandfather in Queen Anne's reign.[51] The rumour mill was keen to match up the attractive widow to someone, however absurd.[52] Mary wrote when Anne left Calwich:

> Except the want of your's and my dear Mamma's company when you are absent, I live just as I wish to do; have much business, many amusements, a pleasant house, charming fields, and a companion that, you know better than I can tell you, crowns all by his friendly and agreeable manner . . .

Adding drily, in case her letter went astray and started fresh rumours:

> I must, for fear of accidents, say 'tis *my brother* that makes me thus happy; for should my letter fall into any hands but yours, it is very likely a brother would be the *last* person thought of!![53]

Brother and sister shared the pleasure of Bernard's refurbishments, overseeing the carpenters making cupboards and closets, the local blacksmith creating a new grate and a plasterer putting tiles around it – English Delft ones, perhaps? New wallpaper was awaited, too.[54]

In London Lady Granville was still manoeuvring. Her son Lord Carteret was now, effectively, prime minister, having been appointed as Secretary of State for the North because of his expertise in foreign affairs. The Spanish war had become entangled with British support for the Austrian ruler Maria Theresa who, despite being a woman, had inherited all the Central European Habsburg family lands and the associated crowns of Hungary and Bohemia. She was immediately challenged by Frederick II of Prussia, who coveted her duchy of Silesia, and important campaigns were being fought on land and by sea. Lord Carteret was recently widowed and his mother was taking responsibility for some of the patronage at his disposal.[55]

For the ladies, one vacancy had opened up when Elizabeth Hamilton left off being a Maid of Honour to Princess Augusta. Lady Granville seemed to have Mrs Pendarves in mind for some other position, probably a Woman of the Bedchamber, if there had been a reshuffle, but Mary herself was thinking of her Granville cousins, who were eligible as Maids. Their half-brother Lord Weymouth had forced them to give up their Longleat apartments and was allowing only £100 a year between them, as his debts were still unpaid.[56] As usual the main lobbyists trying to secure royal household appointments were Mary's Carteret cousins, Lord Carteret and his daughter Grace (now Lady Cowper by her second marriage), but the Duchess of Portland doubted their effectiveness. She explained in a letter to Anne Dewes that she made an especial appointment one Sunday with the 'Arch Dragon', to find out if rumours that Mrs Pendarves would be appointed were true, and was quietly furious to be told that Lord Carteret was too busy with '*doing good to the nation*' by concentrating on the war against France and Spain to be bothered with '*a bagatelle as that*'. The duchess refrained from argument, saying only that it was 'doing the *nation service* to put proper people about the Royal family'; in other words, ensuring the royal family had suitable persons in their households was just as important and indeed patriotic as agitating for the right foreign policy.[57] In the event, the position went to cousin Elizabeth Granville, whom Lady Carteret had maybe favoured all along. Although this was at Mary Pendarves' expense, she was probably delighted, since Elizabeth had far more need of the

income and ensuing pension than she did and, as her letter from Calwich shows, Mary was very content with her life as it was. Indeed, she was probably tired of the way that other people were taking it upon themselves to remould it. The only snag now was that Anne Granville was still unprovided for.

In October that year Anne and John Dewes had a second son, called Bernard after his uncle, and this time Anne's labour was easier. The birth again took place at Gloucester, while John was in London on legal business and staying with Mrs Pendarves. Mary enjoyed the autumn social round as usual, and considered that their cousin, the new Maid of Honour, outshone in looks everyone at court drawing rooms. She wrote to her sister about the merits of the latest singers and the new acting star David Garrick, kept her in touch with the marriages of their acquaintance, and described how she was rearranging the pictures in her house.[58] And so the pleasant London routines, seeing the Percevals, the Portlands and so on, resumed in the spring. When her uncle cancelled a trip to Bath she planned an April visit to Kent with her friend Lady Westmoreland, chatelaine of the exquisite rural villa of Mereworth, modelled on Palladio's Villa Rotunda, though worried this might take time away from going on to visit the Dewes at Bradley.[59] Then she had a letter from her old friend Patrick Delany.

Part II

A Dean's Wife

Mrs Delany

THE PROPOSAL

You, madam, are not a stranger to my present unhappy situation, and that it pleased God to desolate my dwelling; I flatter myself that I have still a heart turned to social delights, and not estranged ether from the tenderness of true affection or the refinement of friendship. I feel a sad void in my breast, and am reduced to the necessity of wanting to fill it. I have lost a friend that was as my own soul, and nothing is more natural than to desire to supply that loss by the person in the world that friend most esteemed and honoured; and as I have been long persuaded that perfect friendship is nowhere to be found but in marriage, I wish to perfect mine in that state. I know it is late in life to think of engaging anew in that state, in the beginning of my 59th year. I am old, and I appear older than I am; but thank God I am still in health, tho' not bettered by years, and however the vigour of life may be over, and with that the vigour of vanity, and the flutter of passion, I find myself not less fitted for all that is solid happiness in the wedded state – the tenderness of affection, and the faith of friendship.

I have a good clear income for my life; a trifle to settle, which I am only ashamed to offer; a good house (as houses go in our part of the world), moderately furnished, a. good many books, a pleasant garden (better I believe than when you saw it), etc. Would to God I might have leave to lay them all at your feet.

You will I hope, pardon me the presumption of this wish, when I assure you it is no way blemished by the vanity of thinking them worthy of your acceptance, but as you have seen the vanities of this world to satiety, I allowed myself to indulge a hope that a retirement at this time of life, with a man whose turn of mind is not foreign from your own (and for that reason not wholly unworthy of you) – a man who knows your worth, and honours you as much as he is capable of honouring any thing that is mortal, might not be altogether abhorrent from the views of your humble and unearthly wisdom. This I am sure of, that if you reject my humble and unworthy offering, your humility will not let you do it with disdain; and if you condescend to accept it, the goodness of your nature, and generosity of your heart, will prompt you to do it in a way most becoming your own dignity, and the security of my eternal esteem, and inexpressible gratitude: at all events, let me not be impaired in the honour of your friendship, since it is impossible I can cease to be, with the truest veneration and esteem, madam,

Your most humble and most obedient servant,

Pat. Delany[1]

This was unequivocally a proposal of marriage, and indeed a heartfelt one. But what kind of marriage was being proposed? The modern biographer is supposed to peer between the sheets in the conviction that it is our sexuality that is the most revealing aspect of our personalities, if not our characters. So the question must be asked: was the marriage on offer to be one of friendship only? What place did it leave for sexual intimacy? Why does Patrick state so clearly that 'however the vigour of life may be over, and with that the vigour of vanity, and the flutter of passion' there will still be 'the tenderness of affection, and the faith of friendship', which make for 'solid happiness in the wedded state'?

One answer might lie in the word 'however'. Intimacy of some passionate kind is not ruled out, but it will not be the main or only avenue of loving intimacy, which will also be expressed through tender concern and friendship, placing the companionship on a broader basis. At nearly 58 – Patrick over-stated his nearness to 60 – Patrick was fifteen years older than Mary, and uncertain how much longer his masculine vigour will last – unlike Edward Young, who seemed entirely confident of his powers, and piqued that Mary had not wanted to play along within the bounds of a proffered Christian wedlock. And this very lack of sexual egotism might well have been extremely attractive to Mary, whose previous sexual

history with Alexander Pendarves was probably very disquieting to her. She had never seemed very desirous of producing children (or being a step-mother) and in any case probably thought that at 43 she would be close to menopause. The emphasis on friendship in the proposal letter must have seemed enrapturing, implying as it does emotional generosity, not emotional demand: giving, not taking. The French romances of which she was so fond had all tended towards portraying the impossibility of a reliable sexual love: the difficulty of mutual certainty, or true communication; the unlikelihood of fidelity; the tendency for passion to imprison the object of such affection within the cage of jealousy. The Christian values so dear to both Patrick and Mary all implied that celibacy might be more godly even than marital devotion. Yet the Book of Common Prayer placed mutual companionship as the first reason for marriage, and it was just this broad avenue of tender friendship that Patrick was emphasising.

But those in contact with Mary at the time had no doubt this would be a normal, consummated marriage. Newly married Elizabeth Robinson, for instance, who had a fine discernment for the sexual chemistry between couples because her parents were so discordant, thought that before she was married Mary was somewhat 'celestial' in her outlook. When she said this to Anne Donnellan she was pregnant and coping with morning sickness, and Anne Dewes had just given birth successfully. In comparison, Elizabeth said:

Pen . . . is not a Daughter of Eve but of the Collateral Branch of Enoch, who walk'd as an Angel before the children of Men. I know she would not be guilty of such a grossièrité as having a child for the world: she is a perfect seraphim, all fine Mind and Spirit and must be grieved her sister should condescend to such mortal matters; indeed nothing is less divine & Angelical than a breeding woman; sick with a piece of toast & butter, or longing for a bit of Tripe-liver or Black pudding.[2]

Ten months later she clearly thought the marriage would bring the former Mrs Pendarves down to earth, and that she and Patrick would have remarkable children. She asked the Duchess of Portland, 'Pray where is Pen? Will she produce a sprig of bays? It must be a little Master Apollo or a Miss Minerva from parents of such Art & Science.'[3]

Despite his cautious words in his proposal letter, Patrick plainly adored her. He wants to lay all his worldly goods at her feet, every bit as much as a

chivalric knight in Spenser or De Scudéry. And he presumes absolutely nothing from or about her. He knows that socially she ranks higher than he does and his hopes are slim. His being entirely from another world – literally another country, the one where she had learnt to unwind and relax her guard – and being someone who had no family connections who thought they knew what she needed or was suited to – must have been enormously welcome to her. She would not have to be wife to a Cornish or Gloucestershire MP or gentleman who knew all her Granville cousins and history, and had decided this would suit their own lineage and role. She was not receiving a proposal mainly because her political connections were useful. It would be a fresh adventure and ideally a revival of that happy Irish idyll a decade before. And although he is a 'foreigner' he is decidedly a kindred spirit: in music, in books, in gardens and the art of domesticity. Yet, as a clergyman of some experience and reputation, he is also a man of status and esteem within his profession, with possibilities for further promotion. Were he to become a bishop he would be on a par with the secular peers in her own family, and her own well-placed relatives like Lord Carteret would surely assist such advancement.

So in her heart she unhesitatingly gave her consent, and indicated to Patrick that this was how she was inclined. But in her own family there would be much less enthusiasm for the match. Patrick was not considered good enough for a Granville because of his birth; his standing as a respected scholar and man of the cloth could not counteract this in the eyes of Bernard, who was still considered head of the family. Mary lived ostensibly quite without restriction, travelling freely between London and Gloucester and visiting Wellesbourne and Calwich. But socialising was one thing, marriage quite another and Patrick was left on tenterhooks as to the outcome of his proposal, while Mary set about asking her mother, sister and Bernard what they thought. After waiting six days Patrick was still unsure where he stood. He wrote again urging Mary that 'I might venture to pronounce that even a parent has no right to control you, at this time of life, and under your circumstances . . . and a *brother* has no shadow of right.' Duty alone – not 'the fickle, the uncertain, the selfish' – should govern Mary. He enclosed with this note to Mary a formal proposal to her only surviving parent – her mother.[4]

Six more days went by before Mary returned from Gloucester. Patrick heard from someone – a servant? – that Mary was now sleeping better, which shows the turmoil she had been in herself. Patrick wrote again:

They say you sleep better, that is the condition of a heart at ease, – would to God mine were so! . . . I awoke early last Sunday morning with these two lines in my mouth: – Go half my heart, and half my soul/Haste home again, and make me whole . . . I wish with more impatience to know whether *that return* is to repair or to rend me to pieces.[5]

At least Mrs Granville's reply was 'not unfriendly' and made plain it was for Mary to decide. And, indeed, by 6 June the couple were not merely decided, they were married. Empowered perhaps by Patrick's convictions that no-one else should decide on her behalf, Mary pressed ahead with what was probably a very small-scale solemnisation of her agreement. Bernard was not fully reconciled, and nor was Countess Granville nor Lord Carteret; but the principals were quite determined.

Mary and Patrick also agreed between themselves a financial arrangement that was very similar to Patrick's agreement with his first wife, but entirely different from Mary's agreement with her first husband. Back in 1717 Mary had been dowerless Miss Granville, and her uncle had agreed with Alexander Pendarves only an interim settlement, with the understanding that it would be revised once Mary's good connections had enabled him to regain some of his fortune after its confiscation for his Jacobite loyalties. Mary had had no direct say in anything, only the thin consolation that she was doing what she could to help her family, and that she had her own significance because of her helpful connections to the Whigs. Now, she had only modest wealth to bring to the marriage, but it had been enough to enable her to live without relying on a husband and to cut a stylish dash in the *beau monde*. It is evident from what she later mentioned to her sister that Patrick made no financial claims on her income, although he was legally entitled to do so, and she was free to go on owning a house in London and paying a pension to an elderly servant – a Mrs Wells who got £5 per quarter.[6] Patrick would cover all the Irish household expenses and they would be able to live comfortably – they kept a carriage, had on average six or seven servants and could entertain generously, as well as carry out improvements at Delville and in County Down. It does not look as though they tried to codify this on paper: if they did, there was no mention of it. The lack of a written 'wedding settlement' is likely to have been because Mary had no debts from a first husband, and no children to consider, unlike the previous Mrs Delany. Further agreements were that Patrick would take leave every third year so that Mary could come to England to see her family and

friends.[7] In between the sisters would keep in touch by 'journal letters', and sketches to show each other new places visited.

'TO HAVE THE FRIENDS I LOVE BEST, LOVE ONE ANOTHER, IS THE HEIGHT OF HAPPINESS TO ME'[8]

Even though Bunny was not fully reconciled to it, the marriage was now a solemn fact. Until Patrick's year of leave was over, the couple could begin their life together in England, visit their friends and family, and decide what Mary would remove to Delville from her London house. Opportunities also existed to network at court to obtain advancement in the Church of Ireland for Patrick – ideally a bishopric if a suitable vacancy occurred. So there was plenty to occupy the newly weds.

Anne and John Dewes were also in transition: John had purchased the Wellesbourne estate not far from his ailing brother, and the couple were preparing to move from the 'cot at Bradley' into the manor house. Mary's letters to her sister unmistakably convey the happiness that the two had become a four. Mary could now echo her sister's ease in matrimony, and there is an underlying delight in mentioning plans and domestic details. No longer a slightly aloof singleton, Mary had entered the mainstream of human affairs, and could embark on the role of satisfied matron. Even though the prospect of children was most unlikely, there were plenty of people in Patrick's extended family to consider.

The surviving letters between the sisters begin in November of 1743, when Mary and her new husband left Gloucester for London. En route on their first day, they stopped for morning refreshment at Cornbury, home of Mary's Hyde cousin, Lord Cornbury, before pressing on to Rousham in Oxfordshire, home of Sir Clement Cotterell Dormer, Patrick's host on his first arrival from Ireland.[9] Lord Cornbury was the brother of the Duchess of Queensberry, and the house contained the superb early Stuart art collection of their forebear Lord Clarendon, first Earl of Rochester, one of the key statesmen of the Restoration monarchy. It was a visual feast for Mary to see so many portraits by Anthony van Dyke, but what must have given her even greater pleasure were Lord Cornbury's parting words, that 'he was obliged to me that he now belonged to Dr. Delany, and that he *had a right* [Mary's emphasis] to claim his friendship and acquaintance'.[10] With these few polite words, Patrick had been included in Mary's wider network of grand kin.

The couple pushed on to Rousham to arrive at two o'clock, still daylight for a November day, and also the moment for family dinner. The ten Cotterells who were there lived up to their reputation for relaxed and warm hospitality. 'It seems to be a family of love', observed Mary. Love, yes, but also sadness: Dormer had been a widower for twelve years, and he and his wife had had five miscarriages and five infant deaths to cope with. But seven of the family, two sons and five daughters, would have been among the sociable gathering. Mary approved of the new library, by William Kent, recently added for the previous owner, Sir Clement's cousin General James Dormer. It was replete with 5,000 books, valuable prints, and bronze portrait busts, a particular genre of General Dormer's collecting mania. The exterior of the house, as modified by Kent, was in a Tudor-Gothic style, respecting its red-brick early seventeenth-century original. Peering out of the windows Mary could appreciate the beautiful garden, still considered as one of Kent's greatest achievements. It was dotted with classical statues such as *The Dying Gaul* and eye-catchers such as a 'cow-castle', with a classical front and gateway, but also gothic battlements. Sadly, the weather was too bad for her to see much of this exquisite garden, and there were probably few leaves left on the trees.[11]

After a few days at Rousham they left at seven in the morning for London, calling in at Bulstrode en route, where they spent most of the time in lively chatter with the duchess, with Don – for once in good health – and with Lady Peterborough. Then they left for Mary's house in Clarges Street. London life immediately demanded a whole round of visits to close friends and family such as the Percevals, Isabella and Robert Sutton, who would shortly lose a young son to illness, and Sir John Stanley, in good form despite advancing years. Mrs Perceval immediately secured tickets for them for the first public rehearsal of the 'Te Deum' or thanksgiving ode set by Handel to celebrate the king's victory over French troops at Dettingen in Germany. Mrs Delany professed herself unable to judge whether the music was, as some were saying, Handel's finest composition so far – but declared it was 'heavenly'.[12] A visit to Countess Granville created a jarring note, as she was cold in manner, and preoccupied with political matters – her son, Lord Carteret, was still Secretary of State and was newly returned from Germany where he had been in close attendance on the king. Sadly, the ship brought also the remains of Lady Carteret, who had died in June.

On a further occasion when Mary visited the countess she was more cordial, and Lord Carteret made vague noises about finding promotion for Patrick.

Meanwhile, Anne and their mother had plans to visit brother Bernard at his Calwich estate in the New Year, taking with them Anne's eldest son, Court, now a toddler, while the newborn, Bernard, was at a wet-nurse in a village near Wellesbourne. John Dewes was in London dealing with legal work over the purchase of the Wellesbourne estate, but he was able to see the Delanys from time to time. Patrick was busy completing for publication a collection of his sermons, which he dedicated to Countess Granville, and had preached his first sermon at St James's church, Piccadilly, on behalf of the Bishop of Oxford. 'On the Duty of Children to Parents' came from the new collection, which dealt with social affections – married couples, parents and children, masters and servants. Patrick's vision of a reciprocity between all members of society was representative of mainstream Anglicanism. Mary observed: 'he knows the human heart was formed for social affections, and that the friendly communion between sisters and friends no way interferes with that of husband and wife; for can we suppose that Providence should make it our duty to love our relations, and that the performance of that duty should be an *injury* to *one another*?'[13]

Despite all her social calls and household management, Mary had done a new drawing: 'I think I may say my pencil has produced a good piece.'[14] She was copying Old Masters in the possession of friends as much as possible, as she did not know how many she would have access to in Ireland. These copies were probably in the form of pencil with notes on colour and so forth, awaiting her leisure for when they could be worked up as oil paintings.[15] She had an agenda all lined up: 'As soon as I am settled in Delville I shall take to oil-painting, and if I can perform tolerably, will send you a copy of my father and mother's picture.' A pastel she had already done, which Anne knew and liked, was a copy of one of Rosalba Carrera's many versions of *Summer*. This, she told her sister, was to be her house-warming present to the Dewes.[16] It was one of three Old Masters she copied, the others being a St Catherine by Veronese, and a Correggio owned by the diplomat and collector Sir Luke Schaub, who advised Prince Frederick on his acquisitions. A pastel copy of the tragic heroine Sigismunda, which she had given to her uncle Sir John Stanley, had gone to the duchess as he had found the subject matter too depressing.[17]

Towards the end of November Mary and Patrick left London to stay at Bulstrode, to enjoy its usual routines. The duchess was in an excitable, slightly restless state; during the summer she had rambled on the Derbyshire/ Staffordshire border near Bunny at Calwich, finding natural history specimens,

and on her return to Bulstrode enthused about the good people of the area. She was then going to resume her wood-turning, which Mary knew would mean that she would shut herself away in her workshop for at least a week.[18] Currently pregnant, the duchess was in a frenzy to finish projects before the birth. They all tolerated her eccentricities and let her be a 'kind sovereign', to whom they paid court; she must have had charm in spades or this imperious determination would have caused resentment. Patrick was also favourably impressed with how the duchess managed her children – which took the form of delegation to suitable people, who followed her remit. Certainly, her children, especially the daughters, were somewhat in awe of her, and scrupulously polite to everyone.[19]

In January, the ducal couple arrived in London for the duchess's formal lying-in to show her newborn to her friends, and following soon afterwards were Patrick and Mary, the latter recovering from a bad fall. Mary reported to Anne how well received her husband was within their circle in London, a vindication of his gentlemanliness and an implicit refutation of their brother's hauteur about the mésalliance: Patrick 'makes himself agreeable to all, and I have the satisfaction of seeing everybody treat him with that kindness which *I think his due*'.[20] The main 'job' now they were in London was to keep alert to the possibilities for a Church promotion for Patrick. In January Countess Granville had already written a letter of recommendation to the Lord Lieutenant of Ireland, currently the Duke of Devonshire, as soon as they heard that a vacancy had come up when the Dean of Down had become Bishop of Raphoe; Patrick might therefore step in as dean.[21] This was the eventual outcome of all the manoeuvring over promotion, but most of their circle, and at times the Delanys themselves, assumed a higher-ranking role as a bishop was the desirable step up, in recognition of Patrick's scholarship and deep devoutness. All the same, the role of Dean of Down did seem one worth lobbying for; as Mary explained to Anne, it was much more convenient than an upward move to Raphoe, further to the north near Londonderry. Being assigned to Down would bring in a good income and leave them free to remain based in Dublin while making regular visits to County Down, about 70 miles from Dublin; it also meant much less ecclesiastical and public ceremony.[22]

All these variables were pondered against the backdrop of the war with France. Any journeys to Ireland in February might encounter the French fleet, now known to be sailing out from Brest – but was it intending to attack Ireland, or, as most people thought, heading for the West Indies to rendezvous with

France's new Spanish ally? On 15 February the king told both Houses of Parliament that the Pretender's son, Prince Charles, known to his supporters as Bonnie Prince Charlie, had left Rome for France, so a Jacobite invasion of some kind was clearly imminent. The Lord Lieutenant delayed his journey back to London until the threat of French invasion was lifted, as well as when winter storms had abated.

Neither Patrick nor Mary let this uncertainty make them idle or despondent: both dealt with it by being busy. Patrick delivered his book of sermons to the press. As it was Lent it was the season for sacred oratorios, so they eagerly went to the sequence of ten performances, though Patrick demurred at attending *Semele*, as it was based on classical myth not a biblical story. Mary went and loved the music. The oratorios included *Messiah*, premiered in Ireland in 1742. Recent Handel scholarship has argued that it was through Mary's interest that Dublin had been the venue for this première. A severe famine in Ireland had resulted in substantial numbers of victims, so three charitable organisations had decided to invite the now renowned composer to compose something for a benefit performance in a new Musick Hall in Fishamble Street. Handel had hesitated and Jonathan Bardon argues it was Mary and her circle from Ireland, such as 'Don', who must have been positive advocates for Dublin's active musical culture, and the likelihood that the Irish audience would be receptive to the new genre of sacred oratorio. Now, in 1742, Mary had the opportunity to hear the result in London with her new husband, who had also been instrumental in facilitating the original Dublin première by ensuring, in his capacity of chancellor of both cathedrals, the participation of their joint male choral singers, despite opposition from his old friend Dean Swift.[23] There were also plenty of family matters on Mary's mind. When they were still at Bulstrode back in December, Patrick, Mary and Don had gone on a visit to Windsor Castle. Mary left it to Don to show her husband the sights while she called on her cousin Anne Granville. Her sister Elizabeth had her salary as Maid of Honour, and with it the prospect of a pension, but Anne was still dependent entirely on income from a trust set up by her half-brother, Viscount Weymouth, and once that ended whenever he died, she feared the trustees would not arrange any more maintenance. Lord Carteret had as usual answered Anne's request for a pension with vague assurances.[24] Now in February and in London, Mary began to think of alternative solutions to this family dependency; the basic solution, as for most women, meant trying to find a suitable husband, or having one

found by family or friends. Mary had a suitable gentleman in mind, a Mr G who already lived near Elizabeth in Windsor; she thought that Bishop Talbot of Gloucester might act as intermediary. He promised 'to watch and do all the service he can; he really seems to enter with zeal into the affair'. Mr G agreed that Elizabeth sounded suitable and had an excellent character, but there the matter stalled. Plainly the non-committal Mr G was set in his bachelor ways.[25]

The opposite was the case with the recently widowed Lord Carteret, who was only too willing to look for another wife. Ironically, he first had an inclination for Elizabeth Granville. Some of the family did not welcome this scenario, and Mrs Delany thought it would not be a happy partnership, but they needn't have worried as Lord Carteret soon began to court the young, very cultured daughter of the Earl and Countess of Pomfret, Sophia.[26]

As to the safety of the Irish Sea, reliable news of naval engagements was hard to come by. The distinguished Admiral John Norris (c. 1660–1749) had been despatched to harass the French Brest fleet, which was now known to be holed up in Dunkirk. The next lot of rumours were about a resounding British victory over the combined French and Spanish fleets. They turned out to be an optimistic version of the indecisive Battle of Toulon, after which Admiral Thomas Matthews (1676–1751), the commander in the Mediterranean, was put on trial and dismissed.[27] The real naval star of the moment was a much younger man, Captain Thomas Bury, who had been given command of a ship the previous year through the combined recommendation of Mary, and Anne Donnellan.[28] Bury captured a Spanish merchant ship in the Gulf of Mexico, with a cargo of gold dollars, cochineal, leather hides and other goods. Estimates as to the amount of gold pieces went upwards from £80,000 and it was supposed that even the mast-hands would get £1,000.[29]

Mary's marriage did not constrict her sociability: as Sarah Chapone had argued, a wife did not need to lose her civic and social identity. On 30 March Mary told Anne about her varied day, sometimes with the dean and sometimes not:

At eleven we went to Northend; at my return I made a visit to the Percevals, dressed and dined at Whitehall [with the Duke and Duchess of Portland], made visits in the afternoon, drank tea with Lady Andover . . . Cousin Fo [Foley] came to town today, I sat an hour with her in my way home, and am now by my fireside with my own D.D., who bears all my flirtations and

rambles with *unchangeable good humour*, and only makes me regret every hour I spend from him.[30]

Small wonder that the latest instalment of Edward Young's *Night Thoughts*, covering nights five and six, lay unread.[31] Patrick met the author and former suitor to his wife, during this London winter, though, and they got on well.[32] The duchess had been correct to think a man with literary interests would have suited Mary, but she had overlooked how much Young's constrictive attitude to women would clash with the latter's independence and self-reliance. Literary compatibility aside, Patrick lacked Young's officious assumption that women would want to defer to and depend on him.

To Mary's delight, brother Bernard then came to London for a spring visit. One good-humoured outing was when he squired his sister, Don and Catherine Dashwood to the newly opened pleasure gardens at Ranelagh.[33] He was cordial to Patrick, though by no means completely reconciled to the marriage, and when he returned to Calwich Mary felt bound to intimate that if the Delanys had time to visit when finally en route to Ireland, she would expect her brother to receive them both. The prospect of getting there kept receding, though this did create the opportunity for Patrick to preach before the king himself on 3 April. She was proud that he did not 'preach for a bishopric', as some expected, but 'thought more of acquitting himself like a good Christian orator'. Despite his nerves the sermon was well received.[34]

On 14 April Lord Carteret married Sophia Fermor. Mary was pleased to see how tactful the groom was towards his grown daughters by his first marriage, who were the same age or older than his bride. Eleven days later the bride was presented at court, wearing 'gold brocade and jewels'[35] and the day after the king himself was godparent to Lady Dysart's latest son. 'So much for the great and magnificent.'[36] The Portland's new son was also to be christened grandly at St Paul's cathedral, where the music was excellent. Finally, on 8 May Mary wrote to Anne: '*The Dean of Down* desires me to make his compliments to you.'[37] Lord Carteret had come in person to make the offer to Patrick and to add that 'the first small bishopric that fell in he might have if he cared afterward to quit Down, but the deanry [sic] is a much better thing than any small bishopric, and we are well pleased with the possession of it'.[38]

Mary could now concentrate on packing up much of what her London property contained and moving to a smaller house for when she and Patrick were in

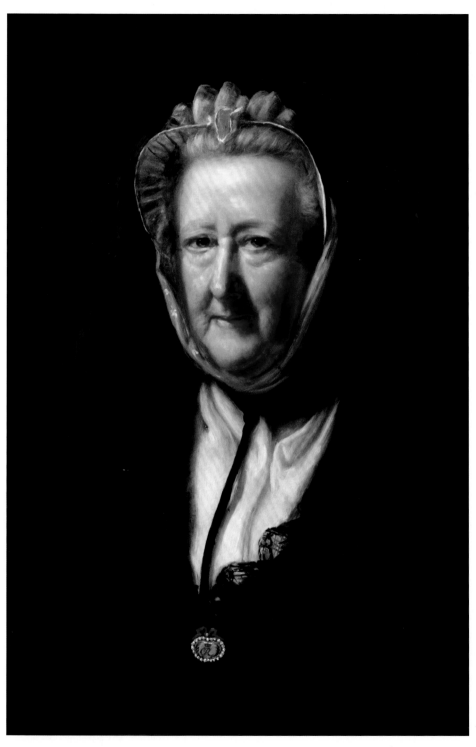

1. This is the portrait by John Opie, then a young, self-taught Cornish prodigy, that misled many generations of viewers to conclude that Mrs Delany was a poor, dependent clerical widow, not a sprightly, artistic, well-connected woman with views of her own.

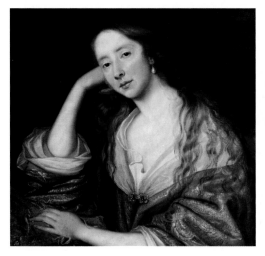

2. Joanna, Mary's great-aunt, was an unfortunate model for Mary as she had been persuaded at nineteen to marry an older landowner, Richard Thornhill, who died only three years later.

3. Mary identified with Minerva figures, here depicted by her 'sister painter', the Royal Academician Angelika Kaufmann. Minerva was the Greek goddess of wisdom.

4. Mary's closest relationship apart from that with Patrick Delany was with her 'sister of the heart' Anne Granville, later Anne Dewes.

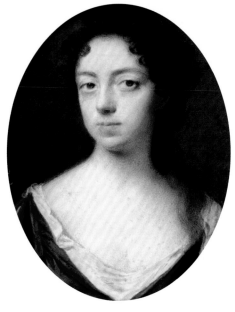

5. Lady Anne Finch was an early literary inspiration from the 1720s and remained Mary's favourite poet throughout her life.

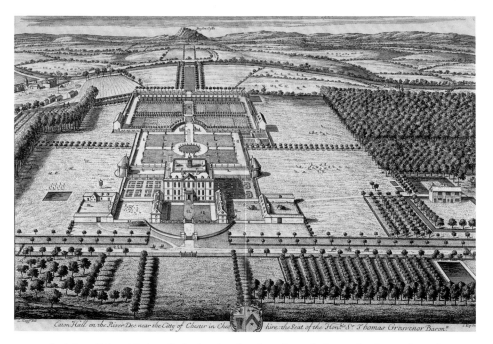

Eaton Hall on the River Dee near the City of Chester in Cheshire: the Seat of the Hon.ble S.r Thomas Grosvenor Baron.t

6. Mary had three links with this Elizabethan 'prodigy house' in Wiltshire: when her uncle Lord George Granville married the widowed 1st Viscountess Weymouth; when his step-son married Mary Delany's Carteret cousin Louisa; and when Elizabeth, eldest daughter of her friend the Duchess of Portland, married Thomas, 3rd Viscount Weymouth. By this time, the formal French gardens had been transformed to English landscape style by 'Capability' Brown.

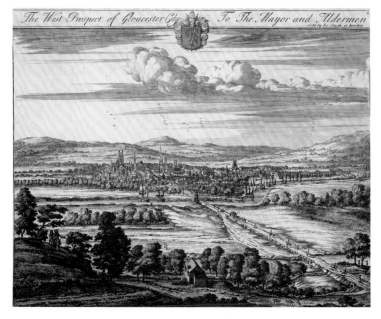

The West Prospect of Gloucester City. To The Mayor and Aldermen.
Sold by Ed. Smith in London

7. Gloucester was a significant cathedral city and inland port. The cloisters in the cathedral are unique in style. Mary's mother and sister worshipped there after they moved to the city; her mother is buried just outside the walls in a box grave identical with her husband's in Buckland.

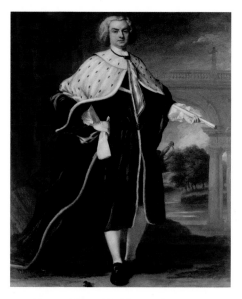

8. In her autobiographical letters, Mary gave literary names from Renaissance fiction to the main characters. Lord Baltimore, Mary's tormenting suitor after her first widowhood, became 'The American Prince' or 'The Basilisk'.

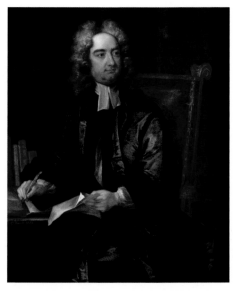

9. Jonathan Swift was Ireland's most acclaimed writer, best known for *Gulliver's Travels* (1726). Mary gained great kudos on her return from two years in Ireland for being known to have been accepted in his circle of literary friends.

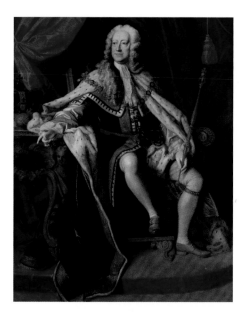

10. Most of Mary's networking as a courtier was done in the reign of George II, painted here by Thomas Hudson, and her description of his coronation has been much quoted.

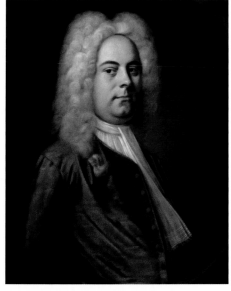

11. Mary was enthralled when, aged ten, she met George Frideric Handel and he conjured marvels from her modest spinet. He often played her extracts from his works while he was composing them. Enjoying his music was a great bond between Mrs Delany and the king and queen.

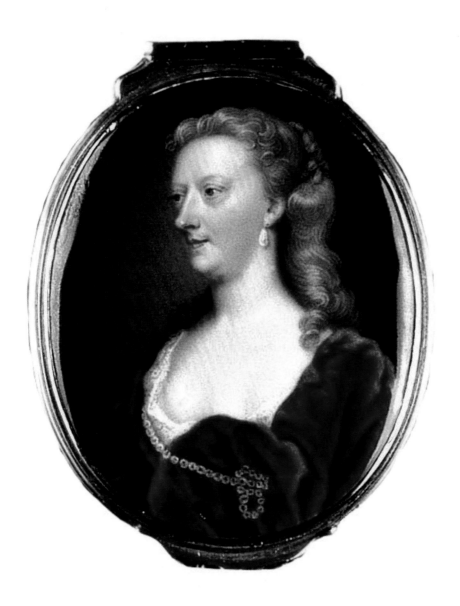

12. This is a valuable image of Mary Delany when she was still the happily single widow of
Alexander Pendarves. It was painted by C.F. Zincke, a miniature painter from Dresden, who
was a favourite in the circle of the 2nd Earl and Countess of Oxford.

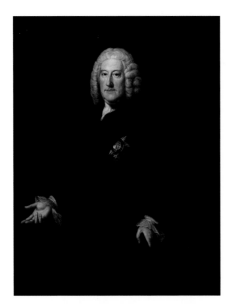

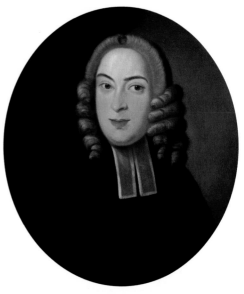

13. Lord Carteret was an immensely significant statesman in George II's reign, who also managed to stay on good terms with Frederick Prince of Wales. Mary's cousinhood to the Carterets helped establish her as loyal to the Hanoverians.

14. Edward Young was a cleric and poet. He tried in vain to woo Mary, who found his over-confidence in his middle-aged attractiveness tiresome. He found her preference for single contentment baffling, and was piqued that the Duchess of Portland had encouraged his suit.

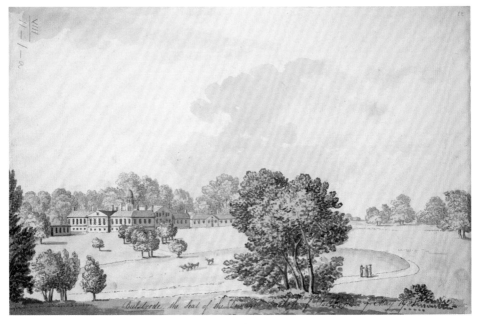

15. Bulstrode was the country base near Windsor of the Duchess of Portland. Over the years it and its collections of art, books, prints, and natural history, including exotic creatures, a menagerie, and an aviary, were to be a much-loved summer retreat for Mrs Delany. Many collages were created there, based on both English and exotic specimens grown in the grounds.

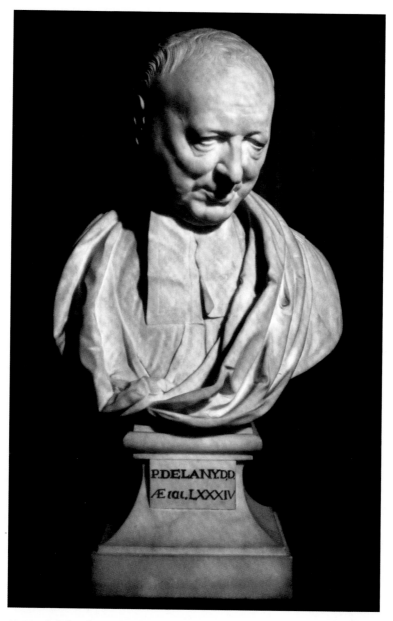

P.DELANY.D.D.
Æ tat. LXXXIV

16. Mary's beloved second husband, Dean Delany or 'DD', cleric, scholar, poet
and prominent public intellectual in Dublin. He was Dean of County Down which
entailed regular visits north. In Dublin he moved in the circle of Jonathan Swift.
His belief in female equality was unusual but most welcome to Mary and her friend
Sarah Sandford.

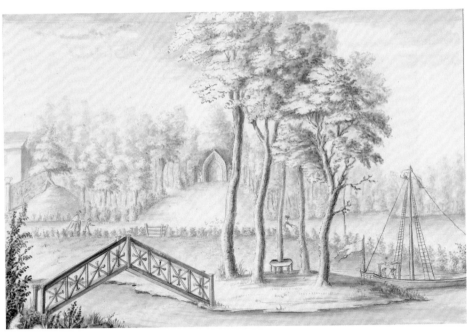

17. Mary eagerly followed news about her brother's house and garden developments at Calwich and drew its progress.

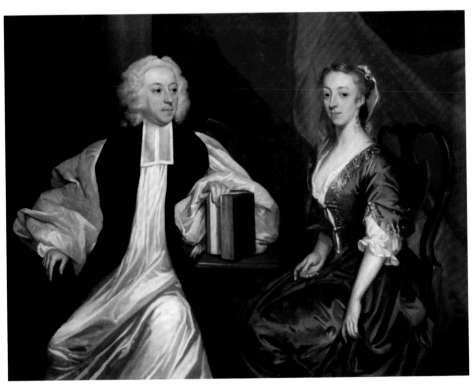

18. The Claytons were a sociable couple and introduced Mary to a more relaxed social milieu, and above all to Patrick Delany. Mrs Clayton was nicknamed 'Cardinella' for her grand airs.

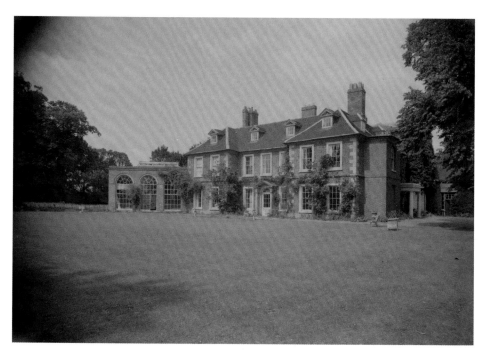

19. Wellesbourne was the four-square red brick building acquired by John Dewes, Anne's husband. It has an unmistakable air of a happy and comfortable gentry family home. Mrs Delany designed two fireplaces in shellwork for it.

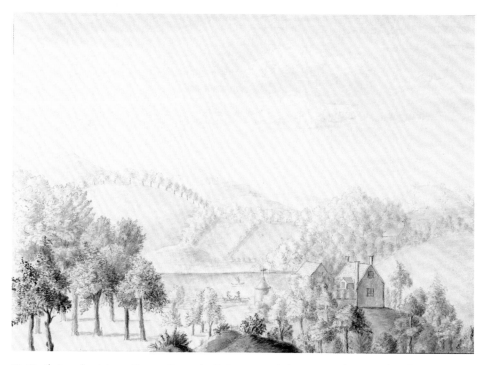

20. On their early visits to County Down the Delanys rented the attractively situated Hollymount, captured here in a drawing by Mary.

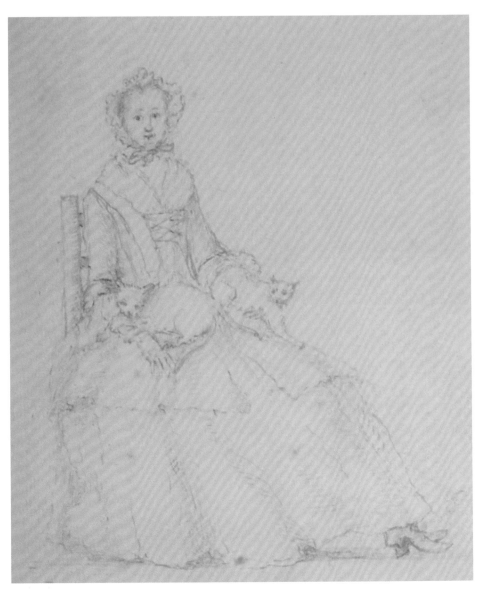

21. No home of Mary's was complete without one or more cat. Perhaps one of these two was Tiger, an early presence in the domestic ménage at Delville, the Delanys' main residence near Dublin.

22. Mary assembled her drawings in Ireland into an album, choosing at least one picture each year. One reason for this was to depict favourite scenes for her sister's benefit in the hope that she would eventually be able to visit in person.

23. Wroxton, on the Warwickhire–Oxfordshire border near Banbury, belonged to the North family (Earls of Guilford). These playful buildings were often dubbed Indian but today would be described as in the Chinese taste. They were attractive venues for short visits whenever the Delanys were staying at Wellesbourne.

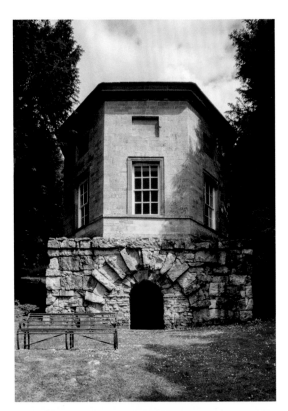

24. The Bath House was designed by the gentleman architect Sanderson Miller, for the use of the Dewes' relative Sir Charles Mordaunt, MP, at his estate near Wellesbourne. It looked like an octagonal folly above but also had a practical function below as a cold plunge bath to ease Mordaunt's rheumatism.

25. Mary's fanciful conceit was that water nymphs had installed plaster festoons below the windows of the upstairs room of the Bath House, from which hung a wall of water drops and icicles. These were all done in shell work, to look like stucco.

London. Sadly for the biographer, Mary told Anne she burnt about a hundred letters dealing with family 'business' – presumably money matters, or requests for places and promotions – in case they fell into inquisitive wrong hands. Some London possessions would go to Anne to help furnish Wellesbourne, including a clock, and a large chair Mary had been working on – probably with a tapestry seat. Mary sent the worsteds and silks along with it, hoping that Anne would finish it in her own time, and then it would be ready for her to use when she visited Wellesbourne.[39] Other gifts included seeds to be shared with brother Bernard, some for the 'hotbeds', that is, covered protected beds, and some for 'natural ground'.[40]

DELVILLE

During her former visit to Dublin, Mary had only once visited Delville as Patrick's literary circle met at his rooms in the city. Now she was Mrs Delany she would have the management of the entire house, which they reached on 28 June. She soon gave a full description of it to her sister: an early decision was which rooms would serve as the guest suite for when Anne could visit. Her drawing room had tapestry hangings, a pair of japanned chests stood on either side of the doorway and the curtains and chairs were in crimson. There was an inner room to act as a bedchamber, also hung with crimson; and just off that, a little closet with intriguing views of Dublin harbour, and a 'range of mountains of various shapes' – the Wicklow Mountains. The approach to the whole house was regular, and the drive was wide enough to accommodate a coach and six. The large hallway had a compartmented ceiling (rather old-fashioned by now), decorated with a Doric entablature around the room. The eating parlour was on a similar scale with a window bay. Mary approved of its having three windows, which brought in plenty of light, and two sideboards, while a further advantage was that it was warm in winter and cool in summer. A third unfinished room off the hallway had a special purpose – it would be their private chapel, 'when we are rich enough to finish it as we ought to do'. This would be decorated with Mary's oil paintings on religious subjects. Further down the hall was a stone staircase with stucco decoration that led to 'a very pretty square room, with a large dressing room within it, which I hope will be my dearest sister's apartment, when she makes me happy with her company'.[41] Also on the ground floor was a little breakfast parlour, where they had supper too when there was no

company, and beyond that their bedroom, which though small had a useful closet off it and an attractive view of Dublin harbour. A staircase near the breakfast parlour led up to Mary's 'English room' – the one she would use as her study. Patrick's library led off this, and he had 'filled up the vacancies of my shelves with the modern poets, nicely bound', as a welcoming gesture. The staircase continued further up to the maids' rooms and there was a back staircase down to the large drawing room. Anne sent this letter on to their mother in Gloucester, who commented 'by her description Delville sounds a charming place'. And indeed it must have been just right for a married bookish couple who also liked and needed to entertain; they had their own cosy quarters, generous space for more formal visitors, plus closets and individual studies or libraries each.[42]

Later in July Mary attempted to do descriptive justice to the garden. The Delville site is now occupied by a hospital, but the walls surrounding it still for the most part remain. Against the walls originally was a circular terrace, containing fruit trees (espaliered against the wall), and on the other side of the walk was a flower border, overflowing with massed roses and sweet briar. At the back of the house was a bowling green, sloping down to a stream that ran through the garden, and as it was hay harvest when Mary wrote this letter, a hayrick was rising near the bottom (Plate 22). This was the garden-level view from their bedroom and small parlour, looking towards 'pleasant meadows, bounded by mountains of various shapes, with little villages and country-seats interspersed and embosomed high in tufted trees', beyond which came the busy Dublin harbour, which 'looks at this instant beautiful beyond all description'.[43] It also recalls the inhabited and man-made activity and order she had enjoyed when living at Roscrow in Cornwall, looking down towards Falmouth Bay.

On the other side of the bowling green there was another terrace walk, which incorporated an oval parterre, 'planted round in double rows of elm trees and flowering shrubs, with little grass walks between them, which will give a good shelter to exotics'. The end of this terrace led to more fruit trees against the wall and a door through to another terrace walk, this time gravelled, and sheltered by more double rows of elms, 'so that we may walk securely in any weather'. These daily walks were very much part of the Delanys' routine. There was also scope for Mary's grotto-creating talents, since further left the ground rose considerably, towards a bank with some stone remains – Mary supposed this was an old castle. Under this higher ground, with an uninter-rupted view over the countryside, was 'a cave that opens with an arch to the

terrace-walk' and Mary intended to re-use a plan for a grotto designed for Calwich. This terrace walk ended in another slope up to a sheltered portico, painted inside, with excellent fresh air at the vantage point; then the walk looped back to the first terrace. The lower part of this garden was more rustic as it sloped down to the paddocks for their cows and deer. Here the fields had 'wild' plantings of forest trees and bushes that looked perfectly natural, and suggests the dean's affinity with the Kentian ideal of 'making all nature a garden'.

Mary added that they had a 'very good' kitchen garden and two orchards, which would make them entirely self-sufficient as far as fruit and vegetables were concerned. She saved until last the kind of eye-catchers and quirky features that always delighted her, 'little wild walks, private seats, and lovely prospects. One seat I am especially fond of, in a nut grove, and the "beggar's hut", which is a seat in a rock; on the top are bushes of all kind that bend over: it is placed at the end of a cunning wild path, thick set with trees, and it overlooks the brook, which entertains you with a purling rill. The little robins are as fond of this seat as we are: it just holds the Dean and myself . . .'[44] An apt symbol of their marital togetherness, surely.

The Duties of a Dean's Wife

O nce Patrick was formally instituted as Dean of County Down, it became imperative to make a brief visit there to see everything in person. The dean's role was to look after the personnel and buildings of the diocese, so this kind of personal inspection was essential. En route they would stay with people they knew, such as the artistic Dorothy Forth, her husband the Hon. and Rev. Francis Hamilton, Rector of Dunleer, and Dorothy's sister, who lived with them.[1] Mary abandoned a host of tradesmen 'upholsterers, joiners, glaziers, and carpenters' and left instructions that Delville should be whitewashed while they were away.[2]

Once at the county town of Downpatrick, the new dean was shocked at the miserable state of the prison and made a grant towards a new one, which would have a chapel and separate accommodation for men and women. Some of the parishioners urged him to rebuild parish churches left in ruins since the 1641 rebellion, too. He embarked on this, with his bishop's consent, little knowing it would rebound on him, for in making better provision for a resident priest at Bright, this interfered with the rights of a landowner 3 miles away who had endowed a Presbyterian chapel, attended mainly by skilled artisans working in the linen trade. They complained to the Irish Linen Board about paying for extra tithes for a Church of Ireland church they did not attend. This was typical of the frictions that occurred between the two Protestant denominations in this part of Ireland and prompted Patrick to write a pamphlet defending the biblical basis of tithes.[3] But it was also typical of his generosity conflicting with non-negotiable legal rights, which had been his way of making his first

146

marriage settlement. As we shall see, this would soon rebound on him too. In the case of the tithes, Patrick ended up paying extra to endow a curate for the rebuilt church. In parallel, Anne was settling into Wellesbourne and the sisters thrived on the descriptions of the other's new home. Mary described Delville's 'English Room', now painted a light olive as a background for pictures, with a frieze painted alternately with flowers and shells, while the spare apartment would have tapestry-hung walls and a rich green damask bed, chairs and window curtains, for when Anne visited.[4]

Sad news arrived in December 1744 that Sir John Stanley had died, and even sadder was the way his nephew William Monck gave neither Bunny nor his sister news of his last illness. When it came to Sir John's will, the Monck nephew interpreted it to mean that some silver basins and covers due to Mary would descend to her without their matching china dishes, which anyone would assume belonged together. Mary wrote a letter heavy with irony to the troublesome nephew, and rejoiced that the house and its superlative garden, which had been such a precious retreat for them all, would be sold – at least that way it would not belong to the churlish William Monck.[5]

In several letters Mary now entered fully into explaining to Anne all about her new husband's extended family, such as a Delany niece, about to marry a suitable lawyer, a Mr Green, and another niece, Bridget Wilson, who had married Mary Barber's son, Rupert Barber, in 1742. She was comfortably off and brought some money to the marriage. Rupert Barber was an enamellist, who occasionally worked in pastel, and had been apprenticed to Arthur Pond.[6] It pleased Mary to note that he was going to teach one of his daughters his 'trade'; here was an example of female talent being properly trained to professional standard.[7] His brother was established as a doctor and would attend the Delanys when needed. A little New Year's dance was based largely on these connections as guests.[8] Mary went to Dublin with the young Miss Delany, and helped her buy clothes worth the £60 the dean had given her on top of a handsome dowry of £500. After they were married, Mr and Mrs Green lived with the Delanys, and Mary found the groom 'very well bred and easy, conversable, and reads to us whilst we work [do needlework] in the evenings, so we spend our time very agreeably'. Two of Mr Green's brothers were sugar bakers, who had given their new sister-in-law a £50 banknote on her marriage.[9]

And yet another marriage was planned for the end of January, this time between a nephew of the dean's and one of Mrs Barber's nieces. The former

would act as a kind of steward, occupying a farm about 12 miles from Delville, and supplying any farm produce not grown or reared at Delville itself.[10] There is something in the insistent detail of all these arrangements that indicates how much Mary was enjoying having her own 'family' to fuss over at long last, and it was also a way to celebrate the good heart of her husband, and show he had enough affluence of his own that enabled him to be generous. 'When this [marriage] is done the Dean has not a relation left that he has not portioned or settled in some comfortable way; and if I were to tell you all the particulars of his benevolence and his goodness towards them you would be astonished that his fortune had answered so well the beneficence of his heart.'[11]

Because his relatives took precedence, Patrick had not been able yet to pull strings for the always penurious Chapones – but one suggestion was that their son Harry should come and study at Trinity College, Dublin where he could live on much less than in England and be a sizar, that is, servant to a richer student, which would nevertheless put him 'upon the same footing as the best gentleman's sons'.[12] On the Granville side, the perpetual problem of Anne Granville's portionless state continued, and efforts to influence a longer-term settlement via the Duchess of Bedford, a Leveson-Gower cousin, had been met with 'insolence' – another marked contrast within Mary's extended kin to Patrick's kindness to his own.

Mary probably knew that it was unlikely that at her age she would ever be a biological mother. However, the concept of the Christian household she shared with Patrick Delany meant that their household would always include relatives and close friends who needed a home. She was a sister, an aunt, a godmother, a surrogate sister and a friend to many, and as such she provided a lot of mothering. Her family letters became increasingly full of comment on how to rear boys and girls to take their place in polite society and become reasonable moderate Christians.

Mary had no regrets over her choices. Anne had told her sister news of the astonishing luck of the young Mr Yate who had been so offended when she discouraged him because of his relative poverty back in 1731: he had now inherited a fortune from a cousin. Mary rejoined: 'I am glad he *had it not* some years ago, for I am now well assured I could not have been so happy with any man in the world as the person I am now united to; his real benevolence of heart, the great delight he takes in making every one happy about him, is a disposition so uncommon that I would not change that one circumstance of happiness for all the riches and greatness in the world.'[13]

The last paragraph of these three letters about the Delanys' extended family at Delville mentioned one of its most cherished members: 'have I told you of a pretty tortoiseshell puss I have? The sauciest and prettiest, most indulged little animal that ever was everybody's favourite. After this important sentence I have no more to add . . .' This was Tiger.[14]

THE DUTIES OF A DEAN'S WIFE

Marriage to a dean in the Church of Ireland was a significant public position, since wives helped to maintain the social and professional standing of their husbands, and to carry out their duties in the widest sense. This was even more important in Ireland than it was in England, since the Protestant Anglo-Irish Ascendancy constituted only about 10 per cent of the population, and existed mainly as a thin layer of landlords, officials, professionals, and to some extent merchants and entrepreneurs, controlling and employing a mass of mainly rural Irish poor. Swift had satirised this dominance as an island floating on top of another island when his protagonist, Gulliver, visited Laputa, in his famous fictional *Travels*. It was the Anglo-Irish minority who were keeping the whole regime loyal to the new dynasty, now in 1744–6 under threat from the Jacobites, supported by France. It was thus socially and politically important as well as ecclesiastically desirable to cement membership within the Church of Ireland by extending hospitality to as many Protestant households as possible. From now on some of the Delanys' entertaining was geared to this part of Patrick's role, and never about giving hospitality simply to their own personal friends – though many guests were, or became, real friends. After returning from County Down in her first spring there was extensive round of social visits in the capital, so that as Patrick's consort she could meet his Dublin-based connections. It was only after these obligations were complete that, with a sigh of relief, Mary could 'return to my pencils and shell-works'.[15] Beautifying their home was of supreme importance to Mary and gave her much satisfaction; it was also an opportunity to improve her artistic performance so that her paintings might add to the decorative effect. It always had to be fitted in alongside a range of obligations, but time alone with her paintbrush, crayon and pencil would always be important to her.

These social and religious routines could have their dramatic side. One of Patrick's duties was to encourage Protestants who were under pressure to

convert to Catholicism to remain true to their faith, and conversely to help Catholics to convert to the Church of Ireland. Soon after their return to Dublin in May 1744, Mary wrote a detailed account to Anne of how Patrick had been instrumental in the reintegration of the two McDermot sisters, Connaught-based heirs to their brother's fortune, to the Church of Ireland. Theirs was a dramatic tale of attempted abduction – at the time often a social custom to make up for the shortage of Protestant brides, as an heiress would be 'abducted' by a young gentleman whom she knew and wanted to marry anyway. But not in this case.[16] The McDermot sisters had been staying with their uncle en route to Dublin to consult with Patrick on the theological aspects of conversion, when four masked men broke in. The eldest sister was dragged outside and tied to the ringleader's horse, but managed to escape, wounded in the arm 'from wrist to elbow'. This ringleader was revealed as their cousin, Flinn, whose proposals had already been refused. He declared she was to marry him by force if neces-sary, but while a priest attempted to perform the ceremony the intended bride again wriggled free, and glimpsing a pan of hot milk on the hearth threw it all over the priest. Eventually she was rescued by a Protestant relative and recov-ered from the ordeal.

Now the formality of recantation could take place at Patrick's parish church at Glasnevin, the church nearest Delville. Mary's role was to hold a dinner before the formal recantation ceremony in church where the sisters solemnly recited their abjuration of 'all the errors of the Church of Rome'. Patrick then gave them a formal blessing and prayed for them. 'I thought they would have been very private and quiet, but eight persons that I did not expect came to dinner beside themselves, still there could not be too many witnesses of so good an action.'[17] Mary ensured this was a congenial social occasion as well as a solemn religious event.

In the early summer of 1745 the Delanys made a more extensive visit to County Down, which revealed to an even greater extent the neglect of the previous dean. The Presbyterians were still encouraging non-payment of tithes to the Church of Ireland. Mary explained to her mother that Patrick was plan-ning to visit 'all the families in his Deanery, which will be a laborious work, but what he is determined to do. It is very strange, but the poor have been so neglected here, they say they never saw a clergyman in their lives but when they went to church.'[18] As Ireland did not have the English system of parish-based poor relief, administered by clergy with assistance from churchwardens, parish

visiting needed a much more determined initiative on the clergy's part. Patrick decided to dine every Sunday at Downpatrick, the county town, where a butler to a former dean had started up a public house, giving scope for Patrick, group by group, to treat all the townsmen and their wives to dinner between the morning and the afternoon Sunday service.

The Delanys were staying 3 miles away at a borrowed house, Hollymount, as they lacked a permanent residence. Mary liked the house, which was on a small promontory stretching into a lake where there were sometimes as many as sixty swans, an agreeable view from upstairs.

> About half a mile off is a pretty wood which formerly was enriched with very fine oaks and several other forest trees . . . it . . . has the finest carpeting of violets, primroses, and meadow sweet [sic], with innumerable inferior shrubs and weeds, which make such a *mass of colouring* as is delightful.[19]

Patrick immediately put into hand a clearance of the paths and soon there was a beguiling oak-wood seat. Penetrating further into the woods one day seemed quite an adventure and Mary took her 'shepherdess's crook' and the dean a stout cane. On this occasion, she and Patrick were well rewarded 'by finding many pretty spots enamelled and perfumed with variety of sweet flowers', particularly the '*woodbine and wild rose* which grow here in great abundance'. Her descriptive language echoes that of Shakespeare's Oberon – 'I know a bank where the wild thyme blows' – while visually the description of the ground being 'enamelled' suggests she had in mind the Elizabethan miniatures that the duchess and her father liked to collect.[20]

A typical day's routine was to:

> rise about seven, have prayers and breakfast over by nine. In the morning the Dean makes his visits, I draw; when it is fair and he walks out I go with him: we dine at two; in the afternoon when we can't walk out reading and talking amuse until supper, and after supper I make shirts and shifts for the poor naked wretches in the neighbourhood.[21]

An itinerant Irish harper was staying in the house with them and played at mealtimes and when Mary was drawing. She did at least three views for Anne. She also copied in oils a picture of Mary Queen of Scots that Patrick liked,

and a version of a portrait of the great 1st Duke of Ormonde after Peter Lely – a copy of a copy.

Early visitors included people like Patrick's land agent, a local curate, a land-owner named Ford with ten children, while the week before they left it was particularly hectic – sixteen on the Tuesday, ten on the Wednesday, twenty-two on the Thursday.[22] They were also guests at homes near Hollymount as well as further afield. This official visiting fully occupied 'team Delany' and their household until their return to Delville in late August, where the garden was 'in perfect beauty' and, most gratifyingly, 'my pussy Tiger knew me and caressed me mightily'.[23]

LORD CHESTERFIELD'S VICE-ROYALTY 1745–6

Once the Jacobite rising of 1745 seemed near defeat, Mary reflected: 'When I consider how great a calamity a civil war is, we cannot be too thankful that a timely stop is put to it'; even the 'Papists' appreciated peace and stability.[24] A good viceroy in Ireland could help consolidate loyalty. From 1745 to 1746 this was the Earl of Chesterfield, whose wife, Petronella Melusina von der Schulenburg, George I's illegitimate daughter, was a long-time acquaintance of Mary's (p. 40). Encouraged by Mary she wore clothes made of Irish fabrics on court occasions, like the celebration of the king's birthday. 'The poor weavers are starving, – all trade has been met with a great check this year.'[25] Mary now accompanied the newly converted McDermots to court, knowing that the Chesterfields would make a particular show of receiving them.[26] The Dublin militia was on alert and made a daily parade, and everyone felt safer when they were reinforced by Dutch and English troops.

In the mornings at Delville, to keep her mind off events turning out badly, and if expecting an informal visit from Lady Chesterfield, Mary arranged her mineral samples and shell collection, considering it was easier to have this inter-rupted than the messier business of oil painting. Never idle if it could be avoided, she also used some of the shells to decorate two garden urns. In all these artistic endeavours, Patrick was solidly behind her: 'his approving of my works, and encouraging me to go on, keep up my relish to them'. Both Lord and Lady Chesterfield soon made their private visit, and were full of polite admiration of all the improvements and garden design: they 'could not have said more civil things than if it had been my Lord Cobham's Stow!!'[27]

Mary was also concerned for Bunny's well-being should he join the militia regiments being raised at county level by leading peers. In Staffordshire, where Calwich was situated, the officer in charge was their Leveson-Gower cousin John. Since Bernard had been an officer, it might have been expected that he would be put in the vanguard, and so Mary was hugely relieved when she later learnt he had been at Gloucester for most of the autumn and winter, with their mother and Anne, already there for the birth of her third child while her husband was occupied with legal business in London. It must be wondered whether Bunny side-stepped joining the militia in order to avoid any secret Jacobite overtures to join their side: after all, he considered himself to be the *true* Duke of Albemarle, a title that existed solely in the mind of dwindling Jacobite loyalists.

To Mary and Anne, the rebels were a private 'plague' as well as a public one, as it made planning to cross the Irish Sea for a visit to England more problem-atic.[28] If Patrick *were* to be made a bishop, he would have to attend the autumn opening of the Dublin Parliament (in which bishops sat in the upper house, as in England). Once again Patrick missed out but Mary insisted to sister Anne, 'I am better pleased to have him remain Dean of Down than have him at the fag end of all the bishops!' The consolation prize for waiting until spring the following year, when wind and tide made sailing easier, would be that they could take an entire year out to visit in England.[29] Still, Mary had felt wistful at times, thinking of her sister being able to visit their brother in Calwich, and he to visit Wellesbourne, which Mary had not yet seen.[30] There was some compensation at Delville, though, as Mary's 'family', in the sense of household, was also growing bigger, with the birth of a boy for Mr and Mrs Green, who were still with them. Mary arranged a small-scale lying-in ceremony for her so that her friends could come and congratulate her. This birth was followed not long after with a fourth child born to the miniature painter Rupert Barber.

Having put in sufficient court appearances in the autumn, the Delanys made fewer in the shorter, dark winter days. When another charity performance of Handel's *Messiah* was staged to benefit poor debtors, Patrick decided they should attend the daytime public rehearsal rather than battle the bad weather and attend the evening performance. Mary was enjoying the new experience of an attentive companion to look after her, and at Christmas and New Year, 'when everybody is engaged in a more public way of diverting themselves . . . I find more pleasure in the quiet enjoyment of my own amusements at home than a crowd can give me'.[31]

To help keep up her spirits through the short, dark, winter days, her old friend Letty Bushe came to stay, adding to the general conversation, playing the harpsichord and encouraging her drawing. Soon February's longer days brought signs of spring in the garden. Mary started planning a bowling green in 'a little odd nook of a garden, at the end of which is a summer house', and she and Patrick started going into Dublin more frequently. He had subscribed to a course of lectures on science, which they both enjoyed a great deal, Mary feeling that what she learnt with pleasure from them only highlighted gaps of great ignorance.[32] By way of oratorios they had Handel's *Deborah* and *Esther* and at the theatre there was the opportunity to watch three luminaries of the stage in a production of Nicholas Rowe's modern classic, *The Fair Penitent*: David Garrick, Thomas Sheridan (father of the better known Richard Brinsley Sheridan) and the new star, Spranger Barry. The Claytons were still entertaining lavishly: 'She loves the show and homage of a rout, has a very good address and is still as well inclined to all the gaieties of life as she was at five-and-twenty; the Bishop loves to please and indulge her.'[33]

The end of February brought the glad news that Anne and John Dewes' third child was a girl, born on 10 February to be named Mary. Anne agreed to 'share' her with her sister.[34] In the extended family, Mary was still trying to help Sarah Chapone get her son Harry placed. Studying at Trinity College Dublin had been abandoned in favour of getting him a place in the colonial administration. Mary had written to a Cornish connection, Edward Trelawney, Governor of Jamaica, on his behalf, and prospects of getting a lucrative position were good. She also sat to the miniature painter, Rupert Barber, to help him develop his clientele by showing samples of his technique, which some considered superior to Zincke's.[35]

By March they could really start planning their visit to England, having secured their turn for a place in the Viceroy's yacht.[36] She and Patrick began preparing house and garden for their year-long absence. Mary planted up the 'pearly bower' with 'honeysuckles, sweet briar, roses and jessamine', where she hoped Anne would one day sit with her. It is noticeable how much attention was paid to scented flowers but 'this year I shall not smell their fragrancy, nor see their bloom but I shall see the dear person to whom the bower is dedicated'.[37] The bower was so named after the family nickname for Anne, 'the pearly dews', a pun on her married name as well as a homage to her fresh complexion. At Calwich there was a 'pearly fountain' and the children would gain the collective sobriquet of the Dewdrops.

A whirl of social activity, including farewell visits to the Dublin court, put the squeeze on the time she could spend finishing off any pictures in oil, but she could at least consider she had finished three copies: an angel based on one from the old master Guido Reni, a half-length of the Duchess of Mazarin for Letty Bushe, and the Husyman portrait of their mother, for Anne and John at Wellesbourne. Finally, they were able to set off in the yacht in the knowledge of 'glorious news from Scotland': the Jacobites were defeated at Culloden on 16 April by an army led by the Duke of Cumberland.[38] He had earned the acclaim of all Hanoverian loyalists and was being celebrated symbolically as the 'Conquering Hero' of Handel's oratorio, *Judas Maccabeus*. To the defeated Jacobites he was 'Butcher Cumberland', who followed his military victories with suppressing the customs and clothing of the Highlands.

JOY AND SORROW IN ENGLAND 1746–7

The first year in England held great joy and also great sorrow, beginning with the sisters' reunion but ending with the death of their mother. Mary and her husband were able to see in person all that had been described of Wellesbourne and the neighbourhood. In November they set out for London via Cornbury and Bulstrode. At the former they were given apartments with 'Indian' wallpaper, consisting of a design of songbirds – what today would be called Chinoiserie. In the evenings they sat in the long gallery that was closely hung with the van Dyck portraits. The Earl of Cornbury was always cordial.[39] Mary's old friend Kitty Queensbury, their host's sister, was there with her husband, younger son and three Scottish friends; as one of her sons had loyally raised a regiment to defend Scotland, the duchess was now allowed back to court and went to show her appreciation that the king had allowed this.[40]

There was plenty of opportunity to stroll or drive around the Cornbury grounds and see the improvements since their last visit; Mary was especially impressed with how a stone quarry had been transformed 'into the wildest prettiest place you can imagine – winding walks, mounts covered with all sorts of trees and flowering shrubs, rocks covered with moss, hollows filled with bushes intermixed with rocks, rural seats, and sheds; and in the valley beneath a river winds and accomplishes the beauty'.[41] In London the Delanys had agreeable lodgings in Pall Mall, next door to the popular Cocoa Tree coffee-house. The

minute she was settled all her old friends came to see her – such as Lady Sunderland, Anne Donnellan and her sister Mrs Clayton, also over from Ireland – and she made many calls, including one on the Dowager Countess of Kildare and several to Mrs Montagu of Hanover Square. There were always Granville and Carteret cousins to see, too.

She went to court with the Duchess of Portland, where both the king and the Duke of Cumberland enquired whether she enjoyed Ireland, while at Carlton House, home of Prince Frederick and Princess Augusta, she wore her Irish green damask and an embroidered head-dress. The dean was presented and 'spoken to very graciously'. Mary's new dress for the king's birthday was a flowered silk on a pale deer coloured background, which she considered pretty and modest, and Bunny gave their cousin Anne Granville a head-dress of Brussels lace to go with her white satin with brocaded flowers.[42] There was even more finery at the Duchess of Queensberry's evening reception or 'rout', but after half an hour of being dazzled with the glamour, Mary had had enough.[43] After all, she had Patrick waiting at home for her 'who always receives me with smiles', and she was going to Kitty the next day to see her recent needlework and painting.[44] Just as Mary was finishing one of her letters to Anne describing all the court visits 'in came Mr Handel'. Mary had recently been composing a drawing on each of the pastoral odes Il Allegro and Il Penseroso by the composer, based in turn on Milton's poetry: it inspired alike the visual and the aural.[45]

In the new year, the dean planned to visit Bath to take the waters, but amiably suggested his wife visit her mother in Gloucester, and then go on to Wellesbourne, bringing Mrs Granville senior with her and the Dewes' son, Bernard, from his wet-nurse. Patrick would then rendezvous with them in Warwickshire. In retrospect this must have seemed a wise arrangement, as it would be the last visit 75-year-old Mrs Granville would make to Wellesbourne and the last time Mary would see her. According to family tradition she was kneeling against her prayer stool when death overcame her. The yacht's departure to Ireland was delayed by contrary winds. Mary and Patrick feared they would run out of reading matter, but there were other resources open to them, such as the natural history of the area. Mary's eye caught a variety of caterpillars, including one 'which some inhuman foot had crushed to death, with a head as green as an emerald'.[46] Back at Delville, they found that Mr Green had added three deer to the little herd, they had a thriving colt and calf, Tiger recognised her, but the robins had not yet done so. The nine-pin alley she had

planned was now complete and she sowed seeds from Wellesbourne into the borders.[47] Returning to Delville also enabled husband and wife to see the house with fresh eyes and to decide what refurbishment project would be next: they decided to concentrate on expanding the library.

In the New Year, John Dewes' invalid brother Court finally died. Anne was proud of the Christian generosity her husband showed in fulfilling the bequests of his brother's will beyond the letter of the law: 'he followed the law of kindness *only*'. She also considered that Mary and the dean were an inspiration to him in his own local charities. One day John delayed going to Maplebury when Anne received a letter from Ireland, so he could read it too. He was impressed by the account Mary gave of how her husband had attended the death-bed of an ageing gardener at Delville, and as John Dewes finally set off he reminded Anne of a charitable gesture she had planned, of getting some clothes made for an indigent child at a nearby farm.[48]

WHAT HAPPENED TO THE WITS?

One of the great triumphs of her first visit to Ireland had been Mary's acceptance among the 'circle of wits' centred on Jonathan Swift, including the female poets like Laetitia Pilkington and Mrs Barber. Ten years later it had proved easy to pick up her friendships with the artistic set – the Forth sisters, and Letty Bushe – but it was quite impossible to recreate the literary life. Patrick had been a prime mover, but after his first marriage, he had gradually discontinued maintaining his Dublin rooms. Another of the leaders, Samuel Madden, was also married and living in the country. In any case, the keystone, Swift himself, was no longer capable of holding his own after 1741, when guardians were appointed to look after him. Tragically, following a stroke, he was no longer capable of rational speech, and he died in 1745. Mary read some of the works that were posthumously published – some sermons, and the amusing jeu d'esprit, *Directions to Servants*. Written from the servant's viewpoint, this included the cook's advice, 'Never send up a leg of fowl at supper while there is a cat or a dog that can be accused of running off with it,' while some could apply to all servants: 'When any Servant comes home drunk, and cannot appear, you must all join in telling your Master, that he is gone to Bed very sick; upon which your Lady will be so good-natured, as to order some comfortable Thing for the poor Man, or Maid.'[49]

Another of the female wits, Mrs Barber, was now an elderly invalid living next door to Delville as one of Patrick's beneficiaries. Though often feared to be on her death-bed, she did not die until 1755.[50] But, crucially, notwithstanding these losses and changes, Mary had not just met one of the leading wits, she had married him; you could say the wits were now centred on or domesticated with the Delanys. The literary conversations that Mary and Patrick had between themselves or with their guests were truly central to their companionship. They were invited to Dublin Castle one evening with the Chesterfields, who 'wished to have us alone, that they might enjoy our company without interruption . . . the Dean and my Lord Lieutenant fell into a very entertaining and agreeable conversation, chiefly of poets and poetry. There is no entertainment equal to that of hearing two very intelligent men talk on agreeable subjects.'[51]

The absent figures in the conversations at Delville were the Pilkingtons. What Mary could not know was that when she and Patrick came back after a year in London, they missed meeting Laetitia, who travelled a week earlier – sheltering on deck in the coach of the newly wed and fabulously rich Countess of Leinster, Emily Fox.[52] Completely impoverished, Laetitia had only been able to make this journey, accompanied by one of her sons, through the financial help of Patrick. Mary was not aware of this charitable donation, but this was not because of any clandestine relationship of Patrick's with the poetess, but because Laetitia had fallen on hard times, become an object of charity and a 'lost woman', no longer fit for the company of respectable ladies like Mary. How had this happened?

Laetitia Pilkington's story was of declining gentility and compromised propriety once her marriage collapsed in 1731.[53] One way Laetitia kept up her spirits was to persist in her acquaintance with a circle of witty men who liked her ability to converse in kind and tease them back. However, this began to earn her the label of a coquette – meaning not so much a sexual tease as something in its way more dangerous: a woman who could equal a man verbally. Matthew tried on several occasions to expose her to seduction by a succession of his friends, as he would not be liable for her maintenance after a legal separation: everything would be her fault, and the 'wronged' husband could also more easily deny paternity of their children. His manoeuvres were eventually successful, and by February 1738 Laetitia was divorced, her husband had custody of the three surviving children, only one of whom would he acknowledge to

be his, and she had no maintenance. Laetitia lost all the people who might protect a married woman: her patron, her husband and her father, who died.[54]

The next nine years saw her living in London, scrambling and slipping slowly down the social scale, trying to make a living. She had also been writing her memoirs, prompted by the famous actor (and Poet Laureate) Colley Cibber's sympathetic hearing of her story. He recognised her ear for remembered dialogue, and knew the public might like her stranger than fiction life-history as much as they had lapped up his own memoir. She solicited subscriptions to publish them over the years. It is clear that one of the few people who emerged as genuine and generous as she grew older and poorer was Patrick Delany. In 1743 he was in England marrying Mary. He was willing to be generous but asked Richardson to make clear she was not to contact him again.[55] But he assisted Laetitia indirectly a couple more times, the last one being in 1747 when he stumped up the fare back to Dublin.

In her book, Laetitia's praise of Patrick contrasts with her sardonic comments on Bishop Clayton, a prelate whom she describes as making charitable donations according to a set table: £1.7 shillings for adultery, half a guinea (10s 6d) for fornication, 5 shillings for venial transgressions. He also donated the annual cost of maintaining ten parish bastards on the off-chance one might have been his. 'What I thought most cruel in him, was, that he never gave a Farthing to the poor women themselves.' She also claimed she had caught him out fondling her own maid on the carpet, and repudiated his assertion that he had done the same with her. 'Don't you think it was a little ill-judged of you to attack my character at the expence [sic] of your own?'[56]

Laetitia's story became widely known when the first volume of her *Memoirs of Mrs Laetitia Pilkington* was published in Dublin in 1748. Mary almost certainly read this first volume; she certainly read the final volume in 1754. Despite her husband's goodness and learning being praised in earlier volumes, Mary now described the book as 'odious'.[57] What might have provoked this dismissal, though, was not necessarily Laetitia's description of her desperate financial stratagems and of the seedier side of Georgian cultural life, or her claims about the essential innocence of her behaviour, but her detailed exposure of the eccentric foibles of Dean Swift. Modern authors now allow that Laetitia's *Memoirs* were the first to depict Swift's extraordinarily complex personality with some accuracy, but in 1748–54 these were unpalatable revelations to the majority of Irish readers, who idolised him.[58]

A DEAN'S WIFE

TRAVELS IN ENGLAND AND
IRELAND 1748–50

In the remainder of the decade the English journeys occurred in alternate
years. In between, the Delanys sometimes had time for extended forays away
from Dublin in addition to the visits to County Down on deanery business. In
early August instead of going to County Down Patrick and Mary set out for
Clogher, in County Tyrone, where Mrs Clayton's husband had been bishop
since 1745. Unusually his diocese had two cathedrals: Clogher was virtually an
overgrown village, but was an ancient religious seat associated with St Patrick;
the larger cathedral was at Enniskillen. The episcopal residence was a large
house on a steep hill, with a garden sloping down fifty steps and opposite a
steep, fir-covered hill. The Clayton's plans included building a grotto. One
incentive to visit was to include nearby Longford's Glyn, a deep ravine associ-
ated with an old Irish legend of a nymph who had fallen in love with a human
admirer. This aroused the ire of the god Pan, who snatched her from her lover's
embrace. She turned into the stream, and he the willow it nourished. The tale
was the subject of a poem of Patrick's translated from the original Irish,
published back in 1731. The natural setting was impressive. Mary attempted a
few sketches, and referred Anne to Patrick's poem for a topographical descrip-
tion. Realising they were quite close to Lord Orrery's home – he had not yet
offended them with his biography of Swift – the Delanys decided to take a day
to visit him. He was happily ensconced with his second wife, Margaret, a
County Tyrone heiress, 'sensible, unaffected, good-humoured and obliging' and
possessed of £3,000 a year. This facilitated various schemes to improve their
estate. So far they had only built a fanciful hermitage that entranced Mary. It
was on an island planted with native trees, with:

> [an] abundance of little winding walks, differently embellished with little
> seats and banks; in the midst is placed an hermit's cell, made of the roots of
> trees, the floor is paved with pebbles, there is a couch made of matting, and
> little wooden stools, a table with a manuscript on it, a pair of spectacles, a
> leathern bottle; and hung up in different parts, an hourglass, a weatherglass
> and several mathematical instruments, a shelf of books, another of wooden
> platters and bowls, another of earthen ones, in short everything you might
> imagine necessary for a recluse.[59]

All the same, these varied and pleasant scenes were not a patch on Delville, which on return looked 'enchantingly pretty'. Tiger was surely there to great her, but this time the most significant resident was young Tommy Green, whose mother had recently died, and whose father was on his law circuit. Poignantly, he clung silently to her, 'for he could not speak, but hugged and stroked my arms, and would not stir one minute from me, as if directed to beseech my protection and make up in some measure his loss'.[60] Otherwise, all the household was well, including the neighbouring Barbers. The garden too had flourished in her absence. Wasting no time after their return, the dean began that Monday with their planned private chapel, pushing out a little bay for the communion table so that it would stand clear of the central isle, and have a circular gothic window.[61]

During a cold and wet mid-October they caught up with the Wellesleys at Dangan, the first visit since Mary's marriage. Her host had recently been created Baron Mornington, and was as affable and pleasant as ever. His three daughters now had a young brother, Garrett, who was Mary's godson, but this was the first time she had actually met him, so the christening must have been by proxy. He was something of a prodigy: he studied hard and excelled, had learnt to sight-read music within a year of starting, and of course was master of fortification and ship building on the large lake and island. There were now more walks cut into the woods surrounding the lake with a variety of seats from which to enjoy the changing vistas, while 'the ground as far as you can see every way has either a tuft of trees, a statue, a seat, an obelisk, or a pillar'.[62]

The Delanys were able to make English visits in each of the following two years. The purpose of the 1749 trip was for them to secure a lease on a London house for Mary, to provide in advance for her widowhood. All visits to England meant ideally visits to four locations: to London, to the duchess at Bulstrode, to Wellesbourne for the Dewes and to Calwich to see Bunny. Early in the 1749 trip Mary made time to stay with the Vineys at Gloucester, in order to visit her mother's grave, visible from the house on College Green. It was a railed-off box grave beside the cathedral's south wall, identical to her father's at Buckland. The sight of it 'put my spirits in such hurry that I could not get the better of it for some time'. Next day, though, she summoned her spirits to go to the cathedral service, 'for there is, after all, but one method can compose the mind properly – which is, performing our duty to the best of our capacity, and praying for grace to sustain us under all trials'.[63]

After visits to Wellesbourne and Calwich the Delanys set off to Bulstrode via Oxford, where Jemmy Viney was now a student, as was the Earl of Guilford's son, Frederick, Lord North, the future prime minister, and his step-brother William Legge, future 2nd Earl of Dartmouth, after whom Dartmouth College is named. Plum cake was brought from his family for Jemmy, while Frederick and William entertained Mary and Patrick to tea.[64] At Bulstrode there was a new creature for Mary to admire and draw: 'an animal that is neither monkey, nor fox, nor squirrel, but something of each creature, very harmless and tame, and kept in the flower garden: it is larger than a great cat'.[65] This turned out to be a hare from Java. Anne Donnellan had been on the look-out for a house for them in London and soon after their arrival in late November they found one to their liking, very near the royal Palace of St James, in St James's Place. Mary thought it very pretty, and the bonus was it included 'a very good bedchamber, a large dressing-room or drawing-room if you please, a little room for a servant, and a light closet within the bed-chamber, which we hope my dearest sister will make her apartment before the first of March'.[66]

Pending completion on the purchase of the house, Patrick and Mary were back at Bulstrode, 'rummaging and sorting shells, and making preparations for a thousand works more than we shall have time to finish. Could you in any way contrive to send me 12 or 14 of your cleaned mussel shells, those that look transparent . . .' This was for a chandelier Mary was making for the duchess's dressing room, and in London Mary bought a papier-mâché ceiling rose at a specialist shop from which it could be hung. However, some of the shells Mary had sent on ahead from Ireland had, frustratingly, gone astray. Mary fanci-fully imagined that 'some envious sea nymph watches an opportunity of seizing a treasure belonging to her own regions, jealous of our rivalling her with her own productions'.[67] Anne had devised a clever drawer for organising shells and on seeing it the duchess instantly said she had to have a similar one, but as Mary drily observed, these schemes often came to nothing through lack of time.[68]

After the New Year there was a whirl of social visits – Anne Donnellan, Isabella Sutton, cousin Grace Foley, Mrs Montagu and her son Frederick, Lady Wallingford – and visits from tradesmen selling dress and curtain fabric. Cousin Elizabeth Granville now seemed definitely to be dying though none of her doctors could diagnose her condition accurately, but she went to the then rural village of Brompton with her sister in the hope of improvement. On the day when her Foley sister, Grace, was to have her most recent daughter

christened, Mary had an urgent summons to Brompton. It looked as though Elizabeth could not last the day and Mrs Delany therefore faced the prospect of breaking this sad news to Grace Foley as soon as her daughter had been baptised. But by the end of the day, Elizabeth had rallied after all. Soon Anne was able to visit and enjoy the guest apartment at St James's Place for most of March and April, before Mary's return mid-May to Delville. Her house was in 'pretty good order, and the garden is *Paradisaical*'. Tiger was very well and the tame robins still hopped close. One of the shell chandeliers had fallen to bits and her pastel pictures had become mildewed. She was able to salvage the pastels, but the chandelier was deemed beyond rescue.[69]

FROM PARADISE TO MOUNT PLEASANT AND BACK

The next prospect was to go north to County Down and settle into the new house they were renting for the deanery, Mount Pleasant. It was completely unfurnished so there was a lot to plan. On trips to Dublin she ordered wall-paper, bed linen, blankets; Mary worked at all these arrangements '*manfully*', while adding drily: '*That* expression does *not suit the occasion*, for if *the men* were to go through all the domestic bustle as we are obliged to do when we acquit ourselves properly, they would think themselves somewhat obliged by the trouble we *save them*.' However, she was appreciative of the fact that Patrick had given her plenty of time to make the needed arrangements.[70] Added to this was a round of social visits so her 'favourite employments', that is, her artistic pursuits, were pushed to the background, though there was time to wash and re-order her shells.[71] The journey north was constantly postponed, so Mary was able to report by Midsummer that the Delville garden was:

> in the high glow of beauty, my cherries ripening, roses, jessamine, and pinks in full bloom, and the hay partly spread and partly in cocks, complete the rural scene. We have discovered a new breakfasting place under the shade of nut trees, impenetrable to the sun's rays, in the midst of a grove of elms, where we shall breakfast this morning [22 June] . . .[72]

The weather that summer was so good she could dine with guests in the garden and take tea in the orangery. The visitors included Dublin's leading philanthropist, Lady Arabella Derry, whose nephew the 2nd Earl of Shelburne would

negotiate the peace with the newly independent America in 1783, and Lady Caroline Fox and her politician husband Henry. Lady Caroline had come to visit her two sisters Emily and Susan, the former now married to James Fitzgerald, 20th Earl of Kildare, and the latter in their care, as their parents were both dead.[73] These sisters were all great-grandchildren of Charles II through his French mistress, Louise de Kérouaille: Mary got out her best china when Lady Caroline and her husband came.[74] There were also reciprocal visits with the Lucan household and Mary continued to be impressed by their development of the garden.[75]

When there were no guests she and Patrick could walk over their meadows, seeing two young fawns, their coach horses being given their oats and their cows being milked. Rooms were being stripped of their furniture for Mount Pleasant, leaving Mary the opportunity to refurbish them. Her work room or 'Minerva' would have pearl-coloured wallpaper; the spare bedroom would be in blue and white, patriotically using Irish-made wallpaper and fabric. Anne, too, was in the throes of alterations and extensions at Wellesbourne: 'Have you put up your shell-work over the chimney, and painted it?'[76]

To help her children recover from various coughs and fevers Anne took them to Maplebury, which meant going through the grounds of Lady Luxborough's house at Burrells. The latter was half-sister of the politician and writer Henry St John, Viscount Bolingbroke, but had an equivocal reputation, as she was long separated from her husband, who had suspected her of at least two love affairs early in their marriage. In effect she had been banished to the country, but she countered this by holding her own as a garden designer and poet, linked in friendship to the influential poet and patron, William Shenstone. With her literary and horticultural interests, a modern reader might think she would have been an ideal female friend and neighbour to Anne: but given the moral niceties involved, Anne hesitated even to be known to have driven across her park. Women 'policed' the moral boundaries of eighteenth-century sociability through whom they 'countenanced' by visits. 'I am not vastly fond of her acquaintance, though she is entertaining, and has made her house and garden very pretty', Anne conceded. In response to this problem, Mary and Patrick took a more liberal view:

> I am vastly entertained at your being acquainted with her in spite of your prudence; but I really see no reason why her acquaintance is to be declined.

If she leads a discreet life, and does generous and charitable things, she ought to be taken notice of, as an encouragement to go in the right path, and your conversation and example may be of infinite service to her. She has lively parts, is *very well bred* [Mary's emphasis] and you may I think, divert yourself with her as much as you can, and D.D. says you will only do a meritorious thing in so doing.[77]

An alarming moment was when Anne witnessed an accident involving 8-year-old Court, newly practising horse-riding. He was thrown from his horse, one foot still in the stirrup, and was dragged along for 140 yards. The footman retrieved him unconscious, and he was feared dead – but he was only concussed and bruised and made a swift recovery.[78] News from Anne of other friends and family included confirmation that Harry Chapone was in Jamaica and his post was the lucrative one of commissioner-general (that is, procurement officer for the governor), so Mary's recommendation of him to Lord Gower had been fruitful, and that their Carteret cousin Grace, who had been a widow since 1746, had now remarried. It was a second marriage for each; her new husband was William Clavering-Cowper, 2nd Earl Cowper, a Lord of the Bedchamber to George II, and brother of Anne Dewes' correspondent, Lady Sarah.[79] The new Lady Cowper was to take a significant part in the sisters' lives and those of Anne's children.

By 21 July Mary could report safe arrival at Mount Pleasant: 'trunks, hampers, unpacking, hay flying all over the house; everybody scrambling for their things, asking a thousand questions as "Where is this to be put?" – "What shall we do for such, and such, and such a thing?"' However, thanks to an efficient new housekeeper things were soon in such good order it was as though they had been there a week.[80] The new residence for the dean was a regular Palladian block of nine window bays, with some handsomely plastered reception rooms, capacious enough for all the necessary entertaining.[81] The neighbourhood was looking forward to the prospect of a marriage between an heiress, Miss Knox, and one of the Forde sons. Mary thought that the groom's father had made a generous settlement on his son, considering he had six more of them, plus three daughters, 'but there is one *error* which most fathers run into. And that is in providing *too little* for daughters; young men have a thousand ways of improving a little fortune, by professions and employments, if they have good friends [i.e. to pull strings for them], but young gentlewomen have no

way, the fortune settled on them is all they are to expect – they are incapable of making an addition.'[82]

Mary was pleased with the garden at Mount Pleasant, '*excellent gooseberries, currants, potatoes*, and all the garden stuff; *fine salmon, lobster, trout, crabs*, every day at the door'.[83] The busy round of visits began again, including one to Hollymount, where their friendly landlord and his wife were in need of consolation for their recent loss of a daughter. At Mount Pleasant they employed the same harper who had been with them at Hollymount, and in the hot summer weather each week she held little dances of about six young people: 'I love to see them mirthful.'[84] Mary was busy making a quilt, and had embroidered a rose, tulip and auricula, and while her hands were at work someone read out loud novels, *The Adventures of Roderick Random* by Tobias Smollett, a French novel, *The Man of Honour*, and recent Irish history – accounts of the seventeenth-century sieges of Drogheda and Derry. The readers included the well-educated and shy young Miss Leonergan, whom Mary had invited for a visit to help diversify her social contacts, which, as an only daughter to a clergyman in a rural area, were otherwise rather limited. These diversions were for evenings at leisure between the 'public days', when they received the local families. Patrick and she also visited some of the repaired churches, such as Ballee, and Bright. Patrick preached there and put a lot of intensity and vitality into his sermon.[85] As they were soon to return south, Mary knew she would have to attend the Assembly Rooms at Downpatrick, since omitting it would cause offence, and told Anne they reminded her of the ones they used to attend in Gloucester.

Mary and Patrick were back home in Delville by the end of September, and found the weather as pleasant as it had been in May. She busied herself gathering 'Flora's and Pomona's gifts' – melon, figs, grapes, walnuts, pears – wondering if Anne was doing likewise; and enlisted her closest friends like Laetitia Bushe, and the three Hamiltons who, along with Mary, made up her 'Quadruple Alliance' – the now widowed Dorothy Hamilton and two of her daughters – to help her clean her picture frames. The term Quadruple Alliance referred to a political alliance in the 1720s formed to adjust the peace settlement of 1713. Did it perhaps connote that four sensible women working together could be as effective in domestic matters as four great powers were in international matters? She was able to complete her refurbished dressing room, and planned a new shell chandelier like the one she had recently made for the duchess. The reorganisation of her 'Minerva' (formerly called the English room) – with its pretty new shelves

for books and china, prompted her to reserve the little closet off for her prints, drawings, mineral and fossil collection, while in a new closet she could keep messier 'working tools' for painting , carving and gilding in a dresser.[86] This gives us some idea of the scope and variety of her activities now she had become the Dean's Wife – and the good order through which she balanced all her interests.

Life, Love and Literature in the Wellesbourne Circle

ANNE AND JOHN DEWES: LIFE AT WELLESBOURNE

*M*ary and Anne were so familiar with each other's lives they did not need to describe each other's situation, only to keep up with news in their 'journal letters'. Fortunately, Anne portrayed her life to novelist and publisher Samuel Richardson in 1750 after a brief visit to his family home in Parson's Green, near Fulham, after which he agreed to help find her a suitable governess to teach her children French before the boys went to formal school.

> Family affairs [i.e. household management] (which I am not above inspecting), my children (to whom I am school-mistress, as well as nurse), the necessary civilities of a large and kind neighbourhood, many other affairs that intervene, besides letter writing, and frequent bad fits of the headach [sic], keep me in constant employment, sometimes more than I could wish in some things, which gives me less leisure for others more agreeable to me, which is reading, and writing to my friends.
>
> Mr Dewes is as busy as I am, tho' he has quite left off the law, but so far as he can be of service to his friends and neighbours, and indeed I must say, he is a counsellor and comforter to them all, having a truly charitable and benevolent heart, and being frequently as much hurried and fatigued in assisting and giving his advice to others, as he was when raising his own fortune. A happy exchange, profit for delight!! For surely the highest joy in this world is to communicate good.[1]

Being a squire's wife was not quite as public a role as being the wife of an MP or a dean, but it was not entirely a private one either. Although Dewes had stopped practising law professionally he used his legal knowledge as magistrate (known as a Justice of the Peace), an unpaid but honoured position in each county, fulfilled by landed gentlemen and sometimes also parsons. JPs were the first tier of justice and decided which cases could be settled at that level and which needed to go to the higher criminal courts. In 1750 a score or so of local magistrates in Warwickshire, including Dewes, were involved in organising the building of a new Shire Hall designed by Sanderson Miller in the county town, Warwick. The Hall was the county administrative centre and also had an up-to-date modern jail.

Although as an antiquary and amateur architect Miller was an early exponent of the Gothic revival, his design for the Shire Hall was in the classical style. He became prominent to men and women of taste and historical inclination when he created a folly on his own estate at Radway near Kineton. This was a 'sham' castle, modelled on the medieval Guy's Tower at Warwick Castle, and was erected on the Edge Hill ridge of his property. For families with a royalist record this was an important place of memory, for it was on Edge Hill that Charles I had raised his standard at the start of the Civil War. Miller designed similar follies at Hagley in Worcestershire for Lord Lyttleton, and at Wimpole Hall Cambridge (where the Duchess of Portland had spent her girlhood, though the folly was not built until the early 1770s).

Miller's surviving diary for 1749–50 gives us some glimpses of the Dewes family and the 'civilities of a large and kind neighbourhood'. When Miller dined with the Dewes family he noted in his diary 'Saw fine drawings of plants etc.', probably Anne's handiwork.[2] Patrick Delany's enthusiasm for gardening would have made him keen to see all the local improvements when the Delanys were at Wellesbourne in autumn 1749. He climbed uphill to see the 'castle,' and also encountered Miller at Wroxton Abbey, near Banbury, about 8 miles away, the seat of the Earl of Guilford. He was one of the Lords of the Bedchamber to Prince Frederick; Miller had designed garden buildings for him, including a Gothick dovecote and an obelisk commemorating Prince Frederick of Wales's visit in 1739. Over the years Mary drew the Great Cascade (September 1746), the Indian (that is, Chinoiserie) seat (Plate 23), and the Chinese house (both 7 October 1754).

North, who married as his second wife Elizabeth Legge, the widowed 2nd Countess of Dartmouth, had a number of children and step-children, including

two step-daughters, who feature in Miller's diary, joining in music and dancing in the evenings. These girls must certainly have made similar visits to Wellesbourne, since Anne and Mary both knew the North family from court circles. Anne was a good keyboard player, and all her children played the harpsichord, while the youngest, John, became an accomplished flautist, like Miller. This was considered a gentlemanly instrument. Miller's four daughters and two sons were not far in age from the Dewes children and so the sociability must have embraced two generations. Literary interests also united the Millers, the Dewes and the Delanys: in 1750, for instance, they were all reading – and surely discussing – Richardson's latest novel, *Clarissa, or, the History of a Young Lady*.

Sometimes when Miller called in at Wellesbourne he found that the vicar of nearby Kineton, the Rev. William Talbot, was already there, and sometimes they went there together. Miller advised a few years later on historically sympathetic repairs and extensions to Talbot's parish church of St Peter. John Dewes was a friend of Rev. Talbot and he might have worshipped there as well as at the parish of Wellesbourne itself. In either case it is likely that John Dewes was a churchwarden and so helped set the poor rate, which was organised at a parish level, and was the basic social safety net for the low paid and indigent. Churchwardens took note of church attendance and might visit to see if non-attenders were ill or disaffected; they also made arrangements for widows, orphans or illegitimate children, disbursing private local charitable funds. Some of the legal advice Dewes gave *pro bono* would have been to artisans or cottagers who might have been literate but not versed in legal matters. Wellesbourne itself was a centre of piety, with family prayers said at nine each evening.

As in Gloucestershire, gentry families like the Dewes would have also been on visiting terms with or related to their MPs; John was connected by marriage to one of the two MPs for the County of Warwickshire, Sir Charles Mordaunt. Mrs Delany rather regretted that John never wanted to become an MP himself, but recognised that he, like Patrick, lacked a certain thrusting ambition to propel them further forward. Back in Gloucester one of the new MPs after the 1751 election was Charles Barrow, the son of a West Indies merchant, who had made money, bought the Highgrove estate near Gloucester and succeeded on his second try on getting his seat in the Commons. Mary rather admired his determination:

I really esteem the man for having made the most of his talents, and raising himself to the dignity which once we little thought he could ever aspire to. And he must have good *sense* as well as assurance to have gained such a point . . .[3]

In 1748 Miller had designed a folly for Sir Charles Mordaunt at his Walton estate, within walking distance of Wellesbourne. It looked like a charming octagonal garden pavilion, but was actually also a practical one: a cold plunge bath, to help ease Mordaunt's rheumatism. The upper storey was an attractive room with large sash windows and beneath was the rugged, grotto-like bath (Plates 24 and 25). After a few years Mary designed some shell decoration for it, and sent over several barrels of shells from Ireland for Anne, some of which were to be used for the purpose. The decorative conceit was that the plaster work represented 'a wall worn by water-drops with icicles sticking to it', so the festoons of shells in the room were '*additional ornaments*; or how could they come in *that form* unless some invisible sea nymph or triton placed them there for their private amusement?'[4] These 'nymphs' – in reality Sir Charles' daughters, under the direction of Anne, and Mary once she was able to visit, had put up festoons on each of the eight sides, above doors and windows, and just under the circular base of the domed ceiling, which had the small plaster 'stalactites' hanging from it. The rococo conceit of the garlands being installed by water creatures perfectly illustrates Mary's playful attitude, together with the decorative flair and zest of her shell-work. Miller's biographer credits her with being an influence on him.[5]

Also not far away was Charlecote House, belonging to the Lucy family, where Shakespeare had famously poached deer; and a little further up the social scale was the Willoughby de Broke family, who, as earls of Warwick, resided at the castle. When Lord North's daughter married into the de Broke family, the Dewes' contacts with it increased. Anne Dewes of course kept in touch with 'the Throcks', Sir Roger and Lady Catherine Throckmorton, who had brokered her successful marriage, and lived at the Tudor ancestral home of Coughton, about 12 miles due west of Wellesbourne. From 1756 to 1761 the immensely wealthy John Spencer, son of the sisters' Carteret cousin Georgiana, was MP for Warwick; John Dewes found him very agreeable.[6] Others Mary and Anne mention include the perennially youthful philanthropist, the widowed

Lady Anne, dowager 2nd Countess of Coventry, who lived 9 miles away in the village of Snitterfield. She was an early friend and patron of Mary Astell, a published writer of religious reflections, and an avid bibliophile. Elizabeth Elstob tried to get hold of her own books to give her, and Anne obtained a French book about shells for her as she was a fellow-connoisseur. Finally, they knew the wealthy merchant John Boyd, a future baronet, whose father-in-law, William Bumstead, owned Upton House and was advised by Miller on improvements.

When Anne married, her mother gave her a recipe book that had been compiled by their mother, which meant some of the recipes were written down in Spain – in Malaga and Madrid as well as Cadiz. The recipes include ones for making medicines to aid sleep, sore nipples, early pregnancy, constipation – poppy water!! – a powder for a woman in labour and a plaster for the chest.[7] Mary thought her sister was particularly good at organising her store cupboard. 'Trifling and insignificant is my storeroom to what yours is! Mine fills only an idle mind that wants amusement; yours serves either to supply your hospitable table, or gives cordial and healing medicines to the poor and sick.'[8] The comparison was probably not that stark; Mary habitually praised her sister, was not behind-hand either in hospitality or plain sewing for the poor, but it might have been the case that she devolved more direct responsibility to storing foodstuffs onto her Delville housekeeper.[9] This 'plain sewing' was doubtless always to hand, to be taken up in any spare moment. Together Mary and Anne also made the more elaborate bed-hangings, bedspreads and chair covers. A large bedspread survives, in the Ulster Museum, designed though not necessarily all executed by Mary. The foliated pattern is made of white knotting, attached to the linen base, producing a very elegant white-on-white effect (Plates 35–7).

In addition to this practical management she was home-schooling her four children in their early years, and would keep her daughter at home when her sons went off to formal school. With so much on her mind Anne had a tendency to headaches. One reason it became so hard for her to cross the Irish Sea to visit the Delville household was that it was logistically difficult for everyone to be simultaneously in good enough health when the Delanys were in residence at Delville rather than Mount Pleasant, and slow communications made firm forward planning difficult. Even going from Warwickshire to her brother at Calwich was hard enough for Anne: when Court had the fall from his pony, the others had whooping cough, and the visit to Bunny was delayed by a month. Sad though it was for Mary, who was so eager to show her sister the delights of Delville and the

attractions of Dublin, it was in reality easier for the dean and herself to come over from Ireland in the Viceroy's yacht and incorporate the visits to Wellesbourne with others to Calwich, Bulstrode and London.

Wellesbourne Hall itself was a fairly modern building, built at the start of the eighteenth century in traditional Warwickshire red brick (Plate 19). The overall footprint of the house was quite deep, extending back in an H shape, and included the new practical additions that the couple commissioned before they moved in. These included a painting room. In time at least two of the fireplaces had shell-work made by Anne with input from Mary.

Given how much Mary described the garden at Delville to Anne, it must be assumed that Anne's letters to Mary would have done the same about the design of Wellesbourne's garden. But apart from the letter that informs Anne that she is sending over the shells for the Mordaunt Bath House, with a larger barrel for Anne's own use, there is no reference to any garden *design* of Anne's own making. Such a keen plantswoman must have had a cutting garden, substantial kitchen garden and herb garden for medicinal as well as culinary use, and an orchard. Mary describes John Dewes as 'visiting his grounds and his woods', which suggests the recreational ground and the forest were separately delineated and treated. Managing and selling the timber would have been a significant part of the estate's income. The only clues about the garden side to Anne's life are some references to specimen plants such as ladies' slipper, which the duchess explained to Mary was rare, requesting a specimen of it, or jagged spearwort, identified as such by the duchess, but known to Anne as Runnet or Rundle grass.

DEBATES ON LOVE AND MARRIAGE

When mid-century men and women debated the nature of marriage, the rights of wives and daughters vis-à-vis the power of husbands and fathers and the sexual indiscipline of men or women, they did so partly through real-life accounts such as Laetitia Pilkington's; partly through legal procedures for separation reported colourfully in the press; and partly in response to serious fiction with moral intent rather than trivial or sensational entertainment. The greatest exponent of moral fiction by 1750 was Patrick Delany's printer, Samuel Richardson, who had become an author himself when he published his 1740 novel *Pamela; or, Virtue Rewarded.*[10]

This tale of a servant rising to gentility through her moral integrity was not a feminist story in the modern sense. However, in imaginatively depicting a woman's emotional and moral dilemmas, in letters from Pamela and others, it spoke for the female point of view, and gave a boost for female moral courage, including the right to defy a social superior who was also a moral inferior. Richardson attracted an enormous female readership, and a handful of selected female friends as well as Richardson's male friends emerged, who read and discussed the character of his next heroine, the eponymous *Clarissa*, published in 1748. Clarissa too was defending her virtue from the archetypal rake, Lovelace, who had determined to prove that even the most virtuous woman could be seduced. Since Clarissa was known for her virtue and piety, if she above all succumbed it would clinch his argument that all women were ready to yield to persuasion. But Clarissa only yields because she is drugged: hers is a rape, not a seduction.

Before she is the victim of male seduction, though, she is also a victim of patriarchal control, since the starting point of the plot is Clarissa's resistance to her father and brother's decision that she should marry an unappealing suitor who wants control of her fortune. The debate on patriarchal rights that ensued was thus a debate about authority in marriage, and the differing roles expected of men and women, in which elite as well as the middling sort women participated. Thus an important link between the religious and aristocratic feminism of court coteries like Mary Pendarves' circle, and the middle-ranking feminism of the Richardson circle, is the friendship between Mary Delany, Anne Dewes and Sarah Chapone, together with Sarah's daughters and future daughter-in-law, Hester Mulso. Hester and her brothers John and Thomas, her close friend, Mary Prescott, who had a long engagement to Thomas Mulso, and the writer John Duncombe, a clergyman and male feminist who celebrated female achievement in *The Feminead* (1754), represented what would now be called the middle-class intelligentsia. John Duncombe's wife Susanna, daughter of the painter Joseph Highmore, depicted this middle-ranking reading circle in Richardson's garden in North End, the area of Fulham where the Stanleys had lived (Plate 27). Anne Dewes and Isabella Sutton, daughter of Mary's old friend Judith Tichbourne by her second marriage, and a peeress from outside their circle, Lady Braidsaigh, could supply insight to Richardson into the outlook of higher-ranking folks.[11]

By 1740, when *Pamela* appeared, Sarah had become immersed in her children, educating her daughters herself and sending her sons to school in Gloucester.

Her letters, said the happily single Mary Pendarves, were mainly on domestic matters.[12] Sarah later explained to Richardson, 'My 4 children are as 4 large avenues to my Heart, through which, their pains and pleasures rush in, in mighty torrents.'[13] But her preoccupation with childrearing and early years' education had not prevented her from reading, and Richardson had occupied a central role. Indeed she told him that the character of Pamela had been invoked constantly as a moral touchstone: 'the blooming Virgin, replete with every Grace, entered their ductile hearts and diffused a faint resemblance of her Sweetness and Manners, and gave some small tincture of the Justness and Solidity of her Sentiments to their puerile Thoughts and Performances'.[14] Thus when Anne Dewes introduced Sarah by letter to Richardson, she sounded almost like a gushing schoolgirl, and in her correspondence with the author on the fictional Clarissa's behaviour her underlying religious and moral philosophy is more explicit. Her close friends must have known her standpoint, but she had only hinted at it in public when she wrote her pamphlet on the *Hardship of the English Laws*.

Essentially, she took issue with Richardson that a woman should be obliged by her parents to marry against her private judgement, arguing that this forced promise was tantamount to perjury. By contrast, he maintained that the laws of God enjoining obedience are stronger than the legal age of marriage at 21, and that in any case parents have a natural right to the obedience of their children while they live under their protection and are a part of their household. What counted would be the effort made by a woman once she had married; it would not be perjury to make a promise about the future.

Sarah, however, maintained her interpretation that this *was* tantamount to perjury. Even if it was true that contracts do come into being in the future tense, they still rest upon the union of man and wife, which cannot be dissimulated. Love and honour are the vital points; protection and obedience are duties that follow on from this. Along with fidelity they depend on the will, and can therefore be performed. But judgement must come first. 'Should a man force gall into my Mouth, no command of another, or Resolution of my own, could enable me to love him who appears to me quite unlovely, or to honour him who appears to me no way estimable.' She argued that we cannot alter our human nature, even if 'mischiefs' ensue.

Men often make use of their Hands to do more Evil, by Murders, Thefts, Robberies, and Wars, than ever they can do good with them; yet this would

be but an ill Argument for cutting off the Hands of our Children, as soon as they are born; but it would be worse to divest Men of their Understandings and Liberty, because their private judgements might mislead them.

Submitting private judgement to authority, including the authority of parents, is therefore fatal because actions can't be undone; whereas people can always revise their private judgements. She believed this was even more important in spiritual than material decisions. In Richardson's worldview, women were constantly being preyed on by unscrupulous fortune-hunters: 'The designers of our sex' make a beeline for single women but are 'afraid of guardians and parents'. In contrast, Sarah argued for a more spiritual interpretation of marriage – not just a contract, but 'a Solemn Engagement'.

> Only free agents can dispose of themselves in an institution made by God
> . . . suppose a Woman does not look upon Marriage as a common Bargain,
> and does not chose to be barter'd for like a Horse or a Cow, she may chance
> to consider it as a religious institution, and not as a civil ordinance, and that
> her Compliance with this civil ordinance is chiefly declaratory of her inward
> Resolution, that by the Grace of God She will perform all Duties required
> of her by this Religious Institution.

With her usual touch of astringent wit, she added, 'You say Truth, sir, That suffering is the test of virtue; but you would not from thence infer, that it would be advisable for a Woman to marry a Man, because she thought he would make her suffer.' In fact it was Sarah's independence of tone that disconcerted Richardson as much as the substance of her arguments. He considered that he had answered many of Sally's ideas about the rights of women in his letters to Hester Mulso, and he referred her to this correspondence. Instead of answering all her points in detail he exclaimed rather incoherently, 'Lord Madam how far you carry it! What an imagination you have.'[15]

MARY ASTELL AND OTHER 'WOMEN WORTHIES'

Discussions about love and marriage were prevalent elsewhere in Wellesbourne circles too. The vicar at Kineton, William Talbot, had connections both with the feminism characteristic of Sarah Chapone and her conversations with

Richardson, and her earlier project to rescue Elizabeth Elstob from penury, which had ended up with her accepting the position as governess in the Portland household. William Talbot and his wife Sarah became part of Sarah Chapone's efforts to celebrate learned women like Elizabeth Elstob. Since the 1730s, George Ballard had been given a fellowship at Magdalen College, Oxford – partly through the influence of Sanderson Miller. When Ballard visited Warwickshire, William and his wife gave him hospitality and encouragement.[16] As Ballard drew near to completing his book, *Memoirs of several ladies of Great Britain, who have been celebrated for their writings or skill in the learned languages, arts and sciences*, he started to think about suitable dedicatees for it among ladies he admired and who had helped him. Sarah Chapone demurred at being a dedicatee, but agreed to be his literary executor. So instead of a dedication to this Sarah, Ballard made a joint dedication of the first part of his historical studies to the Rev. William Talbot, and his wife, another Sarah.

Sarah Talbot's voice survives in a few letters to Ballard. He thought Sarah's marriage to William Talbot was a model one, and suggested she write a treatise about it, but she declined: 'It would require one uncommonly acquainted with religion, with human nature, and the world, to write with success, for my part I do not feel myself of that number, and therefore cannot be induced to make that attempt by the kind partiality you show me.' Another letter from Sarah Talbot discusses Astell's *Some Reflections upon Marriage*, lent her by Ballard – who had been given it by Sarah Chapone. Mrs Talbot writes that she would have been startled into re-examining all her reasons for her choice of husband if she had read Astell before her wedding, but was pleased to find her own rules for choosing were compatible with Astell's. For 'nothing but religion bearing influence over all' can ensure 'the least prospect of a lasting happiness'. To paraphrase, reason is provided by Providence as a guide; if it were recovered as a guide then there would be no need to debate the superiority of either sex. Each would endeavour to strengthen the common good: 'Our sex would be early taught to form their hearts by its dictates and yours to regard and treat them as reasonable creatures.' Thus behind the diffidence, a stronger character emerges: 'The little circle women have to act in is not so trifling as may be imagined.'[17]

Rather to Mary Delany's dismay, Ballard now asked if he could dedicate the second part of his book to her. She was appalled, considering it unladylike to be in the limelight. But the dean felt that it would be an encouragement to Ballard if she agreed, although, as it was well known that Swift had regarded his

wife highly for her literary intelligence, it was not appropriate for an unknown scholar to be *too* fulsome in implying a personal acquaintance with her. Mary demurred entirely and confessed to Anne that it was a point of some disagreement between herself and Patrick that she should acquiesce, whatever form of words Ballard was to use. Various letters passed between Anne Dewes, Chapone and Ballard before an acceptable form of words was found.[18] So in Gloucestershire, Warwickshire and Oxford, in country parsonages far from the metropolis or even a provincial city, women were thinking about the nature and status of marriage and of married women. They believed that in a libertine age, their Anglican faith provided a moral shield against abusive marriages, looked back to Mary Astell's assertion that reason had no sexual character and supported the idea of female civil equality before, during and after marriage.

SINGLE WOMEN AND THE IDEAL MAN

The advantages and disadvantages of the single state were already embodied in the lives of two of Mrs Delany's close friends, Anne Donnellan and Isabella Sutton. They also joined in the conversation with Richardson and his other female advisers as he developed the character of his perfect man, Sir Charles Grandison. His chief real-life male exemplar for this paragon was later widely believed to be the much esteemed William Legge 2nd Earl of Dartmouth, at this point still only a young man, but already recognised as profoundly devoted to religion. Mary's advice to Richardson for creating a 'good man' was that he should 'make him brave and avoid duelling, that reigning curse',[19] and indeed a key point of the novel is when Grandison refuses to duel with the villain of the plot, Sir Hargrave Pollexfen, who goes to the length of kidnapping the heroine, Harriett Byron, in the effort to make her agree to marry him. Mary approved of the finished work on the whole, and thought that Grandison's character was 'faultless' but for one blot, which was the mutual agreement between him and his eventual wife, Clementina, an Italian woman and thus Catholic, that their sons will be raised as Anglicans and their daughters as Catholic. 'Had a woman written the story', Mary observed, 'she would have thought the *daughters of as much consequence as the sons*, and when I see Mr. Richardson I shall call him to account for that *faux-pas*; but on the whole it is a most excellent book calculated to please and to improve all ages'.[20]

Anne Dewes was less specific in her advice. She was keenly aware that women who wanted to marry men without a libertine past (with its attendant risk of

sexual disease – though this was never spelt out), and who would make stable husbands commanding a woman's respect, found that in real life they were likely to be disappointed:

> I believe the young ladies hardly know themselves, for want of patterns, what an agreeable man, with religion and sense, is; which makes me wish you would show them one. They are so used to see those they think genteel and polite, without morals and religion, that they imagine them almost, if not quite, incompatible; and are afraid that if they insist too much on the last, they must give up the first.[21]

In 1751 there was a sequence of deaths in Mary's circle of friends, relatives and public figures. Nearly all had an immediate impact on the women who were connected with them, including several 'singletons'. The first, in early January, was Don's brother, the consumptive clergyman Christopher (Kit), followed soon after by their mother, with whom Anne had shared a home, but with a lot of independence.[22] In March it was Frederick Prince of Wales, and then in April his Gentleman of the Bedchamber, Mary's tormenting former suitor, Lord Baltimore. Finally in May it was the turn of her uncle Lansdowne's step-son, Thomas Thynne, 2nd Viscount Weymouth, who had never recovered his domestic happiness after losing the wife Mary had found for him, her Carteret cousin Louisa (pp. 75–6).

Princess Augusta's bereavement was marked by public mourning, especially by those who had connections with the prince and princess's households. Mary felt for her: as a royal figure she could not retreat into private solitude when she felt like it:

> *She* can have no friend to make up such a loss, and in that, as in many other circumstances, royalty is denied of many comforts which their subjects enjoy. The dignity of her station requires her to appear in, and receive crowds, when her mind is oppressed with a sorrow which would rather seek the darkest shade: *it is impossible* she should *not* feel such a loss, which not only affects her tenderest affections, but also her interest and her power.[23]

These were astute comments: the worst scenario for Augusta was that her grandfather-in-law, George II, had the legal right to take all her children into

his custody because they had a claim on the throne. In fact Augusta was able to play the disconsolate mother so effectively that she was able to retain her control – a big asset since this kept her still at the forefront of influencing the future George III's education, demeanour and even his future marriage.[24] Financially she had less shared income at her disposal since the money Fredrick received as Duke of Cornwall now reverted to the crown. But she was hardly penniless.

For Mary, the big question was how to replace the income her cousin the Hon. Anne Granville had been receiving from the Thynne estate. This was finally resolved when the Duchess of Portland stepped in and secured a government pension for Anne, doubtless by putting pressure on her own relative, the Duke of Newcastle, at that point Secretary of State. She had hoped for £300 p.a. but managed to secure £200, ending Mary's constant worries for her cousin's future.[25] It also made Mary ponder, in the same letter to her sister giving her this news,

> Why must women be driven to the necessity of marrying? A state that should always be a matter of choice! And if a young woman has not fortune sufficient to maintain her in the station she has been bred to, what can she do, but marry? And to avoid living either very plainly, or running into debt, she accepts of a match with no other view than that of interest. Has not *this* made matrimony an irksome prison to many, and prevented its being that happy union of hearts where mutual choice and mutual obligation make it the most perfect state of friendship?[26]

At least lack of means was not forcing Isabella Sutton to find a husband. In 1734 she had been chosen as one of the Maids of Honour to Princess Anne when she married the Prince of Orange – pipping Anne Granville to the post. Her father's losses as one of the disgraced South Sea Company directors had made a court appointment with its attendant pension a wise goal, though this particular appointment was brief, as the Maids all returned to England after accompanying the bride to Hesse. Mary watched Isabella grow from a thin, rather introspective, bookish girl, to a young woman, and gradually warmed to her. Her father had died in 1746, and by 1750 so had her mother, so authority in her immediate family devolved on her brothers, John, an epileptic, and Richard, who followed the route of university and then legal study before becoming an MP and later a statesman. By her mid-twenties, Isabella had become friendly

with the Duchess of Portland and Anne Donnellan, with the latter being a particular if demanding friend. She, Isabella and Sarah Chapone all shared similar religious views.[27] It is likely that Isabella's contacts with these older women had also strengthened a reluctance to marry, especially if there were few candidates who combined rank, politeness and devout Anglican Christianity in the right proportions, so she was still husband-less when she was introduced to Samuel Richardson in 1751.

Richardson already harboured prejudices against well-connected and affluent Isabella. He revealed in a letter to Anne Dewes his discomfort with fine ladies who lived in the expanding West End, filling their time with people in high life, who:

despise the metropolis, which furnishes them with all their beloved luxury, they are building fine houses out of pigsties, and cow-houses, and dog-kennels, in situations which are a hundred times less eligible than the dirt-iest parts of Whitechapel, as it seems for no reason, but to get as far removed as they can from the city. This is taste – and Miss Sutton keeping such company generally, they take up her time too much for her to think of her city friends, tho' she has too much goodness to despise them for being so unfashionably situated.[28]

Anne Dewes gently pointed out that 'the custom and fashion of the world must in some degree be complied with' – in this instance, the taste for living nearer the west – and her sister Mary explained:

Her mother was for near forty years my most steady and well-beloved friend, and I have often promised her, if I outlived her, to show all the friend-ship in my power to her daughter. Dr Delany's generosity and indulgence to me on all occasions puts it in my power to keep my word with my dear deceased friend.[29]

Richardson's sensitivity over differential status must have been mollified, and Isabella, after a diffident start about her suitability to contribute to the evolu-tion of his invented Sir Charles, hints in her first letter that women of like mind, who wanted to marry virtuous men, could try to exert a certain degree of collective pressure:

I believe . . . the idea of a perfect man has been greatly defaced by the scarcity of examples in these later ages, and that the impossibility of making them good, has induced the ladies to contract their pretensions [that is, their expectations] too much. I don't doubt but if they could be all brought to one in the design, a reformation might in some measure be effected; and no method is more likely to persuade, than convincing them by such arguments as in Clarissa [sic], how conducive it would be to their happiness; but then, in the meantime, each particular is apt to think she can do nothing alone towards stemming the torrent, and so they suffer themselves to be borne away by it.[30]

She divided her time between living in London, renting a house next door to her brother John, who covered all the household expenses; visits to John's country seat and their Sutton cousins in Northamptonshire; and to Anne Donnellan and other acquaintance.[31] In 1750 she had agreed for the time being to make her London home with Anne Donnellan, because her brother Richard was abroad, but Mrs Delany observed that Anne was not completely content with her – 'she thinks her not acknowledging or affectionate enough'.[32]

It is clear that Isabella's freedom of movement bothered Richardson a great deal, even if both sides spoke of it in a teasing manner. When she mentioned that she would stay in Norfolk before coming to London, he said: 'How unaccountable are young ladies, who have not the blessing of a *controlling*, or perhaps it would be better said, a *persuading* husband.' In October 1751 when she was in Northamptonshire, she explained her slow replies were due to her social obligations:

What has hindered me from doing almost everything I ought, has been the continual hurry I have lived in ever since I came here; the neighbourhood is extensive, and very sociable, so that we are daily received or paying visits, and three times this week have come home in the evening . . . You can't imagine how this racketing discomposes my indolence.

To which Richardson replied, 'These abominable racketings!! Must they be wherever ladies are?'[33]

Two years later Richardson was still teasing her about her 'racketing' when he wrote in early July, a time of year when the 'quality' normally were making rounds of rural visits, quoting from her last letter:

'Tomorrow set off for Yorkshire . . .' The beginning of *last* week it was, that I called at Miss Sutton's house; at the beginning of the *next* week I am informed, that on Wednesday she puts wings on her shoulders . . . O that some Sir Charles would pin you down to some happy spot, and take the gad-fly from your cap! How unsettled is a woman that is not settled![34]

Perhaps Isabella would have been more ready to 'settle' if there had been more real-life Sir Charles Grandisons available: 'you should not tantalize one with such a pattern, unless you intend to make two or three dozen men by it for the use of your friends, whose taste you have spoiled'. But with Isabella's £10,000 per year income, Mary Delany considered she should not be in a hurry to marry. When a Mr Knight fell in love with her, she considered 'her circumstances will keep her very single'.[35] But Mary knew equally that when Isabella was in mixed company she made a good impression on men. The following year, when Isabella was visiting Wellesbourne, Mary commented, 'happy the person that could engage her for life, but I *don't know* the man that deserves her', and 'I want to know how Miss Sutton likes Charlecote [one of the most beautiful of Warwickshire houses, whose master, George Lucy, was still a bachelor at 40]. If the master of it is not charmed with her, he must be a "*deaf adder*" indeed! And if he is I shall pity him, for *I fear she will not* think him worthy of her smiles.' She regretted that her brother Bernard had not sufficiently a 'sentimental heart' for if he did, 'he could not withstand the charms of our *belle amie*!'[36]

In the autumn of 1751 Anne Donnellan came to Ireland to settle her affairs and decide where to live, and stayed with the Delanys. Mary confided to the Duchess of Portland she was apprehensive about this visit: not only was Anne in a hyper-sensitive state of bereavement, she knew that the latter was prone to vary her humour with even her best friends: '*some tempers*, like *some constitutions*, have an acid that at times makes everything disagree with them. I shall guard against it as well as I can'.[37]

Mrs Delany was right to anticipate trouble. At the first meeting between Anne and her sister, Mrs Clayton, both thoroughly lost their tempers – 'I saw such a scene between the sisters last Monday as frightened me; such taxing on both sides, unkind words and behaviour, such high looks and words, and so impetuous, that it was impossible to say a mollifying word.'[38] She tried next day to act as peacemaker. The cause of this anger was that Anne's mother and brother had each left her all their property, and the Claytons were contesting the will.

Legal complications meant that Anne would not inherit Kit's £2,000 a year in any case, but would still benefit from £6,000 from her mother. Meanwhile, the Claytons were 'in *vast* circumstances . . . How strange and how worthless are such enviers'.[39] The feud between the siblings festered on for the next year.

Mary was always prepared to see life as a comedy of errors, as well as a challenge to moral character. Not long after Anne's arrival, Mary accompanied Mrs Clayton at her invitation to the Lord Lieutenant's levée that observed the king's birthday. Mary was in the Delanys' own coach while Mrs Clayton had a sedan chair with three footmen dressed in green, the Hanoverian colour, and wearing orange cockades, to commemorate the Protestant victory of William of Orange at the Boyne back in 1692. Mary astutely decoded the situation to her sister afterwards:

> Can you tell *why* she desired me to go with her? I can. She was superb in brown and gold, and diamonds; I was clad in the purple and white silk I bought when last year in England; and my littleness set off her greatness! These odd fancies *make me laugh*, and not a bit angry: only rather self-satisfied, that I feel myself above doing the things which make the actor so despicable.

Mary also noticed that the Duchess of Dorset looked suitably splendid in blue with gold embroidery done in Ireland; but her husband was the current Lord Lieutenant, so it was right they should look 'graceful and princely'.[40]

Of course Mary and her house guest particularly enjoyed Dublin musical life, either by attending social occasions such as the Lord Lieutenant's concert for his own birthday, or by playing and singing each evening at home.[41] 'Philomela' (Anne Donnellan) had retained her fine singing voice, and she must also have been a pleasure to listen to when she took her turn at reading out loud. Don soon decided not to live in Ireland and returned to London. She had a house built for herself in Charles Street, off fashionable Berkeley Square, and continued to be a gracious hostess. Handel remained a friend and remembered her in his will, and many of her soirées must have featured music. Mary kept in touch with her, but increasingly found her very exacting; in 1754 she sighed wearily to her sister, whom she knew would understand the difficulty:

> When a long train of friendly offices, and attention *to one's utmost power* has been offered, and the sacrifice not accepted, it is then time to *grow selfish* and

184

do only what is quite convenient and agreeable to one's self, though I hope I shall never . . . withhold any comfort or *reasonable satisfaction* in my power to bestow.[42]

Six years later Anne died, but left a public legacy that endures to this day: a bequest to Trinity College Dublin for a triennial series of lectures, known as the Donnellan lectures 'for the encouragement of religion, learning and good manners', funded from the sale of the house.[43]

Soon after Anne left for England, Bishop Clayton lost all prestige by a heretical interpretation of the doctrine of the Trinity. It cost him further preferment in the Church in becoming an archbishop, and his wife was ill from disappointment, 'with a pain in her face, and many hysterical complaints'.[44] Bishop Clayton died in February 1758, leaving his wife '£1800 a year and a *vast* personal fortune – houses, plate, everything for her life, *unless* she marries again'.[45] Despite the cooling of their friendship, Mary was loyal to 'Don' when it came to the latter's vain and pretentious sister. But being left on her own, and the widow of a disgraced bishop, did not bring Don and Mrs Clayton any closer. In 1759 Mrs Delany was dining with Mrs Clayton and afterwards:

> the discourse ran upon women living single: she said it was a foolish scheme, for *after forty* it was awkward because they *were insignificant:* and she spoke with great contempt of them. I was angry at the indignity, and said, but with great calmness, 'I *wonder you should say so, for who makes a better figure, or lives more comfortably than your sister Donnellan, whose drawing-room is constantly filled with the best company, and whose conversation is much sought after?*' It would have diverted you to have seen how blank she looked. 'Oh! She said, but they grow jealous and suspicious.' – '*Not at all,*' said I, '*unless they were inclined to it when young.*'[46]

Mrs Delany's unmarried friend Laetitia Bushe represented another solution to the problem of genteel singlehood. Possessed of much less wealth than either Anne Donnellan or Isabella Sutton, she had no scope for the kind of larger scale hospitality Don could provide, nor as many relatives as Isabella possessed. But for most of the year she followed a round of private sociability with a variety of friends, and some relatives, although she also kept a modest base of her own in Dublin. Her musical and artistic talents and her conversational sprightliness

made her a welcome guest. S.J. Conolly, who has pieced together a biographical sketch, has emphasised that she wanted to remain an insider near the top, as her father had been in his capacity as secretary to the Lord Justice of Ireland, the Earl of Berkeley. Conolly also suggests that the quartet of female friends in this first Irish visit, pairing off as Anne Donnellan with Miss Kelly, Mrs Pendarves and Laetitia Bushe, might have had a particularly intense charge, which Mary noticed but did not capitalise on when they were all in Dublin together. But when Bushe later met Lady Anne Bligh, in about 1739, the intensity may have been greater, at least on Laetitia's side, and Lady Anne more susceptible to it. For a while it seems to have been a significant relationship to both of them, and Letty was very pained when Anne married a Robert Magill – although she suppressed her partiality and later stayed with them at their country house.

The high-flown language of friendship and sentiment that characterised the Clayton set that first time in Ireland, borrowed from French and Italian romance, make it impossible to evaluate these female friendships or conclude there was an erotic dimension to them – be it suppressed or expressed. The rococo style of language was very effusive, and in the literary tradition they were emulating, for every extrovert heroine there was usually a quieter, wise confidante. When Mary returned to Ireland in 1743, she was happy to resume the friendship, which she valued in large part because Letty was an important inspiration for developing and sustaining female artistic talents.

What Mary could not know was that between these two phases Letty had been so strongly drawn to Lady Anne Magill. This coincided with her recovery from smallpox and the inward knowledge that her now-blemished face was unlikely to be her fortune via an advantageous marriage, and that her own income was unlikely to attract a mercenary match. In the 1740s, still recovering wistfully and somewhat bitterly from the closest phase of this friendship, the Delany circle must have offered Letty a helpfully distracting focus from her secret unhappiness. Letty was both musical and bookish, and Mary valued her company, especially over Christmas and the early part of the new year, when the days were still too short for her to be overmuch inclined to drive to Dublin. It helped keep up everyone's spirits to entertain a little at home when seasonal visiting was awkward until the February days lengthened and the oratorio and dramatic season began in Dublin. Letty always had something intelligent to say and never felt she had to be the only resident friend, blending happily in if the Barbers or the Hamiltons were visiting. Conversely Mary liked

being included in dinners orchestrated by Laetitia when favoured cousins or friends were in Dublin. Finally, Laetitia was a sincere friend and moral support during the difficult phases of the lawsuit, discussed in the next chapter. When she died in 1757, while Mary and Patrick were in London on legal business, the former reflected 'she was truly good and affectionate, and it is melancholy as one advances in years to lose those we think truly love us. Her disorder made a quick progress, but she is graciously released, and in her last moments set an example of true Xtian [Christian] fortitude and resignation.'[47]

The Lawsuit Years

THE LAWSUIT

*I*n the 1750s a shadow fell across the happy union of Patrick and Mary – not from any lessening of their affection, but from an unexpected legal inter2vention from the previous Mrs Delany's relatives, who were determined to challenge Patrick's integrity in how he had treated his step-daughter. By 1752 it was beginning to dominate their lives. Each spouse sustained the other, and coped in similar ways – by keeping busy with their duties and their recreations, maintaining their devotional practices and relying gratefully on the affection of friends and family. For Mary and sister Anne, the fact that John Dewes was a trained lawyer was an extra element of help, as he could combine his warm concern for both women with reassuring legal acumen. Mary always found something to do, and when there were no prevailing social obligations, there was a home to manage and embellish:

> I bustle about as much as I can, and am very busy making ornaments for the chapel, which I believe will be finished this spring. I don't know how to describe in a letter what I am doing, but I assure you *I do everything I can to rouse* and amuse my spirits; and if you and I, my dearest sister, had not many years pursued this method, *what would have become of us?*[1]

Another source of strength was to remember that as a Granville, she was a soldier's daughter, and must live up to the family reputation for fortitude and valour.[2]

The essence of the case being made against Patrick by the Tennisons was that in telling his wife's maid to destroy the private legal agreement, he was despoiling the rightful inheritance that should have gone to his step-daughter and after her death to *her* relatives. Patrick had believed that his first wife's death released him from their mutual agreement, and as his step-daughter never married and died young, there was nothing more to answer, so Patrick remained free to inherit from his wife. The legal fact, which was eventually clarified, was that there was indeed a case to answer, as Miss Tennison did have legal heirs even though she had died unmarried and childless, and her mother's money should have gone to her Tennison relatives. The implication of their suit was that Patrick had destroyed the marriage agreement deliberately, in order to benefit from his wife's fortune – a serious aspersion on his moral character. But even though he and Mary realised that the law might compel them to give the Tennisons financial restitution – literally paying for Patrick's mistake – what mattered most to them was that he would be vindicated from the legal charge of 'spoilation'. As their friend Don said, she hoped that the Irish Lord Chancellor would realise that Patrick acted 'incautiously in forms of law', but 'he has done it *in the integrity* of his heart'.[3]

Given that Mrs Tennison's maid was no longer alive, the court only had Patrick's word for the whole episode of when and why the marriage settlement was burnt. Moreover, the Mr Burke who had drawn up the settlement had gone to Jamaica. The only recourse was to send their agent, Mr Emmerson, to obtain testimony from Mr Burke, who confirmed a copy of the settlement existed back in London. This took up about a year.[4]

Few knew the amount of emotional and spiritual effort that Mary needed to maintain her serenity, like the proverbial swan who is constantly paddling underwater. Thus she kept her guests cheerful, while also consoling herself 'this world is not made for happiness; how vain, how uncertain all our schemes! We must aspire to something higher, and look on all these disappointments as so many weanings from a world so vain as this is.'[5] When Emmerson at last arrived back in Ireland, he brought with him sweetmeats and half a hogshead of matured rum from Harry Chapone, and a welcome sack full of decorative Caribbean shells for Mary.[6] Later in the summer the Delanys set out for County Down, accompanied by seven servants and taking six horses: hardly retrenchment!

But soon came great disappointment: the first stage of the lawsuit went against them. Mary tried to remain grateful amidst all this for her blessings,

such as sister Anne's friendship, and to hope fervently that Patrick would be able to vindicate himself. The Irish Lord Chancellor's penal judgement on this verdict was due in late November.[7] Mary was determined to stay confident that justice would prevail and her husband not be branded as a robber. She hoped her friends would have faith in him, but a clear flaw was that brother Bernard *was* still very cool towards Patrick, though he *had* sent a brief letter expressing his sympathy. Mary couldn't help wishing she could rely on his active help as she had done way back in her earlier marriage, but in the end she had to accept that Bernard's laconic letters were all she was going to get.[8]

During a brief Dublin visit further favourable evidence came to light, from a young woman friend of Patrick's step-daughter, who remembered seeing the last of three wills Miss Tennison had made, which 'makes many acknowledge-ments of DD for his kindness, leaves him the repeating watch which he gave her, and some other marks of her favour and gratitude . . .' The uncertainty was trying, but Mary told Anne 'as long as DD continues in health and keeps up his spirits, and that my friends are satisfied that he has *no way deserved* the treatment he has met with . . . I shall be happy'.[9] The Tennisons hinted they would be prepared to compromise, but the Delanys refused to consider anything that would imply admitting to the spoliation element of the case.

Just at this low point, her old friend Lady Andover sent a beautiful oval shaped cut-paper landscape, with a matching frame, which must have broken into the gloom. It is impossible to know how regularly she and Lady Andover had been keeping in touch, for lack of surviving letters; the duchess had also written numerous letters, which do not survive either, and probably it was through the latter that Lady Andover had learnt discreetly of her old friend's trouble, and sent her this gift as a gesture of moral support.[10]

The verdict continued to lag, because there were no precedents to follow in dealing with this case. Patrick was unique in trying to circumvent unequal marriage laws for this time, though some fathers tried to make amends to their daughters by giving them larger portions on marriage.[11] At this point the Irish Lord Chancellor made an interim summary that everyone considered had cleared the dean's character of the charge of spoliation, even though, after all the time and trouble spent obtaining a verbal assurance from Mr Burke in Jamaica, this had been disallowed as evidence. All that was now required was an exact account of the outstanding differences between the litigants over the money being claimed.[12]

'THE CHILDREN OF THE FRIENDS OF OUR YOUTH'

Alongside the legal complications endured in the 1750s, Mary took a constant interest in the rising generation, from little motherless Tommy Greene, who came with his father on Sundays for lunch, to the grand and wealthy Portland children. 'What a pleasure it is', she reflected, 'to have the children of the friends of our youth so ready to enter into friendship with us!! I think such a union mutually advantageous; the young friend's vivacity and the old friend's experience and seriousness make an agreeable mixture, *if* mutual complacency [i.e. being mutually pleasing] *be properly observed.'*[13] The three sets of children in which Mary Delany took greatest interest would always be her own niece and nephews by Anne, 'the Dewdrops', closely followed by the children of the Duchess of Portland, together with her god-daughter, Sally Chapone, and *her* sister Katherine Anne.

Early in their marriage John had made it clear to Anne that he did not wish their sons to be sent away to one of the 'public' schools of the time. These were notable for indiscipline, and Anne explained her husband 'is fearful of the bad ways and vices they have there to encounter' as well as the physical punishments, bullying and lack of home comfort associated with them. Home-based education was done first by mothers, later aided by live-in tutors and the family chaplain or local vicar, both of whom helped with studying the classics and with personal and religious education.[14] Another option was attendance at a good local grammar school, which meant that pupils could be day boys or weekly boarders. The school John had in mind was both closer and older: Warwick School, said to be the oldest grammar school in England, founded originally by Edward the Confessor in 914, and re-founded by Henry VIII. Fortunately, the school was enjoying a flourishing period, led by two members of the Lydiate family in succession, Richard and Francis, both of them Oxford graduates. Francis was also a vicar at Budbrooke, a few miles away.

A disadvantage socially of such a school was that attendance was unlikely to iron out a provincial local accent. Gentry children often sounded like the servants and local labourers who worked on the lands their parents owned. Warwick boys certainly did have the local accent, since the author Richard Lovell Edgworth, who went there in 1753 aged 8, recalled being 'the object of open ridicule and contempt' because of his Irish accent. He promptly 'acquired the English provincial accent of my companions so effectually as to give no fair pretence for tormenting me on this subject'.[15]

True to her Granville roots, and knowing that her family connections could help introduce her children to a higher sphere than their immediate county circle, Anne was concerned about this. She admitted to her sister: 'I own I am ambitious to have them excel and make a figure.'[16] So this is how it came about that through Samuel Richardson, the widowed Mrs Roach came to live in the household in the summer of 1750, followed by a Miss Charlotte Herbert, to school all the children in French. This was probably the best solution from the boys' point of view: they would blend in seamlessly with the local boys at school and avoid the mockery endured by young Edgworth, and their fancy French would only be known at home. And Mary reassured Anne that learning French in the domestic context was the right thing: all schoolboys 'must lose some part of the polishing they get at home: a herd of little wild creatures playing together entirely off their guard will contract of course some rusticities, which will wear off again'.[17]

What Miss Herbert had in her favour was that, as well as being excellent at 'getting up fine linen and laces', she also had 'gentle refined manners': 'they accustom children betimes to civility, and when they have it not in the nursery they are apt to fly out in the parlour and drawing-room'. Mary and Anne both thought alike that families should be courteous with one another – it was an adjunct of being loving and affectionate. The reverse example of the quarrelling adult Donnellans was very obvious to her: 'Many sad disagreements arise in families for want of manners.' Mary declared:

> I hope the dear children will enjoy the blessing of loving each other with *disinterested affection* [her emphasis], it will give them more real happiness than any other riches.[18]

In order to instil this good behaviour, both sisters believed that parents had to be strict when they were young – even if this went against the grain of tender-hearted mothers. In reference to little Mary, her aunt wrote:

> I know what a world she has to pass through; how *many difficulties* to encounter, *temptations to avoid, afflictions to support* . . . True religion and a command of her passions will be the best armour she can put on. I look upon it as a great advantage to *our girl*, that her parents are not too youthful but have also gained a full experience, which enables them the better to perform the great task of forming and bending a young mind to what is right.

This even extended to occasional use of physical correction: but to Mary the principle was that over-indulgent parents were effectively being cruel to their offspring: 'if they never meet with contradiction till they are of age to engage in the great concerns of life, how will they be able to sustain the contradictions, disappointments and mortifications they must encounter in this world?'[19] The blend of fairness, firmness and love Mary propounded was one recommended in a widely read advice book of the time, *On the Management and Education of Children*. It purported to be written by a 'Lady Juliana-Susannah Seymour' but it was actually authored by an enterprising apothecary.[20] Much of these advice books for girls was aimed towards their future role as wives: Anne Dewes had commented on this and Mary agreed:

> You say true many are the rules given for women's behaviour on the married state, and *much* might be *addressed to the men* [her emphasis]; but you can't expect they will do it by one another, and they would exert their lordliness, should we presume to prescribe to them.[21]

It went without saying between the parents that Mary Dewes would be schooled at home. The child grew up in a household where plenty of books were read and discussed. Home accountancy and other aspects of household management would all have been passed on through accompanying her mother as she moved from nursery to cellar – and Mary junior would cope very ably for her father and brothers as a young household manager after their mother died. Girls also still benefited, as Judith Drake had envisaged, by being with their mothers and other kin on social calls, and from staying with relatives and god-parents to extend their social circle – in this regard Lady Georgiana Cowper would prove invaluable as Mary grew older. A shy and silent daughter would always be encouraged to talk more – but 'forward pertness' (in modern parlance, 'answering back') would be firmly squashed.[22]

It is sometimes thought that the 'accomplishments' of music and dancing were mainly for girls, but this was not so. Boys also benefited from the good deportment and physical coordination inculcated by dancing. For girls, dancing was also a means of good exercise.[23] Mary regularly held little balls at Delville for the Hamilton children on Twelfth Night, and upheld the tradition of a plum cake with a hidden silver penny. These 'balls' happily blended older and younger children together alongside their adult relations.[24]

Mary did disapprove though of girls going to 'public places' until they were about 15, by which she meant the commercial forms of recreation to be found at Spas like Bath or Tunbridge.[25] She was no puritan about the stage, and considered that 'plays well chosen, which expose and punish vice and distinguish and reward virtue, are very allowable entertainments, and might be calculated to do a great deal of good'.[26] Given the musical talents of their mother, aunt and uncle, all the Dewes children acquired keyboard skills, and the youngest, John, became a talented flautist. Playing and singing were social assets for both sexes, and since recreation was necessary, it was better to cultivate those that required 'application' to bring them to perfection, and prevent idle company. However, their father wanted them to keep these talents in proportion, and Mary concurred:

> I agree with Mr. Dewes, that an immoderate love to music may draw young people into many inconveniences: . . . Painting has *fewer objections*, and generally *leads people into much better company*.[27]

Mary was a conscientious godmother and increasingly worried about the likely destiny of Sally (Sarah) Chapone junior. As a clerical daughter Sally had acquired polite manners and read good books; but like her mother before her, her marital options were limited. Socially she would count as a gentlewoman, but financially she was not, as she had no dowry. By 1750 she was in her twenties, and unmarried: was she about to become another singlewoman for Mary to worry over? Soon after her brother Harry had obtained his lucrative post in Jamaica – which Mary had considered she had helped along by speaking to her cousin Lord Gower about him – it looked as though his brother John might be following him:

> I hope Jack will find Jamaica as profitable as Hal has done; and that they will be enabled to make the latter days of their parents comfortable, and provide well for their sisters, who otherwise I think have a melancholy prospect, for all young women bred to idleness, and with a relish to the gaieties of the world, are much to be lamented.[28]

But it is hard to discern what 'occupation' might have been possible for a clerical daughter, whose idea of 'gaiety' probably extended only to the very occasional pleasures of a concert or an oratorio, and whose social horizons had only

recently been enlarged by contact with Samuel Richardson's family. The options for paid work were virtually non-existent for someone of such middling rank. One possibility, though, was for her to be a kind of lady companion, and in 1751 Mary was suggesting a position with a Lady Mansel:

> It would be a very desirable affair, and I could I think, easily obtain it for her by Miss Granville's means . . . An establishment of that kind, if her brother fails abroad, will be a happy thing.[29]

However, Harry only lived until 1755, and the other brother John was not well enough established in the law to be of much financial help.

Nothing came of the 'job' with Lady Mansel, but Sally fulfilled a similar role for a while in 1752, when Don returned from Ireland. This worked for a time and Don was 'better and better pleased with her'. Similar stints helping out as a companion followed.[30] The next year Sally divided her time between visits to the Richardson household in London, followed by return visits with Patty Richardson to the Dewes. Contact with the London Richardson circle introduced her to a little network of budding writers and painters, lawyers and clergy, such as Susanna Highmore, daughter of a painter and an unpublished poet, who married the cleric John Duncombe, a male feminist who celebrated female achievement in his poem *The Feminiad* (1754). But Sally does not seem to have been inspired to any literary initiative herself.[31] This group of middle-ranking young men and women led Mary to ponder long and hard on the constrictive social mores that governed their courtships.

THE PORTLAND CHILDREN

In 1753 and 1754 Mary and Patrick visited England. The positive dimension to this was that they were able to catch up with the Dewes and the Portland children. The underlying reason was more problematic: in spite of various attempts at mediation with the Tennisons, the Delanys were not persuaded that compromise would sufficiently clear the dean's name. They therefore had to pursue an appeal to the English courts and eventually to the Lord Chief Justice in England. In advance of preparing for the 1753 journey, the dean went twice by himself to County Down, and Mary decided to finish decorating the chapel as a surprise for his return. In England by midsummer of 1753, they made two

visits to Wellesbourne, alternating them with time with the Portland family either in London or Bulstrode. The duke and duchess's daughter Elizabeth was now 18, Henrietta 16 and Margaret, who was less robust, and small for her age, was 14. The son and heir, Lord Titchfield (15), was doing well at Westminster school, while 9-year-old Edward was handsome but not likely to turn out to be as clever as his brother.[32]

Bernard was also in London, more cheerful and communicative than usual, possibly because of inheriting the town house in Holles Street, where his parents had first lived after their marriage, from cousin Antony Westcombe. This gave him plenty to organise by way of improvements, and a good reason to attend auctions to buy paintings and objects of virtu. He still tended to be churlish to Patrick. The dean himself was anxious to buy Mary a town house so that she could be in possession of it before the conclusion of the lawsuit – or his own demise. A suitable one was not found until 1755, so they continued to rent. Mary assured her sister that whatever their final choice it would be a house where there was room for the Dewes to stay. During this 1753 visit the Delanys and the Dewes were both reading Richardson's *Sir Charles Grandison*, but the duchess did not like novels, so it was not read out loud at Bulstrode, morally improving though it was. However, Mary's letters to Anne when they were apart were, as she admitted, thoroughly 'interlarded' with discussions of the characters, who were as real to her as those she encountered in London society.[33] The Portland daughters read – and liked it – by stealth, when they were not busy 'at some ingenious employment'.[34]

These 'employments' included copying pictures of roses originally painted on vellum by Mary Delany's great friend Mrs Ford Hamilton, and copying botanical watercolours by German-born Georg Ehret. He was a skilled botanical illustrator much sought after by the elite as a teacher as well as an artist-recorder of their garden flowers and exotic specimens. He was then pretty well resident at Bulstrode, doing a total of 800 paintings on vellum for the duchess. Bulstrode was always a hive of activity: the duchess had added a Gothick summer room to the house, where a lot of the handicrafts could continue all year round. She was still keen on wood-turning and was currently making an amber vase on a jet base. Despite the cold weather in November Mary ventured into the garden to see the recently acquired exotic birds, and to admire the duchess's Asian bull, which had come from the British Fort St David, on the Coromandel Coast. She was intrigued by the creature and drew it.[35] She teased

her sister that when she came to London she and the duchess 'would have an infinite deal of learned jargon about plants together'.[36] To Mary, it was always her sister and her friend who were the botanists at Bulstrode.

Although the dean had been able to keep up his health and spirits so well during more than a year of stressful legal dealings, in January of 1754 he suffered a slight stroke. He was now in his late sixties. His left eyelid became droopy and his mouth 'drawn, and a little awry' after he came back on a Sunday morning from St James's church in Piccadilly. Terrifying though this was to the observant Mrs Delany, he seemed unaware of it, until, reading prayers at home, he realised his speech was a little slurred. The usual eighteenth-century reme- dies were applied. Close friends and family visited – even the curmudgeonly Bernard. However, he was none the worse either for the stroke or the remedies, for after a few days rest he was allowed to eat heartily.[37] The illness accelerated the Dewes' arrival in London for a three-month stay, with little Mary. Their love and John Dewes' legal knowledge would prove sustaining, and Mrs Delany took the opportunity to pay for some early dancing lessons for her niece with the much sought-after French master, Serise.

The Delanys' brief return to Ireland was all that the slow progress of the lawsuit allowed. But one significant element for their 'household family' was that they had taken Sally Chapone with them, and on the way up to Chester for the Irish boat she took the initiative to mention that the road would go very near the gates of a 'Mr Sandford's House' in Shropshire. Taking the hint, when they were nearer Sandford they sent ahead William, one of the postilions, with a note to Miss Sandford, the sister who presided over the household, to ask whether, as they were so close, they might stop and breakfast with them. Immediately her brother Daniel 'mounted William's horse *without* boot or *spur* (except in his *heart*) and met us before I thought William could possibly be there'.[38]

It was evident that the son and heir to the substantial estate of Sandford, who was a clergyman, had an inclination for Sally, and that his sister was very friendly towards her too: but it was also soon clear their father, who was sufficiently affluent, was not disposed to make a settlement for his son, and so enable a marriage.[39] Yet Daniel made a good impression on both Patrick and Mary: the former invited him to Delville, and Mary approved his '*respectful, tender* behaviour' to Sally. The Delanys gave her an agreeable social whirl in Dublin. Thus began a very protracted courtship for the penniless couple, sympathetically monitored by the Delanys, who soon thought of Sandford

Senior as a 'wretch' and eventually concluded he was 'a reprobate'.[40] Marriage for the younger generation further up the social scale was certainly a lot easier: at the same time as this courtship was starting, Mary Delany's friend Lord Guilford could oversee the marriage of his stepson, the young Earl of Dartmouth, to a pretty young heiress, a Miss Nicols, with a fortune of £100,000; her dowry facilitated a prompt wedding.

The dean had been able to keep up his spirits while the lawsuit dragged on by writing a book in defence of his great friend, Jonathan Swift. It will be remembered that he and Mary had been disquieted by Laetitia Pilkington's unvarnished portrait of Swift in her own *Memoirs*, and then dissatisfied by a more literary attempt by Lord Orrery.[41] Patrick's riposte to the latter's book unashamedly included personal anecdotes but officially was published anonymously, and he evaded any attempts at discovering who had authored it. It attracted much attention on both sides of the Irish Sea.[42]

Back in England by the autumn, the couple paid their habitual October visit to the Portlands. This was the year that Lady Elizabeth was due to be presented at court on the occasion of the king's birthday (30 October/9 November). It was still customary for everyone to parade their new clothes, and Lady Elizabeth sounds quite the charming rococo maiden:

Lady Betty is to have a very fine sprig of pearl diamonds and turquoises for her hair, loops and stars of diamonds on her stomacher; her clothes white and silver, mosaic ground flowered with silver, intermixed with a little blue. She rehearsed her clothes and jewels yesterday, and practised dancing with her train . . .[43]

The next big transition was when Lord Titchfield left for Oxford. He had completed his stint at Westminster school with a strong reputation in character and intellect, and now his mother asked her friend to write a letter of advice for this new stage of life. Mary's reply was imbued with chivalric notions:

You have promised her [that is, Oxford University] a nobleman of the first quality, as distinguished for intellectual endowment and moral accomplishments as for all the advantages of his rank, family and fortune . . . Nor is this all: you have promised your sovereign . . . a peer of the first rank to do honour to his Court, and to support his throne – to support it upon the

surest principals [sic] of fidelity (*hereditary fidelity*) and loyalty; and you have promised your country a senator of eminent integrity and ability to protect her constitution, her religion, and her laws.

The way to fulfil all these obligations, familial, moral and political, was to consider them as part and parcel of those Christian obligations incurred at baptism and then renewed publicly as a young adult at confirmation.[44]

Proceeding to London, Mary and Patrick found pleasing distractions in planning the new house, Spring Gardens. The couple's regular reading out loud was constantly interrupted by suggestions such as 'but the larder must be so and so and the pantry so'.[45] She planned a practical garden, growing herbs for the kitchen and green salad plants for the table. Her complaints about the dilatoriness of builders echo across the centuries, and in the end the Delanys borrowed a house from the Veseys nearby in Bolton Row until the builders had finally finished.[46]

THE METROPOLIS AT MID-CENTURY

Although Patrick and Mary were in London because of the lawsuit, it was actually a significant time in its own right, leading towards war that would engage the attention of many in the Delany circle, as combatants or anxious commentators. Tension was building in North America between English and French settlers, aided on both sides by indigenous nations, as the English expanded west over the Appalachian Mountains, and the St Lawrence seaway was contested by French traders. The 'Patriot' politicians, now lacking their princely leader, were re-grouping. Some, like George Lyttelton, joined the ministry, and others, like William Pitt the Elder, remained a gadfly outside it, criticising its sympathy with George II's concern for defending Hanover in the event of a French war overseas. The Delanys still admired the widowed Princess Augusta and in 1754 Patrick had had the satisfaction that she accepted a dedication from him of his *Sixteen Discourses upon doctrines and duties, and against the reigning vanities of this age*.[47] These emphasised the mutual obligations between husbands and wives, parents and children, masters and servants, which transcended conventions of social hierarchy.[48]

Former 'patriots' like Lyttelton and his friend and cousin Gilbert West tried to position themselves as patriots of a moral and religious kind, looking to

the spiritual welfare of the nation, instead of merely a factional, political kind of patriotism that was partly a strategy to dislodge ministers. For West, 'the greatest service that the most zealous Patriot can do his country, is to promote the faith, and thereby encourage the practice [of] the truly divine virtues recommended by Christ and His Apostles'. Another spur to seriousness was the earthquake in Lisbon in November 1755, which occasioned much agonised reflection throughout Europe about how a good God might have permitted many innocents to suffer, especially as it occurred the day after the religious festival of All Saints, while many were attending morning mass. It was a severe quake, retrospectively considered to have been .9 on the Richter scale, and was followed by a tsunami wave rolling up the River Tagus into the heart of the business district. Fires then broke out, destroying many more buildings and their valuable business records. Thousands perished.

Mary knew several people who had some connection with Lisbon; Portugal was Britain's oldest trading partner. The duchess's cousin Edward Hay, the English consul, had had to jump from the second storey window of his house, after which it had collapsed, while his young wife, who had had a baby ten days earlier, was helped out, wearing only her shift, by a maid. Sally Chapone knew a Mr Gore and a Mr Mellish, who were leaders of the port wine business, and stood to lose financially by at least £30,000. Sally went to the latter's London house to help his wife pack 'boxes with all sorts of wearing apparel and necessaries for work, to send to the poor miserable Portuguese'.[49] But by the next winter season in London Mary observed, 'Earthquakes are forgotten, assemblies and balls go on as briskly as if no such warning had been given; indeed, if we stop there it might be innocent, but luxury and gaming run higher than ever.'[50]

This revival of moral seriousness had its further female dimension among the group of women later known as the Bluestockings and centred on Elizabeth Montagu. She was a cousin of West. Her turn towards establishing her drawing room as a place for moral and literary discussion rather than cards and gossip is connected with the revised patriotic agenda she shared with Lord Lytttelton, as well as the absence of a political or courtly scope for herself given her husband's political independence. Unable to network at the royal drawing rooms, she decided she would establish her own salon culture as a high-minded cultural *revanche* against decadence and frivolity. Since George II was a widower and had only his daughter Amelia, his daughter-in-law Augusta and his mistress Lady Yarmouth to assist in presiding over court drawing rooms, there was certainly a

female royal vacuum for providing cultural brilliance and patronage. The ambitious Elizabeth Montagu was becoming what Samuel Johnson later nicknamed 'the Queen of the Blues'. Johnson too saw the need for some moral uplift through periodical essays, founding *The Idler* and *The Adventurer*, both of which the Delanys enjoyed, and soon Patrick was planning a moral periodical of his own. Mrs Delany is sometimes described as a Bluestocking, but although she knew many of its leaders and shared their moral appraisal of national shortcomings, she was in no position for large-scale entertainment nor did she have attention to bestow given the need to follow the lawsuit when she was not in London.

'PUBLIC CALAMITIES AND PRIVATE DISTRESS'[51]

Just after Christmas Day of 1754, the Bulstrode children 'full of joy and spirits had a little dancing – Lord Edward very brisk and happy'. The next day the boy 'complained of an excessive weariness and had no appetite'. Smallpox was soon diagnosed. His sisters were allowed to stay with their mother and brother, which gave Mrs Delany distinct qualms: 'I cannot help being anxious, though I trust in God he will protect them, and he alone can reward such filial tenderness.' In between nursing Edward, Mary and the duchess took their turn at working on a double cross-stitch carpet destined for the 'Gothic cell' at Bulstrode: this must have been a calming task.[52] Mary had her harpsichord brought into the sick room, to try if music could help charm away the discomfort.[53]

Simultaneously with this sickness at Bulstrode, Mary had been trying to assist John Chapone to obtain the role of land agent for the Duke of Portland or a likely vacancy at Althorp when John Spencer (Lady Cowper's son by her first husband), came of age: 'there must be several in such a vast estate'. Neither attempt met success. Although so young, John Spencer had already set his heart on marrying his childhood sweetheart, Georgina Poyntz, daughter of the Duke of Cumberland's Household Steward, Sir Stephen Poyntz (see p. 68). In Mary's view, 'a happier choice he could not have made. She was born a gentlewoman . . . well educated, a most sensible, generous delicate mind, and I think a very agreeable person . . .'[54] In contrast, among the Richardson circle John Chapone may also have met his future bride Hester Mulso by then, but like Daniel Sandford he was not yet in a position to make a proper offer until his professional position was more secure, and constant anxiety was not cushioned by Spencer levels of income.

Finally, in March 1755, Mary and Patrick were told their new house was sufficiently aired for them to move in, and this meant that Anne and John could also plan a spring London visit. The sisters enjoyed two months together there, and they can be imagined busying themselves with the domestic detail attendant on any move. Once the Dewes left, Mary immersed herself in her latest oil-painting project. Her task was to lay the undercoat of paint all over the canvas, which did not require her to summon much creative energy, but it was still a 'dismal Thursday'. Soon, en route to Ireland, the Delanys visited Lady Sarah Cowper, sister-in-law of Mary's cousin Georgiana, Countess Cowper. Mary was interested in the garden and grounds, the former chiefly a kitchen garden and the latter mainly a grove of nut trees, with fruit trees espaliered against a paling. Here was an example of a happily situated older singlewoman whose gift for hospitality meant 'happiness dwells among them'.[55]

It was then Mrs Delany's turn to fall ill, this time with 'cholic' – some type of abdominal pain, which scuppered their travel plans. Mary took all of June and some of July to convalesce, but while she was laid low had much kindness from crusty brother Granville, as well as the ever-solicitous Patrick, united in their mutual love for her. She was recommended first to take the waters at Cheltenham, and then at Bath, and young Sally was invited to continue with the Dewes to Bath. The most sociable of the spa towns, it would widen Sally's horizons and her social experience, as well as benefit her health. On a sad note, news came from Ireland of the demise of the poet Mrs Barber, after a long decline: 'which affected both the Dean and me very much, though we were not surprised at the news; and she is happily released from a painful life, I trust in the mercy of God to enjoy a blessed state!'[56] The duchess's mother, the widowed Lady Oxford, was also in poor health.

Before she left London, Mary went to visit the studio of the Florentine-born painter Andrea Soldi. She and her brother had commissioned him to make a good copy of the Huysmans portrait of their mother. Mary was intrigued by the way Soldi softened the treatment of the eyes in the original, added a flattering white fichu to the neckline, giving the hairstyle a purple ribbon and modifying the glaring yellow of the hair. She tried to persuade Soldi to give her one of his paintbrushes but he pretended to misunderstand her. She was so impressed with his artistry that she and the dean commissioned him to paint Patrick's portrait.[57]

Bernard eventually joined Mary and Patrick at Bath, and Anne with little Mary came too. Bernard was at his best in Bath, which he visited regularly,

charming the elderly ladies with his presence at the cribbage table.[58] For a time, Mary's old friend Lady Andover was there, as was the duchess, but many left in early November for the renewal of the London season. Of the four friends in the friendship ring, Mary, the duchess and Lady Andover had all had to nurse children through smallpox, and currently it was Lady Andover's turn.[59] The fourth, Mrs Montagu, was, Mary thought, unduly fussed at the possibility of meeting her at Anne Donnellan's house when the Portland children were ill, for fear she had brought the disease from Bulstrode. 'Not that she had any fear of seeing me, but *it would make Mr. Mon uneasy*.' 'What advantage is there in having sense and wit *above one's fellows* if it cannot guard one from such extravagant fears and foolish vanities?' Mary expostulated.[60]

During the visit to Bath, which was over by Christmas, young Sally unexpectedly attracted the attentions of another keen admirer, a Captain Smith, whose mother and sister were part of Anne Dewes' wider social circle in Wellesbourne. So where was Daniel Sandford in all this? Despite his evident inclination for Sally, he fell into the category of imprudent suitor: he was not in a position to make a formal offer of marriage. So Captain Smith was to be told that *if*, after his voyage, he had made enough money, and *if* she was a free woman, he could see if Sally was open to persuasion. Sally's parents were written to, and last of all Sally was told of her new admirer. She told Mrs Delany that although she would give the preference to Daniel, she was not so prepossessed by him that she would refuse to consider Captain Smith, and was happy to take her mother's advice.

What stands out is Sally's passivity in all this. Her suggestion months before that they stop at the Sandford residence seems to have been her *only* initiative. But she was an economic dependent. Her comings and goings between her parents, her friends in London in the Richardson circle and her visits to Anne and Mary were all covered financially by either her two godmothers or her parents, who would clothe her and give her some pocket money suitable to her station in life. It is likely that this enforced passivity was a depressing factor in Sally's life.

At any rate, by the December after the Delanys had returned to London, Sally was again seriously ill and unable to eat very much; this was surely stress-related. She confided in Mrs Delany about her perplexity and indecision, fearing to upset Daniel Sandford; otherwise 'she could with cheerfulness submit to whatever her friends recommended'. Her brother John had concluded she could

not be happy with Daniel, and Mary was getting exasperated with him, too, as well as critical of the courtship conventions of the day: 'I think it is very hard a young woman should be kept in an uncertain state, and not at liberty to accept the addresses of another man, because a person she has a high value for, is so mysterious in his behaviour that she cannot tell what his designs are.'[61] In the end Sally told her latest suitor she 'did not know her own mind sufficiently to give him any encouragement'. By Christmas she was well enough to come downstairs and remained in London with Mrs Delany.[62]

The only cheerful prospect as 1755 ended was that Johnny Spencer was well enough to be planning his coming of age, and that the Cowpers and Poyntz ladies had gone to Althorp for the celebrations. And to Patrick his own pearl, Mary, still glowed as splendidly as ever. As a Christmas present to sister Anne he sent her a word portrait of his beloved wife instead of a 'Bath Bauble'. This was a draft from his planned periodical, *The Humanist*; Lord Chesterfield, a regular contributor to *The World*, had been advising him how to go about launching it.[63] In keeping with the style of these magazines, it would include descriptions of different types of women to copy or avoid. Bringing her story up to their marriage, he said:

> She received the addresses of men of various characters, titles, honoures [sic] and fortunes, and gave herself in the end to a man of a very moderate fortune, but whose understanding she honoured, in whose virtue and good treatment she fully confided, and with whom she is thought to live happily, and I hope she does.[64]

He concluded his description with a poem comparing her to her favourite flower, the rose:

> Thou modest rose, of blushing bloom
> Thou fragrant rose, of rich perfume
> Disclosing leaves of heavenly hue
> Distilling drops of honey'd dew
> On whom kind nature lavish pours . . .[65]

January 1756 began with the opulent public consequences of a most private event. Johnny Spencer had always told the Poyntz family he would like to

be married to his sweetheart the moment he came of age. Althorp House was full with 500 guests to mark this event. The day before his birthday he announced that he wanted the marriage to happen before the celebrations were completed, so the chaplain married them with only four witnesses. Soon after they travelled in three coaches and an entourage of 200 to London, making the country folk wonder if the expected French invasion had taken place. Once in London they visited drawing rooms held by both the king and the dowager Princess of Wales. John Spencer was a grandson of the wealthy and imperious Sarah Churchill, Duchess of Marlborough, the wealthiest woman in Britain, who had given £100,000-worth of diamonds to the couple.

In April Mary Dewes came down to London to stay with her aunt again, but initially Mrs Delany spent much her time with the Portland family, as the children had all been struck by scarlet fever, starting with young Edward. The illness began in early April and soon 'Whitehall was a perfect hospital'. Edward recovered first, followed by Betty, and then Harriet and Margaret faced the accustomed treatment of being 'blooded and blistered', the latter involving hot glass cups placed on the back to draw the heat through the body. After about a month of nursing her children the duchess began showing the symptoms herself. A few days later, however, Harriet was recovered, Lord Titchfield succumbing – but the youngest and weakest, Margaret, was dead, or in Mrs Delany's view, transformed to an angel in heaven.[66] The duchess was desperately sad about young Margaret's death but strove to bear up for the sake of the other children. She began to go out again and managed a visit to St James's chapel before the season ended. Just at this juncture of private calamity war with France was declared.[67]

Among Mary's extended kin, Cousin Elizabeth Granville was exchanging her position as a Maid of Honour to Princess Augusta to that of Woman of the Bedchamber. There was some good news to report in the circle of the Chapones and their friends: Hester Mulso's brother John was finally able to marry his fiancée, Miss Young, after a fifteen-year engagement. The clerical preferment he had obtained enabled him to do this and also give a home to his father-in-law. Hester's other brother, Thomas, though, was still in no position to marry *his* fiancée, Mary Prescott, whom Mrs Delany wished could spend the summer at Wellesbourne and have some horse-riding by way of exercise as she seemed to be wasting away.[68] And Hester herself was still attached to John Chapone but without an explicit engagement because he too had not advanced far enough to afford marriage.

AUTUMN IN NORTHAMPTONSHIRE AND BATH

When Mary and Patrick left Wellesbourne in September to make the usual autumn visit to the duchess, they did not go to Bulstrode, but to Welbeck, the Nottinghamshire home she had inherited from her late mother, the Countess of Oxford. The Delanys went at quite a leisurely pace in order to take in various notable houses en route associated with friends in their circle. The first destination was Papplewick Hall, home to Mary Delany's friends Mr and Mrs Charles Montagu of Hanover Square. In the garden all that had been done was to take away the hedges from ten fields to create a more open park dotted about with trees and facing down into a valley, where a stream broke into several cascades. Beside this stream were various stopping points planted with shrubs and containing rural seats, one of which Mary had designed for them in 1742 in the form of a covered temple. 'The prettiness of the place is its being perfectly rural and made with such little expense'.[69] While they were in the vicinity the Delanys took the opportunity to visit Isabella Sutton at her brother's house, Norwood Park: 'the house small but cheerful, the fields lie well to the house, and a large pool that affords them very fine fish'.[70]

This trip had taken them close to the Derbyshire border and thus to estates belonging to the Cavendishes, headed by the Duke of Devonshire, and kinfolk of the Portlands. Lord Titchfield would eventually choose a bride from this important political family. Their goal on this outing was to see the Renaissance gem, Bolsover Castle, inherited by Lady Oxford ultimately from the famous Elizabethan heiress and serial wife, Bess of Hardwick, who had acquired significant estates from each of her four husbands. The originally medieval castle of Bolsover had been altered c. 1617 to reflect a seventeenth-century version of chivalry, which would have been greatly to Mary Delany's taste; the man responsible, Sir Henry Cavendish, later first Duke of Newcastle, was a Cavalier loyalist to Charles I, like her own great-grandfather. In describing the visit to Anne, Mary mentioned how this duke, an expert on equestrianship, entertained Charles I at Welbeck in a series of sumptuous temporary tents.[71] Lady Oxford had taken great care to arrange the family pictures at Welbeck to reflect her Cavendish ancestry and this intrigued Mary.[72]

By the end of September, the lawsuit drew the Delanys back to London, and there was the usual whirl of catching up with friends. Mary and Patrick walked regularly past the site of Johnny Spencer's new London house fronting both

Admiral Hawke's fleet, and 'It is very plain he has had no intention of trying his fortune again on land; to be sure he has had no encouragement to do so.' To help Daniel, Mary continued to pull strings, all of which was fruitless, but meanwhile 'Sally is very well and happy . . . I believe she must perceive the attachment is stronger than ever.' The couple had reached an implicit understanding.[81]

By mid-February the legal decision from Lord Chief Justice Mansfield was edging closer. Mary found that everyone was being very kind to her while she and Patrick were in suspense; even Bernard was 'very obliging' to the dean. She regarded Anne as her chief friend and consoler, but as she was in Wellesbourne, the duchess was a valued substitute in keeping up her spirits. John Chapone agreed to attend the House of Lords every day and to report back the proceedings – not only was he a lawyer, he had a gift for near verbatim recall. Their lawyer, the Attorney-General Charles Pratt, emphasised that his client valued his good character far more than the 'trash in dispute', that is, the Tennisons' financial claims. He laid great stress on answering the point argued by them that Patrick's step-daughter had had a right to inspect the burnt settlement, maintaining this was not the case.

On the first day, while the lawyers were arguing, Mary went to early and mid-morning prayers at St James's, and listened to a sermon. Her brother came and lunched with her, and then she went to the duchess. Several days went by like this and 'DD keeps up nobly'. However, she confided to Anne:

> his distress on my account is more *heart-rending* than anything. Who is there in the world, even among those who are devoted to worldly matters, that has not some time or another been guilty of an inadvertent act; but some happy turn has prevented any mischief ensuing? That has not been our case, and we must submit and make the best of our present disagreeable situation. Our enemies can never rob us of peace of mind, whilst unconscious of having done a wilful injury to anyone . . . Thus my dearest sister, I call to mind every aid.[82]

Happily, after only five days the ordeal was over – and Patrick was finally vindicated of all charges of spoliation. The case was attended by many supporters and notes of congratulation flooded in, which, together with the lawyers' final discussion and her own over-heated nerves prevented Mary from immediately writing of the good news to Anne. The relief was almost indescribable, and it

even looked as though the financial settlement would leave them none the poorer. Mary now had to go on a round of visits to the wives of all the peers who had attended, beginning with Lord Mansfield's wife, chatelaine of their home, Kenwood. He had spoken, Mary heard, 'with angelic oratory' in his final summing up.[83]

From Gladness to Sadness

The intense focus on the lawsuit could now relax. The duchess was soon able to target one the of the major art sales of the decade, that of the late diplomat Sir Luke Schaub's collection. She acquired nearly all she aimed for, scooping up among others, a Claude Lorraine, a Rembrandt and a Rubens. Mary, Patrick and Sally visited first Anne and then Bernard to rest and recuperate, and then took sail to Ireland where the dean's duties awaited him. After reconnecting with Delville and designing a shell-work wreath of flowers for the circular window in the chapel, they drove north. En route they were guests of a substantial Anglo-Irish family, the Annesleys. William Annesley, an Irish MP with an Irish earl's daughter for a wife, was transforming an unpromising locality into a model town, Castlewellan, and thus, greatly to Mary's approval, bringing it employment and investment.

At their clerical friends, the Bayly family half a mile away, they unexpectedly found a little echo of the musical glories of Dublin and London. The resident music teacher to young Miss Bayly turned out to be Cecilia Arne, the deserted wife of the composer Thomas Arne, who had written 'Rule Britannia'. Cecilia had been taught both by Handel and Geminiani, and Mary must have heard her in her heyday as she had premiered roles in operas such as the former's *Alcina* and *Ariodante*. Her voice and her looks had faded, but both were still pleasant. Her musical prodigy niece lived there too and at 9 years old was an accomplished keyboard player, so between them the household could muster a small ensemble of flute, violin and harpsichord to accompany the singing. Mary considered Dr Arne had been a 'bad husband' as he had alleged his wife was mad – today she would probably be diagnosed as depressed.[1]

When Handel died the following year she reflected: 'I could not help feeling a damp on my spirits, when I heard that great master of music was no more, and I shall now be *less able* to bear any other music than I used to be.' A consoling aspect was his bequest of some Rembrandt engravings to her brother Bernard.[2] At the Viceroy's court the same year she also heard the last public performance of Handel's friend, the 75-year-old virtuoso violinist Francesco Geminiani, one of the Italian musicians George I had brought to Britain in 1714. She appreciated how his musical timing and tone was unfaded, although he occasionally had to simplify some passages due to his ageing fingers. But the audience was impatient to get to card-playing and dancing, and sent a message to curtail the musical entertainment, which she deplored.[3]

Patrick preached with gusto at Downpatrick at the start of their first visit and they commandeered the service of the inn to entertain twelve people.[4] After some consecutive years' absences they planned a large ball, mustering twenty-nine guests in total, who reassembled the following day at the Baylys. Mary told her sister that before this occasion 'I have been trotting about the garden with the Dean, contriving new works and weighing grains of ipecacuana and rhubarb for poor patients' who also got the surplus food from these entertainments.[5]

Mary and Patrick also visited Hillsborough, where Wills Hill, later Marquess Downshire, had his country seat. He was an ambitious politician, focused on climbing up the greasy pole in England, where his children were being educated. His daughter Mary was at the same progressive school, run by Mme LePrince de Beaumont, as Lady Louisa Carteret, the now motherless daughter of Lord Carteret's second marriage. Lord Hillsborough was not neglectful of his Irish lands. He was busy building a new house, and when it was finished planned to give the old one to the Downpatrick diocese. For Mary, the most interesting element of the visit was talking to Henry Russell, the old gardener from North End, which Lord Hillsborough had bought after Sir John Stanley died.

By the end of the year Mary had a new gardener of her own to help with her flower garden.[6] Thinking he now knew what disposal income he had, even though the financial settlement with the Tennisons was pending, Patrick told Mary he would allow her £600 per annum for household expenses, which would cover everything but the men's wages, the liveries, the stables, wine cellar and garden, furniture and all repairs: a generous allowance, to be reviewed after six months.[7] From now until the end of the decade the Delanys were able to enjoy

a relatively peaceful time; above all, they could once more go about in Dublin society knowing that Patrick's good name had been upheld.

In the New Year of 1759 Mary had urged her sister to visit London and use the Spring Gardens house, pointing out how beneficial it would be to her niece: 'not only for confirming her dancing . . . but to improve an acquaintance with her relations, who may hereafter be of use to her; so that when she is so unhappy as to want the protection she has at present, she may not be a stranger to those with whom we may naturally wish she should keep up a good correspondence'. As well as useful connections, her time in London society would help Mary acquire 'a grace and a manner which cannot be attained without conversing with a variety of well-bred people, which will . . . give a polish and by an agree-able recommendation render all the good part [that is, her moral character] more useful and acceptable to those she converses with'.[8] If Mary's urging her sister to keep in with their grander relatives sounds calculating, it only reflects the realities of eighteenth-century life, where kinship ties were all-important in helping people along, as well as being appreciated for sentimental reasons. Hence the emphasis throughout Mary's life, and in Patrick's preaching, in imbuing these relationships with genuine friendship. This in young Mary's case meant mainly the Cowper family.

Another aristocratic marriage was in the offing, too, as Lord Weymouth had been accepted by Lady Elizabeth Cavendish-Bentinck, the duchess's oldest daughter. As with his father before him, Mary and his aunt, Anne Granville, hoped this marriage would stabilise their cousin by providing a domestic focus, and so it more or less proved. As his biographer points out, his life is a salutary reminder that 'a flawed personality and manifold failings as a minister were no obstacle to a career at the highest level of government . . . provided they were accompanied by sufficient aristocratic pedigree and reinforced by connections at court'.[9]

God-daughter Sally was now a well-established member of the Delville household. She gladly settled into the domestic routines, taking her turn at reading out loud in the evenings, helping with Mary's needlework, and enter-taining guests at Delville.[10] She had her own cat, who would follow them around the garden.[11] She was also a good plantswoman. She accompanied Mary on her social calls in Dublin, and they visited various locations to collect shells for the decorations in hand, going there with a variety of other company.[12] In June she learnt of her father's death. Anne Dewes evidently stepped in to make arrange-ments for her sister Katherine ('Kitty') Chapone, for their father's rectory

would be needed for the next incumbent, and his son John was trying to pay off their father's debts and settle their mother somewhere. Mary continued her painting and shell-work, and Patrick his planting, completion of the chapel and further library extensions.

The garden was more Patrick's department, but one morning Mary had the 'whim' of suggesting a little bridge from the walnut grove over a rill to the hamlet of Elmy: fondly, Patrick immediately got the workmen to get started on this.[13] The garden wall was lowered to facilitate better views to the slopes where their cattle and deer grazed, and when the optician had reinstalled her *camera obscura* there were some delightful light effects to enjoy.[14] In the chapel, the circular window Mary had designed was now installed, and a wreath of shells in their natural colour created in the shape of oak and vine leaves, with real ears of corn painted in white mixed with it. There was painted glass round the rim, with diamond-shaped cuts at the edges. About eight years earlier when the chapel was being created its ceiling had eighty-six large 'stucco' flowers and thirty smaller ones, made from card and shells.[15] Now Mary added four thin arches in the chancel, two on each side, 'to take off the plain look the walls would have without them'.[16] At the same time as these embellishments, Mary was putting a bow-window in her 'Minerva' or study, with similar festoons of shell flowers, and upholstering chairs and stools with crimson silk.[17] She repaired the *Madonna and Child* copied from a Guido Reni in the chapel, since it had faded, and then embarked on a Salvatore Rosa copy of an original owned by the Bishop of Derry.

For chapel seating there were initially chair covers with roses in chenille within a wreath of oak leaves, all worked on a black ground, to 'give it gravity', even though she thought brown was a better highlighting colour. In the end though she decided this was 'too gay for the purpose' and she 'set all hands at work to finish some crimson double cross-stitch' in diamond-shaped lozenges 'which looks rich and *grave*'. The cross-stitch would have been an easier pattern for anyone to sew, whereas she had done the roses by herself free-hand.[18] Later on a second-hand organ was installed in its niche in the chapel, and Mary asked Anne 'for pretty hymns or psalms set for organ or harpsichord, for I *suppose* I shall be the chief organist'.[19] Anne gave this copying task to her daughter.

Sally also had the tonic of a visit from Daniel. His father was still withholding a decent allowance so he was acting as chaplain to a friend of his in Gloucester-shire, Edward Sampson, squire of Henbury. Daniel was a welcome addition to the Delville household: he got on very well with Patrick, and was a sound source of

advice to the Dewes family over which Oxford college they should select for the eldest son, Court, a subject much canvassed during these months.[20] Daniel was also very good at their evening readings out loud.[21] One significant book all listened to was the translation by their friend, the Bluestocking Elizabeth Carter, of *All the works of Epictetus which are now extant*. The philosopher was the earliest proponent of the classical philosophy of Stoicism, which had become widely admired in seventeenth-century Europe. Mary considered 'her introduction is charming, and the use she makes of the Stoic philosophy, to show how much superior the Christian philosophy is to it'.[22] At some point this year, Mary also wrote something herself – the little moral fable called 'Marianna', in which the young heroine is tempted to follow butterflies from field to field, is plunged into danger and captured by gypsies, but finally rescued by a suitable husband.

Talented though Mary was with her pen, and perpetually enjoyable as her everyday letters are, she would always be more attentive to her paintbrush. Whenever she could, she tried to devote two consecutive days to oil painting. She began a version of *The Raising of Lazarus*, based on a Rembrandt print: 'an immense piece of work: I fear I shall be punished for my presumption in such an undertaking'. This is what she regarded as *real* work.[23]

'SISTER OF MY HEART'[24]

The 1760s was Mary's most difficult decade. In 1761 she lost her sister Anne – her lifelong confidante and friend – and in 1768 her dear DD. Ameliorating these losses, though, was the intensification of her roles as aunt and godmother, and the continuing friendship between herself and the artistically talented Mary, Lady Andover, with whom she had spent so much time during her first widowhood in company with the Duchess of Portland and the future Elizabeth Montagu. Her cousin Georgiana, Lady Cowper, also stepped into the gap in young Mary Dewes' life left by the loss of her mother, amply fulfilling her function as a godmother. Mary Delany spent most of the decade in Ireland, but letters kept her in touch with the family axis in Warwickshire and the Derbyshire/Staffordshire border.

When the decade began there was little sign that her sister's illness, so like her regular bouts of ill-health, would turn out to be terminal. Their letters to each other were full of their mutual interests in the education of the Dewes

boys and girls, in reading, painting and the arts of home-making, and also on Mrs Delany's side comments on her participation in public life as wife to a dean. In January, Court Dewes, Anne's eldest boy, aged 13, was preparing to be entered at Oxford in the spring, and took communion for the first time in preparation for it. His aunt wrote that she hoped he would not adopt the fashionable affectation at Oxford that gentleman commoners should not try to mix with peers. Court would just overlap with her friend Lady Andover's son, who would leave when he came of age in May, and his aunt believed Court should not let 'any situation high or low deprive him of the advantage of conversing with worthy persons; men of quality are not always the most useful companions, but when they are sensible and good there are advantages in their acquaintance'.[25]

Sally Chapone's beau, Daniel Sandford, continued at Delville where he rearranged the library, greatly to the dean's satisfaction.[26] He was considering a role as private tutor to a young aristocrat, but only if he were reasonable and biddable and not spoilt. The problem of spoilt heirs was not confined to boys, as girls with a fortune to inherit could be just as difficult. Mrs Delany's second cousin Sophia Carteret had also been unruly and self-centred, as she had lost her mother at birth and the servants had emphasised how wealthy and important she would be. In despair, her grandmother, Lady Henrietta Pomfret, had appointed a French governess, Mme LePrince de la Beaumont, to take her in hand.

Despite her aristocratic-sounding name, Mme LePrince de Beaumont came from a dynasty of skilled craftsmen in Rouen who specialised in ecclesiastical statuary, and after being educated by Ursuline nuns had found a position teaching dancing and singing to the daughter of the Duchess of Lorraine. Her patroness left her some money and this made her the target of an irresponsible penurious aristocrat, M. de Beaumont, who wasted her dowry in gaming. To protect her daughter and herself financially she had been forced to separate from him, and found her way to London through some English families at the Lorraine court.[27] Her education of Lady Sophia had been a resounding success, and in 1757 she published a book based on her educational methods, *The Young Misses Magazine*. In the summer of 1760, the dean was reading and approving this book. LePrince de Beaumont's methods were conversational, which had the added purpose of teaching the girls French. Mrs Delany urged Mary Dewes, 'I shall be very glad to receive any of your French performances; and if you write or translate but six lines every day it will improve you very much and at least keep what you have learnt.'[28]

Historical, geographical and scientific information was included in the dialogues, as well as the recounting of Bible stories and fables, and the discussion of moral precepts. LePrince de Beaumont's lasting influence lies in her retelling of the story 'Beauty and the Beast' in its modern form. It will be recalled that the Beast provides Beauty with a library when she is detained in his house: symbolically, this suggested that even if women are under problematic male authority, they have been given the freedom to roam intellectually. For above all LePrince de Beaumont wanted girls to be thinkers: 'The science taught by Socrates, is called moral philosophy, and you will see clearly, my children, that it belongs as much to women as to men: for the prerequisite for learning philosophy, is to be thoroughly reflective.'[29]

LePrince de Beaumont comes over as serious but also capable of a light touch. She invented dissected maps, a kind of educational jigsaw puzzle, in order to teach geography, and on the annual visit to Down, the dean, his wife and Daniel Sandford had taken some of these along. These grown-ups found them instructive and amusing. Mrs Delany was reluctantly recognising that the dean was feeling his age in mind and body, and such a playful evening diversion was typical of her tact: 'if he has not something that rouses him to activity he would lead too sedentary a life, and that I am sure would soon destroy him. I cannot say but I am now easily alarmed about him', she confided to Anne, 'but I endeavour to suppress my fears, though it is a hard task where such a friend is in question.'[30]

Alongside these educational and literary concerns, Mrs Delany was also still deeply absorbed in beautifying her house and her garden. The picture of Christ raising Lazarus from the dead for the chapel was still a work in progress.[31] She was using a fine edition of old master prints from the collection of the French financier Pierre Crozat, the *Cabinet Crozat* (1729, 1740) as a source for copying a portrait by van Dyck of a barber. She was also reading the newly published *Inquiry into the Beauties of Painting* (1760) by the Bath-based critic Daniel Webb, which extolled painters such as Raphael, Correggio, Titian, Rubens and Van Dyke as Modern masters following in the footsteps of the Ancients.

One spring day in April instead of distributing her time between various roles:

a rage of painting seized me. I took up my pencils [paintbrushes] and sat down to a picture (at 7 in the morning) I have begun of David with Goliath's

head as big as the life. I believe I shall be able to finish that and the little Correggio before we go northward [i.e. to County Down for the dean's annual visitation]; but I was obliged to leave off work before one to dress, and go to Dublin to Mrs. Vesey, who had engaged Mrs. Hamilton, Sally and me to dine with her at one and go afterwards to the Parliament House to hear a debate on the *deficiencies of the bankers*.[32]

Lady Anne, half-sister to the young Lady Carteret, was married to a banker, so the debate was a significant one for her. The following day Mrs Delany's energy was once more dispersed, but within a fortnight she was telling her sister the picture was almost done. In the garden, the dean had given his wife a piece of ground for a greenhouse with a flower garden in front of it, and Mary wished her brother could visit to advise her on design matters as he had experience of developing his estate at Calwich (Plate 17). A pair of albino robins had been born at Delville, which were kept in a cage while the mother red-breast could feed the surviving one in plain sight.[33] Anne had identified for her a yellow pimpernel specimen and her youngest son John did 'a pretty and exact' drawing of it.[34] Mary was always appreciative of what she considered was her sister's superior botanical expertise, and perhaps we should see the future *Flora Delanica* as in part a memorial to her. Mary had already decided that she was of an age when she was less required to maintain a busy social round, but her social standing meant that certain occasions required her presence. The Lord Lieutenant of Ireland in 1760 was the Duke of Bedford, whose wife Gertrude, née Leveson-Gower, was a Granville cousin. His tenure of office had been uneven and Mrs Delany clearly thought the couple were rather lofty and overbearing.[35] She found the duchess very distant on an occasion when she dressed formally to attend her drawing room. All the ladies were kept waiting for a considerable amount of time and eventually at half-past three they were admitted. Mary and Patrick then went to County Down in June for his annual inspection, and they enjoyed the usual lunches and dinners with their better-off parishioners.[36]

After the visit to County Down was over, the pair made their journey to England, first to the Dewes at Wellesbourne in September, then to Bath in mid-October, and after that to Bulstrode. It was already apparent that Anne Dewes was not well, and her illness must have overshadowed the month they spent together in Warwickshire. Mary's letters to her sister strive to retain their normal journal format, telling her about their mutual acquaintance who were

at Bath – 'We had much discourse about you, many cordial enquiries over you, and many kind wishes for your speedy recovery' – and interesting visits.[37] One was to see the studio of an artist established in Bath since 1758, 'Mr. Gainsborough', who earlier that year had painted the Dewes' near neighbour, George Lucy, squire of Charlecote House, Warwickshire. The Delanys saw his portrait of the musician Ann Ford, a virtuoso on the guitar and viola de gamba, who gave a series of subscription concerts in Bath. For a woman to perform in public was to court notoriety: while actresses were commonplace, female musicians from a genteel background were much rarer, and even the flamboyant Ann seems to have stopped performing in public after her marriage. Gainsborough's portrait was a bravura achievement, matching her spiritedness, showing her holding her guitar on her lap, seated crossed-legged – a masculine pose frowned on for women – in a silvery dress against a vermilion background. Mary's artistic eye could not but admire it, while the moralist disapproved: 'a most extraordinary figure, handsome and bold; but I should be sorry to have anyone I loved set forth in such a manner'.[38]

On 25 October the busy bustle of the invalids taking the waters and their relatives enjoying the social round was interrupted by the startling news of George II's death. The Delanys went to the Abbey church, and later found the Public Room's tea-drinking crowded with people talking of the end of the reign and the future coronation of the king's heir and grandson, George III. Everyone was in a hurry to buy mourning, 'Crapes, bombazine, thick muslin, very broad hems; nothing else talked of; 1500 yards of crape sold at one shop on Sunday night they say.' The 'quality' at all levels dressed in black, including Anne back in Gloucestershire. But Mary was more preoccupied with prayers and advice about her sister's increasingly frequent dizzy spells than about the death of a king whose court she had once aspired to join. There was talk at Wellesbourne of Mrs Dewes going to the nearby hotwells at Bristol, brother Bernard had come for a brief visit and young Mary started to take over the burden of letter-writing for her mother. Her aunt tried to include cheerful or interesting items in her letters to her, such as descriptions of a garden 'all modernized by the ingenious and much sought after Mr. Brown!!' Back in Bath, 'Charity sermons everywhere. DD preaches at the Abbey', and there was better news about Anne's health.[39]

A month later the decision had been made for Anne to go to Bristol after all. Meanwhile Mary tried to amuse her sister with descriptions of the

developments at the 'palace of delights' that was Bulstrode. Work had started on a planned cave in the garden that would be adorned with shells. The duchess and Harriet were busy turning wood, and several decorations for the duchess's bedroom were in hand – a 'carpet' (that is, a canopy) to go around the bed, some knotted work. Mary herself was making some shell-work decoration for the inside of the drawing-room windows. Being busy helped Mary cope with her anxieties for Anne: 'I am glad to be so much employed, as it *hides a little of what my heart is full of.*'[40] Once her sister arrived in Bristol, the Delanys went to join her, and the letters cease. One can but imagine the many prayers that were said and the confidences shared between the sisters, alongside the hot baths and the ineffectual ministrations of eighteenth-century medicine, before Anne died on 6 July 1761. It seems she spared her sister the final scene, sending for the doctor but asking him not to notify Mrs Delany. Death is a private matter.

John Dewes was at Wellesbourne overseeing the rest of their household and wrote with faith and simplicity to his daughter, urging her not to dwell on the enigma of death but to feel inspired by the example of her mother's life:

> My dear Mary, I am but poorly qualified at present to console you upon the great loss you have sustained in the death of the best of mothers; and though upon the whole I think my own loss the greatest, and am but too sensibly affected with it, yet, as a parent, something may be expected from me upon so great a catastrophe. Let me therefore advise you not to dwell too much upon the melancholy subject, but rather *be thankful* that a life *so worthy of imitation* has been so long continued to you, and endeavour to follow her bright example.[41]

Mary Dewes also kept the letter she received from her youngest brother, the 'baby' John, bearing up manfully for someone aged 10, and showing some of the religious inklings that would take him into the clerical profession. The two siblings would always enjoy long letters to each other. He strove to put his mother's welfare in heaven above his own loss, and heroically tried not to wish her back, and he thought of helping his father by being strong in his own way. Still, 10 years old is 10 years old, so, back now at school, 'I cannot but pass my time in great uneasiness. I bare up [sic] against my misfortune as well as I can, and I hope you will do the same, knowing it will be pleasing to my papa . . . One of your dear good letters would be a great consolation to me . . . Pray answer

this soon.' He looked forward to when all the Dewes were reunited at Calwich with their uncle Bernard and the Delanys.[42]

It is to be hoped that the time in Derbyshire did indeed assuage their grief. Their mother left little tokens for all the children, knowing their father had made proper legal provision for them. To Mary, now the mistress of the house, went all her jewels, trinkets and clothes; her watch and chain; and an heirloom traditionally passed from mother to daughter:

> The old china cup with a gilt cover and saucer, that has a setting in gold belonging to it, Mary must have, and give to *her daughter* if she has one, as it has gone from *daughter to daughter* these three hundred years!![43]

As women legally could not make wills, this glimpse of a line of mothers and daughters passing on what was legally known as their paraphernalia, in this case a fifteenth-century cup, is intriguing, but it is typical of a Granville, given their strong sense of lineage.

THE NEW REIGN AND THE NEW BRIDES

Mrs Delany was probably too concerned with her sister's health to take much notice of the flurry of speculation and comment filling the Pump Rooms at the accession of George III, but she did draw one conclusion welcome to her: 'every day contradicts what has gone before; but in this all agree – that the King has begun his reign to the *satisfaction of everybody*, and that there *is* a pleasing pros- pect of our having a King that *will show* a proper regard to religion'.[44] The young king was indeed a conscientious Christian, and hoped to appoint to his ministry and household those with sound morals as well as talent. Unlike his brothers, on whom their mother had bestowed scant attention, Augusta Princess of Wales had ensured he would avoid the libertinism associated with his grandfather George II's court, exemplified in the acceptance of his Hanoverian mistress, Amalie Sophie von Wallmoden, Countess of Yarmouth, as an unofficial consort. George III slowly realised that he would have to appoint politicians who might be gamblers but he insisted when choosing his own household – his Gentlemen of the Bedchamber and so forth – that notorious gamblers were excluded. Mary Delany and her high-principled friends would come to admire the defence of Christian revelation he would support against atheists and free-thinkers, and

it is clear that the courtiers whom he and his queen personally liked were those with religious convictions.[45]

The king was only 21 when he inherited the throne, and not yet married. He did not want to take mistresses so he needed to find a wife. George asked his friend and tutor John Stuart, 3rd Earl of Bute, to initiate a search for a suitable bride, who had to be a foreign, and a Protestant, princess. The choice was Charlotte of Mecklenburg-Strelitz, a small north German principality. Most people had no idea where the new queen came from – Horace Walpole commented, 'I had scarce found Mecklenburg with a magnifying glass' – and a flurry of books appeared about Mecklenburg including a historical survey by Sarah Scott, the sister of the Bluestocking Mrs Montagu.[46]

Though Mrs Delany did not have a ringside seat for the royal occasions, she would have had first-hand accounts from two of her closest friends: the Duchess of Portland, whose younger daughter Harriet was a Maid of Honour at the wedding, and Lady Andover, whose son Henry Howard 12th Earl of Suffolk carried the sword of honour at the coronation. Not long after these royal events there was a wedding in the grander portion of Mrs Delany's Warwickshire circle. Lady Louisa North, daughter of Mary's friend from Prince Frederick's court, Francis 1st Earl of Guilford, and like Lady Sophia Carteret a pupil of Mme LePrince de Beaumont, married John Verney Peto, 14th Baron Willoughby de Broke, whose estate was at Compton Verney near Stratford-upon-Avon. Having inherited from two relatives, Louisa's new husband was wealthy enough to embark on a thorough reconstruction of the family seat. This was master-minded by Robert Adam, who replaced the baroque remodelling done two generations earlier, while Lord Willoughby employed the ubiquitous Lancelot 'Capability' Brown to landscape the grounds.

The marriages in the other parts of the Delany circle could not have been more of a contrast. In January 1761, John Chapone, Sarah Chapone's son, was finally able to marry his long-term fiancée Hester Mulso. Years had gone by while he finished his legal training and then more recently settled his father's debts. When he visited his sister in Bath the previous autumn she was visibly shocked at how ill and gaunt he looked, and indeed he was already suffering from the consumption that killed him ten months after his wedding, which was a quiet affair in London. Much more cheerful was his sister's wedding to *her* long-suffering patient fiancé, Daniel Sandford, in October 1764. The Delanys made every effort to give them a cheerful, public yet homely wedding so there could

be no speculation the couple were privately marrying without his awkward father's consent, which had finally been granted. The dean stood in for Sarah Chapone's late father and gave her away, while the Delanys' friend the Rev. Gustavus Hamilton officiated. It was a cheerful sunny October day; everyone assembled in the drawing room then walked to church.[47] Nor was Sally's sister Kitty left a spinster at home: she was chosen as the second wife of a very wealthy widower, John Boyd, who had given up his business interests in the West Indies for a life of connoisseurship. He had known of Kitty through his first wife's network in Warwickshire, and she may have been a governess in their circles.[48] Such were the real-life scenarios from which Jane Austen would fashion her fictions.

Frustratingly absent from the surviving letters collected by Lady Llanover is any reference to a widowing and a marriage that must have been close to Mrs Delany's heart. In 1762, the 2nd Duke of Portland died. Mary must have written condolence letters to her dear friend but they do not survive; when she was in England in 1763 and visited Bulstrode there must also have been talk between the two about the duchess's change of status. However, although parted from an affable and congenial husband, she was not parted from her home. She remained at Bulstrode with her collections, her garden, her park and menagerie; but, as planned, her son inherited the valuable Welbeck estate from his grand-mother, so as a dowager the duchess was not displaced from a country estate that was both a home and a one-woman scientific institute.[49] On a brighter note, in 1763 when the Delanys came to England, Lady Harriet, the duchess's younger daughter, had found a suitable match with George Grey, 5th Earl of Stamford, and the dowager duchess could visit her when taking the waters at Buxton in neighbouring Derbyshire.

There are hints in the surviving letters that in late 1764 18-year-old Mary Dewes had attracted an admirer, but that for some reason either she had felt it wise to resist his attention and not allow him to turn her head, or had been directed by her father to do so. Her aunt commended her, adding: 'I never pray more earnestly for any blessing on myself than *contentment*!'[50] All this was of a piece with her advice a couple of summers earlier, echoing Mary Astell: 'Our business in this world, my dear, is preparing for another . . . The rules are plain and easy if indolence or luxury do not blind us.'[51] In fact there was romance awaiting young Mary near her uncle's estate at Calwich.

Bernard and the Duchess Befriend Rousseau and Patrick Passes Away

CALWICH ABBEY AND ITS CELEBRITY NEIGHBOUR

*I*n south-west Derbyshire on the border with Staffordshire were Mary Delany's brother Bernard at Calwich Abbey, and Lady Andover at Elford, seat of the earls of Suffolk, a title first inherited by her father-in-law. Her brother, Heneage Finch, 3rd Earl of Aylesford, lived at Packinton, near Solihull, Warwickshire, to the west of the county, so she also had a link near the Dewes. Although parts of Derbyshire were craggy and remote, with rugged landscapes seen as sublime, Ashbourne itself, the nearest market town for Calwich Abbey, was at the cross-roads of six major roads. So this area was provincial, but it was not isolated, and its cathedral cities, country houses and parsonages could be the matrix of a vibrant cultural life. Buxton Spa in the more rugged north-west of the county was already a fashionable centre for the well-to-do to take the waters and coddle their health – including the Duchess of Portland, who was a frequent visitor.

Bernard tinkered endlessly with the Calwich house, and was probably his own architect. He created a lake in the grounds and in 1748 he added a new music room for the house. The drawing room was where he put his chamber organ, a second-hand model from the early eighteenth century by Bernard Smith, which Handel himself had advised him to buy. When the Dewes family came to stay in Derbyshire, one of the great attractions for the men was the excellent fishing to be had all along the River Dove. But there was also constant music making. As John Dewes wrote to his daughter, Mary, 'I hope the agreeable amusements of fishing, hunting, music and cards go on as usual.'[1] All the Dewes

family was musical. The Dewes brothers played chamber music together: when he was still at Oxford John commissioned his sister Mary to buy him a good flute in London. He also composed music: Mary admired his setting of the aria 'Cease the anguish' from Handel's *Attaliah*.

It was in the spring of 1766 that one of the most controversial figures of the eighteenth century, the Genevan philosopher Jean-Jacques Rousseau, stayed in this milieu of county families, many with family and political connections in common. Rousseau had come not to socialise, but to escape from the metropolis and from those he increasingly considered to be his enemies. For a while he stayed at Wootton Hall, 2 miles from Calwich, and despite his fragile mental state, in which he saw conspiracies everywhere against him, he allowed Bernard Granville and his guests to befriend him.

With Bernard he shared a deep engagement with music, and there was the advantage for him of Bernard's fluent French, as Rousseau's English was almost non-existent. Bernard's guests later that summer included the Duchess of Portland; she and Rousseau were united by common interests in botany. The duchess subsequently *wrote* in English to him, but could converse in French beyond music and botany. Rousseau's unorthodox religiosity was a challenge to Mary Delany, and she worried about his probably adverse influence on her brother and her niece. The summer of 1766 was therefore a formative moment in the lives of the Granville family as some of them made Rousseau's direct acquaintance.

Rousseau was both a participant in the Parisian locale of the pan-European movement known as the Enlightenment, and an ardent critic of it. He was always restless and impossible to categorise. When Rousseau later made his religious views public in his educational novel *Emile, or On Education*, many thinkers concluded he had jettisoned too much orthodox Christianity along the way. His novel *The New Eloisa* appeared to condone adultery and suicide, which galvanised readers, especially female ones, as it seemed to sympathise so deeply with their lack of freedom before and within marriage. All his books offered a profound criticism of the psychological deformity modern civilization imposed on its denizens, combined with the political powerlessness of many in pre-revolutionary Europe, and as a result he was at home nowhere. He came to England in 1766 because he was persuaded to accept a pension from George III by the Scottish historian and philosopher David Hume, among others. Hume travelled to England on the same boat with Rousseau, who was

accompanied by his beloved small brown mongrel dog, Sultan.[2] But Hume soon found himself at the centre of what today would be called a media storm, generated by Rousseau's precarious mental stability. Eventually Rousseau met the landowner Richard Davenport, who offered him the use of Wootton Hall in Derbyshire.

'L'HERBORISTE OF LA DUCHESSE DE PORTLAND' AND THE YOUNG SHEPHERDESS

Rousseau settled happily at first into Wootton Hall, enjoying the picturesque aspect, the scope for botanising on his walks and the tranquillity to carry on with his writing of his autobiography, later published as *The Confessions*. Some of this would be written once the weather warmed up in the grotto Davenport had created in the sandstone rock in the garden. Rousseau described his early impressions of the setting in a letter to one of his French friends, Mme de Luze:

> The valley is lined, in places, with rocks and trees where one finds delicious haunts, and now and again these places are far enough away from the stream itself to offer some pleasant walks along its banks, sheltered from the winds and even from the sun, so that in the worst weather in the world I go tranquilly botanising under the rocks with the sheep and the rabbits.[3]

But although Rousseau seemed to be in a tranquil Arcadia, he had already become disturbed: two weeks after he arrived, a satirical letter of Horace Walpole's, which Rousseau already knew about, was published in *St James's Chronicle*, both in its original French and in translation. Rousseau made his own reply to the newspaper. Comments for and against him began to multiply, some much crueller than Walpole's original mockery. Reacting to this magnified public exposure, Rousseau pieced together in his mind various episodes that, in his increasingly paranoid state, persuaded him that Hume was not his friend and benefactor at all, but the centre of a conspiracy. In late June he compiled an enormous broadside detailing his suspicions, and refusing to have anything more to do with the pension negotiated by Hume.

Meanwhile in the late spring of 1766 after his annual visit to London and Bath in the winter months, Bernard wrote to his niece Mary Dewes, who was

about to go back to her father and brothers in Wellesbourne after an extended visit to Lady Cowper in Richmond. He told Mary about her sheep: 'I found all the animals are well here: your Nan has a fine black lamb, so that your number is increased to three.' And: 'Mr Port called here yesterday morning.'[4] This was John Port, né Sparrow, a Derbyshire young gentleman whom she would marry four years later, and who inherited the nearby Ilam estate from his mother's family, after which he took her maiden name.

Aunt Delany knew of the planned visits and in June wrote to Lady Andover, who would come over from Elford,

I rejoice my dear Lady Andover has exchanged the noise and hurry of London for her sweet Hill!! . . . I hope nothing will intervene to rob my brother of the honour you design him, as I know it will give him the greatest pleasure. And our beloved friend at Bulstrode [the Duchess of Portland] I thank God is so well, but she does not feel herself quite well, or she would not go to Buxton.[5]

After a late cold spring, summer came in earnest by early July, and Mrs Delany asked her brother, 'I hope *your neighbour Rousseau* entertains you; is he pleased enough to satisfy a genius, but not so well suited to a sentimental philosopher as to a cynic . . .'[6] Two days later Lady Cowper told her god-daughter about her long journey, first to Durham to see her brother then to her cousin in Derbyshire:

I was very near swimming at Carlton, the waters being out [this would have been when fording the River Trent, near Nottingham]. I asked the post-boy whether the water was deep, he said no, 'only a *slap*' as half filled my chaise!! I caught my feet so quick that my shoes were not wet through, but my petti-coats were, and I was obliged to sit in them, but was so lucky as not to catch cold . . .[7]

In August the planned rendezvous took place: Lady Cowper; Lady Andover from Elford; and the Duchess of Portland, en route to Bulstrode after her visit to Buxton.

In an avuncular way Rousseau was charmed by young Mary. He liked her attentiveness to her ageing and crotchety uncle, and spotted that the shep-herdess already had a shepherd swain in devoted attendance – young Mr Port. Rousseau described himself as the old shepherd in comparison with the young

one. However, it is readily understandable why Mary Delany worried about what influence he might exert on her 20-year-old niece – and her 67-year-old brother, who was already reclusive enough. Not all her letters to Mary Dewes survive, but an important fragment written in early September shows she was familiar enough with the tenor of Rousseau's works to give her a gentle but firm warning. Some of the italicized phrases in the original are perhaps quotes from an enthusiastic letter the niece had written to her aunt:

> Now for a word about Monsieur Rousseau, who has gained so much of your admiration. His writings are ingenious, no doubt . . . I own I am not a fair disputant on this subject from my own knowledge of his works, as I avoid engaging in books from those whose *subtlety* [sic] I might perhaps receive some prejudice, and I always take alarm when *virtue* in *general terms is the idol*, without the support of *religion*, the *only* foundation that can be our security to build upon.

Thinking back to her own social debut, when there was much challenge to Anglicanism from the first generation of Deists, she continued:

> I remember a wise maxim of my Aunt Stanley's when I first came into the great world:– '*avoid putting yourself in danger, fly from temptation, for it is always odds on the tempter's side.*' I had much more to say to you, my dear, but think I have already tried your patience, and I will give you some rest from my reflections, well persuaded your own good sense, with mature consideration, will point out the good, and make you reject the bad as soon as you distinguish them . . .[8]

Aunt Delany also confided in Lady Andover:

> I am glad you have seen *the Rousseau*; he is a genius and a curiosity, and his works extremely ingenious, as I am told, but to young and unstable minds *I believe dangerous*, as under the *guise* and *pomp* of virtue he does advance very erroneous and unorthodox sentiments; it is *not* the 'bons tons' who say this, but I am too near the *day of trial* to disturb my mind with fashionable whims. Lady Kildare said she would 'offer R. an elegant retreat if *he would educate her children.*' I own I widely differ with her ladyship, and would rather commit

that charge to a *downright honest parson*, I mean as far as to religious principles, but perhaps that was a part that did not fall into her scheme at all.[9]

The Lady Kildare in question was Emily, Marchioness of Kildare, née Lennox, the Duke of Richmond's daughter, whose husband was made Duke of Leinster that November. Her scheme to employ Rousseau never materialised, but arguably she took her cue from his novel *La Nouvelle Eloisa* when she later began an affair with the Scottish tutor she did appoint for her younger children, William Ogilvie, had a child by him and married him as her second husband.[10]

Aunt Delany was also interested to hear from Lady Andover about how her niece came over when she was in company. In the same letter, she asked her confidentially, knowing that the Duchess of Portland was too fond of her to be frank,

> May I beg to know how she [the Duchess of Portland] liked my niece? I know the fear of hurting me will keep her from sincerely telling me her opinion if she disapproves; but how can I be of service (to a creature *so dear to me*) at this *distance* if *uninformed* of her manner and behaviour. A hint to her might be of the greatest service, and I should endeavour to do it in such a manner as would not appear like the observation of any particular person. Your sensibility and maternal tenderness will make you feel my meaning and anxiety on so interesting a point, and the *friendship* you honour me with will apologise for an openness of heart – that is the strongest proof of *mine* I can give.[11]

Since Dr Delany's health was too poor for them to make a visit to England, Mrs Delany was enjoying a month's visit instead from two of her nephews, Court and Bernard. She was very impressed with the former, who had '*great* abilities and *great* application' and she thought them both 'sensible and good' and that 'they have made good use of their time'; however, 'as to the polish of the world, it has not yet come in their way, but they are naturally *civil* and "unaffected" '.[12]

However, their sister Mary does display a degree of social polish in her letters, written in French, to the 'old shepherd'. Back in Wellesbourne with her father after a detour via Althorp, her godmother's home during her first marriage, where they enjoyed the picture gallery, she made an embroidered dog-collar for Rousseau's much-loved Sultan. In his thank-you letter Rousseau

wove a pleasant verbal conceit, saying he was envious for the first time in his life that it was Sultan not he who was sporting the chains she had given him the honour of wearing.[13] A year later when Mary was again at her uncle's and Rousseau had returned to France, she teasingly reminded the latter that the previous year she had promised to show him that she had kept a seal he had given her when she made her annual visit. Again he devised a little word-play in reply, saying that while she had kept the impression – that is, the seal – conscientiously, he retained a better impression, since hers made marks on paper, which could be lost, but 'j'ai le vôtre empreint dans mon coeur d'où rien ne peut effacer' (I have yours imprinted on my heart, from where nothing can efface it). There was no uncomfortable, ambiguous flirtation in his phrases, since he always mentioned her beau, Mr Port, hoping that with her uncle's approval she would soon give her sheep their shepherd.[14]

Mary was unable to see Rousseau again during the 1767 annual visit to Calwich because in April that year he had left Derbyshire very abruptly after a contretemps between his companion Thérèse and Mr Davenport's servants. They had not taken kindly to accepting direction from a woman who was really from the same lower rank as themselves, and after a quarrel one of them had sprinkled ashes in the soup.[15]

Bernard Granville though was sorry to return from Bath to Calwich to find his neighbour determined on leaving. He wrote to his niece, who was in London where Rousseau was thought to be:

> I think he proposes making Chiswick the place of his abode for this summer . . . Mr. Davenport's housekeeper behaved in so brutish a manner towards him, that it occasioned his sudden departure from this country – a sad loss to me; I would fain have had him come and stay at Calwich, but could not prevail. If chance should bring you in his way, tell him how I mourn the loss of such a neighbour, and that I wish all good and pleasant circumstances may attend him wherever he is.[16]

Rousseau, once he was re-established in France, staying at the Prince de Conti's chateau in Normandy, told Bernard Granville how often he felt the loss of his company, and that wherever he was he would always carry happy memories of the kindness Bernard had shown him.[17] For several years he wrote to Bernard or enquired after him from the Duchess of Portland, expressing sympathy for the

rheumatism that crippled his hands, and in 1768 sending him a copy of his newly published *Dictionary of Music*.[18]

The duchess was mainly concerned with the botanical interests she and Rousseau shared, but in one of his letters to her he articulated his version of how 'nature led up to nature's God':

> The study of nature takes us away from ourselves, and elevates us to her author. It is in this sense that one becomes truly philosophic; it's in this way that natural history and botany contribute usefully toward wisdom and virtue.[19]

Her summer visits to the spa at Buxton, in the craggier and higher regions of the Peak District, were as much occupied with scrambling around looking for wild flowers as taking the waters, and the exercise must have done her good. She explained to Rousseau that she far preferred these wild specimens to cultivated ones:

> though I am very fond of all kinds of plants yet I must sincerely own to you the wild plants give me more pleasure than those which are brought from the Indies or to see a plant inlarged [sic] by Culture to the size of a crown piece which is not naturally bigger than a silver penny . . .[20]

This absolute focus on plants, as if any of the controversies or fears that were engulfing him were non-existent, was a tonic to Rousseau: if in her eyes he was simply a fellow botanist, this gave him a fresh, simpler identity. When Bernard's house guests arrived in August 1766, Rousseau had completed an exhaustive exchange with Hume, and written to a friend in Paris implying that the public would have to judge the truth about Hume's accusations against him. This inevitably led to Hume getting in first with his own summary of the affair.[21] Turning to botany with Bernard Granville's guests must have alleviated the mental torture Rousseau had experienced in reliving these controversies. In any case, as the duchess wrote to Rousseau in English, which he could read better than he spoke, it may be that they conversed mainly via Bernard Granville as interpreter, which would limit the amount of complicated discussion they could have. Their meetings resulted in exchanging plants that required clearer identification; she gave him botanical dictionaries by two late seventeenth-century authorities, John Ray and John Petiver, and when he left Derbyshire for London,

he wrote that he would like to cast off his old self and be known only as her 'herboriste':

> If my observations can have the least bit of interest for you, the inclination to please you only makes them more important, and the goal of sharing them with you makes me aspire to the title of your herboriste, providing I have the knowledge that would ender me worthy of this designation. Please give me permission, Madame, I do beg of you, to make of this designation a new name which I will substitute for the one by which I have lived so unhappily. I must stop being this person under your auspices, and the title 'herboriste de madame la Duchesse de Portland' will console me painlessly for the death of J.J. Rousseau.[22]

Henceforth for a few years he signed his letters to her as her 'herboriste', even deploying the formal usage 'votre très humble et très obeisant serviteur et Herboriste'. The latter phrase, using deferential phraseology, was a very rare usage given his determination to discard all the formal hierarchies of society.[23] Their contacts continued from 1767 to 1773, until letters and seed parcels went astray.[24] It is even likely that their discussion of how unsatisfactory were the current introductory books on botany planted the seed that led to Rousseau's *Letters on Botany*, which adopted the conventional popularising form of letters to a lady, and was widely read in France and in England.

If his time near Calwich when he enjoyed the friendship of Bernard Granville and his guests was among the happiest moments of his life, perhaps it was because these two eccentric grandees had each opted out of paying much attention to the political world and pursued their private inclinations instead. Bernard Granville and the Duchess of Portland did not completely ignore society's routines; they went to London in the winter season, to Bath or Buxton or Scarborough for their health. They were both essentially apolitical in the wider sense of the term; they ignored public controversy and gossip, and lived by their own light. It was Lady Cowper who followed the ructions in the English press more closely after Hume had publicised the bad feeling that had developed between him and his former beneficiary. Young Mary Dewes Port and her brother Court evidently followed the quarrel and he gave his sister's copy of Hume's pamphlet to Lady Cowper to read.[25] Mrs Delany should probably have worried as much about Rousseau's influence on her nephew as on her niece.

GODMOTHERING

Mrs Delany was unable to visit her English relatives for four years instead of the usual two because of the dean's deteriorating health, which was exacerbated by financial worries.

Her niece was disappointed that the 1765 visit was twice postponed. Her aunt, who was in the last few days of entertaining her niece's two elder brothers, comforted her:

> My dear niece, don't let my *not* coming to England distress you . . . Providence has for the present ordered it otherwise; but I trust your own good heart and principles will make you pass through this life with honour to yourself and your family.

One thing that cheered her own heart was that her niece and nephews were such good friends:

> I am happy beyond expression to find the mutual friendship that subsists among you; no friends can be so truly depended upon as relations (*if they are worthy and sincere*) their connections the same, and if they have generous and enlarged minds, the happiness of any one communicates itself to the rest.

Mary was now staying with Lady Cowper again:

> You are now with a very sensible, kind, obliging and experienced friend, and will, I am sure, make use of every opportunity that comes in your way; still bearing in view [here Aunt Delany paraphrased I Corinthians 9:25] the crown prepared for those who perform their duty in this world; and though I do not recommend any methodistical self-denial of all the good things of the world, I recommend such a *moderate* enjoyment of them as becomes a *rational creature*, which I am sure is all you wish to do.

One wonders if this spiritual nourishment was given in response to her niece feeling sad not only in missing her aunt's visit, but missing her own mother, dead now for five years. Aunt Delany agreed with young Mary's perplexity at her uncle's eccentricities: 'I believe Mr. G. is very well satisfied with you, though

I don't wonder you should sometimes think his behaviour strange . . . he owns to me he has not been well, and I can't help being uneasy about him.'[26]

The dean's age and infirmities weighed heavily on her heart. One day in November, she wrote a number of letters to friends and relatives who would be happy to hear that the 3rd Duke of Portland, son of her friend the duchess, had married the 4th Duke of Devonshire's daughter, Lady Dorothy Cavendish. At 26 the young duke, who had succeeded his father only four years earlier, was currently serving as the king's Lord Chamberlain, but he was also an actively political peer, unlike his father. In fact his politics exacerbated tensions with his mother. He belonged to a coterie of politicians led by Lord Rockingham who were in opposition to the king's ministers. They believed that the true principles motivating the Whigs back in 1688, when James II had been forced out, were being betrayed, and that the main culprit was George III's former favourite, John Stuart, 3rd Earl of Bute – whose wife was such a great friend of the duke's mother. Mrs Delany's letters may have needed careful wording.

But when writing to Lady Andover, she suddenly had a fit of nerves – the combination of this effort with worry over her husband, and her god-daughter's husband, whose asthma had worsened, overcame her momentarily. She admitted to some of the strain she had been under, but as she was writing, rallied at the thought of Patrick's strong constitution, and from the relief of writing to a sympathetic sister figure. 'A sigh relieves an oppressed mind, and it is no more than that; and the communications of friendship give that relief which nothing else can . . .'[27]

Soon Lady Andover had her own sorrows to confide to her friend, for her son, the 12th Earl of Suffolk, lost Maria Constantia, his wife of less than three years, after she had given birth to an infant daughter, christened Maria in her memory. Delany's own household family were doing rather better than in her last letter; the Rev. Sandford was less ill, though Sally was often low, and as to Dr Delany, she was trying to view the glass half-full rather than half-empty. Her husband was now 83, but 'I have much more reason to be thankful he is so well, than to repine at his suffering sometimes, which is only in a gentle degree compared to what others suffer from the same complaint'. She felt ready in this letter to confide the aggravating factors, namely the continuing financial problems generated by the old lawsuit, to her friend. The plaintiffs were disputing the Delany's right to the £4,000 mortgage awarded them in the House of Lords settlement, plus claiming a previously unmentioned £2,000. If the case favoured the plaintiff they would have to orchestrate another appeal, and:

the mortification of soliciting and tormenting my friends over again is a thought hardly supportable . . . this truly, is what keeps D.D so low. I do all I can to make it easy by *concealing* my own fears about it; and at times reason prevails so far as to show me the folly of anxiety for what we can no way help, and cannot be blamed for, and points out *how far our race is run* [I Corinthians 9:24], and therefore worldly matters should seem trivial.

Mary also told her friend that the duchess knew of these impending troubles as she wanted to prepare her for any future development. To have withheld information until a crisis was upon them and then suddenly explained it would have suggested that she had reservations about confiding in her, when the truth was 'she knows and must know, as long as it has any pulsation, what passes in my heart, unless it may be to save her pain'.[28]

The letters to the duchess in which she explained the cloud looming over the Delanys are lost, but evidently she must have canvassed to her that a possible solution was for her to sell the house in Spring Gardens, which the dean had bought for her in 1755 to provide for her widowhood. What Mary didn't know was that the duchess was so concerned about her friend's financial situation that she had taken it on herself to confide in Mary's brother Bernard, while enjoining him to secrecy. The duchess was almost certainly hoping that her friend's wealthy brother would consider ways in which he might help his sister, but all she said explicitly by way of a hint was that she was worried that if Mrs Delany sold the house she would not secure the proceeds from it in her own name. The implication was she would use them to satisfy their litigants. One way that Bernard could have helped was to advance the Delanys the £6,000 they needed as a bridging loan, until their litigants paid up what they owed them. It must have been painful for them to realise that their opponents were trying to ruin them before giving them the money they owed them: malicious delaying tactics that again implied the dean's behaviour to his first wife had lacked integrity.[29]

While being a godmother and grandmother had brought considerable extra responsibilities to Mary Delany and Lady Mary Andover, including caring for babies, Lady Cowper's role as a godmother to young Mary Dewes was much more fun, and she entered into it with zest. Her second husband, the 2nd Earl Cowper, died in 1764 aged 55, but with her irrepressible vitality she soon adapted to widowhood. Her only child was the son from her first marriage, John Spencer, MP for Warwickshire from 1765 to 1771, when he was elevated to the

peerage. His mother was pleased when George III made him Viscount Spencer (1761) then Earl Spencer (1765).[30] He bought his mother Cholmondeley House in Richmond, near to the old Tudor palace that faced directly onto the river, and when Bernard Granville admired it her décor must have been newly finished. Perhaps she had always wanted a daughter, for she stepped fully into the space left by Anne Dewes' death, signing some of her letters to young Mary 'your affectionate mamma'. She was also godmother to her Tollemache nieces at Ham House.[31] Mary Dewes observed to her brother John, 'I do think – to say nothing of her greater qualities – that she has the most constant flow of good humour and good spirits I ever saw.'[32]

Lady Cowper's regular pattern was now to have Mary to stay in the spring and again in the autumn, where she became part of the active social life orchestrated by the countess. As a widow she was now freer to travel, as her intrepid journey to Durham attests. In the early or late spring she would regularly make a return visit of at least two weeks up at Wellesbourne with all the Dewes, after which she sometimes went straight on with Mary to Bernard Dewes at Calwich. She would take the opportunity on returning either from Warwickshire or Derbyshire to visit various connections. Whether at home or as a guest one of Lady Cowper's passions was music. She played the bass viol (which she was confident not to consider improper, as unlike Ann Ford she only played it in private) and keyboard instruments such as the clavichord, and she sang. She would have been a welcome addition wherever she visited.

Lady Cowper was a generous and indulgent employer. Her lady's maid, Godwin, was in a distracted state as she was being courted, and had mislaid her employer's black masquerade corset – perhaps something her employer had worn twenty years before, when these entertainments were more popular. She had wanted to show it to a friend, and Godwin had said Mary had borrowed it. 'If you have you are very welcome, but I rather think she does not know where she has put it, as she has *other things* to think of.'[33] The *other things* resulted in a proposal from the suitor, 'a person in great business in Woolwich', possibly a supplier to the military arsenal there, and Lady Cowper organised a little wedding reception for her. However, young Mary's *tendresse* for Mr Port is never explicitly discussed, and there are hints that a 'Mr W' was rejected, but they probably knew that Uncle Bernard would consider Port not quite good enough for a Granville, and that Mary would need to choose between a man of good character, or better worldly advantages.

The visits and letters with her aunt, uncle and godmother were therefore a social education for Mary Dewes in two senses. Her musical literary and artistic tastes were developed informally by mixing with cultured and talented connections; she may have had specific music teachers from time to time, but playing and singing with Bernard Granville, her brothers and Lady Cowper developed her ear and her technique. Both ladies would have set an example of how to manage a household and create decorative touches. The degree to which Mary since her mother's death was already mistress of the Wellesbourne household in every detail comes over in a message to her brother: 'the key of the clavichord hangs up upon one of the nails in the closet in the little parlour; it has a paper tied to it, and wrote upon, "The Key of the clavichord" '.[34] But most importantly the different social milieux in Warwickshire, Derbyshire and Richmond would have taught Mary how to move in social circles from the gentry upwards to the daughter of a prominent statesman like Lady Cowper, how to adapt her conversational subjects and tone to the people she was with, to be as easy with the older generation as with people her own age, how to join in and when to be silent, how to read out loud in company and when to retire to her room to keep up her correspondence with her family. All this was just as Judith Drake would have recommended sixty years earlier: a gentlewoman should be conversible and socially sophisticated, without any stiff asceticism about mixing in the world, be it derived from Astell's Anglican austerity or Lady Hastings' Methodistical strictness.

THE SAD FAREWELL

By May 1767, the pressure being exerted on the Delanys to make the £6,000 payment was so strong that they had decided to save money by making their English visit, and include Bath to improve the dean's health. Evidently Bernard had not taken the duchess's hint and the Delanys had to make their own plans. As there would still be running costs at Delville in maintaining the Sandfords, with Sally pregnant for the third time, what Mary really had in mind was, exactly as the duchess feared, the sale of the London house. Moreover, in making this heroic effort to travel, what the dean must have intended was that if the Bath waters were ineffective, his beloved wife would be surrounded by friends and family when he died.[35]

By June the Irish party had reached Calwich, with the dean far too tired to contemplate even the next step of going to Bath. Mary was 'undergoing the

fate of Tantalus' in being so near Lady Andover at Elford: 'my heart is full, and longs to unburthen itself to which cannot be done in a letter', while the duchess would not be at Buxton until near the beginning of August – just the time when it would be sensible for the Delanys to go to Bath and secure a good house before the town filled up. But by the end of June Lady Andover at least had found a way to come over to Calwich for a short visit.[36] After Lady Andover returned the dean continued to be more settled, and all the Dewes men but John came over in different stages. Again, though, Mary found her underlying troubles spilling out to her friend, before she checked herself to focus on some grains of comfort:

> This has not hitherto been a year of lucky moments to *us* – chide me my dear Lady Andover for this last *wicked* paragraph. Am I not in England, are not my dear friends better to me than a thousand degrees than I deserve, and is not the Dean miraculously well, *considering what he has undergone?* I will reform, and not dwell on the gloomy but more enlightened part of my portion, and be thankful.[37]

Mary Dewes accompanied her aunt and uncle to Bath, where they ensured she had some amusement and company as well as being a devoted help to them both. But she also had one of her bad winter colds and hot blisters were applied to her back to help cure her cough. However, she was well enough to hold the fort in December when her aunt went to London to sell the Spring Gardens house, and nephew Bernard was there as well to help. Mrs Delany worked as quickly as she could. Meanwhile, so that young Mary would not entirely be absorbed in household management and nursing an invalid, Aunt Delany wrote: 'I insist on your going to the ball on Tuesday if you have a proper chaperon that you like.' After Christmas, Mary joined her aunt in London for a short while and they returned to Bath together, to Lady Cowper's relief; she had feared that the changing weather might have prompted the dean's final decline and doubled Mary's grief.

In early February 1768 Bernard Granville was in Bath for his annual visit, which lasted for nearly three months, and young Mary kept brother John in touch with the Bath events. Also resident there were Lady Andover's son, Lord Suffolk, and the parents of his late wife, Lord and Lady Trevor. Young Mary went to some of the public breakfasts with Lady Trevor, listened to sermons in

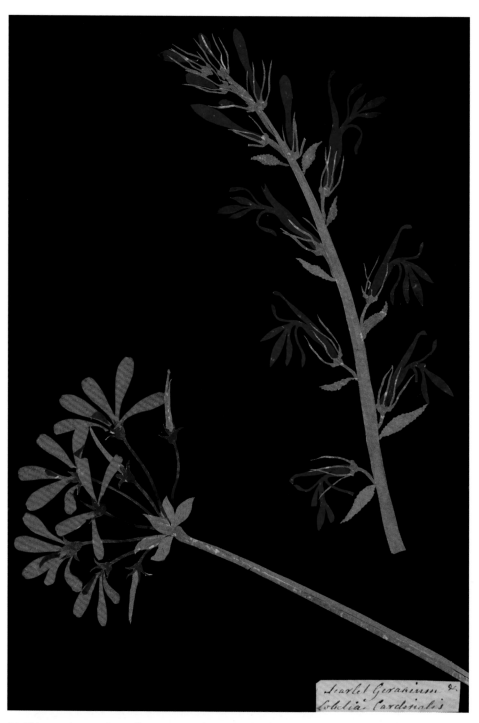

Scarlet Geranium &
Lobelia Cardinalis

26. This was the very first collage, composed in 1773 when Mary noticed the vibrant red of a scarlet geranium's similarity to a silk garment in the duchess's dressing room at Bulstrode and decided almost on a whim to try and 'draw' it by using coloured papers. Mary did not consider it high art but 'frippery' because of its use of perishable materials, and had no intention of depicting nearly a thousand specimens for the 'Flora Delanica', as it subsequently came to be known.

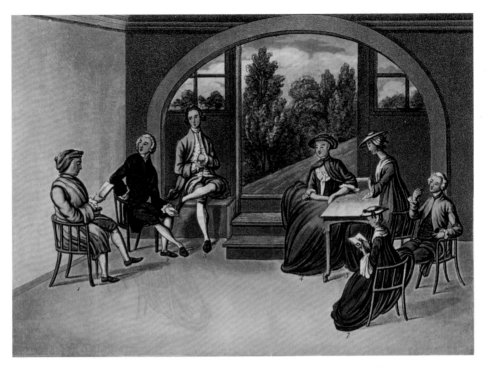

27. This drawing by Susanna Highmore depicts the circle of the publisher and novelist Samuel Richardson. It included his daughters and their friends, who were all in contact with Anne Dewes and Mary, and are thus a link between the 'feminism' of women such as Judith Drake and Mary Astell and a more constrictive middle class 'feminism'.

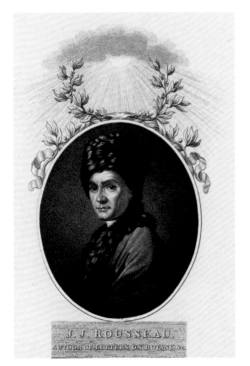

J. J. ROUSSEAU,
AUTHOR OF LETTERS ON BOTANY &c.

28. This print of Jean-Jacques Rousseau, based on Allan Ramsay's famous painting of him in Armenian costume, depicts him almost as a saint blessed from heaven. This is not so far from how his disciples regarded him, of whom Mary's brother Bernard was one.

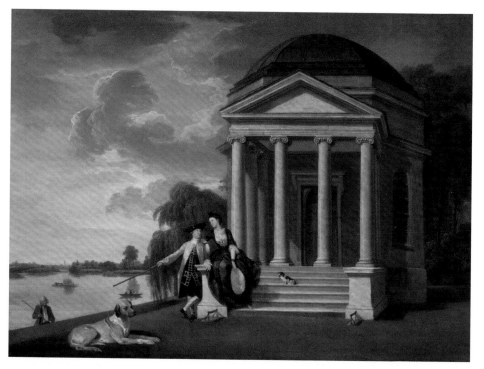

29. The Shakespeare Temple in the actor David Garrick's Thameside garden. Garrick created a
Shakespeare Festival in 1769, much discussed by Mary's niece as well as the Bulstrode circle.

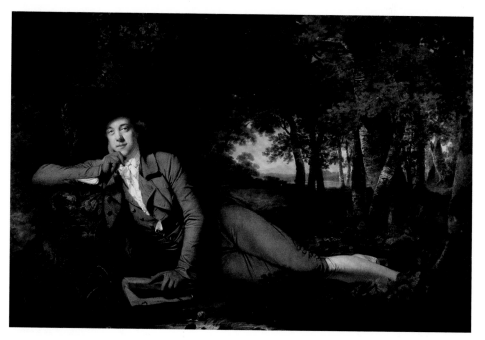

30. Wright's depiction of Boothby includes a book labelled 'Rousseau', as he had been entrusted
with publishing one of his hero's autobiograhical writings. Wright has also depicted him reclining in
thoughtful contemplation, in the style of Elizabethan portrait miniatures.

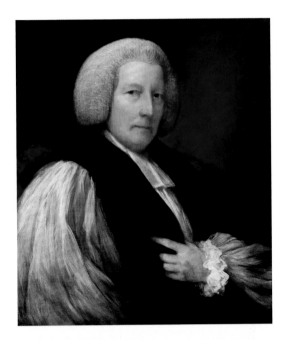

31. Bishop Hurd was very much a part of Mary's inner coterie. He had tutored the older sons of George III and Queen Charlotte. His portrait hung in the queen's bedchamber in Buckingham Palace, alongside one of Mrs Delany.

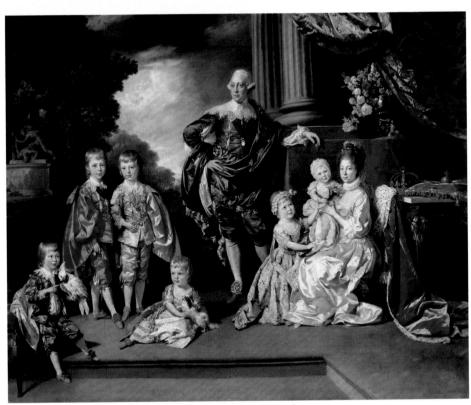

32. This is a portrait by one of Queen Charlotte's favourite painters, the German-born Johan Zoffany. The queen's robe hangs on the back of a chair, suggesting she is happy to discard it once ceremonial duties are over. The cockatoo and the flowers hint at the queen's interests in natural history and botany.

33. William Mason was also a part of Mary's inner circle, although his radical Whig views were not in harmony with her Tory loyalism. However, they had common views on poetry and garden aesthetics, suggesting that these were significant literary influences on the creation of the famous collages.

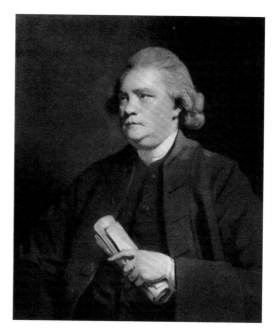

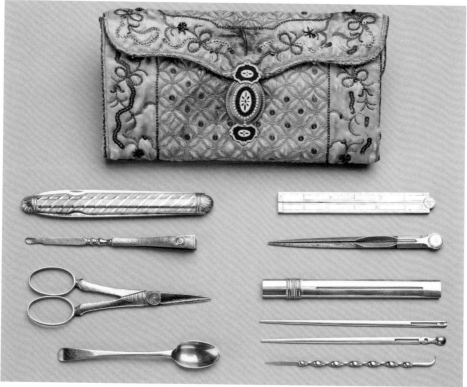

34. Queen Charlotte's gifts show how closely she had observed Mary's methods. The bodkin was used to manipulate the paper components on their flour-paste foundation. The purse, which would hang from a belt, evoked the summer visits between Windsor and Bulstrode when there was respite for Charlotte from court ceremony and time for shared creativity with a trusted friend.

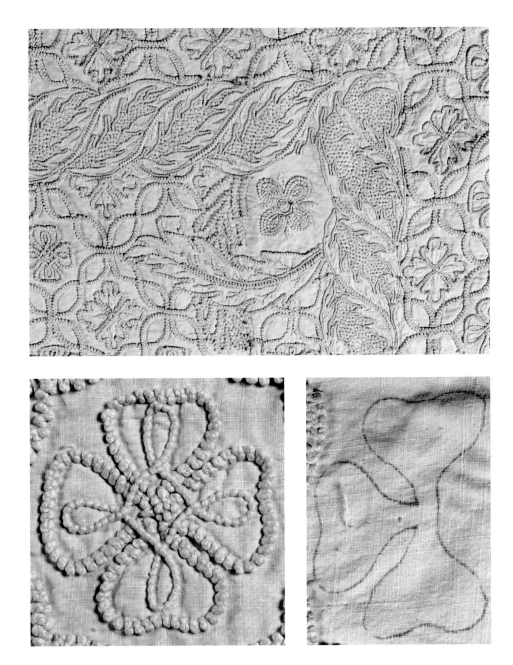

35–7. This white knotted bedspread was designed by Mary as a bedcover for Thomas, eldest son of Sally Sandford and her husband Daniel. Several people probably worked on this, following the inked in pattern with different success. The three images show the whole bedspread, a single flower, and a section where the inked pattern is incomplete.

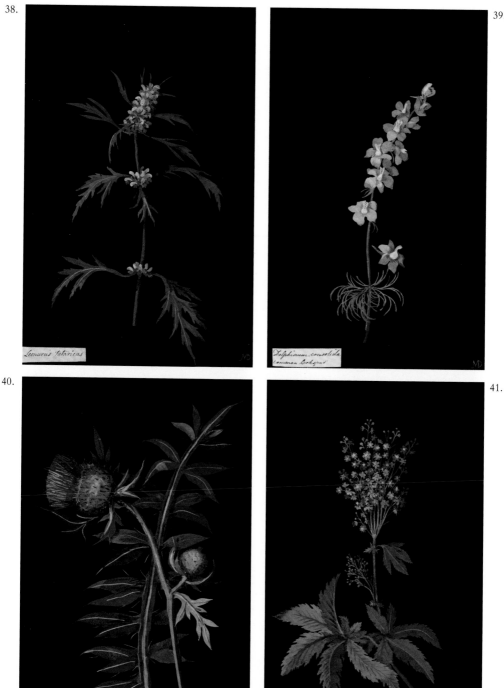

38. 39.

40. 41.

38–41. Even if Mary regarded her 'paper mosaics' only as fripperies, she did aim to be botanically accurate. Her first 'essay' combined samples from South Africa and North America, demonstrating the wide horizons already available to British gardeners and plant collectors in the 1770s. In her own day, it was only shown to a select group of friends, including the royal family.

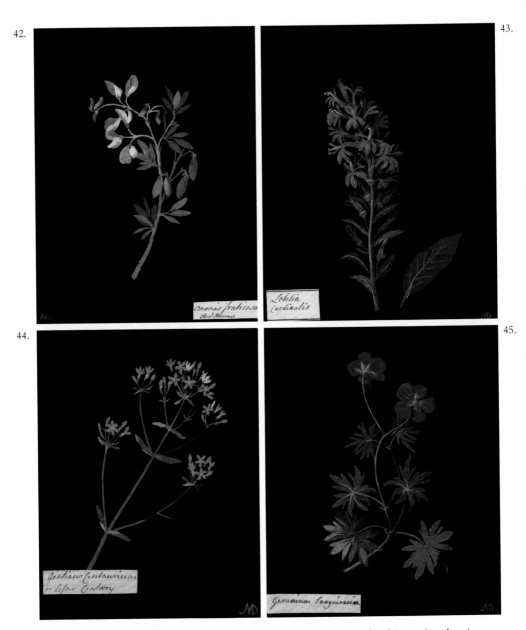

Ononis fruticosa
Rest Harrow

Lobelia Cardinalis

Gentiana Centaurium or lesser Century

Geranium sanguineum

42–5. The duchess's admiration helped the making of collages become an absorbing project, keeping Mary happily occupied and self-reliant whether she was in London, Wellesbourne, Bulstrode or elsewhere. The collages constituted an album amicorum created through the enthusiasm of her friends' providing her with specimens, and in devotional terms, a homage to the Creator.

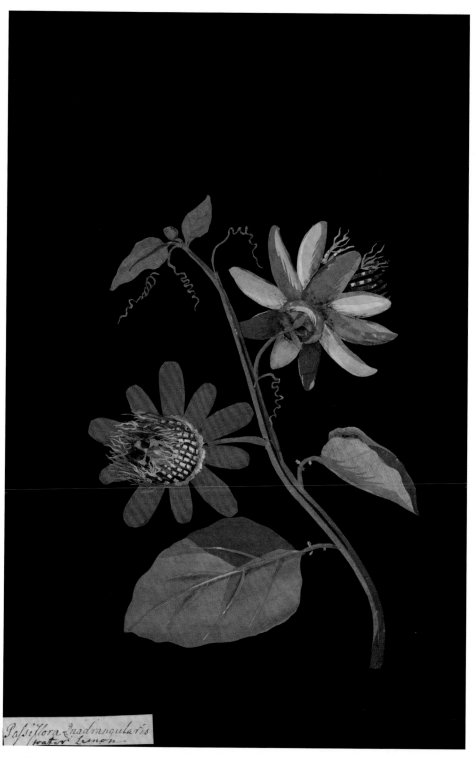

Passiflora Quadrangularis
water Lemon

46. This spectacular specimen was a gift from a friend of whom nothing is known, and was made at Mary's London home, St James's Place in June 1778.

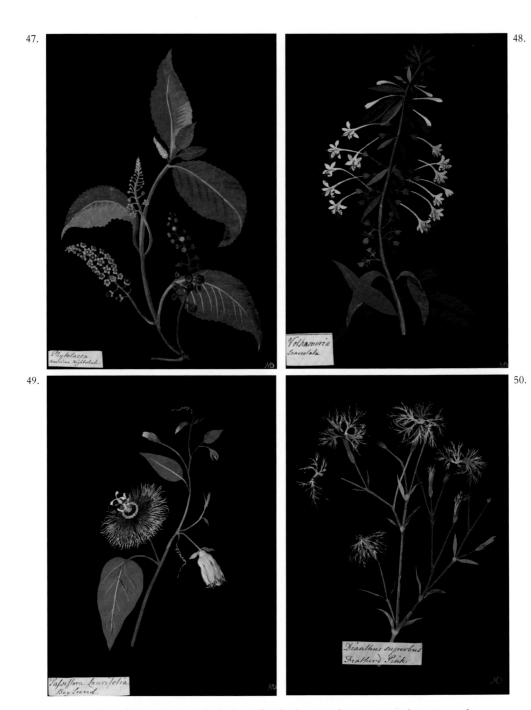

47–50. In the top left, American nightshade cradles the deep purple flowers in its heart. Green leaves highlight similar colour in the veins and flowers. In the top right, delicate silvery tones reveal a deeper pink centre. In the bottom left is one of Mary's most flamboyant collages: a bay-leaved passion flower shades from purple to pink, with citrus yellow highlighting the buds. To the right is a quieter essay, offsetting amber-pink and smoky blue. Though complex structurally it was only her twenty-second collage, one of nine dianthuses in total.

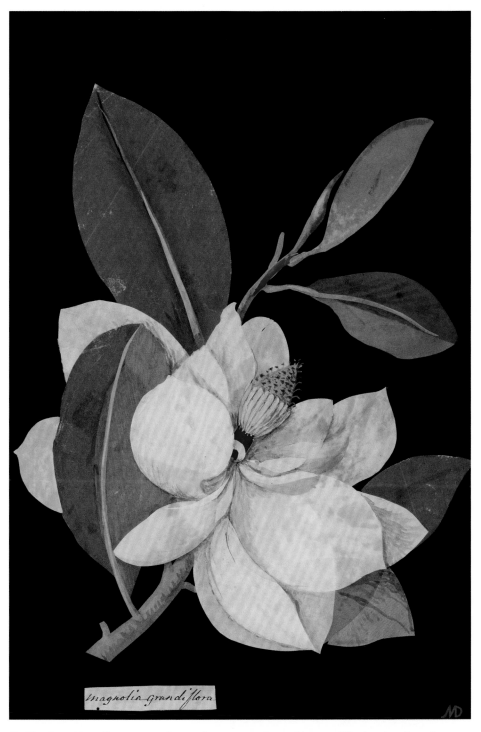

magnolia grandiflora

51. The Great Magnolia was grown in greenhouses, sometimes with great difficulty. A variety of enthusiasts tried their hand at it and shared notes about their successes and failures, as well as discussing their original specimens, the 'mother plants' (see pp. 285–6). Just as men selectively bred horses or hunting dogs, women could observe which plants produced.

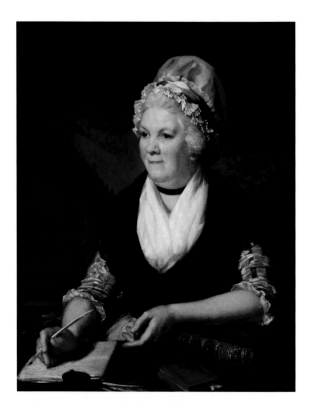

52. Sarah Trimmer was the daughter of Joshua Kirby, who had taught perspectival drawing to George III and Queen Charlotte. The queen asked her to advise Mrs Boscawen, one of Mary's closest friends, on setting up a Sunday school in Windsor. Her *Story of the Robins* was a bestseller for over 200 years.

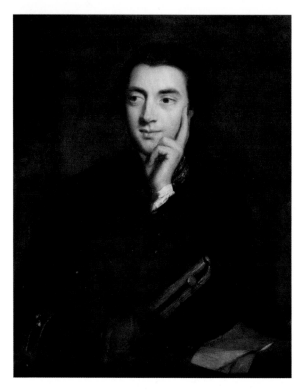

53. Leonard Smelt was much liked by George III. He was a military engineer who had worked in Halifax, Canada, and subsequently in the Scottish Highlands after the defeat of the 1745 Jacobite rising. He had also tutored the king's eldest two sons. George III gave him and his wife a cottage at Kew where Mary stayed when the royal couple was resident there, and she was with the Smelts when she contracted her last illness.

the abbey given by a friend of her brother's and Lord Suffolk's and told him what she thought of their theme and delivery, while also making friends with a philanthropic French widow, a Mme Ravaud, whom she greatly admired. She was part of a circle of charitable women that included Sarah Scott, who modelled their activities on Mary Astell's imagined Protestant Nunnery.[38]

On 27 April Mary wrote to John after her uncle had left, 'The Dean has good days and bad days', though he was able to go out for some air every day, but had 'little or no appetite and great shortness of breath . . . My aunt has a sad time of it . . . the Dean I think, will never leave Bath.'[39] Mary Dewes was correct that the dean would never leave Bath. On 30 April he felt his end approaching, and prayed constantly: 'God of his infinite mercy seal my eyes. He will when He thinks fit' and 'God of His infinite mercy grant me patience, resignation and submission to His will.' On 6 May, at 8 a.m., Patrick Delany asked his servant to close his eyes, and an hour later he had slipped away.[40]

Part III

New Horizons

Seven Widows and the Friendship Circle

THE FIRST MONTHS OF MOURNING

Once Patrick's funeral was over, for which there are no details, Mary was joined at Bath by the duchess, herself a widow of six years standing. She was particularly eager to nip in the bud Mary's immediate plan, which was to buy a small house in Bath once the proceeds of selling Delville were realised, and live the life there of a genteel clerical widow. There was no avoiding the sale of Delville since there were unsettled debts to the ever predatory Tennisons, but her friend insisted she delay any decision for at least six months. The duchess wrote to young Mary Dewes:

> I think it very proper she have a house of her own, but beg she will not determine immediately, nor can I see any reason for her settling at Bath. Why not have a house in London? That would certainly be the most advisable; she would then be among her friends and relations, and she could spend every summer with her friends, who would be so *happy* to have her company . . . I beg she will not take a sudden resolution, at least by no means *to buy* a house in Bath . . .[1]

The duchess was absolutely insistent that Mary should remain in the swim of polite life, with its annual calendar divided between the metropolis and the counties. She enlisted Mary's lawyer, Mr Hamersley, to intervene and counsel caution in proving the dean's will, and urged her to make no decisions for at

least six months. Mary acquiesced in this and let the duchess sweep her off first to Calwich, to see her brother – who of course was also the duchess's cordial friend and fellow-connoisseur – and then, via a brief stop in London, on to the usual late autumn stay at Bulstrode. Mary had initially lacked the energy to write her own letters, so her niece Mary had helped, but grief-stricken though she was, she was able to respond to the troubles of her intimate circle, such as when her friend Lady Andover's little motherless granddaughter was on the point of death: happily the child pulled through.[2]

There was legal business to attend to from time to time but the duchess managed to insinuate various diversions into everyday life, which might include a ride around the grounds if they were at Bulstrode, or an hour spent in the Whitehall 'museum' where the duchess kept her natural history collections, to act as a stimulating interlude. In late August Mary told Mary Dewes that after spending the morning looking at papers: 'I was summoned to the museum above stairs, at twelve o'clock, where my kind friend amused me with about a tenth part of the new prints and shells she has acquired since we last met, which, seasoned with her conversation, banished sad thoughts for a while.'[3]

One of the advantages of a London base was that they had immediate news about fashionable events, and this also supplied diverting topics for letters to niece Mary and brother Bernard. And the most fashionable event at that time was a visit from the Danish king, Christian VII, brother-in-law to George III. He had come without his wife, though, and after noting the variety of entertainments the Danish king both received and gave in the next two months, Mary observed to her niece: 'I pity his poor queen, who must be sadly tantalized to hear of all these fine doings and not have any share of them.'[4] As he had arrived when the capital was relatively empty, his entertainments had barely begun, and the duchess could not resist the temptation to visit her friend Sir William Musgrave, who lived in the house opposite to where the king was staying, taking Mary with her: 'the Duchess had the satisfaction of a glimpse of him, and I of his valet de chambre'. Soon, King Christian became a celebrity attraction for Londoners.[5]

The ladies' plan was to spend as little time as possible in London and then go to the tranquillity of Bulstrode, where Mary was assured that no social demands would be placed on her if she felt unequal to them. But a Portland family emergency altered all this and Mary found herself comforting the duchess and trying to boost her spirits, since the duchess's younger son Edward was taken seriously ill, bringing up blood and becoming feverish after a match

of tennis. The medical remedy then to these symptoms of tuberculosis was to bleed the young man yet more, so no wonder he remained weak and feverish, and his mother feverishly anxious. His two older sisters, one heavily pregnant and one too far away, were unavailable to support their mother, so Mary stepped into the breach and endeavoured to sustain her worried friend. 'Her partiality to me makes me hope I can be of some comfort to her . . . The only consolation we can have, when a friend is sick or in affliction, is to show one's desire of being some consolation to them . . .' To her niece, however, she privately expressed her conviction that Edward was doomed.[6]

But after a week of anxiety Edward's health had improved, and there was also a better account of Bernard's. A month at restorative Bulstrode beckoned, so Mary in her relief of spirits took a folio page to fill up with news and anecdote of all kinds for her niece and brother. This ranged from sad to light-hearted: in the former category was the death of Mary Lepel, wife of Lord Hervey, Queen Caroline's close friend and confidante, which evoked Mrs Delany's insider days in and around the royal court in her first widowhood (see p. 60).[7] In the 'nonsense' side was the latest account of Christian VII's outings. He had been to see the famous actor David Garrick play one of his most popular characters, that of an amiable rake, Ranger, in a comedy by Benjamin Hoadly, *The Suspicious Husband*.[8] The theatre had been so full it became very hot, and the gentlemen sitting in the pit took off their coats, revealing a variety of shirts or sometimes just waistcoats in a spectrum of different colours. Applause was constantly tumultuous, directed to both actor and visiting monarch, and strong men fainted away.[9]

The duchess's current visitors included members and friends of the Polish aristocratic clan, the Czartoryski family, who had sponsored the election of the current King of Poland, a Czartoryski nephew. Internal turmoil in that year inaugurated the first Partition of Poland between Prussia, Austria and Russia, formalised in 1772. While the country was becoming increasingly divided, some of 'The Family', as they were known, were visiting Britain. There was a strong mutual attraction between these grandees and the landowners who dominated Britain's parliamentary monarchy, which reform-minded Polish leaders looked to as a model. Unusually, Lord Titchfield had included a Polish visit in his own Grand Tour. Mary, however, tried to keep clear of these visitors, following the accepted 'opt-out' from too much social life in this early stage of her mourning.[10] Also at Bulstrode were Monck relatives from Ireland – in this case Thomas Monck, who had married the Duke of Portland's sister, Lady

Isabella Bentinck, accompanied by their daughter – both in an invalid state. As Mary liked morning hours and the duchess was decidedly a night owl, the former agreed to preside over breakfast, with the duchess taking over from tea time. The two women were thus co-hostesses at the house, reflecting their egalitarian status as friends – Mary was decidedly *not* a poor widowed dependent. She had her own social standing as the grand-niece of an earl in a family that could count its noble if untitled status back seven centuries. The Portland dukedom was decidedly new in comparison.

In Parliament, Mary wrote for her brother's interest, the chief news was not about conflicts within and about America, but about two divorces: the Duke of Grafton was divorcing his first wife, Anne Liddell, after her love affair with one of Mary's Leveson-Gower cousins.[11] The other was the dissolution of a bigamous marriage made by Augustus Hervey, Molly Lepel's second son, to the female rake Elizabeth Chudleigh. When Mary had some quiet time she read a new biography of Sir Walter Raleigh, which gratifyingly included an account of the prowess of the Granville ancestor, Sir Robert Granville, who had been a fellow buccaneer with the Elizabethan admiral.[12] She also read a new three-volume set of Swift's letters and was somewhat dismayed to find that some of her letters to him had been included. Revisiting her younger self she found she had said little about Bath, though she expected to have encountered Swift there, and had remarked on the relative cheapness of living in Ireland.[13]

The duchess had recovered her health and spirits as her son recovered his, but the wider Bulstrode household had suffered the loss of the estate bird-keeper, Ned Salmon, a victim of smallpox. As in the Whitehall house there were new acquisitions at Bulstrode for Mary to see: oils by the 'night' painter, Adam Elsheimer, and a moonlight scene by the seventeenth-century Dutch artist, Nicholas Berchem. The botanical artist Ehret was in residence 'very busy in adding to her [the duchess's] English herbal'; but after peering down a microscope to dissect more than a hundred specimens he had begun to suffer from eye strain.[14] The duchess, however, 'has been transported at the discovery of a *new* wild plant, a Helleboria'.[15] Sometimes Mary took a basket of food on foot for the creatures, 'much amused by the variety I met with and the delightfulness of the place, that for a time it banished sad thoughts'. One morning she recorded, 'A pretty and uncommon scene is before me on the lawn: a flock of sheep, shepherd and dog at a little distance, and in the foreground (to talk like a painter) fifteen or sixteen hares *feeding with peacocks and guinea-fowl*, that make a beautiful mixture

of pretty objects; but pleasing as all the scenes are here, I frequently elope in my mind, and walk by the waters of Calwich to *the rock* and the *Fairy Pool* and all its agreeable environs, in the company of my dear friends there.'[16] When she 'read' this scene in pictorial terms, Mary may have had in mind a Dutch landscape scene featuring domesticated animals, such as those by Melchior Hondercoeter, who was represented in several English collections. Thus sometimes the Bulstrode park led her to contemplate her family, sometimes the divine Creator:

> Surely an application to natural beauties must enlarge the mind? Can we view the wonderful texture of every leaf and flower, the dazzling and varied plumage of birds, the glowing colours of flies, &c. &c, and their infinite variety, without saying 'Wonderful *and marvellous art thou in all thy works!*' And this house, with all belonging to it, is a *noble school* for such contemplations![17]

There was also a royal postscript to the letter: King Christian's mother-in-law, the Princess Dowager of Wales, had held a ball in his honour, but the stars were young George Prince of Wales and his brother Frederick, Duke of York, 'dancing an Almand and two country dances together'. Young Mary, who was staying with her uncle at Calwich, must have enjoyed the varied types of news. Bernard was planning a little folly on an island in the River Dove and there were always garden improvements at Bulstrode with which to compare it; Mary's aunt sensibly hoped this rustic structure would have a chimney, to prevent damp.[18]

Once her son was better the duchess made a brief visit to see Lady Bute, whose husband had been very ill, leaving her friend Mary to get on with matters concerning the sale of Delville – a depressing occupation, since all kinds of decisions needed to be taken about what should be kept and what put into the sale.[19] The Moncks were still at Bulstrode, and the Poles were still making visits until the masquerade ball to be hosted by the Danish king before he left. There had also been a ball in his honour at the queen's house, opened by the queen dancing with Christian VII, while her Mistress of the Robes, the Duchess of Ancaster, danced with George III. Both ladies were expecting babies in November, but all the same, after the opening two, the queen was able to dance four more country dances with Christian. The similarly expectant elder daughter of the duchess, Lady Weymouth, occupied herself quietly playing cards. George III was indefatigable, and according to custom had a new partner every two dances. His final choice was Lady Mary Lowther, the eldest daughter of Lord and

Lady Bute. They danced a country dance, 'the Hemp-Dressers', which took two hours to run its course, as it involved all the participants gradually progressing down the entire company drawn up in two opposite lines, until everyone had danced with everyone else.[20]

By 4 October, to Mary's relief, the Moncks had left for Ireland. She and the duchess 'endeavoured to sustain our loss philosophically! We had recourse to plants, to books, to work.' Mary was using chenille wool and one thing she embroidered with this survives – a picture of the pet Jonquil parrot, Caton. 'I find no other work amuses me sufficiently and my head will not bear reading a great while together.'[21] It was generally agreed that the best entertainment for the Danish king was at Sion House, home of the very wealthy duke and Duchess of Northumberland, whose hospitality was on the grand scale.[22] Once a monastery, the Thameside house, opposite Kew Gardens, was built around an inner courtyard, illuminated by 4,000 lamps that had various pretty designs, all lit in a single moment. Always technologically curious, the king enquired how this was achieved: but as 200 lamplighters had been deployed the effects were due to human capital, not gadgetry.

At the end of Christian's visit, 150 guineas were thrown out of the window for the crowd to scramble after; £1,000 was left to be distributed among the king's servants, and Lord Hertford (the Lord Chamberlain, who was in charge of protocol) and Lord Talbot (the Lord Steward who oversaw George III's household) had been given fine diamond decorated snuff boxes, as had the actor Garrick. Christian's journey had been 'to conquer a fancy he has for a young lady in Denmark . . . he dislikes his wife extremely'. Mary had every sympathy for her: 'What unhappy wretches are *some* Princesses! How are they sacrificed! [the word she had used to describe her own first marriage].'[23] Caroline Matilda indeed had had poor luck compared with the British queen. She did not fall in love with her husband and he turned out to be schizophrenic.

Once back in London Mary set about finding a house to rent, pending her intended purchase of one. The duchess pressed her to stay for as long as convenient, but the last few weeks had persuaded Mary that the volume of visitors inherent in the duchess's social station did not really suit her, even at relatively secluded Bulstrode.[24] For the time being she had been able to be selective, but this would not remain the case. She had already spotted a suitable rental that was small but in a pretty location, behind the Thatched House Tavern in St James's Street. In front was a connecting street to

St James's, and behind 'it looks onto the Duke of Bridgewater's garden *very pleasantly*, and a coach drives very well to the door, and people of fashion live in the row'. The landlord seemed very reasonable, though it couldn't be ready until after Christmas. It was to be repainted and have new sash windows installed, and some rooms re-papered to her liking. 'It will be some employment and amusement to settle my things in it; and its being so near the park, the chapel and Whitehall makes it very tempting.'[25]

THE FRIENDSHIP CIRCLE ADAPTS

For the next three years Mary's mourning was assuaged by a number of intelligent and characterful widows, who all contrived to keep up one another's spirits by letters and visits, despite concerns over the pregnancies, illnesses and deaths of their children and grandchildren. Mary too acquired a next generation of family, when in 1770 her niece Mary Dewes married 'the shepherd' near to Calwich, that is, John Port of Ilam, and began to have her own children. So, a new variation of the Bulstrode quartet resembled the friendship box of thirty years before. Lady Andover was still very much part of it alongside Mary and the duchess, but the relative newcomer Frances Boscawen had moved nearer the centre, while Elizabeth Robinson, after her marriage in 1742 to become Mrs Montagu, and a leading Bluestocking hostess, was more tangential – at least to Mrs Delany. Mary had only been slightly acquainted with Mrs Boscawen through the Cornish network, but she was soon to emerge as very much a kindred spirit. She was also a continuing link to the original foursome, since Mrs Montagu had liked to discuss ministerial politics with the late Admiral Boscawen. Additionally, very much in her circle were two cousins of Mary's, the dowager Countess Leveson-Gower, and Grace, née Carteret, who was now dowager Countess Spencer, godmother to Mary Dewes and also to Sally Sandford. Sally herself was shortly to become a widow, and her sister-in-law, Hester Chapone, had been one since 1761. Thus what might have been an uninterruptedly gloomy period had many points of light, and a variety of locations and faces. The widows were familiar with some of what each was experiencing, and had found their own ways of dealing with bereavement.

Mrs Delany rented Thatched House Cottage until she found a house to buy in St James's Place, similarly at the heart of the courtier district, within walking distance of the gateway to St James's Palace. Her purchase would be facilitated by a loan from the duchess. With her niece's move to Staffordshire, Mary had

less incentive to visit Wellesbourne, where her widowed brother-in-law John still lived, largely on his own aside from the servants. Two of his sons, Court and Bernard, were established as future landed gentlemen, and spent some of their year in London, while the eldest, Court, also travelled periodically to Spa (in modern Belgium, but then the Austrian Netherlands) for his health, feeling he was returning to his Dewes Flemish roots. John, the youngest son, the ordained clergyman, was still at Calwich. A reply from his father in January 1773 to the young Rev. Dewes, who had sent birthday greetings, reveals the elder John as mostly still hale and hearty, managing his estates and pursuing his rural sports:

> I thank you for your congratulations and good wishes, but it is not reasonable for people at my time of life to think of enjoying years of health. I thank God I am tolerably well in health, but perceive a general decay, which *increases daily* . . . Welsbourn [sic] stands just where it did, and all its appendages much in status quo. I suppose you have seen the brace of fine greyhounds Mr Lucy gave Mr. Port . . . I think a breed by one of them from one of your uncle's Italians would be a good cross. We have had, and still have, the greatest plenty of woodcocks that I ever knew . . . I hope you have plenty of them with you, and of everything else that is good, and am, with best respects to Mr. Granville, your affect[ionate] fa[ther], J. D.[26]

Lady Andover, dowager Countess, was usually based at Elford in the summer, bringing up her motherless granddaughter, Maria Constantine, with the help of her unmarried daughter, Frances. However, the estate was logistically difficult to reach from Ilam, so for Mary to visit her in conjunction with the Ports was awkward, and she was just as likely to see her old friend in London as in Staffordshire. Moreover, sadly for Mary, Bernard's contrariness meant that seeing her niece did not always seem tactful, as Bernard was not always willing to allow visits from either his niece *or* his sister.

When she was not in London, Mary was seasonally domiciled with the duchess at Bulstrode in Buckinghamshire, where she continued to have her own set of rooms. She usually went there in mid-June, when London began to empty out. By mid-July her hostess was invariably setting off to take the waters at Buxton or Matlock in Derbyshire, near her old friend Bernard, or in Tunbridge Wells; she also sometimes bathed in the sea, at newly fashionable Weymouth

and later on at Margate. At these times Mary could visit friends and connections near London, such as Mary, 3rd Countess of Bute, in Bedfordshire, and Lady Mansfield at Kenwood, which the 3rd Earl of Bute had sold to the Mansfields.

She also visited Mrs Boscawen, who was looking for a good residence outside the capital, but a bit nearer into London than the country house her late husband had built at Hatchlands, Surrey, since she needed to be near her youngest son George, still at Westminster school during the week. In central London Mrs Boscawen lived in Audley Street, a short walk from St James's Palace. She additionally went regularly to Tregothnan, Cornwall, seat of the earls of Falmouth. The 2nd Earl, her brother-in-law, was childless, so the title was to devolve on his oldest Boscawen nephew. There were also plenty of other Cornish kin for her to visit. In late August the duchess invariably concluded her round of visits with one to Lord Guilford at Wroxton in Oxfordshire, with Mary included; then the two ladies returned to Bulstrode. When court and parliamentary life resumed in early November, Mary went back to her London house and the duchess to hers in Whitehall, with the Christmas recess at Bulstrode until the New Year. Thereafter both remained in their respective London residences until early June, during which Mary's niece visited her aunt in London and her godmother in Richmond, until her marriage and pregnancies, together with her uncle Bernard's vagaries, modified this pattern. Thus Mary's annual London calendar was still shaped by family, friends and fashionable life, which lasted until the death of the duchess in 1785.

In 1769 the year promised well. Both she and the duchess hung back from some of the available social routines, though keen to hear what went on from the younger generation. The duchess's elder daughter was now back on duty as a Lady of the Bedchamber; the custom of engaging a wet-nurse for young infants meant that she was able to do this only three months after giving birth, but her job as a courtier also meant they saw less of her. However, her sister Harriet, Lady Stamford, 'glittered wonderfully' when she called in on her way to the birthday drawing room at St James's in January.[27]

In mid-May the duchess's younger son, whose life Mary had despaired of, returned well and smiling from his continental sojourn, and pleased his mother by making his first brief call on her. He then attended a royal mid-week levée to signify, as was traditional for any court regular, his loyalty to the crown.[28] By contrast, in midsummer Mrs Boscawen suffered a double blow

as a mother. Her second son William had followed his father's pathway into the Navy, and while he was awaiting his formal commission he went on ahead to visit a friend in Jamaica. In April he went canoeing, the boat capsized, and he was drowned. Given his profession, his mother might have expected to have news one day he was killed in action; but for him to meet his end on a summer day of leisure must have seemed cruelly inexplicable. He was not yet 18. But Mrs Boscawen did not fight misfortune with sceptical anguish; her elder daughter told Mrs Delany that her mother 'continues very composed, walks a good deal, and *don't allow herself to be idle*, which no doubt by leaving a vacancy in the mind nourishes grief; she reads a great deal and *even works* [sews]. All this she does to support herself, and to comfort us; her amazing resignation to the will of God fills me with admiration and respect.'[29] Young William had been recognised by all the family as his mother's favourite, and he was also close to his sisters. His sweet nature meant no-one apparently resented this partiality. His sister continued:

> If you had known the sweet young man we have lost, you would still pity my mother more than you even do now . . . My mother had taken infinite pains with his education, and they succeeded beyond her most sanguine wishes . . . My mother had endured many severe afflictions: and to him she looked for comfort, to rock the cradle of age, if it had pleased God to spare them . . . The extreme tenderness and attention my sister pays my mother, rouses her and makes her wish to make us some return by not sinking under the weight of her misfortune.[30]

Mrs Boscawen's younger daughter had immediately left Badminton with her husband for London, to console her mother, and then they had continued towards Wales, where the duke's sister, Henrietta, was dying. En route they had a serious carriage accident and the young Duchess of Beaufort sustained a severely fractured leg. Although she had good prospects of recovering her mobility, she endured considerable pain, and was obliged to lie very still for weeks on end, while to keep up her spirits various members of the family read out loud to her. Everyone close to the family was impressed with her husband's ministrations: 'Nothing can equal the Duke of Beaufort's tenderness; he is *the best* and most judicious nurse I ever saw, which must be the best cordial that can be administered to the suffering patient', Mrs Boscawen told Mrs Delany.[31]

In Warwickshire the Dewes group included people holding high county office and sitting in either the Lords or the Commons: this political dimension was the backbone of county and national government. It was also a link to positions at court, since families often had relatives who followed careers at Westminster reinforced by positions in a royal household. The North family was typical: the Earl of Guilford had been a Gentleman of the Bedchamber to Frederick Prince of Wales, and his oldest son became George III's first reliable prime minister, lasting twelve years. Sir Charles Mordaunt was a typical 'country' MP, uninterested in the hurly-burly of Westminster politics; he was a Tory by inclination, and solidly Anglican. But after the 1754–63 war was over, near the start of George III's reign, the Earl of Bute sounded him out as to whether he would regularly support the king's ministry, whatever its composition. Bute reported, 'I have seen Sir C. Mordaunt who expressed himself in the handsomest manner, declined at his age entering into employment, but expressed his wishes to see his son in his Majesty's bedchamber.' This was duly granted, so the bridegroom in 1769, Mordaunt's son-in-law, was already a Gentleman of the Bedchamber, though his father remained independent, sometimes voting against the ministry.[32] But not all the Dewes sons were traditionalists: Court, the heir, retained romantic republican sentiments from his reading of Rousseau. Mrs Delany told her niece about a journey back to London she had taken with Court after visiting Lady Cowper in Richmond:

We trotted on briskly, chewing the cud upon the pleasure we had enjoyed at Richmond; when I heard a shouting and calling which I thought belonged to some waggon or stage coach behind us, when a man clothed all in scarlet, with a musket in his hand . . . gave the postillion a smart slap on the back and cried out, 'Stop, for His Majesty is on the road.' The postillion, ignorant of etiquette, and smarting with resentment, was going to exercise his whip hand, I screaming out, 'Stop, stop', and Court the same at the other window, and we had just prevailed as *the post-chaise* past by: and little did His Majesty know how he had flattered one of his humble subjects. I grumbled at the insolence and rebellion of the postillion, Court complained of arbitrary power, and we argued the point – he maintaining that the public road should not be violated by these proceedings – I, that that it was due to royalty to have all these marks of respect kept up: and how do you think the dispute ended? With infinite good humour, and a *strict* adherence to our own opinions![33]

The phrase 'arbitrary power' belongs to the early days of the Restoration of Charles II, when the Whigs thought they should resist apparent moves by the monarchy to extend its latent power to control Parliament, and this language was resurfacing during the first decade of George III's reign, when his reliance on the favoured Lord Bute suggested he was rejecting the achievements of the 1688 'Glorious Revolution'. But Mrs Delany always saw herself as a servant to the crown, even though she had fully accepted that the Stuarts were no longer the right dynasty to sit on the throne, and had never actually been in crown service (unlike her cousin Elizabeth). Rousseau, by contrast, had considered the anglophile tendencies of many Parisian intellectuals were misplaced, pointing out that the manly English voter was only free when Parliament was dissolved and an election was taking place.

An event in 1769 that captured the interest of the whole nation was the Shakespeare Festival in honour of the writer as the canonical national poet and dramatist, the first of its kind. This was the actor David Garrick's brainchild and he organised much of the ceremony and celebration in Stratford-upon-Avon, the poet's birthplace. The Bluestocking circle was interested and Mrs Montagu made her own contribution by writing a book about him, responding to the standard French criticism of his anti-classical 'irregularity' with a defence of national genius. This cultural pride chimed with her aspiration to raise the tone of elite society. Not all of Mrs Delany's circle was impressed with Mrs Montagu's initiatives, though: Lady Cowper was distinctly underwhelmed – 'Mrs Montagu has commence'd author, in *vindication* of Shakespeare, who *wants none*, therefore her performance must be deemed a work of supererogation . . .' Mary asked her niece to send one or two yards of commemorative Shakespeare ribbon.[34]

But the Bulstrode household continued also with their botanical pursuits under Dr Lightfoot's guidance, or in his absence, Ehret's. They were now concentrating on fungi, early autumn being the best time to study them. Like Mrs Boscawen, to hold her grief at a distance Mary contrived to keep occupied. When she withdrew from company, as well as reading and corresponding she embarked on a copying exercise, writing out in a fair hand a translation of the *Flora Anglica* published in 1762 by William Hudson. Hudson was a trained apothecary based in Jermyn Street, St James's, London. He was the first scholar to apply the Linnaean principles of classifying plants to British flora, encouraged by the man who wore the original blue stockings to Mrs Montagu's assemblies, Benjamin Stillingfleet. Hudson compiled his treatise in Latin, the masculine language of international

scientific scholarship, and it is likely that Mary was copying the manuscript notes in English used by Lightfoot for instructing the Bulstrode ladies.[35]

Both women were beneficiaries of the advancements in scientific classification taking place at this time and being disseminated to plantsmen and gentlemen amateurs alike. Mary never felt she understood botanical classification as well as her late sister, let alone the duchess; this copying may have been an effort to reinforce her knowledge. Additionally it would be available in the Bulstrode library to visitors of either sex. Always possessed of a keen eye as well as a neat pen, and more drawn to the visual than the theoretical, that winter Mary also made detailed drawings of the mineral specimens she liked so much.

In rural Richmond, the local assemblies were attended frequently by the king's brother, the Duke of Cumberland, and the queen's youngest brother, Prince Ernest, then visiting Britain. Lady Cowper held her own private assembly for about forty people, and was flattered the prince admired her drawing room.[36] Her godmother's letters show that Mary Dewes' engagement to John Port was now on the table, with its finalisation hinging on Bernard's approval. Winter began, and news of the Boscawen family was fairly good: the young Duchess of Beaufort had been able to return safely to Badminton, and though she needed to use a walking stick, she was at least more mobile. Her mother was well physically, though her other daughter could not say there 'was any abatement to her sorrow'.[37] But now mourning visited the Granville cousins, with the sudden death of the eldest, Grace Foley, at the start of November. Mary's immediate impulse was to want to visit Grace's sister, Elizabeth, at Windsor, to comfort her, but the duchess put her foot down as Mary was under the weather. Less sad for Lady Cowper's god-daughter, Sally Sandford, was the demise of her reprobate and difficult father-in-law at the end of that month, making her husband both a Shropshire squire as well as a man of the cloth. The recent births and deaths of these interlinked families concluded with the happily safe arrival of another son for Lady Weymouth, her second after a sequence of girls.[38]

CONNOISSEURS AND CORNISHMEN

The Delany letters kept by Anne Dewes and her daughter Mary Port represent only a fraction of all the notes and communications Mrs Delany received, so they inevitably mention only a small part of her friendship with one of the supreme taste-makers of the age, Horace Walpole (younger son of the former

prime minister, Sir Robert), who was nearing the end of creating his 'Gothick' castle, Strawberry Hill, along the banks of the Thames in Twickenham. This evidence comes by way of a letter from her niece to the latter's fiancé John Port, telling him that Walpole had invited her to dine at Strawberry Hill on a June evening when the duchess and Mrs Delany would both be present. Mary Dewes had been unable to accept this invitation, but had she gone she would have found that the other guests were Richard Bateman and Frederick Montagu, the son of Mary's friend Mrs Montagu.

It is unsurprising that the duchess would be Walpole's guest, given that she and her father were, like him, great collectors and connoisseurs. Her friend Mary was naturally included in this social intimacy with Walpole, which might have started during her London visits in the 1750s. Lord Lansdowne's daughter, Elizabeth, Maid of Honour then Woman of the Bedchamber to Augusta Princess of Wales, was another link between Horace and Mrs Delany: he knew both her and, typically, the gossip about her after Lady Archibald Hamilton had been ousted from her triple role as Mistress of the Robes, Lady of the Bedchamber and Keeper of the Privy Purse. She had been alleged to be a mistress of Frederick, Prince of Wales, and Elizabeth was supposed to have stepped into her shoes.[39]

But even without these links, Mary would have had claims in her own right on Walpole's attention; both had a good eye and they had common preferences. It's clear from her earliest visits to Cirencester Park, and then the first sojourn in Ireland and on other visits, that she was an early appreciator of the Gothic and the Gothick. She was always attracted to genuine medieval ruins, and to any contemporary *mise en scène* that included trees and garden scapes with built structures. Mary's rococo, playful taste was evident in her own form of exotica, as a maker of shell-work and grottoes, designed in similar vein to Sanderson Miller's follies or the Earl of Guilford's Indian or Chinese garden buildings at Wroxton. She was not, though, an uncritical admirer of the Gothick taste: Walpole's friend Richard Bateman's recent Gothick refurbishments at his Windsor house included an octagonal chapel within his dressing room, over-filled with Catholic devotional objects used purely for decorative purposes. She commented, 'what must offend every serious observer must be the intent of this chapel, for if he does not make use of it *good earnest*, his making a joke of it is *shocking* . . . nobody can justify turning any religion into ridicule, though some ceremonies are trifling and absurd, but I don't suppose he desires to be thought a papist, and perhaps he would rather be thought a heathen!'[40]

In 1761 Walpole had said he knew Mrs Delany 'a little', in response to a letter from Dublin written by George Montagu, describing a visit he had made to Delville.[41] Montagu gave a rapturous account of the Delanys' chapel, comparing it with descriptions of the one Mme de Sevigné, the famous French *epistolaire*, had created for herself in Brittany. The Delany chapel, he explained, was 'all fitted up and painted by her own hand, the stucco composed of shell, and ears of corn the prettyliest [sic] dispersed as imaginable, and her way of life quite abstracted from the great world and given up to a few sensible friends'.[42] Montagu had also praised Mary's commissions for stained glass – another decorative medium she deployed in common with Walpole – as he believed it kept at least one specialist painter from starvation.[43] It is not impossible that Walpole remembered his friend's admiration for Mary Delany's decorative flair and after he had learnt on the grapevine that she had returned to England, he had made a point of transforming the slight acquaintance into a more regular friendship.

As well as Gothick architectural tastes and a liking for seventeenth-century French romances and literary ladies, there was still another artistic penchant that Mary and Walpole had in common: an appreciation of pastellists. When the Genevan master of this medium, Jean Etienne Liotard, first visited England in 1755, Princess Augusta had commissioned him to make portraits of her and her children. Mary would surely have known of this through Elizabeth Granville, or the Charles Montagus. At some point Mary acquired one of Liotard's miniature self-portraits, possibly in 1773 during Liotard's second visit to London. She left it to the duchess but after she predeceased her friend, Mary bequeathed it to Walpole.[44] Why did Mary identify herself with a living artist by buying one of his self-portraits? One simple answer is that he had these for sale unrelated to any particular commission. She was neither vain nor wealthy enough to commission a portrait of herself, but she clearly admired Liotard's abilities, and by extension his female counterparts such as Rosalba Carriera.

Two other personal links to Walpole in the circle of cultured widows was Mrs Boscawen, who was a great friend of the Hon. George Edgcumbe, younger brother to Walpole's wealthy but dissolute school friend and fellow-connoisseur, Richard Edgcumbe, who had died in 1761. He had been the heir of Richard, 1st Baron Edgcumbe, Mary's old suitor, who had been such a significant parliamentary patron and manager of the Cornish interest of Frederick, Prince of Wales. The younger Richard was perforce a Cornish MP and in theory the manager of the family 'interests' in several Cornish boroughs, but what he really enjoyed were

all things artistic – alongside enduring a tortured infatuation with a courtesan known as 'Kitten', and being a compulsive gambler.[45] It was his younger brother George, who was (literally) the sober one, and who pursued a naval career; he had served with Admiral Boscawen in 1758 when they had captured Louisburg during the French and Indian Wars.[46] On other occasions Lady Gower and the duchess were guests at Mount Edgcumbe,[47] and on one occasion the weather was idyllic enough that they drank tea outdoors every day. Unlike his dilettante brother, George was an establishment figure who held several royal household positions, and was rewarded with advancement in the peerage to an earldom.[48]

Also in an axis that combined Cornish roots with antiquarian interests was the current Thomas Pitt of Boconnoc (1737–93), an amateur architect as well as an MP who inherited the family's parliamentary influence. He lived briefly near Walpole in Twickenham in a house named Cross Deep Hall, which he playfully dubbed Palazzo Pitti in allusion to the Florentine Palace he had recently visited, and designed an overmantel and a door in Strawberry Hill.[49] He had also lent Mary portraits he possessed of her grandfather, father and mother. One way and another, then, there was quite a thicket of people and interests to bring together Horace Walpole and Mary Delany, and their friendship was destined to gather momentum, even if there is little epistolary evidence of it now.

FAMILY DEVELOPMENTS *1770–1*

The course of true love did not run smoothly for Mary Dewes and John Port, the main reason being Bernard's ambivalence. The chief person to please when landed families agreed to marriages was a bride's father, not her uncle – and Squire Dewes was persuaded that John could give Mary a proper settlement and that the groom's finances were sound. But bearing in mind that Bernard believed he was rightfully the Duke of Albemarle, rank trumped paternal authority: when it came to marriage his niece was considered a Granville and not a Dewes, and there was doubtless a contribution to her dowry from him in prospect as well. In late May the pair were allowed to consider themselves plighted to each other, but John had had a very discouraging reception from Bernard. His fiancée's godmother Lady Cowper was very welcoming, though, inviting John to visit with or without the Dewes brothers while her god-daughter was at Richmond with her, but Mary Dewes evidently thought this might look presumptuous, as it would give a misleading signal that all was settled, before it truly was. 'A time will come when I

hope we shall both have the superior happiness of enjoying together with my dear Lady Cowper's company . . .' she explained to her intended.[50]

According to the conventions of the time, as the couple now had family approval for their 'understanding' that they would marry, they were allowed to correspond with each other. They evidently mutually agreed to correct each other's mistakes. This was really a little ploy of Mary's to flatter young John's ego. She projected herself as the conventionally less educated young lady – perhaps to reassure her fiancé that despite her rather grand connections, he need not be alarmed that she would upstage him. 'It is rather a hardship upon our sex', she asserted:

> that we have in general our own education *to seek after* we are grown up, I mean as to mental qualifications. In our childhood writing, dancing and music is what is most attended to: and without being a pedant, such a knowledge of grammar as is requisite to make us speak and write correctly is certainly necessary, and also such knowledge of history that one may be able . . . to enter into conversation when those subjects are started . . .

But this statement should not be taken at face value, since in the next sentence she referred to the unconventional female historian Catherine Macaulay as having had to start learning grammar in her thirties when she was writing her very accomplished history of England. This book was an ambitious riposte, from a republican standpoint, to the Scottish historian and philosopher David Hume's Tory-inspired account of the troubled Civil War era.[51] Maybe the republican-minded Court had been influencing his sister.[52]

Mary Dewes went home to Wellesbourne accompanied by her two elder brothers via a stay at Bulstrode. She kept a spinning wheel there, and was acclaimed for her proficiency, so clearly this was the accomplishment she had decided to identify herself with. It also chimed with her pastoral role up at Calwich, where she had her little flock of sheep.[53] Their aunt remained at Bulstrode throughout June, helping supervise the building of the grotto. Digging and delving the grotto, or watching over its being done by the gardeners, was a significant piece of artistic 'work' that helped her overcome the loss of Patrick. There were plans afoot to Gothicise a small lodge in the grounds, and this is likely to have been aided and abetted when those Gothick enthusiasts, Horace Walpole and Dicky Bateman, made a short visit.

The duchess was now a grandmother, with her son, the current Duke of Portland, and his wife and their baby, the new Lord Titchfield, planning visits but postponing constantly because of baby snuffles and his mother's debility. One visit that did come off, though, was made by his mother and her friend to the Thameside home of David Garrick and his Viennese wife, Eva. Garrick was a lively host and young Mary's absence much regretted. In the early evening, the duchess's daughter Lady Weymouth turned up with all her children, and Garrick was a great hit with them. That England's leading actor and his wife, a former ballet dancer, had entertained such a grand duchess and her courtier daughter is a measure of the Garricks' success at distancing themselves from the more rackety elements of the English stage. Thus Mrs Delany observed of Eva Garrick, 'the more one sees of her the better one must like her; she seems never to depart from a perfect propriety of behaviour, accompanied with good sense and gentleness of manners, and I cannot help looking on her as a *wonderful creature*, considering all circumstances relating her' – thus hinting that Eva must have had a racy past in Vienna.[54]

Come September, Mrs Boscawen set off with her daughter and namesake, Frances, for an extended journey in Cornwall; her spirits were lifting a little since the sad bereavement of the previous summer. Her itinerary included a visit to Roscrow, which she made a point of seeing because her friend had once lived there. But if Frances Boscawen was managing to recover some of her usual zest, by September poor young Mary Dewes was beginning to wilt under the stress of Bernard's obduracy. The Dewes family was concerned enough over a chest infection and weight loss to send her to Bristol, accompanied by her brother Court, to see if the hot wellsprings would be beneficial to her health. It may have been viewed as essential in any case for the pining fiancée, but was also a helpful way of underlining to Bernard that he was damaging her well-being. Frustratingly, he breezed into London after a rejuvenating visit to Tunbridge Wells, full of bonhomie, glad to hear his niece was safely settled in Bristol and recommending asses' milk if buttermilk was unavailable.[55] In the end the duchess stepped in as mediator. Mary met her niece at Bristol and accompanied her to Bulstrode, from where the duchess prevented anyone leaving until the wedding took place on 4 December 1770. This meant even the bride's father was absent and her brother did not officiate. In effect the social clout of a real duchess trumped that of a putative Jacobite duke.

Mary Delany's recipe for sociability in London was very similar to what George Montagu had observed in Dublin: 'a warm room with reasonable and cheerful conversation [is] as laudable a way of passing two or three hours as ranting and tearing at a card table. I am an humble spectator and listener.'[56] Concerned moralists thought that the passion for gambling was reaching new heights in this decade.[57] Mary's anatomy of the psychological bind that demeaned the female gambler was acute: she felt women were being their worst enemies.

> It mortifies my sex's pride to see women *expose themselves* so much to the contempt of the men, over whom I think from nature and education if they were just to their own dignity, they have so *many advantages!* and then men plead excuses women have nothing to do with, that they are necessarily from their situations and employments in life exposed to temptations.[58]

She also claimed to be uninterested in politics, but we have to be careful how to construe this. In the next few years both houses of Parliament would become divided on significant issues, such as the rift with the thirteen American colonies, and efforts to reform the East India Company, the trading monopoly that exercised quasi-governmental functions centred in Bengal. Mrs Delany's guests might well have refrained from what we call today issue-led discussion. On the other hand, eighteenth-century politics was family based, and to know who was 'in' and who was 'out' of the king's ministry was the same as imparting news about relatives or friends, and sending them appropriate congratulations. Thus in January 1770 she had told her niece 'I am out of breath with writing cards of congratulation to *all the Guilford House*' because the Earl of Guilford's eldest son, Lord Frederick North, had been made first Lord of the Treasury (prime minister), and exactly a year later she was able to write to Lady Andover to congratulate her that *her* son, the 12th Earl of Suffolk, had just been appointed to be Secretary of State for the North.[59]

In early February she went to the newly established Royal Academy and was introduced by a Mr Crispin to paintings by two of the more unusual early members of the Royal Academy, Benjamin West and Angelika Kaufmann. West was an American and a visitor from Pennsylvania, a Quaker state, and thus was disinclined to obtain royal patronage, *ancien régime* style. Quakers, as radical but peaceable egalitarians, refused to defer to social hierarchies of any sort. All the

same, West was the exact age of George III and the two got on extremely well; he decided to remain in England and eventually became second president of the Royal Academy.[60]

Still more unusual was the inclusion of two women in the early Royal Academy membership. Yet Angelika Kaufmann, a child prodigy from Chur in Switzerland, had had a more typical artistic education for the time than West, having been schooled partly in Rome, then the centre of the eighteenth-century art world. Mary told young Mrs Port, 'My partiality leans to my sister painter; she certainly has a great deal of merit, but I like her history still better than her portraits.' At this stage Mary had given up painting in oils and was yet to invent her method of cut collage; but she must have felt that her Irish years spent copying oils made her familiar enough with the techniques of painting to link her amateur efforts with a successful professional: 'sister painters'.[61]

That spring, some balls were sponsored by 'the quality' themselves, as a kind of private club, which took place in hired rooms, with supper included. The most famous was Almack's, which went through various incarnations over the next fifty years. Mrs Boscawen explained to Mrs Delany that the current version was managed by fourteen ladies, who regulated access very tightly, excluding plenty of well-connected men or women as only 200 were allowed membership. So even someone as politically influential as the Duchess of Bedford was initially excluded. Men were proposed by women and vice versa so no-one could exclude his or her own sex. Mrs Boscawen was clearly relieved that her daughter, the young duchess, could decline gracefully on account of her continuing convalescence. Her being less able to dance was not really the issue – being able to avoid '*deep*' and '*constant*' gambling at cards was.[62]

Being at the drawing rooms presided over by the king and queen remained important; it still acted as a signifier of loyalty as well as a marriage market. Mrs Boscawen was pleased that when her Beaufort son-in-law broke with four generations of non-attendance because of Jacobite sympathies, the king rewarded him by appointing him as Lord Lieutenant of the county of Monmouth, where the family had extensive lands.[63] When Mrs Boscawen's other daughter was at court for the king's birthday in June 1771, she was relieved to find her old friend Lord Edward Cavendish-Bentinck was available as a partner for the minuet: putting on a good show in both dress and deportment was a useful asset for attracting husbands. But there was very little dancing on that occasion as the queen was extremely pregnant and indeed gave birth the very next day to Ernest

Augustus, her fifth son.[64] In the event Mary Port's first pregnancy concluded well, after some initial apprehensions, with the safe birth of a daughter, Georgina Mary Anne. After three months at Ilam, the new great-aunt was at last able to make a visit to her friend Lady Andover at Elford on her way back to Wellesbourne, where she was happy to find the new grandfather, John Dewes, looking 'very hearty and in good spirits'.[65]

The time spent at Ilam and Wellesbourne curtailed Mary's usual autumn period at Bulstrode, but she still included it on her way back to London. The scientific range had now been dramatically extended by the return of Captain Cook and the gentleman naturalist Joseph Banks from their southern Oceanic voyage, which had resulted in the 'discovery' by western eyes of Australia. The explorations were the second goal of the *Endeavour*, whose first purpose was to observe the Transit of Venus in the southern hemisphere, from Tahiti. The astronomy-minded George III and Queen Charlotte had watched what was visible in the northern hemisphere from the King's Observatory in Bushy Park, the king having contributed to the project a substantial sum from his own Privy Purse. The second purpose of the voyage was to discover the rumoured southern continent – and in this it had been spectacularly successful. Countless items of flora, fauna and ethnography had now arrived in London and Hanover to be described, catalogued and pondered over for years to come.[66] Mary and the duchess had been at Banks' London townhouse and seen paintings of Tahitian plants, and a sample of Tahitian female costume. Mary made a little sketch in her letter, of a one-shouldered wrap-around robe rather like a sarong. 'Their commanders are distinguished with a little more ornament, a gorget made of pigeon's feathers and dog-fish teeth. Feathers in their heads, and caps almost as top gallant as a modern English lady's.'[67]

Within three years she had sorted out one house, then repeated the process again when she acquired the house in St James's Place. This time nephews Court and Bernard were on hand to help; she told their sister: 'they have worked for me like little horses, and all my books are in pretty good order, and everything else indeed'.[68] But she was always ready to sally forth to hear about and see sights from the opposite side of the globe.

The First Collages and Bluestocking Initiatives

*T*he year 1772 proved to be one of extremes of temperature: London, she wrote to her niece in Derbyshire on 2 January, was like Lapland.'How beautiful your mountains, your valleys and your woods must appear in their dazzling whiteness', she conjectured, and approved her great-niece being warmly wrapped up: 'those tender limbs require it . . . do *not* [sic] begin too soon to try and harden delicate plants; have every warmth but that of *always* hovering over a fire'.[1] The new London house was proving very snug, especially after she had had cotton wadding hammered over 'every crack and crevice that let in cold air'.[2] When Lady Cowper's friend the musically minded John Fitzwilliam went to visit, he was impressed with 'her cleverly arranged house in St. James' Place. It really surprised me to see with what judgement she has transposed and deposed, and she has made it a very pleasing and agreeable dwelling.'[3]

The Boyds had dined with her and given her more details about the newly widowed Sally Sandford, who faced financial difficulties from rent arrears due from Ireland and the Shropshire estates. Death was also coming closer to the dowager Princess of Wales, which would affect cousin Elizabeth deeply. The town of London as well as the court went into mourning, and it was the view of John Fitzwilliam that 'the poor and needy have lost a *real*, *generous*, *humane*, and most benevolent friend. She gave away annually in the *most private* charities *eleven thousand pound a year* and she has gone thro' a most painful illness with the utmost magnanimity and fortitude . . . It is happy for her she is gone, but it is miserable for the poor!'[4]

Mary knew John was finding the close attendance on his uncle extremely trying, but was cheered to have a letter at mid-month from Bernard, saying

that he was feeling well enough for a therapeutic visit to Bath. He had asked for a print of the Allan Ramsay portrait of Jean-Jacques Rousseau, painted when the latter was in England during 1766; Mary and various emissaries of the duchess had accordingly been scurrying around town trying to obtain one.[5] Hearing that Bernard was ailing, Rousseau himself had written to the duchess to express his concerns.[6] Bernard told Mary that he had been encouraging John to improve his French and his music, and his sister observed – always trying to raise his thought to higher things – that it was good to improve the talents bestowed by Providence.[7]

The fact was, though, that nephew John was utterly miserable about his *'present confinement'*, and was 'beseeching me to get *"a call for him"*, meaning, I suppose, a living', as Mrs Delany explained to his sister. She pointed out that had it been in her power, he would have had one long before, and that several likely patrons had been reminded – 'but when people are to bestow favours they will do it in their own time'.[8] She felt that his duty would sustain him and that now they had reached the end of January the longer days would be cheering; besides, there was that opportunity to improve his music and his French.[9] In the next few months Bernard's health improved, and in early May Mrs Delany was busying herself fulfilling his request for French plums. She included a new-fangled cheese carver, knowing he liked gadgets; these were all to travel with a trusted friend, who would ensure that the print of Rousseau was kept separate from the fruit. However, Mary did try in a June letter to Lady Andover to see whether she or her son might be able to pull some strings, for John, and Bernard roused himself to make a reference to help his nephew get a post.[10]

In London Mary had been recently introduced, at a dinner given by Mrs Boscawen, to Sir Brooke Boothby, Rousseau's devotee. When Mrs Delany met Boothby in London in 1772 he was still known to follow the new fashionable vogue of cultivating 'sensibility'. This encouraged both men and women to profess their superfine feelings, which should include empathy for the distressed. It was also a literary and artistic style and was underpinned by medical theories about the nervous system. Today it is best known through Jane Austen's novel *Sense and Sensibility*.

In the early spring of 1772 Frances Boscawen was renting a house in Enfield, still a rural village north-west of London, and during an evening stroll with her daughter they saw an immense cedar of Lebanon, which she subsequently measured and found to be 9 foot 3 inches in circumference, larger than any the tree-loving

Mrs Boscawen had ever seen.[11] By the end of the spring, Mary was feeling debilitated after the hurry and worry of winding up all the financial and legal affairs consequent on the sale of Delville and the purchase of St James's Place. She was not making many social visits, partly because she was still trying to keep up Sally Sandford's spirits; for the most part it was the duchess who called in on Mrs Delany, not the other way round. She told her nephew John that she was finding it increasingly difficult to read, even with her spectacles, indicative of the first signs of cataracts. Consequently, when she told Lady Andover her plans for her summer she added the proviso 'if in tolerable spirits'.[12] The duchess as usual would be away for most of June and July, first at Tunbridge Wells and then down in Weymouth.

After the cold early in the winter, there was now a long heat-wave that the ladies found difficult. Even the effervescent Frances was wilting: 'how hot and dusty and odious it is to live in the streets of London. It us'd [sic] be a great relief to me to walk in Kew Gardens, or go to buy my own peas in the King's Road, sitting under a spreading apple-tree, while they tied me up a nose-gay ...'[13] At last escaping the town, Frances went north to Enfield, where the air was decidedly cooler. Although it was becoming a fashionable area for affluent business folk to settle and their villas were fast multiplying, the village lacked facilities for provisioning of as much as a strawberry; inviting Mary for a day's visit she laughingly offered only the plain fare of 'beans and bacon'. Nonetheless she urged Mrs Delany to make the nearly two-hour coach journey through Islington, Tottenham and Edmonton. Her daughter Fanny seconded the invitation, her son George 'will gather you a nosegay of his best damask roses' and 'the blackbirds will sing to you'.[14] There is something so refreshing about Mrs Boscawen's vivacity even in sweltering heat that even today her letter is redolent with the coolness of her rural retreat, with its grove of trees, and the large cedar nearby.

The hot weather continued on into July, when Mary was due again at Bill Hill in Berkshire chez Countess Gower, and the duchess at the spa. Mary still felt exhausted by the house move and preoccupied by her brother's ill-health. But soon the duchess too had more to concern her than the temperature, since all the Longleat grandchildren were catching smallpox from one another. Her anxiety for their recovery was shared by the Countess Gower's Bill Hill household until a messenger arrived with good news. The duchess was then able to proceed to Weymouth for the sea and the chance to study the marine life.[15]

At Badminton House, Mrs Boscawen's eldest grandson Henry, known as marquis of Worcester, had also been ill and suffered a brief relapse; but his grandmother was relieved not to be with her daughter just then as the family were engrossed with all the summer entertainment inherent in their position as the leading peerage family in the county, and one now openly loyal to the king.[16] Meanwhile Mrs Delany enjoyed the low-key pattern of the visit with Lady Gower: as she described it to Lady Andover: 'We live tranquilly here and unmolested by neighbours, which suits the dullness of my spirit very well.'

In contrast, the duchess down in Weymouth had been so active she was beginning to pine for Bulstrode, though she was delighted with the rich haul of 'fosils [sic] and butterflys [sic] without end' bestowed on her by Henry Seymer, the squire of Hanmer, near Blandford in Dorset, who was a knowledgeable entomologist, conchologist and mineralogist.[17] She had also been packing 'twenty kinds of sea-plants besides sea-weeds, so that I am as busy as possible'. When she returned, Mary recognised her friend had improved her health and been stimulated by her visit, and was now eager for their annual short visit to Lord Guilford at Wroxton; but she herself was reluctant to travel a distance that now seemed to her far from home. However, as she confided to Lady Andover, 'being so kindly solicited and travelling in such an easy way has conquered my scruples'. She had rather been enjoying the late summer garden routine, and bright moons had masked the shortening days, 'but, every season brings its amusement, and our works and our books reconciles us to candlelight'.[18] The ladies also had been deprived of Lightfoot's instruction, as he was researching his *Flora Scotica*, 'sailing over lakes, traversing islands, clambering over rocks & & among the Western Isles of Scotland, in order to lay his prizes at her Grace's feet next Michaelmas'.[19]

Unfortunately the visit to Wroxton turned out less pleasurably than usual, as Mary had had some kind of insect bite that proved troublesome, and hampered her mobility. Mrs. Boscawen passed on a regular piece of royal news from Mary Tryon, Maid of Honour to the queen, that another royal baby was due 'but that is no news at all, an event of the year of course'.[20] The next royal news was more immediate: the Bulstrode household was to be visited in early September by Princess Amelia, only surviving daughter of George II – George III's aunt. She was still an eccentric and independently minded woman, a keen huntswoman in her heyday and a close observer of the political scene. She may have imbibed some of the feminist discussion of the later 1730s generated by 'Sophia's' essay: she observed to her happily married sister, Anne, who was trying to match make for her:

I sometimes believe you think that unmarried women have no places in heaven for you think nobody can have the least happiness without being tied from morning to night to a creature which may tire one's life out and plague one incessantly with their good advice or commands whilst one is full as wise as they and . . . may be they might make a figure in life if they were more to be known or had a more manly education, we poor women have great disadvantages without making them still worse and putting oneself into a Jackanapes power.[21]

Her visit to Bulstrode was an honour for the duchess, and Amelia wanted to make it as informal as it was possible for a Hanoverian princess to be. But all the same it caused 'some disturbance even in this palace'.

All the comfortable sophas and great chairs, all the pyramids [sic] of books (*adorning almost every chair*), all the tables and *even the spinning-wheel* were banish'd for that day, and the blew [sic] damask chairs set in prim form around the room, only one arm'd chair placed in the middle for her Royal Highness; she came in a post-coach and four, only attended by two footmen and a groom . . . plus a female friend and a lady in waiting.[22]

The duchess met them at the main door while Mrs Delany hung back in the hall, but having greeted her hostess the princess came and greeted Mary 'and said many civil things – which I hope I answered properly'. The steward had ensured the formal lunch was served with the opulent splendour of the household; 'the tone was magnificent and polished to the last degree, yet everything conducted with the utmost ease'. Amelia insisted first on touring house and gardens with just her two ladies, to save her hostess trouble and fatigue, and then being allowed to see Mrs Delany's suite of rooms 'and made me display all my frippery works, all which she graciously commended'. Everyone then sat in the library until seven, when the princess was driven back to Gunnersbury by the light of the moon.[23]

'I HAVE INVENTED A NEW WAY OF IMITATING FLOWERS'

After this interlude, the routines and the letters between Bulstrode, Enfield, Longleat and Derbyshire concentrated on more familial matters. On

22 September it was Georgina Mary Port's first birthday, and her great-aunt wrote her quite a solemn letter, addressed in reality to her parents:

> My dearest little child, this is your birthday, and I wish you joy of its return; perhaps if you knew what a world you are entered into, so *abounding with evil* you would not say '*Ta*' [thank you] to me for my congratulation, but the precepts and example of your excellent parents will teach you how to make so good a use of the tryals [sic] you will necessarily meet with, that they will not only be supportable, but lead to that state of happiness that will have no alloy. For the present I leave you to your infantine amusements which I shall be as ready to contribute to when I can, as I am to testifye [sic] how dearly you are beloved by
>
> Your great A. D.[24]

In a more tart vein Mary reported to her niece what she had heard about the new Duchess of Cumberland, whose marriage the previous year to the king's brother, Prince Henry, had caused some scandal:

> She has her state coach following her wherever she bestows her presence, with three or four *ladies* or rather *misses* called her maids of honour. She wears a sack sometimes white, sometimes other colours, trimmed with roses of ribbon, in each a large diamond, no cap, and diamonds in her hair, and some gee-gaws hovering over her head; a tucker [neck scarf] edged with diamonds, a little twist with a jewel dangling, and no more of a tippet than serves to make her fair bosom conspicuous rather than to hide it.

Too much cleavage and too much hair uncovered equalled much too little decorum to Mrs Delany – and many a respectable peerage and gentry family.[25]

She also reported that Bernard had for once referred tenderly to niece Mary – something not always forthcoming in his grouchy moods.[26] The letters now explored whether young Mary might visit Bulstrode before she gave birth to a second child. This would also depend on whether their being together so far from Calwich – despite Bernard's capriciousness over having them visit him up there – would somehow cause offence. Mary hastened to assure the Dewes that it would not cause her any disquiet if these plans came to nothing, and besides, a visit might mean they would end up returning to Staffordshire in

bad weather. After other news of friends and family, in the same matter-of-fact informative key of a typical 'journal' letter, comes the sentence that has riveted admirers of Mrs Delany's artistry ever since the collage collection became more widely known:

> I have invented a new way of imitating flowers. I'll send you next time I write one for a sample. I have done no work but *finishing* the worked stools, and am now knotting fringe for them, and I have done three chimney boards for the drawing room here, the dining room, and the Dss own bed-chamber. They are mere bagatelles; but the weather has been so fine we lived much abroad [outdoors], and my agility is not now equal to my *imagination*.[27]

Afterwards in the same matter-of-fact tone, she reports the dismay in Mrs Boscawen's family at the plans of her widowed sister-in-law to marry a fashionable physician; it was 'a very unequal match, and which vexes her family'.[28]

How should this throwaway announcement of an artistic innovation be interpreted? First, I suggest, by looking closely at her actual choice of words. It is not a report that a hitherto unknown painter has extended her vocation by using a new medium – coloured paper. She refers to imitation – copying; there is no allusion to invention, that is, composition. The collage is a new way for her to try to reproduce what flowers looked like, based on meticulous observation. This is not combined with any visual rearrangement that an artist might employ when she painted landscape, such as altering where a clump of trees was actually positioned to improve the visual balance of the final composition. It is a new form of *copying*, using a very flat medium – layers of paper – rather than the more three-dimensional medium of embroidery and appliqué suitable for chair covers, or the even more quasi-sculptural deployment of shells or fossils to imitate plasterwork, as she was using or had used in her shell-work mantelpieces at Bulstrode or Delville. The exclusion of the two media of pastel and oils meant that, in eighteenth-century terms, it is also not 'high' art at all but decorative 'frippery', something that might give pleasure, certainly, or even instruction, but was not really lasting, or belonging to any hierarchy of fine art. This is why what follows in her train of thought is a list of activities such as wool embroidery and imitation stucco work.

This all took place when the weather was idyllic – late summer sun after bouts of drought and then stormy rain – the last had been a 'hurricane' on 24

September.[29] Now the weather was tranquil and dry, and the remaining late summer flowers stood out freshly after weeks of withering sun and crushing rain. Her weakened eyes drank in the colour, easier to distinguish than the monochrome of print in daylight or by flickering candles. Feeling less agile, it was also easier for her to sit still and work with paper than tackle messier media that could require standing at an easel. It was a way of being sedentary but not idle – and using a small pair of scissors came readily to Mary, having practised this since childhood. It enabled her to record flowers in detail when prolonged garden walks were less feasible, and it became an all season's occupation in town and country.

It was surely also a means of contemplation and devotion, of memory and commemoration. As she told Bernard in a later letter, her immersion in her shell collection was not just because 'the beauty and variety that delights me, as it is impossible to consider their wonderful construction of form and colour, from the largest to the most minute, without admiration and adoration of the great Author of nature'. Any close observation of the natural world, be it bird, tree, flower or shell, was a means of glimpsing a larger supernal world – and so a way of alleviating anxiety, as death threatened any Arcadian moment with its presence. In seeking this spiritual dimension to nature there was also reassurance for the Christian teachings of resurrection and immortality. Bernard was the third and last of her siblings to survive; his possible demise hovering constantly in the back of her mind throughout all the season of this year would surely have prompted thoughts of the 'sister of her heart', Anne, whose daughter had become so close to her. Surely the collages also became a homage to what she always regarded as her sister's greater botanical knowledge, especially in systematics, and her skill in their depiction in a different medium, watercolour?

MRS DELANY, THE BON TON AND
BLUESTOCKING INITIATIVES

The implications of her venture into collage, and its growth into a full-scale botanical survey, were still in the future. The invention of her new way to imitate flowers had yet to gather momentum. Together with the usual exchange of news of daily events, what Mary and her circle were most exercised by, as 1773 turned into 1774, was the contrast in manners and morals within the aristocracy and their protégés, and Bluestocking efforts to instil seriousness and

counteract the hard drinking and gambling, and, by implication, the promiscuity and venereal disease that accompanied it.

For Mrs Boscawen the most significant event was the engagement in the summer of 1773 of her younger daughter, Frances, to a member of the Leveson-Gower family – thus uniting the Boscawens to the family descended from Jane, eldest daughter of Mary's Granville grandfather. Despite the distant nature of the connection, Mrs Delany was still recognised as a cousin of the groom (see Family Tree). Within a week the Dowager Countess announced she was coming to London to meet him and ready to pull strings on the young captain's behalf.[30]

The 1770s saw a high point of dissipation among the younger set, with the magnetic personality of the MP Charles James Fox, the reckless and flamboyant young politician and friend of Georgiana Duchess of Devonshire, among its leaders. Mary and her friends were not reacting in moral panic to distant news and gossip in the papers, but to the misconduct of their own friends and relatives. For instance, the two elder sons of Mary's late cousin, Grace Foley, had by 1773 become inveterate gamblers and cronies of Fox, and Thomas had lost £50,000 gambling at the Newmarket races.[31] Fortunately for their father, their elder sister, Grace, who soon after was married to the Irish peer James Hamilton, 2nd Earl Clanbrasil, would avoid the worst excesses of the *bon ton*. But respectability in itself was not enough to meet the tone of the duchess's circle: some intellectual élan and cultural initiative was also required. When Countess Clanbrasil visited Bulstrode with her husband a few months after their marriage, Mary complained, 'her languor of spirits and want of exertion seems insurmountable; she sees without speculation, and hears without reflection'. Ostensibly, taking interest in nothing, she had nothing interesting to say; 'but not so her lord', Mary continued, 'for he takes notice of everything . . . I like him mightily; he is good humour'd, easy, well-bred, and *deep* in search of botany, which has afforded an ample field for *conversation*'.[32] The earl was the Duke of Portland's cousin, and was currently MP for Alexander Pendarves' one-time constituency, Helston in Cornwall.

Individual families could try to achieve reform of wayward children by similar legal devices as those deployed by the Foleys. But another approach, was the new-old preventative strategy of encouraging better social and moral education for both sexes – but especially women, seen both as the guardians of morality and the maternal educator, but, confusingly and inconsistently, also as the sex most in need of direction. One difference between the generation of

women who first read Mary Astell, and the young women of the 1770s, was that their power to refuse an unliked or unreliable suitor was now more widely supported. Scapegrace Tom Foley liked an heiress, Lady Caroline Carpenter, but she chose another Herefordshire-based landowner, Uvedale Price, whose aesthetic theories were to mould the movement of 'the picturesque' in land-scape design. He had both wealth and cultural flair to recommend him. Moreover, her aunt Lady Alicia was one of Queen Charlotte's first Ladies of the Bedchamber, and a patron of the progressive governess, Mme LePrince de Beaumont (see pp. 216–17).[33]

Thus, the 1770s generation required a new conduct book that would address new intellectual horizons as well as new fashions, entertainment and leisure habits. The latest attempt to nurture moral fibre, written in 1773, came from a writer known very well to Mary Delany's personal circle: Sally Sandford's sister-in-law, Hester Chapone. After such a long pre-engagement, within a year of marrying Sally's brother Jack in 1761, she was a widow. Hester's *Letters on the Improvement of the Mind* enjoined rational self-improvement instead of heedless amusement, and the first half was devoted to the reasonable and thus believable foundations of Christianity, which she believed provided the underlying incentives to moral behaviour. The second half explored the range of subjects that were now open to women, such as the natural sciences and mathematics.

That same summer Mary had been enthusiastically telling her niece about the explorations made by Joseph Banks and Daniel Solander in Scotland, includ-ing their reports on the island of Staffa, whose little-known rock formations were identical to the Irish phenomenon, the Giant's Causeway. They had then travelled on to Iceland, where they had seen volcanoes and hot geysers.[34] When Dr Lightfoot set out on another Celtic expedition, this time to Wales, where he intended to climb Mt Snowdon and document flora in the Anglesey peninsula, he was accompanied not only by Joseph Banks, but also by one of Lord Warwick's sons, who, Mrs Delany observed, 'is *far gone* in the pursuit of natural curiosities: I wish he could infuse the same inclination into the young fashionable men of the age; a short experience would make them sensible how preferable such pursuits are to their destructive ones, on the turf, and at Almacks, &.'[35]

Mrs Delany had encouraged Hester to write her conduct book, and was delighted that 'it sells prodigiously'. She sent it to Bernard thinking it would interest him.[36] One of the most interesting responses to it in her circle is in a letter written to the Rev. John Dewes from his father, a year after its publication.

The unhappy way Mr. G. [i.e. Bernard, Mary's brother] is in at present, seems to me to be owing to the great dejection of spirits he is under, occasioned as I apprehend by his long and severe illness, wch [sic] makes him see everything thro' a false mirror, otherwise I hope and verily believe he would not have those doubts and difficulties he at present labours under. I don't know wr [sic] he or you ever saw a book in two vols., said to be wrote by the widow of J. Chapone; . . . she puts the foll. Question, viz. 'Can those who think of God with servile dread and terror, as of a gloomy tyrant armed with almighty power to torment and destroy them, be said to believe in the true God – in that God who, the Scriptures say, is love!'

In putting his finger on the depressing effect of theological views with a stern, discouraging character, John Dewes may well have diagnosed accurately a prime cause of Bernard's troubled spirits. Conversely, Hester Chapone's sunnier reasonable religious faith goes a long way to explaining why her book had such widespread acceptance.

MRS DELANY'S 'VIRTUAL' MODERN HISTORY PAINTING: 'TRUTH INTRODUCED TO ROYALTY BY AN ANGEL'

A second strategy for trying to raise the moral tone of later Georgian society goes to the heart of what some of its main movers and shakers, such as Mrs Montagu, wanted to do. This was to provide an alternative form of large-scale entertaining, based on French models, but applied to British circumstances. When she began her assemblies in the later 1750s, she was worried about the demoralised state of Britain, socially, morally and militarily, which she considered was the root cause of the poor showing of the Army and Navy in the early stages of the 1756–63 war. She wanted not only to emulate the French style of salon, as a venue for literary encouragement and philosophical discussion, but also to uphold moral standards.[37] As young Mary Hamilton, a preceptress to the royal princesses and a future protégé of both the duchess and of Mrs Delany, said of Mrs Vesey's drawing room, there was no-one there with an equivocal reputation:

there one meets with a charming variety of society that suits any mood one happens to be in; viz: the learned, the witty, – the old & young, the grave, gay, wise & unwise . . . The elegant female, the chaste matron, the severe

274

prude, & the pert Miss, but be it remembered that you can run no *risque* in Mrs Vesey's parties of meeting with those who have no claim to respect, as is so often the case in mixed assemblies in London.[38]

Miss Hamilton was right: in a large assembly it was much easier to conduct a sly flirtation or make assignations, precisely because there were so many people that amorous manoeuvres, adroitly handled, could quickly pass unnoticed, and it was impossible to exclude everyone deemed equivocal. At Mrs Montagu's drawing room, more than at Mrs Vesey's, who had the knack of letting people relax and mingle, even the seating was precisely regulated and there was nowhere to hide.

Mrs Delany no longer had the scope or the context for socialising and being a hostess that she had once had in Dublin as wife to a dean and well-regarded man of letters. It's clear that as the decade wore on, she still preferred such small-scale soirées at St James's place among a chosen few, than to try to be a fashionable yet high-minded hostess. And she could not but remark on the frantic competition among the *bon ton* to invent new kinds of inane party in May 1773, just as Hester Chapone's book was published:

My fine neighbour, Lady Clermont, sent cards last week to a few of her acquaintance (not exceeding 300) 'to drink tea and walk *in the park*' . . . Her Grace of Bloomsbury [the Duchess of Bedford], immediately after, sent her cards to invite 'to drink tea and walk in the fields'.[39]

These were at least parties that eschewed gambling, even if in Mrs Delany's eyes they seemed vacuous.

Finally, a third strategy was the one that the king and queen had adopted, which was to use the royal drawing room as a barometer of social and moral approval. It had always been possible to indicate disapproval either by the monarch turning his back to someone (when George II did this it was described as 'rumping') or excluding them altogether from the royal drawing room. George III tried to be more consistent in excluding the improper, though he had to bow to circumstance in making political appointments. He even had to give ministerial office to Charles James Fox. Just as Queen Caroline had urged the court to read Bishop Berkeley's critique of scepticism, *Alciphron*, back in the 1730s, so now George III and Queen Charlotte pointedly showed their approval

of the Scottish man of letters who, it was considered, had persuasively answered David Hume's scepticism. This was the poet and philosopher James Beattie, in his *Essay on the Nature and Immutability of Truth in Opposition to Sophistry and Scepticism* (1770). The agenda was to strengthen confidence in the authenticity of religion, not merely to enjoin morality. It was considered vital to know that the religious anchorage of morality was safe, because both true and rational.[40]

Before reaching the capital Beattie was given an honorary doctorate at Oxford, after which he was a guest at Bulstrode. Hester Chapone wrote to Mrs Delany there, 'I feel the greatest gratitude to Dr. Beattie for his successful endeavours to rescue this nation from that gloomy skepticism which a few false philosophers of dangerously shining talents have so fatally spread amongst us.' When Beattie and his wife proceeded to London to attend the king's levée, Mrs Delany imagined how this could be painted as a modern 'history' painting whose subject was '*Truth* introduced to Royalty *by an Angel*' and regretted that her artistic talents were now in decline, or she would have attempted such an 'emblematical' picture.[41]

EDUCATING DAUGHTERS OF THE GENTRY REVISITED

Mrs Delany had returned to her London house ten days before Christmas, and found that 'the American affairs are now the only topick [sic] of conversation'. There was social news, too of course, such as the engagements of two of Lord Cathcart's daughters to two Scotchmen, 'the Duke of Atholl and a Scotch Mr Graham, men of good characters and great fortunes'. Moreover, 'all these young women have been chosen, not altogether for beauty, but they are remarkable for their *proper behaviour*, and I hope it will encourage reserve and modesty'.[42] She had entertained similar hopes of young Georgina Spencer, granddaughter of her cousin Lady Cowper from her first marriage. Georgiana was presented at court in June, shortly after marrying William Cavendish, 5th Duke of Devonshire. But Frances Boscawen had already noticed that the duke had been at Ranelagh pleasure gardens without his wife a few days after their wedding: a bad augury.[43] In January 1775 the young duchess called on Mrs Delany and told her very sincerely that when she was resident at Chatsworth (the county seat of the dukes of Devonshire, in the Derbyshire Peak District) she hoped that Mary Port would visit from Ilam, not so far away.[44] But Georgiana was already caught up as one of the leaders of fashion within the

high-living fast-moving young set, her febrile social whirl masking marital incompatibility and the intense pressure to give birth to a male heir.[45]

Mrs Delany and her sister, Anne Dewes, had worried about how to bring up young Mary Dewes. Now that the latter was the young matron Mary Port at Ilam, the same worries over the balance between prudence and sophistication preoccupied great aunt and great niece. The latter now consulted the former about all sorts of questions on the upbringing of her family. Her husband had been obliged to adopt the daughter of some cousins, a Miss Parsons, who was in her early teens. How to find a governess who would not demand too high a salary nor assume she was to mingle too closely with the family? This would become a staple of fiction, as in Austen's *Emma*, when it seems the impoverished gentlewoman Jane Fairfax will be forced to follow this route.[46] Happily a Miss Vranken proved highly suitable.[47]

Home education was better for girls, Mrs Delany thought, than genteel boarding schools, 'where the cabals, the party-spirit, the fear of the governess, the secret and foolish indulgences of the maids, sometimes teach dissimulation, jealousy, resentment, and revenge, − a sad train, and as mischievous as the ichneumon fly that gets into the chrysalis of the poor innocent caterpillar, and devours its entrails . . .' Boys, however, might benefit from school, and for her eldest son 'a good school if he grows unruly will tame him'.[48] Girls should not be allowed to grow up too quickly. She was appalled that her late cousin Grace Foley's fifth child, Anne, was already unofficially engaged at only 14. 'What behaviour and conduct can be expected from children's being so soon introduced into a state that requires the utmost prudence? but', she conceded, 'Mr. F. gives him a good character, and his estate adjoins Witley.'[49] The marriage of young Andrew Foley to his cousin was turning out well, too; the bride was so attached to her neighbourhood she could hardly be persuaded to leave Newport for London for her lying-in. There was no danger the vortex of the metropolis would swallow *her* up.[50]

BERNARD'S DEMISE

Mary was well enough to attend church at Christmas 1774, but by the New Year it was evident that her brother was inexorably failing. Writing to one of the Vineys back in Gloucester, she acknowledged, 'I have nothing to hope from thence but that the goodness of God will support my dear brother under his sufferings, and that in the end they will prove *blessings*; but glorious as that

expectation is, it is impossible not to feel the present affliction as a subject too grievous to dwell on.'[51] She continued to write to Bernard with news both of family and the *bon ton*. She was using what connections she had to get patronage for nephews John and Bernard Dewes. The new Bishop of Litchfield was her old friend Richard Hurd, so she hoped a prebend's stall at the cathedral could be arranged – which would give John both a clerical income and a public status.[52] She had also been making use of her friendship with the prime minister, Lord North, to get a public appointment for the legally trained Bernard, as one of the Lottery Commissioners, and had received a promising hint from Lady North she would succeed; the appointment was indeed confirmed two months later.

The Ports had sent down some venison and she saved it to give to the brothers when they dined one Sunday evening with her in London, the day after a supper of 'the coterie': Bishop Hurd, the Duke and Duchess of Portland, Mrs Montagu and her son Frederick, and the clergyman William Mason, poet and aesthete, who was now advising Frederick on laying out his gardens at Papplewick, Nottinghamshire. She told Bernard she liked Mason's sermons, too.[53] That January she was also swept along one evening by the duchess to one of the Bluestocking assemblies hosted by the '*other* Mrs Montagu'. She found the crowd overwhelming and escaped as soon as she could, but, on reflection, realising that she was none the worse for wear, embarked on a series of visits. It seemed that the setbacks of 1774 were behind her.

Bernard was failing physically but Mary felt he was altered in spirit and making his amends to God. She sympathised with how difficult he must find the cold weather, adding 'even when sorrow and sickness bear hard upon us, if we attend the call, it opens our eyes and hearts, it makes us recollect past errors, brings to our aid *contrition* and *repentance*, and joyful hope; and tho' our mortal part shrinks at sufferings, our immortal part soars to *everlasting happiness*'.[54] These sentiments were now kindly received by Bernard, and she told nephew John, 'The *resign'd* state of his mind is my *greatest consolation*, as *such reflections* must be so to him.'[55]

Over the next few months she took immense trouble to execute his commission for a portable chalice and paten so that he could take communion at home administered by John, being in no fit state to attend church. Bernard also wanted her to arrange re-setting an enamel of their beloved Aunt Stanley, taking it from inside an agate snuff box onto the top instead, to be surrounded by a ring – something of a risky business as the enamel might be damaged

when removed. Eventually Mary succeeded in having the picture re-set safely, surrounded by turquoises and brilliants. She also sent portraits of their parents, of Lady Joanna Thornhill, their great-aunt and their Carteret cousin Lady Dysart, to enrich his picture gallery.[56] Books included William Mason's life of his friend the poet Thomas Gray, famous for his 'Elegy Written in a Country Churchyard'.[57] There were weekly posies of flowers supplied by John Boyd and his wife Katherine, Sally Sandford's sister.

There were still interludes with no letters directly from Calwich and by June she learnt that currently even Mary Port had not been welcomed to visit her uncle.[58] Although Mrs Delany was now willing physically to make the long journey, she still hesitated to do so for fear her brother would refuse to receive her, for one reason or another, or that if admitted she would be too overwhelmed by his decline to be of use.[59] So she kept up with her usual routines, and still wrote letters. In May she went to Bulstrode. The Bluestocking Mrs Montagu was widowed in late May; her widowhood would be followed by her further development as a hostess, philanthropist and patron of architecture. Meanwhile Frances Boscawen's main concern was anxiety for her son's safety in Boston, after the commencement of hostilities at Lexington and Concord in April, and she could not bear to read the newspapers. But at the end of June she had a letter from him, assuring her he was well, and she was able to contemplate visitors again.[60]

Finally, on 26 June Mary wrote what was to be her last letter to Bernard, still being cared for by nephew John and the Calwich household servants. Now there had been a heatwave, she wrote, which she supposed might be as injurious to his health as the severe winter weather. She had seen the other Dewes nephews and praised their attentiveness and family feeling to their uncle. At Bulstrode the botanical garden was thriving and the duchess sent her 'best compliments' to her dying friend and fellow-connoisseur. Mary thought her friend's absorption in her garden increased her well-being, and added, in implied praise for Bernard's own horticultural enthusiasm, and the spiritual consolation he had maybe derived from it:

How happy it would be for the world if they delighted more in natural plea-sures, which lye open to everybody, instead of racking their brains and time to invent irrational entertainments, that . . . put a stop to every serious consideration, and which lay in no store for the hour of pain and trial, when nothing can support them but . . . a *reliance* on the mercy of God, and

submission to his will, with the joyful hope of eternal happiness! I am afraid I have made my letter too long. I will only add my warmest wishes. Adieu.[61]

One can only hope for Mary's sake that John Dewes was able to read this to his uncle in time before he died on 2 July. Bernard had been the much-loved older brother, a masculine presence in the family who commanded as much deference as her father or uncle, and during the first year of her arranged marriage, a staunch companion and ally. When she was a young widow in London, they had enjoyed many pleasures: entertaining together, decorating his London house and Calwich, the garden there and at their uncle John's retreat at Northend, Handel's music, and Bernard's participation in collecting pictures for himself and her great friend the duchess. As he reached his end, she confided to Mary Port that she considered that he had had an unhappy temperament early soured by disappointments (in love, and in his expectations of the dukedom of Albemarle), which had been exacerbated by his 'having had too little contradiction and government in childhood'.[62] She alluded to his tendency to suspect others – had this led him to accuse Patrick Delany of being a fortune hunter when he married Mary? These defects had been cruel when directed at her; but she had not let them erode her affection. On the other hand, he had no vices (such as gambling or sexual incontinence) and she was confident that at the end he had resigned himself to divine Providence. The stress of her bereavement nonetheless made her briefly ill.[63]

Contrary as ever, Bernard's will had an unexpected sting. Anne and John Dewes had always been led to believe that with the eldest boy, Court, inheriting Wellesbourne, Bernard's estate at Calwich was destined to his namesake, the second son, Bernard. But instead the Rev. John Dewes, who had borne the brunt of residing at Calwich and enduring his demanding temperament, had been rewarded with the majority of the estate, turning him into both a squire and a parson. This was certainly an ample reward for his labours, but with a much smaller inheritance this left Bernard less well off than from his childhood he had anticipated.[64] The brothers, however, did not let it impair their mutual friendship. Mary hinted to John she had no doubt that some of his new affluence would find its way to the excluded Mary Port and Bernard, and she was confident that in due course Bernard's hurt feelings would abate.[65]

Reviewing the Collages and Glimpsing Royal Felicity

FRIENDS AND FLOWERS

*I*n the first autumn of her bereavement, Mary mused over her brother's life and death, and her physical health in the first six months was variable. But once her energies began to flow again, she found it easier to absorb herself very satisfactorily in her flower portraits, and as always she found being busy was one of the most effective ways to check her spirits from declining. Even when physically debilitated, she still strove to keep active mentally. Nephews and niece and friends alike rallied to her, and she found fresh purpose when the Port family needed extra help after 1778.

In St James's Place she was soon unwell with some kind of influenza, which was very prevalent in a long wet autumn, and she went to Bulstrode later than usual, thereby missing an impromptu royal visit from the king and queen and their two eldest boys.[1] But once she was able to travel there, Bulstrode proved a good place to convalesce, for herself and for the duchess, whose rheumatism was aggravated by her own bout of flu. However, the energetic and robust Mrs Boscawen managed to evade all the contagion, and had her mind focused on the following spring. In the intervals between the bad weather, she was busy extending her flower borders, and by mid-November told Mrs Delany she had enriched the extra 14 inches thereby gained 'with good mould, [and] such a profusion of jonquils, ranunculus's, and tulips and hyacinths sett [sic] in them that when I have the honour to see you in the month of May you shall fancy yourself in Flora's own cottage'.[2] Similarly eager to keep busy, Mary had

resumed her mosaics once at Bulstrode. They included humble English plants that had already been portrayed for the duchess by Ehret in watercolour as part of her 'English herbal'.[3]

This highlights a very important point about the number and variety of collected herbals in the circle of the duchess and Mrs Delany. Ehret painted a collection of *English* common plants in watercolour for the former. Thomas Hudson compiled the first Linnaean-based English Flora and Mrs Delany copied an Index for it, for teaching purposes at Bulstrode. The Reverend Lightfoot compiled a Scottish herbal before proceeding with a Welsh one, and Thomas Pennant's travels in Cornwall, aided by Mrs Boscawen's and Mrs Delany's contacts, included comments on plants as well as shells and antiquities. But the *Flora Delanica* was unusual because it also drew on *global* specimens derived from a number of people in the duchess's circle. Thus it was both more and less ambitious than the others, which mostly had deliberately focused on precise geographical locations. It included English common plants as well as specimens from the five continents, such as the *Alstroemerias*, examples of Mexican and Peruvian lilies from South America, named by Linnaeus after the Swedish botanist Count Clas Alstroemer, whom Mary had met in July 1774 when he visited Bulstrode with Dr Lightfoot; and the bay-leaved Passion flower, originating in the West Indies, supplied by Lord Bute.[4] Yet as the medium of portrayal was throw-away paper, Mrs Delany called them 'fripperies': she did not see them on the same scale of artistic achievement as Ehret's professional accomplishments.

The spring of 1776 brought liveliness and variety to the London scene, as well as to the garden at 'Glanvilla', as Mrs Boscawen had named the villa in Colney Hatch, Middlesex, she had now acquired. As soon as winter ice began to thaw, people increasingly resumed their visiting, and Mrs Delany in St James's Street found most evenings that 'from eight to ten my little circle is pretty well filled'. The duchess always kept company with her until the last visitor had disappeared. 'I am sometimes tired, but on the whole it is good for me, as I cannot read by candlelight as much as I used to do.'[5] In March and April, she told her great-niece, she completed twenty plants.

POETRY AND POLITICS

Mindful of how kind Mrs Delany had been in the early stages of her grieving for Admiral Boscawen, Mrs Boscawen continued to be one of the circle who wrote

regularly, especially after her own spirits revived when her remaining son returned from the dangers of the armed encounters in America.[6] Knowing what a poor correspondent the duchess was, Fanny Boscawen also relied on Mary to keep her informed as to the duchess's well-being. A regular visitor to Mary's evening gatherings, was the poet-clergyman William Mason, also a friend of Bishop Hurd and of Frederick Montagu, son of 'Mrs Montagu of Hanover Square'.[7] She noticed Mason's inherent shyness and his darting participation, which like a meteor made bright but short visits, and appreciated how well Hurd drew him out in social conversation.[8] Mason was a parish priest and man of letters, and also a garden designer and theorist.

However, other sides to Mason stemmed from his ardent Whig politics. Mason liked needling both the political and ecclesiastical establishment. On the one hand, Mary remained a very close friend of Francis, 1st Earl of Guilford, whose son, Frederick, Lord North, was George III's first minister from 1770 to 1782. He was affable and a good House of Commons debater, respected by many gradations of opinion in the House. To the king, he was a godsend, as he was the first minister to enjoy more than a few years of tenure as 'prime minister'. But the coterie embraced some of North's strongest critics: Frederick Montagu and the Duchess of Portland's sons inclined towards the 'Rockingham' group of Whigs, who clustered around Charles Wentworth-Watson, 2nd marquis of Rockingham. The most divisive political issue in Lord North's ministry was America, with the Rockingham group as the main opponents to North, and sympathetic to the American leaders.

One of Mason's closest friends was George Simon Harcourt, 2nd Earl Harcourt (1737–1809), for whom Mason designed his most famous garden, at Nuneham Courtenay in Oxfordshire. Before his father died, Viscount Nuneham, as he was then known, felt his father's political and diplomatic service to the crown had been inadequately rewarded. Consequently, the future peer seldom attended court, and when he inherited in 1778, instead of immersing himself in Westminster politics, he still concentrated on his garden and instituting philanthropic projects more inspired by Rousseau than by Christianity,

There were, then, cultural and political sympathies that took Mason well away from Mrs Delany's Tory loyalism. The book of Mason's she would have approved the least, *An Heroic Epistle to Sir William Chambers* (1773), jointly authored with Horace Walpole and anonymously published, was a critique of the king's alleged 'oriental despotism'. It argued that the Chinese taste, evident

in Chambers' buildings of world architecture at Kew, such as the Pagoda, were evidence of the king's affinity for 'oriental despotism'. This was code for old-fashioned Tory belief in the royal prerogative, since Chambers' redesigns destroyed Kew's symbols of Anglo-Saxon liberty, commissioned by Queen Caroline. In the eighteenth century, a garden was often a lot more than a garden.

However, the poem Mason wrote in four volumes between 1774 and 1781, *The English Garden: A Poem in Four Books*, may have been indebted to Mary's own views on what would later be termed picturesque gardening. There is no reason to suppose that because controversial politics were put on one side at St James's Place, Mrs Delany went to the opposite extreme and said nothing while her male guests talked. Both she and the duchess had been developing and looking at gardens for the last forty years. Since Mary's earliest literary 'apprenticeship' under the aegis of her uncle, the patron of Alexander Pope (a poet Mason had eulogised in one of his earliest efforts), Mary had been interested in landscape and garden buildings. She had admired what Lord Bathurst had done at Cirencester Park to create an imaginary ruin; she had designed grottoes in Ireland, in Fulham for her uncle, at the Mordaunt family estate in Warwickshire, and at Bulstrode – only recently completed – and had been a regular visitor to Lord Guilford's Wroxton, where she had recorded its Chinoiserie garden structures. She had admired Sanderson Miller's imitation antique castle and may have influenced him. So if the conversation at St James's turned to gardening, she had something to contribute – in a conversational, polite, non-adversarial spirit. Mason's poem would make an important distinction between a 'horticulturist', that is, someone who grew plants, and a 'gardener' – who was an artist, using the ingredients of hills, woods, water, fences and areas of flower planting, and this was how Mary too regarded gardens. She was not a plantswoman to the degree her sister and the duchess were; but she was a keen observer of the entire *mise en scène*.

There was a lot of good-humoured acceptance among Mary's friends and guests that their views could differ. Eighteenth-century 'politeness', the willingness to accommodate political and other differences, worked towards uniting a closely knit elite, with many bonds of family, marriage and neighbourhood that could cement them together. There were times when Mary deplored the intense politicisation of English elite life – 'I am sick of the mischiefs of politics', she wrote to her niece in the spring of 1776. 'They tear asunder the very vitals of friendship; set familys [sic] and friends at variance . . .'[9] But an MP like Frederick Montagu was an ameliorator, not a gladiator, much

respected as an interlocutor between Lord North and the Rockinghams.[10] He joked with Mrs Delany about Mason's contrarian views, and passed on chatty news about the North family. In one postscript in 1776 there was news about three generations of them:

> PS Lord Guilford is perfectly well at Waldershare [his estate in Kent], where the Willougby's [sic] are going. I have opened my letter again to inform you that Mr. North, Lord North's son, is going to be married to *Miss Egerton, the great Cheshire heiress.* Old Sam Egerton gives her *one hundred thousand pounds down.* I don't write in figures, for fear you should think I put an 0 too much.[11]

The practice of 'politeness' was one reason why some women disapproved of those of their sex who were too outspoken on public matters. Mary mostly managed to negotiate political tensions, such as the kind of sentimental republicanism derived from Rousseau espoused by Court Dewes. He had fallen in with Brooke Boothby (p. 265) on previous visits to Spa. When Court set out for Paris in November 1776, he successfully persuaded his sister to write for him a letter of introduction to Rousseau, who attracted these admiring visits now he was living in Paris. But Court was baffled in his hope of meeting the enigmatic philosopher. He made his way on foot on the muddy Paris streets, which lacked pavements, to Rousseau's lodgings, presented his letter of introduction, but was told that his hero was not well enough to receive visitors. His second try produced the same result, so he decided that he would give up if a third one was similarly fruitless.[12]

GARDENS, GREENHOUSES AND GRANDCHILDREN

Another shared topic between the widows was the progress or otherwise of growing plants. One of the most impressive of all the new species was the *Magnolia grandiflora*, which was propagated in greenhouses. Lady Gower was very successful, and in June 1776 was able to report, '*Mother Magnolia* has more buds [than] I can count, her daughters are all fruitful, and [the] two standards in the parterre show for bloom that never bloomed before!' Mary seized her opportunity to make a portrait of this striking flower when she visited briefly in August [*Flora Delanica* 6:57].[13] Frustratingly, though, the following year at Bulstrode the duchess's gardeners had much less success with cuttings from this same plant: it was a wet and windy spring

and some looked promising, but in the end none would bloom at all.[14] One consequence of Linnaeus's classification of plants, which was based on a sexual designation of the male or female 'organs' of plants, was a tendency to classify plants themselves as either male or female. It must also have seemed natural to this circle of matriarchs to be as interested in the 'lineage' of plants from one mother plant, as they were in their own ancestresses, and now their increasing brood of children and thus grandchildren.

In the summer of 1776 Mrs Delany's niece Mary went to visit her brother the Reverend John at Calwich, and her brother Bernard made his way up there too, in order to make a better acquaintance with Anne de la Bere, who must have been staying there or close by visiting relatives, as by the end of July they were engaged. Mrs Delany, the first to be consulted about his intentions, had thoroughly approved her nephew's choice and believed 'they have . . . great reason to expect a reasonable share of felicity, as they act upon reasonable and good principles'.[15] Now that her brother Bernard was dead, she had in effect become the head of the family: a matriarch.[16] Although the de la Bere family had never gained a title they could trace their ancestry to the Norman Conquest, and this alone must have been an initial recommendation in Mrs Delany's eyes – though not as important as character and a sensible outlook.

As usual, in August there was a brief royal visit to Bulstrode from the king and queen, this time with none of their children. Diffident as always, Mary had begged not to be on display – but Lady Weymouth was sent to her apartment with a request to show their majesties her 'hortus siccus' and she hastened to comply. She was charmed by the interest they took in her enterprise. Mary had been anxious that the convalescent duchess might be obliged to stand too much, but the royal pair insisted she be seated for most of the two-hour visit.[17]

After this visit, the duchess began her trip to bathe in the sea at Weymouth, accompanied by the chaplain Dr Lightfoot, and for once a letter to her friend was preserved – one of the few surviving direct glimpses into their rapport:

My dearest dear friend . . . your dear delightful letters are the joy of my heart. The other day I was on the beach, the wind blew a brisk gale: I got into a little sand grotto, and read your charming letter over and over while Mrs. Le Cocq was travelling about in search of shells, butterflys [sic], and plants . . . I am, my dearest friend, Most affectionately yours, M.C. Portland.[18]

In her search for conservatories to emulate, Mrs Boscawen described herself to Mrs Delany as 'sitting to dinner most comfortably with Lady Bute at Luton Hoo'. She had begun by applying to the gardener and spent an agreeable hour with him, when Lady Bute's invitation to join her and her guests arrived. Nearby in the same county was Wrest Park, the home of Earl de Grey. As Mrs Boscawen put it, the 150 acres of garden were '*Versailles* in some places, in *others* a more pleasing English garden . . .', and thought that 'Mr Mason could make some improvements'.[19]

By mid-December Bernard and Anne were living in Mrs Delany's London house for their first few weeks of married life. Frances Leveson-Gower spotted them on one their first outings attending a play by William Mason, the blank verse drama *Caractacus*, the quasi-legendary British king who led resistance to the Roman invasion of AD 43. They soon began renting Malvern Hall, a new Palladian house in Solihull, not far from Wellesbourne.[20] Their only daughter, Anne, was born promptly the following year, though her mother had had a difficult pregnancy.[21] Spring in 1777 was long in coming: Bulstrode, Henrietta, Lady Stamford, told Mrs Delany, was suffering from strong north-east winds, but she knew Mary would have enjoyed the early spring flowers: 'there are many of your favourites in full bloom; and . . . the woods in the garden are enamell'd with primroses, violets &'.[22] In May Mrs Boscawen evoked the 'good, crackling, blazing wood fire' at Glanvilla that she and her Leveson-Gower daughter retreated to after a tiresome wet day in London. The ladies had their books to settle with and two of the Leveson-Gower boys scampered around indoors on a hobby horse bestowed by Mrs Delany on the eldest.[23] Perhaps they were pretending to hunt, since Mary cut out strings of paper stags and greyhounds for him. Lady Gower at Bill Hill found the long-delayed summer meant the magnolias did not bloom at all. But she was pleased that Capt. Leveson-Gower had netted some prize money, and was about to be paid his father's legacy, and that Frederick Montagu had now benefited from the George Montagu inheritance.[24]

Concern that she might not live long prompted Mary to begin a letter to her great-niece from 'Lady Propriety'.[25] This did not differ substantially from the sentiments she had conveyed to the child's mother (p. 277), but there were now some books she could recommend, such as Hester Chapone's *Letters on the Improvement of the Mind*, which ought to be read at least once a year. The general tenor of the advice again is to avoid affectation. This has particular resonance as regards dress, as it is hard to think of an era from then to now when women

adopted such levels of artificiality as the high headgear and wide panniers of the 1770s, which were gleefully caricatured. The main point for Mary Delany is that a genteel lady will not stand out too much from the crowd: 'In the country nothing is more absurd than to dress fantastically, and turn the brains of your humble neighbours; who will pique themselves in apeing *the squire's* daughter . . . Moderation is always genteel.'[26]

Mary also updated her niece on her own recent visit to Lord and Lady Bute at Luton Hoo. She had netted twelve rare specimens, and she was full of admiration for the sheer range of its plants. 'The place is magnificent: the woods, the lawns, the water, and the immense collection of trees, flowers, flowers and shrubs "from *the cedar to the hyssop on the wall*," charming [she was borrowing Mason's words here], and the weather so constantly fine that I tour'd round the park, or winding thro' a variety of ridings every day with Lady Bute for two hours, in her little, low easy chaise.'[27] The rarer specimens listed from Luton for that year include an African milkwort, an Arabian Lotus and a Bay-leaved Passionflower, as well as a Melancholy Stock [*Flora Delanica*: 6:67; 6:38; 7:54; 5:23]. After such a wet spring, this Indian summer warmth must have been a real tonic.[28] By 19 September the mosaics numbered 400 specimens. Mary was starting to be more strategic, turning her gaze to exotics rather than natives, and sending Lady Gower quite a list of plants she would like to attempt copying.[29]

Her niece Mrs Port had been away, too, for some of the summer, and wrote to her aunt at how delightful it was to return home and to the rest of the family. Mary hastened to reply, and to praise the Ports' family life in contrast to the grand doings of the ducal Devonshire family, 'the great neighbour' at Chatsworth, Derbyshire:

> I see you all together, and so rationally engaged, that I think you are more enviable than your *great neighbour*: in all states Providence has thought fit to temper our worldly happiness with allays [sic: alloys] of sickness, pain, sorrow; the *greatest* and *richest* are so far from being exempted that they feel them with the added mortification that all *those superior* advantages they possess can't ease a pang . . .[30]

As always, death could come from nowhere: Lady Cowper reported that Simon, 1st Earl Harcourt, fell into a well trying to rescue his favourite dog, and also mentioned another misfortune among her Tollemache nieces and nephews,

that of the death in a duel of Lady Bridget Tollemache's husband, the Hon. Robert, while in New York. He was a son of Mary's late cousin, Grace, Lady Dysart, and a naval officer serving in America.[31],[32] Then one of his sisters fell off her horse, fractured her skull and had her face kicked: it was too early to say if her looks would be affected, but as an unmarried girl any loss of her beauty might lessen her marriage chances.[33] Mrs Delany's reaction to the Tollemache duel was distinctly bracing: she thought his wife, a wealthy widow, was literally better off without him, since she had already sold investments to pay off his debts. His conduct seemed typical of the hedonistic extravagance of the age, which made her want the spendthrifts to turn into cobblers and tailors to earn an honest living.[34] The loss of another Tollemache the previous winter when he was swept overboard his naval ship in a hurricane was quite another matter for his sisters, she thought.

FAMILY LIFE IN WARWICKSHIRE AND WINDSOR

Early in 1778 the Dewes could look forward to an expanded family, as the Rev. John Dewes had fallen for Harriet Joan de la Bere, the younger sister of Bernard's wife, and was losing no time in making all the preparations, such as ordering a coach, and discussing the marriage settlement with her father.[35] Another bride in the wider Delany/Dewes circle was Lady Caroline Stuart, fifth daughter of the Earl and Countess of Bute, who married the Anglo-Irish Hon. John Dawson, heir to the Earl of Portarlington. 'It is *not* a great match, but a *very reasonable* one . . . and friends on both sides are satisfied.'[36] On a very cold Sunday in January 1778 Lady Caroline visited Mrs Delany wearing her wedding finery after attending a drawing room at St James's, where she had been presented as a married woman. Her hostess described her appreciatively as 'glittering like the moon in a limpid stream: white and silver, or rather all silver – the prettiest silk I ever saw – and richly trimme'd with silver, festoon'd and betassell'd . . .'[37]

She was soon delighted to receive her first full-length letter from Georgiana Mary Ann Port, 'very well written for a first attempt', together with an embroidered fire screen. The nephews also sent shells and other natural curiosities, 'some of which are the best of the kind I have met with', especially one wrapped up in a bit of brown paper that the duchess identified as *Helix arbusturum*. Mary wrote to her great-niece: 'I wish my dear bird and I could work together; I could join my tears to yours we are at so great a distance, but as it is not in our power

to meet at present, we must live in hopes that we shall before it is very long.' The flowers Mary made without Georgiana's help that spring in London included two varieties of Auricula – the latter much prized in eighteenth-century gardens where they were often grouped together in pots on stepped, sometimes semi-circular, display stands. Both came from her old friend Mrs Dashwood, who might well have specialised in growing them. She also gave Mrs Delany a Star of Bethlehem.[38]

But at Wellesbourne the little girl had her own 'work' to do: her great-aunt explained it was her duty to help look after her expectant mother, 'to read to her and lull her to sleep when she is not well enough to talk, to cheer her by her lively prattle, and by your own gentle manners, to set an example to your dear brothers not to disturb her with any noise'.[39] The pregnancy was concluded with the safe birth of a second daughter to the Ports, whom they named Louisa. The second Dewes–de la Bere wedding took place at the end of March. In May and June, she completed a Purple Flowering Rosebay, and an *Erica longiflora*.[40]

On 12 August 1778 there was the most elaborate visit to date of the royal family to the Bulstrode estate. Mary began a detailed description the next day to Mary Port, who would obviously share it with her husband and children at Ilam, and her nephew and his new bride at Calwich; and similar summaries to Lady Andover, and to her friend Dorothy Forth Hamilton in Ireland. The king and queen visited on the birthday of George, Prince of Wales, and first of all in Mary's narration came the list of the whole party – a substantial entourage, described with little hints of the language of chivalry. She shared with her friend Bishop Hurd an interest in the ballads of this late medieval era, and composed a modern ballad to describe the return visit to Lady Andover.

Soon the Bulstrode visitors began to disperse, and Mary embarked on the journey to Warwickshire whose end destination was to Bernard and Anne at Malvern Hall, 'to see my *new* little niece, and enjoy a nest of nieces and nephews for a week only'. Little Anne, named after her mother and grandmother, was only a few weeks old; the second newest was Louisa Port. With Bernard married, the responsibility for keeping company with their father, now 84, fell more exclusively on Court, the bachelor brother, who described his rather dull uniform life – '*reading*, *music*, and *walking* in ye morning, and quadrille in the afternoon'.[41] Up in Staffordshire, a financial catastrophe overtook the Ports. The precise details are unclear – probably some faulty investments – but one consequence is not: Mrs Delany's offer to Mr and Mrs Port to have

young Georgiana spend every spring in London with her, to save them some expense and provide her with tuition in deportment, dance, calligraphy and French. This was gratefully accepted.

LONDON LESSONS

So it was, then, that the first five months of 1779 saw Mary take on a fuller mantle of active great-aunting, just as she had formerly taken a seasonal role as an aunt to her niece Mary. Just as Mary Dewes had been introduced to the duchess's children, now Georgiana Port was meeting the duchess's grandchildren. Just as Mary Delany had sometimes come home to find her niece and Patrick tucking into supper together, so she now found her great-niece standing in as hostess in the drawing room:

> I dined, yesterday at Lord Guilford's; only met the Ladies Dartmouth and Willoughby, their Lords were squabbling in the House of Lords . . . I came home at half an hour past eight and who should I find *gracing* my sofa but Duchess of Portland and Lady Stamford, and GMA *doing the honours* of my drawing room, much to the satisfaction of all parties![42]

So as far as actual lessons were concerned, some of them consisted of the same combination of the social graces with basic intellectual skills that Anne Dewes had instilled in her daughter Mary, mother of 'GMA'. The great-aunt wanted to ensure that GMA would not suffer the complacent scorn of any man on the basis of a barely legible hand or poor spelling, so Mrs Delany made her practice a few lines each day, preventing any letter of greater length to her family until her improved style had become a habit.

But education in the sense of instruction was only a part of the stay with her great-aunt. The London winter was also a social education in itself, which broadened her experience beyond the limitations of the Staffordshire/ Derbyshire borders. Some of this social immersion in Mrs Delany's particular milieu illustrated expected social customs, as when Mrs Delany took her along to pay a courtesy visit to the Royal Governess, Lady Charlotte Finch, to congratulate her on the appointment of her daughter, Mrs Fielding, as a Woman of the Bedchamber to the queen.[43] Guests at St James's Place who were also connected to the royal households included the royal princes' governor, Bishop

Richard Hurd, and the military engineer Captain Leonard Smelt, who had been a sub-governor of the two elder royal princes. Smelt was a Yorkshire-born military engineer who had served in Flanders, helped survey the Scottish Highlands after the '45 rebellion and redesigned the fortifications in Newfoundland. He taught the two eldest royal princes between 1771 and 1776. His decency and technological aptitude very much endeared him to the king.[44] Most important of all was the immersion in the various kinds of natural history that was so central to the lives of Mrs Delany, the Duchess of Portland, and friends like Mrs Boscawen and Lady Bute. Mary continued to make paper mosaics during her great-niece's stay, and after it was over she recalled how she had had a useful assistant: 'my little handmaid was wanting, to pick up my papers, to read to me, to hum her tune, and to prattle to me!' she recalled.[45] Work always began after breakfast and prayers, and she postponed letter-writing until the evening, even though her vision was less clear then, in order to make the collages when her eyes were at their freshest.

Tantalisingly we do not know exactly which of the collages were seen by GMA as her great-aunt was making them.[46] She told Georgiana's mother that the flowers she was depicting in April 1779 included 'rare specimens from all my botanical friends', together with specimens she purchased from nurseries. Quite a number of these were acquired as April turned towards May, when she and her charge made a whirlwind tour of specialist plant sources. One day they went 10 miles to Dr Fothergill, the renowned Quaker physician, who lived in Upton, Essex, and she 'crammed my tin box with exotics, overpowered with such variety I knew not what to chuse! [sic]'. GMA was 'delighted, fluttering about like a newborn butterfly, first trying her wings, then examining and enjoying all the flowers'.[47] A specimen from Dr Fothergill was portrayed on 15 April, the *Antholozia cunonia*; others, such as an iris and a campanula purchased from Mr Lee's nursery that year, were not portrayed until August.[48] Mary must often have had to wait until later to portray them, when her purchases had germinated and success-fully reproduced themselves. It might have taken a year or more, and several generations of plants, for a successful specimen to grow and produce a suitable flower for a mosaic. The date of a mosaic when noted in Mrs Delany's index is therefore not a reliable indicator of when it was first added to her garden.

Great-aunt and great-niece also visited the Chelsea Physic Garden, which Mary had known since she was about her great-niece's age. The medicinal proper-ties of plants were still important in her circle. Finally, not long before the

visit ended in late May, great-aunt and niece visited Mr Pitcairn's botanical garden in Islington, where an *Ixia longiflora* was obtained, and portrayed on 5 May, complementing an *Ixia bulbifera* acquired from Mr Lee, portrayed on 4 April.[49]

As well as the gathering and portrayal of plants, young Georgiana was introduced to the joys of shell collecting. After an afternoon and early evening with the Duchess of Portland's daughter, Lady Stamford, she came back with 'shells in abundance; and her collection increases so fast that you must provide her with a cabinet to keep them, for she promises herself much joy in sorting and entertaining Mr Beresford with them'.[50] Geographical facts might well have come up when Mary was making collages of non-native plants, some from the Americas, some from the South African Cape or simply if they came from English counties the little girl did not yet know. Thus, a lot of what her great-niece imbibed during this first visit was through informal, yet sociable avenues. But Mrs Delany also reminded Georgiana of how much she could teach herself, simply by reading:

> Reading will not only make you wise, but good in a serious way; and supply you with infinite entertainment in a pleasant way. Reading will open your mind to every ingenious *art* and *work*, and by observing how amiable a well informed person makes herself and how much esteem'd, it will raise yr [sic] desire of being the same, and make you take pains to deserve as much.[51]

There is no implication here that there are subjects that girls ought to avoid because of their gender: instead the whole world of amateur learning, amateur in the best sense of the term, as self-directed improvement, is open to them.

Although at first Mary had missed her 'little bird' enlivening her home, as always the heat and dust of London and its increasing emptiness as her circle left town for country made her eager to get to Bulstrode at the end of May. Once there, she just had time to refresh herself, 'with brushing off the dust and a dish of tea, settling my drawers and preparing for my works', when the duchess arrived from Weymouth, where she had been recovering from a bad cough. They waited until the next day to tour the grounds, and she described to young 'GMA' how:

> The deer, the hares, the pheasants, the pea-fowl, &, &, are all well, and bounding, frisking and fluttering, not forgetting the squirrels as brisk and merry as any of them; the park and gardens in nice order, and when the

deer and the mistress of them (who delights in making everything happy about her) is perfectly well, there can be nothing to be wished for but hearing of the health and welfare of absent friends . . .[52]

TAKING STOCK: THE LITERARY INSPIRATION OF THE PAPER MOSAICS

As the life-cycles around her ebbed and flowed, where did Mary's activities fit in? The revival of her role as an aunt figure, as well as learning about a health scare of her brother-in-law's, prompted Mrs Delany to take stock of the plant collage project early in July 1779. Giving her thoughts the heading:

PLANTS

Copied after Nature in Paper Mosaic, begun in the year 1774

She added a verse of her own composition:

Hail to the happy hour! When fancy led
My pensive mind the flow'ry path to tread;
And gave me emulation to presume
With timid art to trace fair Nature's bloom:
To view with awe the Great Creative Power
That shines confess'd in the minutest flower;
With wonder to pursue the glorious line.
And gratefully adore the Hand divine!

The poem suggests that 'treading the flowery path' was a new initiative. As an artist, she had not painted or drawn flowers in crayon or watercolour; she had, however, made plaster roses for the Delville chapel ceiling. Now, though, she attempts 'with timid art to trace fair nature's bloom'.[53]

Implicitly, to Mary's mind, this is to copy what God has designed, not what human beings have theorised. She is not following prescribed rules of composition; there is no narrative, no artistic hierarchy. This is not like trying to draw and paint within the grander genres of historical and moral subjects she had previously attempted. In composing the collages she takes an unapologetically egalitarian approach. The great majority are centred on a uniform sized page,

be they a humble hedgerow flower or a flamboyant exotic. In her mind, all are products of the same divine intelligence. As William Mason, known to be an admirer of John Milton, said in Book Three of *The English Garden*,

> at the dawn of time,
> The form-deciding, life-inspiring word,
> Pronounced them into being.

Mason is echoing the first words of John's Gospel, 'In the beginning was the Word, and the Word with God, and the Word was God.' And in the book of Genesis, as Mary would often have read, 'the earth was without form, and void; and darkness *was* upon the face of the deep . . . And God said, Let there be light, and there was light.'[54]

The flowers hang in the darkly inked space, as if they have come into being in an instant out of nothing. They are depicted in a vacuum, growing neither in flower bed, field nor forest. No theory of evolution stands behind them because none, in a modern sense, yet exists; they simply *are*. The flowers exist as and for themselves, but also as evidence of a transcendent Creator. They are also unfathomable in their beauty and organisation. They are to be wondered at, revered.

Why does she depict them like this, alone, almost hanging in space? Mason's poem also said:

> Countless is vegetation's verdant brood
> As are the stars that stud yon cope of heaven;
> To marshal all her tribes in ordered file Generic or specific
> might demand his science wondrous Swede, whose ample mind . . .
> Stretched from the hyssop creeping on the wall
> To Lebanon's proud cedars.[55]

The comparison of the variety of plants to the plenitude of the stars is telling. Mary's earliest scientific concepts were acquired in the 1730s, when Newtonian astronomy was all the rage. The emphasis was on the plurality and infinity of worlds. People looked through the telescope or naked eye at the dark night sky. When it was dark it was really dark, and the stars stood out with only candle or lamplight as feeble competition. If plants were as numerous and varied

as stars, perhaps that made it easier to visualise them glowing on a page in brightness against a dark background. Mary is the child of an era in natural history that drew on the Miltonic imagination. At the conclusion of book two of *Paradise Lost*, for instance, Milton conjures up the image of the fallen angel Lucifer returning towards earth:

> . . . at leisure to behold
> Far off the empyreal heav'n, extended wide
> In circuit, undetermined square or round,
> With opal tow'rs and battlements adorned
> Of living sapphire, once his native seat;
> And fast by hanging in a golden chain
> This pendent world, in bigness as a star
> Of smallest magnitude close by the moon.[56]

Various suggestions have been made on why Mary chose the black background for her portraits – was she following planting practices, which often concentrated on situating isolated specimens on a dark, weed-free earth ridge? Was she inspired by the embroidery on fashionable black backgrounds she had worn in her thirties? By the enthusiasm for black japanned-ware? By the marquetry of expensive furniture, where there were often contrasts of dark wood and lighter inlay, with ivory or coloured bone? There were excellent examples of each of these types at Ham House, where her Tollemache cousins lived. All of these and more, probably – but let us not discount the universe, as conceptualised by the Newtonian astronomers and Georgian epic poets, as a formative framework. Mary would place a curved sheet of the black paper behind her specimen with the light in front so that it would accentuate the three-dimensionality of the view, and create highlights of light on petals or contrasting colour leaves to enhance the sense of volume. Like stars on a dark night, each plant glowed in all its mystery and originality.

However, although she gives each plant the same treatment, making it central to the page as far as possible, be it large or small – even low-growing plants are in the centre of the lowest part of the page – this must not be mistaken for a *completely* unedited naturalistic interpretation. No representation is ever that simple. There must always have been some editing of the plant specimen itself going on, with decisions as to how to clean and prune it. For instance, her portrayal of narcissus includes very few leaves, yet actual specimens of narcissus,

daffodils, tulips, snowdrops and so forth often have an apparently disproportionate number of leaves to flower stem. Her specimens are often very free of the leaf layers on the stem, so some simplifying has gone on. On the other hand she can be equally good at portraying the untidiness of some plants at ground level, or the symmetry of how some leaves appear to frame the flower in a perfect balanced way, or even to dance across the page in a playful liveliness.[57] Joseph Banks praised the *botanical* accuracy of the project, but there is also an artful placing on the page. The term she used to characterise her work, paper *mosaic*, suggests deliberate artifice, yet also the art that conceals art, so that it is very hard, even with the aid of a magnifying glass, to see exactly where the paper joins are, or when a few actual leaves are included, or some body-colour added. It was Lady Llanover's understanding that she judged how to cut her shapes by eye alone.[58] It seems astonishing that someone probably suffering from cataracts was able to have such pinpoint accuracy, with the use only of scissors, flour-paste and a couple of bodkins to cut and manipulate the pieces on flat paper. She must have had an exceptional eye to start with.

If the dark backgrounds give the impression that each specimen is self-existent, this does not mean they are unclassifiable. To the contrary: they are given their Latin name and their common name, on the front of the mosaic, and their name according to the new system of Carl Linnaeus, Mason's 'wondrous Swede' on the back, with the year and sometimes the precise date of composition, the place where it was made (predominantly Bulstrode, or St James's), and sometimes the donor. But in composing them Mrs Delany did not work methodically through a class or a species. This must have been partly to do with specimen availability. Different specimens of lily or almond, for example, are made at intervals between 1775 and 1779; this does not suggest a very methodical survey, but a much more scattered, opportunistic approach; she made immediate use of what was in bloom and what she was given. She does not seem to have divided her time into sections when she deliberately concentrated, say, on roses, before moving on to another category. So their grouping into albums does not come from an organisational principle governed by the new botanical rules, or the time when they were composed, but through subsequent rearrangement: and the ten volumes display the collages in *alphabetical* order, with alphabetisation starting with the Latin name.

Since each volume has the index in her handwriting, it must have been Mary Delany herself who chose the dictionary format, which had the additional

advantage of making it easier to adjust the sequence into albums as their number grew, providing each album of collages was left unbound until the project was finished. This supersedes an earlier, simply numerical listing: collages dating from the first couple of years, 1774–5, have a large Arabic numeral on the reverse. It was characteristic of her to order pictures into an album – she had done this with her Irish landscape views. It is thus consistent with her orderly habits to have wanted to order and label the mosaics. But whether alphabetical or chronological, it is suggestive that both are systems of organisation that come naturally to *women or men of letters*, not natural scientists – and literature was Mary's first love. A truly botanical approach would have been to organise the portraits into genera and then species, according to Linnaean principles, as Hudson had done with his *Flora Anglica*. But although Mary had copied out Hudson as translated by Lightfoot, it is probable that she did not feel she had internalised Linnaean principles sufficiently to order her group of nearly a thousand specimens according to them, and use this on an everyday basis. Furthermore, she may have been influenced by Mason again, in eschewing solely botanical organisation. The lines of *The English Garden*, quoted above, continue, referring to Linnaeus's taxonomy:

> Skill like this which spans a third of nature's realm, our art requires not sedulous alone to note those general properties of form, dimension, growth, duration, strength and hue . . . (ll. 94–8)

This is surely a recipe for what Mary aimed to do – especially to portray form, dimension and hue. With respect to the colour spectrum, she is as astonishingly good at portraying plants verging towards a monochrome palette as she is at suggesting the full range of mauve, lilac, plum, violet and purple hues, which are less often reproduced in contrast to reds and whites.

The alphabetical principle also made it easier for friends to enjoy the collages, as it was consistent with the kinds of sociability they followed. It was common for town or country house libraries to be used as informal sitting rooms in the evenings.[59] Collections of prints and drawings were kept unbound in special bureaus; architectural designs were often in plan chests; coins, medals, cameos and miniatures, etc. all had their own types of cabinets. With the greater interest in natural history came specifically designed storage, with compartments for shells, fossils, dried specimens, birds' eggs and their nests and so

forth. Mary's collages would almost certainly have been kept unbound, like engravings and drawings, but within provisional album covers to make it easier to inspect them and even to pass them around. For her friends with little botanical knowledge it must have been a lot more comprehensible to be shown a flower labelled with a Latin name and the common one: *Violetta adoratta*, 'sweet violet', for example, or *Primus spinosa*, 'blackthorn'. This would be even more helpful to female friends who, if they had no Latin, would not know that *spinosa* meant thorny. It was also easier for Mary herself to find the separate portraits as their numbers grew. Even if different varieties of tulips or lilies or thrift had been made over the years, providing she could recall the Latin name she would still come across the entire group, regardless of whether the individual specimens had been created in 1774, 1776 or 1781. Thus, all the geraniums would end up in an accessible sequence. Mary's organisational strategy was a friendly one, to herself as main maker and main user, and to her circle.

I have argued that one *motivation* for the making of the *Flora Delanica* was commemorative: it began, perhaps, with some sense of paying tribute to her siblings, Anne and Bernard. But when it came to *implementing* this project, it became a celebration of the friendship she was experiencing in the 1770s. Many of the specimens were provided by friends of long standing, with the Duchess of Portland as the most significant. Mary was one of the more unusual types of eighteenth-century gentlewomen, because of her relish for her independence. But alongside this ran a streak of very selective reliance on a handful of significant others.

Now, as a widow, her 'work' gave her a sense of purpose and dignified labour. She might feel less physically energetic and enterprising, but she did not want people to feel she had to be looked after and entertained. One day in 1777, a year when she was doing a large number of the portraits, she apologised to Mary Port for having been too busy to have copied out some promised verses. She pictured how her niece might react to this, and reflected on female and male occupations:

Now I know you smile, and say what can take up so much of A.D.'s time: No children to teach or play with; no house matters to torment her; no books to publish; no politicks to work her brains? All this is true, but *idleness never grew in my soil*, tho' I can't boast of any very useful employments, only such as keep me from being a burthen to my friends, and *banish the spleen*; and therefore, are *as important* for the present use as matters of a higher nature.[60]

Remember that spleen does not mean bad temper, in the modern sense, but low spirits: Lady Anne Finch's poem 'On the spleen' is still a touchstone in her thinking nearly fifty years since she recognised the author as one of her favourite poets.

So Mary was purely happy with her regular mornings with her flowers, and her visits when she was given them as gifts or acquired them from specialists. Now she was sustained by a slightly different type of social institution than when she was in Ireland; this time it was a grand aristocratic estate, presided over by a widow who had not moved into a dower house, but continued to manage the large staff who ran her married home and all its household departments, to entertain on a grand scale, and devote her time to natural history. In effect, the duchess was running a private scientific research institute, to a far greater degree than any estate run by a male. Bulstrode provided the duchess's friend Mary with her own set of rooms, the amenities of a grand house, its role as a hub of collecting from all over the world, its provision of several specialists such as the resident cleric Dr Lightfoot or the visitor Dr Solander, and the amenities of a library, including a print collection.

In turn Mary provided the comforting fact that she had known the duchess's parents, as well as her children and their marriages and *their* emergence into parenthood. The continuity was precious, and so was the duchess's moral support. Thus the stock-taking of 1779 noted that what might have seemed a self-indulgent whim received recognition from a knowledgeable friend and connoisseur:

> I shou'd have dropped the attempt as vain, had not the Dowager Duchess of Portland look'd on it with favourable eyes. Her approbation was such a sanction to my undertaking, as made it appear of consequence and gave me courage to go on with confidence. To her I owe the spirit of pursuing it with diligence and pleasure . . . my heart will ever feel with the utmost gratitude, and tenderest affection, the honour and delight I have enjoy'd in her most generous, steady and delicate friendship, for over forty years.[61]

Moreover, the acquisition of plants grew very naturally out of long-established annual routines. A specimen obtained at Luton Park from Lady Bute might actually be taken with her to Lady Leveson-Gower at Bill Hill where it was copied as a mosaic – for instance, the Climbing Fumitory [*Flora Delanica* 4:37], newly

introduced to England. The more Mary's projects gained momentum, the more friends like Lord North or Lord Dartmouth or Lady Bute would look out for specimens for her. Her closest friends became collaborative assistants in supplying the raw material. Some came from Kew, and as the project drew to a close Queen Charlotte selected twenty specific plants for Mrs Delany to portray. But although the project became a dominant motif of her everyday life, there was no need to *change* her way of life to accommodate it – it just became an extra dimension of the way she had always lived when in England.

GLIMPSES OF 'ROYAL DOMESTIC' FELICITY

The war in America continued to have an impact on various members of Mrs Delany's coterie. Captain Leveson-Gower had some leave 'after many perils' – alas for the biographer these were not specified. Among her children needing more than her ordinary attention, Lady Bute's eldest daughter, Mary, Lady Lowther, had a 'hectic fever' making her unable to travel to Luton Park. Sir James Lowther was a litigious bully, from whom Lady Mary was discreetly separated. 'Thus, My dear Madam,' Lady Bute observed to Mrs Delany, 'you see in a numerous family, it is *seldom* one can expect any joy without a considerable setback.'[62] On a more positive note, Caroline, wife of the agreeable John Dawson, was also at Luton, and her mother assured Mrs Delany, all there would be 'overjoyed' to see her.

From Mrs Delany's point of view, the greenhouses at Luton Park were often a splendid source of exotic plants, just as the mansion was full of pleasant company, but Mary had to delay a visit in 1780 as her aged servant, Mrs Smyth, who had been with her since 1745, had recently died after a long period of debility, and a replacement had yet to be found. Eventually she appointed a suitable young woman, Lydia Rea – a name, the Countess Stamford wittily observed, which sounded like a Linnaean classification. She was young and energetic, and able to write a letter for her mistress very capably if needed.[63] Once settled at Bulstrode for the early autumn, Mary worked on portraits of flowers from the park and gardens that were mainly English varieties, such as the Creeping Smooth Hawkweed [5:29], or a kind of snapdragon, Round Fluellin [1:67] but she also portrayed a newer species, a form of mimosa given to her by Walpole's fellow aesthete Dicky Bateman [5:86] and the Dianthus Jersey Pink [*Flora Delanica*: 5:29; 1:67; 5:86; 3:77] from the island of Jersey, base of the Carteret family for many generations, given by

Horace Walpole's cousin, General Seymour-Conway, who was its governor. His estate, Park Place, was near Windsor.[64]

If the first five months of the year had been absorbed by Mary Delany's great-niece GMA, the highlight of the last five was the sequence of visits made by the royal family to Bulstrode, and return visits by the duchess and Mrs Delany to Windsor. Mary wrote several accounts of these, addressed to her niece, great-niece and Lady Andover, varying the details included to suit the recipient. The one to the latter makes clear that the invitation for the duchess to visit Windsor and to bring Mrs Delany too was more in the nature of a princely summons than a mere invitation. The date was 29 September – the birthday of the princess royal, Charlotte, the eldest daughter. The one to Mary Port comments that very little notice was given, since the Bulstrode party was expected that very evening. This meant that she could keep to her usual morning routine, and began a flower mosaic of a lily, *Arum divaricartum* [*Flora Delanica* 1:87], commonly known as Wake Robin or Fryer's Coin.

They were prompt to the minute in arriving at the Queen's Lodge during a thorough downpour of rain. The duchess was as usual bundled up in three layers of cloaks, but before she could take these off the king took her by the hand indoors, and Bishop Richard Hurd was charged with looking after Mrs Delany. They went straight into the drawing room, where all the family was gathered, with the exception of William, the third son, aged 14 and already serving in the Royal Navy as a midshipman.[65] The letter to young Miss Port included some fashion details: the queen was in embroidered lutestring, a glossy form of silk; the princess royal wore deep orange or scarlet – Mrs Delany couldn't quite distinguish which; Augusta was in pink and Elizabeth in blue. None of these quite grown-up girls wore aprons, which were less *à la mode* now. Little Princess Mary, in cherry red, who was nearly 4, could not remember Mrs Delany's name but making a low curtsey, resourcefully said instead, '*How do you do, Duchess of Portland's friend; and how does your little niece do. I wish you had brought her.*' The king carried alternately the youngest two in his arms – Princess Sophia and Prince Octavius. The latter was carried to Mrs Delany, and he 'held out his hand to me, which, on my taking the liberty to kiss, his M made him kiss my cheek'. 'I never saw more lovely children; nor a more pleasing sight than the King's fondness for them, and the Queen's; for they seem to have but *one mind*, and that is to make everything easy and happy about them.' Emphasising this royal domestic fondness would have appealed to a 7-year-old, whose parents doubtless behaved in similar fond fashion to her and her siblings.[66]

The rest of the royal household was placed in the concert room, which led off the drawing room, and music was played continuously, with the king walking between the two rooms. When any of Mrs Delany's favourite songs, not alas specified, was sung, the queen made sure to come and stand at the door leading into the concert room, and a large chair was taken for the duchess to sit on. Promptly Prince Ernest, then 9, tugged a chair almost as big as he was, and put it beside her for Mrs Delany.[67] They stayed until 11 p.m., drove home by the moon, supped after midnight and went finally to bed at 2 a.m. This was in tune with the duchess's night owl ways, but her friend felt she wasn't tired at all, precisely because she had been able to sit for nearly the entire evening.

Three days later, Mrs Delany was presiding over breakfast for some of the current Bulstrode guests, when she received a message that some of the royal family was on its way over. This sounds inconsiderate, but the opposite was intended – it was to prevent the household from going to unnecessary trouble. Even with just an hour's warning Bulstrode easily rose to the occasion, 'and altho' magnificence always belongs to Bulstrode, it is not less agreeable when under the veil of ease and *abated* ceremony, and I believe their Majesties thought so, as they never appeared more pleased and gracious'. The king and his two elder sons were wearing the blue and gold Windsor uniform, which the king had designed, and drove the queen personally in an open chaise despite incessant late October rain, 'but they inure themselves to *all weathers*'.[68]

But soon the very short November days often meant the light was so bad that Mrs Delany could do few collages, and found it hard to read or write letters, though Miss Rea assured the Ports her sight itself was no worse.[69] Mrs Boscawen sent her a detailed account of the *Annona isopetalia* or custard apple plant, and a specimen, hoping 'it may in time be promoted to a place in certain invaluable folios' and detailing how between them people like Dr Fothergill or Mrs Lee had been able to grow it from a tiny handful of seeds. 'A neighbour of mine, the Revd. Mr. Neate, had the seed from Spain, gave 2 of them to Clark, (the botanical) butcher at Barnet, who has given one to Mr. Fothergill, and rais'd a plant with another. Mr. Neate gave 2 more seeds to Mrs. Lee's gardener at Totteridge, and she has two plants . . .'[70] But her friend had already portrayed this rarity two years earlier from a seedling originating at Syon House, seat of the dukes of Northumberland across the river from Kew, and donated to Bulstrode [*Flora Delanica* 1:56].

The final events in 1779 that Mrs Delany described to her great-niece with the help of Miss Rea, was another pair of visits in December from the royal

family. The first was quite low-key – on a Saturday between one and three: an all-female party of the queen, the princess royal, Princess Augusta and Princess Sophia, directed mainly to the duchess. But it concluded with a delightful surprise: the queen pressed into Mrs Delany's hand:

> a packet . . . and said, in a most gracious manner, she hoped Mrs. Delany would look at that sometimes and remember her. When your aunt opened it it was a *most beautiful pocket case*, the outside white satin work'd with gold, and ornamend [sic] with gold spangles; the inside – but it is impossible for me to describe it, it is so elegant; it is line'd with pink sattin, and contains a knife, sizzars, pencle, rule, compass, bodkin, and more than I can say; but it is all gold and mother of pearl . . .[71]

There was also a letter, in the queen's own hand, suggesting that Mrs Delany might want to 'wear this little pocket-book, in order to remember, at times when no dearer persons are present, a very sincere well-wisher, friend and affectionate queen'.[72] By wearing, the queen meant that the gift would hang from a belt, as a purse might also do. It was to be a memento of their summer contacts during the London winter, during which Mary did not attend court functions.

The second visit was much grander, with its picturesque quality highlighted by the fact that it was on a winter evening, illuminated by torchlight. As well as the king and queen, the party this time consisted of three of the princesses, Lady Courtown, the Prince of Wales and three of his gentlemen in waiting, plus Mary Hamilton, together with sundry grooms who:

> carried flambeaus [sic] before them, and they made a very grand show in the park; her Grace had the house lighted up in a most magnificent manner; the chandelier in the grate [sic] hall has not been lighted before for *twenty years*. Their entertainment was tea, coffee, ices and fruits . . . They were all admiration at the lighting up of the house, and the elegance of everything about them.[73]

Did the queen feel that this venerable lady was a bit like an honorary great-aunt? Charlotte had come as a 17-year-old bride to Britain just after her mother had died and had never seen her remaining sister since. Although two

of her brothers made several visits, perhaps she felt cut off from her *female* German kin, and wanted to show her appreciation for a woman whose knowledge of her adopted marital family stretched back so many decades. And the very fact that she met Mrs Delany on private ground, either at Windsor or Bulstrode, must have been a relaxing one, in contrast with the official drawing rooms where the queen was required to show no sign of special favour. With Mrs Delany, she could unaffectedly show admiration for an individual, for her artistry and their common love for flowers and all things decorative and familial.

CHAPTER SIXTEEN

Poignant Farewells and New Developments

'A YEAR OF GREAT MORTALITY AMONG MY INTIMATES AND FRIENDS'

*M*ary's eighty-first year was punctuated by more departures than arrivals, though she endeavoured to accept what she considered to be the will of Providence, to be grateful for the ways in which she enjoyed a fortunate life, and to consider that even for the young death could be seen as a favourable exchange from the turbulence and unpredictability of the human scene. The year 1780 was also the year of the greatest civil disturbances of the century, which directly affected some of her immediate circle and would predispose the three kingdoms towards political and social conservatism.

The first loss of 1780 was that of Thomas Charles Fountayne, the 21-year-old grandson of her dear friend Mrs Montagu of Hanover Square. Although he had had encouraging signs of recuperation, he had never really recovered from a riding accident two years earlier. The anxiety created by his illness exacerbated his grandmother's already poor health, and she too died in June. Having known her all his life, her son Frederick now began to regard Mrs Delany in a quasi-maternal light.

Just as formative as her friendship with the Charles Montagus, was that with the Forth sisters and their connections, whom Mrs Delany met on her first visit to Ireland half a century before. She had especially admired Dorothy Forth's talent for painting insects and flowers, and perhaps this was also a seed that came to fruit when she began the paper portraits; more obviously it had motivated her

306

to take drawing lessons from Arthur Pond when she had returned to London in 1733, and wanted to 'aim at everything' (p. 95). Dorothy had married the Hon. and Rev. Francis Hamilton, whose father was James, 6th Earl of Abercorn, a member of the extensive Hamilton family, which also included several with household connections to the Prince and Princess of Wales. In January 1780 Mary learnt from a letter begun by Dorothy but completed by her daughter that her mother was making less and less effort to go out and about, even though her doctor was encouraging her to stay active. These were worrying symptoms of final decline. But at the same time Mary was also getting to know a younger member of the Hamilton clan: this was Mary Hamilton (1756–1816), a grand-daughter of the 6th Earl of Abercorn, and also a niece of the diplomat and connoisseur Sir William Hamilton. She had already lost both her parents, and rented her own lodgings in Clarges Street nearby in St James's. The king and queen made her a sub-governess to the royal princesses, and she became a regular link between the queen and the Bulstrode household. With her knack for getting on with the next generation, Mrs Delany began to take her under her intellectual wing, and introduced her to the pleasures of natural history; the young woman was already friendly with literary women such as Elizabeth Carter and Hester Chapone, so she also introduced the young woman to Anne Finch's poetry. When Georgina Mary Ann came for her second winter, she met Miss Hamilton too, together with some of the educational intelligentsia who linked the royal family to the Bluestocking circle, such as Elizabeth Carter, Hester Chapone, and Leonard Smelt and his wife.[1]

This winter to spring visit was the same and yet not the same as before, as more was expected of the great-niece. She had a French master now, and encouragement to overcome her diffidence at speaking French. She made some progress in her handwriting, but after she returned home, Mrs Delany continued to pull her up when it was sloppy, or when she got forms of address slightly wrong, pointing out that deficiencies would reflect badly on the whole family in general and herself in particular. Her demands for clearer hand writing or blacker ink also reflected growing problems with her sight. She emphasised, too, that GMA's mother, who in February had had her sixth child, could not be expected to oversee 'an exercise wch [sic] indeed is in your own power to do well, and in which you been so fully instructed'.[2] She also reminded her of their 'frequent' conversations about 'Mrs. Propriety'. Her niece was not always the demure creature expected of her: another stricture was about her tendency to

be a mimic. In modern terms — she could clearly be rather cheeky. She was probably no more ebullient than the average gentry child, and revelled in the attention she received from some distinguished folk. Indeed Mary Delany told Mrs Port that when the Duchess of Portland invited Bishop Hurd on Georgina's behalf to a birthday supper for Mrs Delany, which 'GMA' was planning in cahoots with Miss Rea, the bishop had answered 'he would come from Kew on purpose to obey the summons of so innocent, so fair and so virtuous a young lady as Miss Port'. It was not a surprise, surely, if some of this kind of courtly attention went to Miss Port's head.[3]

And of course, she did have fun, too. Miss Rea, the new waiting woman, was not far from childhood herself, and they had daily romps in the park before lessons began. Hester Chapone's friend, the Rev. Burrowes, included her in a dance he organised for about three dozen young people, centred on his own children, nieces and nephews, and Mrs Delany reported: 'I saw her dance like *any fairy*, and worthy of a more practiced partner than came to her share.' Great-aunt and niece went in May to a concert and dance given by Mrs Walsingham to mark the occasion of her daughter's eleventh birthday, and Mrs Delany marvelled afterwards in a letter to Mary Port at the continuing fashion for exaggeratedly high head-dresses, adorned with fantastic ornamentation, achieved by elaborate wigs. This meant that 'one of the most beautiful ornaments of nature, fine hair, is entirely disguised; it appears to me just as ridiculous as if Mr. Port was to fell all his fine hanging woods and feathered hills, and instead of all the beautiful hues of various greens, should plant only *Scotch firrs* [sic] and *brambles*!' She realised that the only three ladies who had not succumbed to the vogue were herself, Lady Bute and the duchess, who sat comfortably on a sofa together. But since this fashion was 'as delicate to treat of as politics . . . I don't venture it in conversation, but give it vent here by way of digression'.[4]

Listening to Handel arias more than compensated for looking at strange headgear. While Georgiana was much occupied with the plans for her great-aunt's birthday supper, the great-aunt was just as absorbed in getting a pink dress made for the little girl for when she was going to visit Buckingham House, the queen's residence, on 4 June, George III's birthday. Mrs Stainforth, the queen's housekeeper, would ensure she would be glimpsed by the royals as people assembled for the special birthday drawing room. So there were plenty of treats to be enjoyed for all generations during this visit.

Then, in complete contrast, before Georgina and her Uncle Court could get back to Wellesbourne and Calwich, an unnerving spate of violent civil unrest engulfed London for almost a week, an episode that came to be known as the Gordon Riots.[5] These were the result of a petition to Parliament presented by the deranged MP Lord George Gordon, head of the Protestant Association, protesting against a series of measures relaxing the restrictions on religious minorities such as Catholics, who would now be able to be army officers.[6] This legislation was prompted because so many of the regular officers were needed in America that the home defences were becoming inadequate to defend both Ireland and the mainland. To most British people, the Catholics were the group that aroused their strongest prejudices. The gunpowder plot of 1605 was annually recalled, and allowing Catholics to bear arms was considered most unwise. More than 600,000 people followed Lord Gordon to Parliament; he soon lost control over his followers and the violence began.[7] The mob chose their targets deliberately, and soon touched members of Mrs Delany's close circle, in particular the Lord Chief Justice, Lord Mansfield. His house in Bloomsbury was looted, and then burnt to the ground, with important documents lost, along with books and furnishings: he, his wife and their household narrowly avoided being injured. The Countess of Weymouth was desperately afraid for her mother's safety, believing that residents in Whitehall would also be targeted, and she persuaded her to stay with her other daughter in Mayfair one evening. The next day, when no attack had happened, the duchess, Mrs Delany and Georgiana withdrew to Bulstrode. News began to trickle in from others in their circle. Hester Chapone took refuge with her friends the Burrowes; Lord and Lady Edgcumbe went to Harrow; while Fanny Boscawen could see houses burning from the attic floor of the house in Great Audley Street, before she departed for Glanvilla.[8]

The king was adamant the rioters should be stopped and personally headed units of the militia deployed to restore law and order. It was all thoroughly alarming, but with the arrest of Lord Gordon after a week, on the charge of treason, calm began to return. And news arrived that Charleston in South Carolina had surrendered to General Clinton: a happy relief to loyalists like Mrs Boscawen, assuring them that at least there was effective control elsewhere in the empire.

The normal rhythm of summer visits was resumed, but death's shadow from other causes now fell on the Dewes family. Lady Cowper was increasingly unwell 'and she bears it with her usual resolution and fortitude'.[9] Knowing that

Harriet was most certainly going to lose her much-loved godmother, Mrs Delany proffered some consolation to her niece in advance:

> how thankful ought we to be for the many blessings we enjoy which no body, no accident of life, can rob us of; the reflection of doing our duty, the wonders and beauties of creation, the love of our real friends as long as we are permitted the enjoyment of their *society*; and when it is the will of heaven *that* should cease, the consideration that all tryals are sent to refine us for a blessed state, where only true, (that is permanent) joys are to be found.[10]

This was as explicit a hint as her cousin would allow to be given to her god-daughter, who was still recovering from her most recent pregnancy.

But only eleven days after this letter came news not of Lady Cowper's demise, but that of nephew Bernard's wife, Anne Dewes, together with her second baby, who had lived for just three hours. Mrs Delany felt deeply for the close-knit siblings and their wives. Her heart went out foremost to the bereaved husband, and she thought it would be best for him to go to Wellesbourne, where, although his father was failing, 'the *natural dissolution* that attends old age will make a very little addition to the anguish he now feels and the society of his excellent bror [sic] and change of scene I should hope be some consolation to both'. After a few weeks, the brothers visited the estate of Hagley in Worcestershire formerly owned by Lord Lyttleton, whose dissolute son had recently died without an heir. Bernard and Anne Dewes had therefore considered renting it; stylistically it was an important Palladian house, and among the garden buildings was a sham castle designed by the Wellesbourne neighbour Sanderson Miller. Bernard did decide to make his home there, leaving Malvern Hall with its sad memories of his short married life, but knowing his wife had seen the new abode.[11]

Lady Cowper died on 21 August. John Dewes Sr duly passed away a week later aged 86. It was now decided that Georgina Mary Anne Port should be known as Georgiana, in honour of her godmother – a version of her given names also recognised her grandmother, Anne Dewes, who had sometimes been known as Anna. Finally, given the intimation Mary had received in the New Year, it cannot have been too surprising that six weeks later she learnt that Dorothy Hamilton had now died. In a catch-up letter to the Vineys in Gloucester, she reflected, 'This has been a *year* of great mortality among my intimates and friends. Alas! How fleeting are earthly joys?'[12]

310

The year 1780 saw less royal contact between Bulstrode and Windsor castle, and what there was, was also of a slightly different kind. This was the year that Prince Alfred was born, and the duchess and her daughter Lady Weymouth both went to his christening; but he was the only one of the royal children who died very young, in 1782, after his inoculation for smallpox took a serious turn. Other news for the little girl was that 'a rabbit has had the presumption to find his way to the hares' supper, and made one of the circle the night before last; but orders are given for his execution, or *banishment* at least'. The Bulstrode chaplain Dr Lightfoot was soon to be married, but after being a bachelor so long he had a nervous fever, and the ceremony was postponed. He was currently cataloguing the duchess's collection of birds' nests.[13]

Early in November there was another very special gift from the queen through Mary Hamilton, a lock of the queen's hair. Mrs Delany took this as a great honour – she found it hard to show 'how gratefully sensible I am of the high honour the Queen has done me by bestowing on me a lock of her beautiful hair' – and was tremendously grateful to her young protégé for having made known to the queen that she yearned to have this.[14] Such exchanges were more usual between very close family members or if someone had been directly in service to the queen – as a Maid of Honour or a Lady of the Bedchamber. And as we know, Mrs Delany had never exactly held such a formal post in any of the female royal households. But perhaps the way in which she and the duchess enjoyed private visits from the royal family, and supported in return the queen's enthusiasm for spinning and so forth, was, to them, a kind of very modest honourable service to the queen, which emboldened her to ask this tangible token of favour.

Of more specific use for the Port family was the queen's promise that she would make one of the nominations at her disposal for a place in Christ's Hospital School in favour of one of the Port boys. The Ports were pleased that one of their sons would have a guaranteed good education, based on classics and mathematics, and decided the best candidate was their third son, George Rowe Port. He took his place at the 'Bluecoats' school' as it was popularly known, in 1785, when another nominee, one of Lady Willoughby's sons, died after a sudden illness. Nine years later he became a 2nd Lieutenant in the Navy, but his career was cut short when he died of fever in Antigua. Such was the ethos of service his great-aunt believed in so strongly, that came into play when the British were again at war, this time against revolutionary France.[15]

'I READ AND WRITE WITH GREAT DIFFICULTY BUT FIND NO ABATEMENT IN MY ATTACHMENT TO MY FRIENDS'

In 1781, having reached her eighty-second year, Mary did begin to feel some diminution of her faculties. In the new year she told her nephew John Dewes: 'I am tolerably well; have some very sinking days, but, on the whole am as well as old age will allow.' In general, her doctor advised her to avoid anything stressful, and to see only the 'quintessence of her acquaintance'.[16] All the same, she looked forward eagerly to when Mrs Port could come with Georgiana towards the end of January. The plan was to continue with her education, and she in turn would be able to read books or letters out loud to help her great-aunt conserve her sight, with Miss Rea taking dictation of some of the correspondence. The role of Mary Hamilton, the new royal sub-governess, as an intermediary between the queen's household and St James's Place, began to grow; and so did the latter's knowledge of 'conchyliology', the science of shells, under the duchess's direction. Mary was pleased for Lord Guilford that another Legge step-grandson, the Hon. William, was now a Gentleman of the Bedchamber to the Prince of Wales, while the Earl of Guilford's own grandson had now taken over the roles of Queen's Secretary and Comptroller from his grandfather.[17] As the season neared spring and her health stabilised, Mrs Delany was sometimes able to welcome as many as seventeen visitors over two days; but she also enjoyed the opportunity for deeper, one-to-one visits, such as one from Court, who dined with her before attending a concert: 'I was well pleased no other visitor came: nothing is so soothing as a single sensible kind friend's conversation when the mind is in a sensitive state, who is also interested in the subject that occuppys [sic] our thoughts.' Sometimes her visitors came specifically to be shown the *Flora Delanica*, as she now called her albums of paper mosaics: she mentions a party of four on one morning in May, but tantalisingly does not say which of the 'quintessence' these were.[18]

Mary was well enough by mid-March to write quite a long letter herself to her nephew John's wife, Harriet. She regretted their distance from London, which meant she did not see the couple as much as she would have liked, but 'I cannot but felicitate you and my dear nephew for being settled far from the follies and temptations which infest this great whirlpool of London, and for filling your station of life with honour and true domestic happiness'. Both partners in the marriage had a substantial station in life to fill, as John was

both a squire and a parson – a squarson, in Georgian terminology. This would intensify the amount of charitable care, and the consistency of moral example, they would feel bound to provide. Their son, another John, had been born the previous year, and Harriet was pregnant again:

> I hope you are as well as yr. present circumstances allow you to be, and that you are cautious not to run any hazards. Yr. kind guardian and protector, I am sure, will be watchful, and the care of your health is the *only* point where it may be necessary for him to exert the lord and master. No long walks, I beseech you, nor jolting in tough roads; every fatigue to be avoided as much as possible.

As to her own health, Mary wrote:

> I can truly say I have no complaint but what is the natural attendant of old age . . . and am most grateful to Providence for allowing me so many enjoyments beyond my years! When my friends are well and happy *I am* so; when otherways I recollect this is a world of tryal, and that our sorrows are sent to refine us for a better state, and wean us from a vain attachment to this life. My little circle of *choice friends* and the kind remembrances of *absent ones*, are the only cordials I have recourse to, and they cheer without intoxication.

She looked forward to the next day when Harriet Dewes' husband, her brother Thomas, and Daniel Sandford, oldest of Sally's sons, were all coming to dinner with her before going to the oratorio.[19]

Georgiana's lessons from visiting tutors continued: Mr Bolton was still trying to improve her handwriting, but after a few more lessons Mrs Delany would take over, since the child was now more interested in maps and geography. When she returned home Mrs Delany suggested that her father would improve her arithmetic and the multiplication table, and for music she had begun formal keyboard lessons with a Mr Snow. One afternoon she went with Mrs Delany and the duchess to see a display of African anthills in the possession of a Mr Smitman. After four hours of observation Georgiana wanted to write down all that she recalled in a letter to her family at Ilam – a useful exercise in remembering this live natural history lesson. There were also plenty of opportunities to practise her dance steps with friends such as Lady Stamford and her daughters.[20] This year the London visit

was prolonged until her mother's latest pregnancy came nearer its conclusion with the birth of a third daughter, christened Harriet.

After her great-niece left, chaperoned up to Staffordshire by some of the Foley cousins, Mrs Delany was free to make her own local visits. Mrs Boscawen would have liked aunt and niece to have been able to visit when rain had refreshed her garden during a hot June, and it was fragrant with the smell of new-mown hay and honeysuckles, but that didn't chime with the travel plans. Still, if she could visit two weeks later, Mrs Boscawen told her she would find her garden 'all over roses'. This year the duchess was trying out the resort of Margate in Kent to bathe away her rheumatism, before going to Weymouth.[21] It was continuing to be a hot summer and as the drains at St James's needed repair, both a smelly and a noisy business, Mrs Delany took refuge at Whitehall – which felt odd as the duchess was already away – and then finally got to Mrs Boscawen in late July. Lord Mansfield's house Kenwood was about two and a half miles away and one day he invited the whole household, which included Mrs Boscawen's two eldest Beaufort grandsons, who spent each weekend away from Westminster school with their grandmother, to dine and see his gardens and woods. Mrs Delany managed a 2 mile walk with her host and though she felt a little tired, the pleasurable company and conversation had sustained her.

Mary also told her great-niece about a domestic drama back at the London house involving the pair of pet parrots. One of them was found with some of his feathers torn away, drawing blood, 'and the poor little creature droop'd sadly for three or four days, but is now recover'd'. Miss Rea thought the culprit was the household cat, but the cook, whose cat it was, stoutly maintained it was done by a mouse. 'I leave you to decide which is most likely?' Sadly, the male parrot did not live much longer, and Miss Rea added a postscript to a letter from Bulstrode two months afterwards explaining he had been carefully put into a box and taken to a London taxidermist to be stuffed.[22]

One new correspondent now was a friend of William Mason's, the cleric, aesthetic theorist and progressive educator Rev. William Gilpin, who was popularising and adapting views about 'picturesque' beauty. Formerly based at Cheam, near Streatham, in south-east London, he now had a parish in the New Forest, Hampshire, and had published a primer for the aspirational print collector, *Essays on Prints*, which in 1781 reached a third edition. His motive in writing to Mrs Delany, though, was not so much to discuss his writing and watercolours, as to seek her intervention to help a niece of his find employment

teaching fine embroidery to young ladies. She had learnt her skills at 'Mrs Wright's school for embroidering females', a charity that the queen supported, and may have worked on the state bed for Queen Charlotte at Windsor, whose floral designs were by the Royal Academician, Mary Moser.[23] More than 4,000 botanically accurate flowers were portrayed, embroidered on the hangings. Gilpin was inordinately grateful for her success in 'placing' his niece.[24]

A STAG-HUNT AND A MODEL MARRIAGE

In the early winter of 1781, George III decided that the two elderly ladies might like to join the queen for a stag-hunt at Windsor. Such hunting was a centuries-old royal pursuit, though Charlotte was not especially interested in the sport – or indeed in any sport – and usually simply witnessed the start of the hunt, and then drove back to Windsor, to be ready to meet the participants on their return. Dictating her account to Miss Rea, Mrs Delany described for Georgiana how she and the duchess had left at a quarter to ten in the morning (remarkably early by the duchess's standards) to see the assembly of the hunters and the release of the stag; 'the poor trembling creature bounded over the plain in hopes of escaping from his persuers [sic], but the dogs and the hunters were soon after him and all out of sight'. The Bulstrode party returned home to be ready to welcome the queen, the two eldest princesses and the current Lady in Waiting, Lady Courtown, and they all enjoyed a hunt breakfast in the usual lavish Bulstrode style. The queen and her party stayed until two, and then met the hunters returning to Windsor. The dogs were not allowed to kill the stag, which must have been a relief to tender-hearted young Georgiana Port.

The experience reminded Mrs Delany of an incident from her youth that she related to Mary Hamilton, who delivered a letter of thanks to Windsor the next day. The 17-year-old Mary Delany, then living in Buckland, had been en route across country to dine with a local family, riding a staid old horse, and wearing a pink silk dress and a straw hat-brim like a visor to keep the sun out of her eyes, when her horse spontaneously joined a cross-country hunt. Off they both went; she arrived dishevelled, having kept her host and visitors waiting, and then rode home shoeless and bareheaded, with the hem of her pink dress ripped to shreds, to a severe reprimand from her mother.[25]

Mrs Delany's letter to her niece Mary then described how the princess royal and Princess Elizabeth had enquired after Georgiana and asked what she

liked to do with her time. Her great-aunt explained that Georgiana liked reading better than needlework, and when the princess royal asked what books she enjoyed, told her 'you seem'd to like history and travels as far as you could understand them, and the Spectators and French stories adapted to your age'. The French stories must surely have included the anthologies by Mme LePrince de Beaumont, whose books Mary and Patrick had discovered twenty years earlier (pp. 216–17), and the playlets for children written by Mme de Genlis, who was governess in the junior branch of the French royal family, which are specifically mentioned on another occasion.[26]

She then continued in her letter, to draw a moral point:

> I woul'd not have you think, (tho' I'm very sensible of the honour's [sic] done me,) I tell you this out of vanity, for I feel my *own small* consequence, but I *tell you* to show you how such manners become the highest rank, and tho' so far above us, they are not in *these particulars* unsuited to our imitation; for civility, kindness and benevolence, (suitable to the different walks of life,) are in everybody's power, from the palace to the cottage . . .

Finally, Georgiana received the poem in ballad style, as if 'Written by an ancient Bard, in an ancient forest of this ancient place, time out of mind' – evoking the Elizabethan literature read in the early days of the Bulstrode circle – which her great-aunt had been mulling over for some time.[27] It must have been a very delightful package of letters for the Port family to receive up at Ilam.

The other highlight before Christmas was a marriage much approved by the royal family as well as the bride's family, and long predicted by high society, between Heneage Finch, 4th Earl of Aylesford, Lady Andover's brother, and the duchess's third granddaughter, the Hon. Louisa Thynne, Georgiana's favourite in the Portland family. Louisa was known to be both beautiful and modest – no likelihood of *her* becoming a gambler or hectic fashionable female rake. Her 30-year-old husband was trustworthy and close to the king, both as a courtier – he had already been the Queen's Master of the Horse and was currently one of the king's Lords of the Bedchamber – and as a politician. He was just the kind of cultured peer the king liked. He was a distant cousin of Charles Jennens, the librettist for Handel's *Messiah*;[28] he was also a talented artist, a collector and a man of taste who commissioned a Roman-born, London-based architect, Joseph Bonomi, to rebuild Packington Hall, and 'Capability'

Brown to remodel the park.[29] When the queen herself came over to Bulstrode to congratulate the duchess personally on the match, Mrs Delany had been doing some spinning. The queen had immediately asked for a spinning lesson from Mrs Delany, and the duchess promised to obtain a wheel for her. Mrs Delany had it sent to the queen via Mary Hamilton, with a little verse:

Go, happy wheel! Amuse her leisure hour
Whose grace and affability refin'd,
Add lustre to her dignity and power,
And fill with love and awe the grateful mind.[30]

CONCLUDING THE COLLAGES

One thing could not be evaded: Mary's eyesight during 1782 was now deteriorating to the point where she could no longer create her colleges consistently. The fact that she could see colour better than black and white is an indication that she was probably suffering from cataracts, so reading print or handwriting was the first stage of her difficulties – especially given that paper was commonly not the very bleached white of modern times, and the ink used for handwriting varied in intensity and could in practice be a brown-grey, not black, depending on how it was mixed.[31] Clear contrast on the written page could not be guaranteed. Given that reading out loud was a normal social practice, though, this was not as much of a limitation as might be assumed. When staying with her great-aunt, Georgiana had always read to her as she 'worked' and in her absences others could take over, such as Mrs Astley, a clergyman's daughter and maid/companion, who succeeded Miss Rea in July of 1782. Why she left is unknown, but she was a young woman and may simply have met a suitable marriage partner. Domestic service for the young was not usually the prelude to a lifetime's occupation, but simply an early part of the adult life-cycle. 'Mrs' Astley may have been a widow or a single woman of slightly older years, who was therefore referred to as 'Mrs' in deference to her maturity, not her marital station. Anne Astley was regarded more as a kind of 'dame de compagnie' than a servant, and had some prior acquaintance with the Dewes family – she certainly knew Bernard Dewes and his household at Hagley, including the motherless little Anna's governess, Miss Cameron. Mrs Astley read to her employer when she was still attempting to contrive the mosaics. She also took dictation for letters when her employer

wanted to rest her eyes, though Mrs Delany still aimed to write some of her correspondence herself.[32]

Of course, it was easier for her to create the collages in the summer months when the daylight hours were brighter and longer. On 9 August 1782 she set to work on a specimen sent by the queen from Kew, which resonated in several ways: it was a native of Jamaica, where her aspirant playwright younger brother had died, and was named *Portlandia grandiflora* after the duchess. Six weeks after that her eyes allowed her only 'with some difficulty to attempt a flower now and then'.[33] Towards the end of the year Mary graciously conceded to herself that she would never quite reach the target number of exactly 1,000 specimens. She made the final alphabetical organisation of the images into ten volumes, and placed a valedictory poem in the first one:

> The time has come! I can no more;
> The vegetable world explore
> No more with rapture cull each flower
> That paints the mead or twines the bower;
> No more with admiration see
> Its beauteous form and symmetry;
> No more attempt with hope elate
> Its lovely hues to imitate!
> Farewell! To all those friendly powers
> That blest my solitary hours;
> O sanctify the pointed dart
> That at this moment rends my heart;
> Teach me submissive to resign
> When summoned by the Will Divine.[34]

The verses are a ringing declaration of confidence by this devout Anglican that the human has intimations of the divine, and that, in the words of Charles Jennens for Handel's *Messiah*, 'I know that my Redeemer liveth'.

Interestingly, it was to the Rev. Wiliam Gilpin, who may have begun to have similar eye symptoms, that she confided her anxiety that she might lose her sight altogether. Replying in clerical vein, he tried to comfort her by assuring her that she had many other resources to sustain her:

you feel, I doubt not, that happiness from *inward* resources wh [sic] nothing external can give. I have indeed sometimes thought yt [sic] an *abridgement* of ye pleasures of sight is *not* an *un*desirable middle state between this world and ye next. The vanities of life are, in great degree, excluded. We are sequestered, not by any human institution, but by our great Creator himself, from too violent an intercourse with ye world . . . With ye works of art I am almost satiated. For ye works of *nature* I have *still* a *relish*; but even here I find my eyes among my greatest misleaders; they are continually *distracting* my attention, and carrying it off among trifles . . . Thus, dear madam, it is easy for us to *console* a neighbour; ye great point is, to bear the calamity with that *fortitude*, wh you do when we feel it ourselves.[35]

However, Mrs Delany did not need her eyesight to be perfect for her to enjoy the resources of friendship; indeed, the flickering candlelight on the evening visits of her 'coterie' must have enhanced the intimacy and relaxation they enjoyed. Happily there is never any comment that her hearing or her memory was impaired. One new acquaintance was Joseph Warton, the litterateur and head-master of Winchester College, founded in 1382. He visited her one July morning when he was in London, possibly in connection with the publication that year of the second volume of his study of the poet Alexander Pope. 'I wish he resided at *Westminster* instead of *Winchester*, that I might enjoy more of his sprightly and edifying conversations', she remarked to Mary Hamilton.[36]

Another new contact was the Cornish painter John Opie. He was a carpen-ter's son from a small village near Truro, and when he came to London to see if he could compete in the metropolitan art market, his mentor and sponsor, the popular satirist Dr John Wolcot, encouraged him to 'trade' on a persona of an unlettered native genius, a kind of Cornish *enfant sauvage*. He soon caught on among the *bon ton*, and was given recommendations by Sir Joshua Reynolds, among others, for however little formal training he had, it was undeniable he could achieve a very good likeness. To Mary, Mrs Boscawen refers to him as '*your favoured Opie*', remarking that he was thrilled to have been invited to Bulstrode, surely the most likely location for his portrait of Mrs Delany.[37]

By whatever route the recommendations came about, at some point about the end of 1781 or early in 1782 the king commissioned this portrait (Plate 1).[38] What it does show is her intelligence, her amiability – a smile seems perpet-ually about to escape her – and her composed character. It also reveals her as a

loyal friend of Queen Charlotte, as she wears the locket surrounded by pearls the queen had given her. But this is the only attribute in the picture: there is no inclusion of books, artist's materials or of music, though these latter two were added later to the frame of the copy commissioned by Lady Bute; no reference to any form of craft or needlework; and no hint of a drawing-room interior or of a landscape through a window. In contrast, Mrs Boscawen mentions that Opie's recent portrait of Lady Jerningham included her spinning wheel, indicating *her* 'occupation'; but since it is the king who has commissioned this picture of his wife's friend, the most important attribute is the locket. Moreover, if Opie had been at Bulstrode, he would surely have been shown the paper mosaics. It cannot then be a coincidence that their maker is painted in a similar way to the one she had chosen for their 'portraits' – emerging out of nowhere against a painted dark oval background on black, and like the mosaics illuminated from the front. Is the smile hovering on her lips a hint of playful collusion between artist and sitter about this choice of pose?

Old friends kept Mary informed of their summer excursions. Parliament was in recess and, moreover, Lord North had resigned after the conclusive military defeat in America. Lord Rockingham succeeded him for a few months and Frederick Montagu became one of the Lords of the Treasury. He then went up to Papplewick to visit his estate, and returned to London via Stowe, and the Harcourts at Nuneham Courtenay. He found Stowe too artificial, scorning its '*ridiculous temples*', though admiring the more free-form Elysian fields. At Nuneham though, its principal designer, William Mason, was in residence, and Montagu had nothing but admiration for it: 'The situation and place are delightful; and such a flower garden as excels every flower-garden which ever existed either in history or romance. Bowers, statues, inscriptions, busts, temples; all planned by Mason.'[39]

For the king and queen it was a sad summer, for they had recently suffered the loss of Prince Alfred, who died of consumption one month short of his second birthday. On 1 September they made their way to Bulstrode, their first visit outside of Windsor castle after this bereavement, accompanied only by the three older princesses and the Prince of Wales. 'They were not in spirits, especially the queen, who seem'd much affected, and that every word was an exertion, tho' always most gracious.' However, the king did his best to rally everyone, suggesting they all, including Mrs Delany, sat around the table for the breakfast chocolate, and this indeed succeeded in creating a more cheerful

atmosphere. The Dartmouth family had also had a sad time, losing their fourth son, Heneage, aged only 18; but this was tempered by the forthcoming marriage of their heir, Lord Lewisham, to Lady Andover's niece, Lady Frances – 'a very agreeable match to all parties'. Mrs Boscawen's Leveson-Gower daughter also gave birth, and, after a sequence of boys, this was at last a girl. 'I *think* Lady Gower *will forgive* this *one* girl *to civilize the boys*,' her grandmother observed.[40]

After the sad visit made to Bulstrode when the king and queen were grieving, the bad weather meant further visits tailed off. On one occasion the queen came over accompanied only by her Lady in Waiting, the Anglo-Irish Lady Dartrey. The usual courtesy return visit from Bulstrode was described to Mary's Irish friend, Frances Hamilton. It deftly shows the differing characteristics of the royal couple. Mary and the duchess were leaving just as light was fading on the dark December afternoon after their very quiet interlude with the queen, who had been demonstrating her new silk fringing frame to them, thinking it was the kind of handiwork that would not tire her friend's eyesight. As they went outside they encountered King George returning to Windsor with his greyhounds after some coursing, and he insisted they stay a little longer. Charlotte then urged them back into her sitting room, as it was warmer than that of the king, who was notoriously impervious to the chill of the old castle. When the friends returned to Bulstrode two hours later than anticipated they were delighted to find Mary's nephew Bernard had arrived.[41]

The following spring brought mixed fortunes to the royal and the Dewes/Port families. Queen Charlotte and King George lost their eighth son, Octavius, at just over 4 years old, as he did not survive his smallpox inoculation, whereas Mary Port successfully gave birth to her seventh child and third daughter, called Frances after her Boscawen godmother, Mrs Leveson-Gower. Both the king and queen found the loss of Octavius exceptionally grievous, but endeavoured to reconcile themselves to Providence.

The duchess's elder son now reached a kind of political zenith, as nominal head of the ministry established in April 1783; in actuality it was an unexpected coalition between Lord North and his radical Whig foe, Charles James Fox, which no-one could regard in any other light than the most blatant expediency. The king especially deplored having to give high office to Fox, a man whom he regarded as an unprincipled gamester, who was also having a deplorable effect on the Prince of Wales. Frederick Montagu was again on the Treasury bench in this ministry. His summer visits included the bishop's palace

at Hartlebury, the official residence of Richard Hurd as Bishop of Worcester. He had just completed some rebuilding, including a new library that impressed Frederick. He told Mrs Delany it was 'an excellent room, with a very good collection of books, and *your friend's* picture in the room' – that is, a copy of a portrait of Queen Charlotte by Thomas Gainsborough.[42]

The very dry spell was making London unusually smelly, and Anne Astley was pleased when her mistress did finally leave it via a visit to Mrs Boscawen at Colney Hatch. The latter then went to her daughter at Badminton, where she admired the flowerbeds designed by Mason.[43] On her way home Mrs Boscawen made her first visit to Longleat, where young Lady Weymouth made her very welcome. Frances was immediately impressed with the unique character and setting of the Elizabethan mansion and described it in a letter to Mrs Delany: 'It appear'd the very *finest* place I ever saw in my life. The sun shone perfectly bright, the water was all silver, the light and shades (of the fine trees) were beautifull [sic]; in short the whole with its distant hill so entirely excited my admiration, the superb majestic [sic] structure being unique, that I dare say I shall never see anything that I like upon the whole so well.' She also relished the menagerie with its oriental pheasants, their plumage like white muslin cloaks on top of black mourning feathers, and the Carolina ducks.[44]

On the same trip she saw the Hoare family's newer creation at Stourhead, whose remarkable landscape gardens, dotted about with strategically placed buildings and follies, she found rather stagey: 'it has many pretty *opera* scenes in it, but is not in the style of Longleat – far from it'. She thought the building Mrs Delany would have liked best was the 'Gothick' convent in the woods, with painted glass windows, and an altarpiece said to have come from Glastonbury Abbey – but she hastily added that this might have been a fanciful fake 'for I am easily *taken in* upon these occasions'.[45]

Once the duchess and Mrs Delany were re-established at Bulstrode in October for the autumn, the king could not wait to bring them happy news. Mary described his solo visit to her Irish correspondent:

A few days after our arrival here, the Duchess of Portland and I were sitting in the long gallery very busy with our different employments, when, without any ceremony, his Majesty walked up to our table *un*perceived and *un*known till he came quite close to us. You may believe we were at first a little flustered, but his courteous manner soon made him a welcome guest. He came

to inform the Duchess of Portland of the Queen's perfect recovery after her lying-in, which made him doubly welcome.[46]

The pain of bereavement in May had been further assuaged by the birth of Amelia, the final royal baby.

REMINISCING WITH MARY HAMILTON

At the end of 1783 Mary Hamilton came to stay at Bulstrode for almost all of December, and this greatly enriched and deepened her friendship with Mrs Delany. The younger Mary mixed in the Bluestocking circles hosted by Mrs Montagu.[47] The regular routine was soon established: as the duchess seldom rose until noon, the two Marys breakfasted together at about nine-thirty in the elder's dressing room, and the younger Mary read out any letters the latter had received. When the duchess emerged at about 1 p.m., conversation was in the library and might include looking at drawings or specimens of natural history. Supper was at 10 in the evening, when joint conversation was resumed, with the bonus of no servants overhearing. This left everyone free to talk about others, whether in the past or present, with no fear of private revelations seeping out to a very gossipy interconnected world. If we bear in mind that Frances Burney's designated footman when she joined the royal household was cousin to Horace Walpole's, it brings it home that gossip of all kinds and in many different quarters could spread very easily indeed.

Mary Hamilton lent a ready ear to all that her co-hostesses could tell her about court life in the early part of the century; as a member of the royal household it was helpful to find out about previous reigns: and as her Hamilton relatives had had so many connections with Prince Frederick's circle any mention of this era was of personal significance. The duchess also talked about her enthusiasm for the Elizabethan age, and let her copy some of her manuscripts from that era, especially those of a devotional character; and Mrs Delany told her about her own early life and court contacts. Conversational topics could vary widely, from the distant past to the immediate present, such as the ballooning craze, spearheaded by the Neapolitan Consul, Vincenzo Lunardi – what Miss Hamilton summarised as 'the common chit-chat of the great world'.[48]

But Mrs Delany also looked far back, and several times discussed her arranged marriage. She emphasised to the young guest how important it was

for 'young women [to be] cautious . . . what society they entered into, and *particularly wth* whom they *appeared in public*', thus passing on the advice she had herself received from Lady Anne Stanley.[49] She told her about the notoriously libertine set of the Hell Fire club, men and women alike who ridiculed the Bible. (This was an earlier incarnation of the better-known club of the same name presided over by Francis Dashwood at Wycombe Abbey.)

The most important figure among these reminiscences of the first decades of the eighteenth century was the imperious Sarah, 1st Duchess of Marlborough, one-time favourite of Princess Anne before she became queen, and wife of the famous general John Churchill. Her grief was always excessive. She was found praying lying prostrate on the ground when her daughter Diana died, saying she was too wicked to kneel. One manifestation of her sadness, but also her worldliness, was that the very day after this loss she had sent word to recover her daughter the former Duchess of Bedford's jewels, claiming they had only been on loan. Her grief when her only son died was similarly 'boundless', due as much in the opinion of the Duchess of Portland to thwarted hopes as maternal sorrow: 'her vanity was wounded, ye future hope of an ambitious mind was destroyed'.[50] This son had been in attendance on the Duke of Gloucester, the longest surviving child of Queen Anne, and heir presumptive to the English throne.[51]

Also from this earlier era came narratives about Swift and his friend Vanessa, Alexander Pope, and Lord Harley, the duchess's grandfather, together with reminiscences Mrs Delany was well equipped to make concerning John Wesley and the first Methodists. John and his brother Charles, she explained, had begun with meeting on Sunday evenings to read the Bible, and to find out about anyone needing charitable relief: 'This was a happy beginning, but ye vanity of being singular, and growing *enthusiasts*, made them endeavour to gain proselytes and adopt that system of religious doctrine which many reasonable people thought pernicious.'[52]

As she was on her home ground, the duchess could show Mary objects from various types of her collections: missals and rosaries dating from the reign of Elizabeth I, miniature enamel paintings of the same date by Peter and Isaac Oliver, as well as the large collection from her own youth by Christopher Zincke, and portfolios of prints. She showed her the room where she did her wood-turning as well as the places where her books were kept and her china displayed.[53]

Sometimes Mrs Delany felt energetic enough to walk instead of drive around the grounds. This option must have been linked more with winter weather,

whether she had slept well or the unevenness of ground outside, rather than mobility as such, for her young friend also noted that although their rooms were about 80 foot apart down a long enfilade 'so often does she trot to and fro, and that at the age of 84, that it makes me often blush for my own lazyness'. One morning:

> we went first to the greenhouse, wch forms one wing of the house; in an enclosure before it are many beautiful birds, some fine peacocks, remarkable pretty bantams, etc., and two grues or Numidian cranes . . . they are so tame that they come hopping to us and eat bread out of our hands . . . We then went to the grotto, and Mrs Delany told me what a source of amusement the forming it had been to her . . . she began it just after the death of her belov'd sister.

On another day, they looked over a barrel of shells received from the West Indies, but the duchess concluded most of them were uninteresting, and gave young Mary some duplicate shells and fossils from her own collection. Altogether it was a pretty thorough induction to the ways and enthusiasms of Bulstrode.[54]

Mary also met some of the upper servants, whom she noted by name in her diary, such as the housekeeper Mrs Woodward, who showed her all her storecupboards; the artistically talented house steward Mr Levers, who showed her his large portfolio of drawings; and the gardener who was so knowledgeable about fungi, Mr Agnew. Of course Mrs Delany had brought Anne Astley with her, as well as her own butler, George.

Finally, and most poignantly, Mrs Delany confided to her young protégé her deepest fears and her most intimate hopes. She said that she did not fear death as such, but did worry about the impact her departure would have on the duchess; as the latter was fifteen years younger than her friend it was natural to assume Mrs Delany would predecease her. 'She look'd forward to my being *a comfort to ye Duchess* when *she was no more;* desired I wd *remember* it was *her wish* I wd give her as much of my time as I could; that ye Dss loved me and she knew it wd give her comfort if I did so, etc. etc.'[55] Mrs Delany's other hopes were centred on her still unmarried eldest nephew, Court, who would inherit the Wellesbourne estate. Quite early in Mary Hamilton's stay, Mrs Delany started to drop hints – saying outright she wished him to marry. Next she suggested that he might meet Miss Hamilton at St James's Place so they could both look

at her prints, but this was all water into the sand, as Miss Hamilton had already met her Derbyshire squire, Mr Dickenson, and during the course of 1784 there are increasing references to when she 'might change her name', that is, marry.[56]

THE LONDON ROUND AND A NEW LITERARY CONTACT

From the beginning to the end of 1784 there was little or no indication that any parting through death of one of the two friends was imminent. It proved a year of interesting incident, both private and public. Miss Hamilton, who arrived back in Clarges Street just before Christmas, was soon reabsorbed into her busy life, catching up with her various kin and friends like two of her Hamilton uncles, Sir William, the diplomat, on leave from his post in Naples, and his brother Frederick, a clergyman; and various members of the Bluestocking circles. Mary knew that her widowed Uncle William was already squiring the enticing courtesan Emma Hart around London, but in Bluestocking assemblies, including Mrs Montagu's or Mrs Boscawen's, they would never come face to face.

Once the two Bulstrode hostesses arrived at their respective town houses after Christmas, Mary Hamilton again was welcomed by them both. Mrs Delany showed her the shell collection she had amassed at St James's Place, and at the Portland's Whitehall headquarters, the duchess showed her 'fine gems, antiques, miniature pictures &.', and Mary helped her rearrange a cabinet of agates.[57] There was a more important confidential role she could perform for the duchess, which was to act as go-between for the latter and Sir William Hamilton regarding the purchase of the famous Roman glass vase known then as the Barberini vase after the seventeenth-century Roman patrician family who then possessed it. Dating from the early common era, it was made of blue cameo glass overlain by white, which had then been etched away, leaving an array of neo-classical motifs, and its distinctive character became more widely known when the potter Wedgwood succeeded in making several jasper-ware copies and other similar objects in the 1790s.[58]

By early February Georgiana Port had resumed her familial role in the London household so Mrs Delany saw Mary Hamilton less frequently. Poised as she was between childhood and young womanhood, Miss Port was nonetheless considered by the duchess to be old enough and tactfully affectionate enough to bear sad tidings to her great-aunt of the imminent death of Lady Mansfield, which took place on 10 April. Though not as close a friend as the duchess,

Mrs Boscawen, Countess Leveson-Gower or Lady Andover, her friend knew that Lady Mansfield was held in grateful regard by Mrs Delany, if only because of the part Lord Mansfield had played in concluding the lawsuit against Patrick some thirty years before, and that they took a common interest in gardens.

During an unusually hot May before Georgiana left for Wellesbourne, the household at St James's Place was quietly planning a small birthday celebration on 15 May, Mrs Delany's birthday, for guests such as Bishop Hurd, Frederick Montagu and Dr Bryant. These birthday suppers were now restricted to just six select friends. However, an unexpected request from the king and queen to attend them at the Queen's House overrode the plans. The duchess and her friend had to concede graciously and off they went in the duchess's coach, but in fact the royal couple had remembered it was Mrs Delany's birthday and had a surprise of their own. As Georgiana explained 'when they had been there a little time the Queen told Lady Weymouth to tye a string round my A. D's neck, and at the end of the string was the King's picture set in gold and diamonds, and the Q—n beg'd Mrs. Delany to accept it'.[59]

The next day high society and music connoisseurs had the thrill of the first Handel Festival, held at Westminster Abbey. It observed the twenty-five years since Handel had died and at the same time confirmed the canonic status this composer had achieved as one of the great 'British' composers, despite his German birth. The king was Handel's greatest 'fan' but this was not an officially organised event – rather, it was the work of privately organised patrons known as the Academy of Ancient Music, headed by John Montagu, 4th Earl of Sandwich, First Lord of the Admiralty. Proceeds from ticket sales went to various charities, including one for retired musicians.

In November of this Handel-themed year, the king made a special request to Mrs Delany that she would lend him her late brother's catalogue of all Handel's works, together with the five volumes in the Granville possession but not the king's, in order to assist Charles Burney in completing the fourth volume of his *General History of Music* (1776–89). The finished version was dedicated to the queen in words composed by Samuel Johnson. The king assured her that great care would be taken of them, but when they were returned with grateful thanks one of the volumes lent was missing and never returned. Mrs Delany was far too polite ever to draw this to the king's attention, but all the same it must have felt irksome.[60]

The year 1784 was also that in which Charles Burney's novelist daughter Frances begins to appear in Mary Hamilton's and also Mrs Delany's correspondence,

and at the latter's London home. The contact with the novelist had evidently first been effected by Hester Chapone,[61] but when Mary Hamilton spent her month at Bulstrode, she brought with her a copy of Burney's best-selling novel of 1778, *Evelina, or the History of a Young Lady's Entrance into the World*, as Mrs Boscawen had recommended she read it. It is not clear whether the latter had only just come across it, but Mary Hamilton was hardly a novice in dealing with the hazards of society, as the year the book had appeared was the same year she had been the object of the young Prince of Wales's impassioned attentions. She had managed to discourage his sentimental onslaught and by the end of the year he had switched focus to the actress Mary Robinson, often called Perdita after her most successful Shakespearean role. Burney's story centres on the naïve heroine's faltering progress in mastering the ways of the fashionable world, during which she is rescued by the aristocratic Lord Orville from pestering overtures and unfortunate associations in the Pleasure Gardens at Vauxhall, while also negotiating the demands and embarrassments of her vulgar relatives in the City of London. She is rewarded in the end by Orville's hand in marriage.

Once back in London, Frances Burney is mentioned again in Miss Hamilton's diary, more as part of a group of visitors than being singled out as a guest of Mrs Delany's especial choosing. It is clear she was angling to be included as a regular part of Mrs Delany's set but not much evidence of partiality was forthcoming from Mrs Delany herself. Frances was casting around for new contacts because she had felt it was prudent to distance herself from her patroness Hester Thrale, who had startled society on being widowed by marrying her children's resident music tutor, Gabriel Piozzi. She was considered to be betraying far too much passion for a younger man who was also her social inferior.

During the summer months, the ladies had made their usual visits. It was an election year of unusual controversy, as the king had encouraged a vote in the Parliament against Lord Shelburne's ministry and replaced him with a new first minister, William Pitt the Younger, second son of the indomitable Lord Chatham – and younger also in the sense that he was only 24. In Cornwall Mrs Boscawen witnessed the social ripples of the contests at close hand as her son, now Viscount Falmouth, and his new wife, Elizabeth Crewe, gave election balls to voters in and around Falmouth.[62]

The duchess fretted in Margate, first because it was too hot and then because it became so cold and blustery she was obliged to stay indoors. She became so bored she resorted to reading the newspapers while the house felt as

though it was about to blow down, and started counting the days when she could return to Bulstrode.[63] During the bad weather Sally Sandford had been in London visiting with Mrs Delany. When most of the *bon ton* had arrived back in town, on 15 September there came the thrill of Vincent Lunardi's first successful manned balloon ascent in England, starting from the Royal Artillery Grounds in Moorfields. He was accompanied by a cat and a dog and a pigeon; the latter flew away and the former two were set down a little later as both were getting queasy.[64] The balloon was subsequently exhibited at the Pantheon. A month later Frederick Montagu up in Papplewick agreed with Mrs Delany that he was getting weary of all the newspaper stories about it. But little Georgiana was thrilled to see the actual balloon at the Pantheon when she came to London as usual in the New Year of 1785, and told her father she would like to travel in it herself: 'I should like to go up with him, provided he does not cross the sea, as there is no danger in the world: for if it should burst it descends so gradually it is impossible to be hurt.' There were probably two views as to the safety of balloon travel at Ilam.[65]

THE PARTING OF FRIENDS

When Georgiana was dreaming of going up in Lunardi's balloon, her great-aunt was very preoccupied with the imminent demise of her redoubtable cousin, Lady Leveson-Gower, who had been seriously burnt in a fire at her home, Bill Hill. Her little niece had sent a message in the letter to her father that Mrs Delany was well in body but low in spirits, but it was generally felt that when the countess passed away without a groan nine days later it was a merciful release. Her kindness was much remembered and Mrs Delany treasured some devotional writings found with her cousin's papers.[66] Thereafter Mrs Delany had an uneventful but pleasant spring, after a protracted winter when she had gone out very little. She told Mrs Frances Hamilton:

> my fireside was enriched by the constant kind attentions of my friends and acquaintance, who preferred a warm room and a sincere welcome from one they are so partial to, to the dissipated manners of the times, which is, to live in public *from morning to night*. My health during this season, has been better than my years could promise; though *sensible* of that decay, which, though *awful* is to lead me to that happiness I humbly hope for.[67]

329

When the temperature finally rose in May, George III invited the two friends to an evening at Buckingham House, to hear the actress Mrs Sarah Siddons give a private recital to the royal couple and some chosen company. This included three generations of the Cavendish-Bentinck ladies – the duchess, her daughter Lady Weymouth and her young married granddaughter Lady Aylesford. In June the Handel concerts at Westminster Abbey were repeated, and Court Dewes came down to London to attend some of them, while his aunt managed to attend two.[68] Mrs Boscawen was reluctantly leaving her much-loved but drafty Glanvilla and buying a house in Richmond, between its royal gardens and those at Kew – not only was it larger but she thought its proximity to the royal residences made it more secure. Also towards the end of June Mary Hamilton finally agreed to marry her faithful suitor, John Dickenson, and Mrs Delany sent them her warmest congratulations, adding in a postscript: 'Our dear friend at Whitehall continues mending.'[69]

For there had been a disconcerting health scare just when Miss Port left London and the two friends went to Bulstrode. Both hoped that 'the tranquillity of Bulstrode will make us all well', but in this instance it may have been that Bulstrode was part of the problem. There seem to have been various factors at work – the duchess already had seen an enigmatic rash on her arms before they left London – but at Bulstrode she had 'a bilious complaint', and so did her butler, who also died, which suggests some kind of viral infection.[70] On 14 July Mrs Boscawen had positive news of the duchess's 'amendment', but by 17 July it was all over. Mrs Delany was physically fatigued, but spiritually confident that 'her friend was "not lost" ' but only ' "gone before" ', so that despite her deep grief she retained an underlying resilience.[71] Of course everyone rallied to support her – Court, already in London, attended on her and Georgiana returned as soon as she could.

Young William Sandford was deputed to write some of the letters to well-wishers, including Mrs Frances Hamilton, and he described the reaction of the duchess's son, the current Duke of Portland, who said that 'ever he should see his mother in Mrs. Delany' and that he 'should always think himself fulfilling his late mother's wishes when he obeys her commands or contributes in anything to her satisfaction'.[72] The duchess was buried in Westminster Abbey, near her husband and her Harley forebears. It is highly unlikely Mrs Delany attended – even for grandees, funeral services were often small. Nor was she left any bequest in the will – which was according to her knowledge and agreement. She and her

friend had discussed this eventuality, and Mrs Delany was vehement that money should not pass out of the duchess's family. It was understood by each that the money advanced for the London house would be repaid to the Portland estate when Mrs Delany died and the St James's house was sold. Any inheritance was confined to a few personal mementos, including a picture of two mice by Raphael, and the duchess's personal small blue and black snuff box. The chairs Mary had embroidered for Bulstrode went to Georgiana, and so did any pictures she had made during her many visits to the estate.[73]

The most obvious change this bereavement would make in Mrs Delany's circumstances was that an annual change of scene between early May and late September would no longer be possible. With the death of Lady Gower, her range of homes in which to stay had also contracted, although it was likely she would still be at a visitor to Lady Bute, or to the much nearer new home of Mrs Boscawen at Richmond. However, the king and queen were prompt to recognise the gap created by the reversion of Bulstrode to the reigning Duke of Portland, and they immediately did something practical to remedy this. They offered their friend the use of a house in Windsor at St Alban's Street, and while this was being made ready she and her great-niece were to have the use of another. Furthermore, she was to have £300 per year to assist financially in running this second home. This was the amount a Maid of Honour or Woman of the Bedchamber normally received as a pension, but George and Charlotte were going to give it each year as a personal gift, expressly to avoid any appearance that Mrs Delany was 'on the books' as a dependent.[74]

A ROYAL CORDIAL

This, then, was the origin and rationale for what Mrs Delany described as a 'Royal Cordial' – the frequent informal visits made by both George and Charlotte, together and separately.[75] They began almost as soon as Mrs Delany took posses- sion at Windsor early in September, after she had recovered from a sudden bad fever. Her nephews had already returned to Wellesbourne, so to help keep the young Georgiana company, she invited Frances Burney to stay, and was favourably impressed with her. On 9 September Mrs Boscawen toiled in vain from South Audley Street downhill to St James's Place and back, in the vain hope of finding Mrs Delany still in the London house. It was too early in the season for anybody much to have been around – even the sedan chair carriers were

out of town, picking hops for extra money in Kent. Mrs Boscawen left a footstool cover she had made in tapestry for the new house with the cook, Molly Butcher. The main motif was a purple heart on a gold background, signifying the goodness of royalty, with surrounds of green and grey ground 'so that old and young, all hearts, unite in that one centre you are acquainted with'.[76] In a postscript as long as the original letter she added some details about her son entertaining the 'sailor prince', William, Duke of Clarence, when his ship was moored in Falmouth harbour.

The visits to the castle from St Alban's Street were indeed increasingly informal – no coach and horses with flaming lights were needed any more. In early November, in a letter to Ireland, Mrs Delany summarised the usual proceedings:

> I have been several evenings at the Queen's Lodge, with no other company but their own most lovely family. They sit round a large table, on which are books, work [needlework], pencils and paper. The Queen has the goodness to make me sit down next to her; and delights me with her conversation, which is informing, elegant and pleasing beyond description; while the younger part of the family are drawing and working etc. etc., the beautiful babe, Princess Amelia, bearing her part in the entertainment: sometimes in one of her sister's laps; sometimes playing with her father on the carpet; which, altogether with, exhibits such a delightful scene, as an Addison's pen, or a Vandyke's pencil, to justice to it.

Music played on in the adjoining room.

In return, the king, queen and six or seven of their children might come for evening tea with Mrs Delany. The younger ones would play the card-game commerce, with Georgiana presiding, assisted by Lady Louisa Clayton and her daughter Emily. The two girls became fast friends. Lady Louisa, a sister of the Royal Governess, Lady Charlotte Finch, had had a lifelong career as a Lady of the Bedchamber to Princess Amelia, George III's long-lived aunt. The older princesses had had drawing lessons with Emilia Clayton's step-sisters. Georgiana and Emilia identified strongly with the health and doings of the princesses Sophia, Mary and Elizabeth. The first two had recently breakfasted with Mrs Delany and had played some pieces of Handel to their hostesses. 'They looked like little angels,' Georgiana told her mother. 'They are very fair, with

blue eyes, and hair exactly like Fanny's [one of the Port siblings] which they have a vast deal of, and which curls all down their backs; they go about without caps, and are so engaging in their behaviour, that every body must love them, and admire those who made them what they are.'[77]

Emilia Clayton's step-sister Marianne was engaged to be married later that year. Her future spouse was the Hon. Henry Frederick Fox, the younger brother of none other than Charles James Fox, the reckless gambler and *bête noire* of George III. But he was quite unlike his brother and much more like his sober and reliable Digby cousins. Mrs Delany had heard that he had already shown a 'steady attachment' to his future bride. Aged 31, he was a career military officer who had fought in America, and was currently on leave from his base in Halifax, Nova Scotia.[78]

As the year reached early autumn and winter, there were new arrivals to assuage the huge gap left by the duchess's departure: Mrs Boscawen's daughter-in-law Elizabeth Crewe had produced an heir, and Lady Beaufort was recovering well from her earlier pregnancy. Lady Stamford was about to marry her only girl, Harriet, to a suitable man, Sir John Chetwode. Harriet's mother declared '*Good sense, religion*, and a most *angelic temper*, are *three* most desirable qualities; and most likely to constitute, as well as to procure, happiness. *These*, I am happy to say, I think Sir John Chetwode possesses in a high degree.' Finally, Lady Weymouth's third daughter, Sophia, who had married George Ashburnham, Lord St Asaph, the previous year, had now provided *that* family with a son. But in Lord Guilford's family there was grief: his daughter Lady Willoughby had lost a son to a sudden illness while they were visiting at Waldershare, and for the second time his step-son Lord Dartmouth endured the death of a son on the threshold of manhood when William Legge died, aged 19.[79]

Mrs Delany was also preoccupied with lineage. The Grenvilles of Stowe were laying claim to the *Granville* surname, but as she explained to her youngest nephew John, her brother Bernard's heir, she believed 'it was laudable, and proper, that the names of respectable families should be kept up, especially by a *direct* descendant of *so worthy* and so *great* a man as Sir Bevil Granville, (who died for his king and country), and not let his name sink in oblivion'. This was made known to the king, and one evening when he met Court Dewes at his aunt's house George sanctioned the change of name from John Dewes to John Granville, and Court duly informed his brother this would be ratified officially.[80]

Although Mary had kept up her health and spirits admirably in an unusually taxing year, by the end of it her diary has brief but frequent references to indifferent well-being and poor sleep. There was consternation too for the king and queen, as Princess Elizabeth had severe 'spasms' and suspected whooping cough that winter, but eventually her condition improved.[81] Being on intimate terms with the royal family meant, as Lord Guilford put it, to be 'in a course of taking a very sincere share in the joys and sorrows of the Royal Family'.[82] Elizabeth spent her time uninterruptedly at Kew, where it was thought the air was better than at Windsor. Her cough was probably tubercular in origin.[83] Finally, after two months of cold weather and poor health at the start of 1786, Mrs Delany was able to note in her diary for February that she and Georgiana were setting out for the London house 'on a fine soft day after the severe frost', and that they reached St James's within three hours, not too fatigued. Immediately she had plenty of interesting and welcome visitors: Sally Sandford and her two elder sons; Lords Guilford and Dartford; Mr Lightfoot and Miss Carter; Lady Bute and Horace Walpole; Mrs Boscawen; a servant of Dr Wharton bringing a brace of partridges . . . Her first London season without the Duchess of Portland was beginning with all the coterie visiting St James's Place, and learning to live without the latter's regular presence.[84]

The main topic of insider news was that the Prince of Wales was assumed to have contracted a private marriage with the widowed Mrs Fitzherbert. As she was a Catholic, this could never have been a public marriage – but as a devout Christian, she could not consent to be merely a mistress. Unfortunately for her, the continental practice of morganatic marriage, in which there was financial provision and some degree of status, but no inheritance rights for wife or children, was unacceptable in Britain. The rumours of the marriage were indeed true, but there were plenty of other stories about the practical jokes of the prince and his bachelor set in Brighton.[85]

While Mrs Delany was in London, the Windsor house was being modified to make it larger, resulting in its becoming 'most convenient, elegant and comfortable'. However, all did not quite go according to plan, as in early April a member of Mrs Delany's Windsor household became seriously ill. At Lady Weymouth's suggestion, the queen lent another house to Mrs Delany, who returned to Windsor to supervise the invalid. She still returned to London for a few days in June in order to go to the concerts at Westminster Abbey.

Mary described the routine of her new Windsor life in a July letter to Frances Hamilton:

I seldom miss going to early prayers at the King's Chapel [St George's Chapel], at eight o'clock, where I never fail to see their Majesties and all the royal family. The common way of going up the chapel is through the *great entrance* pillars, at the corner of which is a narrow winding staircase, which leads to the chapel; but their Majesties, with their usual goodness and indulgence, have ordered that I should be admitted through the *great staircase*, which is of *very easy* ascent. When chapel is over, all the congregation make a line in the great portico till their Majesties have passed; for they *always walk* to chapel and back again, and speak to everybody of consequence as they pass . . . I come home to breakfast generally about nine o'clock, and if I (and the weather) are well enough I take the air for two hours. The rest of the morning is devoted to business [household or financial matters], and the company of my *particular* friends; but I admit no formal visitors, as I really have no time for it, but every one here is very civil and very considerate. My afternoons I keep *entirely to myself*, that I may have no interruptions whenever my royal visitors condescend to visit me: their usual time of coming is between six and seven o'clock, and they generally stay till between eight and nine. They *always* drink tea here, and my niece has the honour of giving it about to all the royal family, as they will not suffer me to do it (though it is my place). The Queen always places me on the sofa beside her, and the King, when he sits down (which is seldom), sits next the sofa.

She also added that the royals often dropped in during the mornings, 'and *take me as they find me*, not suffering any body to give me notice of their being come'. As with the impromptu visits to Bulstrode, this was to prevent pressure on their hostess to prepare anything special – but it also exerted pressure of a different kind, as Mrs Delany felt obliged to be available anyway, 'just in case'. But to her mind, this was a great honour.[86]

Georgiana, now a tall and slender young adolescent comparable in height to Sally Sandford's eldest son, John, was integral to life in Alban Street because she was both companion and secretary to her aunt, now that the latter's sight was so much worse.[87] However, as well as being a reflection of their mutual fondness, her visiting was also a factor in the young woman's social training for a kind of 'career' as a court insider. It put her in possible reach of even being a Maid of Honour one day, and it continued the role sustained over several generations

of the Granville ladies, that of networking on behalf of a family whose social standing now lay between being grandchildren to an Earl, and being mainly of gentry/professional status. So, if Georgiana can look as though she is boasting to her father rather patronisingly when she writes about the grander relatives or court visitors she is meeting, it probably did not seem like that to her family in Derbyshire or Warwickshire, who had no regular role in attending court: rather, it would seem she was doing precisely her 'job' in the family: making sure that the king and queen knew who they were, and keeping the now rather provincial Granvilles within their purview. In September 1786, when the Arch-Duke of Milan, son of Maria Theresa of Austria, Queen of Hungary in her own right and co-ruler, with her eldest son Joseph, of the Holy Roman Empire, visited Windsor incognito, Georgiana explained to her father that this meant a lot of ceremonial could be avoided – not that no-one knew who they were.[88]

FRANCES BURNEY'S COURT APPOINTMENT

When Mrs Delany described her regular Windsor routine to Frances Hamilton she added news about a new development in her acquaintance with Frances Burney. Thanks to Mrs Delany's mediation with the queen, the writer had been made Second Keeper of the Robes, to replace Mlle Hagedorn, who had been with the queen since their arrival in England in 1761. Mlle Hagedorn was now retiring to Germany. The king had wanted to reward Charles Burney for his scholarship on the history of music, but no suitable vacancies of a musical kind were then available. Leonard Smelt had suggested that Burney's daughter might be given a place at court instead.

Mrs Delany summarised her estimate of Burney to Frances Hamilton succinctly, referring to Burney's second novel:

An event has taken place lately which gives me great satisfaction. I am sure you are acquainted with the novel entitled *Cecilia*, much admired for its good sense, variety of character, delicacy of sentiment, &c &c. There is nothing in the book that is not possessed by the author of it, Miss Burney. I have now been acquainted with her three years: her *extreme diffidence of herself*, notwithstanding her great genius and the applause she has met with, adds lustre to all her excellences, and all improve on acquaintance.[89]

However, when Lady Llanover was compiling her edition of her great-great-aunt's letters in the late 1850s, she had her own views on Frances Burney – and they were thoroughly prejudicial. She thought Burney thoroughly exaggerated her role in Mrs Delany's life and that her account was self-serving, if not invented. When Burney had stayed at Windsor to help Georgiana settle with her aunt in the new house, Mrs Delany had praised 'her admirable understanding, tender affection, and sweetness of manners [which] make her valuable to all those who have the happiness to all who know her'. Lady Llanover's scornful gloss on this sentence is 'For "admirable understanding", *talent* might be substituted: for "tender affection", a "gentle sympathising voice"; and for "*sweetness of manners*" (*apparently*) timid and undeviating attention and respect to Mrs. Delany.'[90] Llanover also consulted the now elderly Mrs Astley, now Mrs Agnew (did she marry the Bulstrode gardener or one of his relatives?) to see if she agreed with Burney's accounts; and on the whole she did not.[91] As Lady Llanover judged, rather harshly, Burney's court diary is an unreliable account of Mrs Delany's senior years:

> Miss Burney's situation certainly was anomalous . . . for though as a dresser she *had a fixed* though subordinate position, as a successful novel writer she had a sort of undefined celebrity won by her talents; and though as the daughter of a music master she had previously no *individual position* whatsoever, there was in her case more personal interest manifested on account of her being the daughter of so excellent a man as Dr. Burney, who was much respected . . . She had a *particularly* large share of *vanity*, a *particularly* lively imagination, and between both, she made numerous mistakes in the course of her various representations of her *four characters – of the* timid nobody; the *wonderful girl* who had written 'Evelina'; the queen's dresser; and the *amiable* and *devoted daughter* 'Fanny Burney'.[92]

Although the diary seems to promise an unrivalled witness to the final years of Mrs Delany, it does need to be treated with a large degree of caution. It illustrates vividly how unalike Burney and Mrs Delany were in their attitudes to serving the monarchy. And ultimately the two women would never really comprehend each other, for Frances would never be able to tell her benefactress how much she disliked her position, just as she could not admit this to her father either.[93]

A DRAMATIC THREAT

Unquestionably one of the most serious incidents in George's reign took place on 2 August 1786 and far outweighed any self-dramatising analysis that might have been occupying Frances Burney's mind in the third week of her service to Queen Charlotte. When he arrived at St James's Palace, to conduct a regular levée, George was threatened by a mentally unstable woman, Margaret Nicholson, trying to hand him a petition in which was a concealed knife. With great presence of mind he discerned that she was ill and stepped forward as people rushed to assist, declaring he was well and that his assailant needed help: 'The poor creature is mad! Do not hurt her! She has not hurt me.'[94] He ensured that no-one should go ahead to Windsor and alarm the queen with the news until he had arrived first. He broke the news himself, somewhat abruptly, eager to show that he was safe and well. In the next few days well-wishers poured into Windsor and Kew to rejoice in the king's fortunate escape. Frances Boscawen and Lord Guilford immediately wrote to Mrs Delany to enquire whether she had felt disturbed by the incident.[95] Mrs Delany replied to these anxious queries by explaining to everyone that the king and queen had immediately ensured she would be insulated from the news until the following morning, in case it disturbed her sleep. On the day of the attack the evening parade on the terrace went on as usual, though the queen and princesses were still both in a state of shock mixed with tearful relief. Over the next few days, the king tried to act as normally as possible to reassure everyone he came into contact with that all was well. Gradually, things began to regain a more normal shape, and the drawing room on the first Sunday after the attack was very well attended, as more than the usual number of court habitués thronged to pay their respects and express their gratitude for the king's preservation.

There was then a run of special ceremonies to celebrate several of the royal children's birthdays, as so many of them were born in August or September. The usual way to observe this was for court insiders to wear new clothes and to make a point of attending prayers at St George's chapel. Princess Amelia's birthday was on 7 September, and she was so young and unaffected that it cheered everyone to see her enjoying the attention she received. Looking down from a window in the castle, Burney saw the enlarged crowd and their deference to the senior figure of Mrs Delany in her sedan chair, being carried to the royal breakfast after the morning prayers. In the evening Burney and Miss Port

accompanied her in her sedan chair for the first time to go to the terrace and wait for the royal party to go by. Thus Burney was gradually assimilated into Mrs Delany's regular routine with the royal family.

To Burney, Mrs Delany was almost a providential figure, a 'Guardian Angel' sent to help her negotiate the manifold hesitations and incomprehension of her first months at court. She might have been chagrined to find that when her benefactor described her regular routine with the royal family to Frances Hamilton in Ireland, she is at first mentioned so little: the inference is clearly that initially Burney had a fraction of the importance to her than vice versa. Be that as it may, it is certainly true that Mrs Delany, with her usual tact and discretion, helped her with various dilemmas. Initially Burney was far from clear what scope she had to entertain her own friends and literary acquaintances or respond to the importunities of others: though she was entirely correct to be cautious. Early on in her days at Windsor Mme La Fite was lobbying Burney to assist in gaining an introduction for the German novelist, Sophie La Roche, to the royal princesses, and Burney knew that to be used as an avenue of access like this would displease the queen; at the same time, La Fite was lobbying her to become a literary correspondent of the French writer Mme de Genlis, who was governess to the children of Philippe d'Orléans, the head of the junior branch of the French royal family (who would inherit should all Bourbon claims die out). Her playlets and stories for children were widely read, and in fact Queen Charlotte recommended them to her brother Karl, partly because they encouraged girls to be instructed in natural science. Burney and her father had both met Mme de Genlis in London in 1785.

Mary simply advised Burney to ask her employer about Mme de Genlis. Burney thought that the rumours that the former had been mistress to the duc d'Orléans were not true, in which case it would not compromise Burney's reputation for respectability if they were known to be literary friends – the kind of information about two celebrity writers that would be bound to be 'leaked' to the cognoscenti if a correspondence began. To Burney's surprise – it seemed that de Genlis was so elegant and correct in anything she did – the queen informed her otherwise, and strongly urged her to keep her distance. This was doubtless reinforced by the queen's knowledge that the duc was a racing crony of George, Prince of Wales, and had drawn him into his circle of gambling for high stakes in cards and sport. Similarly, with La Roche, Frances was unsure how she should respond to her attempts to get herself introduced to the

princesses, but Miss Planta intervened on Burney's behalf to the queen; and again the queen confirmed Burney's initial instincts to shut off these advances, adding that if La Roche's entreaties had prevailed, it would have been an encouragement to her 'to bring foreigners forever to the lodge, wholly contrary to the pleasure of the King'.[96] Behind this was George III's own concern to avoid any impression that his court had too many foreign retainers being paid for by British taxpayers. Eventually, Burney was sufficiently confident that she could have some visitors of her own choosing, and invited a mix of Mrs Delany and her great-niece; two of Mrs Delany's set at St James's, the scholar Dr Bryant, and her eldest nephew Court Dewes; plus the new Windsor friend Miss Planta, to dine with her at Kew, 'and it all went very well'.[97]

Public recognition of Mrs Delany's *artistic* talent during her lifetime was made crystal clear in print during the same autumn of 1786, when Horace Walpole reprinted at Strawberry Hill the second edition of his *Anecdotes of Painting*. En passant, when mentioning the Duchess of Portland's collection of miniatures, he included the comment that Mrs Delany 'was a lady of excellent sense and taste, who painted in oil, and who at the age of 74 *invented* the art of paper mosaic, with which material (coloured) she executed, in eight years, within 20 of 1000 various flowers and flowering shrubs with a precision and truth unparalleled'. This was concise and unambiguous – and reflected Walpole's celebration of 'amateur' art, which he preferred to what he saw as the jaded hierarchies of the Royal Academy.[98]

MRS BOSCAWEN IN RICHMOND, AND MRS DELANY AT KEW

For a large part of 1786 Mrs Boscawen was preoccupied with her plans to move to Richmond. In spite of her confidence that it had better security than more distant Glanvilla, with night watchmen regularly calling out the hours after darkness, she actually had three break-ins before the final move, when minor items were stolen, despite domestic staff sleeping on the premises. Her new house, Rosedale Cottage, was the former home of the poet James Thomson, author of the well-loved poem *The Seasons*, and of the patriotic masque from the era of Frederick Prince of Wales, *Alfred*.[99] She described herself to Mrs Delany in August, sitting in her 35-foot-long drawing room, probably pondering how to furnish it, and then enjoying Horace Walpole popping in for a lively visit.

In December, Mary dictated a long letter to her friend Frances Hamilton, explaining how her time at Windsor was now interspersed with visits to Kew:

I believe you know nothing of my flights to Kew, which is about ten miles from this place. The Royal family once a fortnight take Kew in their way to London. They leave Windsor on Tuesday, and return on Saturday. Their majesties were so gracious as to hint their wish for my spending some days at Kew when they were there, and to make it completely agreeable and commodious, engaged Mr. and Mrs. Smelt, who live there, to invite me to *their house* – a pleasure of *itself*, that would have given me wings for the under-taking . . . I think you can hardly be a stranger to the character of Mr. Smelt, a man that has the honour of being *friend to the King* . . . Mrs. Smelt is very sensible, friendly, agreeable woman . . . They were visited more than once a day by their Majesties or some of the Royal family, which pleasure I had the honour of partaking. We were appointed to dine every day at Miss Burney's table, at the Lodge. [Kew Palace]. It is very magnificent, and the society very agreeable, of about eight or ten persons belonging to their Majesties. Coffee was ready about six o'clock; about seven the King generally walked into the room, and, after that, commanded me and Mrs. Smelt to follow him to the Queen's apartment, where we drank tea, and stayed till near ten o'clock.[100]

MRS DELANY AND THE YOUNGEST GRANVILLE

The New Year of 1787 did not work out as envisaged any more than 1786 had done. Mrs Delany came to London on 10 January, but almost immediately it was her health that gave way. She had already had a fever since the New Year, which had been dealt with by fasting and being bled twice, so of course that put her in a weakened state, contrary to the hopes of eighteenth-century medical practice. Her household took care of her assiduously, and she got over a 'putrid sore throat' and more feverish infections, but could not assure her friends she was really able to go out and about until the end of March. She explained to Mary Dickenson, now a mother, 'I am thank God, much better than I had reason to expect, yet far from being able to exert myself as I did before this late illness', and was able to go outside the house for just half an

hour at a time. She returned to Windsor at the start of May, and felt greatly complimented that she was the first to be called on by the king and queen when they also arrived on 12 May, bringing with them the oldest and youngest princesses, Charlotte and Amelia: 'It made my heart glad to see them look so well, and in such good spirits', she told Frances Hamilton. She was glad to find Frances Burney had recovered from illness, too. Always ready to be positive and appreciative of everyone's kind attention, she must have considered that the real silver lining to this whole cloud of debility was that when Georgiana did eventually return, by late May, it was in the company of the Rev. John's wife, Harriet, with their only child, another John Granville, together with his cousin Anne Dewes from Hagley. Young John was now to start school at Eton.

It would have meant a huge amount to the great-aunt to think that the perpetuator of the Granville name would be at Eton. Not only would it enable her to have him visit from time to time at Alban Street; it also multiplied his opportunities of being taken notice of by the king and queen, since they took especial notice of all the Eton boys. He would grow to young manhood under the royal eye, six generations after his great-great-grandfather Sir Bevill had devoted himself to the defence of Charles I. Perhaps she dreamt of his eventually obtaining a place at court, as a Groom of the Bedchamber or suchlike. When he went back to his parents for the August holidays, his great-aunt observed:

> *he is indeed* a treasure worth cultivating and preserving, and I am always delighted to have him when he can come to see me . . . I think he is happy to spend some time with you and his father to confirm those civilities in his behaviour which you have so well begun, and which the multiplicity of rude school boys, with whom he is engaged, will not promote, and I never met with a chid that takes reproof with more sweetness of temper . . . he is the darling of every individual in my family [household].

The younger boys at Eton lived in houses that included a matronly figure, always referred to as their dame, as well as a master, and Mrs Delany was glad to find that his was very maternal towards him.[101]

Mrs Delany was also engaging herself on behalf of her godson Daniel Sandford, still a student at Oxford. He was preparing a translation into French of a devotional work for Queen Charlotte; unfortunately nothing of it has survived and we do not even know what it was, except that it was by 'G', so

perhaps it was one of the lesser works of Charlotte's favourite theologian, Gellert. Also a grown young man was John Leveson-Gower, first child of Mary's distant Leveson-Gower cousin Admiral John, 'now grown a very companionable personage – the same for whom you us'd to make greyhounds and *hares* that look'd distress'd (tho' of white paper)'.

Mrs Boscawen's young relative Miss Sayer was staying with her, and she and two other ladies were much absorbed in organising a Sunday School for Richmond, at the queen's request. They had consulted the doyenne of religious education, Sarah Trimmer, who was very active in the initiative to establish these schools. Their aim was to make the pupils literate as well as religious. Sarah Trimmer was better known as the author of the best-selling children's book, *The Story of the Robins*. Mr Trimmer had an extensive brick-making business at Brentford that supplied the royal palaces with building materials. Many of their twelve children had a godparent from among the royal children, and some of her books were dedicated to the princesses.[102]

Altogether, then, Mary, as well as her friend, had plenty of the younger generation to absorb her interest and keep her looking forward. Mrs Frances Hamilton's daughter, Mrs Preston, came over to England in September 1787, and was amazed at how spry she found her to be. It was twenty years since she had last seen her when she and Patrick left Ireland:

> but I was soon set at ease, by seeing the same apprehension [comprehension], attention, benevolence, and comfortable enjoyment of every pleasant circumstance in her situation, that you remember in her. Her enquiries, her remarks, her whole conversation, full of *life* and *ingenuity*; and that kind heart and manner of expressing its feelings, as warm as ever. She is as *upright* and *walks as alertly*, as when you saw her.

Harriet Granville confirmed this evergreen quality in Mrs Delany, too, exclaiming in November 'she is astonishingly well for her age, and has the enjoyments of a much younger person'.[103]

Mrs Delany's return to London in New Year 1788 went much more smoothly than the previous two, but was overshadowed first by Emilia Clayton's death after the seriousness of her tuberculosis accelerated just before Christmas, and also by the sudden heart attack that ended Dr Lightfoot's life in February. In this winter of 1787–8 it was Mary's eldest nephew, Court, who was in

search of better health, and was wintering at Pau, in south-west France, hoping to benefit from its dryer climate, and to manage an extension of his trip as far as Spain. Otherwise his great-aunt had survived the winter very well, and on 4 March Mrs Astley wrote to Daniel Sandford from the London house: 'Mrs Delany I have the pleasure to inform you, is in very good health, and so is Miss Port.' The last letter that Lady Llanover was able to include was another one to the same godson, about his French translation for the queen, and his new 'botanical friendship' with John Sibthorp, the Sherardian Professor of Botany at Oxford.[104]

It was in pursuit of botanical pleasures, and to meet the royal family with her friends the Smelts at Kew, that Mrs Delany contracted a fatal chill there on 7 April 1788. Back at St James's Place, she was bled and blistered, and given quinine, despite her long-standing apprehension that this particular treatment would harm and not heal her. But at first it seemed to do her good, and her trusted physician Dr Turton confidently pronounced her to be on the mend by 13 April. But this was a false dawn, and to everyone's shock and disbelief, she passed away on 15 April, a month short of her eighty-ninth birthday. Her will requested that she be buried with 'as little expense . . . as decency would permit', so the funeral took place at her parish church, St James's, Piccadilly, a few steps from her London home.[105] Her friend Bishop Hurd composed the memorial tablet, still to be seen, which stated she was the daughter of Bernard Granville, and the niece of Lord Lansdowne: a soldier and a writer respectively – two professions she admired the most. It concluded with the tribute

She was a lady of singular ingenuity and politeness, and of unaffected piety. These qualities endeared her through life to many noble and excellent persons, and made the close of it illustrious by procuring for her many signal marks of grace and favour from their Majesties.

Coda

Soon after this biography was begun, the author was in Piccadilly and popped into St James's for another look at this memorial. The church, one of the most vibrant parishes in London, was busy with rehearsals for an Italian opera whose performers had unmistakeably Irish accents. Mrs Delany, who had feared that popular operas like *The Beggar's Opera* would crowd out the taste for Italian *opera seria*, would have been thrilled that it is not neglected, and indeed that there is an annual London Handel festival that includes his operas and oratorios. Almost opposite in St James's Piccadilly is the Royal Academy of Arts, which after a nineteenth-century hiatus resumed electing 'sister-painters'. Further down is the left turn to St James's Palace, its gateway unchanged since Mrs Delany's day, although some of the street configuration is altered. The monarchy continues, and its much-loved sovereign Elizabeth II became the longest-reigning monarch in British history in 2017. And the British are still a nation of gardeners and readers, stitchers and singers.

Cast of Characters

IMMEDIATE FAMILY

See also the Granville family tree, p. viii

JOHN GRANVILLE, 1st Earl of Bath m. JANE WYCHE, *grandparents*

LADY JOANNA THORNHILL, sister of 1st Earl of Bath, *great-aunt*

DENIS GRANVILLE, brother of 1st Earl of Bath; Dean of Durham and Jacobite; mentor of George, Lord Lansdowne (qv), *great-uncle*

BERNARD GRANVILLE m. ANNE WESTCOMBE, *parents*

ALEXANDER PENDARVES (1662–1724), MP and Cornish landowner, *first husband of Mary Delany*

THE GRANVILLE UNCLES

LORD GEORGE GRANVILLE

 m. MARY VILLIERS, widow of Thomas, 1st Viscount Weymouth

 THOMAS, 2ND VISCOUNT WEYMOUTH, *stepson*; inherits Longleat

 m. LOUISA CARTERET, daughter of John, 1st Earl Granville and 2nd Earl of Bath; *see also* CARTERET FAMILY

SIR BEVILL GRANVILLE, Governor of Barbados

THE GRANVILLE AUNTS

ANNE, m. Sir John Stanley, Irish baronet; Maid of Honour to Queen Mary II

ELIZABETH, d. unmarried

CAST OF CHARACTERS

MARY DELANY'S SIBLINGS

BEVILL (1705–36), aspiring writer, then clergyman; m. Mary A. Rose, d. in Jamaica

BERNARD, aka Bunny (1699–1775), Squire of Calwich, Derbyshire; friend of G.F. Handel and of Jean-Jacques Rousseau

ANNE (1707–61), wife, home educator of her children, correspondent of Sarah Sandford (qv) and Samuel Richardson (qv)

m. JOHN DEWES (1695–1780), lawyer then Squire of Wellesbourne, Warwickshire

THE DEWDROPS
Children of John and Anne Dewes

JOHN, baptised 23 July 1741

COURT (1742–93), d. unmarried

BERNARD (1743–93), m. ANNE DE LA BERE, *sister-in-law*; d. 1780; one child, Anne

MARY (1746–1816), m. John Port of Ilam, Derbyshire; eight children, including:

GEORGINA MARY PORT (1771–1830), later Georgianna, *Mary Delany's London companion*

GEORGE PORT (1774–94), Charterhouse pupil, nominated by Queen Charlotte; naval officer

JOHN (1744–1826), clergyman, heir to Uncle Bernard, m. HARRIET DE LA BERE, *sister-in-law*; one child, John, d. 1800

BEVILL, baptised 20 September 1747, buried 5 July 1748. The cathedral records do not mention burials for the Dewes children but this would be because they were not buried there

THE GRANVILLE COUSINS
Children of Lord George Granville and Mary Villiers,
including four daughters:

Hon. ANNE, aka 'Gran', Violet, Babess, Lady Abbess; unmarried

Hon. MARY, m. William Graham, Squire of Platten, Ireland

Hon. GRACE, aka the Princess, Primrose

m. Thomas Foley (created Lord Foley, 1st Baron of 2nd creation, 1776); seven children including:

Thomas, 2nd Baron of 2nd creation (1742–93), inherits Gt Witley estate; crony of Charles James Fox; gamester and Whig politician

Grace (1743–1813), m. James Hamilton, 2nd Earl of Clanbrasil, 2nd creation; founder knight of Order of St Patrick, 1783. Wedding performed by her half-uncle, Robert Foley, Dean of Worcester

Edward Foley (1747–1803), inherited Stoke Edith estate; Foxite Whig and gamester

Andrew Foley (1748–1816), father's executor and heir to Newport estate, m. cousin, Elizabeth Tomlinson, heiress of Boulter Tomlinson MP

Anne, m. Sir Edward Winnington, 2nd Baronet

Hon. ELIZABETH, aka Betty; unmarried; Maid of Honour then Woman of the Bedchamber to Augusta Princess of Wales

THE CARTERET COUSINS

Descendants of GRACE CARTERET, aka 'The Old Dragon', d. 1744, daughter of John Granville, 1st Earl of Bath. M. George Carteret, 1st Baron Carteret, as planned by their parents when the two were still children. The Carteret family were based in the Channel Islands. Grace became Countess Carteret in her own right in 1715

JOHN CARTERET, 2nd Baron Carteret, after 1744 also 2nd Earl Granville, son of Grace Carteret. Statesman; offices include Lord Lieutenant of Ireland (1724–30)

m. 1 FRANCES HORSLEY. Their children include:

GRACE, m. Lionel Tollemache, 2nd Earl of Dysart; owner of Ham House, Richmond

LOUISA, m. Thomas Thynne, 2nd Viscount Weymouth, owner of Longleat. Their son Thomas, 3rd Viscount Weymouth, was created 1st Marquess of Bath; m. Elizabeth Cavendish Bentinck, daughter of Margaret Cavendish Bentinck, 2nd Duchess of Portland (qv under EARLY FRIENDS)

FRANCES, m. John Hay, 4th Marquess of Tweeddale

GEORGINA, m. 1 Hon. John Spencer: son John Spencer, 1st Earl Spencer, m. Margaret Poyntz; their children include Georgiana, 5th Duchess of Devonshire, friend of Charles James Fox, Opposition Whig MP and gamester; m. 2 William, 2nd Earl Cowper as his second wife; godmother to Anne Granville and also to her daughter Mary Dewes

m. 2 Sophia Fermor, daughter of Earl and Countess Fermor (qv). One daughter, Sophia, m. William Petty, 2nd Earl of Shelburne. Statesman; architect of peace with USA in 1783

THE LEVESON-GOWER COUSINS

Descendants of JANE GRANVILLE (d. 1696), daughter of 1st Earl of Bath, who married SIR WILLIAM LEVESON-GOWER, 4th Baronet. His affair with his sister-in-law, Mary Osborne, wife of Charles, 2nd Earl of Bath, prompted the latter to leave England to fight in the continental wars against the Turks to recover Hungarian provinces following the defeat of the Turkish siege of Vienna in 1683. Jane and William's son John was created 1st Baron Gower in March 1702. Lord Gower's son and heir John was raised further in the peerage to become Earl Gower in 1746. His children from his first marriage included several daughters who married well, such as Gertrude, who as 4th Duchess of Bedford was an effective counterpart to her husband as Lord Lieutenant of Ireland, 1756–61, and an important political hostess for the Whig political faction named after the duke

Earl Gower's third wife was Mary Tufton (d. 1785), a keen gardener. As the Dowager Countess Gower she lived at Bill Hill, Berkshire, purchased after the death of her first husband, Anthony Grey, Earl of Harold. She became a close friend of Mary Delany and of Frances Boscawen (qv), whose daughter Frances married Countess Gower's second and only surviving son, Captain John Leveson-Gower. John and Frances Leveson-Gower had a total of eight children; the eldest b. 1774 (*see also* MARY DELANY'S LONDON COTERIE). Countess Gower's sister Margaret, m. Thomas Coke, 1st Earl of Leicester, builder of Holkham Hall, Norfolk, having already become Baroness de Clifford in her own right, in 1734, when her father died

MARY DELANY'S EARLY FRIENDS

JUDITH, LADY SUNDERLAND, née Tichbourne; m. 1 as third wife Charles Spencer, 3rd Earl of Sunderland, Whig statesman; great-nephew of Sarah Churchill, 1st Duchess of Marlborough. M. 2 Sir Robert Sutton, financier; one of their children is Judith Sutton, singleton and friend of Anne Donnellan (qv)

CATHERINE HYDE (Kitty), 3rd Duchess of Queensberry; daughter of Henry Hyde, 2nd Earl of Rochester, niece by marriage of Mary Delany's Leveson-Gower cousins (qv). Court insider, lady of fashion, patron of writer John Gay

CAST OF CHARACTERS

Jane Hyde, sister of Charles Calvert Lord Baltimore (qv) (NB no relation to Catherine Hyde, Duchess of Queensberry)

Charles Calvert, 5th Lord Baltimore; aka 'The American Prince' and 'The Basilisk'. Proprietor of the state of Maryland, USA. Suitor of Mary Delany after death of Alexander Pendarves. Great-grandson of Charles II through Lady Charlotte Fitzroy, daughter of Charles II's mistress Barbara Villiers, Duchess of Cleveland, and thus also distant cousin of George II through their common descent from James I, King of England. Lord Baltimore was a Gentleman of the Bedchamber to Frederick, Prince of Wales, and one of his close political confidantes. After the inconclusive courtship with Mary Delany he married Mary Janssen, daughter of a Huguenot banker. Lady Charlotte Fitzroy, who m. Edward Lee, 1st Earl of Litchfield, and her daughter, Elizabeth Lee, 4th Lady Baltimore, were both child brides, like Mary Delany's Carteret cousins Grace and Georgina Carteret. Elizabeth Lee, aunt of 5th Lord Baltimore, married first her cousin, Captain Francis Lee, then Rev. Edward Young, poet (qv)

Sarah Chapone (also Sally, Deborah, Sappho), née Kirkham. Mary Delany's first friend on leaving London for Gloucestershire. Granddaughter, daughter, niece, sister, wife, mother-in-law and grandmother of Anglican clergymen. Author of *The Hardship of the English Laws in Relation to Wives* (1735) and *Remarks on Mrs. Muilman's Letter* (1751) m. Rev. Daniel Chapone. Platonic friend of John Wesley, known later as the co-founder of Methodism. Correspondent of novelist Samuel Richardson, introduced to him by Anne Dewes. The Chapones have four children:

> John, lawyer, m. Hester Mulso, Bluestocking (qv)
>
> Harry, colonial administrator
>
> Sarah (Sally), Mary Delany's god-daughter, m. Rev. Daniel Sandford, Shropshire squire and parson, and have four sons: John (heir), Daniel (becomes Bishop of Edinburgh), Thomas (naval officer), Edward (lawyer)
>
> Katherine, m. as second wife Sir John Boyd, merchant and art collector, owner of Danson House in Lewisham

Catherine Collingwood, early friend of Mary Delany; marries as second wife Sir Robert Throckmorton, member of significant Catholic family, estate at Coughton Court, Alcester, Warwickshire. They introduce Anne Granville to John Dewes in Bath

CAST OF CHARACTERS

MARY CATHERINE WALLINGFORD, Lady Wallingford; daughter of John Law, disgraced Scottish financier who created a financial 'bubble' in France in 1720 parallel to the South Sea Bubble in London the same year. Wife of William Knollys, titular 4th Viscount Wallingford, MP for Banbury. One of the Patriot Ladies following parliamentary debates in 1739

ANNE, LADY COLLADON, wife to Sir Theodore Colladon, Chief Physician at Royal Hospital, Chelsea, residence for Army veterans

 MRS GEORGE MONTAGU, their daughter, aka 'My Mrs Montagu', 'Mrs Montagu of Hanover Square' (in contrast to Bluestocking hostess, Mrs Montagu neé Robinson, of Portman Square). 'My Mrs Montagu' married George Montagu MP, Auditor to Frederick and then Augusta, Prince and Princess of Wales. Two children:

 Frederick Montagu MP. Creates garden at Papplewick, Northamptonshire, advised by William Mason, clergyman, poet and garden theorist, and improves estate. Mary Delany refers to him as her 'son' when his mother dies. Inherits fortune from George Montagu, principal correspondent of Horace Walpole (*see also* under MARY DELANY'S LONDON COTERIE)

 Anne Montagu, m. Dr John Fountayne, Dean of York; one son, Thomas

ROBERT HARLEY, 1st Earl of Oxford, leading Tory statesman in reign of Queen Anne, m. Elizabeth Foley. The Foley family make one of the first industrial fortunes in seventeenth-century Britain and acquire lands and political influence in Worcestershire, Herefordshire and Gloucestershire. Elizabeth's sister Sarah Foley married Robert Hafley's brother Edward. Grandparents of Margaret, 2nd Duchess of Portland (qv). Elizabeth and Sarah's brother Thomas created 1st Baron Foley of Kidderminster 1712, 1st creation, one of 13 peers created to ensure a majority in House of Lords in 1713 to agree to Peace of Utrecht ending war with Spain. (George Lord Lansdowne (qv) is also a 'Utrecht' peer.) Estate at Witley Park, Worcs; London House in Hanover Square. Children include:

EDWARD HARLEY, 2nd Earl of Oxford; son of Robert Harley. Collector and connoisseur, estate at Wimpole, nr Cambridge. m. Henrietta Holles, heiress to John Holles, 1st Duke of Newcastle; one daughter, Margaret, 2nd Duchess of Portland (qv)

ABIGAIL HARLEY, sister of Edward and Robert Harley, m. George Hay, 8th Earl of Kinnoul; he followed George Granville as MP for Fowey 1710–11. Also a

CAST OF CHARACTERS

Utrecht English peer, as Baron Hay of Pedwardine, Herefordshire. Imprisoned 1715–17 for suspected Jacobite sympathies. Their heir, Thomas, 9th Earl (courtesy title Lord Dupplin), was key figure in Commons to Duke of Newcastle administration

THE PORTLAND CIRCLE

MARGARET CAVENDISH BENTINCK, 2nd Duchess of Portland; m. William Bentinck, 2nd Duke of Portland. They have five children:

William, 3rd Duke, Lord Titchfield until he inherits dukedom; m. Lady Dorothy Cavendish, sister of 4th Duke of Devonshire

George, m. Elizabeth, daughter of Rev. Richard Cumberland, clergyman and playwright

Elizabeth, m. Thomas 3rd Viscount Weymouth, later 1st Marquess of Bath, inherits Longleat (*see also* under George Granville, Lord Lansdowne). Children include Hon. Louisa Thynne, m. Heneage Finch, 4th Earl of Aylesford (qv)

Harriet, m. Lord George Grey, 5th Earl of Stamford; seat at Burleigh House, Stamford, Lincolnshire

Margaret, d. of scarlet fever

FRIENDS IN WARWICKSHIRE/OXFORDSHIRE

LADY ANNE COVENTRY (*see under* LITERARY MEN AND WOMEN)

HENEAGE FINCH, 1st Earl of Aylesford, father of Mary Finch and Heneage Finch, 2nd Earl of Aylesford

MARY FINCH, m. William, Viscount Andover, heir to earldoms of Suffolk and Berkshire, who predeceases his father. Seat at Elford, Derbyshire

HENEAGE FINCH, 4th Earl of Aylesford, estate at Packington, Warwickshire. Marries Hon. Louisa Thynne, daughter of Elizabeth, viscountess Weymouth, later marchioness of Bath, and granddaughter of Margaret Cavendish-Bentinck, 2nd Duchess of Portland (qv)

WILLIAM LEGGE, 2nd Earl of Dartmouth, statesman. Step-son of Lord Guilford and step-brother to Lord North (qv). Methodist, Abolitionist and supporter of new industry. Estate at Sandwell Hall between Birmingham (Warwickshire) and West Bromwich (Staffordshire); also at Lewisham nr London

SANDERSON MILLER, gentleman architect and antiquarian; estate at Radway, Warwicks, nr Wellesbourne

CAST OF CHARACTERS

Mrs George Montagu (*see under* MARY DELANY'S EARLY FRIENDS, Lady Ann Colladon)

Mrs Edward Montagu, née Elizabeth Robinson, Bluestocking hostess (*see under* LITERARY MEN AND WOMEN)

Sir Charles Mordaunt, MP for Warwickshire; estate at Walton d'Elville; Mary Delany designs stucco for his bath house

Frederick North, 1st Earl of Guilford, Gentleman of the Bedchamber to Frederick, Prince of Wales; Secretary to Queen Charlotte. Estates at Wroxton, Banbury, near Banbury/Warwickshire border; and Waldershare, Kent

Lord Frederick North, son and heir to Lord Guilford, inherits as 2nd Earl of Guilford; George III's first minister 1770–82

George Frederick North, son and heir to the above, becomes 3rd Earl of Guilford; Secretary and Comptroller to Queen Charlotte

LITERARY MEN AND WOMEN

Mary Astell (1666–1731), devout Anglican, Cartesian philosopher and author of *A Serious Proposal to the Ladies* (1696) and *Some Reflections on Marriage* (1702). Her writings were still in circulation in Warwickshire in 1750s

Bishop Fenelon, French bishop, tutor to Louis XIV's grandson, the Duke of Burgundy, for whom he wrote the educational fable *Telemachus*; also author of *Treatise on the Education of Women* (1697)

George ballard, trained as a tailor, based originally in Chipping Campden, Gloucestershire, he became a self-educated antiquarian at Magdalen College, Oxford, and a feminist historian of women. Compiler of *Memoirs of Several Ladies of Gt Britain*, 2 vols, 1752. The second volume was dedicated to Mary Delany with her reluctant consent. Her sister and her Warwickshire circle helped to find subscribers for its publication

Mrs Barber (*see under* IRISH FRIENDS)

Frances Burney, novelist and would-be biographer of Mary Delany. Daughter of Charles Burney, musicologist, whose *History of Music* was dedicated to Queen Charlotte. Father and daughter were both friends of Dr Johnson, the literary critic, lexicographer and public moralist. Frances was also a protégé of Mary Delany, who facilitated her public appointment in 1785 as Queen Charlotte's 2nd Keeper of the Robes and informal role as Reader

Lady Anne Coventry, bibliophile, devotional writer and philanthropist. Friend of Mary Astell (qv). Daughter of Henry Somerset, 1st Duke of Beaufort,

and long-lived widow of Thomas Coventry, 2nd Earl of Coventry; resident of Snitterfield, Warwickshire

JUDITH DRAKE, author of *An Essay in Defence of the Female Sex* (1696), dedicated to Princess Anne

ELIZABETH ELSTOB, protégé of Mary Delany and Sarah Chapone; Anglo-Saxon scholar; Mary Delany obtains pension for her from Queen Caroline, consort of George II; after queen dies 1737, Elstob becomes governess to daughters of Duchess of Portland

LOUISA FERMOR, 1st Countess Fermor, friend of Frances Seymour, and fellow Lady of the Bedchamber to Queen Caroline; letter-writer; her daughter Charlotte, m. Hon William Finch, became governess to children of George III and Charlotte

ANNE FINCH, 2nd Countess of Winchilsea. Mary Delany's favourite poet. Née Kingsmill, m. Col. Heneage Finch, later 5th Earl of Winchilsea. Great-aunt to Francis Horsley, first wife of Earl Carteret (qv)

MARY HAMILTON, Bluestocking; sub-governess to royal princesses 1777–83. Granddaughter of 3rd Duke of Hamilton, daughter of a career soldier, niece of Sir William Hamilton, diplomat and antiquarian; m. John Dickenson, Derbyshire squire. In London lived in Clarges St near to Elizabeth Carter, Bluestocking and classical scholar. Visitor in 1784 to Duchess of Portland and Mary Delany at Bulstrode; Mary Delany hoped she might marry her eldest nephew, Court Dewes (*see also* MARY DELANY'S LONDON COTERIE)

BATHSUA MAKIN, author of *An Essay to Revive the Ancient Education of Gentlewomen* (1673) and governess to Charles I's youngest daughter, Elizabeth

MARY, LADY WORTLEY MONTAGU, wit, satirist and letter writer; muse of Alexander Pope; woman of letters, friend and London neighbour of Henrietta Countess of Oxford (qv)

 Daughter Mary, m. John Stuart, 3rd Earl of Bute, favourite of George III; estate at Luton Hoo. Gardener and botanist respectively. Their youngest daughter Lady Louisa Stuart, singleton; companion to her mother, traveller and historian

SAMUEL RICHARDSON, printer, publisher and novelist. Centre of London literary circle and correspondent of Anne Dewes, Anne Donellan and the younger Judith Sutton

ELIZABETH ROBINSON (1718–1800); m. Edward Montagu, 1742, coal owner and mathematician, grandson of Edward Montagu, 1st Earl of Sandwich. Aka

Mrs Montagu, 'Queen of the Blues'; Bluestocking hostess, patron, philanthropist. London houses in Hill Street, then Portman Square, country residence Sandleford Priory, Berkshire

SARAH ROBINSON, sister of Elizabeth Robinson, m. George Lewis Scott, mathematician and preceptor to George III when he was Prince of Wales. Separated from her husband at instigation of her father and brothers. Subsequently shared her home with Lady Barbara Montagu, sister of George Montagu Dunk, 2nd Earl of Halifax. Novels include *A Description of Millennium Hall* (1762)

FRANCES SEYMOUR, née Thynne, Countess of Hertford, ward of Lord Carteret until marriage to Lord Algernon Seymour, heir of 6th Duke of Somerset; Lady of the Bedchamber to Queen Caroline; patron of non-conformist moralist Elizabeth Singer Rowe, and novelist Charlotte Lennox; letter-writer

THE THREE SCANDALOUS MEMOIRISTS: three mid-century autobiographical writers who in different ways used their memoirs to illustrate the pitfalls of eighteenth-century marriage and the vulnerability of woman with no money:

CONSTANTIA PHILLIPS, subsequently Mrs Muilman. Her harrowing memoir of teenage seduction by an exploitative aristocrat, *An Apology for the Conduct of Mrs Constantia Phillips* (1748), was anonymously critiqued by Sarah Sandford (qv), at the invitation of novelist and publisher Samuel Richardson

LAETITIA PILKINGTON (1709–50), poet, early biographer of Jonathan Swift, beneficiary of Patrick Delany (*see also under* IRISH FRIENDS)

FRANCES, LADY VANE, estranged wife of William, 2nd Viscount Vane, second cousin once removed to Margaret, 2nd Duchess of Portland (qv). Vane's sentimental self-justifying narrative of her two marriages and serial amours is interpolated into Tobias Smollett's novel *The Adventures of Peregrine Pickle* (1756)

JONATHAN SWIFT *see under* IRISH FRIENDS

SIR GEORGE WHELER, author of *The Protestant Monastery; or Christian Œconomicks* (1698). Nephew by marriage of 1st Earl of Bath. Landowner and polymath

EDWARD YOUNG, clergyman and poet, earned British and Continental fame for 'Night Thoughts', 1742–5; tutor to Mary Delany's younger brother

Bevill and suitor to Mary Delany (*see also under* Charles Calvert, 5th Lord Baltimore)

IRISH FRIENDS

MARY BARBER, society versifier and wife of a Dublin draper. One of several female poets encouraged by Jonathan Swift

RUPERT BARBER, son of Mary Barber, talented miniaturist in enamel, protégé of Mary Delany who sat for him to encourage others to commission portraits. He and his family were neighbours to the Delanys at Delville

GEORGE BERKELEY, Bishop of Cloyne, Ireland. Theologian, philosopher and philanthropist. Led unsuccessful attempt to found a university in Bermuda to train clergy who would convert Native North Americans to Christianity; his supporters included the Percival/Donnellan network. Mary Delany admired him and his wife while considering their domestic piety too severe

LAETITIA BUSHE, gentlewoman and talented topographical artist who inspired Mary Delany to improve her drawing on returning to London after the first Irish visit. Welcome house guest at Delville during winter months after Mary Delany married when she did not socialise in Dublin

KATHERINE CLAYTON, aka Cardinella; sister of Anne and Christopher Donnellan; wife of Bishop Robert Clayton of Killala, Ireland. She and her husband were host and hostess to Anne and Mary Delany on the latter's first visit to Ireland 1731–3. Subsequently Mary Delany and Patrick looked after Anne Donnellan during her visits to Ireland to settle protracted litigation with her sister over their brother Christopher's fortune

PATRICK DELANY, Mary Delany's second husband (1686–1768). Theologian and author; friend of Jonathan Swift; founder member of Dublin Society; Chancellor of Christchurch, Dublin; Dean of County Down. M. 1, 1731, Mrs Margaret Tennison, propertied widow, d. 1741; m. 2, 1743, Mary Delany. Had Dublin rooms at Trinity College in Dublin and villa and garden, Delville, at Glasnevin, 7 miles from the capital

ANNE DONNELLAN, friend of Mary Delany. Aka 'Don', 'Sylvia' and 'Philomel' for her remarkably fine singing voice. Step-daughter of Philip Perceval, and step-niece of Sir John Percival, 4th Baronet and 1st Earl of Egmont (Irish peerage), both sons of Sir John Percival 3rd Baronet. Donnellan's mother, Martha, née Usher, had first married Nehemiah Donnellan, Lord Chief

Baron of the Irish Exchequer. The Percivals, Donnellans and Ushers were prominent Anglo-Irish families who occupied high positions in the Church of Ireland, the legal profession and Irish politics. The Percivals were also active in Westminster politics. Mary Delany introduced Anne to Elizabeth Robinson (qv), Bluestocking. She used her inherited wealth to build her own house in Charles Street, London, after her mother died

DOROTHY FORTH HAMILTON, one of three sisters née Forth whom Mary Delany first met in Dublin in 1731. She was a talented amateur painter of flowers. Not to be confused with 'My Mrs Hamilton', wife of Mr Henry Hamilton of Dunleer, whom Mary Delany considered to be her 'chief female friend' after she moved to Dublin

Rev. MATTHEW PILKINGTON and his wife Laetitia. Both were poets who were made much of by Swift, who was amused by their diminutive stature. His mischievous tactics put Matthew at odds with Alexander Pope, and the former's desertion of Laetitia and their children caused her great hardship

JONATHAN SWIFT (1667–1745), Britain's greatest satirist and Ireland's greatest eighteenth-century Patriot. Best known for *Gulliver's Travels* (1726). His appreciation of Mary Delany's conversational and epistolary talent conferred great kudos on her

ELIZABETH VESEY, leading Bluestocking hostess, from a prominent Anglo-Irish family based in Lucan, Ireland. M. 1 William Hancock, Irish MP; his sister became her lifelong friend and household manager. M. 2 Agmondisham Vesey, her cousin. She had a better knack of making her guests feel relaxed at her London soirées than did Mrs Montagu

MARY DELANY'S LONDON COTERIE

FRANCES BOSCAWEN, Bluestocking and gardener. Descendant of John Evelyn, diarist, bibliophile and polymath, through his grandson Sir John Evelyn's marriage to Anne Boscawen, sister of Hugh, 1st Viscount Falmouth. Evelyn's study of trees, *Sylva* (1670), was reprinted in 1776; Frances evidently inherited his love of tree planting. Married Edward Boscawen, third son of Viscount Falmouth, one of Britain's most able and popular admirals, in 1742. Her husband gave Robert Adam one of his first commissions to build his country house, Hatchlands, in Surrey. After his death in 1761 Frances became a notable hostess in her London home in South Audley Street. Two

of her three sons predeceased their mother and the last inherited the Falmouth title from his uncle. The Boscawens were a leading political family in Cornwall, usually at odds with the Granvilles and Pendarves. Her daughter Frances, b. 1746, married the Hon. John Leveson-Gower (qv); her daughter Elizabeth, b. 1747, m. Henry Somerset, 5th Duke of Beaufort, and had twelve children. Their country seat was at Badminton, Gloucestershire

RICHARD HURD, Bishop of Worcester, Church of England prelate, writer and aesthetic theorist. Archdeacon of Gloucester and eventually Bishop of Worcester. His residence at Hartlebury would have been the royal residence if France had invaded after 1792 when the revolutionary wars began. Tutor to the Prince of Wales and his brother Frederick, Duke of York; friend of both the king and queen, who had a picture of him in her bedroom at Kew Palace

LORD GUILFORD (qv)

DOWAGER COUNTESS LEVESON-GOWER (qv)

Rev. WILLIAM MASON, Church of England priest, aesthetic theorist and garden designer; ardent Yorkshireman and supporter of the Yorkshire Association, a lobby group for parliamentary reform. His curate Christopher Alderson assisted Queen Charlotte with designing the gardens at Frogmore. Politically a supporter of the Rockingham Whigs, led by the 3rd Duke of Portland after the marquis of Rockingham's death. His poem *The English Garden* acknowledges the taste of the 2nd Viscount Newnham and shares the tastes of Mary Delany

'MY MRS MONTAGU' and her son FREDERICK MONTAGU, MP (qv)

DUCHESS OF PORTLAND and her two daughters (qv) LOUISA COUNTESS OF WEYMOUTH, Mistress of the Robes to Queen Charlotte, and HENRIETTA COUNTESS OF STAMFORD

MARY STUART, 3rd Countess of Bute (qv), and her unmarried daughter the Hon. LOUISA STUART, historian and traveller

LEONARD SMELT and his wife Jane, military engineer who helped redesign Windsor landscape. Greatly respected by George III who made him Deputy Governor of his two eldest sons 1771–81. In London, he moved in literary and artistic circles centred on Dr Johnson's Club, including Charles and Frances Burney. Queen Charlotte made available a cottage at Kew for him and his wife Jane where Mrs Delany stayed in the last few years of her life

Notes

INTRODUCTION

1. *Letters of Lady Louisa Stuart to Miss Louisa Clinton*, ed. Hon. James Home (Edinburgh: David Douglas, 1901), 2 vols, vol. 1, 52–3.

1 MISS MARY GRANVILLE

1. The evidence for this secret past only came to light in 2004, thanks to the assiduous research by Dr Francesca Suzanne Wilde in the papers of Lady Llanover's father, Benjamin Waddington, who married Mary's great-niece, Georgianna Mary Port. Francesca Suzanne Wilde, London Letters (1720–28) written by Mary (Granville) Pendarves to her sister, Anne Granville, in Gloucester. A sequence from the Autobiography and Correspondence of Mary Delany (1700–88), formerly Mary Pendarves, née Granville, PhD thesis, University of York, April 2005, etheses.whiteroseac.uk/9843, pp. 26–7, and Appendices 1 and 2.
2. His legal wife was Lady Mary Somerset, daughter of the 1st Duke of Beaufort.
3. It subsequently came into the possession of their son Bernard, as Mary's brother Anthony Westcombe had no heirs.
4. Elizabeth Crittall, ed., *A History of the County of Wiltshire*, Victoria County History, vol. 8, 234–9, accessed online.
5. Ibid., 234–9.
6. Frances Harris, *Transformations of Love: The Friendship of John Evelyn and Margaret Godolphin* (Oxford: Oxford University Press, 2003); Roy A. Sundstrom, 'Godolphin, Sidney, first Earl of Godolphin (1645–1712)', www.oxforddnb.com/view/10.1093/ref:odnb/9780198614128.001. 0001/odnb-9780198614128-e-10882.
7. 'Granville, Hon. John (1665–1707)', www.historyofparliamentonline.org/1690-1715/member/
8. General Monck had been made Duke of Albemarle.
9. In 1702 George was one of several men of letters and MPs who contributed to a new translated anthology of the speeches of the ancient Greek orator Demosthenes, first proclaimed when Athens was preparing for war with Philip of Macedon. The translations were a coded way of encouraging the elite to nerve itself to fight France again. Elizabeth Handyside, *Granville the Polite: The Life of George Granville, Lord Lansdowne, 1666–1735* (London: Oxford University Press, 1933), and 'Granville, Hon. John (1665–1707)', www.historyofparliament online.org/1690-1715/member/

10. Lady Llanover, ed., *The Autobiography and Correspondence of Mary Granville, Mrs Delany* (London: Richard Bentley, 1861–2), 6 vols, vol. 1, 8 (henceforth Llanover vol.: pp.).
11. Ibid. 13.
12. J.C. Sainty and R.O. Bucholz, *Officials of the Royal Household 1660–1837* (London: University of London Institute of Historical Research, 1997 & 1998), 2 vols; for an expanded online version see *Office-Holders in Modern Britain: Volume 11 (Revised), Court Officers, 1660–1837*, ed. R.O. Bucholz (London, 2006), British History Online, http://www.british-history.ac.uk/office-holders/vol11; *The Database of Court Officers 1660–1837*, www.luc.edu./history/fac_resources/bucholz/DCO/DCO.html.
13. 'Granville, Hon. John (1665–1707)', www.historyofparliamentonline.org/1690–1715/member/
14. Bucholz, ed., *Office-Holders in Modern Britain: Volume 11*; Craig Rose, *England in the 1690s: Revolution, Religion and War* (Oxford: Blackwell, 1999).
15. Hannah Smith, 'Mary Astell, *A Serious Proposal to the Ladies* (1694), and the Reformation of Manners in Late-17th-century England', in William Kolbrener and Michal Michelson, eds, *Mary Astell: Reason, Gender, Faith* (Aldershot: Ashgate, 2007), 31–49, at 41.
16. Unfortunately this has now disappeared.
17. Llanover 1: 3.
18. Miss Bertie was one of two daughters born out of wedlock by 'Elizabeth Allen, called Mrs Pulteney', to Peregrine Bertie, son of the 3rd Earl of Lindsey, the Vice-Chancellor. Llanover 1: 3.
19. Smith, 'Mary Astell'; Bridget Hill, 'Judith Drake' (fl. 1696–1723), ODNB online https://doi.org/10.1093/ref:odnb/37370
20. Mary Astell, *A Serious Proposal to the Ladies*, ed. P. Springborg (Peterborough, ON: Broadview Literary Texts, 2002), p. 23.
21. Ibid.; Ruth Perry, *The Celebrated Mary Astell, An Early English Feminist* (Chicago: University of Chicago Press, 1986).
22. Llanover 1: 5–6.
23. See note 9.
24. HoC, ODNB.
25. See Cast of Characters.
26. Judith Tichborne was a niece of Sir John Stanley's sister-in-law. She came from a gentry family in Hampshire who could trace their estates there back to the twelfth century. Llanover 1: 8.
27. Pat Rogers, *Pope and the Destiny of the Stuarts: History, Politics and Mythology in the Reign of Queen Anne* (Oxford: Oxford University Press, 2005).

2 CORNISH BRIDE

1. David Burnett, *Longleat: The Story of an English Country House* (Wimborne, Dorset: The Dovecote Press, 1988).
2. Llanover 1: 22.
3. *The Spectator*, no. 10 (12 March 1711), in Joseph Addison and Richard Steele, *Selections from The Tatler and the Spectator*, ed. Angus Ross (Harmondsworth: Penguin, 1982).
4. Steele, Richard [George Berkeley], *The Ladies Library, written by a Lady* (London: Jacob Tonson, 1714), 3 vols, vol. 2, 20.
5. Adam Nicolson, *Gentry: Six Hundred Years of a Peculiarly English Class* (London: Harper, 2012).
6. Llanover 1: 22.
7. V.H.H. Green, *The Young Mr. Wesley* (London: Edward Arnold, 1961), 215.
8. Llanover 1: 82.
9. Ibid. 335, 425.
10. Ibid. 22–3.
11. The original play is attributed to Thomas Doggett, aficionado of the Kit-Kats: Michael Evenden, 'Flora's Descent; or Hob's Re-Re-Re-resurrection', *Eighteenth Century Studies* 44(4) (2011): 565–7.
12. Henry L. Snyder, 'Spencer, Charles, third Earl of Sunderland (1675–1722)', ODNB online, https://doi.org/10.1093/ref:odnb/26117.
13. Llanover 1: 23.

14. Ibid. 24.
15. Ibid. 27–8.
16. Ibid.
17. Ibid. 29.
18. Ibid.
19. Ibid.
20. Ibid.
21. Ibid.
22. Ibid. 30.
23. Ibid. 47.
24. Ibid. 37, 53.
25. Ibid. 38.
26. Ibid. 44.
27. Ibid.
28. Ibid. 39.
29. Ibid. 38–40, 50.
30. Ibid. 50.
31. Ibid. 50–1.
32. Ibid. 49.
33. Lady Lansdowne alludes to initial success with investments, and the end of the Bubble – and thus of financial opportunities – in June 1721. Llanover 1: 59. It is more than likely Pendarves had mirrored his friends' investment.
34. Ibid. 62–3.
35. Information from leaflet available at Buckland, now a hotel: Anon., *Buckland Manor*.
36. Llanover 1: 62–3.
37. Isobel Grundy, *Lady Mary Wortley Montagu, Comet of the Enlightenment* (Oxford: Oxford University Press, 1999).
38. Llanover 1: 99.
39. E.g. ibid. 79, 104.
40. Ibid. 70.
41. Ibid. 84.
42. Ibid. 85.
43. Ibid. 90.
44. Ibid. 90–1.
45. Ibid. 100–1.
46. Ibid. 94.
47. Ibid. 95.
48. Ibid. 107.

3 THE NEW WIDOW AND THE AMERICAN PRINCE

1. Llanover 1: 109.
2. Ibid.
3. Lady Mary Wortley Montagu, *Essays and Poems and Simplicity, a Comedy*, eds Robert Halsband and Isobel Grundy (Oxford: Clarendon Press, 1977); the article appeared in *The Spectator*, no. 573 (28 July 1714).
4. Llanover 1: 113–14.
5. Ibid. 109.
6. Ibid. 111–12.
7. Ibid. 106.
8. Ibid. 130.
9. Ibid. 129.
10. Caroline Heighway et al., *Gloucester Cathedral: Faith Art and Architecture: 1,000 Years* (London: Scala Publishers, 2011).

11. E.g. Michèle Cohen, *Fashioning Masculinity: National Identity and Language in the Eighteenth Century* (London: Routledge, 1996).
12. Cited from Wesley's unpublished diary by Green, *Wesley*, 208–9.
13. Varenese is sometimes identified with Mary Pendarves but Green (ibid.) shows clearly that the correct identification is Sarah Kirkham.
14. Cf. Lady Hertford's friendship with Elizabeth Singer Rowe, discussed in Marjorie Reeves, *Female Education and Nonconformist Culture 1700–1900* (Leicester: Leicester University Press, 2000), 19–42. Robert Kirkham's notice of Elizabeth Kirkham's interest in Wesley is cited in Green, *Wesley*, 214.
15. Ibid. 216.
16. Ibid. 214.
17. Llanover 1: 139.
18. These must have been cousins on her mother's side.
19. Llanover 1: 150; the phrase concludes 'to make the nauseous draft of life go down'.
20. Ibid.
21. Ibid. 250–1.
22. Ibid. 168 and 207–8.
23. Myra Reynolds, ed., *The Poems of Anne, Countess of Winchilsea* (Chicago: University of Chicago Press, 1903), ciii, cxvii, cxv; 'Countess of Winchilsea, Anne Finch', www.poetryfoundation.org/bio/anne-finch.
24. Isobel Grundy, 'Lady Mary Wortley Montagu and Her Daughter: The Changing Use of Manuscripts', in George L. Justice and Nathan Tinker, eds, *Women's Writing and the Circulation of Ideas: Manuscript Publication in England, 1550–1800* (Cambridge: Cambridge University Press, 2002), 182–201.
25. Llanover 1: 133.
26. Ibid. 131.
27. Ibid. 132.
28. Ibid. 133.
29. Ibid. 152–3 for all quotes in this paragraph.
30. Ibid. 158.
31. M.A. Stewart, 'Berkeley, George (1685–1753)', ODNB online, https://doi.org/10.1093/ref:odnb/2211
32. 'Perceval, John (1683–1748)', 'Perceval, John (1711–70)' and 'Oglethorpe, James Edward (1696–1785)', all in www.historyofparliamentonline.org/1715-1754/member; Betty Wood, 'Perceval, John, first Earl of Egmont (1683–1748)', https://doi.org/10.1093/ref:odnb/21911; Clive Wilkinson, 'Perceval, John, second Earl of Egmont (1711–1770)', www.oxforddnb.com/view/article/21912; Betty Wood, 'Oglethorpe, James Edward (1696–1785)', www.oxforddnb.com/view/article/20616.
33. Llanover 1: 155–6.
34. Ibid. 164–5.
35. Ibid. 177.
36. Ibid. 179.
37. Andrew C. Thompson, *George II, King and Elector* (London: Yale University Press, 2011); Michael Schaich, 'The Heir over the Waters: Frederick Louis, Future Prince of Wales, in Hanover', unpublished paper given at Society for Court Studies Conference, 'Heirs and Spares', Oxford, 19–20 September 2013. I am grateful to Dr Schaich for letting me see this paper and for our discussions about Prince Frederick.
38. Llanover 1: 187.
39. Ibid. 184–6, 189–90.
40. Ibid. 190.
41. Llanover 1: 192.
42. Ibid. 194.
43. Institute of Historical Research, *Office-Holders in Modern Britain, Household of Princess Caroline 1721–27*, https://www.history.ac.uk/resources/office/caroline-alpha, and *Office-*

Holders in Modern Britain, Household of Queen Caroline 1727–37, https://www.history.ac.uk /publications/office/queencaroline.

44. The couple had sixteen children, ten of whom died in infancy; two more sons died in their teens as junior naval officers, and one died in a duel.

45. Llanover 1: 203, 205.

46. Mark Laird and Alicia Weisberg-Roberts, eds, *Mrs. Delany and her Circle* (New Haven, CT: Yale University Press, 2009), 133–4.

47. Ibid. 218.

48. Ibid. 228–9.

49. Ibid. 230.

50. Ibid. 134.

51. Ibid. 233.

52. Ibid. 233.

53. Ibid. 241. I am indebted here to Faramerz Dabhoiwala's discussion of this courtship in *The Origins of Sex: A History of the First Sexual Revolution* (London: Allen Lane, 2012).

4 IRISH IDYLL

1. Llanover 1: 241.

2. Ibid. 236–7.

3. Ibid. 241.

4. Ibid. 254–5.

5. Mary stayed there on her return from Ireland, in June 1734. Ibid. 478. 'She is very good-humoured and easy, and the place is the finest of its kind in England.'

6. Ibid. 242.

7. Ibid. 247.

8. 'Jansen, Sir Theodore', www.historyofparliamentonline.org/1714-1754/member.

9. Llanover 1: 253.

10. Ibid. 272.

11. Mechtild Gretsch, 'Elstob, Elizabeth (1683–1756)', ODNB online https://doi.org/10.1093/ ref:odnb/8761.

12. Elizabeth Elstob, *An English-Saxon Homily on the Birth of St Gregory* (London: W. Bowyer, 1709).

13. Llanover 1: 264.

14. Ibid. 284.

15. Ibid. 263, 271.

16. Ibid. 275.

17. Ibid. 274–5; 342 for edited version of her comment on Lord Tyrconnel. The unedited version cited here is from Angélique Day, ed., *Letters from Georgian Ireland: The Correspondence of Mary Delany 1731–68* (Belfast: Friar's Bush Press, 1991), 4, citing the mss original at Newport Public Library. Readers in 1861 would not have liked to think of Mrs Delany using the exclamation 'Hang My Lord Tyrconnel'.

18. Llanover 1: 274.

19. Graham Reynolds, 'Zincke, Christian Frederick (1684?–1767)', ODNB online, https://doi. org/10.1093/ref:odnb/30295.

20. Llanover 1: 283.

21. B. Earnshaw and T. Mowl, *An Insular Rococo* (London: Reaktion Books, 1999), 160–2.

22. Ibid.

23. Llanover 1: 288–9, 305.

24. Ibid. 289.

25. Ibid. 294.

26. Ibid. 332.

27. Ibid. 292.

28. Ibid. 301.

29. Eoin Maginnin, 'Coal, Corn and Canals: Parliament and the Dispersal of Public Moneys 1695–1772', in D.W. Hayton, ed., *The Irish Parliament in the Eighteenth Century: The Long Apprenticeship* (Edinburgh: Edinburgh University Press for the Parliamentary History Yearbook Trust, 2001), 71–86; Edith Mary Johnston, *Ireland in the Eighteenth Century* (Dublin: Gill & Macmillan, 1974), 90–4; John Turpin, *A School of Art in Dublin since the Eighteenth Century* (Dublin: Gill & Macmillan, 1995), 10–11, 64.

30. M. Dunleavy, 'Samuel Madden and the Scheme for the Encouragement of Useful Manufactures', in A. Bernelle, ed., *Decantations* (Dublin: Lilliput Press, 1992), 21–8, and James Livesey, 'The Dublin Society in Eighteenth-century Irish Political Thought', *Historical Journal*, 47(3) (2004): 615–40.

31. On 25 November 1731 Mary told Anne 'we dined at Dr. Madden's, who always enquires after you'. Llanover 1: 315, note.

32. Margaret Anne Doody, 'Swift and Women', in Christopher Fox, ed., *The Cambridge Companion to Jonathan Swift* (Cambridge: Cambridge University Press, 2003), 87–111.

33. Llanover 1: 343–4; for neglected correspondents, 349.

34. Ibid. 297–9.

35. Ibid. 315, 343–4, 411.

36. Ibid. 344.

37. Ibid. 342.

38. S.J. Connolly, 'A Woman's Life in Mid-eighteenth-century Ireland: The Case of Letitia Bushe', *The Historical Journal*, 43(2) (June 2000): 433–51.

39. Llanover 1: 336, 370, 373–4.

40. Ibid. 340.

41. Ibid. 338.

42. Ibid. 345.

43. http://visionsofthepastblog.com/2012/08/19/dangan-castle-summerhill-co-meath/; Llanover 1: 348–9.

44. Ibid. 364.

45. Ibid. 372.

46. B. Rand, ed., *The Correspondence of George Berkeley and Sir John Perceval* (Cambridge: Cambridge University Press, 1914), 281.

47. Llanover 1: 297.

48. Charles Pratt Camden, *The Reverend Patrick Delany, Appellant . . . Thomas Tenison and others . . . Respondents* (London, 1758).

49. Ibid. 375. This area of Ireland has many religious sites dating back to prehistory.

50. Ibid. 379. Faussett is identified by David Woolley, ed., *The Correspondence of Jonathan Swift* (New York: Peter Lang, 2007), 4 vols, vol. 3, 648–9, Letter 1042, Mary Pendarves to Jonathan Swift, 29 May 1733.

51. Llanover, 1: 386, italics in the original. For 'improvements', see Toby Barnard, *Making the Grand Figure: Lives and Possessions in Ireland 1641–1770* (New Haven, CT: Yale University Press, 2004).

52. Llanover 1: 396, 402.

53. Ibid. 396. Mary was subscribing to the four-volume edition of Jonathan Swift's *Works*, published in Dublin in 1735.

54. Kelly died that October in England where she had gone to benefit from the Bristol spa waters.

55. Llanover 1: 405.

56. Ibid. 406–7.

57. Burnett, *Longleat*, 101–3.

58. Llanover, 1: 411–13, original italics.

5 WOMAN OF FASHION

1. Cited www.regencyhistory.net/2014/04/the-society-of-dilettanti.html.

2. Llanover 1: 414–15; also in David Woolley, ed., *The Correspondence of Jonathan Swift* (New York: Peter Lang, 2007), 4 vols, vol. 3, Letter 1042.

3. As her uncle said to Mary, 'my necessary retreat from the world, and his necessary appearance in it, have kept us asunder more of late than I could wish'; Llanover 1: 419, Lord Lansdowne to Mary Pendarves, no date but near to 24 October 1733. Bathurst's son destroyed evidence that his father had been implicated in the Atterbury Plot of 1722, after which Lansdowne had left England to join the Pretender in France. James Lees-Milne, *Earls of Creation: Five Great Patrons of Eighteenth-Century Art* (London: Century Hutchinson with the National Trust, 1996).
4. Llanover 1: 420–1. Also in Woolley, ed., *Correspondence of Swift*, vol. 3, Letter 1066.
5. Llanover 1: 428.
6. Ibid., 419.
7. Richard G. King, 'Anne of Hanover and Orange (1709–59) as Patron and Practitioner of the Arts', in Clarissa Campbell Orr, ed., *Queenship in Britain, 1660–1837: Royal Patronage, Court Culture, and Dynastic Politics* (Manchester: Manchester University Press, 2002).
8. Veronica Baker-Smith, *Royal Discord: The Family of George II* (London: Athena Press, 2008), and idem, *A Life of Anne of Hanover, Princess Royal* (Leiden: EDJ Brill, 1996), pp. 193–206.
9. Llanover 1: 437.
10. Ibid. 442–5.
11. Ibid. 1: 448–9, italics in the original.
12. Ibid. 446.
13. Ibid. 109, italics in the original.
14. Llanover 1: 457.
15. Ibid. 492.
16. Ibid. 491.
17. Llanover 1: 458.
18. Ibid. 461, 476–7.
19. Ibid. 461, 465.
20. Ibid. 472–4.
21. Ibid. 478. In the event, the Percevals and Don did not go to Dublin until the following autumn.
22. Louise Lippincott, *Selling Art in Georgian London: The Rise of Arthur Pond* (New Haven, CT: Yale University Press for the Paul Mellon Centre for Studies in British Art, 1983). Unfortunately Lippincott identifies Anthony Westcomb as Mary's uncle, not her cousin, and Lord Lansdowne as her grandfather, not her uncle.
23. Susan Jenkins, 'Lady Burlington at Court', in Edward Corp, ed., *Lord Burlington – The Man and his Politics: Questions of Loyalty* (Lewiston: Edward Mellen Press, 1998), pp. 149–79.
24. Lucy Worsley, 'Female Architectural Patronage in the Eighteenth Century and the Case of Henrietta Cavendish Holles Harley', *Architectural History*, 48 (2005): 139–62.
25. Llanover 2: 33.
26. Cf. ibid. 20.
27. Ibid. 1: 618.
28. Llanover 1: 485, 30 June 1734. At this point Mary seems to be sticking to landscapes without colour.
29. Ibid. 6: 499.
30. Louise Lippincott, 'Arthur Pond's Journal of Receipts and Expenses , 1734–1750', *The Walpole Society*, 54 (1988): 220–333. See also Kim Sloan, 'Industry from Idleness? The Rise of the Amateur in the Eighteenth Century', in Michael Rosenthal, Christiana Payne and Scott Wilcox, eds, *Prospects for the Nation: Recent Essays in British Landscape, 1750–1880* (New Haven, CT: Yale University Press for the Paul Mellon Centre for British Art, 1997), 285–305.
31. Llanover 1: 608.
32. Lippincott, 'Arthur Pond's Journal of Receipts and Expenses', 220–33.
33. For Goupy, Llanover 1: 498; 2: 32 and 505. For the duchess's two lessons from Bernard Lens, ibid. 1: 609.
34. Llanover 1: 347.
35. Ibid. 498, 534.

36. Kim Sloan, 'Mrs Delany's Paintings and Drawings: Adorning Aspasia's Closet', in Laird and Weisberg-Roberts, eds, *Mrs. Delany and her Circle*, 100–29.
37. Llanover 1: 184.
38. Ibid. 590.
39. Ibid. 612.
40. E.g. ibid. 426, in February 1733–4; and ibid. 594, in March 1737.
41. Ibid. 485.
42. Ibid. 579. In 1734 he was appointed organist at St Martin-in-the-Fields (present-day Trafalgar Square).
43. Ibid. 596.
44. Ibid. 370, for Mary recommending that Sarah read Dr Berkeley and Dr Delany; ibid. 395 for quote on Sarah's raptures.
45. Ibid. 487.
46. Green, *Wesley*, 214.
47. Douglas Hay, 'Property, Authority and the Criminal Law', in Douglas Hay et al., eds, *Albion's Fatal Tree: Crime and Society in Eighteenth-century England* (London: Allen Lane, 1975), 17–63, and, for clerical JPs, Paul Langford, *Public Life and the Propertied Englishman, 1689–1798* (Oxford: Oxford University Press, 1991), 411–20.
48. Bodleian Libraries, Ballard MSS, microfiche 43: 20, Sarah Chapone to Elizabeth Estob, 11 January 1735. Later Sarah also had to delay passing on some of the subscriptions she had collected for Ballard because her husband had not been paid money owed to him. Ballard MSS, microfiche 43: 159, Sarah Chapone to George Ballard, 11 January 1751/2.
49. Llanover 2: 39. Benson was installed as Bishop in 1735.
50. Ibid. 137.
51. Amy M. Froide, *Never Married: Singlewomen in Early Modern England* (Oxford: Oxford University Press, 2005), esp. chapter 6, 'Spinsters, Superannuated Virgins, and Old Maids: Representations of Single Women', 154–81, passim.
52. Barbara J. Todd, ' "To be some body": Married Women and the Hardships of the English Laws ', in Hilda L. Smith, ed., *Women Writers and the Early Modern British Political Tradition* (Cambridge: Cambridge University Press, 1998), 343–60.
53. Patrick Delany, *Revelation Examined with Candour, by a professed friend to an honest freedom of thought in religious enquiries* (London, 1732), 3 vols, vol. 1, 5. Samuel Richardson later reprinted this book for Dr Delany: Thomas Eaves and Ben Kimpel, *Samuel Richardson: A Biography* (Oxford: Clarendon Press, 1971), 42.
54. Woolley, ed., *Correspondence of Jonathan Swift*, vol. 4, Letter 1154.
55. Llanover, 1: 497–8, note.
56. Ibid. 528.
57. Ibid. 531.
58. Woolley, ed., *Correspondence of Jonathan Swift*, vol. 4, Letter 1154, Anne Donnellan to Jonathan Swift, 10 May 1735.
59. Llanover 1: 532, 534.
60. This and preceding paragraph, ibid., 539 and 540, note.
61. Llanover 1: 501.
62. Ibid. 615, 562.
63. Ibid. 501.
64. Ibid. 556.
65. Three years later John Perceval married Lady Catherine Cecil, a daughter of the 5th Earl of Salisbury.
66. George Collingwood had estates in Eslington in Northumberland, where the duke had extensive properties
67. Llanover 1: 606; for more on the Throckmortons, Nicolson, *Gentry*, 45–68.
68. Ibid. 2: 118
69. Ibid. 1: 574.
70. Ibid. 565.

71. Ibid. 2: 21–2.
72. Llanover 2: 15.
73. Norma Clarke, *The Rise and Fall of the Woman of Letters* (London: Pimlico, 2004), 74–7.

6 CONTENTED ASPASIA

1. Lady Hastings was a doyenne of fashion, but within a few years a leader of her own 'connection' in the Methodist religious revival led by Mary's old friend John Wesley.
2. Llanover 2: 45.
3. Ibid. 44–5.
4. Ibid. 1: 115, 314.
5. See Cast of Characters.
6. Discussion and illustrations of embroidered court dress in Clare Browne, 'Mrs. Delany's Embroidered Court Dress', in Laird and Weisberg-Roberts, eds, *Mrs Delany and her Circle*, 66–79.
7. Llanover 2: 71–2.
8. Ibid. 79
9. Elizabeth (Robinson) Montagu to Mrs Robinson, 1740, 22 July, MO 4712, Elizabeth Robinson Montagu Papers, The Huntington Library, San Marino, California.
10. Llanover, 2: 77.
11. Ibid. 75.
12. Lady Llanover's suggestion; ibid. 78.
13. J.M. Blatchly, 'D'Ewes, Sir Simonds, first baronet (1602–1650)', ODNB online, https://doi.org/10.1093/ref:odnb/7577; H.R. Tredder, Rev. I. Gadd, 'D'Ewes, Garrat (b. in or before 1533, d. 1591)', ODNB online, https://doi.org/10.1093/ref:odnb/7574; Llanover 2: 90, note.
14. Woolley, ed., *The Correspondence of Swift*, vol. 3, Letter 1042; ibid. vol. 4, Letter 1154; Llanover 2: 81.
15. Elizabeth (Robinson) Montagu to Anne Donnellan, 1740, 21 August MO 809, Elizabeth Robinson Montagu Papers, The Huntington Library, San Marino, California.
16. Ibid., 1740, 3 August, MO 808, Elizabeth Robinson Montagu Papers, The Huntington Library, San Marino, California.
17. Llanover 2: 91, 95–6.
18. Ibid. 97–8, 161–2.
19. Ibid. 107.
20. Ibid. 115.
21. Ibid. 131–2.
22. Ibid. 116, 131.
23. Ibid. 151.
24. Elizabeth (Robinson) Montagu to her sister Sarah Robinson Scott, 1740, 1 December, MO 5569, Elizabeth Robinson Montagu Papers, The Huntington Library, San Marino, California.
25. He stayed on in the prince's household as Gentleman Usher of the Black Rod.
26. Elizabeth (Robinson) Montagu to the duchess, 1739, 18 July, MO 277 A, Elizabeth Robinson Montagu Papers, The Huntington Library, San Marino, California.
27. Elizabeth (Robinson) Montagu to the duchess, 1740, 21 June, MO 272, Elizabeth Robinson Montagu Papers, The Huntington Library, San Marino, California.
28. Elizabeth Montagu, *The Letters of Mrs. Elizabeth Montagu with Some of the Letters of Her Correspondents*, ed. Matthew Montagu (London: T. Cadell et al., 1809–13), 4 vols, vol. 1, 17–21.
29. A fragment of a letter to her sister Sarah Robinson Scott, shows she is about to write to Mrs Pendarves for the first time and is clearly a bit nervous. Elizabeth (Robinson) Montagu to Sarah Robinson Scott, 1740, August (no exact date), MO 5543, Elizabeth Robinson Montagu Papers, The Huntington Library, San Marino, California.
30. Elizabeth (Robinson) Montagu to her mother, 1740, 27 May, MO 4708 Elizabeth (Robinson) Montagu to her sister, 1740, 25 June, about Mrs Pendarves accompanying her to cold baths,

MO 293, Elizabeth Robinson Montagu Papers, The Huntington Library, San Marino, California.

31. Elizabeth (Robinson) Montagu to Duchess of Portland 1740, 25 January, MO 290 A, Elizabeth Robinson Montagu Papers, The Huntington Library, San Marino, California.

32. Elizabeth (Robinson) Montagu to Sarah Robinson Scott, 1740, 20 August, MO 5543, Elizabeth Robinson Montagu Papers, The Huntington Library, San Marino, California.

33. Elizabeth (Robinson) Montagu to Sarah Robinson Scott, 1740, June (no exact date), italics added, MO 5527 A, Elizabeth Robinson Montagu Papers, The Huntington Library, San Marino, California.

34. Elizabeth Einberg et al., *Manners and Morals: Hogarth and English Painting 1700–1760* (London: Tate Gallery Publications, 1987), 148–9.

35. Elizabeth (Robinson) Montagu to Sarah Robinson Scott, 1740, 27 August, MO 5544, Elizabeth Robinson Montagu Papers, The Huntington Library, San Marino, California. Original spelling and punctuation.

36. Llanover 2: 146–9.

37. Elizabeth (Robinson) Montagu to Duchess of Portland, 1741, 17 May, MO 299, Elizabeth Robinson Montagu Papers, The Huntington Library, San Marino, California.

38. Llanover 2: 135–6.

39. Ibid. 140.

40. Harold Forster, *Edward Young: The Poet of the Night Thoughts, 1683–1765* (London: The Erskine Press, 1986), p. 29, note.

41. Elizabeth (Robinson) Montagu to Sarah Robinson Scott, 1740, 8 October, MO 5556, Elizabeth Robinson Montagu Papers, The Huntington Library, San Marino, California. The series of seven satires was collected as *Love of Fame* in 1728, and reprinted constantly. James E. May, 'Young, Edward (bap. 1683, d. 1765)', ODNB online, https://doi.org/10.1093/ref:odnb/30260.

42. Ruth McClure, *Coram's Children: The London Foundling Hospital in the Eighteenth Century* (New Haven, CT: Yale University Press, 1981). Elizabeth (Robinson) Montagu to Anne Donnellan, 1740/1, 1 January, MO 813, Elizabeth Robinson Montagu Papers, The Huntington Library, San Marino, California.

43. *The Complaint, or Night Thoughts on Life, Death and Immortality*, was published in nine parts between 1742 and 1746.

44. Forster, *Edward Young*; Henry Pettit, ed., *The Correspondence of Edward Young 1683–1765* (Oxford: The Clarendon Press, 1971), 100–1.

45. Ibid. 129.

46. Forster, *Edward Young*, 168–71. E.g. Pettit, *Correspondence*, p. 313, on *Clarissa*, and Llanover 3: 92.

47. Llanover 2: 176–80, 'Aspasia's picture, drawn by Philomel, in the year 1742'.

48. Ibid. 153.

49. Ibid. 166–7, see also ibid. 137.

50. Ibid. 172–3.

51. Pettit, ed., *Correspondence*, p. 133. This Sir Thomas Hanmer should not be confused with Lord Egmont's son-in-law, who died in 1737.

52. D.W. Hayton, 'Hanmer, Sir Thomas, fourth baronet (1677–1746)', ODNB online, https://www.oxforddnb.com/view/10.1093/ref:odnb/9780198614128.001.0001/odnb-9780198614128-e-12205.

53. Llanover 2: 185–7, 189–90.

54. Ibid.

55. Elaine Chalus, *Elite Women in English Political Life c. 1754–1790* (Oxford: Clarendon Press, 2004).

56. Elizabeth (Robinson) Montagu to Sarah Scott Robinson, no date: in Box 4, covering 1740, MO 5560, Elizabeth Robinson Montagu Papers, The Huntington Library, San Marino, California.

57. Llanover 2: 198, italics in the original.

58. Ibid. 204.
59. Ibid. 208.

7 MRS DELANY

1. Llanover 2: 210–12.
2. Elizabeth (Robinson) Montagu to Anne Donellan, 1742, 10 October, MO 5560, Elizabeth Robinson Montagu Papers, The Huntington Library, San Marino, California.
3. Elizabeth (Robinson) Montagu to the duchess, 1743, 15 August, MO 5560, Elizabeth Robinson Montagu Papers, The Huntington Library, San Marino, California.
4. Llanover 2: 213–14.
5. Ibid. 215.
6. Ibid. 169; 3: 74.
7. This is made explicit in Llanover 3: 74.
8. Llanover 2: 130.
9. Roderick Clayton, 'Cottrell, Sir Clement (1686–1758)', ODNB online, https://doi.org/10.1093/ref:odnb/6399.
10. Llanover 2: 20.
11. Ibid. 219–21. On William Kent's work at Rousham for General Dormer, Julius Bryant, 'From Gusto to Kentissime: Kent's Designs for Country Houses, Villas and Lodges', and John Dixon Hunt, 'Landscape Architecture', in Susan Weber, ed., *William Kent: Designing Georgian Britain* (New Haven, CT: Published for Bard Graduate Center: Decorative Arts, Design History, Material Culture, New York, by Yale University Press, 2013), 221–2, including illustration of library, and 382–7.
12. Llanover 2: 222.
13. Ibid. 226, 282, original emphasis; Thomas Keymer, *Richardson's Clarissa and the Eighteenth-century Reader* (Cambridge: Cambridge University Press, 1992).
14. Llanover 2: 227.
15. Ibid. 265.
16. Ibid. 282; Keymer, *Richardson's Clarissa*.
17. Llanover 2: 260.
18. Ibid. 229 and 230.
19. Ibid. 234, 238, 521.
20. Ibid. 230, 234, original emphasis.
21. Ibid. 241.
22. Ibid. 251.
23. Jonathan Bardon, ' "The Finest Composition of Musick that was Ever Heard": Ireland's Role in Securing Handel's *Messiah* for Posterity', *Handel News* 60 (January 2017): 5–8. I owe this reference to Dr Kenneth Campbell. Idem., *Hallelujah: The Story of a Musical Genius and the City That Brought his Masterpiece to Life* (Dublin: Gill & Macmillan, 2015), 291, 267.
24. Llanover 2: 235.
25. Ibid. 269, 277, 284.
26. Ibid. 244, 268, 287,
27. Ibid. 274, 279
28. Ibid. 267,291
29. Michael Phillips' Ships of the Old Navy website, *Solebay*, www.ageofnelson.org/MichaelPhillips/info.php?ref=5897.
30. Llanover 2: 287–8, original emphasis.
31. Ibid. 291, 293.
32. Ibid. 295.
33. Ibid. 299.
34. Ibid. 289.
35. Ibid. 294.
36. Ibid. 297.

37. Ibid. 300, Mary's italics.
38. Ibid. 301.
39. Ibid., 285.
40. Ibid. 25–6, 290–1.
41. Ibid. 309.
42. Ibid. 309–11, 312.
43. Ibid. 314–15.
44. Ibid. 315–16.

8 THE DUTIES OF A DEAN'S WIFE

1. The Hon. and Rev. Francis Hamilton was a son of James, 6th Earl of Abercorn (1661–1734).
2. Llanover 2: 321; Patrick Delany, *Essay toward Evidencing the Divine Origin of Tithes* (Dublin, 1748), introductory note. Ballee church took until 1749 to complete and Bright until 1745.
3. Llanover 2: 329–30.
4. Ibid. 339.
5. Ibid. 333, 345–7.
6. Neil Jefarres, *Dictionary of Pastellists before 1800*, online edition, www.pastellists.com.
7. Llanover 2: 429.
8. Ibid. 335.
9. Ibid. 340.
10. Ibid. 339.
11. Ibid. 339.
12. Ibid. 338, 341.
13. Ibid. 341.
14. Ibid. 342.
15. Ibid. 343.
16. Toby C. Barnard, *The Abduction of a Limerick Heiress: Social and Political Relations in Mid-eighteenth-century Ireland* (Dublin: Irish Academic Press, 1998).
17. Llanover 2: 348–53.
18. Ibid. 359, original emphasis.
19. Ibid. 360.
20. Ibid. 367, 369, 375. See *A Midsummer Night's Dream*, Act 2, scene 1, 249–52.
21. Llanover 2: 362.
22. Ibid. 363, 378.
23. Ibid. 380.
24. Ibid. 391.
25. Ibid. 400.
26. Ibid. 394.
27. Ibid. 395–6.
28. Ibid. 409.
29. Ibid. 367, 364.
30. Ibid. 386.
31. Ibid. 408, 411.
32. Ibid. 426.
33. Ibid. 422–3.
34. Ibid. 433.
35. Ibid. 429.
36. Ibid. 433.
37. Ibid. 432.
38. Ibid. 436.
39. Ibid. 442.
40. Ibid. 469.
41. Ibid. 443.

42. Ibid. 447, 450–1.
43. Ibid. 448.
44. Ibid. 448.
45. Ibid. 451.
46. Ibid. 458.
47. Ibid. 3: 460, 465.
48. Ibid. 484
49. Jonathan Swift, *Directions to Servants*, Foreword by Colm Tóibín (London: Hesperus Press, 2005), 25, 8.
50. Llanover 2: 481.
51. Ibid. 402–3.
52. I owe this observation on the timing to Norma Clarke.
53. My account follows Norma Clarke, *Queen of the Wits: A Life of Laetitia Pilkington* (London: Faber & Faber, 2008); Laetitia Pilkington, *Memoirs of Laetitia Pilkington*, ed. A.C. Elias (Athens, GA: University of Georgia Press, 1997), 2 vols; and Lynda C. Thompson, *The Scandalous Memoirists: Constantia Phillips, Laetitia Pilkington, and the 'Shame of Publick Fame'* (Manchester: Manchester University Press, 2000).
54. Pilkington, *Memoirs*, ed. Elias, vol. 1: 49.
55. Ibid. 1: 301.
56. Pilkington, *Memoirs*, ed. Elias, vol. 1: 229–30.
57. Llanover 3: 312. The Bulstrode circle shared this verdict.
58. As noted by both Elias and Thompson.
59. Llanover 2: 492.
60. Ibid. 299.
61. Ibid. 499–500.
62. Ibid. 502.
63. Ibid. 507.
64. Ibid. 516.
65. Ibid. 518.
66. Ibid. 520.
67. Ibid. 522–3
68. Ibid. 526–7.
69. Ibid. 546, 558.
70. Ibid. 2: 552, 554, 566.
71. Ibid. 553, 557.
72. Ibid. 558.
73. Ibid. 546 for Lady Arabella Derry.
74. Stella Tillyard, *Aristocrats: Emily, Caroline, Louisa and Sarah Lennox, 1740–1832* (London: Chatto & Windus, 1994); Llanover 2: 565.
75. Llanover 2: 559, 563.
76. Ibid. 559, 561, 572.
77. Ibid. 556.
78. Ibid. 584–5.
79. Ibid. 560, 566.
80. Ibid. 572.
81. My warmest thanks to Dr Brenda Collins for helping me find the site of this in July 2013. Sadly it is now a roofless ivy-covered ruin, situated near Downpatrick and overlooking Lough Longford. *Archaeological Survey of Northern Ireland, County Down* (Belfast: HMSO, 1966) gives details of the interior when it was intact in the early 1960s.
82. Llanover 2: 575.
83. Ibid. 576.
84. Ibid. 581.
85. Ibid. 582, 588–9.
86. Ibid. 592, 94, 600.

9 LIFE, LOVE AND LITERATURE IN THE WELLESBOURNE CIRCLE

1. Anna Barbauld, *Correspondence of Samuel Richardson, selected from the original manuscripts, . . . to which are prefixed a biographical account of that author, and observations on his writings* (London: R. Phillips, 6 vols, 1804), 4: 25–6.

2. *The Diaries of Sanderson Miller of Radway*, ed. William Hawkes (Stratford-upon-Avon: Dugdale Society in association with Shakespeare Birthplace Trust, 2005), 14, 234, 27.

3. Llanover 3: 64, 66. The Highgrove estate is now the home of HRH Prince Charles but the house is different. 'Barrow, Charles (1707–89), of Highgrove, Glos.', www.historyof parliamentonline.org/volume/1754-1790/member/

4. Llanover 3: 284, 307.

5. Jennifer Meir, *Sanderson Miller and his Landscapes* (Chichester: Phillimore Press, 2006).

6. Llanover 3: 455, 457.

7. *Receipt Books c. 1575–1800 from the Folger Shakespeare Library, Cookery Books 17 c*, Adam Matthews Publications, British Library Ms Add 277, Reel 7. I am indebted to Felicity Roberts for telling me about this recipe book.

8. Llanover 2: 601.

9. Ibid.

10. I have explored the themes of this chapter more extensively in my article 'The Sappho of Gloucestershire: Sarah Chapone and Christian Feminism', in Deborah Heller, ed., *Bluestockings Now!* (Farnham: Ashgate, 2015), 91–110.

11. Tom Keymer, 'Bradshaigh, Dorothy, Lady Bradshaigh (bap. 1705, d. 1785)', www.oxforddnb. com/view/article/39721. Anne sent her sister copies of letters from 'the Lancashire Lady' but although Mary considered them written with 'great vivacity and wit' she disagreed with her assessment of *Clarissa*. Llanover 2: 620.

12. Llanover 2: 137.

13. Victoria and Albert Museum, National Art Library, Forster Collection XII, SC to SR, 25 April 1750, 129/1.

14. Ibid., SC to SR, 15 December 1750, 129/1.

15. SR-SC 18 April 1752, Forster MSS XII, 2, ff. 62–73.

16. Sarah Chapone to George Ballard, 2 March 1743/4, Bodleian Library, Oxford, Ms Ballard, microfiche 43: 136; for Dean Delany approving Ballard's life of Margaret Roper, ibid. 43: 138, same to same.

17. Sarah Talbot to George Ballard, ibid. 43: 195, 198–200. Mrs Talbot cites the parable from Matthew 7: 24–7.

18. Bodleian Library, Oxford, Ms Ballard, microfiche 43: 171, drafts of the dedication to Mrs Delany.

19. Barbauld, *Correspondence of Samuel Richardson*, 4: 42.

20. Llanover 3: 257.

21. Barbauld, *Correspondence of Samuel Richardson*, 4: 15.

22. Llanover 3: 10.

23. Ibid. 33, italics in the original.

24. John L. Bullion, 'To Play What Game She Pleased without Observation', in Campbell Orr (ed.), *Queenship in Britain*, 207–35.

25. Llanover 3: 21, 23, 25. Mary still considered that *some* of the pension to 2nd Viscount Weymouth's man of business, a Mr Wilson, who got £1,000, could have reasonably been divided between the two women.

26. Ibid. 25.

27. Mary mentions their mutual interest in the theories of John Hutchinson; Llanover 3: 94.

28. Barbauld, *Correspondence of Samuel Richardson*, 4: 73, 21 June 1751. Richardson means that the new town houses were sometimes squeezed in onto the former stable and service areas of established locations.

29. Ibid. 107 and 36.

30. Ibid. 126.
31. Mrs Delany observed this arrangement in 1755: Llanover 3: 332.
32. Ibid. 56.
33. Barbauld, *Correspondence of Samuel Richardson*, 4: 111, 129–30, 132.
34. Ibid. 139.
35. Llanover 3: 185, 198.
36. Llanover 3: 283, 285.
37. Ibid. 48.
38. Ibid. 55.
39. Ibid. 90.
40. Ibid. 51.
41. Ibid. 57.
42. Ibid. 456.
43. See: www.ballyd.com/history/annedonnellan.htm.
44. Llanover 3: 96.
45. Ibid. 393.
46. Ibid. 545.
47. Llanover 3: 469.

10 THE LAWSUIT YEARS

1. Llanover 3: 82, italics in the original.
2. Ibid. 205.
3. Ibid. 144, also 149.
4. Ibid. 77.
5. Ibid. 101, 103.
6. Ibid. 108.
7. Ibid. 138–40.
8. Ibid. 141, 148, 153.
9. Ibid. 147, 149–50.
10. Ibid. 171, 174.
11. Deborah Wilson, *Women, Marriage and Property in Wealthy Landed Families in Ireland, 1750–1860* (Manchester: Manchester University Press, 2009).
12. Llanover 3: 190
13. George Lucy, 1714–84, never married and was often in poor health. He was an early patron of Thomas Gainsborough in Bath, and commissioned Capability Brown to relandscape the grounds at Charlecote Park, famous for being where William Shakespeare had poached some deer. Quotations from Llanover 3: 285.
14. Llanover 2: 485; see also www.abingdon.org.uk/our_history/.
15. I am very grateful to the school's archivist, G.N. Frykman, for answering my queries and allowing me to draw on his history of the school. Llanover 3: 248 corrects RLE's faulty memory in his *Memoirs*.
16. Llanover 2: 485.
17. Ibid. 3: 48, 85, 178, 247.
18. Ibid. 58, 187, original emphasis.
19. Ibid. 2: 622, 618.
20. [Juliana-Susannah Seymour], John Hill, *On the Management and Education of Children* (London: R. Baldwin, 1754).
21. Llanover 3: 218.
22. Ibid. 237.
23. Ibid. 27–8.
24. E.g. ibid. 74, 333.
25. Ibid. 2: 237, 3: 92.

26. Ibid. 3: 541.
27. Ibid. 207, original emphasis.
28. Ibid. 2: 560.
29. Lady Llanover identifies this Lady Mansel with Amy Cox, wife of the Welsh baronet Sir William Mansel. But I suggest it may have been Lady Barbara Mansel, sister-in-law to Mary's uncle Lord Lansdowne, widowed in 1750.
30. Llanover 3: 163.
31. Ibid. 29–30, 219.
32. Ibid. 247.
33. Ibid. 253.
34. Ibid. 262, 241.
35. Ibid. 262.
36. Ibid. 263.
37. Ibid. 267–9.
38. Ibid. 275–6, original emphasis.
39. Ibid. 278.
40. Ibid. 4: 248.
41. John Boyle, *Remarks on the Life and Writings of Dr Jonathan Swift* (Dublin, 1st edn 1751); Patrick Delany, *Observations upon Lord Orrery's Remarks on the life and writings of Dr. Jonathan Swift: Containing several singular anecdotes relating to the character and conduct of that great genius, and the most deservedly celebrated Stella. In a series of letters to his Lordship* (Dublin: R. Main, 1754).
42. Llanover 3: 287.
43. Ibid. 300.
44. Ibid. 342–3; original emphasis in the quote.
45. Ibid. 294–5.
46. Ibid. 302, 306, 296.
47. Ibid. 272.
48. Ibid.
49. Lanover 3: 379.
50. Ibid. 3: 419–20.
51. Ibid. 383.
52. Ibid. 314, 316.
53. Ibid. 314–15, 322–3, 325–7.
54. Ibid. 326, 339–40.
55. Ibid. 352.
56. Ibid. 356–7.
57. Ibid. 359, 408.
58. Ibid. 362, 364–5.
59. Ibid. 397–8.
60. Ibid. 334, original emphasis.
61. Ibid. 394.
62. Ibid.
63. Ibid. 363.
64. Ibid. 392.
65. Ibid. 393.
66. Ibid. 424.
67. Ibid. 427.
68. Ibid. 408.
69. Ibid. 437.
70. Ibid. 438.
71. Ibid. 448.
72. Lucy Worsley, 'Female Patronage in the Eighteenth Century and the Case of Henrietta Cavendish Holles Harley', *Architectural History*, 48 (2005): 138–62.
73. Llanover 3: 445.

74. Ibid. 455.
75. Ibid. 448–52.
76. Ibid. 453.
77. Ibid. 458.
78. Ibid. 459, original emphasis.
79. Ibid. 462.
80. Ibid. 475–6.
81. Ibid. 493.
82. Ibid. 489.
83. Ibid. 490–2; Camden, *The Reverend Patrick Delany, Apellant*.

11 FROM GLADNESS TO SADNESS

1. Olive Baldwin and Thelma Wilson, 'The Young family (per. c.1700–1799), Musicians', ODNB online, https://doi.org/10.1093/ref:odnb/69663. Cecilia Young had a meagre allowance from Arne, some income from compositions, and financial support from her niece before and after the latter's marriage.
2. Llanover 3: 550, original emphasis. Hugh Maclean, 'Bernard Granville, Handel and the Rembrandts', *The Musical Times*, 126(1712) (October 1985): 593–601.
3. Llanover 3: 587; David J. Golby, 'Geminiani, Francesco Saverio, 1687–1762', ODNB online, https://doi.org/10.1093/ref:odnb/38886.
4. Llanover 3: 501–4, 511.
5. Ibid. 504–5, 508–9.
6. Llanover 3: 530.
7. Ibid. 530.
8. Ibid. 537.
9. H. M. Scott, 'Thynne, Thomas, third Viscount Weymouth and first Marquess of Bath (1734–1796)', ODNB online, https://doi.org/10.1093/ref:odnb/27425; Llanover 3: 547, 564.
10. E.g. Llanover 3: 531, 574.
11. Ibid. 543, 545–6.
12. Ibid. 538, 556.
13. Ibid. 558.
14. Ibid. 566.
15. Ibid. 2: 626; this was in December of 1750.
16. Ibid. 3: 363.
17. Ibid. 542.
18. Ibid. 565, 372.
19. Ibid. 571.
20. E.g. Llanover 3: 557, 569–70.
21. Ibid. 568.
22. Ibid. 579. First published in London by Samuel Richardson in 1758. Patrick subscribed for six copies of the Dublin edition, printed by Hulton Bradley.
23. E.g. Llanover 3: 548, 556, 579, quote from 574.
24. Ibid. 626.
25. Ibid. 582–3.
26. Ibid. 592.
27. Lorraine was a French-speaking duchy and, until 1766, part of the Holy Roman Empire.
28. Llanover 3: 600.
29. *Magasin des adolescentes: ou dialogues entre une sage gouvernante, et plusieurs de ses élèves de la première distinction. Par Made Le Prince de Beaumont* . . . (London, 1760), 2 vols, vol. 1, 82–3, my translation.
30. Clarissa Campbell Orr, 'Aristocratic Feminism, the Learned Governess, and the Republic of Letters', in Sarah Knott and Barbara Taylor, eds, *Women, Gender and Enlightenment* (Basingstoke: Palgrave Macmillan, 2005), 30. Llanover 3: 597.

31. Llanover 3: 585.
32. Ibid. 590.
33. Ibid. 598.
34. Ibid.
35. Ibid. 585, 16 Feb. 1760; 586–7. 'Russell, John, fourth Duke of Bedford (1710–1771)', ODNB online, https://doi.org/10.1093/ref:odnb/24320.
36. Llanover 3: 596, 599.
37. Ibid. 605.
38. Ibid. 605, 23 October 1760. 'Thicknesse [née Ford], Anne', and Kathleen Turner, 'Thicknesse, Philip (1719–1792)', ODNB online, ODNB online https://doi.org/10.1093/ref:odnb/27179; Michael Rosenthal and Martin Myrone, eds, *Gainsborough* (London: Tate Publishing, 2002); Susan Sloman, *Gainsborough in Bath* (New Haven and London: Yale University Press, 2002): 74, 160–2.
39. Ibid. 611–13.
40. Ibid. 618–22, 623–4.
41. Ibid. 630–1.
42. Ibid. 332–3.
43. Ibid. 634.
44. Ibid. 614.
45. Clarissa Campbell Orr, 'The Late Hanoverian Monarchy and the Christian Enlightenment', in M. Schaich, ed., *Monarchy and Religion: The Transformation of Royal Culture in Eighteenth-century Europe* (Oxford: Oxford University Press, 2007), 317–42.
46. W.S. Lewis (ed.), *The Yale Edition of Horace Walpole's Correspondence* (New Haven and London: Yale University Press, 1937–83), vol. 9, 378, 22 July 1761, HW to George Montagu; Sarah Scott, *The History of Mecklenburg from the First Settlement of the Vandals in that County to the Present Time*, 2 vols (London: J. Newbery, 1762).
47. Ibid. 4: 25–7.
48. Ibid. 81.
49. David Wilkinson, *The Duke of Portland: Politics and Party in the Age of George III* (London: Macmillan, 2003).
50. Llanover 4: 41–2.
51. Ibid. 19.

12 BERNARD AND THE DUCHESS BEFRIEND ROUSSEAU AND PATRICK PASSES AWAY

1. Llanover 4: 56.
2. David Edmonds and John Eidinov, *Rousseau's Dog* (London: HarperCollins, 2006), 171–203.
3. R.A. Leigh (ed.), *Correspondance complète de Jean-Jacques Rousseau*, 52 vols (Geneva and Oxford: Voltaire Foundation, 1965–98), 29: 198, no. L 5197, Rousseau to Mme de Luze, 10 May 1766, as translated in Edmonds and Eidinov, *Rousseau's Dog*, 232.
4. Llanover 4: 58.
5. Ibid. 59.
6. Ibid. 65.
7. Ibid. 67.
8. Ibid. 80–1, italics in the original; undated but conjectured by R.A. Leigh to be 10 September 1766, MD to Mary Dewes; see also Leigh, *Correspondance complète*, 30: 357, no. 5427.
9. Llanover 4: 80–1, italics in the original.
10. Llanover 4: 76.
11. His appointment began in 1766; in 1772 he became Lord Lieutenant of Ireland. Llanover 4: 76.
12. Ibid.
13. Edmonds and Eidinov, *Rousseau's Dog.*
14. Leigh, *Correspondance complète*, 31: 224, 246–7, 9 December 1767; 35: 57, 25 January 1768; 39: 172, 23 July 1773.

15. Cited in ibid. 33: 705, from *Gentleman's Magazine*, May 1767; ibid. 37: 275.
16. Llanover, 4: 106–7.
17. Ibid. 122.
18. E.g. ibid. 139–40; also in Leigh, *Correspondance complète*, 35: 57–8.
19. Leigh, *Correspondance complète*, 30: 313–14, no. 5400, 3 September 1766, my translation.
20. Ibid. 32: 173, 4 February 1767.
21. Edmonds and Eidinov, *Rousseau's Dog*, 171–203.
22. Leigh, *Correspondance complète*, 33: 209–10, 10 July 1767.
23. As noted by ibid. 35: 4 January 1768.
24. Ibid. 37: 41–2, February 1770; ibid. 39, 17 February and April 1772; ibid. 39: 92–3, 19 July 1772; ibid. 39: 172, 25 July 1773; ibid. 39: 203–4, 28 October 1773.
25. Llanover 4: 94–6. Edmonds and Eidinov, *Rousseau's Dog*, 213–17 and 219–30 for the reactions in France and England to Hume's account.
26. Ibid.
27. Ibid. 88–9.
28. Llanover 4: 101–3 (both quotes).
29. Ibid. 90; financial details ibid. 108.
30. Ibid. 54. As Earl Spencer, not Earl *of* Spencer, his titled ranked equally with that of a marquis.
31. Lady Cowper seems to have been relatively unaffected when her cousin and Mary's great-aunt, Anne Granville, oldest daughter of George Lansdowne, died in October 1767, telling Mary Dewes: 'One ought not to lament poor Mrs. Granville's being released from her misery, *She* was *always good*, in spite of bad example, and is now, I do not doubt, amply rewarded.' Llanover 4: 122. Anne had suffered from cancer since June 1765. Llanover 4: 52; also 54, 93, 132.
32. Llanover 4: 120.
33. Ibid. 125–6, 138–9.
34. Ibid. 108–9, 142–3.
35. Ibid. 112–13, 116–17.
36. Ibid. 118–19.
37. Ibid. 127, 129–30, 137.
38. Llanover 4: 132.
39. Ibid. 143–4.
40. Ibid. 144.

13 SEVEN WIDOWS AND THE FRIENDSHIP CIRCLE

1. Llanover 4: 148.
2. Ibid. 149.
3. Ibid. 181.
4. Ibid. 150.
5. Ibid. 154, 170.
6. Ibid. 189.
7. Ibid. 155.
8. 'David Garrick, 1717–1779: A Theatrical Life', http://folgerpedia.folger.edu/David_Garrick,_1717%E2%80%931779.
9. Llanover 4: 155–6.
10. Ibid. 160.
11. Ibid. 158.
12. The biography was by Sir William Oldys. Llanover 4: 158.
13. This is probably the three volumes of letters prepared by John Hawkesworth, as part of an edition of the complete works. The letters were first published in 1768.
14. Llanover 4: 158–9.
15. Ibid. 163.
16. Ibid. 163.
17. Ibid. 173, 162.

18. Ibid. 165.
19. Ibid. 161, 167.
20. Ibid. 169.
21. James Greig, ed., *The Diaries of a Duchess* (London: Hodder & Stoughton, 1926).
22. Llanover 4: 186.
23. Ibid. 190.
24. Ibid. 188.
25. E.g. ibid. 198.
26. Ibid. 229, 231.
27. Ibid. 200.
28. Ibid. 209–10.
29. Llanover 2: 223.
30. Llanover 4: 223–5.
31. Ibid. 232–3.
32. 'Mordaunt, Sir Charles (1697–1778)', www.historyofparliamentonline.org/volume/1754-1790/member.
33. Llanover 4: 205–6.
34. Elizabeth Eger, 'Out Rushed a Female to Protect the Bard: The Bluestocking Defence of Shakespeare', in Nicole Pohl and Betty Schellenberg, eds, *Reconsidering the Bluestockings* (San Marino, CA: Huntingdon Library, 2003), 127–55; Llanover 4: 237, 241, 267.
35. Llanover 4: 243.
36. Ibid. 242
37. Ibid. 246.
38. Ibid. vol. 19: 16, note 19.
39. Ibid. vol. 10: 11, 18 February 1762, GM to HW.
40. This is now in the Lewis Walpole Library, Farmington, CT. Michael Snodin with the assistance of Cynthia Roman (eds), *Horace Walpole's Strawberry Hill* (New Haven and London: Yale University Press, 2009), 315. For Bateman's high camp tastes, Llanover 4: 176–7.
41. Lewis (ed.), *Horace Walpole Correspondence*, vol. 30: 165; vol. 4: 219–20; 302–3; 589. Timothy Mowl, *The Great Outsider* (London: John Murray, 1996), 123, 148.
42. Llanover 4: 226.
43. E.g. ibid. 219.
44. Snodin and Roman (eds), *Strawberry Hill*, 71; Silvia Davoli, *Lost Treasures of Strawberry Hill: Masterpieces of Horace Walpole's Collection* (London: Scala Arts and Heritage Publishers Limited, 2018) – the Liotard self-portrait was displayed for this exhibition in a cabinet in the Tribune, not its original location: see p. 112.
45. It was the earl's younger brother who had been in Lisbon during the earthquake of 1755 (see p. 200).
46. Llanover 4: 399.
47. For example, ibid. 398–400.
48. Ibid. 401, 416.
49. Ibid. 400.
50. Ibid. 416.
51. Ibid. 402.
52. Ibid. 402.
53. Ibid. 408.
54. Ibid. 284.
55. Llanover 4: 406.
56. Ibid. 406, 431.
57. Ibid. 406, 431.
58. Ibid. 327.
59. Ibid. 428.
60. Llanover 4: 444
61. Ibid. 425–6, 430.

62. Ibid. 261–3.
63. Ibid. 433, 438. For Beaufort's resumption of court attendance, ibid. 375–6.
64. Confusingly for the unwary reader Longleat is in Somerset but the town of Weymouth, which gave its name to their then title, was in Dorset.
65. Llanover 4: 442.
66. Andrea Wulf, *Chasing Venus* (London: Windmill Press, 2013); Thomas Biskup, 'The University of Göttingen and the Personal Union 1737–1837', in B. Simms and T. Riotte, eds, *The Hanoverian Dimension in British History (1714–1837)* (Cambridge: Cambridge University Press, 2007), 128–60.
67. Llanover 4: 387.
68. Ibid. 448.

14 THE FIRST COLLAGES AND BLUESTOCKING INITIATIVES

1. Llanover 4: 399–400. The book was finally published in two volumes in 1777.
2. Ibid. 401.
3. Ibid. 416. This would have been Prince Augustus, the sixth son, born 27 January 1773.
4. Ibid.
5. Ibid. 404.
6. Ibid. 419.
7. Ibid.
8. Ibid. 406.
9. Llanover 5: 40.
10. Llanover 4: 431.
11. Ibid. 483–9.
12. Ibid. 510–11.
13. Ibid. 403.
14. Ibid. 438.
15. Llanover 5: 135–6.
16. Christopher Baker, William Hauptmann and Maryanne Stevens, eds, *Jean-Etienne Liotard 1702–1789* (London: Royal Academy Publications, 2015), 47.
17. Llanover 4: 474.
18. Ibid. 448.
19. Ibid.
20. Ibid. 451.
21. Cited in Veronica Baker-Smith, *Royal Discord: The Family of George II* (London: Athena Press, 2008), 109.
22. Llanover 4: 455–6.
23. Ibid. 446.
24. Ibid. 457.
25. Ibid. 465–6.
26. Ibid. 446.
27. Ibid. 469.
28. Ibid.
29. Ibid. 5: 114–15.
30. Ibid. 4: 576.
31. Ibid. 5: 90.
32. Ibid. 94.
33. Ibid. 100.
34. Ibid. 104.
35. Ibid. 106–8.
36. Ibid. 109.
37. Ibid. 111, 129.
38. Ibid. 133.

39. Ibid. 114, 121.
40. Ibid. 137–8.
41. Ibid. 139.
42. Ibid. 99, 109, 146.
43. Ibid. 109.
44. Ibid. 147.
45. Ibid.
46. Llanover 6: 93, 107, 134.
47. Ibid. 114.
48. Ibid. 105.
49. Ibid. 113.
50. Robin Simon, 'John Opie (1761–1807)', ODNB online, https://doi.org/10.1093/ref:odnb/20800. I am grateful to Robin Simon for discussing with me Opie's being introduced to the king by Mrs Delany.
51. Llanover 6: 100–2.
52. Ibid. 106–7.
53. Ibid. 103.
54. Ibid. 116.
55. Ibid. 123.
56. Arthur Sherbo, 'Cumberland, Richard (1732–1811)', ODNB online, https://doi.org/10.1093/ref:odnb/6888
57. Llanover 6: 124.
58. Llanover 6: 135–6.
59. Ibid. 140–2.
60. Anita McConnell, 'Beckford, William Thomas (1760–1844)', www.oxforddnb.com/view/article/1905; D.E. Ostergard, ed., *William Beckford, 1760–1844: An Eye for the Magnificent* (New Haven, CT: Yale University Press, 2001).
61. Llanover 6: 137.
62. Ibid. 143–4.
63. J.M. Rigg and Rev. R.D. Eagles, 'Gunning, Sir Robert, first baronet (1731–1816)', ODNB online, https://doi.org/10.1093/ref:odnb/11749; da Gantz, *The Pastel Portrait: The Gunnings of Castle-Coote and the Howards of Hampstead* (London: Cresset Press, 1963).
64. Elizabeth and Florence Anson, eds, *Mary Hamilton, afterwards Mrs. John Dickenson at Court and at Home. From letters and diaries 1756–1816* (London: John Murray, 1925).
65. I am very grateful to Lisa Crawley, Assistant Keeper Special Collections, for enabling me to see the Mary Hamilton Papers in the John Ryland's library, Manchester before they were fully catalogued.

15 REVIEWING THE COLLAGES AND GLIMPSING ROYAL FELICITY

1. Laird and Weisberg-Roberts, eds, *Mrs Delany and her Circle*, 299.
2. Llanover 5: 175.
3. Laird and Weisberg-Roberts, eds, *Mrs Delany and her Circle*, 275; Llanover 5: 163, 173. There is no separate catalogue of Ehret's watercolours for the Duchess of Portland.
4. *Flora Delanica* 6:21, 6:25, 7:654.
5. Llanover 5: 195, 197.
6. Ibid. 131, 135, 141–5.
7. Ibid. 11.
8. Ibid. 70, 79.
9. Llanover 5: 196.
10. Ibid. 276–7; 'Montagu, Frederick (1733–1800)', www.historyofparliamentonline.org/volume/1754-1790/member/
11. Llanover 5: 276–7.
12. Ibid. 272–3.

13. Ibid. 255. *Flora Delanica* 6:57. Lady Gower does not mention the mosaic in her letter of 4 September 1776, replying to one from Mrs Delany dated 2 September, but says, 'I am deeply in yo' debt for ye days you bestowed on me: though few in number they were all you had.' The mosaic itself is dated 26.8.76.
14. Llanover 5: 230, 303, 321.
15. Ibid. 236, 248.
16. Ibid. 325, 392, 248, 343.
17. Ibid. 251.
18. Ibid. 254.
19. Ibid. 266–7.
20. Ibid. 284–5; www.saintmartins-school.com/who-we-are/our-history.
21. Llanover 5: 297–8, 292–3.
22. Ibid. 290–1.
23. Llanover 5: 292.
24. Ibid. 295.
25. Ibid. 308–11.
26. Ibid. 310–11.
27. Ibid. 317.
28. *Flora Delanica* 8:67, 6:38, 7:54, 5:23.
29. Ibid. 330.
30. Ibid. 318–19, 337.
31. Ibid. 320, 337; Lewis (ed.), *Horace Walpole Correspondence*, vol. 32: 398. Horace Walpole mentions her 'frequently quoted bon mots' and her penchant for *double entendres*. Lewis (ed.), *Horace Walpole Correspondence*, vol. 32: 132 n. 13 and 233 n. 12.
32. See Cast of Characters.
33. Llanover 5: 350.
34. Ibid. 339.
35. Ibid. 355.
36. Ibid. 339.
37. Ibid. 342; Mrs Godfrey Clark, ed., *Gleanings from an Old Portfolio: containing some correspondence between Lady Louisa Stuart and her sister Caroline, Countess of Portarlington, and other friends and relations* (Edinburgh: privately printed, 1895), 4 vols.
38. Respectively, *Flora Delanica* 7:99, 7:100, 7:3.
39. Llanover 5: 345.
40. *Flora Delanica* 7:49, 9:44, 7:44; 8:30, 8:31, 9:7.
41. Ibid. 392–3.
42. Ibid. 414.
43. Ibid. 417.
44. Susan Hots, 'Smelt, Leonard, bap. 1725, d. 1800', ODNB online, https://doi.org/10.1093/ref:odnb/25754
45. Llanover 5: 430.
46. Ibid. 421.
47. *Flora Delanica* 1:64, 1:13 and 2:46.
48. *Flora Delanica* 1:70, 4:71.
49. Ibid. 426. *Flora Delanica* 5:80 and 5:81.
50. Ibid. 427.
51. Ibid. 447.
52. Ibid. 434.
53. What follows was written independently of Mark Laird's superb discussion of the sequence and subject matter of the mosaics in chapter 6 of his *A Natural History of English Gardening* (New Haven, CT: Yale University Press, 2015). We both reached the conclusion that the collection of mosaics constitutes a kind of album amicorum. Here I have emphasised more of the intellectual and social context provided by Mary Delany's family and coterie.
54. John 1:1 and Genesis 1:2–3, both from the King James Version of the Bible.

55. William Mason, *The English Garden*, lines 87–94, in *The Works of William Mason* (London, 1811), 4 vols, vol. 3.
56. John Milton, *Paradise Lost*, Bk 2, lines 1045–52, in *Poetical Works*, ed. Douglas Bush (Oxford: Oxford University Press, 1969), 255–6.
57. For example, *Flora Delanica* 1:67, where the snapdragon leaves seem to engage in a rhythmic dance, as do *Disander prostrata* [3:89] and the *Dodecathian meadia* [3:90]. *Flora Delanica* 5:97 shows the very untidy groundsel leaves.
58. Llanover 6: 97.
59. Cecil Aspinall-Oglander, *Admiral's Widow, being the Life and Letters of the Hon. Mrs. Boscawen from 1761–1805* (London: Hogarth Press, 1942), 95.
60. Llanover 5: 327.
61. Ibid. 443–4.
62. Llanover 4: 457.
63. Llanover 5: 457–8, 461, 484.
64. *Flora Delanica* 8: 78.
65. Llanover 5: 473.
66. Ibid. 474.
67. Ibid. 473–4.
68. Ibid. 480.
69. Ibid. 495.
70. Ibid. 487.
71. Ibid. 495–6; Laird and Weisberg-Roberts, *Mrs. Delany and her Circle*, 228.
72. Llanover 6: 76.
73. Ibid. 5: 495–6.

16 POIGNANT FAREWELLS AND NEW DEVELOPMENTS

1. Llanover 6: 85; Llanover 5: 511.
2. Llanover 5: 511, 551.
3. Ibid. 526, 522, 551.
4. Ibid. 517, 515, 525.
5. The coincidence of Mrs Delany's birthday party and the royal one so close to the riots meant any mention of either occasion in letters to Mary Port was eclipsed.
6. Christopher Hibbert, *George III: A Personal History* (London: Penguin Group, 1999), 215–25; Jeremy Black, *George III: America's Last King* (New Haven, CT: Yale University Press, 2006), 244–5. Aspinall-Oglander, *Admiral's Widow*, 102–3.
7. 'Gordon, Lord George (1751–93)', www.historyofparliamentonline.org/volume/1754-1790/member/
8. Aspinall-Oglander, *Admiral's Widow*, 103.
9. Llanover 5: 552.
10. Ibid. 5: 553.
11. Ibid. 554–5, 561.
12. Ibid. 562, 566.
13. Ibid. 563–4, 569.
14. The lock of hair is still in the Royal Archives: GEO/ADD/264.
15. Llanover 6: 5, 448, 388n.
16. Ibid. 4.
17. Ibid. 2. George III wrote to Lord Dartmouth: 'I am certain his sons must have been bred up in the school of virtue and decorum, as such I think of your second son Mr Legge for one of [the Prince of Wales's] Grooms of the Bedchamber.' The king hoped, rather optimistically, that such a proper young man would be a good influence on his wayward heir. *Historical Manuscripts Commission, Dartmouth*, vol. 1, 441, Letter from George III, 23 December 1780.
18. Llanover 6: 6, 18, 17.
19. Ibid. 10–11.

20. Ibid. 16–17.
21. Ibid. 25, 30, 31, 32, 35.
22. Ibid. 50. The parrot cage evidently travelled between London and Bulstrode.
23. www.hrp.org.uk/exhibition-archive/secrets-of-the-royal-bedchamber/the-royal-beds/#gs. tXa=A4Y.
24. Llanover 6: 38, 72, 79.
25. Ibid. 70.
26. Ibid. 35.
27. Llanover 6: 71–3.
28. Ruth Smith, 'Jennens, Charles (1700/01–1773)', ODNB online, https://doi.org/10.1093/ ref:odnb/14745.
29. www.packingtonestate.co.uk/.
30. Llanover 6: 71–3, 81.
31. I am grateful to my colleague at Anglia Ruskin University, Prof. Shahina Pardham, for discussing Mrs Delany's symptoms with me.
32. Llanover 6: 93, 107, 134.
33. Ibid. 114.
34. Ibid. 158.
35. Ibid. 105.
36. Ibid. 94. *Essay on the Genius and Writings of Pope* (1756 and 1782), 2 vols. Warton also edited Pope's poetry.
37. Llanover 6: 113.
38. Robin Simon, 'John Opie (1761–1807)', ODNB online, https://doi.org/10.1093/ref:odnb/ 20800. I am grateful to Robin Simon for discussing with me Opie's being introduced to the king by Mrs Delany.
39. Llanover 6: 100–2.
40. Ibid. 116.
41. Ibid. 123.
42. http://hartleburycastletrust.org/.
43. Llanover 6: 135–6.
44. Ibid. 140–1.
45. Ibid. 140–2.
46. Ibid. 147.
47. I am very grateful to Lisa Crawley, Assistant Keeper Special Collections, for enabling me to see the Mary Hamilton Papers in the John Ryland's library, Manchester before they were fully catalogued.
48. Llanover 6: 159, 172.
49. Ibid. 162.
50. Ibid. 16.
51. Frances Harris, *A Passion for Government: The Life of Sarah, Duchess of Marlborough* (Oxford: Oxford University Press, 1991).
52. Llanover 6: 175.
53. Ibid. 171.
54. Ibid. 164, 160.
55. Ibid. 179.
56. Ibid. 169, 170, 173, 180, 188, 234.
57. Ibid. 197, 201, 204, 206.
58. Ibid. 199–205. Later the vase, known now as the Portland vase, was purchased by the duchess's son, and was on long-term loan to the British Museum, which now owns it.
59. Llanover 6: 216.
60. Ibid. 235–7.
61. Ibid. 278.
62. Ibid. 224, 226–7, 234.
63. Ibid. 224, 227.

64. www.hatfield-herts.co.uk/aviation/lunardi.html.

65. Llanover 6: 235, 250.

66. Ibid. 251.

67. Ibid. 259.

68. Ibid. 254–7.

69. Ibid. 259.

70. Ibid. 265.

71. Ibid. 265, 263.

72. Ibid. 264–5.

73. Ibid. 272–4.

74. Ibid. 271–4.

75. Ibid. 287.

76. Ibid. 281, 2

77. Llanover, 6: 388.

78. Peter Sabor, ed., *Court Journals and Letters of Frances Burney*, vol. 1: *1786* (Oxford: Clarendon Press, 2011), 219.

79. Llanover 6: 310, 303.

80. Ibid. 300–1.

81. Ibid. 340, 342.

82. Ibid. 338.

83. Ibid. 338, 340; Flora Fraser, *Princesses: The Six Daughters of George III* (London: John Murray, 2004), 90–1, suggests that Elizabeth's cough may have been tubercular.

84. Llanover 6: 316, 320, 326, 340.

85. Ibid. 341.

86. Ibid. 365.

87. Georgiana eventually mastered how to write quickly in a legible style: ibid. 289.

88. Ibid. 337, 389.

89. Ibid. 366.

90. Ibid. 279.

91. Ibid. 316–17.

92. Ibid. 362.

93. Sabor, ed., *Court Journals and Letters of Frances Burney*, vol. 1: *1786*, xxv.

94. John Brooke, *King George III* (London: Panther Books, 1974), 498; Black, *George III*.

95. Llanover 6: 159.

96. Sabor, ed., *Court Journals and Letters of Frances Burney*, vol. 1: *1786*, 176.

97. Llanover 6: 176, 256.

98. Cynthia Roman, 'The Art of Lady Diana Beauclerk: Horace Walpole and Female Genius', in Snodin and Roman (eds), *Strawberry Hill*, 155–68.

99. www.richmond.gov.uk/local_history_j_thomson.pdf.

100. Llanover 6: 427–8; Susan Hots, 'Smelt, Leonard (bap. 1725, d. 1800)', ODNB online, https://doi.org/10.1093/ref:odnb/25754.

101. Llanover 6: 449, 476.

102. Barbara Brandon Schnorrenberg, 'Trimmer [née Kirby], Sarah (1741–1810)', ODNB online, https://doi.org/10.1093/ref:odnb/27740; see also http://hockliffe.dmu.ac.uk/items/0245.html.

103. Llanover 6: 454, 460.

104. Ibid. 476.

105. Ibid. 477–81.

Select Bibliography

PRIMARY SOURCES

Manuscripts
Ballard, Ms, Bodleian Library, Oxford
Elizabeth Robinson Montagu Papers, Huntington Library, San Marino, California
Granville Letters, Newport Public Library, Wales
National Library of Wales, Aberystwyth
Victoria and Albert Museum, National Art Library, Forster Collection.

Printed primary sources
Astell, Mary, *A Serious Proposal to the Ladies*, ed. P. Springborg (Peterborough, ON: Broadview Literary Texts, 2002)
Baker-Smith, Veronica, *Royal Discord: The Family of George II* (London: Athena Press, 2008)
Barbauld, Anna, *Correspondence of Samuel Richardson, Selected from the Original Manuscripts, . . .*, 6 vols (London: R. Phillips, 1804)
Berkeley, George, *Alciphron, or: The Minute Philosopher*, 3 vols (Oxford: The Clarendon Press, 1732)
Camden, Charles Pratt, *The Reverend Patrick Delany, Appellant . . . Thomas Tenison and others . . . Respondents* (London, 1758)
Cicero, *On Moral Ends* (1702)
Day, Angélique (ed.), *Letters from Georgian Ireland: The Correspondence of Mary Delany 1731–68* (Belfast: The Friar's Bush Press, 1994)
De Lafayette, Mme, *The Princesse de Clèves*, trans. Terence Cave (Oxford: Oxford University Press, 1992)
Delany, Patrick, *Religion Examined with Candour* (London: C. Rivington, 1733)
Elias, A.C. (ed.), *Memoirs of Laetitia Pilkington*, 2 vols (Athens, GA: University of Georgia Press, 1997)
Gay, John, *Fables*, 2 vols (London, 1727)
Kerhervé, Alain (ed.), *Mary Delany (1700–1788) and the Court of King George III*, vol. 2 of Michael Kassler (gen. ed.), *Memoirs of the Court of George III*, 4 vols (London: Pickering and Chatto, 2015)
Leigh, R.A. (ed.), *Correspondance complète de Jean-Jacques Rousseau*, 52 vols (Geneva and Oxford: Voltaire Foundation, 1965–98)
Lewis, W.S. (ed.), *The Yale Edition of Horace Walpole's Correspondence* (New Haven and London: Yale University Press, 1937–83)
Llanover, Lady (ed.), *The Autobiography and Correspondence of Mary Granville, Mrs Delany*, 6 vols (London: Richard Bentley, 1861–2)
Mowl, Timothy, *The Great Outsider* (London: John Murray, 1996)

SELECT BIBLIOGRAPHY

Ovid, *Metamorphoses*, trans. Samuel Garth (Verona: The Limited Editions Club, 1958)

Rand, B. (ed.), *The Correspondence of George Berkeley and Sir John Perceval* (Cambridge: Cambridge University Press, 1914)

Steele, Richard [George Berkeley], *The Ladies Library, Written by a Lady* (London: Jacob Tonson, 1712)

Swift, Jonathan, *Directions to Servants* (London: Hesperus Press, 2005)

Swift, Jonathan, *Gulliver's Travels* (Harmondsworth: Penguin, 1967)

Wortley Montagu, Lady Mary, *Essays and Poems and Simplicity, a comedy*, ed. Robert Halsband and Isobel Grundy (Oxford: Clarendon Press, 1977)

Visual sources and artefacts

Flora Delanica, 10 vols, British Museum, Prints and Drawings, acquired 1897 (Mrs Delany's collages)

National Gallery of Ireland, 2722 (Delany album)

Ulster Museum, Belfast embroidered bedcover

SECONDARY SOURCES

Anon., *Buckland Manor, History*

Barnard, Toby C., *The Abduction of a Limerick Heiress: Social and Political Relations in Mid-eighteenth-century Ireland* (Dublin: Irish Academic Press, 1998)

Bucholz, R., 'Going to Court in 1700: A Visitor's Guide', *The Court Historian* 5(3) (Dec. 2000), 181–216

Burnett, David, *Longleat: The Story of an English Country House* (Wimborne, Dorset: The Dovecote Press, 1988)

Chalus, Elaine, *Elite Women in English Political Life c. 1754–179* (Oxford: Clarendon Press, 2004)

Clarke, Norma, *Queen of the Wits: A Life of Laetitia Pilkington* (London: Faber & Faber, 2008)

Cohen, Michèle, *Fashioning Masculinity: National Identity and Language in the Eighteenth Century* (London: Routledge, 1996)

Crookshank, Anne, 'Amusement Arcadia', *World of Interiors* (Condé Nast Publications), April 1998: 130–9

Davoli, Silvia, *Lost Treasures of Strawberry Hill: Masterpieces of Horace Walpole's Collection* (London: Scala Arts and Heritage Publishers Limited, 2018)

Doody, Margaret Anne, 'Swift and Women', in Christopher Fox (ed.), *The Cambridge Companion to Jonathan Swift* (Cambridge: Cambridge University Press, 2003), 87–111

Dunleavy, M., 'Samuel Madden and the Scheme for the Encouragement of Useful Manufactures', in A. Bernelle (ed.), *Decantations* (Dublin: Lilliput Press, 1992), 21–8

Earnshaw, B. and T. Mowl, *An Insular Rococo* (London: Reaktion Books, 1999)

Handyside, Elizabeth, *Granville the Polite: The Life of George Granville, Lord Lansdowne, 1666–1735* (London: Oxford University Press, 1933)

Harris, Frances, ' "The Honourable Sisterhood": Queen Anne's Maids of Honour', *British Library Journal* 19(2) (1993), 181–98

Harris, Frances, *Transformations of Love: The Friendship of John Evelyn and Margaret Godolphin* (Oxford: Oxford University Press, 2003)

Hayden, Ruth, *Mrs Delany: Her Life and Her Flowers* (London: British Museum Press, 1992)

HMSO Belfast, *Archaeological Survey of Northern Ireland, County Down* (Belfast: HMSO, 1966)

Green, V.H.H., *The Young Mr. Wesley* (London: Edward Arnold, 1961)

Grundy, Isobel, 'Lady Mary Wortley Montagu and Her Daughter: The Changing Use of Manuscripts', in George L. Justice and Nathan Tinker (eds), *Women's Writing and the Circulation of Ideas: Manuscript Publication in England, 1550–1800* (Cambridge: Cambridge University Press, 2002), 182–201

Grundy, Isobel, *Lady Mary Wortley Montagu, Comet of the Enlightenment* (Oxford: Oxford University Press, 1999)

SELECT BIBLIOGRAPHY

Johnston, Edith Mary, *Ireland in the Eighteenth Century* (Dublin: Gill & Macmillan, 1974)

Kerhervé, Alain, 'Mrs Delany's Virtual Library', in *Mary Delany (1700–1788) and the Court of King George III*, vol. 2 of Michael Kassler (gen. ed.), *Memoirs of the Court of George III*, 4 vols (London: Pickering and Chatto, 2015), 291–304

Livesey, James, 'The Dublin Society in Eighteenth-Century Irish Political Thought', *Historical Journal* 47(3) (2004), 615–40

Maginnin, Eoin, 'Coal, Corn and Canals: Parliament and the Dispersal of Public Moneys 1695–1772', in D.W. Hayton (ed.), *The Irish Parliament in the Eighteenth Century: The Long Apprenticeship* (Edinburgh: Edinburgh University Press for the Parliamentary History Yearbook Trust, 2001), 71–86

Munns, Jessica and Penny Richards, 'A Woman of Extraordinary Merit: Catherine Bovey of Flaxley Abbey, Gloucestershire', in Caroline D. Williams, Angela Escott and Louise Duckling (eds), *Woman to Woman: Female Negotiators during the Long Eighteenth Century* (Newark: University of Delaware Press, 2010), 101–16

Nicolson, Adam, *Gentry: Six Hundred Years of a Peculiarly English Class* (London: Harper, 2012)

Perry, Ruth, *The Celebrated Mary Astell: An Early English Feminist* (Chicago: University of Chicago Press, 1986)

Reeves, Marjorie, *Female Education and Nonconformist Culture 1700–1900* (Leicester: Leicester University Press, 2000)

Retford, Kate, *The Art of Domestic Life* (New Haven, CT, and London: Yale University Press, 2006)

Rogers, Pat, *Pope and the Destiny of the Stuarts: History, Politics and Mythology in the Reign of Queen Anne* (Oxford: Oxford University Press, 2005)

Rose, Craig, *England in the 1690s: Revolution, Religion and War* (Oxford: Blackwell, 1999)

Smith, Hannah, *Georgian Monarchy: Politics and Culture, 1714–1760* (Cambridge: Cambridge University Press, 2006)

Smith, Hannah, 'Mary Astell, *A Serious Proposal to the Ladies* (1694), and the Reformation of Manners in Late-17th-Century England', in William Kolbrener and Michal Michelson (eds), *Mary Astell: Reason, Gender, Faith* (Aldershot: Ashgate, 2007), 31–47

Snodin, Michael, with the assistance of Cynthia Roman (eds), *Horace Walpole's Strawberry Hill* (New Haven and London: Yale University Press, 2009)

Somerset, Lady Anne, *Ladies in Waiting from the Tudors to the Present Day* (London: Weidenfeld & Nicolson, 1984)

Tague, Ingrid, *Women of Quality* (Woodbridge, Suffolk: The Boydell Press, 2002)

Turpin, John, *A School of Art in Dublin since the Eighteenth Century* (Dublin: Gill & Macmillan, 1995)

Wilde, Francesca Suzanne, 'London Letters (1720–28) written by Mary (Granville) Pendarves to her sister, Anne Granville, in Gloucester. A sequence from the Autobiography and Correspondence of Mary Delany (1700–88), formerly Mary Pendarves, née Granville', unpublished PhD thesis, University of York, April 2005

Worsley, Lucy, 'Female Patronage in the Eighteenth Century and the Case of Henrietta Cavendish Holles Harley', *Architectural History* 48 (2005), 138–62

DATABASES AND ONLINE RESOURCES

British Museum: www.britishmuseum.org/research/collection_online/search.aspx (Delany collages)

Crittall, Elizabeth (ed.), *A History of the County of Wiltshire*, Victoria County History, vol. 8, www.british-history.ac.uk/vch/wilts/vol8

'Gloucestershire Archives References to Black & Asian people, pre-1939', www.gloucestershire. gov.uk/CHttpHandler.ashx?id=26307&p=0, p. 2

History of Parliament: www.historyofparliamentonline.org/

Oxford Dictionary of National Biography (ODNB): http://www.oxforddnb.com/

Sainty, J.C. and R.O. Bucholz, *Officials of the Royal Household 1660–1837* (London: University of London Institute of Historical Research), 2 vols: www.luc.edu./history/fac_resources/bucholz/DCO/DCO.html

Index

Relatedness to Mary Delany (née Granville) is inserted in brackets after an entry.

Reference to 'Mary' in a subheading is to Mary Delany, the subject of this book.

See also Cast of Characters

INDEX

INDEX

INDEX

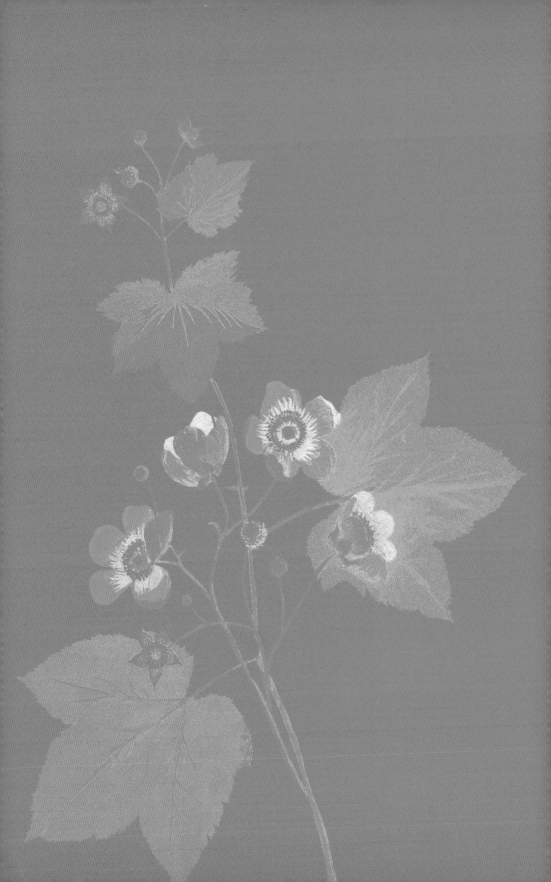